History as a Profession

History as a Profession

THE STUDY OF HISTORY IN FRANCE, 1818–1914

PIM DEN BOER

Translated by Arnold J. Pomerans

PRINCETON UNIVERSITY PRESS

PRINCETON, NEW JERSEY

Translated from Pim den Boer, *Geschiedenis als Beroep: De professionalisering van de geschiedbeoefening in Frankrijk (1818–1914)*. Copyright © 1987 SUN, Nijmegan

Library of Congress Cataloging-in-Publication Data

Boer, Pim den.
[Geschiedenis als beroep. English]
History as a profession : the study of history in France (1818–1914) /
Pim den Boer ; translated by Arnold J. Pomerans.
p. cm.
Includes bibliographical references and index.
ISBN 0-691-03339-0 (cloth : alk. paper)
1. Historiography—France—History—19th century.
2. History—Study and teaching—France. I. Title.
DC36.9.B6413 1998 907′.2044—dc21 97-39415 CIP

The translation was made possible by a grant from the Netherlands Organization for
Scientific Research

This book has been composed in Berkeley Book Mod.

Princeton University Press books are printed on acid-free paper and meet the guidelines
for permanence and durability of the Committee on Production Guidelines for Book
Longevity of the Council on Library Resources

http://pup.princeton.edu

Printed in the United States of America

10 9 8 7 6 5 4 3 2 1

PARENTIBUS

CONTENTS

ILLUSTRATIONS

Figures 1, 2, 3, 4, 5, 7, 8, 9, 11, and 12 used by permission of the University Library, Utrecht.
Figures 6 and 10 used by permission of the Bibliothèque Nationale, Paris.

THIS STUDY has two objectives. The first is to provide an institutional analysis of nineteenth- and early-twentieth-century French historical studies. This account of the creation and the operations of French research institutes seeks to throw fresh light on the structural and contingent aspects of the growth of historiography. The approach owes much to Robert K. Merton's contribution to the sociology of science, to Joseph Ben-David's institutional comparisons, to Derek J. de Solla Price's quantifying approach in scientific research, and, for the French-speaking world, to Robert Escarpit's sociology of literature.[1] Karl Popper's and Thomas Kuhn's work in the philosophy of science, though intellectually challenging, proved less relevant to the research. The history of the humanities seems to raise problems different from, and ought to be tackled in terms other than, those suggested by the editors of the *International Encyclopedia of Unified Science.*[2]

The second objective is to reappraise pre-1914 history studies at French universities. At first I kept that objective to myself—it was dictated not by the head but by the heart. In purely intellectual terms Lucien Febvre, that brilliant polemicist, seems to have been absolutely right: nothing but one's instincts can make one feel sympathy for such historians as Charles Seignobos and Charles-Victor Langlois, men he demolished so effectively.[3] Not until I began my own research did I realize how unfair his treatment of these two men had been.

Generous tribute has been paid throughout the world to the historians associated with the *Annales d'histoire économique et sociale,* a journal now published under the title *Annales: Economies, Sociétés, Civilisations* (founded in 1929), and to the "extra-mural" Sixth Section of the Ecole pratique des hautes études, now the Ecole des hautes études in sciences sociales (founded in 1946). After the Second World War French historiography gained unchallenged worldwide supremacy, taking the place of its nineteenth-century German predecessor. Panegyrics to the *Annales* school went hand in hand with laments about predecessors. It was generally agreed that French academic history had passed through "a barren period" before 1914. Henri-Irénée Marrou and Philippe Ariès, in particular, inveighed against the men who had taught them at the Sorbonne, echoing Febvre's blistering attack on Seignobos and his colleagues.[4] And though Marc Bloch still had some reservations, he too was highly critical of his teachers.[5] The resulting black-and-white picture suggests the existence of two diametrically opposed forms of historiography, one degraded, the other immaculate. There appeared to be a glaring contrast between the impeccable standards of the *Annales* and the historical studies of its precursors. A gulf had opened up in the progress of historiography, a split between the multidisciplinary and wide-ranging structural studies of the *Annales* school—which flourished outside the universities—and the narrow historical studies of its academic forerunners whose attention had been myopically and exclusively focused on political events.[6]

This negative picture was highlighted by a theoretical exposition by François Simiand, whose authority seemed beyond challenge. That sociologist's celebrated diatribe against the historical method of Seignobos and his colleagues is still considered the last word on the subject.[7] However, the history of historiography becomes a caricature of itself if historical research into a given period is judged purely by theoretical presuppositions. The historiographer feels drawn to the workshop of the historical craftsman, and a good way to enter it is by a quantitative and institutional approach.

This study will show that the black-and-white picture of historiography is a distortion. The "extramural" *Annales* school owed its striking success to the fact that a solid basis for historical research had been laid at French universities before the First World War.

A grant from the Dutch National Research Council, enabled me to spend the 1976–77 academic year in Paris. At first the overwhelming volume and diversity of the source material I encountered there suggested to me that I ought perhaps to confine my research to the life of Gabriel Monod or Ernest Lavisse, two key figures in French academic historiography before the First World War. I drew fresh courage, however, from Jean Glénisson's seminars in the learned Institut de recherche et d'histoire des textes and especially from Charles-Olivier Carbonell's *Histoire et historiens*, a thesis published in 1976. Carbonell introduced me to the world of historiographic bibliometry. A general appraisal of historical works and historians provides a starting point for fitting the academic study of history into the framework of historical writing as a whole and for setting the professional historian in his social context. The historian too can be studied as a member of a group.

One result of my own bibliometric endeavors was that I became increasingly conscious of the need to discover why university historians played so small a part during the first seventy-five years of the nineteenth century. The mere fact that I should even concern myself with this subject was held against me. It must have been in the spring of 1977, when I was browsing among the papers of the Ministry of Education at the Archives Nationales, that a brisk, rather short man tapped me on the shoulder and invited me to coffee at the bar facing the entrance to the Palais Soubise. He turned out to be Guy Thuillier, a man of wide-ranging scholarship. He had deduced from my clumsy approach that I must be a foreigner, and curious, as it behooves the historian to be, he had also found out that I was working my way through files on professors in the arts faculty. He fired a broadside at the intellectual poverty of academic historians past and present. "The local *érudits*—those were the real scholars. You are wasting your time collecting data on professors of history." When I insisted that I was fascinated by the small world of the faculty of arts, he showered me with details of studies on local historians in his beloved Nivernais.

This and other experiences led me to widen the scope of my thesis. Even so, the professionalization of historical studies continued to play an important role even in the new approach. I decided to use a simple definition: *professionalization* is the increase in the number of professionals. By *professional historians* I

refer to those who earn their living from the study of history. Their intellectual contribution need not differ from that of nonprofessional historians. The distinction is one of social position. It was only in the nineteenth century that governments began to pay large numbers of people to study the past, to teach history, or to administer archives. This growing state involvement laid the foundations for the social status of present-day professional historians. Historians were being turned into state officials; in earlier centuries the number of such officials had been very small indeed.

All this brought home to me that higher history education must be treated not as an isolated showpiece but as a direct result of state investment in historical research and of the emergence of a job market for qualified history teachers in secondary schools. The structure of the first four chapters was now clear. A bibliometric introduction would be followed by a survey of state investment in history; next there would be a review of the teaching of history in secondary schools; and only after that would I look at institutes of higher education.

Even so, no historian can confine him- or herself to an institutional and quantitative approach, however useful it may be. That sort of analysis is too bureaucratic, detached, and abstract. The historian will also want to look at the life and work of the men associated with institutional developments. The reports of the inspectors of higher education reflect a whole world of minor and major historians. In chapter 5 I try to correlate the changes in the attitude of the typical professor of history with the growth in the number of professional historians. The sixth chapter is devoted to the intellectual contributions of these professional historians. I have chosen several categories of historical writing for closer analysis.

Quantification is an important feature of this book, but I hope that the numerical approach has not become an end rather than simply a means. My computations are based on a number of serial publications, including the records of the Dépôt legal in the *Bibliographie de la France* and the financial records of the Ministry of Education. In addition, several series of unpublished sources have been consulted, including the personal files of professors and reports by school inspectors and the police. In the case of some important historians I have also made use of their private correspondence. For a general survey the reader is referred to the bibliography.

My initial intention was to begin the survey at about 1870 because it was after that date that the arts faculties underwent important institutional reforms. However, my decision to widen the scope meant going further and further back in time in order to place the intellectual statistics, the funding of historical studies, and the teaching of history at secondary schools in the correct historical perspective. By contrast, when it came to the life and work of university historians, my attention remained focused on the years since 1870, the actual beginning of the modern study of history in French institutes of higher education. The terminus ad quem was the outbreak of the First World War, which is generally seen as a historical watershed. As the war took its toll, intellectual life lost its bearings. Such events demonstrate the relative nature of all institutional development.

History as a Profession

The Contours of French Historiography, 1820–1914

"THE INCREASE in printed matter published in France over the past few years has been much greater than the increase in the number of people, horses and sheep," Baron Charles Dupin observed with satisfaction in 1827.[1] Among the many causes of this trend the busily computing baron mentioned that more people had learned to read (12 million out of a total population of 26 million, compared with a mere 7 million before the Revolution) and that they were devoting more time to reading. Dupin was even able to calculate that people read three hours a month on average, which amounted to six minutes per person per day. Moreover, during the past few years people had been reading serious rather than light books: civilization was forging ahead.

Baron Dupin derived his optimistic views of progress and enlightenment at the time of the Restoration from a comprehensive report on the state of the French press during the preceding years recently published by the comte de Daru.[2] Daru's approach was down-to-earth. The production of printed matter of all kinds had created a large industry in which many people earned their living, to the tune of about 34 million francs a year, converting cheap base materials such as rags, soot, oil, skins, and so on, into paper, print, and bindings. Daru was anxious to convey a clear picture of the economic importance of an industry hamstrung by all sorts of regulations. He pleaded for greater freedom of the press on purely economic grounds.

As an early-nineteenth-century liberal, however, Daru was interested not only in the output but also in the contents of printed matter. To that end he compiled a survey of the writing that had rolled off the presses during a given period in order to provide what he called "intellectual statistics,"[3] which would mirror the trend of public opinion. According to Daru, intellectual output, that is, printed matter, reflected the state of society inasmuch as it, and the press in particular, was bound to agree with the taste of the readers. If the press was thought to be unsatisfactory—and what government ever thought otherwise?— then, according to Daru, the solution was not to put obstacles in its way but to change public opinion.

Of course, the relationship between public opinion and the press was not nearly as simple as Daru made it out to be. First of all, the press itself plays a large role in shaping public opinion. The interests and ambitions of those who run this branch of industry can help to paint the wrong picture of the outlook of the man in the street.

Second, in no country has the press fully reflected public opinion, least of all in nineteenth-century France, with its widespread agrarian regions, each with a mainly oral culture of its own.

Third, there is the additional problem of registering the intellectual output. A large number of cheap little volumes, often reprinted in the provinces, were never registered at all. This "unregistered" infraliterature might be religious or subversive in character. At the time, Avignon, for instance, was a center for reprinting religious works on a large scale,[4] while Geneva was an active center for the printing of Enlightenment propaganda.[5]

Fourth, there are also more general objections to applying quantitative methods in the intellectual field. Is counting and classifying titles (which is what it comes down to in this case) the right approach? Are differences not masked by averages? Does not dabbling in such figures confine the investigator to the periphery of the phenomenon under investigation? Is it not wrong in principle to use such crude means for answering subtle questions? Although all of these objections to Daru's intellectual statistics (and to modern quantitative cultural historians) have some justification, intellectual statistics provide an overall picture and a numerical framework that cannot otherwise be obtained. Although intellectual statistics have their limitations, they are nevertheless important as preliminary guides.

THE OUTPUT

Daru gave the number of sheets produced for printing, which, depending on the required format (folio, quarto, octavo, etc.), could be folded into various numbers of pages.[6] The figures covering the period from November 1811 to December 1825 are the basis for table 1. It will be noted that during these fourteen years of Empire and Restoration literature, history, and religion jointly accounted for a good two-thirds of the literary output, and literature and history combined, for more than half. These figures, however, do not mean very much unless they are compared with figures covering another period. The changing proportions associated with the various fields can then be used to highlight intellectual trends in society.

If we compare the percentages of published titles in the period prior to the French Revolution (ignoring size and circulation), we discover a slight recovery under the heading of religion, which dropped from 35 percent in 1723–27 to just over 10 percent in 1784–88, to rise again by nearly 14 percent in 1811–25.[7] Almost a century later, in 1909, the figures for religion would be more than halved, to account for just 6 percent of the total output.[8] The figures under the heading of law were found, by various soundings, to have remained relatively stable through the centuries, ranging from 8.3 percent in 1784–88 and 8.4 percent in 1811–25 to 7 percent in 1909. The proportion of literary works decreased steadily, from 31.2 percent in 1784–88 to 25.2 percent in 1811–25 to 18.9 percent in 1909. The very mixed heading of art and science, which according to the soundings had risen from 20 percent to 30 percent shortly before the Revolution, could not, according to the Daru report, have amounted to more than 16.1 percent, or at most to 21 percent, in 1811–25 (the total

TABLE 1
Intellectual Output, 1811–1825

Subject	% of Total Output	
Religion	13.8	
Law	8.4	
Science	8.0	
Philosophy	2.2	
Political economy, administration, finance	2.9	
Military science, military administration and legislation	1.2	
Arts	1.8	
Literature	25.2	
History	31.5	
Various almanacs, etc.	4.9	
Total	100.0	(1,152 million sheets)

ªIncluding politics and polemics; when these are excluded, the percentage is 27.5

minus the amounts for religion, law, literature, and history) and 29.3 percent in 1909, but the classification criteria, however global, render these comparisons more uncertain than comparisons used for the other headings. The share of history, about which more will be said below, rose from 18.7 percent in 1784–88 to 27.5 percent in 1811–25 to reach 30.3 percent in 1909.

These percentages, which, as I have stressed, must be treated with some reservation because of the differences in the criteria and units of classification used, ignore one hard fact completely, namely, the gigantic increase in the absolute figures. Thus, although fewer than 4,500 titles could be listed for the five-year period 1784–88,[9] that is, fewer than 900 a year, the meticulous librarian Eugène Morel was able to list 11,000 books and brochures of various formats in 1909.[10] In other words, the intellectual output had grown twelvefold in 125 years. Religion, for instance, considered in absolute figures, accounted for less than half as many publications during the five-year period 1784–88 as it did in 1909 alone. The reduction from 14 percent to 6 percent thus went hand in hand with a steep increase in the absolute figures.

The expansion of the intellectual output was uneven. Although there was an increase during the First Empire and the Restoration, book production stagnated from the late 1820s to 1850 and then increased again during the Second Empire and at the beginning of the Third Republic, with a maximum output of 15,000 titles at the end of the nineteenth century. The beginning of the twentieth century saw another reduction, which was followed by a slight recovery before the First World War.[11] But these cyclical fluctuations due to a combination of industrial and technical, general economic, and cultural factors are less important than the general trend, which shows that in the decades preceding

the French Revolution 900–1,000 titles were produced annually, compared with 12,000–15,000 at the end of the nineteenth century.[12]

Whatever one's objections to the view that intellectual statistics mirror social development, it is certain that printed matter gained a much wider circulation and, we may assume, greater influence during the period under review. The increase in the number of books, journals, and readers thus seemed to justify Baron Dupin's optimism. Whether his optimistic view of the salutary influence of this trend on the mental attitude of the nation at large was equally justified is a different matter.

The Accumulated Output

A book, once published, disappears from the current output figures. But books endure and can also be read in later years. One way of determining the increase in the number of books and at the same time fitting them under our various headings is to look at what may be termed the *accumulated* output.[13]

In 1897 the largest repository of intellectual products in France, the Bibliothèque Nationale, contained more than 2 million items (some "items" comprising large series made up of many volumes), whereas in 1684 the Bibliothèque du Roi could boast no more than some 35,000 folios, quartos, and octavos.

Léopold Delisle's lengthy introduction to the printed catalogue of the Bibliothèque Nationale contains figures on which I have based my estimates of the stock of books at the end of the seventeenth century and at the end of the nineteenth. Approximately 20 percent of the headings used in 1897 are not included here because they are not comparable. If nothing else, the increase in the number of such headings reflects growing specialization (see appendix 1).[14]

In any case, we can tentatively note a few differences that were probably the result of developments partly reflected in the annual figures. Thus religion came to hold a relatively much smaller place in the intellectual statistics; history lost some ground in relative terms, primarily owing to the decreased importance of church history; and law, natural science, and arts and letters came to hold a relatively larger place. There was a marked decrease in such old and in part still pronouncedly humanistic disciplines as philosophy, French language, grammar, rhetoric, and poetry. Medical science too decreased in relative importance. The increase in the number of plays and novels was so great that the overall literary output increased slightly.

A comparison of the 1811–25 output (table 1) with the accumulated 1897 output (table 2) shows that literature, history, and religion, which together accounted for just over two-thirds of the former, had shrunk to just over one-half of the latter. And although literature and history had had to yield some ground, each still accounted for more than one-fifth of the total. The greatest loser in relative terms was religion.

TABLE 2
Accumulated Output, 1684 and 1897

	% of Total Output			
Subject	1684		1897	
Religion[a]	26.6		8.3	
History[b]	25.9		23.4	
Law	6.4		7.1	
Natural science	2.4		3.4	
Arts and letters	4.0		6.4	
Philosophy	6.8		4.7	
Medical science	7.8		4.4	
Language, grammar, rhetoric	4.8 ⎫		2.5 ⎫	
Poetry	7.6 ⎬	20.2	6.5 ⎬	21.6
Polygraphy and miscellany[c]	⎪		⎪	
	7.8 ⎭		12.6 ⎭	
Not comparable	0		20.7	
Total	100.0		100.0	

[a]Including church history and church law.
[b]Excluding church history; when it is included, the percentage is 30.7 for 1684 and 25.2 in 1897.
[c]Plays and novels.

The Share of History

The proportion of historical works in the intellectual output was considerable. Calculations based on the 1701 Enquête Royale into the state of the book trade show that the proportion of historical works in 1699, 1700, and 1701 was 18.3 percent, 20.6 percent, and 18.4 percent, respectively, or 43, 51, and 42 books.[15] During the years 1784–88 the proportion of historical works was 18.7 percent. By 1811–25 that figure had risen to 31.5 percent.[16] A century later Eugène Morel calculated that the proportion of historical publications came to 30.3 percent if the more or less inseparable history and geography of other countries were included and to 25.4 percent if this sector was not included.[17]

The list of books in the *Bibliographie annuelle de la France* suggests lower proportions. On the basis of this source, Charles-Olivier Carbonell, the pioneer of quantitative historiography, arrived at 8.9 percent for 1820, 8.3 percent for 1830, 9 percent for 1840, 9.6 percent for 1850, 9.4 percent for 1860, 8.4 percent for 1870, and 10.1 percent for 1874.[18] Calculations based on several other criteria yielded percentages for 1878–1907 (based of 13 soundings) ranging from 6.8 percent in 1878 (873 out of total of 12,825) to 13 percent in 1907 (1,404 out of a total of 10,785).[19] Unfortunately, the *Bibliographie* is a very unreliable source. While the dictum "wrong figures, right curves" may be applied to other areas of quantitative history, in this particular case the strictures by the meticulous Eugène Morel seem to have hit the nail on the head.[20] A sudden touch of influenza suffered by a library official in the Dépôt légal, and

the intellectual output seemed to decline dramatically. The classification was chaotic: a book on Toulouse Lautrec was entered as local history. The number of double entries was considerable, and a great deal of the infraliterature was not listed because it had not been submitted to the Dépôt légal, even though such registration was compulsory. It was even said that publishers only sent unsalable stock to the Dépôt légal. In the case of history, a large part of the difference between the careful calculations Morel made in 1909 and the *Bibliographie* of the same year seems to have been due to the defective registration of the large number of local-history publications, most of them printed in small editions in the provinces and never submitted to the Dépôt légal in remote Paris.

From those figures on which we can rely it appears that the share of historical works in the intellectual output during "the long nineteenth century" (to 1914) was greater than it had been in the eighteenth century and also greater than it would be in the twentieth century—certainly after the Second World War.[21] After 1945 the share of historical works never reached 10 percent of the annual output. In any case, Pierre Chaunu's "overall picture," according to which historical works have accounted for about 10 percent of the intellectual output ever since Gutenberg's galaxy,[22] was not borne out by the figures we have for the nineteenth century.

In the nineteenth century history was, in fact, exceptionally popular—it was the century of history. This popularity was also reflected in literature and on the stage.[23] Writers often chose the past as a backdrop; indeed, the nineteenth century was the heyday of the historical novel. All that is widely known of course.

More fundamentally, it was during this period that the historical method was elaborated,[24] the study of history acquiring an unprecedented epistemological status. As a result, history developed enormous pretensions and dared to vie for the crown of learning with the time-honored *sciences maîtresses*—philosophy, theology, and rhetoric. People were beginning to consider the history of philosophy to be of greater importance than the *philosophia perennis*, to place literary history and historical philology above the eternal rules of rhetoric and grammar. In biblical studies they even cast doubt on God's Word, treating Christianity as part of the general history of religion. In political philosophy organic theories gained much ground, while "inorganic" politics fell into discredit and was considered to be hopelessly old-fashioned. What had been upheld as indisputable truths for centuries now seemed valid only inasmuch as it could be fitted into the general context of historical developments.

This change in intellectual climate might be described as the historicization of the worldview. The world, culture, society, political organization—indeed everything came to be seen as the effect of a historical process, as a development. Changes in social and political life were no longer considered deviations from the original order or revolutions of the eternal wheel of time; instead, they appeared to be significant and essential stages in a development that was generally described as progress. Needless to say, many traces of the historicization of the worldview had appeared in earlier times[25], but it was only in the nineteenth

century that history developed the grandiose pretense of being able to explain everything.

The theoretical foundations of this historicization of the worldview were laid mainly in Germany, to be rounded off into the philosophical system that became know as historicism.[26] Nowhere else were the pretensions of the irresistibly advancing historical "sciences" so closely welded into a methodology as they were in Germany. Historicism has often been described as a German tradition because its elevation and elaboration into a philosophical system was the work of Germans. The general changes in the intellectual climate, however, were less confined by national frontiers. In France too history pretended to explain everything. The present could be understood only if it were seen as the consequence of a process of development. Historicization of the worldview must not be confused with historicism. The first refers to an enriched knowledge and understanding, the second is an amalgam of theories, a philosophical system, an abstraction that led to hairsplitting and scholastic polemics.

Alongside a change in taste (reflected in the growing popularity of history in novels and plays) and the change in the intellectual climate was yet another possible explanation for the increased share of historical writing in the intellectual output at large. The turbulent events of the recent past and the chaotic succession of political regimes had cast doubt on the perennial value of the traditions. History had become *the* intellectual tilting ground. Since olden times it had been studied for a variety of reasons: as a diversion, out of pure interest, for inspiration, and also to legitimize all sorts of causes. The last reason proved a two-edged sword. Historiography has a Janus face: it can strengthen as well as undermine traditions.[27] After the Revolution, during the Restoration and throughout the nineteenth century, France was flooded year after year with publications that could be considered so many political polemics about principles, prospects, and reforms. All of them could be lumped together under the heading "history" because all were more or less historical in content, if of varying academic merit.[28]

There have been many references to growing middle-class interest in history following the Enlightenment. The distinguished historian Friedrich Meinecke, in particular, spoke of petit-bourgeois intellectual curiosity about such historical subjects as the origins and development of social customs, technical progress, and the satisfaction of daily needs.[29] The economic and political rise of the bourgeoisie went hand in hand with an appropriate "emancipatory" historiography. Are there grounds for arguing that bourgeois interest in history influenced the growing share of historical works in the overall intellectual output? Figures mentioned later in this chapter do not point in that direction. "Bourgeois" historical interest, though clearly discernible, did not have a preponderant influence on the share of historical writing in the general intellectual output.

Changes in taste, the historicization of the worldview, and the emergence of political polemics in the form of historical treatises may well explain the excep-

tionally large share of history in the intellectual production of the long nineteenth century compared with its share during the preceding and following periods. A fourth factor was the consolidation of national consciousness. To explain the much smaller proportion of historical works in the intellectual output of the twentieth century—a share even much smaller than in the eighteenth century—one can of course argue that tastes had changed and that the historical approach had lost some of its explanatory power, or that national consciousness had ebbed, but the most important reason was that in the wake of great changes and rapid developments tradition had ceased to be a reliable guide. History had accelerated to such an extent that the old traditions were barely recognizable.

During the interval between the ancien régime and the emergence of an industrialized society there was a break with tradition. Tradition became the subject of polemics. It was no longer taken for granted, but it was still close enough to make current debates look like historiographic arguments.

The Gap between Elite and Mass Culture

The great interest in historical writings reflected in the "official" intellectual statistics is in striking contrast with the share of history in popular, sometimes illegal, literature.[30] The proportion of historical texts in the Troyes Bibliothèque bleue, the large list of very cheap, shoddy little blue-covered books peddled from house to house and very popular during the first half of the nineteenth century, especially in rural areas, was no more than 2 percent. It is of course an open question to what extent the Bibliothèque bleue reflected the interests and ideas of the broad rural masses of French society. Similar question marks have been placed after the claim that the official intellectual statistics are a reflection of public opinion. In particular, the absence of clear expressions of social protest in popular literature has given rise to suggestions that it must be considered a deliberate sop to the poor, for which peddlers happened to find a ready market. Recently more subtle interpretations have emphasized other forms of writing in which social dissatisfaction was expressed as burlesque humor or carnivalesque inversions of reality.[31] As for the share of history, it goes without saying that the lists of publishers aiming primarily at the rural market and at people with small purses would have included few historical works. People were of course keen on stories "from the past" involving heroes, murderers, and highwaymen, and these often included such historic figures as Charlemagne, Napoleon, or the outlaw Louis Dominique Cartouche. However, legend engulfed the historical core and the story was generally told out of time, or at least without regard for chronological order, when a minimum sense of chronological order is needed by anyone writing history. Historiography that does not satisfy this condition cannot possibly be classified as history.

This constriction leads us to an exclusive definition of historiography. Stories set in the past are not necessarily historiography, nor are the many recorded oral histories set in any particular period. Historiography proper was and is

largely the work of a literate (and hence) elitist culture. Historiography is an artifact, an artificial memory, and something other than a spontaneous recall and vague understanding of the past.

Historiography satisfies no primary need. It goes without saying that in the absence of any form of historical understanding, of memories and reminiscences, human identity is inconceivable. But historiography meets this fundamental human need to a very limited extent only. In any case, the identity of the rural masses of French society was not forged by it. Their historical need was patently satisfied in a different way.

The spate of historical knowledge that Nietzsche considered to be typical of the nineteenth century[32] and that is reflected in the intellectual statistics was absorbed by only the trend-setting stratum of French society, the largest consumer of the printed word. The French peasants were not yet infected with the "historical sickness."

A Shift in the Historical Output

When we wish to examine quantitative developments *within* the historical output, we can do no better than to compare the accumulated output in the Bibliothèque Nationale in 1897 with the accumulated output in the king's library in 1684.[33] Table 3 illustrates how the historical sector was subdivided. That church history was the greatest loser in relative terms (falling from 4.8% to 1.8%) need not surprise us in light of the preceding remarks. Striking is the drop in Italian history (from 3.8% to 0.9%), which reflects Italy's loss of religio-political and cultural influence. The decline of the Spanish empire may explain the drop in Spanish and Portuguese history from 3.3 percent to 0.4 percent. The appreciable decline in ancient history (from 2.9% to 1.5%) can be attributed to the decreasing hold of the classical tradition.

German and English history had to make do with a more modest position, but interest in the enemy on France's eastern borders, who was expanding with frightening speed, remained relatively high. In any case, at the end of the nineteenth century, after the humiliating defeat of 1870 and with a new confrontation in prospect, the Bibliothèque Nationale contained many more books on German history than on church history and twice as many as on ancient history.

A drop also occurred in the number of books on geography and general history (from 2.8% to 1.9%). Does that mean that the unification of the world by transport and the media did not lead to a relative increase in writings about geography and world history? In fact, certain concepts included under this heading seem to have changed so much that a quantitative comparison is not possible. Lengthy expositions à la Bossuet of *histoire universelle* went by the name "world history" in the seventeenth century and laid claim to being universal. That sort of general history along biblical lines continued into European history and culminating in one's own country and time was not, in fact, very ecumenical, certainly not by modern standards. The decline of this heading was

TABLE 3

Subdivision of the Historical Sector of the Accumulated Output, 1684 and 1897

	1684		1897	
Section	*%*	*No.*	*%*	*No.*
Geography and general history	2.8	1,006	1.9	39,452
Church history	4.8	1,701	1.8	36,726
Ancient history	2.9	1,044	1.5	30,754
Italian history	3.8	1,355	0.9	19,422
German history	3.8	1,60	3.0	61,929
British history	1.5	526	0.7	15,424
Spanish and Portuguese history	3.3	1,163	0.4	7,912
History of Asia, Africa, America, and Oceania	1.1	383	1.1	22,095
French history	4.8	1,723	13.6	279,408
Total		35,000		2,050,000

perhaps an indirect reflection of the fragmentation of the Christian conception of world history and of the lack of an equally influential alternative.

The output in non-European history remained stable (1.1%). The absolute mass of information about other continents may have increased from the reign of Louis XIV to the republic of M. Armand Fallières, but in relative terms the number of works on extra-European history had not grown. Interest in the exotic does not date from the time of modern imperialism but is ageless.

The most striking result revealed by these statistics, however, was the gigantic increase in works on French history: from 4.8 percent in 1684 to 13.6 percent in 1897. At the end of the nineteenth century, the area French history, with nearly 280,000 items, was the largest in the library. Even earlier, five-year soundings of the eighteenth-century intellectual output had reflected growing interest in the national past,[34] and in the nineteenth century this interest remained very keen. A number of other phenomena also reflected this trend, for instance, the inclusion of French history in the school curriculum (see chapter 2). At the end of the nineteenth century the total stock of books on French history was much greater than that of all books on non-French history combined. That certainly had not been the case in 1684. The process of nation building begun during the eighteenth century and completed in the nineteenth was clearly mirrored by changes in historical interest.[35]

French History

As a preliminary guide to subdivisions of the heading "French history" I shall once again refer to the stock of printed matter in France's largest storehouse of such material in 1897.[36] Table 4 shows that the more or less chronological sections (2 and 3) accounted for more than a quarter (27.9%) of the total output. Interest in political institutions and particularly in the constitution (sec-

TABLE 4

Subdivision of the Heading "French History" in the Accumulated Output, 1897

Section	%	No.
1. General	1.6	4,565
2. History of given periods	0.9	2,597
3. History of given governments	27.0	75,600
4. Newspapers and periodicals	4.1	11,582
5. Religious history	6.7	18,724
6. Constitutional history	11.5	32,222
7. Administrative history	6.3	17,650
8. Diplomatic history	0.4	1,126
9. Military history	1.5	4,203
10. Manners and customs	1.3	3,552
11. Archeology	2.5	7,025
12. Local history	17.7	49,543
13. History of social classes	0.4	997
14. Family history	1.0	2,887
15. Biography	16.9	47,153
Total	100.0	279,408

tions 6 and 7) was very great (17.8%). Foreign policy as an independent entry (section 8; of course the foreign policy of successive rulers was also treated under section 3) came surprisingly far down the list, even if we include military history, which is of course a mistake inasmuch as not all military campaigns were waged abroad. The history of manners and customs had begun to attract a fair amount of interest (1.3%), in any case more than genealogical history (section 14, 1.0%). There was a special section for the history of social classes (13), but its share was still very small and almost identical with that of diplomatic history. With a share of 16.9 percent, biography was an important section. Local history, including French archeology, accounted for rather more than one-fifth of the accumulated output (20.2%).

Unfortunately we lack specific information about the stock of books in the library in earlier times. To put the figures given in table 4 into some perspective we can compare them with the corresponding percentages in what we might call "imaginary" libraries, that is, in historical bibliographies. In the eighteenth century the abbé Jacques Lelong, the punctilious librarian of the Parisian house of the Oratorians, in the rue Saint Honoré, compiled a famous bibliography of French historical writing that was meant partly as a guide for people building an "ideal" library. It also included manuscripts. The first edition appeared in 1719 and comprised 17,487 titles; the second, greatly enlarged edition, edited by Fevret de Fontette, a member of the parliament of Dijon, appeared almost a century later, in 1768, and comprised 48,223 titles. The enlarged edition was due not only to the inclusion of books published during the intervening forty-

nine years but also to the more extensive study of certain sections published during that time.[37]

Alas, we have no "ideal library" of the same size for the nineteenth century. However, some comparative material is provided by Gabriel Monod's bibliography of French history published in 1888.[38] But this bibliography is much more selective (comprising a total of 4,542 items); for that reason only the proportions and method of classification are of interest to us. Remarkably, Monod gave pride of place to the German challenge. He wanted to provide France with something akin to Friedrich Christoph Dahlmann's *Quellenkunde* (Source study), the first edition of which had appeared in 1830 and the fifth, edited by Monod's German tutor, G. Waitz, in 1883. Monod realized that France had lost her lead in the sphere of scholarship in general and in the auxiliary historical sciences in particular. Lelong's bibliography had not been reprinted since the eighteenth century, let alone supplanted by new publications of similar quality. Monod's own did not pretend to be exhaustive, nor did it proffer advice for building up libraries. All Monod set out to do was to provide students with a practical guide. But despite these differences, a brief comparison of the two bibliographies is not unrewarding.

In Monod's bibliography too church history was in decline—shrinking from 31.2 percent in 1719 to 23.7 percent in 1768 and to a mere 2.8 percent in 1888. In the 1897 stocks of the Bibliothèque Nationale the proportion of books devoted to church history was, however, still 6.7 percent. Monod obviously considered other printed matter to be more suited to the needs of young students. More striking still, incidentally, was his "secularization" of the bibliographical order. The two eighteenth-century works had still placed church history before political history and had adopted the ecclesiastical division of France into bishoprics and parishes. The late-eighteenth-century edition had merely introduced several innovations. Thus, the section "Treatises on the Rights and Benefices of the Church of France" had been arranged more systematically by M. Hérissant, an advocate in the parliament of Paris, and reissued under the title "Treatises on the Rights and Liberties de Gallican Church." There had also been a new section, the "History of Persons Claiming to Be Inspired or Possessed, to Be Visionaries, etc.: Historical Books and Papers on This Subject." In absolute terms the share of church history had still doubled (from 5,456 to 11,404). With the Protestant Monod the Catholic Church lost its traditional pride of place—in his scheme the only subdivisions were "church law," "Gallic Church," and "Protestant Church." Local Catholic Church history was classified by town.

In the eighteenth-century editions political history had been divided into dynastic history (of the kings and their most important servants) and the *histoire civile* of those over whom they ruled, with particular reference to provinces, towns, important families, academies, universities, illustrious men, and famous women. By "civilians," however, these editions referred to something other than the common man. Although selective and elitist, they nevertheless reflected a

striking increase of interest in "the ruled"—in 1719 these accounted for 17.2 percent of the entries (3,011 items) and in 1768 for 29.2 percent (14,090 items). The exorbitant share of kings and their most important servants decreased accordingly, from 45.9 percent (8,031 items) to 39 percent (18,777 items). The classification was again quite different from that used by Monod in the late nineteenth century. In the eighteenth-century bibliographies the kings were treated first, followed by the genealogy of the royal family, court ceremony, the "Political Treatises on the Kings and the Kingdom of France," the "Compendium of Public Acts" (only in the second edition!), and the "Treatises and Histories of French Institutions." In the late-nineteenth-century bibliography, by contrast, the institutions took pride of place, the monarchy as an institution being judged to be more important than the king's person. But, remarkably, in the 1888 edition too the lives of successive kings set the chronological pattern for the heading "History by epoch." In later chapters I shall return to the importance of institutions in this "royalist" chronology.

The eighteenth-century bibliographies did not have special headings for methods and techniques. In 1888 a start was made with an extensive section (7.6%, or 346 items) devoted to the auxiliary historical sciences, to bibliography, and so on. Growing interest in these subjects reflected a more systematic approach that to a certain extent was to remain characteristic of professional academic developments. As we shall see, advantages as well as disadvantages sprang from the stress on "historical methods"—or from what may be referred to as the methodological approach. And although it cannot be said that history was never written in a methodologically responsible manner in the eighteenth century, Monod was the first to choose such a manner explicitly.

Again, whereas Lelong had begun with the geographical and natural history of France, Monod ignored these subjects, which he considered extraneous to history proper. The interest in "the ruled" was reflected in 1888 in such new socio-historical areas as the history of social classes, of industry, of commerce, and of agriculture, which, however, were very small sections (approximately 0.5% each). For the history of social classes the percentage was near the percentage in the accumulated output (0.4%).

Books in military and maritime history made up less than 0.5 percent of Monod's bibliography, even smaller than the percentage of military history alone in the 1897 stock of books (1.5%).

The problem in comparing Lelong's bibliography with Monod's is that the latter reflects not so much the actual historical output as the concerns of a leading academic historian during the first decades of the life of the Third Republic. Monod, with his pacifist leanings, did not consider military history to be all that important in the training of young students. The same applied to genealogy, which he did not even mention but which nevertheless accounted for 1 percent of the stock of books in the library.

More generally, we can say that the eighteenth-century bibliographies (which aimed more at completeness and are therefore more relevant for purposes of numerical comparison) were based on a thematic rather than on a chronological

system of classification. Or we might say that the chronological arrangement was often applied within a thematic division, the subjects having been classified first. Admittedly, Monod also used a thematic division, but almost two-thirds of his bibliography was subsumed under the heading "History of given periods," law, manners, and institutions being treated accordingly. Chronological order took precedence over thematic unity. This was much more obvious in Monod's guide for students than in the classification used at about the same time in the Bibliothèque Nationale, where more than a quarter of the stock of books (27.9%) was subsumed under the history of given periods and government, law, manners, and institutions were placed under separate headings. Here too "dry" bibliography provides us with clues to the characteristic intellectual pre-occupations of academic historians.

Since 1898 there has been a reliable and highly selective means of drawing the contours of French historiography from the Middle Ages on. In that year the *Revue d'histoire moderne et contemporaine* was launched. It reflected the more systematic and professional approach first evinced ten years earlier in Monod's bibliography and included a cumulative annual bibliography under the meticulous supervision of G. Brière and P. Caron.[39] Based on the catalogue of books on the Middle Ages compiled four years earlier by A. Vidier for *Le Moyen Age*, the list was almost complete, covering not only separate publications of very uneven merit but also articles published in various journals. The absolute and relative figures of this annual *Répertoire méthodique* cannot be compared because the criteria, always carefully set out, kept changing. Thus the increase from 2,017 items in 1898 to 3,638 in 1899 was largely due to the perusal of 543 journals instead of only about 400 and to the first inclusion of the period from 1871 onwards. During 1903, the year with the highest number of entries, the 5,977 items also included, as was duly mentioned, the history of literature and science published during the previous year. The combined edition for 1904, 1905, and 1906 covered a total of only 6,891 items because of a lack of finances and manpower. Hence the *Répertoire méthodique* is not suited to year-to-year comparisons, but it proffers an unsurpassed picture of the output in about 1900 of writings on French history after 1500.

Publication figures at the beginning of the twentieth century are remarkable in several respects (see table 5). Their marked difference from the figures just given reflect at least five new historiographic developments.

First, the share of religious history is notable. At just over 14 percent, it had suffered a setback since the 1768 bibliography (23.7%), but it was much greater than in Monod's 1888 bibliography (2.8%) or in the accumulated output of 1897 (6.7%). This greater share may point to renewed interest in religious history at about the turn of the century and may also be linked to what we know about the men engaged in historiography, a subject to be discussed below. In connection with the share of religious history, it should also be borne in mind that medieval history was not included under this heading.

Second, military history was more amply represented in 1901 than Monod's

TABLE 5

The 1901 Output of Publications on French History after 1500

Subject			No	%
Military history			773	14.6
Religious history			747	14.1
Domestic politics			945	17.9
History of events[a]	673	(12.7%)		
Institutional history	101	(1.9%)		
Biography	171	(3.2%)		
Diplomatic history			230	4.4
Social and economic history			559	10.6
Colonial history			90	1.7
History of science, literature and art			1,369	25.9
Local history			422[c]	8.0
Biography and genealogical history			112	2.1
General			31	0.6
Total			5278	100.0

[a]1500–1789, 146 (2.8%); 1789–1815, 409 (7.7%); 1815–1900, 115 (2.2%).
[b]History of science, 271 (5.1%); history of literature, 579 (11.0%); history of art, 519 (9.8%).
[c]The date are incomplete.

bibliography or the stock of books in the Bibliothèque Nationale in 1897 might have led one to suspect. This greater representation would indicate growing interest in this subject as well.

Third, the share of social and economic history (10.6%) was larger; compared with the earlier figures, this increase indicates not so much a revival of old interest as the growth of a relatively new concern.

Fourth, diplomatic history was much more amply represented in 1901 than it had been in the accumulated output of 1897. Here too there had been a recent increase in popularity, which was also reflected in other data. The popularity of diplomatic history around the turn of the century (4.4%) was the more remarkable in that political history clearly attracted fewer writers. In 1901 not only political events but political institutions were less attractive than might have been expected from the 1897 accumulated output: respectively, 12.7 percent in 1901 compared with 27.9 percent (the sum of headings 2 and 3 in the Bibliothèque Nationale in 1897; see table 4) and 1.9 percent in 1901 compared with 17.8 percent (the sum of headings 6 and 7 in the Bibliothèque Nationale in 1897). In recent studies of innovations in the study of history, historiography in about 1900 has been described more than once as *histoire événementielle* pure and simple. In terms of quantity, however, this description is completely false.

Fifth, the heading "biography" attracted fewer writers than it had in the past. In the accumulated output its share had been 16.9 percent for centuries, but in 1901 political and nonpolitical biography combined accounted for no more than 5.3 percent. On this point, however, we must proceed with caution, as a biographical approach was used in a great many of the books classified under

the headings "history of science," "history of literature," and "history of art," which together accounted for more than a quarter of the 1901 output.

Comparative material is lacking for the remaining figures, but it seems unlikely that the respective shares of the history of science, literature, and art should have been fixed at 5.1 percent, 11 percent, and 9.8 percent for decades. These high percentages may possibly be linked to the popularity of the historical approach in the study of art and literature, to which I shall return.

The extraordinary interest in the twenty-five years of the Revolution and the Empire (1789–1815), which greatly exceeded interest in the ancien régime and the rest of the nineteenth century combined, bore witness to the undiminished hold of this turbulent period on historiographers writing almost a century later.

Local History

The shift in the output from non-French to French history was largely the result of an increase in local-history studies. In the "imaginary library" of 1719 the share of French history was 5.2 percent (914 items); in the second half of the eighteenth century, thanks partly to better studies about the earlier period, it had risen to 10.2 percent (4,936 items); and at the end of the nineteenth century French history's share in the stock of books kept in the Bibliothèque Nationale was 20.2 percent (56,568 items), archeology included. The very low share of French history in Monod's 1888 bibliography (5.4%, or 245 titles) and in the annual output of 1901 (2.1%) reflects the decision to assign local-history studies to specialized local bibliographies.

Now, the local-history output was much greater than the share of local histories in the largest library in Paris or in "national" bibliographies compiled in Paris might suggest. Local history comprised a flood of heterogeneous, often hard-to-obtain publications with a small run (rarely more than 200–300 copies). An indication of their scale can be found in Robert de Lasteyrie's large and carefully compiled (but also incomplete) bibliography of historical and archeological works published by learned societies since 1888. Local histories were also published outside these learned societies of course, and in Paris there were several historical societies that did not concentrate on purely local studies, but it is nevertheless possible to form an overall impression.

In the period 1886–1900 the count ran to 48,500 items (mostly articles), or 3,200 a year, and in the following decade to 42,500 items, or 4,250 a year.[40] Until the First World War local history continued to grow apace. The nation-building process, which I cited above as an explanation, seems to belie this trend. But once again, historiography seemed to have a Janus face. On the one hand the nation-building process was accompanied by a triumphant advance of nationalist historiography, but on the other hand the opposition to national unification and the emphasis on local and regional peculiarities was proudly supported by local historiographers. In that respect too history was an intellectual tilting ground during the "long" nineteenth century.

The organizations par excellence for writers of local history were the learned

societies.[41] These bodies, of which the oldest were called *académies*, whereas many of those founded in the nineteenth century were known as *sociétés*, *associations*, or *commissions* and carried the name of a town, department, region, or, occasionally, the name of a famous person (e.g., the Académie Stanislas in Nancy, named after Stanislas I, father-in-law of Louis XV, former king of Poland, last duc of Lorraine), might have a more or less specialized character. According to Pierre Caron, the old academies did shoddy work at about the turn of the eighteenth century: their *bulletins* and *mémoires* were made up of a ludicrous amalgam of poetry, rhetoric, obituaries, disquisitions on virtue, along with articles on natural science and history. The more recently founded societies generally produced better work.[42] The many polymathic societies that sprang up at the beginning of the nineteenth century and in which local history and archeology came to take a large place over the years, made way increasingly for specialized historical associations.[43]

In 1886–1900, 258 provincial and 66 Parisian societies published historical and archeological texts.[44] In 1901–10 there were 264 such provincial and 86 Parisian societies (including those in Neuilly). The Parisian figures, it must be stressed, did not always reflect specific *local* history or archeological studies. In any case, the figures show that in 1886–1900 every society published approximately ten publications a year (324 societies produced 3,200 publications) and that in 1901–10 the corresponding annual average was twelve (350 societies issuing 4,250 publications).[45] The local- history output grew significantly during the second half of the nineteenth century and at the beginning of the twentieth. The number of associations increased, and a larger variety of people became involved in local history.

The geographical distribution of historical and archeological societies was rather uneven. With one exception, every department had its own society, but some departments had an appreciably better organizational infrastructure for local investigations than others. Charles Dupin, the "technocratic" baron we met earlier, had shown during the Restoration, in the latter half of the nineteenth century, that France was bisected by an imaginary line running from Saint-Malô to Geneva into a northern and a southern half that differed markedly in wealth, economic development, and standards of education. The Hexagone, the name sometimes given to France because of its shape, was not a single unit but consisted of two "populations."[46] In the north lay the rich and highly developed France whose people could read and write, and to the south stretched the poor and underdeveloped France of the illiterate masses. This division has recently been rediscovered, albeit with a number of subtle distinctions.[47] It explains why the south saw considerably less historiographic activity in the mid–nineteenth century than the north.[48] But did the distinction between an idle and a studious France still hold at the end of the nineteenth century? Based on a comparison of the number of societies per department in the twenty-eight northern and the fifty-eight southern departments in 1885–1900, we can indeed postulate that the north had a more productive infrastructure for the organization of local-history studies (see table 6).

TABLE 6
Number of Societies per Department, 1885–1900

	Northern Departments		Southern Departments	
Number of societies	No.	%	No.	%
5 or more	10	36	5	9
4	4	14	6	10
3	8	28	10	17
2	3	11	14	24
1	3	11	22	38
0	0	0	1	2
Total	28	100	58	100

Note: For a breakdown by *department*, see appendix 3.

If we take into account the number of inhabitants per department and divide the population figures by the number of societies, we are left with an artificial *departmental quotient*, by which the local-history activity of the studious north can be distinguished even more clearly from that of the indolent south (see table 7). A particularly good performance was given by the northern departments Calvados (with 9 societies for 417,000 inhabitants), Seine (Paris, with 66 societies for 3.3 million inhabitants), Côte-d'Or (with 7 societies for 368,000 inhabitants), and Seine-et-Marne (with 6 societies for 359,000 inhabitants) and by the southern departments Savoie (with 5 societies for 260,000 inhabitants) and Haute-Garonne (with 7 societies for 459,000 inhabitants). The only department without a productive historical society was Ardèche (363,000 inhabitants). The populous departments in the center of France, namely, Allier (424,000 inhabitants) and Dordogne (465,000), and in Brittany, namely, Morbihan (552,000 inhabitants), were the least active in the historiographic field, having only a single society each.

TABLE 7
Departmental Quotient, 1885–1900

	Northern Departments		Southern Departments	
Departmental quotient	No.	%	No.	%
Less than 100,000	11	39	4	8
100,000–150,000	12	42	20	34
150,000–250,000	2	7	16	27
More than 250,000	3	11	18	32
Total	28	100	58	100

Note: For a survey by *department*, see appendix 4.

THE PRODUCERS

Having looked at the historical output, that is, at the production of historical works, we shall now attempt to draw the statistical contours of their primary producers, that is, of their authors.

The only relatively large-scale empirical studies of these men were made by Charles-Olivier Carbonell, the father of quantitative historiography. He looked at 1095 authors who were active in 1866–75 and at 1310 active in 1900–1905. Although we may complain of the incompleteness of his sources—those in local history were particularly inadequate—there is no doubt that his was the most comprehensive overall picture of historical writers. The results of Carbonell's research are given in table 8.[49] In 1866–75 the clergy, the nobility, and professional historians (professors, teachers, archivists, librarians, curators of museums, and research workers) made up 59 percent of all historical authors. At the beginning of the twentieth century these three pillars of historiography still accounted for more than half (51%) of the producers. The share of the nobility had sharply declined (from 20% to 7%), that of the clergy had appreciably increased (from 16% to 20%), and that of professional historians had risen slightly (from 23% to 24%).

The decline in the contribution of the nobility could be attributed partly to the fact that after thirty years under the Republic many nobles and *faux* nobles were reluctant to vaunt their real or alleged patents of nobility. Moreover, the nobility had increasingly entered various professions instead of resting on their hereditary laurels. Aristocratic authors engaged in a profession were not entered under the heading "nobles."

The increase in the number of clerical authors cannot be attributed to the increase in the number of priests during the intervening thirty years but was a consequence of their better education and their increased interest in scholarship, a subject to which I shall return.

Nearly a quarter of our writers were professional historians; that is, they earned their living by teaching history in higher or secondary education or by looking after historical material in archives, libraries, and museums. At the time no one could make a full-time living by writing history books. The growth in the percentage contribution of professional historians was small, which may seem surprising in view of the increase in the number of posts held by historians in the educational and administrative fields. If we put the number of teachers and professors of history at the beginning of the twentieth century at 1,000 and if, bearing in mind gaps in the records, we put the number of those who published self-contained historical works during the first five years of the twentieth century at a maximum of 200, then we arrive at a rather disappointing ratio of 1:5. However, it ought to be remembered that professional historians published much of their work in specialist journals, which were not included in the count, and that, more generally, no professional ever distinguished himself by the volume of his written output. Rather, professionaliza-

TABLE 8
Authors of historical Works, 1866–1875 and 1900–1905

	% of Total Authors			
Authors	1866–75		1900–1905	
Catholic and Protestant clergy	16		20	
Nobles	20		7	
Professional historians[a]	23		24	
Jurists	13		12	
Journalists	9		6	
Soldiers	3		8	
Others and unknown	16		23	
Total	100	(1,095)	100	(1,310)

[a]Including teachers and lecturers, 13.0% in 1866–75, 12.0% in 1900–1905; and archivists, 6.7% in 1866–75, 6.4% in 1900–1905.

tion, in the sense of the growth of the number of professional historians, exerted considerable influence on the *quality* of historical writing, on the spread of historical knowledge in schools and universities, and on the organization and cataloguing of historical material in archives, libraries, and museums.

Among the remaining categories, we find that the jurists (administrators, magistrates, and advocates) held on to their considerable share (decreasing by only 1%, from 13% to 12%), that the journalists were losing interest (from 9% to 6%), and that there was a very spectacular rise in the number of army officers, who of course were mainly interested in military history (from 3% to 8%).[50] Here too, as with the clergy, one is inclined to find the explanation in better education and greater incentives. Perhaps one may even venture a psychoanalytic explanation for the striking increase in the number of churchmen and soldiers writing history. For Freud, church and army were "artificial groups" that owed their existence not only to external pressures but also to libidinous attachments to Christ or to some general.[51] Freud did not enter into the intensity of these libidinous attachments, but is it not possible that at the beginning of the twentieth century the violent struggle surrounding the separation of church and state in France, no less than the Dreyfus affair, had helped to swell the libido of the servants of the repressed church and the compromised army or, for that matter, to deflate it—either explanation may be correct since psychoanalysis is after all the study of eternal recurrence—but in any case to change it so much that they could invest more of their energy in historiography? It is an attractive but not very convincing explanation. What is certain is that in the predominantly celibate existence of men shut off in the presbytery, monastery, or barracks history provided some diversion and that the ideals of past martyrs and heroes were a source of inspiration and solace for persecution or humiliation in the present.

To highlight the role of professional historians, who are discussed in the following chapters, let us now look more closely at the other two pillars of historical writing in 1866–75, the clergy and the nobility. It seems very likely that during the first half of the nineteenth century the clergy and the nobility's share was even greater than I have indicated and that professional historians' share was considerably smaller, but there is a dearth of reliable and detailed studies on the subject.

The staying power of the first and second estates in the age of the "bourgeois conquerors" was remarkable.[52] Although the rise of the bourgeoisie in the nineteenth century was unmistakable, and though the victor made his presence felt in the rising science of historiography, the losers, the church and the nobility, jointly still dominated the historical output in 1866–75 (36%). After the turn of the century, when the share of the nobility had declined markedly but that of the clergy had increased, together the two still accounted for more than a quarter of the written output (27%). Moreover, it should if all writings on local history, in which the clergy and the nobility were particularly active, had been included, their share would undoubtedly have been much greater still. Only at the turn of the century did professional historians start to take a clear interest in local history, their influence manifesting itself not so much in the quantity as in the quality of the writing.

The First Estate

The clergy have played a dominant intellectual role since the rise of Christianity; during the Middle Ages there was even what may be termed a cultural monopoly of clerical "intellectuals." The influence of the servants of the church proved more lasting in historiography than in other disciplines (theology excepted). When the scepter of learning was wrested from the church in the seventeenth and eighteenth centuries, the study of history (especially of church history but of secular history as well) in France remained largely in the hands of monks.[53]

The Revolution had a devastating effect on clerical studies of history. The studious orders were dissolved, large quantities of material were lost during the confiscation of libraries and other historical possessions, and persecutions decimated the ranks of the clergy and put an end to a great deal of historical flair. The nineteenth century was a time of recovery. Although the clergy never regained the position they had held before 1789, their influence grew again, especially during the second half of the nineteenth century.

Clerical studies of history depended on two factors: the number of those called to the ministry and the quality of their education. Although the antireligious drive led to the abolition of state bursaries for minor seminaries (in 1830) and economic circumstances created marked differences in the annual number of ordinands, there was a steady increase in the total number of secular priests from 1810 to 1880. In 1810 France counted 31,870 priests, and in 1857

that number had risen to 56,500. That meant a relative increase from 1 priest per 913 inhabitants to 1 priest per 639 inhabitants. The effects of the anticlerical government policy in the eighties did not fail to make themselves felt, but during the second half of the 1890s, in the calmer political climate of the Ralliement, the number of ordinands tended to rise. In 1901 the number of secular priests was still 55,702. However, the second secularization wave (beginning in 1901) was to have enormous repercussions on the number of calls to the priesthood: the number of ordinations fell from 1,733 in 1901 to 1,518 in 1904, 1,088 in 1910, and 825 in 1913.[54] Poor peasant families with many children— it rarely happened that an only child became a priest—were the main source of prospective priests.[55] According to Taine, the church had to dig deeper and deeper, into the lowest stratum of society, to find the needed clerics.[56] The peasant would send his brightest but least robust son to the seminary: "Go there. You will become a priest, you will have white bread. You will eat chicken on Sunday."[57] But after 1905 the curé had to pass the plate to make ends meet. A slightly built peasant lad who was good in school now preferred to be a teacher.[58]

One of the reasons for the tough government policy was the spectacular growth of religious congregations in the second half of the nineteenth century. Numerous old orders had been resurrected and new ones had been founded. The new monastic spirit was strongly attached to Rome and caused a number of conflicts with the more Gallican secular clergy. The Second Empire had not put the slightest obstacle in its way. The number of priests and monks had risen from 3,159 in 1851 to 17,676 in 1861. In 1877 their number was 30,286, and in 1901, 37,000.[59] The most improbable stories were told about their fabulous wealth. Most spectacular of all was the growth of the female religious orders. In the nineteenth century religion increasingly became a woman's affair. The causes of this development fall outside the scope of this study; suffice it to say that never before had France counted as many nuns as it did at the end of the nineteenth century—before 1789 there had been no more than 35,000, but by 1877 their number had risen to 128,000. (Among men, the situation was quite different; the number of monks had dropped to less than half of what it had been under the ancien régime.) By far the greatest number of these men and women did practical work, in education, nursing, and in orphanages. The number of people who joined religious orders for purposes of study or contemplation was far less than. In 1900 only 1,800 men and 4,000 women were members of contemplative orders.[60]

The intellectual level of the clergy at the beginning of the nineteenth century left much to be desired. The ecclesiastical powers thought it was important for those consecrated as bishops to have come from the nobility (76 of the 96 bishops consecrated during the Restoration were noblemen), been priests under the ancien régime, and opposed the Revolution and to be above the age of seventy.[61] Intellectual qualities, preaching skills, and theological talent were hard to find in the Restoration episcopate. Monseigneur de Quélen, archbishop

of Paris, set the tone when he proclaimed from the pulpit in Notre Dame that "Jesus was not only the son of God but also came of very good family on his mother's side" and that there were good reasons for considering him the lawful heir to the throne of Judea.[62]

After the revolution of 1830 there was a marked change. Of the seventy-seven new bishops found in France during the July Monarchy only about ten were nobles and just four had suffered revolutionary persecution in person. Most of the new bishops were relatively young—between forty and fifty—and more than a third came from the world of education and learning.[63]

The Catholic intellectual revival, which was quite distinct from the restoration of clerics to positions of power and wealth, was zealously championed by such liberal Catholics as Lamennais. He accused the clergy of being politically *encanaillé*, that is, of mixing with the riffraff, advocated the liberation of the church from its oppressive ties with the state (whence the term *liberal Catholicism*, which had little to do with free thought), and championed education and study. According to Lamennais, the influence of the clergy had declined appreciably among the "educated classes" because the clergy themselves were not highly educated. The theology taught at seminaries was mostly a narrow-minded and degenerate form of scholasticism. To parry anti-Christian attacks, the clergy had to study harder and so restore the scepter of learning to the hands of the church. Regaining intellectual prestige was the best way to win back lost souls.[64]

A very important role in this intellectual recovery program was assigned to history. "All of history must be rewritten," Joseph de Maistre proclaimed.[65] The libelous charges levied against the clergy had to be refuted and the ancient glory of the mother church restored. Young Catholic journals such as *Le Correspondant* (founded in 1829) and the *Annales de philosophie chrétienne* (founded in 1831) accordingly devoted much space to historical articles. "Catholics, let us study history, there lies our strength today and also our glory."[66] Historical research was recommended to the clergy as an aid in apologetics. General apologies for Catholicism ought to make way for a close look at the facts, for specialist knowledge. Every effort must be made to till the historical field. "Here we cannot be beaten . . . there is no historical reconstruction that does not redound to the credit of Catholicism," wrote Montalembert, who played an important part in the Catholic revival.[67] Even in his successful *Histoire de la Sainte Elisabeth*, a book on the life of a young woman in the thirteenth century in which suffering and love were movingly depicted, he tried to do his bit for the restoration of "the Catholic and historical truth." Because of the pressure of other work, he had to postpone his attempt to vindicate the monastic orders until much later.[68]

Yet it was not only the Middle Ages that merited study. Augustin Bonetty, publisher of the *Annales de philosophie chrétienne*, claimed that the public was beginning to realize that "religion rests entirely on tradition, that is, on history rather than on reasoning."[69] It was thanks to recent historical discoveries and to the philosophy of history (the term used by Bonetty) that the beneficial influ-

ence of Christianity and the church was being understood better. According to Bonetty, such new sciences as geology, paleontology, and prehistory, to which the *Annales* devoted much space, all brought striking confirmation of the truth of biblical history. Philology, linguistics, and Oriental studies also "demonstrated that there was a single center of civilization on earth, as the Bible has taught us." American antiquities proved that De Bonald and De Maistre had been right to insist that these savage people were descended from civilized men who had fallen into decline. And when Bonetty wrote a travel book on Tahiti in which the history of the snake was mentioned, he presented that history as a direct proof of God's wish to convey some idea of the truth to every nation,[70] a view, incidentally, that resembles the twentieth-century structuralist view of myths, with this minor difference: in the latter, Lévi-Strauss has taken the place of divine inspiration.

I have called history the intellectual tilting ground of the nineteenth century. Catholic historiography, like that of its opponents, was often blindly apologetic but also had real merits. Such general Catholic journals as *Le Correspondant* carried important historical articles, many of them written by clerics.[71] One of the oldest specialist historical journals, the *Revue des questions historiques* (1866), was actually an independent offshoot of the historical column in the *Revue du monde catholique*, founded in 1861 for the specific purpose of countering the influence of the liberal *Revue des deux mondes*.[72]

At the beginning of the nineteenth century the Catholic revival and anti-Gallican ideas were still largely confined to an elite, but in the 1860s ultramontanism also became very popular among the lower clergy. In particular, the ultramontane party waged a broad historiographic campaign in an attempt to destroy the reputation of Bossuet, the father of Gallicanism, and to have his writings banned.[73] A great many other books on French church history were placed on the Index Librorum Prohibitorum because of their Gallican views. Joseph Epiphane Darras's ultramontane church history, first published in 1854, followed by many reprints, became *the* textbook for use in seminaries.[74] The apostolic succession of the most important churches, which had been challenged by erudite monks in the seventeenth and eighteenth centuries, was once again presented as a demonstrable fact.[75] The Benedictines at Solesmes spread fantastic tales about the miraculous peregrinations of the Apostles in Gaul. In this way clerical historiography tried to return to a popular tradition that was unenthusiastic about the strict critical method codified by the Benedictines during the ancien régime. In 1867 a Jesuit accused his predecessors of "insupportable aristocracy." According to him, the Bollandists had rejected too many pious stories about the saints "for the sole reason that they were popular."[76] In the second half of the nineteenth century clerical historiography fell under the sway of the *assumptionist* devotion,[77] a term used to characterize Catholicism as a mass movement, the assumptionists being renowned as organizers of mass demonstrations and mass propaganda. The huge pilgrimages to Paray-le-Monial, Notre Dame de la Salette, and Lourdes were looked upon warily by the church authorities, who refused to recognize most of the miracles. The assumptionists,

by contrast, played precisely on popular devotion and ensured that nothing stood in the way of its spontaneous expression.

This deliberate policy of fervent popularization did the quality of clerical historiography no good but was an efficient means of countering the equally fervent anticlerical agitation. In any case, within clerical historiography there was a world of difference between the more elitist, cerebral, and near-Jansenist Catholicism propounded in *Le Correspondant* and the more plebeian, emotional ultramontanism aggressively propagated by Louis Veuillot in *L'Univers* with much success.[78] When several clerical historians tried at the end of the nineteenth century to restore historical criticism to Mabillon's high standard,[79] they were most fiercely opposed by their own coreligionists. It was the price a successful mass movement had to pay.

LOCAL CHURCH HISTORY AND ARCHEOLOGY

In the eighteenth century the majority of the episcopate and of the clergy had a nationalistic outlook. Alongside the state, the church was an important instrument of Gallicization and of national unification. Even during the Revolution many churchmen continued to identify themselves with the indivisible Republic. Latin may have been the language of the church, but French found its staunchest champions among the clergy. In a famous address to the Convention the abbé Grégoire stressed the necessity of a common language, the better "to eradicate all prejudice, to develop truths and talents, to fuse all citizens into one national mass . . . and to ease the running of the political machine."[80] The church considered the various regional dialects so many bastions of paganism. Bertrand Barère de Vieurac gave voice to the feelings of many in 1794 when he described superstition, counterrevolution, and federalism as non-French: "Federalism and superstition speak low Breton; the emigration and hatred of the Republic speak German; the counterrevolution speaks Italian, and fanaticism speaks Basque. Let us smash these instruments of evil and error. . . . Our language ought to be one, like the Republic."[81] Barère, the Anacreon of the guillotine, may have been the mouthpiece of the third estate, but when it came to Gallicization the church was wholeheartedly behind him.

It was not until the nineteenth century that the church began to look at patois with fresh eyes. It now appeared that these regional dialects served as a cordon sanitaire against the flood of subversive ideas and writings that were being unleashed in purer French.[82] The turning point was the revolution of 1830 and the ensuing anticlerical policy pursued in the early years of the July Monarchy. The state having ceased to be an ally, the clergy turned increasingly to the provinces and regions, where they could count on the support of the legitimist nobles who after 1830 had withdrawn to their estates in the provinces. The episcopate, which in the first decades of the nineteenth century carried the "dream of unity" in its cultural baggage and was steeped in Gallicanism, made way after 1830 for more outspokenly Rome-orientated prelates, who took a more favorable view of French regional differences.[83]

By and large, however, the attitude of the church was ambivalent. Uniformity

happens to be part of the inner logic of institutional Catholicism. In the seminaries students were not allowed to speak in dialect, though dialect was the mother tongue of many. A priest was expected to deliver his sermons in French. Attempts to preach in patois as a token of pastoral concern were sometimes considered insulting by the congregation, who interpreted them as casting doubt on their knowledge of French.[84]

The regional and local interests of the clergy greatly stimulated historical research.[85] Of the three divisions of local church history—bishopric, monastery, and parish—the bishopric at first attracted the most attention, its study being frequently equated with provincial history. The clergy had a traditional reputation in this field. Old works were reprinted or translated from the Latin, and earlier studies that had remained in manuscript form were published posthumously. In addition, a number of new monographs were printed (about forty of the total of sixty in 1820–70).[86] There were signs of a clear shift in the content and execution of these works when compared with the famous editions brought out by the Maurists and others during the ancien régime. The latest editions were being printed without annotations and contained little unpublished material. Some were mere extracts from old editions. Less stress was laid on religio-political matters and on bishops than on manners and customs.

A similar shift could be detected in monastic history. In this field the Benedictines had been the leaders during the ancien régime, and the results of their countless studies had been left in manuscript form and stored away in large dossiers. Their nineteenth-century successors made grateful use of all this preparatory material and confined themselves far too often to lumping it together in undistinguished editions, in which, moreover, all references were omitted.[87] Annotations, in fact, were often considered unnecessary ballast by the new school, whereas the old Benedictines had been particularly keen on erudite notes. But then, the nineteenth-century clerics no longer permitted themselves the luxury of erudition but concentrated on the production of texts with a moral and social function.[88] Again, whereas the old Benedictines had dwelled at length on donations, immunities, and privileges, the nineteenth-century historians preferred to throw light on monastic life, relations with the outside world, duties, and services and ignored complicated legal nomenclature and legal history. Their apologetic intention was obvious. The stress was now on social work and the labor of monks in the fields.[89] Historiography had to refute the traditional criticism that monks were parasitic, stingy, and lazy, which was particularly virulent and highly topical in the polemics about the proposed restoration of the teaching role of religious congregations.

Parochial historiography took wings a little later, in the 1840s. It too was an old interest. For centuries the parish priest had been keeping the chronicles of his parish up to date, and in the mid–eighteenth century the abbé Lebeuf, with his usual precision, paid considerable attention to parishes in his great work on the bishopric of Paris. However, the revolutionary upheavals had undermined this tradition. Parish priests had other things to worry about.

The revival of historical interest revolved first of all around the tangible past.

The struggle for the conservation of church property that had fallen prey to revolutionary vandals or to shrewd businessmen was waged with great devotion. But the clergy had also been to blame for the destruction. Simple village priests and curates sometimes had no eye for such treasures. We are told that keen young communicants were rewarded with attractive illustrations torn out of a book that, on closer inspection, proved to be a magnificent thirteenth-century parchment breviary.[90] That sort of thing was later pilloried as *lèse-science*. But the times worked to the advantage of the conservation of "Christian and national works of art." The indignant voices were heeded, the Middle Ages were popular, and the authorities helped. Guizot's efficient influence made itself felt in the 1830s. The authorities voted special funds for the conservation and repair of historic material and introduced a general inspection of monuments directed by such men of distinction and influence as Ludovic Vitet and Prosper Mérimée.[91]

After archeology it was history's turn. But because so many of the old documents had been scattered or lost as a result of the revolutionary upheavals, attention was first focused on contemporary parochial history. In 1847 the diocese of Poitiers and others were asked to contribute papers to a clerical training congress on what had happened from 1790 to 1802 in every parish under their jurisdiction.[92] Older people could still be consulted about this turbulent period. Everything known about the fate of those who had remained loyal to the church, who had been imprisoned or killed, or who had been forced to go into hiding or exile had to be brought to light. Cases of apostasy, which were said to have been very rare, had to be recorded as deterrent examples. The restoration of worship, too, and the names of those who had fought for it, and exactly when, had to be recorded in the diocesan archives as so many landmarks for future historians.

A few years later an instruction by Monseigneur Pie (bishop of Poitiers) to priests on the building, restoration, maintenance, and decoration of church buildings expressly stated that priests had to keep records concerning the history of their parishes, including the period after 1802.[93]

In other dioceses similar attempts were made to raise the intellectual level of the clergy and to stimulate the study of local history. In Orléans the overly conscientious hand of Monseigneur Dupanloup made itself unmistakably felt.[94] At examinations for holy orders the examiner was no longer to be allowed to get up while the candidate was speaking or open or shut doors too noisily. The bishop even saw fit to issue clear instructions about the oiling of creaking door hinges. Refresher courses for the clergy became more frequent and were made compulsory. During the first few years of Dupanloup's episcopate questions on the Bible, dogma, and morals were complemented with historical questions. In 1855 a special competition (on the *emulatio* principle) was initiated, in which good presentation was specially rewarded. The quality of the entries still left much to be desired, but then the questions were still much too broad. What answer could one expect from a village priest asked to discuss the historical, theological, and philosophical aspects of the most widespread heresies? The

most valiant attempt proved utterly inadequate but was nevertheless rewarded with the collected works of St. Augustine in the hope that the candidate might derive greater advantage from them in the future. Dupanloup was a good teacher and realized after a few years that although asking historical questions had been a good idea, the questions themselves had been too wide-ranging and hard, presupposing broad knowledge and familiarity with historical criticism and the proximity of well-stocked archives and libraries. Henceforth Dupanloup confined his questions to local matters—the church in Orléans or saints and famous men in the Orléanais. In the course of the 1860s as many as nine books submitted for this competition were published.

The simplest form of historical study was the compilation of parochial chronicles. "This noble yet modest industry," to which the clergy were urged to devote one day a week, pastoral and other duties permitting, was meant to lay the foundations for the historiography of the future.[95] In 1864 the writing of parochial chronicles was placed on the agenda of the Congrès archéologique de France, an annual gathering of amateurs held in various parts of France with attractive excursions to churches, receptions at chateaux, and inspections of private collections. The motto of this venerable society, many of whose members were clerics and men with double-barreled names, was *Instruire afin de conserver* (Teaching in order to conserve), in the literal as well as in the metaphorical, political sense.[96] The society, which was set up in 1837 under the legitimist Arcisse de Caumont,[97] chalked up considerable successes in the struggle for the conservation of church property. In addition, it aimed to encourage servants of the church to keep chronicles of "religious and historical facts" within the confines of their parish.

At the 1864 congress the abbé Aillery laid out the system of classification to be followed in compiling parochial chronicles.[98] This was one of the first attempts to tackle local historiography systematically and along uniform lines and hence merits some attention. Later too these ideas were still used, except that the local teacher took over the role of the priest, formerly the sole village intellectual.

The abbé Aillery's system of classification (partly borrowed from Arcisse de Caumont) distinguished four periods.[99] First was the Celtic, or primitive, period, with Druid monuments called menhirs, stone axes, graves, earthworks, traditional place names, legends about fairies, white ladies, wells, and so on. Second was the Roman-Gallic period, with the remains of villas, arms, coins, implements, paths, camps, and so on. The third period was the Christian era, beginning with the establishment of Christianity and an account of abbeys, priories, their patrons, and the parish church together with an archeological description of objets d'art, the burial ground, ancient documents, a list of parish priests and vicars, episcopal visits, fraternities, inscriptions, and seals. This was followed by accounts of the Merovingians and the Carolingians, with their arms, ornaments, implements, and coins; the feudal period, with keeps, castles and manors, lists of lordly names, coats of arms, tombstones, seals, and so on; and then the modern period, which began in the sixteenth century, with the wars of

religion, the Revolution, the constitution of the clergy, the wars of the Vendée, and the Concordat. Fourth was the present, in which there was urgent need for a *statistique actuelle* (current statistics), particularly of the distribution of the land, the population, the revenue of the parish and of the church, taxes, schools, the administration, assemblies, and cadastral surveys.

The aim of the congress of 1864 and of a number of comparable episcopal initiatives was to encourage the clergy to compile chronicles, rather than monographs, with all the printing problems these entailed. The relationship between chronicle and historiography was of a hierarchical kind. Even less literary and intellectually endowed priests could contribute their mite to the former, and the work could be carried on by their successors. The parish chronicler did the indispensable spadework for the later historian, who might, with a masterly hand and great powers of imagination, create order out of the profusion of data collected in the chronicles. In this respect the French bishops were more practical and less haughty than Benedetto Croce, who took a very dim view of chronicles ("Historiography is living history, chronicles are dead history").[100] The bishops saw clearly that the quality of historical work at the top depended on the collective routine work done at the bottom.

The exertions of the clergy in the field of local history were reflected not only in the numerous journals devoted to local history but also in general local periodicals such as the *Semaines religieuses* and *Bulletins paroissiaux*. Comités d'histoire diocésaine were founded in many bishoprics during the last quarter of the nineteenth century, and quite a few of them published periodicals of their own.[101]

CONTEMPORARY CHURCH HISTORY

Analyses of the contents of chronicles show that the clergy were much more interested in pre-1789 history than in the present.[102] Local clerical historians clearly preferred the glorious past, which had not been troubled by so many turbulent currents. In general, by dwelling on such institutions as episcopates, monasteries, and parishes they ignored modern life, which largely took place in the quickly growing towns. The organization of the church was not only prerevolutionary in administrative terms but also preindustrial in socio-economic terms.

Most clerical writing on contemporary history took the form of biographies, bishops in particular being a favorite subject. Before 1914, in addition to obituaries, there were fifty-five substantial biographies of bishops who had died between 1855 and 1905, most of them written by secular clergymen.[103] In this type of writing the apologetic intention was generally much more pronounced than it was in local history. Current controversies were reflected in these pious biographies; critical aloofness went by the board. Moreover, the approach was generally inward-looking.[104] Pastoral activity and dogmatic questions of church policy were illustrated by the lives of religious zealots. The world outside the church was wicked and not worth mentioning.

The general picture of clerical historiography is thus one based primarily on

earlier local history[105] and on contemporary history that mostly took the form of biographies of high church dignitaries.

Only after the First World War, in the 1930s, was this institutional and biographical pattern extended with an incursion into the sociology of religion, in which the religious acts of these revered believers held pride of place.[106]

The Second Estate

The illusory simplicity of the division of society into three estates, each with its own way of praying, fighting, and working, had come to grief long before the French Revolution. A clear definition of the nobility had been hard to formulate even under the ancien régime.[107] The prefix *de*, titles, and coats-of-arms were not enough to define a person as a noble, no more so than the ownership of a chateau or a manor.[108] Almost anything could be bought with money. In the nineteenth century, when the nobility had ceased to be a legal category, the distinction between nobles and commoners grew even more blurred.

Estimates of the size of the nobility in 1789 already varied from 80,000 to 400,000 depending on the criteria used. Thus, according to the broadest definition and the biggest estimates (which are probably wrong), the nobility accounted for at most 1.5 percent of the population of France (26 million) in 1789.[109] A century and a half later, in 1938, it was estimated that there were only 30,000 genuine nobles and 60,000 who pretended to belong to the nobility,[110] jointly constituting a mere 0.2 percent of the population of France (then 42 million). The demographic decline of the nobility was evident, but their unmistakable numerical retrenchment did not necessarily imply that their influence had decreased as well. Political power and wealth can increase even if they are concentrated in the hands of a smaller number of persons. And political developments in nineteenth-century France proved that the nobility were far from played out.[111]

Particularly in times of crisis for the central authority, such as after the revolution of 1848 or after the defeat of 1870 and the Paris Commune, the strength of the nobility made itself felt in the results of local elections.[112] It is little wonder, then, that Daniel Halévy, that astute observer, dated the end of their political power to no earlier than the late 1870s.[113]

Although many nobles were poor, there were no grounds for speaking of a general pauperization of the nobility in the nineteenth century. Indeed, the large noble estate tended to expand, though smaller estates were harder to keep up. In the 1840s the largest domains were still predominantly in noble hands. If we forget about Paris, then the great majority of those with the highest tax assessments on the electoral lists (266 of the 387 who paid more than 5,000 francs and even 40 of the 50 who had to pay more than 10,000 francs) were nobles.[114] Thus, even when the political influence of the nobility had appreciably decreased, their economic position remained considerable. Material possessions are easier to maintain than political power.

All the same, unlike the clergy, the nobility passed through a period of de-

cline in size, power, and wealth in the nineteenth century. The clergy regained influence by transforming themselves into a mass organization that played a very active part in the increasingly democratic political system. For the nobility this was by definition impossible. The nobility remained a considerable power-house after the Revolution, but their loss of position was inevitable and could at best be deferred by obstinate rearguard actions.

Compared with the clergy, the nobility were a much more heterogeneous group. One was chosen for the church, but one was born into the nobility. The church practiced selection and control; it was a hierarchical institution based on more or less meritocratic ecclesiastical principles. The higher clergy might lead a worldly life on occasion, and worldly diversions could be enjoyed by one and all, but life in the presbytery or the monastery was clearly less extravagant than it was in the chateaux, what with hunts, receptions, and balls. A nobleman had a great many things to attend to.

Members of the second estate had long since engaged in intellectual activity. The breaking of the cultural monopoly of the clergy had largely been the work of generals and magistrates, among whom the nobility had always been strongly represented. Needless to say, military prowess did not necessarily go hand in hand with intellectual brilliance, but leadership in battle obviously demanded organization and planning and frequently led to studies of the past. The historical reports by generals, often in the form of memoirs, are among the earliest critical historiographies.

By the eighteenth century, however, the ancient feudal and military character of the nobility had been reduced to their symbols. The distinction between the *noblesse d'épée* and the *noblesse de robe* had become blurred. In the prerevolutionary parliaments even the scions of ancient noble families held judicial positions. Their legal and administrative experience was reflected in historical reports and dissertations constituting the oldest form of historiography. In the eighteenth century the nobility took a very active interest in intellectual life.[115] The Enlightenment may be called a bourgeois movement, but noble authors played a considerable part in it. Quantitative analyses of members of the relevant societies and subscribers to journals and to serial works show that the nobility was strongly represented. Nearly all the literary and political salons were held in aristocratic homes.[116] Was Taine therefore right to claim that the feudal aristocracy had turned into a *société de salon*? "No doubt the aristocrats still bear the sword, they have a brave and proud tradition, they know how to kill one another, especially in duels." But at the end of the eighteenth century their greatest talent was living the good life, and their real occupation was attending receptions.[117]

Needless to say, not all nobles shared a taste for the latest intellectual fashions. Most of them read little and had little to say about current affairs. Few owned books, and the libraries of those who did often consisted of a few pious, genealogical, and heraldic works, together with some chivalrous novels and a copy of Nostradamus. The intellectual level of the average rural nobleman prob-

ably differed but little from that of the average simple peasant: most books were heirlooms and remained unopened.[118] But even though the intellectual level of the average rural nobleman may have been low, there were among the nobility a creative elite and a somewhat larger group with marked intellectual curiosity (or at least pretensions to it).

Active and passive participation in intellectual life (in this case the writing and reading of historical works, as distinct from telling or listening to accounts of the latest events or of personal experiences) has always been the privilege of those favored with money or fortunate circumstances. The disproportionate involvement of the nobility in the intellectual life of the past therefore need not surprise us. It seems more than likely that when the military and administrative role of the nobility became less prominent, historiography and the reading of historical works came to play a more important role than in the past. Next to supervising the administration of their landed estates and engaging in other economic activities, against which, incidentally, the nobility continued to be prejudiced for a long time, they considered historical pursuits a worthy occupation.

The end of the Restoration in 1830 spelled the beginning of the "internal emigration" of the second estate. After the July Revolution many nobles refused to participate in the government or the administration. The new regime, for its part, also took active steps against them: 68 deputies were dismissed and 175 peers barred, including all those appointed by Charles X. The civil service and the army were purged of 76 prefects, 196 subprefects, nearly 400 mayors, and 65 generals. Within a few weeks these were followed by hundreds of officers, diplomats, and magistrates who refused to take the new oath and sacrificed their careers and good pay out of loyalty to the old dynasty.[119] Several fervent ultraroyalists fled abroad with the Bourbon prince, but most of his adherents, who came to be called legitimists, withdrew to their provincial estates.[120] This so-called internal emigration proved a stimulus to French provincial life. The energy and time of these highly experienced men, many of whom had enjoyed the best educations, went increasingly into the land. As a result, they paid greater heed to the revenue from their estates, and their bonds with the peasants were reinforced by daily contacts. Their presence also was felt increasingly at agricultural shows.[121] Agriculture was being encouraged by competitions and by education. The improvement of the Charolais cattle breed was one of the results of this trend.[122] Horse-breeding took pride of place among the agricultural interests of these mounted notables.[123]

A typical example of the "agrarian reaction" by the legitimists was the Association normande, founded in 1831.[124] It was but one of the initiatives taken by Arcisse de Caumont.[125] This *homo universalis* of the provinces, whose father had been imprisoned during the Revolution and who, born in 1801, had been brought up amidst Norman emigrants returned from England, founded numerous provincial societies. The agrarian ones, based on the British model, were meant to stimulate agriculture by competitions and by education and to oppose

the free trade movement with the help of statistical studies. An Association bretonne followed the Norman example, and the Congrès scientifique nationale was set up as an umbrella organization, in Caen to counter the centralizing influence of Paris.

Caumont's activities in the archeological field bore the most fruit.[126] He not only founded many new archeological associations but was also the heart and soul of the Société française d'archéologie, mentioned earlier. By the age of twenty he already had an *Essai sur l'architecture du Moyen Age* and a *Statistique monumentale du Calvados* to his credit. His classifying approach to medieval architecture earned him the nickname "the Linnaeus of archeology."[127] England's influence was also felt in Gothic studies. Many British gentlemen of leisure visited the Continent, and Normandy in particular, after 1815 in order to come to grips with the roots of their own Gothic style.

The indefatigable Caumont set up an anti-Parisian, regional, and once again boldly legitimist organization, the Institut des provinces, in 1838. Caumont's success prompted the Orleanist government to spring into action, or at least into generosity, the better to gain provincial support. The role of the authorities will be discussed in chapter 2; here let me merely observe that the inspired leadership of this Norman noble helped to create a favorable climate for the conservation and study of his country's medieval heritage, although his interest in monuments and art history had unmistakable ideological overtones. "This glorious apologist for religion," he was called at the Mass read at the unveiling of his statue in Bayeux in 1877.[128]

In addition to having ideological aims, Caumont's activities were designed to attract blue-blooded tourists. To that end, the archeological reports composed by this gentlemen of leisure were larded with information about places of special culinary interest. As befitted a connoisseur, he complained about the decline of village inn kitchens. *Eau-de vie* and coffee have replaced the roast," one could read in this early Guide Michelin. Caumont saw fit to include a *Statistique routière* (Road survey) and a *Guide des baigneurs* (Bathers' guide) for Trouville in his long and earnest bibliography.

Caen, Caumont's home base, was a notorious legitimist stronghold.[129] In the winter noble families would take up residence in their *hôtels* lining the most expensive streets of the town. In Brittany, in Anjou, in the Vendée, and in Maine the legitimist influence was stronger still.[130] A distinction has been made between rural legitimism in the west of France and the more urban form in the south, particularly in Toulouse,[131] where the respected Académie des Jeux floraux was a breeding ground for Carlists (a term widely used at the time). In the north and in the center of France the legitimists were more scattered, and although there was some legitimist influence in every department, it was less dominant than in the west or the south. Paris too had its legitimist salons. The nobility would spend six months of every year in their stately homes in the rue de l'Université, the rue de Lille, the rue de Varennes, or other streets in the most elegant quarters. Alfred de Vigny has left us a description of the atmosphere of salons in the expensive Faubourg Saint-Germain: "The conversation

there is often literary. At the moment (1842–43), the memory of the havoc wrought by the Revolution of 1789, of the sorrow of exile, of the mutilations during the Terror, and of the oppression under the Empire have lent it a religious, slightly mystical and elegiac tone."[132] The internal emigration clearly did not cause all legitimist nobles to turn their back on the Paris winter season, with all its worldly delights and splendid entertainments, after having spent the summer buried away in chateaux deep in the provinces.

Perhaps nowhere else was there so much legitimist dedication to local studies as in Brittany. The study of Breton history, Breton archeology, and the Breton language had a patent political objective, particularly in the circle associated with the *Revue de l'Armorique*, founded in 1842, where such men as Aurélien de Courson and Hersart de la Villemarqué made their presence felt.[133] Had Brittany not always erected a Chinese wall against modern ideas? Calvin's and Voltaire's pernicious doctrines steeped in heresy and unbelief had never taken root here precisely because the Breton tongue had acted as a cordon sanitaire. Breton historical studies were dominated by the ideas of vicomte de Bonald and comte Joseph de Maistre.

The *Revue* set out to drive home to its readers, with the help of articles on the history, monuments, and laws of the ancient Bretons, the idea that "nations cannot renounce their past without destroying their future." This twisted and prejudiced approach was bound to give rise to the most curious arguments. There were long columns of fierce discussions about the authenticity of the early medieval Breton lyric, the *Barzaz-Breiz*. The funny side of this literary cause célèbre was not so much that this brainchild of an overenthusiastic nineteenth-century amateur was mistaken for an authentic document—even the best scholar can fall into a trap—but that the *Barzaz-Breiz* was elevated into the letters patent of legitimist and Catholic Brittany, a literary question transformed into a political and social rallying cry.[134]

Of course not all nobles were legitimists; some of them sided with the young Orleanist party. This group coincided more or less with that of the constitutionalists during the Restoration, men who believed the king was obliged to defend the constitution and denied that he was possessed of divine rights. Then there were also a great many Napoleonic nobles and politically neutral noblemen. Shortly after the revolution of 1830 the differences between legitimists and Orleanists were at their fiercest. In some regions the Orleanists were isolated, with people poking fun at their awkward manners and lack of experience and ostentatiously staying away from receptions given by the prefect or raising obstacles to marriages.[135] In 1843 many of the most highly taxed estate owners called on the duc de Bordeaux in London—the so-called pilgrimage to Belgrave Square—where the legitimate pretender, *l'enfant du miracle* (the posthumous son of the duc de Berry), received nearly a thousand fervent supporters (including the above-named Hersart de la Villemarqué) after the death of the young duc d'Orléans.[136] After the revolution of 1848 and the Second Republic the differences between Orleanists and legitimists became less pronounced because both parties opposed the regime during the Second Empire. However, in the

1870s, when there seemed a real chance that the monarchy might be restored, the conflict was rekindled. Even the question of the flag (the tricolor of the Revolution versus the white banner with the Bourbon fleur-de-lys) raised insuperable difficulties, as one might expect from men with fine principles and decorations.

On 23 August 1883 the legitimate pretender died childless in an Austrian castle. The time seemed ripe to bury the hatchet. In 1885 the royalists, who had merged with the conservatives, won 176 seats in the first round of the parliamentary elections and the republicans won 127. But the Republic rallied its forces, and by whipping up support for its candidate during the second round of the elections managed to gain a parliamentary majority.[137] The comte de Paris, of Orléans descent but the only remaining candidate to the throne, was banished. General Boulanger's abortive coup in 1889 was perhaps the last real chance the monarchists had of seizing power, but even during that affair it became clear that a new Right, one with a completely different social makeup and different convictions, and one with whom the old legitimist nobility could identify itself no more than could the Orleanists, was taking shape.[138] The 1880s brought down the curtain on any serious national political ambitions the traditional royalist Right may have had. The style, the ideas, and the supporters of the conservative factions were drastically changed at about the turn of the century.

At the local level too the power of the old notables waned during the latter half of the 1770s and in the eighties. The number of republican mayors increased, and the composition of local and departmental councils shifted in favor of the republicans.[139] Even so, nobility remained influential much longer at the local level than at the national level. Outside the political arena their role in certain sectors of the civil service and of society was still considerable. The army, the fleet, diplomacy, the magistrature, the financial world, and the church became sanctuaries for the children and grandchildren of nobles who had made their last attempt to restore the old order in France in the 1870s.[140]

It is particularly difficult to give a general account of the historiographic output of the nobility. A rough statistical survey of the writers of historical works cannot reflect distinctions between ancient and newly acquired titles or between authentic and dubious ones. The nobility were a much more heterogeneous group than the clergy. There was no hierarchy and no discipline, no bishop or abbot to drum their duties into those under their charge and to see to their *ora et labora*.

In general, the historical interest of noble historiographers was more varied than that of the clergy. By far the greatest number of clerical historians wrote religious history. Their eye was directed inward. For the nobility, a calculation for the years 1866–75 shows that only a third of their historical writing was about their own estates.[141] Admittedly, they had a predilection for heraldry and the genealogy of their own families, and in that sense their interests can be said to have been narrower than those of the clergy, to whom parish and local church opened up a relatively wider horizon.

The greater part of historical writing by nobles covered the most diverse subjects: national history, local history, Oriental studies, prehistory, numismatics. Many had enough time to travel and enough money to build up collections. Connoisseurs with noble connections could go from castle to castle to feast their historical and artistic sensibilities.[142]

Emigration may not encourage writing, but the interruption of the daily routine and isolation do make for closer attention to one's surroundings and lend a special cachet to history. The revocation of the Edict of Nantes gave birth to a special refugee literature, the French Revolution to an emigrant literature, and the twentieth century added the *Exilliteratur* of Germans and Russians. It is perhaps going too far to compare the internal emigration of 1830 to these waves. When all is said and done, the nobility were simply returning to their ancestral castles and nobody drove them out of the country, but still they looked at their own surroundings with different eyes. The result was a spate of writings on local history by legitimist nobles. Often they also acquired a thorough grounding in the auxiliary historical sciences, which were needed particularly for medieval studies. Among the graduates of the Ecole des chartes were a great many aristocratic names. An increasing number of noble *chartistes* sought work in the expanding departmental archives. As a result, many nobles became professional historians, turning their backs on what is called the second estate of *historiens oisifs* (leisured historians).[143]

While the legitimist nobility, especially in western France, had ties with the local peasant population, the Orleanist nobility was much more closely connected with upper-middle-class circles. It was the weakness of Orleanism in general that it lacked mass support. Whereas the legitimists withdrew to their provincial chateaux after 1830, the Orleanists, who had far fewer roots in the soil, stayed on in Paris after 1848 and frequented the more intellectual salons and academies.[144] The Second Empire also meant that the time had come for the Orleanists to devote themselves to their "beloved muse." Duc Albert de Broglie, the comte d'Haussonville, the vicomte de Meaux, and the comte de Montalembert were just some of the leading Orleanists who wrote historical books during the Second Empire, none in the field of local history. Even such members of the royal family as the duc d'Aumale diverted themselves in their English exile by writing history books.[145]

Remarkably, it was not always the wielders of political power who wrote such books. Much as such liberal-constitutional historiographers as Guizot, Thiers, Mignet, Thierry, and Barante had their heyday during the Restoration, right-wing legitimist and Catholic historiographers flourished during the July Monarchy, and such left-wing republican opponents as Lamartine, Michelet, Louis Blanc, and Alphonse Esquiros rose to fame in the 1840s, so the Second Empire was the age of Orleanist historiography. Wielding political power thus seemed to impede the study of history, opposition and retirement to encourage it. This bore out the age-old belief that history is a favorite diversion of politicians edged out of public life. Opponents of the regime and frustrated and retired people are more inclined to take stock of the past, and have more opportunities

to do so, than politicians thrown into the maelstrom of great decisions. In a sense historiography may thus be said to be a form of compensation. But I have strayed from my subject.

The cream of the Orleanists (including notables not belonging to the nobility) could be found in the Académie française.[146] We can even speak of a special type of historiography, namely, *histoire académique*, which was still very influential in about 1900 and held a particularly great fascination for the upper middle classes.[147] It was a conservative historiography and aimed to clarify the political evolution of governments and countries, paying particular attention to revolutions, changes of regime, parliaments, ministries, diplomacy, and war. The masses were ignored and the chain of cause and effect was thought to be purely political. Religion was treated as part of political history. All in all, it could not be called a reactionary historiography, and it viewed the ancien régime with suspicion.[148]

The legacy of "noble" Orleanism was clearly enshrined in this *histoire académique*, which at the end of the nineteenth century still reigned supreme in the Académie française; was taught at the Ecole des sciences politiques, dominated by such *maîtres à penser* as Montesquieu and Tocqueville;[149] propagated in such periodicals as the *Revue des deux mondes*; and published by such famous houses as Plon and Calmann-Lévy. Albert Sorel, Pierre de la Gorce, and Gabriel Hanotaux were heir to this tradition.[150] As a result, the work of those noble historiographers, who had written such penetrating reflections on various rulers, was continued on a high intellectual plane and, as is customary with writings of this kind, without any parade of book learning. The tenor of their writing was one of resigned pessimism, unlike the aggressive style of the historic publicists round the ultraroyalist *Action française*[151] and of the much more ideological and less detached clerical historiographers.

These valuable historical writings also became outdated in time. They remained a kind of historiography written from on high and as such ignored the reality of democratized and industrialized mass society. Still, time passed more slowly in the calm French provincial towns than it did elsewhere. At about the turn of the nineteenth century, and until deep into the twentieth century, "academic history" continued to sell well to solid middle-class provincials.

CHANGES IN THE SOCIAL FABRIC

All historiography is to some extent the product of its age. With the passage of time, the view of the past becomes partly changed. In general, we may put it that the more technical, the more referential, and less selective historical works are, the less time-bound will they be. By contrast, significant, conceptual, explicative, and synthetic historical writings are more dependent on the social context and on the author's personal viewpoint. In a copy of a medieval document, a price list, or a set of census figures it is harder (although not always impossible) to discover time-bound attitudes than it is in a general outline. But even if

we make allowances for this fact, we would do well to remember that the writing of history is dependent on the society that generates it.

It is very difficult to determine the precise influence on historical studies of French social changes in the nineteenth and twentieth centuries. Certainly in the case of historiography there was no simple mechanical relationship between infrastructure and superstructure, between productive relationships and intellectual products. By way of a conclusion to this chapter I shall try to give an impression of the shift in the social framework at two levels: in French society at large, the macrocosm, in which historical studies of every kind were set; and in the French provinces, the microcosm, in which practically nothing other than local-history studies was pursued.

The Macrocosm

The France where in about 1870 more than a third of all historical writing was the work of the first and second estates was still a predominantly agricultural country. Even so, from the beginning of the nineteenth century there was a relatively steady move of the population from the countryside (defined as villages with fewer than 2,000 inhabitants) to the towns. In 1801 the ratio of the rural population to the urban was 77:23, in 1846 it was 75:25, and in 1911, 56:44.[152] There was thus a steady process of urbanization, but the absolute figures show that in the first half of the nineteenth century the agrarian population was still growing. Never before had the French countryside been so densely populated as it was in the middle of the nineteenth century. In 1801, 13 million people were engaged in agriculture; in 1864 that figure had increased to 14 million. Down to the 1850s there was no such thing as a rural exodus: the shift to the towns did not go hand in hand with the depopulation of the countryside.[153]

A fairly inaccurate count of occupations in 1866 shows that 51.5 percent of the population made their living off the land and 28.8 percent made theirs from industry.[154] Only after the Second World War did it become customary to divide the active population into a primary, a secondary, and a tertiary sector. Agriculture and industry (including construction and power supplies) make up the first two sectors, based on manual labor and great physical exertion. The tertiary sector comprises commerce, the service industries, transport, banking, insurance, administration, and education. Much of this sector involves clerical work and, in any case, demands less physical exertion than the other sectors. After a slight rearrangement of the original data, we arrive at the figures shown in table 9.[155] These figures show that during the second half of the nineteenth century there was a marked increase in the percentage of white-collar and intellectual workers. At the same time, the joint percentage of peasants and manual laborers dropped from 78 percent to 73 percent of the active French population.

Those who had to earn their bread by the sweat on their brow and whose hands were black with soil or oil did not often produce historical texts. Writing

TABLE 9
Distribution of the Active Population by
Sector, 1851 and 1906

Sector	1851	1906
Primary	53%	43%
Secondary	25	30
Tertiary	22	27
Total	100	100

history is an elitist occupation. Intellectual activity presupposes a good education, and a good education takes time and money. There are good reasons why our word *school* is derived from the Greek *skholè* (σχολη) meaning leisure spent in the pursuit of knowledge. Even so, nineteenth-century developments slowly eroded the intellectual hegemony of persons with time and money. More important than the decline in illiteracy in this connection was the shift from physical to "cerebral" activity.[156] White-collar workers increased the reservoir of "potential" historians. By that I do not mean to imply that a budding historian lay hidden in every grocer's clerk, bank teller, or civil servant. The difference between the primary and secondary sectors on the one hand and the tertiary sector on the other hand had a negative rather than a positive effect in that it highlighted the size of those population groups who rarely played an active part in the recorded intellectual culture of history books and journals. However, the reduction of the working day from an average of thirteen hours in 1830 to ten hours in 1900[157] and the introduction of twenty-four-hour observance of Sundays, made compulsory in 1906, ensured that more free time was available for reading historical works by anyone wishing to do so. The knowledge-parched elite of the labor movement in particular had an insatiable thirst for reading in their rather limited free time. Jaurès's *Histoire socialiste*, aimed at a wide public, was a great success. But the working hours still remained long and hard, and the peasants, at least, confined their reading to indispensable texts. One of the first peasants to become a writer around the turn of the century was Emile Guillaumin, who spoke with a more authentic voice about the situation of peasants in the Bourbonnais than did any number of middle-class authors who had never labored on the land. But writing with a gnarled hand was something Guillaumin too found hard work.[158]

To fill out the statistical contours of the potential writers of historical works, we must first draw an overall picture of the "tertiary" sector.[159] Its expansion was most marked in commerce, banking, and transport: from 618,500 employees in 1856 to 2,955,900 in 1906. This was a relative increase from 4.4 percent of the active population (men and women) in 1856 to 14.2 percent in 1906. More important for us—since this group included a particularly large number of historical writers—was the much smaller but nevertheless unmistakable increase in the number of persons in the free professions and the civil service:

from 952,300 in 1856 to 1,626,100 in 1906, an increase from 6.7 percent of the active population (men and women) to 7.9 percent.

Among the free professions the increase was greatest in the medical sector: from 49,500 in 1866 to 146,000 in 1906, a threefold increase in forty years. The legal professions remained fairly stable, growing from 56,000 to 58,000. The number of engineers and architects expanded appreciably: from nearly 23,000 in 1896 (the first year for which data are available) to nearly 65,000 in 1911. The number of people earning their living from literature and art (including journalists, a category of particular interest to us) rose from 40,000 in 1896 to more than 50,000 in 1911.[160]

France was known as a country with a very large number of civil servants. Starting in 1866 with as many as 748,000 officials in the service of the state, the various departments, and the communes, the Third Republic managed a steep increase to 1.2 million in 1906.[161] Most of that increase was due to the enlargement of the army and the police from 375,000 (1866) to 616,000 (1906), the number of officers increasing from 15,000 to 30,000.[162] This development explains the increase in the number of military historians from 3 percent in 1866–75 to 8 percent in 1900–1905 (see table 8).

Two other official growth sectors were less important sources of potential historians: the postmen, in 1906 more than 95,000 in number, and the more than 77,000 officials in the state industrial sector. The magistrature expanded but slightly (from 10,700 in 1866 to 13,600 in 1906), the number of senior law officers not exceeding 3,000.[163]

The educational sector is of particular importance to our discussion. French education was divided into a public and a private sector. The teaching staff in the public sector increased from just over 65,000 in 1866 to 149,000 in 1906, largely at the expense of the private sector. In 1866 the latter, with a staff of 92,000, was still much larger than the former. In this area, however, the data are uncertain as there were no general school inspections and, for the officials of the ministry, the wish was often father to the statistical data published in the heat of the school conflict. But all the uncertainty notwithstanding, the two sectors seemed to have achieved balance in 1901, each employing a staff of between 138,000 and 140,000. During the first decade of the twentieth century, however, the ratio changed clearly in favor of public education, partly as a consequence of determined republican policy. By 1906 the number of teachers in the private sector had dropped to 104,000.[164]

The great majority of teachers taught in elementary schools, which dispensed mass education that was compulsory and free of charge. Secondary education was elitist—optional and expensive. In the great parliamentary inquiry held in 1898 under Ribot the number of staff in public lycées and collèges was put at close to 9,000 and the number in the private sector at close to 4,000, of whom 3,000 worked in denominational schools.[165] (In 1842 the total number of teachers in secondary education was estimated at about 4,000.)[166]

The Historiographic Potential

Is there any point, after presenting all these figures, in introducing the concept of the historiographic potential of a given society? The number of people in the free professions, which demand, relatively speaking, more cerebral than physical exertion and consequently have greater historiographic potential, was about 280,000 in 1906. If we add senior officials in the magistrature and army officers (estimated at 3,000 and 30,000, respectively) and teachers in public and private education (a total of 253,000 persons in 1906), then the overall historiographic potential of the professional population of France can be put at 566,000.

In 1901 the number of secular and regular priests (many of whom were of course engaged in education and were thus counted twice) came to almost 93,000.[167] If, for lack of precise figures, we estimate the number of adult nobles and would-be nobles at 45,000 for the period ending in 1914,[168] then we can put the historiographic potential of the first and second estates at the beginning of the twentieth century at 138,000, that is, at less than a quarter of the historiographic potential of the professional population. In light of these very broad estimates, the percentage of historical writers drawn from the clergy and the nobility (27% in 1900–1905 [see table 8]) is not surprising.

If we look at only the clergy, the nobility, and the professional population, then we ignore a large group highly typical of French society in the nineteenth and the early twentieth centuries, namely, the 550,000 persons who described themselves as *rentiers* or *propriétaires*, men of independent means.[169] They did not constitute a social class or an organic group, sharing neither birth, education, position, nor wealth; the only common factor was that they all lived on unearned income. The social and economic circumstances that made this group so large in the period before 1914 need not concern us here, no more so than their lack of the least sense of shame about not being actively engaged in productive work. The history of the concept of work—of the work ethic in the twentieth century—has yet to be written.[170] Our concern here is to gain a very general impression of the size of a group who had time and money to devote themselves to history if they felt like it. No figures are known about the wealth of *rentiers*, but estimates suggest that no more than 50,000 of their total number of 550,000 belonged to the upper middle class.[171] Most were *petits rentiers*, people who could manage to live cheaply in the provinces but who could barely afford any luxury other than doing no work. The great majority of these *petits rentiers* lacked the education or the intellectual interests of civil servants, of people in the free professions, and of the clergy. The nobility must be considered the crème de la crème of the *rentiers*, the educational standard of young noblemen being generally much above the average. If, at a guess, we include one out of two *petits rentiers* in our historiographic potential and add the number of upper-middle-class *rentiers*, we arrive at a total of 300,000 potential *rentier* historians. (A summary of these hypothetical computations of the histo-

TABLE 10
Estimated Historiographic Potential in the Early
Twentieth Century

Sector	No
Free professions and civil servants	566,000
Clergy and nobility	138,000
Rentiers	300,000
Total	1,004,000

riographic potential of French society before the First World War is given in table 10.) We can therefore conclude that in a population of 38–39 million souls just 1 million—no more than 2.5 percent of the population—could be counted as potential historical writers.

I have introduced the concept of historiographic potential to elucidate two points. First, it puts the intellectual statistics in perspective. In a society lacking mass media, modern working conditions, and education the intellectual statistics, in this case the statistics reflected in the historical output, show that a maximum of 2.5 percent of the population could have contributed to the writing of history. Historiography, of course, was affected by the character of the society that brought it forth, but it certainly did not reflect the productive relations of that society as a whole; rather, it mirrored the preoccupations and diversions of 2.5 percent of the French people who, thanks to personal circumstances, held intellectual sway over the rest.[172]

Second, the historiographic-potential figures show that in the third quarter of the nineteenth century three groups accounted for a disproportionate share of the historiographic output, namely, the clergy, the nobility, and professional people. At the beginning of the twentieth century only two of these three groups, the clergy and the professional historians, remained. In the course of the twentieth century the share of the clergy decreased and, partly as a result of the expansion of the job market for them, that of the professional historians increased.

Finally, it should be noted that even these hypothetical computations tell us nothing about the number of women involved.

The Microcosm

At the end of the nineteenth century, marked changes occurred in the historiographic potential, especially in the field of local history. The urbanization of France, or at least the acceleration of the movement of people into the towns, did not yet mean the expansion of the selective historiographic potential of the urban population. Thus, some towns that witnessed a rapid growth in population in the wake of expanding economic activity had a far lower standard of literacy than towns with traditional employment in the administrative, ecclesiastic, or legal fields and also boasting *lycées* and faculties. In the west, for instance, Quimper was better placed in that respect than Brest, Rennes was better

placed than Nantes, and in the north Valenciennes and Douai were more liter-
ate than Roubaix or Lille. Just as the degree of literacy was strongly dependent
on the number of administrative and industrial posts,[173] so historiographic po-
tential seems to have been as well.

If, for lack of other data, we infer the involvement in local-history studies
from the organizational infrastructure of local societies, then we discover the
striking fact that of the thirty-seven towns with more than 40,000 inhabitants in
1896 the four without historical societies—Tourcoing (73,000), Calais (55,000),
Saint-Denis (53,000), and Levallois-Perret (46,000)—also lacked prefectures
(and hence a significant number of administrative posts) even though all these
towns were growing in economic importance.[174] Of the eighty-nine departmen-
tal capitals, all of which had prefectures and administrative posts, only five did
not have either a historical or an archeological society at the beginning of the
twentieth century.[175]

Of the twelve French cities with more than 100,000 inhabitants in 1896 four
cut a particularly bad figure, with just one historical or archeological society
each: Saint-Etienne (129,000), Roubaix (124,000), Le Havre (117,000), and
Reims (100,000). All four had rapidly expanding industries. Marseille, the third
most populous city in France, had just three societies for 450,000 inhabitants.

In 1885–1900 twelve cities had four or more historical or archeological soci-
eties each. If we leave Paris (with 66 societies and nearly 2.5 million inhabit-
ants) out of account because of its peculiar role as the national center of many
societies without local-historical interests, then it is striking that such very large
and economically important cities as Lyon (449,000) and Bordeaux (247,000)
had only seven societies each, while the smaller Rouen (107,000) could boast
eight. Caen (39,000), the home of Arcisse de Caumont, had six societies, as
many as Toulouse, which was three and one-half times its size (140,000).
Bourg-en-Bresse (15,000) had four societies, as many as Lille (205,000), the
great industrial city in the north.[176] Urbanization thus had no effect on the
organizational infrastructure of local-history studies.[177]

The study of local history was greatly influenced by the increase in the number
of commercial jobs and civil servants in the provinces. In this connection, we
probably would do well to speak not only of the historiographic potential but
also of its target. Membership in a historical or archeological society did not
necessarily mean that one possessed the ability to write history. According to
one expert, "Those citizens in Montpellier who wanted to spend their leisure on
intellectual pursuits were generally busy with history, because it is one of the
fields in which you most easily gain the illusion of writing remarkable books,"[178]
but even that exertion was too much for many members of these societies. In
most cases a society revolved round a small, active hub, sometimes just one
person, and when he was absent the society would die a gentle death, only to
be resurrected by another enthusiastic amateur or professional historian. Al-
though in some cases membership was purely formal and the fees proved hard
to collect, we can nevertheless assume that such *sociétés savantes* were centers of

"historical culture," that is, broad groups of readers and writers supporting the study of local history. From the 1880s on there was a perceptible change in the "historical culture" of the provinces. Hand in hand with the growth of the tertiary sector, with economic expansion and political democratization, went a transfer of political power in many provincial towns. After the resignation of Marshal MacMahon, whom many had considered a kingmaker, the Third Republic acquired its first republican president in the person of Jules Grévy. The *Marseillaise* was officially adopted as the national anthem, and Quatorze Juillet was declared a national holiday in 1880. Of great importance to the political life of the provinces was the Local Government Act of 1884.[179] The mayor and his councillors were henceforth elected by the citizens (Paris remained the exception). The meetings of the local councils became public. The ground was thus laid for the politicization of the countryside, and in many rural towns the republicans were able to seize power. As noted earlier, the 1880s put an end to any real pretensions the notables may have had to national power. On the local level, however, they continued as a political force in several regions, though the republicans continued to make impressive advances.

The transfer of political power was reflected in some of the new historical societies. In cities and small towns where local societies were set up for the first time the polarization was much less obvious than in cities where new, pro-republican societies competed with old and respected academies that had been dominated by the notables since olden times. In Nevers, for example, the Société académique du Nivernais was founded in 1883, its republican bias providing a counterweight to the old Société des lettres, sciences et arts, which had very close ties with the archbishopric.[180] And in Clermont-Ferrand the Société d'emulation de l'Auvergne, founded in 1884, was much less conservative than the old Académie des sciences, belles lettres et arts de Clermont-Ferrand. A glance at the contents of the recently founded society's *Revue d'Auvergne* shows that there was local interest in socio-economic history and in modern topics that had been taboo in the Académie.[181]

Needless to say, not every new society in a city with an established old association was of republican stamp.[182] Some cities gave birth to specialized societies. The old ones, with their polymathic character, no longer satisfied, and many special historical or archeological societies were founded for reasons other than political rivalry. In some cases, such as in Montpellier, there was in fact a hierarchy of local associations rather than rivalry between them. The younger society was an antechamber to the older, more illustrious one.[183]

While not denying that there was independent interest in local history, in the soil on which one stood and the buildings by which one was daily surrounded, and without wishing to reduce local historiography to political activity, we can nevertheless say that the "new social strata," whose future rise Léon Gambetta had foreshadowed in his famous address of 1872, made their influence felt in the life of historical societies. "New social strata" was an elastic but essentially correct designation for a middle class of small industrialists, merchants, shopkeepers, artisans, builders, office workers, and civil servants. This middle class

forged links with the lower classes in town and country. Although there were marked social and economic distinctions between them, the new strata had greater sympathy for the aspirations and expectations of the ordinary people. The microcosm of Mazière-en-Gatine, in the department of Deux-Sèvres, on which a fine monograph appeared in 1943, reflected this "general" trend.[184] The nobles, the old bourgeoisie, the notables, the proprietors, were succeeded by the party of pharmacists, veterinary surgeons, advocates, doctors, and teachers. They turned their backs on "society," that is, on the city establishment.

The rise of a more democratic, prorepublican form of regionalism fitted into these social developments. Regionalism (a term that, according to Littré, dates back to the beginning of the Third Republic)[185] was an ally of traditionalism and reaction until the end of the nineteenth century, but the nineties witnessed the rise of republican regionalism.[186] At the beginning of the Third Republic, when the republicans gained control, progressives tended to be suspicious of any limitations of the powers of the state by decentralization and federalism. At the end of the century the novelist Eugène Le Roy became a leading exponent of republican regionalism, thanks especially to his *Jacquou le Croquant* (1899), a book about the "White Terror" and about peasant resistance during the Restoration.[187] The novel was melodramatic, but it was sprinkled with authentic descriptions of peasant life in Périgord and written with a keen perception of the prevailing socio-economic conditions. Le Roy admittedly wrote in French, but a French richly interlarded with the local patois. He thus differed in several respects from members of the Félibrige in the south, a society led by Frédéric Mistral. The latter advocated the use of the *langue d'oc* (without lasting success, however), was more interested in cultural matters than in socio-economic questions, and stood to the right of the political center. It was his reading of Le Roy that encouraged Emile Guillaumin, the *métayer* (tenant farmer) we met earlier, to turn his hand to writing. Guillaumin's more or less autobiographical book published in 1904 under the title of *La Vie d'un simple* had an explosive effect on French republicans, comparable to the impact Harriet Beecher Stowe's *Uncle Tom's Cabin* had on Americans.[188] It highlighted the deprivations and subjugation of the rural proletariat. In numerous regions of France feudal servitude was still being practiced—one hundred years after the French Revolution. The book alerted public opinion, and there were many references to it in the Chamber. As a result, left-wing politicians too began to concern themselves with the provinces and their inhabitants, on whom they had previously looked down as a reservoir of soldiers used during the 1848 oppression and for crushing the Commune. Regionalism became presentable in republican eyes. In the provinces republicans began to act more confidently than before as they increasingly tried to identify themselves with the past of their own region.

It is tempting to argue along parallel lines with Raoul Girardet, according to whom French nationalism shifted from left to right during the nineteenth century,[189] that regionalism moved in the opposite direction, but that would be going too far. In the nineties the Left too began to lose its allergy to regionalist ideas, and later one could find a growing number of left-wing politicians with

regionalist sympathies. For all that, many regionalist movements were reactionary. The antithesis between Left and Right that held on the national plane could also be found at the provincial level, albeit adapted to the specific conditions.

Especially at the turn of the century there was a sharp political polarization in many provincial towns. In the resulting climate the Dreyfus affair elicited an incredible response. The fierce anticlerical stand taken by the republican Combes administration exacerbated the differences even further. In this heated atmosphere the Chamber adopted Jean Jaurès's suggestion and in 1903 appointed a committee for the study and publication of documents on economic life during the Revolution.[190] A network of correspondents was set up in the provinces. The letters of Augustin Cochin, son of an Orleanist leader, who traveled from castle to castle with letters of introduction from his father to examine previously unexplored archives for his original and penetrating studies of the Revolution, reflect his anger with teachers who, on orders of the commission, were poaching on "his" "historic" preserve.[191] But whereas the nobles had retired to their castles, the bishops were about to launch a historical counteroffensive, encouraging the local clergy to turn their hands to history.[192] In Rouen a Comité de recherche des documents économiques de la Révolution was set up to examine economic documents connected with the Revolution, and this committee ostentatiously boasted that it had no links with the Ministry of Education. In Troyes a Société départementale de la Révolution dans l'Aube was founded in 1907.[193] General local-history journals such as *L'Anjou historique* launched bitter counterattacks on prorepublican historians of the Revolution.[194]

Once again it became clear that historiography was not the "automatic" product of social changes. In the case of local-history studies the rise of "new social strata" did lead to the creation of new historical societies, but this went hand in hand with a historiographic counteroffensive led by the bishops. Rise and fall of political influence were accompanied by historiographic changes. The study of history might be used to legitimize the emancipation, but it could also serve as a form of compensation.

We may say that in general the growth in historiographic potential came later in the provinces than it did in Paris. In a 1902 survey of local-history societies the level-headed Pierre Caron contended that members of provincial societies were still recruited predominantly from the nobility and the (upper) middle class. Among them were local scholars and "most of the persons who wield social influence in the country, for whatever reason. . . . Public servants, teachers, and professors sometimes have difficulty in joining; hence they often refrain from applying for membership."[195] At about the turn of the century there was therefore still prejudice against professional historians in various local-history societies. This explains why the influence of professional historians made itself felt later in the study of local history than it did in the study of national history. However, from the 1840s, when the departmental archives were first organized, archivists began to give a strong impetus to regional studies. Even so, in the

lycées and faculties, where most professional historians were to be found, little attention was paid to local history at the end of the nineteenth century.[196]

The extension of the historiographic potential in French society was a consequence of socio-economic developments in the second half of the nineteenth century. The usefulness of such concepts as historiographic potential is *indirect*. The employment of professional historians in the teaching of history and the administration of the historical heritage preserved in archives and museums was a direct consequence of decisions taken by the authorities. Long before the historiographic potential of French society began to increase perceptibly the government had recruited historians, who, however small their number, exerted a disproportionate influence on the output of historical writing.

Paying for History

FORTUNATE INDEED the historian whose time is his own. By far the largest number of historians, however, nowadays practice their craft as paid servants of the state, so much so that we take it for granted that the government should be paying a large number of people to study the past, to teach it to students, and to work in archives. In earlier times, when the process of nation building was less advanced, this method was far from usual; not until the nineteenth century was the study of history first patronized by the authorities. True, even nowadays the state is rarely a direct participant in the production, distribution, and consumption—the writing, publishing, selling, and reading—of historical material, but a growing number of historians are nevertheless being paid by the state. Increasing state involvement in the employment of persons in, or their release for, historical studies is the basis of the social position of most contemporary historians. They have been turned into civil servants.

The nationalization of historical studies has taken various forms, nineteenth-century French political regimes of widely divergent hue investing money in such work, each in its own way and for motives of its own. A political-phase approach, inappropriate for so many historical subjects, is therefore the most useful in the present case. It should, however, be remembered that though the state may subsidize the study of history for specific ends, such subsidies can have unintended results. In this chapter we shall be looking at developments exclusively from the point of view of the state. In later chapters, however, professional historians will be viewed, not as passive objects of government interest, but as active students of history. The cynical dictum "The man who pays the piper calls the tune" does not, fortunately, apply unreservedly to professional historians in the service of the state; they have considerable leeway for skillful manipulation.

State investment in the study of history should be viewed against the background of growing state expenditure in general and expenditure on education in particular. An important mid-eighteenth-century study defined government finance as "the art of assigning, collecting, and then distributing the sovereigns' share of the public wealth."[1] In 1789 the "sovereign's share" of the wealth of France came to 531 million *livres tournois*. That, in any case, was the budget Jacques Necker, director of finances (the title of minister was denied him because he was a Protestant) presented to the States General on 5 May 1789.[2] By 1914 the total expenditure of all the ministries had grown to 3.3 billion francs. Because the value of the *livre tournois* was more or less equal to the pre-1914 gold franc, this meant a sixfold increase over 125 years.

The causes of this marked increase included the expansion of trade and industry, the increased circulation of money, and population growth (from approximately 26 million souls in 1789 to 40 million in 1914).[3] The old tax system was largely maintained during this period. If a great deal of money was needed, as in 1870–71, then the classical solution was to borrow it; not until 1913 did the Senate agree to a very modest form of income tax.[4] During this period of economic liberalism the size of the budget was not determined by political considerations; the state felt the impact of economic developments but rarely intervened. However, though the sum of the state's finances may have been determined largely by factors over which politicians had no influence, the *distribution* of these resources was politically determined. Politicians may have had only a small say about the revenue, but they did control the expenditure. For all that, a large part of the expenditure was the result of previous debts, such as in 1789, when no less than 46 percent of the expenditure consisted of interest on debts (237 million *livres tournois*).[5] Apart from interest, military expenditure was traditionally the largest item. In 1789 it was exceptionally low— 26.3 percent, or 140 million—but generally it accounted for at least one-third of the total. In 1914, the climax of the armed peace, 58 percent of the budget was spent on the army and navy (1.925 billion francs).

The army and navy had for long been the exclusive responsibility of the state. In education, by contrast, the task of the state was thought to be very limited until the Revolution. The sum allocated for "education and science" (the king's gardens and library, universities, academies, *collèges*, art, and science) came to no more than 0.23 percent of the total budget (1.2 million *livres tournois*). In 1914 that share had risen to 10.3 percent (344 million francs), notwithstanding the military pressures. Next to military expenditure, education was the fastest-growing sector. Increasing expenditure on the social services during the period leading up to 1914 was as nothing compared with the cost of education. In 1789 people may have felt differently than we do about social responsibilities, yet the old monarchy spent 1.2 percent of the budget (6.4 million *livres tournois*) on gifts, alms, hospitals, foundlings, charitable works, lotteries, aid to refugees, and so on.[6] In 1914 the budget of the recently established Ministry of Labor and Social Insurance still accounted for no more than 3.4 percent (112 million *livres tournois*) of the total budget.[7]

A comparison of the 1789 budget with that of 1914, 125 years later, highlights a general trend. For a detailed examination of the education budget (out of which most professional historians were paid), I have chosen several random samples from the intervening years. For practical reasons I have selected 1825 as the starting point—it was not until the Restoration that the budget was systematically prepared and subjected to parliamentary control by the émigré baron Louis, who had acquired the necessary skills in England, and by the conscientious Villèle.[8] For centuries the budget had been kept a secret. When the reformist author Véron de Forbonnais had published his interesting financial studies in the middle of the eighteenth century he had had the good sense to do so (anonymously) in Basel. He was rightly afraid of being accused of

TABLE 11
Education-Budget Estimates, 1825–1914

Year[a]	Millions of Francs	% of Total Budget
1825	5.7	1.1
1835	12	2.2
1842	16	2.4
1850	22	2.9
1860	21	2.7
1870	24	2.8
1880	57	4.6
1890	137	10.0
1900	208	9.6
1910	282	13.0
1914	344	10.3%

Sources: Absolute figures are from BN 4° Lf[156] 8; percentages are based on the total number of "services généraux des ministères."

[a]The revolutionary year 1830 is not included; the 1840 and 1841 budgets could not be found in the BN.

disclosing state secrets and familiar with the errors and political prejudices bequeathed by a "less philosophical age."[9] All the secrecy, the muddle of separate funds, and the jumble of budget allocations came to an end in the 1820s. However, publicity is not the same as candor. In a sense every budget has been and continues to be a form of deceit. The government has a free hand in implementing it; there is nothing to stop it from misappropriating funds, and special credits widen its scope even further. In the period under review this was particularly true of military expenditure, invariably the biggest item in the budget. Educational expenditure too involved official as well as off-the-record elements, but for lack of other information the historian must rely on his own wits and on the official figures. The survey in table 11 is proffered with this caveat.

These figures were further distorted by technical complications, but a general trend can nevertheless be extrapolated. A doubling, in both absolute and relative terms, between 1825 and 1835 was followed by a gradual rise until 1850, after which there was no increase until 1870, followed by a steep rise during the first decade of the Third Republic. The 1880s were a period of explosive growth; in the 1890s there was a rapid increase in the absolute amount, but in view of the expanding budget this meant a relative decline. The first decade of the twentieth century saw marked growth in absolute as well as relative terms. The 1914 figures were distorted by the threat of war, which brought a gigantic increase in military expenditure to the detriment of other departments. In absolute figures, however, the rise in educational expenditure from 1910 to 1914 was considerable.

In the course of the nineteenth century the government came increasingly to treat education as a matter of national importance. For centuries there had been

no compulsory education; instead there had been a kind of free market in which educational supply and demand were largely determined by economic and social circumstances. The teaching orders had played a large part in the educational system of the ancien régime, so that increasing state involvement in education during the July Monarchy and the Third Republic was politically motivated. Against this background Guizot, and Jules Ferry after him, set his distinctive stamp on educational policy. It was again for political reasons that during the Second Empire and particularly during the 1850s the state again made way for private and denominational education. Modern historians speak of the "illusion of politics" and have questioned the real influence of politicians on the development of education.[10] Needless to say, education is dependent on economic development and on social circumstances, but in reaction to the re-publican eulogies to Ferry's achievement modern historians go to extremes when they call the influence of politics an "illusion." That Ferry made funds available for primary education is an incontrovertible fact. It is true that he built on earlier foundations, but his policy filled three holes in French educational policy: it extended education to girls and to the countryside and ushered in compulsory education.[11]

The education budget provides us with a general framework for the more spe-cific state expenditure on history. It seems reasonable to assume that historical studies profited from increases in the educational budget and that history too suffered when that budget went into decline. A closer examination of the contri-butions of successive political regimes, however, shows that there was nothing like a direct relationship between the two. What all political regimes did display was ideological bias. During the Restoration, no less than during the July Mon-archy, the Second Republic, the Second Empire, and the Third Republic, the study of national history served to legitimize the current political approach. When it came to allocating funds to history, it was obvious that no government acted without an ulterior motive.

THE RESTORATION

The passion for history conceived by the postrevolutionary elite in the fire of the Romantic movement was not reflected in the allocation of public funds; the unmistakable popularity of history was the result of private initiatives. The Res-toration lacked funds to indulge in such luxuries. Money and care went toward the resuscitation of the old traditions. The grotesque culmination was the coro-nation of Charles X in Reims cathedral on 29 May 1825. After some hesitation it was even decided to have the new king perform a public miracle. Following an age-old custom ridiculed even in the eighteenth century, Charles X touched some 120–30 scrofulous patients: "The King is touching you; may God heal you."[12] Yet, as I have said, the fervor with which the pre-1789 traditions were revived proved of little financial benefit to the study of history.

Roughly speaking, there were four ways in which the state was able to encourage historical studies. The first and most traditional method was personal patronage in the form of a pension often coupled to the title "royal historiographer." The second method was to provide state subsidies for such "research" institutes as the Académie des inscriptions et des belles lettres (AIBL) or to found new institutes of a similar kind. The third method was to allocate funds, large or small, to the care of archives, books, art treasures, and monuments. And the fourth was to foster the teaching of history by employing specialist teachers. That took money, of course, but then the history lessons given by nonspecialist teachers cost money as well. The institutionalization of history education did have some effect on the budget because the salary of specialist teachers could exceed that of other teachers (which, incidentally, it did not do for a long time), but the difference was not significant. Needless to say, though, this trend had direct repercussions on the professionalization of the study of history (see chapter 3).

Those paid by the government in this way were, in our terms, professional historians; they earned their living by writing, research, administration, or teaching. In practice there was, of course, distinction between these various activities. A history teacher might do research, and so might an archivist; a member of the AIBL might not only publish the results of his researches but sometimes also write "real" history, and who was to draw a line between the two? The only purpose of such distinctions is to make the subject easier to handle, and a brief retrospective survey may also help to put the educational policy of the Restoration into proper perspective.

The King's Historiographer

Fortunate nations may have no history, but kings without a history are far from fortunate. Dynastic history was an essential facet of royal dignity. A recent study has shown that from 1554 to 1824 French kings employed a total of 104 persons with the title *historiographe* (12 in the sixteenth century, 71 in the seventeenth century and 14 in the eighteenth century; there is some uncertainty about the rest).[13] *Historiographe du Roi* was actually not so much a function as a title with an attached financial reward. Those who bore that title held a subordinate position at court and were considered to be little more than lackeys. Historical research was not, in principle, what they were expected to do; the crucial qualification was literary and poetic skill. Rhyming chronicles, panegyrics, and historiography were not treated as distinct genres at court. Racine was commissioned to write a "history of the present realm," and in the same capacity of royal historiographer Voltaire wrote verses about a battle that had been won three days earlier (a contribution that may therefore be called "instant poetry"). In the seventeenth century, and especially before 1660, under Richelieu and Mazarin, France teemed with *historiographes*, so much so that Louis XIV grew tired of men of letters ready to turn their hand to anything. History was something that often bored him: "The King does not occupy himself greatly with

history, for being forced to listen to sermons and harangues and to read books dedicated to him, he has grown tired of them all."[14]

La Bruyère has formulated the relationship between "great men" and historiographers as follows: "The lives of heroes have enriched history, and history has embellished the action of heroes: hence I do not know who is more indebted to whom: those who have written their history to those who have supplied them with such noble material, or the great men themselves to their historians."[15] In that sort of climate skeptical views of history flourished.

In the eighteenth century Jacob-Nicolas Moreau, an experienced administrator, in particular gave new meaning to the office. He set out to create a documentation center for the use of the administration and the government and hence to practice "institutional history" in the manner of Montesquieu. "The *historiographe* of the monarchy must study the fabric of the state and everything that renders it stronger or weaker . . . and he must only set forth the virtues and vices of the prince inasmuch as they are relevant to the defense, the safety, the government, and the morals of the state."[16] This documentation center came to be called the Cabinet des chartes and was placed under the supervision of a committee headed by Moreau, who from 1775 on enjoyed the title *historiographe de France*. The importance of that project should not be underestimated. A team of Benedictines and others copied and classified 40,000 documents from 1764 to 1789. A mission to the royal archives in London yielded a harvest of 7,000 copies and one to the papal archives in Rome 8,000 more. The aim was to publish two great chronological series, one made up of document and deeds, the other of letters. The Revolution prevented their publication.[17]

The king's historiographer disappeared with the monarchy. The word was in bad odor, which explains why Napoleon, in a note on the encouragement of literature in 1807, emphatically advised against the use of the term *historiographe*. For were such people not just hacks paid to write history for monarchs or governments? "It is hard to believe that good history can be written to order," he wrote. "But," the emperor continued, "what *can* be done to order, is to write historical studies based on the scrutiny of original documents. If such studies are incorporated in a sound account of the facts, then such work is indeed related to historiography, though its author is no historian in our sense of the word."[18] The emperor, in short, saw the point of financing historical research but not of financing historiography.

Even though Napoleon did not restore the office and title of *historiographe*, he did take an interest in the contents of historical writings. The imperial censors kept a vigilant eye on all contributions.[19] In 1808, when the abbé Halma begged leave to continue the *Histoire de France*, Napoleon had a clear idea of what its tenor should be. The decline of the Bourbons and the chaos of the Revolution had to be presented in such a way that the reader would breathe a sigh of relief when he or she came to the Empire. Any other version had to be suppressed, if necessary by police intervention, Napoleon added cynically.[20] Studies that suited his book, on the other hand, received public subsidies. In a few cases the money was well spent. The astute Lemontey was granted a "pension" by the

emperor for writing a history of France from the time of Louis XIV. He was given free access to the relevant documents and displayed a penetrating insight into the workings of the monarchy, anticipating Tocqueville's views on centralization.[21] After the restoration of the monarchy, however, the censors became fussy about the treatment of past royal figures. For the time being even "selective" disclosures were disallowed. Upon Lemontey's death in 1826 his notes and manuscripts were confiscated by the comte d'Hauterive, director of archives at the Ministry of Foreign Affairs. D'Hauterive also saw fit to prevent the publication of the bitter and disgruntled memoirs of the duc de Saint-Simon for ten years.[22]

The court had to be shown in all its old glory, and everything possible was done to present the Revolution as a regrettable break in an age-old tradition; that was why the *historiographe du Roi* had to be brought back. The last to be honored with that title was Chateaubriand (1817–24).[23] This literary genius, who had opened up new horizons in the study of the past by a fundamental reevaluation of Christianity and the Middle Ages, condescended to accept the king's money. The king, for his part, could congratulate himself on having the man on his payroll even though he did not expect the latter's literary contributions to be swayed in any way by such financial considerations. It was a long way from the poor men of letters at the court of the Sun King! The "consecration of the writer" begun with Voltaire in the eighteenth century was complete.[24]

Research Institutes

The great exemplars of organized and collective historical research had been studious monks in the seventeenth and eighteenth centuries. Among the Jesuits it was the Bollandists, and among the Benedictines the Maurists, who did the most exemplary work, but other congregations also made important historical contributions, if more incidentally. The secular authorities were happy to rely on the erudition of monks, although the crown had, of course, long been accustomed to drawing upon secular magistrates and lawyers, the better to shore up the royal prerogatives with precedents uncovered by historical research.

Colbert, the great minister of Louis XIV, appointed a committee to provide inscriptions, approve heraldic devices and medals, select suitable motifs for tapestries, and deliver "historical know-how" for festive occasions and ceremonies at Versailles. Not until after its reorganization in 1715 did this Académie des inscriptions et des belles lettres become the chosen meeting place of ecclesiastical and secular scholars.[25] The AIBL, whose history thus went back to the seventeenth century, initiated a number of comprehensive research projects in the eighteenth century modeled on a series of publications by Maurist monks from the abbey of St. Germain-des-Prés. The eighteenth century, the age of Enlightenment, of the "philosopher historians," was also the age of comprehensive series of "baroque" writings by historical scholars. Needless to say, it was the done thing for more worldly "philosophers," who wrote for a larger audience, to scoff at these "antiquarian apes,"[26] especially those wearing a cowl. However,

more intelligent Enlightenment historians valued their contribution. Thus Edward Gibbon, having purchased twenty volumes of the *mémoires* of the AIBL in 1759, explained that he had never before acquired such a lasting source of "rational amusement" for a mere twenty pounds sterling.[27]

The Revolution abolished the "royal" academies, including the AIBL, and also closed the religious orders, but in 1795 the Convention resuscitated the old academies under the name Institut de France.[28] The clerical specialists were instructed to continue the most important publications of the old AIBL and some of those of the Maurists as well, though some of the latter had reached a dead end long before the Revolution.

In 1796 Dom Brial was commissioned, under the auspices of the Institut, to carry on the great work of the Benedictines, the *Recueil des historiens des Gaules et de la France*, a collection of the most important chronicles. In 1807 the then minister of the interior, whose department was in charge of the Institut, decided to continue a second great Benedictine enterprise as well, namely, the *Histoire littéraire de la France où l'on traite de l'origine et du progrès, de la décadence et du rétablissement des sciences parmi les Gaulois et parmi les Francois; du goût et du génie des uns et des autres pour les lettres en chaque siècle*, a bio-bibliography of ancient authors, the last volume of which appeared in 1763.

Even before the Restoration there had been a resumption of some of the AIBL publications, for instance, the *Notices et extraits des manuscripts de la Bibliothèque du Roi et d'autres bibliothèques* and the collection of chronologically arranged decrees of French kings (provided with a subject index). Originally Louis XIV had commissioned three lawyers of the Paris parliament to do the work, and members of the AIBL had continued it in due course.[29]

The Restoration authorities kept the Institut de France in name, but they did away with its division into classes and replaced these with the old *académies royales*. The only section to be abolished was that dealing with the *sciences morales et politiques*, which was thought to be tainted with sensualist philosophy and to have cast doubt on the existence of innate qualities and God-given laws. In 1825 the Institut was allocated 425,000 francs, of which nearly 100,000 francs went to the AIBL, more than to the Académie Française and the Académie des beaux arts (only the Académie des sciences received a larger sum).[30] The allocation to the Institut was substantial, between 7 and 8 percent of the total state expenditure on science, literature, art, and education. Elementary education had to make do with considerably less (50,000 francs). By way of comparison, we might look at the sums allocated in 1914: 700,000 to five academies (which was no more than 0.2 percent of the education budget) and more than 220 million francs to primary schools (which accounted for more than 60 percent of the total education budget). The government had set its sights on new objectives and was prepared to bear the financial consequences.

But although the Restoration regime was relatively generous to the AIBL, it failed to infuse it with fresh spirit. The AIBL had become a retirement home for decorated scholars rather than an academic workshop, a cozy debating club for aging members who, incidentally, could make a show of remarkable energy

when it came to the election of new members. Lectures and minutes were scrupulously recorded, eulogies and obituaries for other members unfailingly printed. The ritual game of a learned society was played in deadly earnest, so much so that the learned members had little spare time for the publication of source material.

Compared with the period 1799–1814, the fifteen years of the Restoration that followed thus saw a decline in such publications. In 1806–14 three volumes of the *Recueil des historiens* were published, in 1799–1813 six volumes of the *Notices et extraits des manuscripts de la Bibliothèque* (du Roi), and in 1814 just one volume of the *Histoire littéraire de la France*, in other words a total of ten volumes in three series. In 1815–30, however, just eight volumes in these three series were issued.[31] Not until the 1840s were there attempts to reverse this trend, both by the authorities and by the society.[32]

The main obstacle to continuing the various series of publications following the abolition of the learned religious orders was the lack of erudite recruits for the humble study of sources. The AIBL continued to bring out editions produced along the old lines; however, the monks had been fed, clothed, kept warm, and housed and could therefore work for the greater glory of their order and of God with the prospect of salvation as a reward, something the AIBL could not offer the so-called *auxiliaires* (some six in number). Their pay was 1,200 francs annually and remained the same until the twentieth century. Nor could they console themselves with the renown they earned by their work because the editions were published anonymously.

The Ecole des chartes was founded expressly to fill the gaps in paleographic knowledge. A first step in that direction was taken in 1821, but it was not until 1829 that the new body began to show its mettle. The Ecole des chartes set out to train assistants in the auxiliary sciences, not to turn out archivists, something that would later become the Ecole's most important function.[33] Without that new function, without reorganization, and without the spur it received from the July Monarchy, the Ecole might well have been doomed.

Archives, Libraries, and the Conservation of Monuments

We can distinguish three important phases in the history of archives: first, centralization coupled with nationalization; second, public access; and third, the compilation of inventories. These developments were not concurrent. The Trésor des chartes in the Sainte Chapelle had long been closed to the public. That archive, a repository of government records and of proofs to ancient titles, was a secret preserve. A government not swayed by the opinion of its subjects is averse to publicity. Thus an eighteenth-century archivist described an archival item as a "jewel, a breastwork against the incursions of adverse neighbors."[34] And what applied to neighbors held equally well for the king's subjects.

Centralization of ancient documents was an old government ambition. The founding of the Cabinet des chartes by the *historiographe* Jacob-Nicolas Moreau in the second half of the eighteenth century bore witness to this fact. During the

Revolution the records of the royal house, of noble families, and of religious organizations were confiscated and taken to the capitals of the various departments.[35] The notorious law of 7 Messidor (25 June 1794) placed them into four categories: (1) valuable papers relating to church and state property; (2) documents and charts of historic, academic, and artistic value; (3) proofs of feudal rights, to be destroyed the better to eradicate all traces of them; and (4) worthless papers that could be packed off to the munitions factory.[36] The distinctions were based on the factual contents of the documents; their provenance was not taken into consideration. Material was often divorced from its historical setting, something that had also happened with private collections, albeit on a smaller scale.

Napoleon's passion for centralization, inherited from the Revolution, was boundless. In 1809 the rapidly expanding archives were transferred to the Hôtel de Soubise. Napoleon's dream was an enormous treasure house on the Seine where all the archives of his newly created empire could be assembled. Apart from avarice, he also had sound political motives for laying his hands on precious old papers and, if necessary, for keeping them secret. Moreover, the archives were open to "reliable" visitors only, and these had to pay an admission fee.[37] Nor can it be said that the ownership of these looted documents in any way weighed on the conscience of successive French governments, for instance, that a scholar from Maastricht anxious to examine ancient documents taken from the chapter of St. Servatius, the oldest church in Holland, had henceforth to repair to Paris. Apart from practical and financial motives, there may also have been an irrational psychological factor: perhaps these ancient documents held magical powers? The past had been stood on its head and had to be exorcized. Ownership of ancient documents provided a sense of security.

The Revolution had introduced free access to the archives as a public entitlement. The proclamation of the "archival human rights" was mainly due to Armond Gaston Camus, a *conventionnel* and the first keeper of the Archives Nationales.[38] There was a practical reason for opening the archives to the public: to enable all citizens to inspect records relating to the material circumstances created by the abolition of the feudal system. This practical step laid the foundations for "disinterested" historical research. The Empire then reversed this open attitude, particularly with regard to the recent past, but the Restoration put the clock back completely, resuscitating the ancien régime approach to archives. Secrecy was again the watchword when it came to embarrassing details of the life of royalty in earlier centuries. (I have already mentioned the steps taken against Lemontey.) However, the July Monarchy did restore a little more openness.[39]

The centralization of archival material was not revoked during the Restoration, but a large number of confiscated items were returned to their former owners. As for the third development, namely, the compilation of archival inventories, no headway was made during this period; this important job was not tackled seriously until the mid–nineteenth century. The allocation of funds to the Archives du royaume, incidentally, was by no means small (80,000 francs

per annum), and it would increase significantly during the life of the Second Empire.

More money still was spent on the Bibliothèque du Roi (200,000 francs per annum). This collection had originated in the Cabinet du Roi. In 1663 Colbert thought that the day of private collectors had gone and that their greatest treasures ought to be kept at court. Compared with the collections of other European rulers, that of the French king was rather small, but it was enlarged with parts of Mazarin's enormous collection, with gifts and legacies by the king's kinsman Gaston d'Orléans (manuscripts, in 1667), by Hippolyte de Béthune (1662), with the abbé de Marolles's large collection of engravings and drawings, and with gifts from Tellier, archbishop of Reims (numerous manuscripts, including St. Augustine's De Civitate Dei), and Roger de Gaignières, who had set up a kind of private historical museum.[40] La Colbertine, Colbert's private library, was added to the royal library in 1731. By confiscation of the libraries of the religious congregations and of noble émigrés, the stock of books was increased by more than 300,000 volumes during the Revolution. In 1818 the Bibliothèque du Roi contained 800,000 volumes in addition to a large collection of manuscripts, drawings, and engravings.[41] Among the masses of unclassified material visitors and thieves could rummage to their heart's content. It was not until the Second Empire that a systematic catalogue of the Library's history books was begun.

In 1794 Alexandre Lenoir, who had courageously saved many treasures of church art from the iconoclastic fury of the Revolution, organized an exhibition of these items in the Musée des monuments français, established in the old monastery of the Petits Augustins.[42] The young Michelet and many of his contemporaries experienced a real historical thrill on that occasion. However, the museum was closed during the Restoration as too flagrant a reminder of the revolutionary confiscations. Church and noble possessions were given—or "stolen"—back. As for the conservation of monuments, the Restoration authorities continued the policy of the comte de Montalivet and his friend the comte de Laborde, who during the First Empire had conducted the first official inquiry meant to pave the way for a statistique monumentale.[43] The restoration of the royal church in Saint-Denis was begun as early as 1806. The funds allocated for the conservation of ancient monuments were, incidentally, rather meager; those earmarked for building new churches and the renovation of old ones (without special historical interest) were much more generous. Thus the building of the new Madeleine took a great deal of money. It was meant to contain monuments expiatoires to the "august and royal victims of the Revolution."[44] The chapelle expiatoire also was built during this period. Gallia poenitens et devota et grata brought expiatory offerings. Because the Restoration authorities could not get over the past, forgetting nothing and learning little, they were unable to attend to the national heritage, a task to which the dynamics of the reaction clearly did not lend themselves.

THE JULY MONARCHY: HISTORY AS A NATIONAL INSTITUTION

"The gap between our age and earlier times is so wide, and politics are so unlike those of previous centuries, that the government is able to make the public privy to part of our historical treasures without fear or scruple." So wrote Guizot shortly after 1830.[45] His view was characteristic of that held in government circles after Les Trois Glorieuses of July 1830. The duc d'Orléans, son of Philippe Egalité, had fought alongside General Dumouriez at the battle of Jemappes. He was expected to implement the principles of 1789, a "citizen king" whom the old European dynasties viewed as a "patron and patent instigator of that crusade of universal agitation."[46] In the event, Guizot turned out to be the power behind the throne of a *roi fainéant*, an idler king, and in any case the dominant figure behind government policy toward the study of history during that period. He was minister of education from 1832 to 1837 and also exerted considerable influence in the other ministerial posts he held during the July Monarchy. In particular, he created a separate department for education and then extended its scope.[47] His policy involved the growing separation of public education from the church. Before then the church had gained a stranglehold on the Université, a secular institution set up by Napoleon for the training of teachers.

Guizot considered the educational facilities provided by the state a means of increasing the popularity of the authorities. Parents were more concerned than ever about the future of their children: "Family sentiment and duty have a strong hold today. I say sentiment and duty, not the family spirit that prevailed in our old society." Political and legal family ties had weakened, but natural and moral ties had grown very strong: "Never before have parents been so affectionate and close to their children, never before have they been so concerned about their children's education and future," wrote Guizot, a historian of family-centered psychology before his time.[48]

The government objectives were reflected in the budget. The educational allocation was doubled from 1.1 percent in 1825 to 2.2 percent in 1835 (see table 11). In absolute figures, it rose from 5.7 million to 12 million francs.[49] The most conspicuous rise occurred in primary education (from 1.5 million in 1834 to 4.6 million in 1835). The Convention had already made ambitious plans in this field and had enshrined them in the educational act of 1795 (which Guizot described as "sterile words however sincerely meant"), but the Empire had not been very keen to teach the three R's to its foot soldiers; all the Emperor had seemed to care about were the *lycées* for officers. During the Restoration educational initiatives had reverted to the church. Guizot was familiar with the problems of public education in a country on which the Reformation—"that coercive action by the state within the family"—had had no lasting effects, and he accordingly advocated free competition between state and private education. Alongside that he advocated the establishment of training colleges for secular teachers. These, the écoles normales primaires, would not only raise the educa-

tional standard of teachers but also have a salutary effect on the social order, inasmuch as they offered the working class a chance of upward mobility, and thus have a stabilizing influence: "Moreover, they open up a career to classes of the population who have never before been able to look forward, from the day they were born, to anything but the exertions of physical labor." This would exert a "moral influence" on a part of the population whose dealings with the authorities were largely confined to contacts with tax collectors, chiefs of police, and gendarmes.[50] The entire project might well be considered a shrewdly mounted cultural offensive by means of a fifth column. During a century of educational progress conservatives and liberals each had their own reasons for trusting in the salutary effects of education. In Guizot's eyes, state-supported primary education was by no means areligious, let alone antireligious. Guizot warned against rivalry between priests and teachers (which was in fact to become very fierce during the second half of the nineteenth century), which he felt would have disastrous effects on the "moral standing" of schools.

Guizot's education acts of 1833 profoundly affected government influence on primary education. In secondary education the basis for state control had already been laid by Napoleon, who had been loath to leave the training of the future leaders of society to the church. The Napoleonic Université, a secular *congrégation* of teachers in secondary schools, had its own property and the right to raise money. It was largely able to pay its own way. Guizot took several further steps: the Université budget was simplified and regularized, and the state took charge of the collection of money and had control over it. However, Guizot wanted to safeguard the independence of this educational institution in all other respects. He was firmly convinced that a number of large, stable, and independent institutions were essential if future social upheavals were to be averted.[51] His work as a historian largely revolved about these matters, and he was determined to pursue the same line in his ministerial capacity.

Within the general frame of educational policy the July Monarchy paid special attention to the teaching of history. However, as we shall see in chapter 3, this had little effect on the allocation of funds. Yet growing state concern with historical research and with the conservation of the historical heritage did have clear financial repercussions. New institutes were founded and existing ones injected with fresh funds.

For a better understanding of the motives behind the attempt to encourage historical studies with the help of a coherent government policy we must return to the studies of French history made during the Restoration by the opponents of the regime who came to power in 1830 alongside the "King of the Barricades," Louis-Philippe.

Liberal opponents of the Restoration regime and its increasingly reactionary stance, especially after the murder of the duc de Berry in 1820, drew political inspiration from the national past. That was a relatively new phenomenon. The French revolutionaries of 1789 had turned their backs on their country's past, which they found lacking in a "progressive" tradition, and had instead drawn

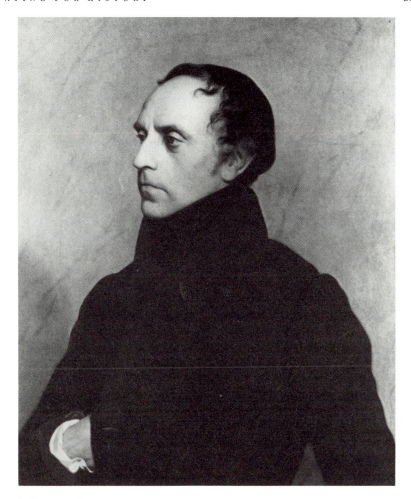

1. François Guizot

their political inspiration from antiquity, with Gracchus as their idol.[52] King and church had dominated French history. French historiography had become fossilized as a result; the chronicles of Mézeray, Daniel, and Velly had codified a picture that offered little revolutionary inspiration to the new republicans.

Historical arguments proved to be very effective weapons against the Restoration regime.[53] The origins of the royal prerogative, the sources of aristocratic privilege, the effects of the settlement of the Franks in Gaul, the "national" German assemblies—all these were topics of burning interest. History provided the opponents of the Restoration with an armory of political weapons, the more so as the regime kept harping on every least detail of the tradition.

The *historiographes du roi* and the *continuateurs* of the ancient chronicles had, of course, been criticized even earlier by philosopher historians of all sorts, ranging from champions of the nobility such as Boulainvilliers and Montlosier

to vague primitive communists à la Rousseau such as Mably.[54] Even so, no real alternative to Catholic-monarchist French history had been put forward. At the beginning of the nineteenth century the general public still devoured the writings of Velly and Anquetil because "in libraries as in commerce, objects of ancient manufacture have for long enjoyed an assured turnover."[55] It was not until after 1820 that works casting a new light on the French past for the benefit of a wider public first appeared.

Augustin Thierry was probably the most successful writer of such works. At the end of 1820 he launched a sensational attack on the "false color" and "false method" of previous historians. At that time Sismondi's *Histoire des Français* had not yet been published, nor had Barante's *Histoire des ducs de Bourgogne* or Guizot's *Essais sur l'histoire de France*. In the contemporary sources of earlier periods Thierry had discovered no evidence for such age-old historiographic axioms as "Clovis was the founder of the French monarchy" or "Louis le Gros granted their freedom to the towns," the second of which was even quoted in the preamble to the *charte constitutionelle* of 1814. Thierry's opposition to the regime was made quite clear in his articles on the revolt in Laon and on the civil war in Reims. He shed fresh light on the medieval origins of the third estate. Thierry had often been pilloried as a bourgeois historian. That was only to be expected and was not wholly unjustified, but one ought also to remember the originality and fruitful aspects of his work and recall that it paved the way for new interpretations. It was Thierry who launched a vast historiographic operation that was to provide generations of younger historians with material for their research. The result was a chain of reappraisals and discoveries. A case in point is the fluctuation of opinions on Etienne Marcel.[56] The eighteenth-century scholar Secousse, a member of the AIBL, had of course come across this rebellious "provost of the merchants of Paris" while astutely sorting the documents referring to Charles the Bad, the rebellious vassal and king of Navarre. But royal patronage of Secousse's research into the past of the monarchy made it more than likely that he would come up with a one-sided interpretation of the events. In Thierry's wake, however, such Young Turks as Jules Quicherat and Tommy Perrens quashed the old condemnation of Etienne Marcel.[57] The process of reappraisal Thierry had initiated culminated, after 1871, in the official unveiling of the equestrian statue of Etienne Marcel in the garden of the Hôtel de Ville, the authorities having previously denied him a place among the sculptures on the front of the renovated town hall. There may well be a new iconoclastic wave in which his statue will be smashed as a symbol of a hated class. However, that chapter in the appraisal of Marcel has still to be written.

Next to Thierry, Guizot was the leading oppositional historiographer during the Restoration, and one, moreover, who was to rise to a position of great influence during the Orleanist period. The subjects he chose, such as the origins of representative government in Europe, were highly topical.[58] In the context of contemporary history the treatment of the French Revolution by Thiers and Mignet also carried a clear political message.

After 1830 oppositional historiography became triumphantly conservative

and adopted a polarizing stance. It became a defense of the existing order, Guizot now being convinced that it had a calming political effect. That was also his expressed justification of national investment in it: "By bringing society face to face again with the events and passions that have gone before us on the same soil, under the same sky, we help to render the ideas and passions of the day less narrow and less sharp." Guizot was a firm believer in the educational value of historical understanding: "A nation curious and informed about its history is almost bound to have saner and more equitable opinions even about current affairs, conditions of progress, and future prospects."[59] Knowledge of history generated a sense of justice and an open mind about old and new values in French society. A nation grew in political understanding and moral worth by coming to know and to love its own history. After so many turbulent events there was a need for a firm anchorage in the present, which would foster education in citizenship, then still in its infancy. There was a great need for a national institute of historical research. Alongside the AIBL, the guardian of the past of the nation's rulers, another official body was needed to dwell on the past of those over whom they had ruled.

Historical interest in the latter was, however, selective, as might be expected in an age of limited franchise. Although the electorate had been doubled after the advent of the July Monarchy, in 1831 it still comprised no more than 250,000 persons in a total population of 32.5 million.[60] What seemed to matter most was the past of those constituting the basis of the regime. They were given a free hand to accumulate wealth, and the state was pleased to provide a historical justification for their way of life, but in any case that justification had ceased to be dynastic. For the sake of stability and depolarization, the harvest of the historical fruits of the Romantic Movement was to be treated as a national heritage. The aim was to "assuage political passions" and to "redress popular prejudices" with the help of a better, unbiased presentation of the various elements constituting French society, of "their mutual relations and rights, and of the value of their historical traditions in a modern social blend."[61] It all sounded well balanced and reassuring, expressed in less violent language than had been heard during the Restoration. But history can be ruthlessly ironical. In the 1840s the July Monarchy was challenged in its turn by an opposition quoting history. Michelet, Quinet, Esquiros, Louis Blanc, and the most successful of them all (at least in the short term), Lamartine, rewrote the history of the Revolution in a republican vein with Jacobin or Girondist overtones.[62] These works were inspiring, effective, and politically sensitive vindications of republicanism and as such broke with the tradition of the constitutional monarchy upheld by a Mignet or Thiers. Thierry was upbraided for having ceased to glorify the vanquished and having become the chronicler of picturesque anecdotes about the ruling families, amusing his public with spicy stories about the concubines of the sons of "Chloter" or about the loves of Mérowig and Brunehilde. Michelet objected to such entertainment, and when Barante, going back to Froissart, reported the lavish banquets of Philip the Good, Michelet could hear the mutterings of the victims of history, who appealed to him not to forsake his duty as

a historian: "History takes account of us. Your creditors summon you. We have accepted death for one line from you."[63]

With regret, Guizot later recalled how far Michelet and Quinet had strayed from the right (i.e., the Orleanist) path. Michelet had been Guizot's substitute at the Sorbonne and had also been appointed to teach the princesses on Guizot's recommendation. "Another two rare and generous spirits whom the evil genius of the age has seduced and drawn into its impure chaos," Guizot reminisced in sorrow.[64] But that was yet to come. Guizot was still at the beginning of his career, which he began with impressive resolve.

The Comité des travaux historiques

At the beginning of 1834 Guizot asked for an allocation of 120,000 francs for the work of a Comité des travaux historiques. This was a larger sum than the annual allocation to the time-honored AIBL. In a famous circular, Guizot defined the aim of the Comité as the publication of "any important but as yet unpublished material bearing on the history of our country."[65] This work was incumbent upon the state as "guardian and repository of these precious bequests of centuries past." It represented a fundamental change in the view of the state's role in historical research.

Manuscripts were to be tracked down throughout the kingdom, and their publication was to go hand in hand with the opening to the public of the archives of the various ministries. In particular, there was to be public access to the well-run archive of the Ministry of Foreign Affairs, then headed by Mignet.[66] This step was symbolic of the general feeling that a break with the past was long overdue. The papers of that ministry had always been considered top-secret. Reports by ambassadors and the like were thought to have the sole function of training budding diplomats. The archive was a kind of data bank in which diplomacy and espionage were inseparably intertwined, and there was as yet no arms race to render such information obsolete almost overnight. As late as 1914, scale models of towns from the time of Vauban were still serviceable.

Naturally, secrecy was still maintained when it came to recent history, but "obviously, facts and documents from before the reign of Louis XV no longer appertain to politics but have become part of history."[67] If the beginning of the eighteenth century were declared the dividing line between information to be made available to the public and information to be kept secret, then neither the interests of the state nor those of particular families would be jeopardized. There was thus still a "secrecy" margin of more than a hundred years, but during the Restoration even that would have been considered too small.

In the Chamber, Guizot heard a great many criticisms. Garnier-Pagès accused him—not altogether unjustly, as I have indicated—of "wanting to deprive the newspapers of young men of principle, the better to attract them to and involve them in studies unconnected with politics." But fortunately Guizot had the support of another deputy, who welcomed public interest in diplomatic correspondence as "a good school . . . for training politicians," something badly

needed in France.[68] Clearly, the times were not yet ripe for an expensive state organization devoted to pure research.

The publications of the Comité were not intended to be of passing interest only. The series was meant to be a "lasting homage to, and, as it were, a durable institution in honor of, the origins, the memory, and the glory of France."[69] To that end, the publications would focus on the nation rather than the dynasty. The scope was very broad: in addition to politics and diplomacy, attention would also be paid to the history of art and architecture, of ideas, customs, and habits, at the regional as well as the local level.

It was an ambitious project. The difficulties were grossly underrated, or perhaps one might say that the demands made on source publications at the time were still rather slight. There was no trained staff to do the work, nor was such staff considered essential at first. One professor at the Ecole des chartes mused in a preface to his edition of letters copied in the eighteenth century for the Cabinet des chartes whether it was really necessary to correct dubious points in the work of one's predecessors: "Does interest in history really demand so much care?"[70] And from the revealing account of a colleague it appeared that the Comité was popularly referred to as the "Committee of highly unhistorical works."[71]

Still, it was the age of great (re)discoveries, including that of Abélard's *Sic et Non*, a manuscript unearthed in the library at Avranches and published by Cousin. Historical enthusiasm was high and not yet inhibited by the demands of strict academic criticism. In that respect there were few advances on the work of eighteenth century scholars; in many cases, nothing more was accomplished than the publication of their manuscripts. Nathalis de Wailly, who wrote a manual for his colleagues, left no doubts about that: "I but rarely deviated from the general principles laid down by the Benedictines."[72] Even so, his *Eléments de Paléographie* (1838, in two thick folio editions) was a useful survey. It comprised four parts, devoted, respectively, to (1) chronology ("the art of verifying dates"), a concordance of calendars of cycles of religious festivals, and so on, and a list of European princes; (2) the style and nomenclature of charters and frequently used formulations, with an alphabetical list of princes, the better to check the authenticity of royal charters; (3) paleography in the strict sense of the word, that is, the deciphering of writings and the determination of their age; and (4) the study of seals, for although "heraldic science is no longer common practice," it was still said to provide valuable information on medieval history.

Paleography in this wider sense was the mother of several auxiliary sciences. Philology had not yet come into its own in the study of the nation's past. That was not to happen until the 1860s, in the work of Paul Meyer and Gaston Paris, and later with the help of special journals, professorships, and institutes.

Fortunately, Guizot had no clear idea of the abundance of source publications; otherwise he might have recoiled from the task. He spoke in his circular of "all important documents." Of course, it all depended on what was meant by "important." Even so, Prosper Mérimée, who was a member of the Comité, had raised all the crucial questions at the very first meeting, in Guizot's presence.[73]

Guizot had assured the Comité that neither time nor money would be lacking, and the government did in fact prove generous. In 1842 the record sum of 150,000 francs was allocated to the Comité, an allocation not equaled before the First World War.[74] But of course there could never be enough money for the publication of *all* important documents.

The activities of the Comité are reflected in the number of published volumes in the *Collections des documents inédits sur l'histoire de France*. The first volume appeared in 1835, and by 1852, 103 volumes had been published. After that the enthusiasm subsided: 37 volumes appeared in 1853–70; 44 in 1870–85, and 22 in 1886–1900.[75] More volumes were published during the first twenty years of the Comité's existence than in the next fifty years. In addition, the Comité did a great deal of work that did not appear in print. The Comité's archive contains many copies of documents testifying to a great deal of diligence. Many of these copies have become very valuable because a large number of the originals have since been lost, especially in the northern towns that suffered grave damage during the various wars.[76]

One of the first volumes in the series was a journal of the States General meeting at Tours in 1484.[77] It was originally written in Latin by a deputy but was published in translation. The use of the French language constituted an important difference from the AIBL series, which was published predominantly in Latin. That was understandable, because the object was to present a wider audience with an eyewitness account of what was considered to be the historical basis of a constitutional monarchy answerable to parliament.

A special project highlighted the ideological motive behind the government initiative, namely, the proposed publication of the charters granted to towns and communes by kings and nobles, together with the "original charters and constitutions of the various corporations, masters' associations and private societies" in France, so as to bring home the "numerous and diverse origins of the French bourgeoisie, that is, of the first institutions that served to emancipate and raise the nation."[78] The July Monarchy had gone in search of its origins. The result was a perfect program for a bourgeois-institutional philosophy of history. Its supervision was placed in Thierry's safe hands.

The main job of the Comité was to circulate historical texts and foster interest in the past rather than to deepen academic knowledge. In that respect the Comité was the child of an age in which the idea of progress had not yet come to dominate historical scholarship. The belief that it was possible to gather knowledge through detailed studies and extreme specialization had not yet taken root. There was a widespread conviction that the sources were there for the picking, and in a sense that was true, certainly of the manuscripts of eighteenth-century scholars. The Comité lacked a permanent staff; people were paid by the piece, which stimulated speedy research but not in-depth studies. For all that, the shortcomings of these persons should not be exaggerated. Several Guizotins were held in high regard. Thus Jules Quicherat is still considered a model historian with a methodical approach, one who made scrupulous use of

the auxiliary sciences.[79] Moreover, the Comité set an example of collective historical work and paved the way for the planning of future research.

The Ecole des chartes

The reform and reorganization of the Ecole des chartes occurred toward the end of the July Monarchy. By then the absence of historical experts was beginning to make itself felt, and there were also plans to set the departmental archives on their feet. The crucial factor in the life of the Ecole was the near trebling in 1846 of the funds allocated to it annually—from 12,400 to 33,400 francs.[80] The Ecole never again experienced this kind of expansion, although the allocation was, incidentally, relatively small compared with the Comité's own budget. Even so, such liberality was not to the liking of the budget commission. The members of the commission saw no reason to encourage young people to choose so "ungrateful a task" as paleography, especially since there were no jobs in this field. However, at the insistence of some members of the Chamber, including Ferdinand de Lasteyrie and Taillandier, the then minister of education, the comte de Salvandy, provided the extra funds.[81] Henceforth the Ecole had its own premises in the Hôtel de Soubise, which also housed the Archives Nationales, containing a library and a collection of facsimiles. In addition, the teaching methods were improved.

At the opening of the reorganized Ecole in May 1847 the minister explained complacently that the school would aim to "attach young minds to the existing institutions" by the study of all the efforts and struggles that had gone into their creation.[82] In the ministerial scheme, the Ecole would be training the foot soldiers to serve under the officers writing bourgeois institutional history. The *chartistes* themselves were rarely tempted into general historiography or into "philosophizing" about historical institutions. In general, the graduates of the Ecole des chartes preferred to stick to the sources. In the course of the century the school gradually developed into the leading training center for archivists. The characteristic attitude of the average *chartiste* was "documentary," with all the advantages and disadvantages that entailed. Needless to say, such concentration on documents should not be equated with impartiality or objectivity.

The Service des missions

State encouragement also took the form of liberal allowances for foreign travel of a more or less academic nature. In 1842 the allocation to the Service des missions amounted to 12,000 francs. A year later that sum was multiplied by a factor of ten under minister Villemain. The idea was to transform foreign travel from an occasional activity into an activity supported by a permanent institution. Not only travel for historical purposes was to be covered but also "research in the natural sciences and geography, as well as the study of languages and more generally of everything relevant to our culture."[83]

A good example of such a foreign mission, the cost of which was, as usual,

passed from one ministry to the next even after a special service had been created for this very purpose, was that of Joseph Melchior Tiran, a cavalry officer on special leave. His mission gives us a better picture of the real situation than any amount of figures can possibly hope to do.[84]

Tiran, an expert in Hispanic studies, was being paid by three ministries in 1841: Guizot, then minister of foreign affairs, contributed 3,000 francs at Mignet's behest; General Pélet de la Lozère, head of the War Archives, provided 2,000; and Villemain, minister of education, 1,500 francs. Mignet, with whom Tiran had close ties, expected him to collect material in Spain for his (Mignet's) history of the Reformation. The journey turned into an exciting adventure with fierce competition from English collectors, who often paid high prices for documents without having much expert knowledge, and also from experts, including William Prescott and the formidable Louis Prosper Gachard. Because Napoleon had previously ordered the transfer of valuable papers from Simancas (Spain) to Paris, Tiran, being a Frenchman, came up against considerable Spanish resentment. Gachard too was in bad odor for having failed to pay due tribute to Philip II. And so everyone had a handicap in the race for access to these closely guarded, rich, and chaotically run archives. Copying, haggling, and stealing were the order of the day. Flair and money were indispensable aids to currying favor with the untrained but wily staff. The copyists were slow and their prices high, but there was no alternative at a time when it was hard to gain access to archives, when few documents had been published, and when there were neither photocopies nor microfilms. Even so, it was also a period in which historical research could still be heroic. Wrapped in blankets against the freezing cold, Tiran continued to work in Simancas until he was struck down by fever and colic.

The French presence in Algeria lent Tiran's mission additional importance. The government was anxious to learn more about countries ruled by Arabs for a long time, and about Spain in particular. Could the Reconquista serve as a model for the conquest of Algeria by French soldiers and missionaries? In any case, General Pélet de la Lozère entertained the hope that Tiran would come upon Arabic and Spanish manuscripts that might contribute to the rewriting of Algeria's political history.

Tiran's mission was but one of many. Research abroad, supported by various ministries, was a web of diplomacy, intelligence work, and historical study, one influencing the other, sometimes fruitfully but often leading all into blind alleys. French overseas expansion was coupled not only to strategic, geographical, and political research but also to historical and cultural pursuits. Every military expedition included men with academic interests—Alexander the Great, Napoleon, Bugeaud. Learning followed the flag.

The Ecole française d'Athènes

In addition to individual missions, a permanent mission was set up in Athens in 1846.[85] The Ecole française d'Athènes was a perfect example of the entangle-

ment of diplomacy with scholarship. The motives behind its foundation were political and literary rather than archeological. Before the battles of Sadowa and Sedan, France had been obsessed with the "English challenge," not least in the eastern Mediterranean. Queen Victoria's breach in 1843 of the royal ostracism of Louis-Philippe and the meetings that followed did little to alter the position. General feelings were inflamed after the humiliating defeat that followed Thiers's "game of poker" in 1840. When Guizot was handed the foreign affairs portfolio in October 1840 he deliberately aimed to create an *entente cordiale* despite the prevailing anti-English sentiment. But then Guizot never courted popularity. In 1847 the July Monarchy seemed ready to invest more than 61,000 francs in a permanent base in Athens as a complement to the ever-changing procession of diplomats.[86] To Guizot the entente policy was no obstacle to the further strengthening of French influence.

The establishment of the school was not, of course, dictated by political considerations alone. There were many genuine philhellenists in France who wanted to regenerate Greece with the help of French education. The Greek Revolution and the Romantic Movement had been welcomed enthusiastically in France, and the school may be seen as a kind of halfway house between a branch of the Alliance française and a Romantic literary club. It was the creation of diplomats and men of letters—no scholars had been involved. This very fact was to become a source of conflict: should the Ecole be a finishing school for students of the classics or a genuine research institute? In any case, it was originally a private hunting ground for *normaliens* in which scholars of the academies wielded little influence. Actually, the journey to Athens, with an obligatory stop in Italy, was something of a grand tour at state expense. Small wonder then that thrifty contemporaries objected so strongly: "If one took into account the cost of Greece in the expenditure of modern nations, then one might be tempted to stage a coup d'état and to cut Greece out of our tradition altogether."[87]

However, the power of France was at stake, and who could be stingy in such circumstances? The staff of the school was fully aware of the political implications: "Our arrival has greatly upset the English minister." The objective was clear: the school was set up "to expand the sway of our banner over Greece," a pupil wrote in 1847.[88] Even so, the academic spirit quickly spread in unforeseen ways. Another pupil wrote to his father: "It is a good thing to be hemmed in between groups from Russia, England, and France, while remaining independent of them all. We needs live in a camp, but in a camp of lettered persons."[89] The members of the school were thus anything but docile champions of France.

The Institut de France

During the July Monarchy the money allocated to the Institut de France increased appreciably (from 425,000 francs in 1825 to 562,000 in 1842).[90] In the 1840s, in response to the urgings of minister de Salvandy and the *académicien* Pardessus, the AIBL became more active. From 1832 to 1849 it published six-

teen volumes in various series.[91] Guizot's resurrection of the Académie des sciences morales et politiques (ASMP) in 1832 was perhaps the clearest expression of government objectives.[92] The surviving members of this section of the Institut, founded in 1795 and closed in 1803, bore the stigma of regicide because two of them (the abbé de Sieyès and Merlin) had voted for the execution of Louis XVI. That might have been overlooked after 1830 had some survivors of the group of sensualist *idéologues* not been much too materialistic and atheistic for Guizot's taste. With the help of Victor Cousin, he made sure that the new ASMP became a haven of spirituality and idealism.

In 1840 this section of the Institut was a faithful mirror of the opinions that held sway in government circles.[93] Co-optation ensured a high representation of members of the Chamber, senior officials, and rich notables. The ASMP was meant to be the think tank and incubator of government policy, an antidote to socialist utopias. Its members did important work. The first inquiries into pauperism were launched, and prize competitions were held on such topics as education, the penal system, and the abolition of slavery. In keeping with the prevailing fashion of institutional "philosophical" history, many of these burning questions were viewed in historical perspective. In addition, there was a historical section, over which Mignet ruled supreme. Guizot's work was held up as an example.

It was during this period that Mignet wrote his (unpublished) outlines for a *histoire philosophique* of the institutions.[94] Tocqueville's *L'Ancien Régime et la Révolution* was the finest fruit of this school, which may be described as a center of historico-sociological political science for notables who wanted to be wise not just for next time but for good. This *histoire politique* was a world apart from the general scheme of resurrection, retribution, and last judgment that the visionary Michelet had considered the historian's true sphere. But then Michelet had had a different social background, and in his day you could only be a notable by birth. Michelet was a born romantic; though he was a member of the ASMP, he never felt at home in it and never left his mark on its activities.

The Conservation of the National Heritage

The allocation of funds to the Bibliothèque Nationale rose steeply (from 200,000 francs in 1825 to 284,000 in 1842, an increase of 40%). However, none of the other public libraries (Mazarine, l'Arsenal, and Sainte-Geneviève) nor the Archives Nationales received similar increases.[95] The government's most important action in the sphere of conservation was the establishment in 1830 of a Service des monuments historiques, headed by a general inspector. That office was held briefly by Vitet and from 1834 to 1860 by Mérimée. Interest in archeology and architecture was to be coordinated wherever it existed already and to be fostered wherever it did not—such was the government's acknowledged task. In 1840 a list of 954 medieval monuments was published; it did not include cathedrals because their upkeep was in the hands of the Ministry of

Culture.[96] An archeological section of the Comité des travaux historiques was charged with the acquisition of the relevant documents.[97]

Special funds were allocated for the conservation of ancient monuments (600,000 francs in 1824),[98] but restoration proved to be fearfully expensive, with the result that progress was slight. The involvement of various levels of the administration and of state and church make it exceedingly difficult to compute the precise state allocation of funds for the work of restoration, at least until the separation of church and state in 1905. After that date many churches were classified as historic monuments and their upkeep became the responsibility of the state. In retrospect, the church might well be grateful for this measure, for the upkeep of these monuments turned out to be a costly business.

Louis-Philippe cannot be accused of dynastic pettiness. In 1840 he authorized the return of Napoleon's ashes[99], and even earlier he had dipped into his private coffers and lavished 23 million francs on the restoration of the palace of Versailles and its transformation into a museum. During the wedding of the duc d'Orléans (17 June 1837) the museum was opened by the king himself and "consecrated to the glory of all France."[100]

Another important event in the history of French museums was the acceptance by the government of a legacy from the collector Alexandre de Sommerard. The Musée des thermes et de l'Hôtel de Cluny, reserved for the collection, was opened in 1844; inside, the remains of a second-century Roman bath were elegantly amalgamated with one of the few surviving fifteenth-century private houses. We are told that on the first day 12,000 visitors turned up to admire the 1,400, mainly medieval works of art.[101]

The plan to catalogue departmental and communal archives was less successful; in 1834 Guizot still considered it a project for the future. Nevertheless, in 1841 the Ministry of the Interior set up a committee and charged it with care of the archives and with presenting a classification program. From then on, the minister issued circulars setting out better ways of administering and classifying the documents. The will was there, but a shortage of financial resources and manpower meant that results were few and far between.

Characteristic of the lack of interest in inventories was Mignet's attitude toward the archives of the Ministry of Foreign Affairs. His task was not an easy one. His department had a bad reputation because it was traditionally staffed by members of the aristocracy (in 1840 eight of the nine ambassadors were nobles, as were nineteen of the twenty-one ministers plenipotentiary and twenty-seven of the thirty-one embassy secretaries). Empty ceremony and childish court etiquette was what the Chamber called it, and it accordingly ordered that the budget of the ministry be cut. The allocation for the archives was reduced from 70,000 francs in 1832 to 40,000 francs in 1849.[102] Worse still, the archivist played fast and loose with what little money there was: Thierry received funds from this source, and his friend Bérenger was offered a grant. Not surprisingly, this state of affairs had detrimental effects on the archives. One of Mignet's

successors complained in 1880 that the inventories had not been kept up to date and were inaccurate.[103]

Compiling inventories was not Mignet's strong point. However, he did try to make the archives more accessible to the public, and he was ready to help research workers. He was genuinely interested in history, but the Orleanist spoils system still ensured that the archivist's post was a benefice reserved for the king's favorites, who in turn let their friends share in their good fortune.

The Academic Model

History was popular. It would be wrong to suggest that the government was the prime mover behind this trend; if I have focused on government initiatives, it is only because I have been viewing developments from the state's viewpoint. Memoirs were in great demand by what were still mainly prosperous readers, but the audience was fast expanding.[104] On the initiative of Guizot, among others, a private society for the publication of source material, the Société de l'histoire de France, was founded in 1835. One year after its foundation it had one hundred members; by 1860 their number had grown to four hundred fifty. Within twenty-five years the society had published seventy-one volumes and spent 360,000 francs.[105] In some of the provinces too there was a great deal of activity, as I have already mentioned. The fervent legitimist Arcisse de Caumont was responsible for launching numerous initiatives.[106] Guizot took the view that the Orleanist authorities must help stimulate historical interest in the provinces. He sent out circulars to mobilize the local learned societies, urging provincial intellectuals to combine forces. De Salvandy, Guizot's successor, set aside 50,000 francs of his budget for distribution among the sixty most important societies; Guizot, for his part, thought it more sensible to subsidize specific publications than to lavish money at random.[107] And he was obviously right.

The idea behind this policy was once again the almost obsessive search for stability after so many revolutionary upheavals. As soon as the education of the masses took wing and necessarily led to a great advance of "the numerous classes given to manual work," it was, according to Guizot, of the utmost importance to ensure that the "well-to-do classes engaged upon intellectual work" did not lapse into indifference or apathy. Once there is a growing intellectual movement among the masses and the upper classes are filled with inertia, dangerous confusion is bound to ensue.[108] The third estate had to be shaken awake under Orleanist leadership.

There was great faith in the activities of the national and regional learned societies: the academies were at that time generally considered to be "the natural and almost unique cure for . . . those shortcomings of a social system that, side by side with great public benefits, tolerates very weak laws, very badly shored up liberties, and individual lives that are both listless and unsettled."[109] The money allocated for primary education was intended to raise the cultural level of the common people; secondary and higher education had to make do with less. As for state investment in the study of history, the July Monarchy put

its trust chiefly in the institutional framework of the academies. We might call this the academic research model.

An academy was a place where scholars met as equals—it was not a training institute. Fellow members listened to one another's work and discussed it. Unlike in most other societies, the number of members of the national academies was fixed. When a member died, a funeral oration was given, sometimes by the permanent secretary, and the vacancy was filled by co-option. An academy might have international links; many corresponded with, and honored, foreign luminaries. Contests were held to stimulate specific studies. There were laureates but no pupils, exemplars but no disciples. There was an exchange of information between academic equals but no transfer of knowledge or skills from masters to pupils. All this was probably bound up with a conception of scholarship based on the belief that scholars were born, not bred. Mediocre students could be taught all sorts of things, but genuine savants could never be produced by training. There was little, if any, faith in the view that the future of learning lay in the accumulation of detailed studies. There was no belief in an "idea of progress" at the back of history and hence no certain belief that the future would produce greater knowledge. At the time the study of history did not yet share the optimistic outlook of the natural sciences; it still lacked a window on the future.[110]

The academic model, the chosen model for state investment in the study of history during the July Monarchy, had an Achilles heel. Despite all the initiatives and their many merits, there was a dire lack of properly trained staff, which handicapped the Comité des travaux historiques in particular. In addition, some of the prizes meant as incentives for young students were diverted to experienced scholars. This was a result of social fossilization: from 1840 to 1855 the highest history prize, the Académie française's Prix Gobert, became the annual salary for Thierry, who had fallen ill.[111] Such "confiscations" were by no means unusual: Henri Martin also was awarded that prize several times. The idea was to enable men of acknowledged talent to continue their work. The reorganization of the Ecole des chartes was the result of a belated realization that training institutes for the young were badly needed.

That the study of history became a concern of the state may be considered the most original and lasting contribution of the Orleanist regime. After Guizot, no government could content itself with the glorification of the dynasty and for the rest rely on the censors or on secrecy. Interest had shifted to the nation as a whole and publishing activities were encouraged. However, there was still no training of experts, no professionalization or specialization. Because trained staff members were lacking, no significant progress was made in the badly neglected area of classifying the material stored in libraries or in archives. A small group of more or less talented scholars was given a chance to do research work, but there was no significant increase in the number of permanent posts for historians.

THE SECOND REPUBLIC

"In the afternoon of 24 February 1848, precisely eight years less a day after Thierry finished a book in which he called the July Monarchy the logical con- clusion of French political history, I stepped behind the nation into the Tuil- eries, whence Louis-Philippe had just fled."[112] This sarcastic comment by Arbois de Jubainville, a young and rather eccentric scholar, on the Orleanist "Whig- interpretation" of the constitutional monarchy and on Thierry's view of the role of the third estate, was fully justified. The Second Republic, incidentally, was to have an even shorter life than the July Monarchy, despite all the high expecta- tions it had raised.

On 24 March 1848 the Provisional Government decreed that work on the Louvre must be completed: "The co-operation and devotion of the people have given the Provisional Government the strength to finish what the monarchy has had to leave undone." The Louvre was to be called the Palace of the People and would become a repository of "all the products of thought constituting the treasures of a great people."[113] The men of 1848 were no iconoclasts. Vandalism, so often and eagerly blamed on the revolutionaries, was given short shrift in 1848. By the very act of renaming a royal castle the Palace of National Industry, the "graybeards" ensured that the collections in it would remain intact. Al- though soldiers had been billeted in the building at first, and a hospital and a storehouse had been set up there after the June days, the painter Jeanron, a staunch republican who was appointed director of the "national" museums, managed to clear the building of all these tenants.

However, republican rule over the Louvre was short-lived. When Louis-Na- poleon was elected president on 10 December 1848, Alfred-Emilien, comte de Nieuwekerke, was made its director. The comte was said to be a sculptor, but in any case he was a handsome man, and as the lover of the princess Mathilde, Louis Napoleon's cousin and official hostess until his marriage, he could count on a decent career at the Bonapartist court to be. The *grand dessein*, that is, the plan to link the Louvre to the Tuileries, was implemented during the Second Empire. Resolute steps by the Public Works Department ensured that the inau- guration could take place in August 1857.

The Second Republic policy of investing public funds in the study of history had no lasting results. Once Louis-Napoleon had been elected president of the Republic, it was only a matter of time before there would be a coup d'état; it came on 2 December 1851. In keeping with its revolutionary tradition, the republican government had given high priority to education and learning, but the government had been too short-lived for this policy to be felt.

When Cavaignac, having restored public order following the bloody days of June 1848, decided to make a start on restoring the *ordre moral*, he enlisted the aid of the ASMP.[114] Adolphe Blanqui was charged with making inquiries into the moral and economic condition of the working class in various towns, and he proceeded along lines similar to those of earlier academic investigations. How-

ever, Cavaignac's suggestion that academicians ought to contribute to the education of the masses was a new departure. Following the introduction of universal suffrage, thanks to which 9 million males were suddenly granted the vote (compared with 250,000 during the July Monarchy), the political education of the great majority had become a burning issue. The academicians did their best to further this process by writing short books that could be sold cheaply to the male electors (women, of course, did not have the vote and had to wait for it until 1944). The subjects covered were justice, cooperation between the various social classes, property, true democracy, and so on. Mignet wrote a life of Benjamin Franklin as a clarion call to civic virtue. Franklin was ambassador to France in the early days of the Revolution, with which he sympathized, and could claim that Robespierre had defended him against a charge of sacrilege. The writings of this philosopher of the American republic, translated and adapted, were very popular and had the approval of Catholic and Protestant authorities alike. Franklin fitted well into the gallery of secular saints that had to be set up if socialism was to be exorcized.

However, an academy was not a suitable channel for the popularization of knowledge and moral precepts. It proved difficult to combine academic studies with educational practice. Guizot was fully aware of the limitations of his own (re)creation. Although he wholeheartedly endorsed the propagation of the basic principles of social order, marriage, property, respect, and a sense of duty, he realized that an academy was not the best means of doing so—anyone who thought it was would be "misusing a good plan in order to delude himself about the nature of the work of such associations."[115]

According to many republicans, the classical and ideal way of influencing the voting behavior of the masses was through education in state schools, but that took time and money; it was not until thirty years later that the men of the Third Republic managed to put their predecessors' plans into practice. As early as 1848 Hippolyte Carnot, an out-and-out republican, was no longer considered to be a fit minister of education. After the June days and on the advice of Thiers (who was, in fact, a skeptical freethinker), the bourgeois thought it best to throw themselves into the arms of the bishops. In March 1850 the law of Falloux even ended the formal state monopoly in secondary education.[116] By 1860, when Guizot, the architect of the 1833 laws on elementary education, wrote his memoirs, he had lost his faith in its edifying effects: "Such work needs more universal and profound forces, it needs God and misfortune."[117]

The complacent historical justification of Orleanist rule had been confuted. Incense and myrrh were now offered up to the Republic. The students at the Ecole des chartes, "having in their studies followed the gradual development of French liberty over the centuries, have greeted its crowning achievement with joy," stated a manifesto delivered to the town hall by a student deputation.[118] They petitioned the authorities to change the name of the Ecole royale de chartes to Ecole des chartes et d'histoire de France. The abolition of the monarchy and the introduction of universal manhood suffrage had made a particularly strong appeal to the popular imagination. The history of the Great Revo-

lution had been a powerful spur to republican opposition to the July Monarchy. Now that the Revolution had succeeded, it was time to implement the wonderful old plans. And because school education still left much to be desired, the historical parallel could best be brought home by festivals and monuments. The Great Revolution was still wrongly considered a time of chaos, of the guillotine, and of assignats. It was high time the true revolutionary gospel was preached and the revolutionary learned catechism by heart. "The day when the Revolution, resuscitated, shall restore France to herself, it will need to reveal itself in its true guise . . . as a religion raising its own altar," Michelet wrote in his plan for a monument to the Revolution.[119]

On 24 March 1848 the Jeu de Paume at Versailles was officially declared a historical monument; not only religious buildings were to be conserved but also the place where the national will had for the first time been proclaimed with "radiant solemnity."[120] On 24 February 1849 the anniversary of the Revolution was festively celebrated, and on 4 May the proclamation of the Republic at the first session of the Constituent Assembly was commemorated by the placing of a tablet followed by a church service in the Madeleine. In 1850 the sum of 200,000 francs was lavished on the second of these anniversaries. But in that very year—1850—much more money was spent to honor the memory of Napoleon; no trouble or expense was spared for the crypt in the Dôme des Invalides. Very complicated and hence very expensive was the transport from Russia of the porphyry for the sarcophagus, which was modeled on that of the Roman emperors. In 1850 the budget of the Second Republic included an entry of 512,000 francs for Napoleon's tomb.[121] On 2 December 1851, the anniversary of Napoleon's coronation, there was a Bonapartist coup d'état. Precisely one year later, on 2 December 1852, after a plebiscite—the outcome of which was a foregone conclusion—the president of the Republic (meanwhile honored with the title *prince-président*) was proclaimed Emperor Napoleon III.

THE SECOND EMPIRE

For many decades the Second Empire was depicted in the blackest of colors. Immediately after the capitulation of Napoleon III a start was made with a collection of source material bearing on the imperial regime and intended to show it in the worst possible light. A government of national defense was proclaimed on 4 September 1870, and just three days later it appointed a committee to sort out the papers discovered in the Tuileries. On 24 September the first set of incriminating documents was published, followed by one or two further installments every week, each selling at 40 centimes. Newspapers often reprinted the texts in full, and unofficial reprints circulated as well. These publications were in such great demand that as early as October the committee expressed the hope that this type of source publication might prove self-supporting and not cost the authorities a single centime.[122]

No wonder they did so—the publications were packed with revelations of

the misdemeanors and maladministration of a cruel Corsican half-breed and a superstitious Spanish woman who had brought misfortune upon France. There were also disclosures about the censorship practices of the *cabinet noir* (where personal letters were opened and, if need be, copied), about acts of oppression, about the doings of the emperor's mistresses and their illegitimate children. The financial records provided solid evidence: the existence of a private purse, gifts to members of the imperial family, the costs of a christening ceremony (close to 900,000 francs for the *prince impérial*), the *liste civile* . . . A number of special beneficiaries were listed by name and surname. In short, the whole system was laid bare as a means of satisfying the clients of the regime, the *instrumenta regni*, and also as a system of social security for loyal servants. Payments for normal services and small presents were listed as well. The heading "Dowry?" gave rise to speculations that, in view of Napoleon III's reputation, were only too obvious. In the event, however, many of these suspicions proved to be unfounded, especially those relating to the daughters of faithful but impoverished soldiers.

All this exposure was a salutary antidote to the mass of Bonapartist propaganda that had flooded the country for twenty years. Yet in some respects the imperial system was better than later prorepublican historians tried to make out. Thus it could take credit for many real achievements in the fields of economic policy and public works.[123] The study of history also benefited from generous and effective government encouragement, albeit coupled with narrowminded censorship and dictatorial interference.

The Imperial Court

The executive was to play a dominant role from then on. "France does not want by petty suspicions to muzzle a power vested by her in an assembly enjoying unprecedented confidence," Raymond-Théodore Troplong proclaimed sonorously in the Senate.[124] Executive power, however, had also to be centralized. The Maison de l'Empereur, closely linked to the Ministère de l'Etat, became the hub of power and took an increasing share of the state budget. The court was now the nerve center of the administration. Accordingly, the study of history was no longer the exclusive province of the Ministry of Education, which was very poorly funded during the early years of the regime. Any account of state support for historical studies must therefore begin at the beginning—with the emperor and his court.

The administrative pattern of the ancien régime was resuscitated. Power was vested in courtiers, some of whom bore the title minister. The emperor, a man who had been swept to power by a conspiracy, who had kept his plans secret even from his intimates, and who was essentially unpredictable and irresolute, had the final word. Napoleon III has often been called a precursor of the modern dictators, and this view has tended to obscure the traditional aspects of his reign. For all his modern ideas, he also hearkened back to the past, to Caesar, the Roman emperors, Charlemagne, and of course his own uncle.

The court ceremonial of Napoleon I, which had been severely pruned during

the July Monarchy, was restored. The imperial lady-in-waiting, Tascher de la Pagerie, complained that "the *roi citoyen* kept a rather bourgeois court" and that the "elected" emperor was forced to fill his court with "elements prone to let themselves go."[125] The result was the court's pompous and vulgar Second Empire style.

But was the emperor's court really so much costlier than the royal courts, as is so often alleged? According to Necker's survey of 1789, the expenses of the royal family came to 33 million *livres tournois* and the *pensions* and *gages* to another 33 million, that is, to 12 percent of the total state expenditure. In 1825 the expenses of the royal family came to 9 million and the *liste civile* to 25 million, making a total of 34 million, or 6 percent of the budget.[126] Clearly, the Bourbons had been more thrifty during the Restoration, but then the responsibilities of the court had been drastically reduced since the Revolution. The cadet branch of the Bourbon family had been even more economical; a contemporary computation showed that they spent 316 million in seventeen years and six months, or 18 million a year.[127] The Empire was more profligate, but precise calculations are hard to make. More than ever, the budget was one great big lie. There was some suggestion of amalgamating the Ministère de l'Etat with the Maison de l'Empereur, and there was some overlap between other departments and the emperor's privy purse, but the whole was a knot that was impossible to disentangle. The figures published in 1870 and 1871 gave no more than incidental details, not least for ulterior motives, and comparisons with earlier governments were lacking. Marion, the expert chronicler of state budgets, mentioned 34 million francs for the Ministère de l'Etat and the Maison de l'Empereur in 1853 (the year of the emperor's wedding, which cost 1.5 million francs) and 25 million in 1854.[128] Even compared with the expenditures of the Bourbons during the Restoration, these figures are not particularly high.

A grand marshal of the palace, a chief master of the hunt, a court chaplain, a lord chamberlain, a master of ceremonies (a post held by that notorious fop, the duc de Cambacérès), and an equerry received 40,000 francs each in addition to their pay as senators, officers, or ministers. In addition to these men holding plum posts, there was an army of underlings drawing fat salaries. However, it would be quite wrong to regard these appointments as purely ceremonial. All sorts of posts that are nowadays filled by civil servants were held by courtiers or at least by men appointed by the court. The nineteenth century is still far too often painted in modern colors. It is most commonly viewed as a time of growth of state influence, of officialdom and bureaucratization, in short, the rise of the modern state—and that is also the way it tends to be described in this chapter—but in fact "courtly society" still held considerable sway in France for most of the nineteenth century.

The Emperor's Historical Concern: "Imperialism"

Napoleon III tried to imitate Napoleon I in many ways, but he also had other imperial idols. After his second abortive coup d'état in 1840 he was imprisoned

in Ham House, where he planned to write a history of Charlemagne, focusing attention on the question, "What was the situation in Europe before Charlemagne and what was his influence on later generations?" "It is more politic for me to fall back on a past that no longer incites passions," he wrote to Madame Cornu, his learned adviser, foster sister, and loyal friend in adversity.[129] Within a year, however, he had abandoned this idea and decided to devote his attention instead to writing a manual on the past and future of the artillery, which he felt it behooved a Bonaparte to write. The result, if we are to believe the experts, was a creditable study.

However, for one bearing the name of Bonaparte a greater idol than even Charlemagne was Caesar, in whose memory Napoleon I had dictated a *Précis des guerres de César* on St. Helena. The imperial concern did much to stimulate French studies of Roman Gaul—before the Second Empire no French government had been so active in this field. The propaganda motives were obvious, the political aims unmistakable: the past of the French nation had to be extended back to imperial Rome. The monarchy, when viewed in this way, was no more than an interlude, albeit one that had lasted for centuries. The rise of the third estate also was a relatively short-term historical process. Roman Gaul simply had to be brought back into the picture, and the legitimizing purpose of this project was openly proclaimed. It was imperialism in the broadest sense, and although history may have been subverted in the process, historical scholarship did not do too badly.

The emperor decided to write a book on Caesar himself. Until 1866, maps of Gaul graced the walls of his study (after Sadowa they made way for maps of Germany). With the help of a great many well-known and not so well-known scholars, Napoleon III was able to assemble a considerable collection of documents.[130] No trouble or expense was spared. An independent opinion of this collection was given in a report by the *chartiste* Jules Soury, who proposed in November 1870 to transfer the confiscated documents from the Tuileries to the Bibliothèque Nationale. Foreign celebrities such as Theodor Mommsen, A. W. Zumpt, and W. Drumann were consulted at length.[131] French specialists in classical history, although plainly no match for their German counterparts (and this was true of all European experts during the nineteenth century), were brought in as well. Historical geography was given a considerable impetus in 1858 by the creation of a committee for the study of the topography of Gaul; Latin epigraphy was honored with a chair at the Collège de France under Léon Renier as an acknowledgment for past, and in the hope of future, collaboration on the imperial project.

Archeological studies of ancient Gaul benefited considerably from the veritable battle fought to determine the precise location of Alésia. In this battle imperial army officers faced republican archeologists, the imperial offensive having elicited fierce republican resistance. Regional rivalry and local patriotism played their part as well, setting the champions of *Alaise comtoise* against the defenders of the *Mont auxois: Bourguignons* versus *Franc-comtois*.[132] It all amounted to a full-scale mobilization of soldiers and professors, conservatives and liberals;

even the duc d'Aumale threw himself into the battle with a daring archeological charge. A vast scale model was built in an effort to reproduce the historical situation faithfully; in 1867 it was set up in the brand-new Musée des antiquités nationales de Saint-Germain-en-Laye. This museum, in which the premonarchist past of France was henceforth illustrated by means of realia was in a sense the culmination of the archeological campaigns.

In this connection it is possible to argue that French archeology had become secularized to a certain degree. Increasing attention was being paid to pre-Christian objects, and there was a growing involvement of nonclerical scholars in local archeological studies. Prehistory was still in its infancy, but even so, prehistorical finds were assigned a special room in the Saint-Germain-en-Laye museum at the last moment.[133] There were strong clerical objections to this decision, for the exhibits were considered to be dangerous material, likely to add fuel to all sorts of unbiblical hypotheses about God's Creation.

At about this time, Jules Quicherat, a staunch republican who had fought bravely against the imperial troops at the paper battle of Alésia, decided to write a manual for amateur archeologists. The fragment of that work that has come down to us clearly reflects its author's wish to break the monopoly of clerical archeologists, of village priests. "Just as the peasants are the natural purveyors of archeological objects, so elementary teachers should be the attentive reporters of these discoveries."[134] He made no reference to the wide network of village priests and curates who of old had played so important a role in the archeological exploration of remote corners of the country (and who were often the only interested persons in those parts). Quicherat's aim was the establishment of a secular, republican training institute for archeological digs.

Besides Léon Renier, Wilhelm Froehner and Alfred Maury also collaborated closely with the emperor in his work on Caesar. Froehner's role in the eventual publication of the *Histoire de Jules César* (2 vols., 1865–66) was particularly marked, although his contribution was not officially acknowledged. From 1863 on Froehner would read the emperor extracts from the works of Mommsen and Drumann almost every day.[135] At that time he had a post in the Musée de Louvre and was therefore a member of the imperial household. He was paid 5,000 francs a month for his assistance. The Emperor's Latin was poor, and Froehner had to correct the mistakes in his manuscript, which was also read by Saint-René de Taillandier, a professor at the Sorbonne. Froehner had replaced Léon Renier as the emperor's chief adviser, which testifies to the soundness of the emperor's judgment, though it was also a strong move in a court intrigue. Renier was a protégé of Madame Cornu; together with her husband, he had bought the valuable Campana collection in Rome.[136] Then the director of the Louvre, the playboy Nieuwekerke, supported by Princess Mathilde, the emperor's cousin and former fiancée, had insisted that the Louvre take charge of that collection, and the Louvre faction had won the day. Then Madame Cornu had played a neat countermove: she had ensured that the AIBL had the final say about the how the collection was to be integrated into, and distributed through-

out, the Louvre. Young Froehner, for his part, had been Nieuwekerke's discovery. Because of his solid German training, Froehner had no equal in France, and the director of the Louvre was only too glad to provide the emperor with an eminent and learned assistant who, moreover, belonged to his own faction and thus to thumb his nose at Madame Cornu, who had a reputation as a scholar.

Because he was a German and an intimate of the emperor, Froehner's part came to an end after 1870. Attempts to find him a position elsewhere were blocked by Renier, who could never forget that Froehner had pushed him into the background. Froehner was unable to finish his great projects; for all his learning, henceforth he made a meager living by preparing sales catalogues for dealers in coins.

Other erudite collaborators were more skillful manipulators, so their careers were not cut short in 1870. Thus, Alfred Maury, who had only had a sporadic, many-sided, but by no means thorough training (characteristic of the *cursus honorum* before it became professionalized), was nevertheless appointed deputy librarian at the Institut de France in 1844.[137] In 1858 he became secretary to the committee for research into the topography of Roman Gaul, which was expected, in particular, to come up with the precise routes taken by Caesar. In 1860 Maury was appointed librarian in the Tuileries with an annual salary of 6,000 francs; his duties included being a kind of learned factotum to the emperor. In 1862 he was made a professor at the Collège de France. When the emperor's book was finished, Maury was appointed director of the Archives de l'Empire in the hope that he would quickly find his way in a field with which he was quite unfamiliar. His courageous behavior during the siege and the Commune protected him from dismissal, at least according to his official obituary, although it seems likely that Maury also protected his flank with republican connections. Madame Cornu, his patroness, incidentally, did not have a bad name among opponents of the Empire. At one point she had even aided the Orsini family. (Félice Orsini had tried to assassinate Napoleon III on 14 January 1858, which resulted in sensational carnage.) Madame Cornu had shown that she did not approve of dictatorship and oppression. Her circle was more or less the "liberal" wing of the Bonapartist camp.

Maury was a scholarly jack-of-all-trades. His memoirs are an excellent source of information on all the intrigues that went into financing historical research at the imperial court.[138] Maury lacked the sharp pen of the duc de Saint-Simon—every court seems to get the chronicler it deserves—but he did have an appealing modesty that was rare among prominent scholars. On his deathbed he showed that he knew what his own writings were worth: "They will not endure." When he was dying, he felt sustained by the knowledge that thanks to the trust the emperor had placed in him, he had been able to encourage young men of talent: "I shall not die entirely forgotten because I have raised Longnon."[139] And in fact the impecunious Longnon, who had a natural gift for historical geography, had, at Maury's behest, received a grant of 1,200 francs from the emperor's privy purse in 1868. That grant had helped to persuade Longnon's father to allow his son to choose an uncertain academic career and to turn his

back on the financial security of a cobbler's life. Longnon too continued to do well after the demise of the Second Empire: in July 1871 Maury was able to persuade Jules Simon, the then minister of education, to find the young man a position at the Archives Nationales at an annual salary of 2,500 francs.

During the July Monarchy, and thanks mainly to Guizot, who believed that independent organizations made for a balance of power and social stability, the authorities preferred to finance societies that were run like academies, that is, societies that chose their members by co-option or that were permanent institutions. Napoleon III, by contrast, favored direct contact with individual beneficiaries. In a sense this was a return to the classical system of patronage, although the emperor did not dismantle the institutions set up by the July Monarchy. He particularly liked the patronage system when it came to research into Roman Gaul because it allowed him to use the results more directly for his own purposes.

The careers of a great many scholars received substantial imperial encouragement. In 1870 the keeper of the imperial account books noted with obvious satisfaction that not much money had been spent on arts and letters and that the only beneficiaries had been known Bonapartists or completely unknown individuals: "The Empire set out to restrain intellectual curiosity, not to attract brains."[140] That was well put but not altogether true with regard to the study of history. The scholars Napoleon III supported were by no means the least talented. It even seems probable that this direct form of patronage opened up a scholarly career to some whose lowly social origins (especially in the case of Léon Renier and Auguste Longnon) would have ensured that their talents went by the wayside in the more elitist atmosphere of the July Monarchy. This is a small point in favor of the Empire compared with the sad list of careers it cut short.

Bonapartist Repression

In financial terms, the Second Empire was not a bad period for such research establishments as the Institut de France (once again called "imperial"); its allocation grew from 571,000 francs in 1850 to 661,000 in 1870. Over the same period the state contribution to the Collège de France increased from 180,000 to 280,000 francs, and a number of *missions scientifiques* also fared well.[141] But although the budget was not pared down, freedom of speech certainly was. The authoritarian regime would not even leave the august Institut de France alone; Fortoul, the minister of education, tried to mount an "academic coup d'état" against it.[142] He wanted to subdue a body widely considered to be an Orleanist viper's nest, one in which legitimists and liberal Catholics made common cause to keep Bonapartist candidates out. In 1855 it was decreed, *inter alia*, that the combined annual session of the Institut's five classes would henceforth be held on 15 August, La Saint-Napoléon. The first prize became the Prix de l'Empereur, and a new section was added to the ASMP, whose members would be

appointed by the emperor. Previously there had been a fierce battle for prizes and appointments in which the opponents of the Bonapartist regime were able to do as they pleased without risking their heads. Co-option in particular was a ploy the leading academicians had used to their best advantage. In what came to be known as the "war of allusions," Villemain, the *secrétaire perpetuel* of the Académie française, delivered an oration on Demosthenes, and Guizot quoted the abbé Montesquiou, who had been made a member of the Académie in 1816 by order of the king: "I am not an academician; academicians are not made by the king."[143]

Napoleon III was not equal to this outburst of academic animosity and more or less disowned Fortoul, who at long last had succeeded in getting himself elected to the AIBL. Not only had he lost the fight to strengthen the Bonapartist hold on the Institut but he had become disenchanted with his work as an academician. "What a ridiculous way for great men to pass their time," he wrote in his diary.[144] The dictatorial pressure was also felt in the Collège de France. In 1852 the revolutionary triumvirate—Michelet, Quinet, and Mickiewicz—was officially dismissed; a year earlier their professorial colleagues had already shown their disapproval of Michelet's polemical and politically biased teaching, and in March 1851 his lectures had been suspended. Within the Collège of France any form of opposition to the government was frowned upon.

In the 1860s, when the atmosphere became somewhat more liberal and Ernest Renan was given a chair at the Collège de France with the support of the freethinkers at the imperial court, it quickly appeared that the limits of tolerance were fairly narrow. No minister of the crown could ignore the solid pressure of the clergy. Renan's lectures, in which he made no attempt to avoid controversial issues, were suspended. His famous remarks on Christ's divinity proved the final straw: "An incomparable man—so great that even here, where everything must be judged in the light of positive science, I would not gainsay those who, struck by his exceptional character, call him God." The uproar and rioting in the Quartier Latin during and after Renan's inaugural lecture forced Rouland, the minister of education, to intervene.[145] Rouland's successor, Victor Duruy, a man with an anticlerical reputation, tried to help Renan, who had been suspended, by giving him a senior post in the imperial library. However, Renan, freed from financial worries by the spectacular success of his *La Vie de Jésus*, haughtily refused the offer. Minister Duruy was made to look foolish, attacked as he now was on two sides.

Later on Renan tried to regain his chair with the support of the anticlerical Prince Napoléon, brother of Mathilde.[146] The chances looked good: the Empire was now more or less officially liberal, and the emperor was at loggerheads with the pope. In March 1870 Napoleon had a long conversation with Renan in Princess Mathilde's salon, but the Empire collapsed before Renan's appointment could be ratified. That did no harm to his reputation.

The Empire was notorious for its censorship. But has there ever been a real empire without censors?

The Heyday of Inventories

The care of documents and the preparation of inventories made great progress during the Second Empire. The Archives Impériales (once more "imperial"), and the Bibliothèque Nationale in particular profited from steep budget increases. The allocation to the great archive in Paris increased from 108,000 francs in 1850 to 184,000 in 1870; that to the Bibliothèque Nationale (quite apart from additional grants for the preparation of catalogues) rose from 289,000 francs in 1850 to 495,000 in 1870. In relative terms, the increases during these twenty years (1850–70) were much greater than the increases during the next forty years of the Third Republic (1870–1910).[147]

The July Monarchy had introduced greater public accessibility; the plums had been picked from the enormous archival cake and many of them had been published. However, there were signs of serious concern about the administration of the archives, and a special inspectorate was set up. At first Guizot recoiled from the gigantic task of taking inventories of all the archives, but during the 1840s the first ministerial circulars on the subject were nevertheless issued. It is no exaggeration to call the Empire the *haute époque* of inventories.

The national archives were the first to be tackled, followed by the departmental and then the municipal archives. In 1855 a guide to the national (then imperial) archives by Henri Bordier appeared.[148] It is significant that this truly pioneering work by a Protestant, republican author gave an unbiased account of the French Revolution's positive effects on the archives. Others took a different view. The marquis de Laborde, director of the Archives Impériales, drew a very negative picture of the effects of the Revolution in *Les Archives de France: Their Vicissitudes during the Revolution and Their Regeneration under the Empire* (1867). A republican reaction was not slow in coming: Eugène Despois took it upon himself to exonerate the Convention. He even compiled a statistical list of destroyed churches and abbeys, which seemed to prove that the Revolution had not been the worst culprit.[149] It was the old debate on revolutionary vandalism, the subject of abbé Grégoire's famous report in 1794, all over again.[150] Despois, incidentally, was not greatly impressed by the preservation of documents in general; he referred to the "idolatrous worship of old paper" and inveighed against prurient interest in erotic tidbits and culinary anecdotes from the past. The only documents he was really interested in were important, that is, politically relevant, ones.[151] According to Despois, the sorting operation ordered by the revolutionary authorities had been justified in principle; all that really mattered was to discover whether important documents had been destroyed accidentally as a result, and that had rarely happened.

The vehemence with which such opinions were held bore witness to the fact that the Revolution had lost none of its topical appeal in an age of quickly changing political regimes. No matter what prejudices he may have held, Laborde, who was succeeded in 1869 by Maury, that versatile courtier we met

earlier, was an outstanding archivist, perhaps the best France produced before the First World War, except for Charles-Victor Langlois.

Inventories of the provincial archives were also tackled with a will. They were badly needed. Some idea of the state of these archives may be gathered from a travelogue Jules Michelet wrote in the summer of 1835.[152] As part of his editorial work on the volumes of his *Histoire de France* that dealt with the Hundred Years' War and the religious disputes, he visited dozens of towns in southwestern France. Armed with an introduction from the minister of education, he inspected archives stored in prefectures, town halls, municipal libraries, schools, and courthouses and noted a host of malpractices. There were countless disputes about old documents taken from the expropriated monasteries and claimed back during the Restoration. In the smaller departmental capitals as well as in such large cities as Bordeaux and Toulouse the archives were in a deplorable state. At best the documents were being kept in old cabinets that could be locked, as had been the custom during the ancien régime, but in many places precious old records had been casually tucked away in leaky attics infested with rats and mice; there was a considerable fire risk and ample opportunity for thieves to make off with valuable items. In Montauban records were being sold off, and in Limoges there was no staff of any kind. If anything at all had been preserved in these places, it was thanks to private collectors or to aged priests. The situation was appreciably better in places where a prefect took an interest in the records. In Bordeaux, however, the archivist at the prefecture had an obsessive fear of infection; he also thought that the archives had been impregnated with arsenic, and so he cautiously kept his distance from these treasures. Michelet, who had no such fears, discovered that many registers had rotted away. In the parliament of Bordeaux half the archives had been destroyed by vermin or lost during two successive removals. In Pau people accused one another of stealing valuable documents. In Toulouse, though the archives of the parliament had been admirably classified by a *décorateur gothique* who doubled as archivist, the housing of the archives in the prefecture appeared to be abominable.

Michelet's journey took place before a proper start was made on the organization of the departmental archives. That organization began with the creation of an archives committee and the requirement that prefects budget for the conservation of the archives under their jurisdiction. In 1841 a circular was drawn up setting out the guidelines for classifying and compiling inventories covering the period before 1790. In 1853 it became the legal duty of departments to conserve and classify archives, and beginning in 1861 the departmental inventories began to appear in print. They were to grow into an impressive series.[153]

Although it gave a powerful boost to the cataloguing of archives, the Empire had a bad name when it came to public accessibility. Documents from the First Empire in particular gave rise to touchy exchanges. Thus there was a bitter quarrel about the ownership and publication of the correspondence of Napoleon I. Prince Napoléon asked to be handed some documents but failed to

obtain them (the emperor himself refused to release them), and he complained about the Orleanists in the Archives Impériales.[154] A considerable sum of money (50,000 francs in 1860) was set aside in the budget for the publication of the correspondence of Napoleon I. This was yet another means of honoring the memory of the founder of the regime.

The national library (imperial once again) also blossomed during the Empire, a fact to which its great reading room still bears witness. In 1860 the number of books in it was almost double the number in 1818. Under the energetic leadership of Jules Taschereau, *administrateur-général* from 1852 to 1874, not only was work started on the new building, designed by the architect Henri Labrouste, but a systematic catalogue of the history section was begun.[155] Equally important in the life of the library was the fact that Léopold Delisle joined the staff at the beginning of the 1850s—he is still remembered with gratitude by every French medievalist.[156] Working at great speed (and hence not as meticulously as he might have done), he opened up unknown historical worlds with his catalogues. Delisle's long and industrious career at the Bibliothèque Nationale, spanning fifty-two years, thus took wing during the Second Empire; it must be added that toward the end of his career he became rather obstructive and tyrannical.

The Comité des travaux historique also exhibited a passion for inventories. After the first feverish burst of activity, after a host of publications of readily accessible sources, which appeared in quick succession but lacked coordination or critical acumen, the tempo slowed. However, new series of inventories and repertories were launched; the large number of coordinated and coordinating surveys reflected an obvious need for a systematic approach to classification. The topographical dictionaries that had often been compiled on the private initiative of local societies in the various departments were now granted state patronage. In 1861 the first volume of the *Dictionnaire topographique* of the series was published; by 1870 nine volumes had come out, and during the years 1871–74 another five volumes followed, largely as a result of initiatives taken during the Empire.[157]

Another series, the *Répertoires archéologiques*, was also launched at the time; six volumes were published in 1861–71. The committee for the study of the topography of Gaul, founded in 1858 and has already been mentioned in connection with the "imperialism" of Napoleon III, was an independent body; it was not incorporated into Guizot's creation until 1881. The third new series was the *Catalogue général des manuscrits des bibliothèques publiques en France*, though this useful series had actually been launched as early as 1841, following a report by Villemain. It was intended to be a complement to the source publications of the Comité. The first volume appeared in 1849, the fourth in 1872.

In 1858 Rouland, who succeeded Fortoul as minister of education, added a science section to the Comité, which was then subjected to numerous name changes and rearrangements of its divisions. The science section was meant, *inter alia*, to produce a *Description scientifique* of France, comprising a survey of

the geology, botany, zoology, meteorology, and general statistics of every department.[158] This ambitious project was quickly abandoned, but the underlying idea was characteristic of the prevailing passion for surveys and inventories, a process thanks to which the study of history lost its exclusive control over this source of government research funds. One logical outcome of this development was the change in the Comité's name in 1881 under Jules Ferry, the positivist minister of education in the Third Republic, from Comité des travaux historiques to Comité des travaux historiques et scientifiques. The funds voted to the Comité were not, however, increased; the annual state contribution in 1870 was the same as that set by Guizot in 1834 (120,000 francs).[159]

Following the spadework during the July Monarchy, the Second Empire was able to make significant headway in the compilation of inventories. Yet it is far from certain how many of these advances were the specific effects of interventions by the imperial government. As far as studies of Roman Gaul were concerned, state influence was unmistakable, but the same cannot be said of the study of other periods. Possibly the need for compiling inventories and for orderly arrangements was a logical sequel to the marked rise in historical interest during the previous period. Moreover, the compilation of inventories was greatly facilitated by the newly established organization of the provincial archives and by the fact that the Ecole des chartes had begun to turn out a small but regular stream of trained archivists. The Ecole des chartes (the state contribution to which rose from 35,000 francs in 1850 to 47,000 in 1870) gradually turned into a training institute for archivists; in 1850 the government even decreed that posts for archivists were to be reserved for graduates of the Ecole des chartes. Although this decree was still widely ignored in the provinces, the government intention was clear. From 1849 to 1914 the Ecole produced 782 graduates, an average of 13 a year, and a growing number of these *archivistes-paléographes* obtained jobs in archives and libraries. Of the 540 inventories of provincial archives published from 1861 to 1920, 370 were produced by *char-tistes*, as were 100 of the 273 inventories of the Archives communales et hospitalières published in 1920.[160] France's headstart in this field was due in no small measure to the Ecole des chartes.

The wish and the will to do this valuable work, or at least the appreciation of the need for it, was largely a reflection of the ethos and approach fostered by the Ecole des chartes during the second half of the nineteenth century. Important results were achieved even without large increases in government funding—grants are not invariably spurs to action.

State Education under Pressure

In 1850 the state allocated 22 million francs to education; in 1860 the figure was reduced to 21 million. The drop represented a relative decrease from 2.9 percent to 2.7 percent of the total sum allocated to all departments.[161] The plebiscites had shown that there was no good reason for launching an expensive education program for the "laboring classes." During this first, "authoritarian"

phase the Empire did not want to get drawn into arguments about state schools, especially since the church was on its side and public education had acquired a poor reputation. Lay teachers, those "frightful little rhetors,"[162] were held responsible for the "red" attitude of peasants and workers. More scope for the religious teaching congregations and stricter supervision by the prefects were needed. In secondary education the "nominal" state monopoly was abrogated by the law of Falloux (1850). However, Napoleon's Université, which provided training for teachers in both higher and secondary state education, was not abolished, republican attempts to blacken minister Fortoul notwithstanding.[163] The Université retained the right to confer degrees. For all that, freethinkers and "positivists" now had a hard time in the teaching profession.

After 1860 the Empire became more liberal, though under pressure from the clergy severe sanctions were still imposed on unbelievers and any who dared to voice religious doubts. The Université had a hard time in its "Bonapartist exile,"[164] denominational education proving a highly successful challenge to that secular institution. Even so, the state allocation to education was stepped up in the 1860s: from 21 million francs in 1860 to 24 million in 1870, a relative increase from 2.7 percent to 2.8 percent of the total budget.[165]

Needless to say, the great latitude extended to Catholic schools was a blow to state education, but that does not necessarily mean that the general standard of education declined. Competition can prove beneficial. Elementary- and secondary-school attendance and literacy among army conscripts made considerable headway during the Second Empire.[166] Investment in state education increased only slightly from 1850 to 1870 (after an unprecedented drop in the 1850s), but all in all, education did make some progress. The church supplied a cheap solution while helping to foster a socially conservative attitude.

A Great Minister: Victor Duruy (1863–1869)

Only one minister of education in the Second Empire was to enjoy a good reputation among later republican historiographers. Victor Duruy, minister of education during the "liberal" period of the Empire (1863–69) was considered to be a *grand ministre*, and in the most recent studies the modernization of higher education is said to have started under his ministry. This positive assessment was fostered largely by Ernest Lavisse, the high priest of education in the Third Republic, a man whose career began in 1867 in Duruy's office.[167] Duruy may not have been the most important minister of education France had known until that time, but he certainly left his mark on the study of history in France. In the field of historical research he was responsible for founding the Ecole pratique des hautes études, and he also considerably influenced the teaching of history (see chapter 3).

Victor Duruy was an anticlerical Bonapartist, a rabid antipapist, and a firebrand. He came from a family of highly skilled craftsmen, men who had been engaged in the weaving of tapestries for seven generations. Victor was born in 1811, and as he was the second son, there was no future for him in the work-

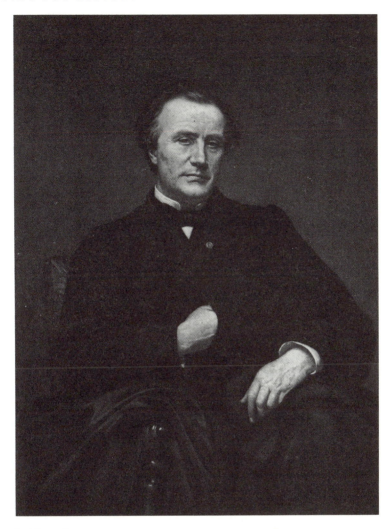

2. Victor Duruy

shop. He grew up among people filled with nostalgia for the First Empire and with hostility to the resurgent church. The army attracted him, and he decided to join the Algerian forces if he failed the entrance examination to the Ecole normale supérieure. In the event, he passed and became a successful history teacher. Duruy gained the confidence of the king and was given the task of teaching the king's promising son, the duc d'Aumale, at the Collège Henri IV, it being Louis Philippe's policy to have his sons educated at school, as the Parisian bourgeoisie did, rather than taught in isolation by private tutors. In Paris Duruy had, however, to make do with half the salary he received in Reims, where he had briefly taught before (he took a cut from 3,200 to 1,600 francs). This was

because his rank at the Parisian *collège* was lower, but then he was also closer to the hub of the world.

He made his name as the author of a manual of Roman history on which he had worked for ten years, the first two volumes appearing in 1843–44. According to him, the subsequent volumes, in which he sided with the Roman Empire against the Republic ("an oligarchy of one hundred families who ground down 60 million people") had been finished by 1850, but he decided not to publish them because they might have been regarded as mere flattery of Napoleon III.[168] These volumes were not issued until 1872, and if his story is true, it does him credit.

All in all, Duruy favored the imperial form of government. In his Latin thesis on Tiberius (1853) he criticized the unfair ideas of such anti-imperial aristocrats as Tacitus. The submission of his French thesis gave rise to a notorious incident. Désiré Nisard, one of the members of the jury, accused Duruy of using a double moral standard in his attempt to gloss over the crimes of Augustus. The public realized at once that Nisard was actually alluding to Napoleon's coup d'état of 2 December, and the whole thing blew up into a major row. Duruy proved to be equal to the occasion, but he was no flatterer. As he explained later, he agreed in essence with Nisard that any judgment of a political figure had to take the circumstances into account, "but this is not, and should not, be said in a place consecrated to the instruction of young people, who will consider these words, not as the prudent reserve of a historian, but as nothing but an apology for violent seizures of power and as the servile connivance of a sycophant."[169]

In 1849, when the devout Catholic Falloux blocked Duruy's appointment to the Ecole normale supérieure, Duruy turned his hand to an extremely important (and profitable) task: the writing of schoolbooks. His work on Roman history gained Duruy access to Napoleon III. In 1859 he was invited to the Tuileries, where he talked to the emperor about ancient Rome, incidentally mentioning the forty emperors who had been murdered between the reigns of Augustus and Constantine. Even so, he cannot have made a bad impression on the emperor since his career started to take wing. Following the publication of Duruy's pamphlet demonstrating that the popes had acted no better than any run-of-the-mill Italian prince and that these holy fathers had not been above the use of unholy means—a pamphlet commissioned by the authorities and published by Duruy anonymously[170]—the emperor wanted to appoint him *inspecteur-général* of schools, but Rouland, the then minister of education, had already picked another candidate. Duruy was paid a compensation, and when this important post fell vacant again in 1862, he was finally appointed to it. At the same time he was also made a kind of private secretary to the emperor, whom he helped to write his book on Caesar. Napoleon III, who had gained the laurels of victory in the Crimea (at Sebastopol in 1855) and in Italy (at Solferino in 1859), was not a man whose wishes could be ignored. To cut a long story short, Duruy became minister of education in 1863.

He set to work feverishly. Reports, inquiries, and circulars kept pouring forth

(Duruy shared the general enthusiasm for inventories and surveys).[171] People with a distrust of printed matter dubbed him a "ministre circulassier." But printed matter was not all he produced. In particular, he lent his support to numerous scientific missions.[172] His crowning achievement in the field of historical research was the foundation of the Ecole pratique des hautes études in 1867.

The Ecole pratique des hautes études—IVe Section

The Ecole pratique des hautes études was a Bonapartist creation. Its fourth section, devoted to historical and philosophical studies, was probably in line with the plan by Napoleon I, conceived in 1807, to set up a special school for literature and history and to attach it to the Collège de France. However, there were many differences between the two. Napoleon's objective had been entirely pragmatic; he had envisaged a center where politicians and soldiers could gain a wider view of the world, something for which he believed there was a great need.[173] Philology had not yet become the dominant discipline among the humanities, nor had the seminary system, probably the most important innovation of the Ecole, as yet been introduced into early-nineteenth-century France.

The seminary system, by which students were initiated by a scholar into the rules and rituals of learned source criticism, had been in use in Germany for a long time.[174] The salons and soirées, for instance, those still presided over by the aged Thierry, where ideas were exchanged and the younger generation received intellectual stimulation, provided no real alternative to the thorough training of scholars. The academies, for their part, were meeting places for scholars with an established reputation, whereas the *conférences* of the Ecole normale supérieure were too general in character and too geared to the examination syllabus. The curriculum of the Ecole des chartes came closer to the objectives of the seminary system at least as far as the study of French history was concerned, though its main goal was still the practical training of archivists.

It was Duruy's intention to augment the lectures at the Collège de France with seminars, or laboratories for research and education, as he called them. They would be training institutes for savants and would pave the way for advances in research. According to Duruy, there must be a clear division of labor between the faculties, in which the end results of research were presented, and the great new institutes, where research had still to be done.[175] In his view the two thus had quite distinct functions. It is therefore quite mistaken to consider Duruy the pioneer of the great changes wrought in the arts faculties during the eighties. The typically French solution would have been to make no attempt to reform an old, and worm-eaten institution, with all the problems that entailed, and instead set up a brand-new, parallel institution that would eventually take over the duties of the old. As Duruy put it, the Ecole des hautes études was meant to sow the seeds for the destruction of the "crumbling walls" of the Sorbonne. But Duruy, as I have said, thought there had to be a clear division of tasks. That was not simply ministerial cunning on the part of one loath to

offend existing institutions; Duruy stuck to this view even after he had left his post at the ministry. The Ecole normale supérieure was to serve the elite of the teaching profession, the Ecole des hautes études would cater to future savants, and the Sorbonne would prepare candidates for examinations, including the *agrégation*. According to the skeptical Duruy, the Sorbonne would never be able to adopt the broad educational approach of the Ecole normale and must needs fail to "keep the sacred fires of the intellect ablaze."[176]

Nevertheless, Duruy genuinely wished to breathe new life even into the Sorbonne. He regretted that that institution had to make do with a building built in the time of Louis XIII, while the Bibliothèque Impériale sported a new home. It was in Duruy's office that the young Lavisse enviously read again and again consular reports about the flourishing German universities.[177] A comparison of their students with the French made sad reading. Duruy himself wanted changes but did not think that the arts faculties should cease to open their lecture theaters to the public at large. They must not consider it their sole task to teach full-time students, as was being proposed in the 1880s. He also opposed the rise of "faculty imperialism," the wish to incorporate the *grandes écoles* into the faculties.

All in all, the Ecole des hautes études was never intended to be an antifaculty, nor would it ever turn into one. The subjects taught were of no interest to school teachers of history; they were more in line with those offered at the Collège de France. Léon Renier, who became president of the fourth section, seems to have played a leading role in enlisting the support of the court as well as the Ministry of Education; Madame Cornu also did what she could for the Ecole.[178] Michel Bréal, Gaston Paris, and Gabriel Monod were sounded; all of them had studied in Germany and therefore knew how seminars were run— unlike Alfred Maury, who became head of the history section because it would have been difficult and foolish to pass him over. Maury, like Renan, who was also approached, saw few advantages in the seminar system. In fact he found it rather hard to cope with his new post. He saw himself as a kind of literary adviser to students at the Ecole des chartes, who were knowledgeable enough but had considerable problems when it came to writing.[179]

Gabriel Monod was able to give the historical part of the fourth section a characteristic profile by convincing Maury of the benefits of seminars. During this early stage in the life of the Ecole, Monod made feverish attempts to have the position of the fourth section firmly defined, something that was far more difficult to accomplish for a history department than for departments devoted to philological studies.[180] He felt that the method of teaching history used at the Ecole normale and at the Ecole des chartes ought not to be duplicated, and he accordingly chose as his subject the historical critique of medieval historiographic sources, a field originally covered by the AIBL's great series of publications. He also considered the resumption, by modern methods, of Thierry's series of source publications on the third estate. Monod was anxious to open up a job market for students of the Ecole des hautes études, and he hoped they might become paid assistants in the production of such a series. The Achilles

heel of his dream of a *grande école* for scholars was in fact the lack of career prospects for them; the small number of students at the Ecole was a consequence of this lack. The reports on the first seminars note that there were never more than nine students (except for Renier's class, which had eleven).[181] Monod's own seminar was attended exclusively by students from the Ecole des chartes and by the self-taught Auguste Longnon. Monod had not yet been able to interest *normaliens* in the study of historical sources.

The merits of the fourth section, which was by far the largest until the irresistible advance of the famous sixth section after the Second World War, are undeniable. The *Bibliothèque de l'Ecole des hautes études, sciences philologiques et historiques* bears witness to this fact: no less than sixty-three of its excellent volumes were published during the first twenty years of the life of the fourth section. In particular, philology, the critical study of (classical and nonclassical) ancient languages, found in the fourth section the "institutional" cradle that had been lacking in France. Seminars provided a fruitful combination of research with the education of research workers. The isolation of the professors at the Collège de France was ended, and a small number of young scholars was able to earn a slender living as *répétiteurs* (later called *directeur-adjoints.*)

In the annals of the French humanities the achievements of the Ecole des hautes études hold a place of honor even though in terms of numbers it was a rather small venture, certainly as far as the historical section was concerned. In 1883 this section was made up of Maury, the nominal *directeur d'études*; Monod, the *directeur-adjoint*; and five assistants.[182]

The social impact of the Ecole on the historical profession thus remained very slight. Those involved in the work of the school were a handful of disinterested persons. Few historians who had passed the extremely difficult *concours d'agrégation* had the idealism needed for the pursuit of pure learning, for copying the example of Monod, who had turned his back on the good salary he earned as a teacher at the Lycée Henri IV for the meager pay of a *répétiteur* at the Ecole (1,400 francs initially and 2,000 francs at a later stage).[183] Moreover, there were no firm prospects of a permanent appointment.

The mouthpiece of the young Ecole was the *Revue critique d'histoire et de littérature*, founded as early as 1866. In the late sixties it terrorized historians with merciless reviews, many of them based on philological arguments, by the Romanists Gaston Paris and Paul Meyer and the classical historian Charles Morel, all of whom had been taught at German universities. This strategy of murderous reviews was adopted at the end of the 1870s and in the 1880s by the *Revue historique* and in the 1930s by the *Annales*. Clearly, murder by review was a stepping-stone to success.

If we compare the Ecole des hautes études with the Comité des travaux historiques, founded thirty-five years earlier, we are struck by several differences. The Ecole was largely the creation of erudite courtiers; the Comité was more of an independent ministerial creation, though even Guizot worked under the king's

wing. The Ecole provided education for young research workers, something the Comité did not do. The research chosen by the school was largely into non-French history; philology had made its entry as queen among the auxiliary sciences, and in some respects it was even able to take pride of place over history itself. That had not yet happened when Nathalis de Wailly wrote his manual for members of the Comité.

More generally, the influence of "scientism" made itself clearly felt at the Ecole. The sciences were treated as models for the humanities. Later a science section was added to the Comité des travaux historiques. The name of the fourth section then became Sciences philologiques et historiques. The depolarizing effect Guizot had attributed to historiography was now thought to hold for all the *sciences*. Academic research was considered the best sedative for an elite open to political agitation and polarization: "Science, which calms and elevates, that truth whose least fragment is recovered from the past by history, and from the present by the study of the physical world, is worth more than all the world's riches," was the declared opinion of Victor Duruy.[184]

The Conservation of Monuments

As early as the 1840s, during the period of the July Monarchy, the star of Eugène-Emmanuel Viollet-le-Duc, the moving spirit behind the reappraisal of the Gothic style, and a man of enormous energy and great charm, had begun to rise. During the Second Empire he was able, thanks partly to his excellent contacts with Princess Mathilde and the Empress Eugénie, to effect a series of gigantic restorations. In the 1840s he took part in the restoration of the Sainte-Chapelle, started on the restoration of the abbey of Vézelay and of Notre Dame in Paris, and was put in charge of the restoration of the church of Saint-Denis, on which an unsuccessful start had been made at the beginning of the century. Numerous other monuments were also tackled by Viollet-le-Duc: the Saint Sernin in Toulouse, the cathedrals of Reims, Amiens, Clermont-Ferrand, Laon, Meaux, and Châlons-sur-Marne, the fortifications at Carcassonne and Avignon, the enormous castle of Pierrefonds . . . In later years serious reservations were voiced about his views on restoration, views that predominated in the Service des monuments historiques from the 1850s to his death in 1879. Nevertheless, it is generally agreed that the countless drawings and sketches Viollet brought back from his many travels constitute an unrivaled body of documents, which he later collated in two extremely influential *dictionnaires* of architecture and interior design.[185] Admittedly, Viollet-le-Duc can be accused of blindness to the severe beauty of the Romanesque style and of exaggerating the rationalism and functionalism of the Gothic style (a Gothic cathedral, according to Viollet, was as rationally designed as a Greek temple);[186] nevertheless, his refreshing views paved the way for a better understanding of the structural principles of Gothic architecture. His critics' main objections concerned his views on restoration.

Viollet's starting point was that the restoration of a building should not be confined to its maintenance and repair but came down to "restoring it to a

complete state that may never have existed at any given moment."[187] The results, argued those who put a premium on historical accuracy, were "mendacious restorations." Viollet would have done far better, many medieval archeologists felt, to leave the ruins alone rather than produce these tabula rasa reconstructions. For all that, Viollet's conception, no matter how much it flew in the face of the correct historical approach, is not untenable in principle. But more important still for a reassessment of Viollet's work is the fact that if he and his supporters had never appeared on the scene, fewer buildings would have survived. The Second Empire was a period of intensive building in which Paris lost its medieval character through Haussmann's transformations. Admiration for Gothic architecture was still uncommon; in any case, Viollet's vigorous policy saved the Gothic monuments of many French towns, no matter how fancifully neo-Gothic in form.

The funds voted for the conservation of monuments were increased appreciably in the 1840s. In 1860 the sum was nearly twice as much as in 1842—1.1 million francs compared with 600,000, but these figures are misleading.[188] A number of large-scale restorations were funded separately or paid for by the *service de cultes*. In any case, growing amounts of money were allocated for restorations every year. The initiative of the July Monarchy was continued with a will by the Second Empire and later by the Third Republic.

An indication of government activity is found in the number of historical monuments on the official list. In 1840 there were 954, most of them religious monuments dating back to the Middle Ages. By 1875 the list had more than doubled; 1,924 monuments were listed, of which 1,153 were religious and 421 military and civic monuments dating back to the Middle Ages and the Renaissance, 58 were of Celtic origin (dolmens and menhirs), 136 were of Gallo-Roman provenance, and 156 were classified as "miscellaneous."[189] Even though secular considerations had clearly made headway in the preservation of the national heritage, the care for the monumental heritage of Christianity had not suffered as a result.

Court Patronage

In the history of government involvement in the study of history the Second Empire was anything but a blank page. It presided over unequaled growth in the allocation of funds to the most important archive and the largest library in the land and actively encouraged the compilation of inventories. Very special attention was paid to research into Caesar's Gaul, and the Musée des antiquités nationales (dating back to before the monarchy) was opened. The foundation of the Ecole des hautes études by Duruy proved, in the long run, to be at least as important as Guizot's creation of the Comité. Much more was being done than merely continuing along the lines drawn by the July Monarchy.

The emperor's encouragement of historical scholarship did not always take the form of subsidies to the Ministry of Education. State education was hard-pressed for funds in the 1850s; not until the 1860s was there a slight increase

in the allocation. Meanwhile, the imperial court provided most of the funds invested in the study of history either through the emperor himself or through the ministry directly linked to his person (the Maison de l'Empereur or the Ministère d'Etat).

The Orleanist oligarchy had a liking for co-option; the Bonapartist dictatorship favored patronage. The emperor preferred courtiers to academicians, though courtiers could of course be found in the academies. After the death of Minister Fortoul, Mérimée disclosed his plan to dismantle the Ministry of Education: "Would it not be fitting if all scientific and literary establishments fell under the Ministère d'Etat or the Maison d'Empereur? That view was held so firmly during the old monarchy that the Museum of natural history was called 'The King's Garden' and the professors at the Collège de France bore the title of 'The King's Readers.'"[190] According to Mérimée, the "scientific missions," the great library, and the Ecole des chartes all ought to fall more directly under the emperor's authority, much like the Louvre and the Archives Impériales, which were already included in the imperial budget. Mérimée's reference to the system of royal patronage was as explicit as it was revealing.

Sainte-Beuve had similar plans for subsidies to "men of letters." The association of writers deserved imperial support and might perhaps be housed in the Louvre. It was easier to influence, not to say direct, literature if the agency granting the subsidies was controlled by the emperor. If possible, the emperor might attend one of its meetings every year.[191]

The proposals of such men as Mérimée and Sainte-Beuve, not the least among French intellectuals, provided a blueprint of what may be called the court model of state involvement in art and science. These proposals bore witness to capitulation to and collaboration—or less harshly put, to accommodation—with the powers that be. The Ministry of Education was never paid one centime too much, but no costs were too high for the emperor's court. The only way to obtain grants of money under the Bonapartist regime was to apply to the court.

THE SPENDTHRIFT THIRD REPUBLIC

In 1870 the budget of the Ministry of Education was 24 million francs, and by 1910 that figure had risen to 282 million, an increase from 2.8 percent to 13 percent of the general budget. In short, the ministry had turned into a spendthrift department. After the railways, education had become a major item in the budget, and this by the end of the nineteenth century, that is, well before 1905, when the first timid steps were taken to increase social expenditure with the introduction of social benefit payments, which added fresh fuel to the budget debates. Slowly but steadily the state extended the range of its activities. The number of civil servants kept rising, especially in the education sector. There was a constant stream of indignant protests; railing against the "spending orgy" of the Third Republic became a liberal pastime. The main blame was said to

attach to parliamentary democracy. In the mid–nineteenth century the republican system had still been upheld as one of careful husbandry, patently opposed to the waste of public money. Virulent antifiscal sentiments were put into play. The Republic was said to be cheap; there was no upkeep of stables, no lackeys in expensive livery, no fancy mistresses, no featherbrains and wastrels. "In peacetime the taxes levied by a Republic should not amount to one-tenth of the royal taxes," wrote *L'Ami du Peuple* on 19 March 1848.[192] But not in the Third Republic, which, according to a liberal commentator on the budget, was a "continuous incitement to spend money, a drain on the economy."[193] This was only to be expected, the political system being what it was. Safeguarding privileges and making promises was the best way for a candidate to succeed; conversely, the electors gave their votes to those candidates they felt would best dance to their tune. The electorate would "rather obtain preferential treatment, pensions, favors of every kind, than have the public purse properly controlled."[194] This attitude was said to be the direct result of the fact that in the Republic the "educated and propertied classes" had been stripped of their influence by the "multitude." But no matter what the opponents of the Republic may have felt, the growth of the education budget seemed unstoppable. It was the inevitable consequence of a deliberate education policy.

Republicans have never ceased extolling their achievements in the sphere of education, but recent studies have cast doubt on this interpretation and have shown the achievements of Jules Ferry and his colleagues in a less exaggerated perspective (see below). That was a useful reaction, and one, moreover, that highlighted Ferry's real achievements. Genuine progress had been made in three areas: compulsory education, education in remote villages, and education for girls. Ferry built on the old system; he did not create elementary education out of a vacuum, as the republican catechism alleged. But no matter what the effect may have been on the scope of education (hardly any research into the qualitative aspects of education has yet been done), there can be no doubt about the increased costs. As education spread, it probably improved slightly; what is certain, in any case, is that it became much more expensive.

It is possible to break down the absolute and relative increases in the cost of education during specific periods, but that is not our concern here.[195] Suffice it to say that the steepest relative increase occurred in the 1880s (from 4.6% in 1880 to 10% in 1890). The great education laws had far-reaching financial repercussions. What was important was (and this factor might give rise to misunderstandings about the total cost of education) that in 1881 a majority in the Chamber demanded that henceforth elementary education be financed predominantly out of the *national* budget and that local educational subsidies based on contributions by the municipalities be reduced. The political motive was clear: the antirepublican influences in the regions had to be curtailed. The laws of free (14 June 1881) and compulsory education (28 March 1882) were followed by a law governing the organization of education (30 October 1886); in July 1889 the Senate laid down a pay structure for elementary teachers. A seasoned republican like Emile Combes knew only too well that the "republican idea" was not

TABLE 12

Absolute and Relative Costs of Elementary, Secondary, and Higher Education as
Reflected in the National Education Budget, 1870–1910 (in millions of francs)

Year	Total Budget	Elementary		Secondary		faculties	
		Amount	%	Amount	%	Amount	%
1870	24	10.0[a]	41.7	3.7	15.4	4.2	17.5
1880	57	30.1	52.8	8.7	15.3	8.8	15.4
1890	137	86.1	62.8	17.7	12.9	11.4	8.3
1900	208	145.5	69.9	22.9	11.0	12.7	6.1
1910	282	208.4	73.9	31.6	11.2	14.8	5.2

Sources: Annual budgets in BN 4° Lf[56] 8, vol. 3.
[a]Plus 10 million francs "for expenditure on special resources."

enough to bind teachers to the regime; he thought it was a pipe dream to rely
exclusively on sentiment. "The peaceful army waging war on ignorance . . .
pursuing it to the lowliest villages . . . has to be paid." Still using the martial
metaphor, he went on to propound this bit of wisdom: "Money is the sinews of
war."[196] That was republican policy, and it did not come cheap. In the budget,
salaries for teachers rose from 50 million francs in 1889 to 108 million in 1891;
the increase slowed down in the 1890s. However, with the Republic of the
radicals came new wage rounds and a new education law (1903). The most
important item in the education budget, namely, the salaries of teachers in
places with less than 150,000 inhabitants, stood at 123 million francs in 1900
and rose to 180 million in 1910.[197]

Compared with the cost of primary education, the cost of secondary educa-
tion was small, and that of higher education smaller still (see table 12). In table
12 the absolute amounts and the relative percentages are placed side by side.
The table clearly reflects the educational preoccupations of the Third Republic.
The rapid increase in the education budget was very largely the result of the
growing costs of elementary education. The rise in the cost of secondary educa-
tion after forty years of republican rule was appreciable (+754%), as was that
of the faculties (+252%), but both were overshadowed by the rise in the cost
of primary education (+1,984%). In political terms, this was an understand-
able development, and one in keeping with republican ideals. More than 95
percent of all children below the age of eleven were in elementary schools
(approximately 6 million boys and girls at the start of the twentieth century).
Secondary state schools were attended by at most 5 percent of all boys between
the ages of 11 and 17 (110,000 pupils in 1910) and by an even lower percent-
age of girls. The faculties taught fewer than 2 percent of male students between
the ages of 19 and 24 (more than 41,000 male students in 1910–11). Here too
the number of female students was still very small, although it was increasing
perceptibly (with nearly 4,000 in 1910–11).[198] In a democracy, where the num-
ber of votes counts, it was not surprising to find that the largest investments
were being made at the bottom of the pyramid, benefiting the greatest number

of electors. That too was in keeping with the republican ideal; moreover, it attracted the largest number of votes.

Preferential Treatment of the Faculties

Although the rise in expenditure on the faculties paled before the costs of elementary and, to a lesser extent, of secondary, education, the allocation of funds to the faculties rose appreciably. Indeed, when the sums involved are compared with the allocation to other institutions of higher learning and research, the faculties seem to have come off best by far. It is therefore permissible to speak, after the "academic" model of the July Monarchy and the court patronage system of the Second Empire, of the "facultative" model of the Third Republic.

In the 1870s the increase in expenditure on the faculties was at its maximum (+4.6 million francs); no comparable increase was recorded again before the First World War. In the 1880s the growth was much less marked but still appreciable (+2.6 million), and in the 1890s it was smallest (+1.3 million francs). During the first decade of the twentieth century expenditures increased again, by 2.1 million francs, appreciably less, that is, than the increases in the 1870s and 1880s.[199]

Table 13 places the increases in the faculty subsidies in relief by comparing them with those of other institutions of higher education and research after forty years of republican rule. Many of the figures in the table do not, of course, represent only the study of history. In 1910 the arts faculties received less than 1.5 million francs out of the total allocated to all the faculties, and within the arts faculties less than a quarter of the allocation was set aside for the study of history.

The greatest increase in funds allocated to the Collège de France occurred in the 1870s (from 280,000 francs in 1870 to 458,000 in 1880). During that decade the number of chairs was increased from thirty to thirty-eight, and a professor's pay was raised from 7,500 to 10,000 francs. In the 1880s two new chairs were added (in the history of religion and the history of economic doctrines), and two more were added in the 1890s (in the history of science and social philosophy). In 1910 there were 43 distinct teaching appointments: 17 in languages and literature, 13 in science, 3 in philosophy, 2 in law and economics, 3 in epigraphy and archeology, and 5 in history.[200] The Collège de France did not have permanent chairs. Whenever a new chair was about to be established, the first step was to decide on its name, and only then were potential candidates discussed. In practice of course those making the appointment did have a particular candidate in mind, but the system was more flexible and more accurately reflected the development of academic concerns than did the system of teaching appointments used in the faculties.

The Ecole française d'Athènes had an archeological and epigraphic rather than a historical bias. Its "scientific era" did not dawn until after 1870, when it ceased to be an extension of the Ecole normale and became an independent center for epigraphic and archeological studies.[201] People accustomed to the ele-

TABLE 13

State Allocations of Funds to Various Higher-Education and Research Institutions, 1870 and 1910 (in thousands of francs)

Institution	1870	1910	% Change
Faculties	4,425	14,813	+249
Collège de France	280	583	+108
Ecole française d'Athènes	64	118	+84
Comité des travaux historiques	120	203	+69
Ecole des chartes	47	76	+62
Bibliothèque Nationale[a]	496	744	+50
Archives Nationales	184	226	+23
Ecole des hautes études	300[b]	353	+18
Institut de France	661	697	+5
Public libraries in Paris[c]	209	211	+1
Ecole normale supérieure	308	273	−11
Ecole française de Rome[d]		72	
Institut français d'archéologie orientale (Cairo)[d]		108	

Source: BN 4° Lf[156], vol. 3.

Note: Note included are the "missions scientifiques" because many allocations to them were ad hoc allocations.

[a] In addition to special credits for the compilation of catalogues
[b] Taken from the 1875 figures
[c] Mazarine, Arsenal, and Sainte Geneviève
[d] Not existent in 1870

gant reports of *normaliens* were disappointed with the dry-as-dust new catalogues of inscriptions. This reorientation may have made the school more "scientific," but its tenor also became more nationalistic. The rival had meanwhile changed. After the "English challenge" it was now the turn of the "German challenge," which had to be warded off with a fat corpus of "antiquities." The school remained a purely archeological institute.

In 1874 a special French House was opened in Rome. After a time it ceased to concentrate exclusively on archeology and expanded its activities to include art history and research into the papal archives. Here too rivalry between the great powers was the motive force, as it had been during the early years of the school in Athens. The great strategist behind this counteroffensive in the wake of the French defeat of 1870—in which scholarship was the continuation of war by other means—was Albert Dumont, the future director of higher education.[202]

The increase in the allocation to the Comité, which received 50,000 francs annually beginning in 1903, was largely due to a special commission charged with looking into the publication of documents relating to the economic history of the Revolution. Over the same forty years of republican rule the rise in the allocation to the two giants in the field of preservation, namely the Bibliothèque Nationale and the Archives Nationales, was modest, that to the Bibliothèque

Nationale, moreover, being clearly effected at the expense of the other three Parisian libraries.

From a financial point of view, the Institut de France made little progress during this time. Its allocation did not increase significantly, and its relative position on the financial scale became less and less significant (shrinking from more than 2.5% of the total education budget in 1870 to less than 0.25% in 1910). The AIBL, which accounted for roughly one-fifth of this budget, provided no exception to what was in fact a general decline. In 1893 Arbois de Jubainville drew a sorry picture of the work published by that body.[203] Of the five series in folio format devoted to the Middle Ages and to classical antiquity, two had been suspended, and among the remaining three only one volume had been published in ten years. The French shortfall was in striking contrast to the brisk activity at the universities of Berlin and Vienna. This embarrassing revelation of academic inertia, or at least of inefficient and unproductive academic methods, at the beginning of the 1890s acted as a spur to a new effort. The *Recueil des Historiens* was started afresh, and from 1899 to 1910 eight volumes of this series were published.[204] In 1908–9 two volumes of the new series *Chartes et diplômes* appeared, and a handy new series of art-historical and archeological studies, the so-called *Fondation Piot*, was also brought out, eighteen volumes of which were published in 1894–1910. These were followed by the series *Notices et extraits des manuscrits* and *Historiens des Croisades*. Volume 33 of the *Histoire littéraire* was published in 1906. Apart from these serial works, there were of course the usual run of annual reports and proceedings.

The importance of the AIBL, incidentally, was greater in the narrow field of historical research than its relatively shriveled finances and the decline in the number of publications during several periods might suggest. Money and printed output are not everything; in the world of scholars the AIBL was a kind of supreme court bestowing honors, giving prizes, and, moreover, exerting considerable influence on appointments to the Collège de France. It was a peak to be looked up to. Being elected to the AIBL was the crown of a scholar's career. However, the Académie never developed into an academic workshop, several model publications notwithstanding.

The allocation to the Ecole des hautes etudes calls for a marginal note. The total allocation to its five sections (a fifth section, religious studies, having been added in 1885) had not risen very greatly since 1875, but the allocation to the fourth section had been more than quadrupled (from 30,000 to 123,000 francs).[205] The fourth section was obviously the darling of the Third Republic during this period, much as the sixth section (economic and social science) would become a showpiece after the Second World War under the Fourth and Fifth Republics. The percentage increase in the allocation to the fourth section was therefore greater than that to any other institution listed in table 13. With its increase of 301 percent, it was also the most highly favored section within an institution that did not otherwise expand appreciably. In the fourth section, by the way, the position of philologists was much stronger than that of historians. In 1896 the history division was made up of Monod, as director, and five

assistants, which was roughly the same number as in about 1880. After the Second World War the place of historians in the sixth section was to become much more powerful than it was in the fourth section.

The only real loser was the Ecole normale supérieure, which had always had an arts section and a science section. The former was the larger of the two, but even there history teachers were far outnumbered by teachers of philology, literature, and philosophy. The dismantling of the Ecole normale was part of a deliberate "anti-elitist" policy in higher education at the beginning of the twentieth century, which saw a more egalitarian faculty model and the abolition of special schools as the ideal. The Ecole normale had to be absorbed into the Parisian faculties. After cherishing it (in 1890 its allocation had been increased to 514,000 francs, more than that of the Collège de France), the republican regime decided, at about the turn of the century, to put an end to the independence of a school that was much more popular with students than was the arts faculty.[206] Most lecturers were absorbed into the staff of the arts faculty, and the Ecole normale continued to serve as a boarding school for outstanding students, who had always been able to study at the state's expense. The number of lectures at the Ecole normale was severely cut.

The continued existence of the Ecole des chartes came under threat as well.[207] Voices were raised demanding that this school too be absorbed by the faculty. However, the school was able to resist such "faculty imperialism" and even to have its allocation of state funds significantly increased.

The Conservative versus the Progressive Option

Behind the rise of faculties (and especially of arts and science faculties), a rise that made so large a claim on the state contribution to higher education and research, there hid conservative as well as progressive political ideals.[208] A kind of monster alliance had been forged to foster the growth of the faculties, which explains why in the 1870s, when power was still largely in conservative hands, the increase in the allocation to the faculties was much greater than in the 1880s, when the Republic was run by genuine republicans. These, incidentally, were quickly overtaken by more radical republicans on the left and decried as rank opportunists.

The conservative motive behind the wish to reform the faculties was sharply brought home by Ernest Renan's pamphlet *La Réforme intellectuelle et morale de la France* (1871). This was a rallying call against democracy after the traumatic experiences of France's defeat by Germany and of the Commune. "Birth takes precedence over election . . . the whim of birth is smaller than the whim of the ballot box" was Renan's expressed opinion after the experiences with universal (male) suffrage and the plebiscites of Napoleon III.[209] He and many conservatives advocated the creation of universities by the fusion of reformed and expanded faculties, as seats of learning fit for aristocrats. Within that elite the influence of the church must, however, be stemmed. Free thought was paramount; religion must not be allowed to stand in the way of learning. This

anticlerical conservatism, incidentally, was selective. The church could and should, of course, continue to teach and uplift the masses; indeed, that was good for social peace and order: "Let us preserve religious education for the people, but we ourselves must be free" (149). The antipathy of French conservative circles to the growth of higher education was incomprehensible to Renan—were the German universities not bulwarks of an aristocratic, reactionary, almost feudal spirit? (155)

Ideas like Renan's were widespread during the first decades of the Third Republic. Social conservatism and academic free thought went hand in hand when it came to "shaping a rationalist spirit in the universities, ruling through science, proud of that science and reluctant to allow privilege to perish for the sake of the ignorant crowd" (159). The influence of Auguste Comte's positivism on this social utopia was marked. The leading place of philosophers in Plato's system had been taken by scientists in Comte's. Could society possibly gain greater freedom as a result? Every age produces its own enemies of the open society, and these enemies adopt different guises according to the changed social conditions and ideas. The belief shared by Renan, Taine, and other "great thinkers" was that "science" would lead society to order and calm. There were no links between science and popular rule: "Rationalism does not lead to democracy."[210]

But alongside this conservative motive a progressive approach also lurked behind the policy of faculty building. At the end of the 1870s and the beginning of the 1880s, when the Republic became increasingly republican, the conservative motive had ceased to be opportune and was even frowned upon by an increasingly left-wing Chamber. It now had to be made clear that democracy, in particular, had much to gain from flourishing faculties. For greater effect, the French Revolution was dragged in, whenever possible, to justify their growing importance. That took some intellectual juggling, since universities had been privileged clerical corporations under the ancien régime. But where there is a will there is a way. The *Revue internationale de l'enseignement*, from 1881 the official organ of the influential pressure group behind the reforms (the Société de l'enseignement supérieur, of which Pasteur was the president and Ernest Lavisse the secretary), was packed with references to the Enlightenment and the Revolution. It ran a column, the "Revue Rétrospective," in which pronouncements on education by d'Alembert, Diderot, and others were regularly printed.[211]

The key figures behind the associated increases in state allocations were the successive directors of higher education, who were wont to remain at their post for a long time, in any case much longer than the ministers of education. From 1870 to 1890 France had twelve different such ministers in sixteen different cabinets. By contrast, there were just three directors of higher education from 1868 to 1902, and it was such men that ensured continuity. From 1868 to 1879 the post was held by Armand Dumesnil, who had started his career as a clerk in the Ministry of Education in 1838, at the age of nineteen.[212] Duruy appointed him director, and he braved many a political storm. Dumesnil was no great scholar, but he did write good reports and drew up useful plans, and

under him the state allocation for higher education and research rose more steeply than ever before. In July 1879 he was kicked upstairs by Ferry and replaced by the able Albert Dumont.[213] When the latter died suddenly in 1884, at the age of forty-two, he was succeeded by the influential Louis Liard, who remained at this post until 1902.[214] It was Liard, formerly a professor of philosophy, who enshrined the democratic-republican view of French higher education in a work running to two volumes.

Liard's attitude was typical of the progressive approach to university reform. Poor Dumesnil, under whose leadership education had made the largest financial strides, came off worst in Liard's view of things. Albert Dumont, to whom Liard respectfully dedicated his work, was said to be a democrat "after a fashion, that is, a very elevated and highly philosophical fashion."[215] Dumont was in fact a key figure in the transition from the conservative to the progressive approach.

Originally an epigrapher with works of great scholarly precision to his credit, Dumont was undoubtedly a man of vision and of diplomatic and administrative talents. He was the founder of the Ecole française de Rome and reorganized the Ecole française d'Athènes. This elegant man may not have looked like a run-of-the-mill democrat, but he nevertheless proclaimed the view that particularly in a democracy higher education was a necessity. That was because traditional ideas kept losing their hold and public opinion had therefore to be remolded: "An elite elaborates ideas, the masses then live by them, breathing them in like the air around them." Moreover, higher education was an essential means of shoring up elementary and secondary education: "The elementary-school pupil is a worker, the secondary-school pupil a foreman, the high-school student creates and invents." And, Dumont added significantly, bearing France's shameful defeat in mind, "A nation of workers and foremen is soon beaten by one of inventors."[216] A democracy must have education as its main pillar, and a (meritocratic) elite was indispensable to its educational system. Faculties had to serve as laboratories for learning, ideas, and morals reserved for the elite. Dumont's tone was noticeably much less conservative than Renan's and Taine's but not yet as openly democratic-republican as Liard's. For Liard, the reform of the faculties and of higher education in general was simply the implementation of the ideas of 1794 and 1795.[217] After 1795, he claimed, the organization of higher learning had been frozen save in some minor respects. By contrast, he identified the Revolution, the Republic, and democracy with higher education and the pursuit of knowledge. Whatever truth there may have been in that, it was certainly the language to use if one wanted to lay one's hands on state funds. And respectable though Liard's contribution may have been in legislative and substantive respects—though it did not meet the high expectations it had aroused[218]—in purely financial terms the 1870s must be considered the most successful decade not merely in percentage increases but also in absolute figures.[219] To record this fact is not only a tribute to the forgotten Dumesnil; it also helps us to arrive at a proper assessment of the work of the "Republic of the republicans" after 1879, when the Senate also gained a republican majority and Jules Grévy became the first republican president.

A New View of Higher Learning

Whatever the progressive or conservative approach to faculty reforms may have been, the reforms themselves unquestionably bear witness to a new conception of higher learning. The idea that education and research had to be combined won ground. According to the traditional view, clearly expressed by Duruy, there was a division between research and education, between "those capable of making discoveries in science and of producing enduring work in the arts" and others, especially university professors, whose task it was to expound on the resulting masterpieces. The reformers were anxious to abolish this distinction. Albert Dumont, for one, was perfectly clear on this point; his central theme was the organization and continuity of academic studies.

Collective research, the division of labor, and specialization were not typical of French scholarship, in contrast to what was happening in Germany. Dumont, and others like him, envisaged an accumulation of detailed studies by a "mass" of highly organized and well-trained investigators. The weakness of French scholarship lay not in a lack of genius but in the poor organization, deployment, and training of the academic foot soldiers. "The French master far too often revels in his solitary glory."[220] People had become disenchanted with fitful academic methods, with leaping from one genius to the next at random, without preparation, without a clear line. Instead they had come to believe in the extension of academic learning and in the idea that its future would be the more predictable and regular the closer one kept to the "correct method" and the better organized one was. This approach might be called the rationalization of academic pursuits, a demystification of the process of scholarly progress, with all the limitations, advantages, and disadvantages that entailed. The new conception of scholarship was to have considerable repercussions on the new type of professor and on the pursuit of historical studies at the universities (see chapters 5 and 6).

This new conception went hand in hand with the "philologization" of academic pursuits. Philology became the "master science." "The weakness of philology . . . explains all the shortcomings of French higher learning," Dumont wrote in 1874. If one does not know a language, one cannot possibly study the original documents written in it, and that was the cause of a host of errors: "You cannot have recourse to the manuscripts, you do not verify the texts you quote, you neglect the rules of exactitude and precision that are incumbent on every scholar."[221] Dumont was not the only one to believe that French scholarship was in need of a philological catharsis before important advances could be made in the historical and social sciences.

Government Support for the Study of the Revolution

Much as the July Monarchy extolled the rise of the third estate and the Second Empire stimulated the study of Roman Gaul, so the Third Republic, which became genuinely republican in about 1880, paid special attention to the history of the French Revolution. The ideological reasons and the legitimizing

function of this approach were self-evident. For the first time, the French Revolution was the object of nationally funded research; it had become a source of inspiration for the authorities and deserved being written up in shining letters.

The republicans' affinity with the educational program of the Legislative Assembly, and of the Convention in particular, led to a call for a source publication covering the educational program of the Revolution. On the urgings of Ferdinand Buisson, a committee was set up in 1881 and later incorporated into the Comité des travaux historiques et scientifiques for the specific purpose of researching and issuing unpublished documents on the subject of public education from 1789 to 1808. In 1882 Jules Ferry, the minister of education, urged the Comité to do more work on the period after 1789. The study of the Revolution was delegated to the social and economic sciences section of the Comité, because, so the argument went, it was important to study the period after 1789 "from a point of view different from the strictly historical one"; to focus attention on "those factors which in the past had had a special effect on the economic and moral life, and on the law and the institutions of France."[222] At first very little happened, but after 1885, with the celebration of the centenary of the Revolution in view, the Comité became a hive of activity in a determined drive aimed at the "investigation and publication of documents about the Revolution of 1789." Fifty volumes appeared from 1889 to 1918.[223] Nearly half of them (22) were devoted to the publication of the *Actes du Comité du Salut publique*. The series was edited by Alphonse Aulard, who occupied the special chair for the study of the Revolution founded in 1885 by the city council of Paris. J. Guillaume, the secretary of the Comité, published one volume containing the reports of the education committee of the Legislative Assembly and six volumes of reports by the Convention.[224] At the same time six volumes of Carnot's correspondence and another four of letters by Madame Roland appeared. Most of these were mainly politically inspired historical source publications by a committee that, ironically, fell under the social and economic sciences section (until 1913). Within that section, incidentally, some work on economic history was in fact done: in 1894–1912 G. d'Avenel published the *Histoire économique de la propriété, des salaires, des denrées et tous les prix en général depuis l'an 1200 jusqu'à l'an 1800*, a gigantic work in six volumes, long since completely superseded. But by the end of the nineteenth century the turn of the economic history of the Revolution had not yet come, as Jean Jaurès discovered when he wrote his *Histoire socialiste de la Révolution*.

With the radicals holding power in the Bloc républicain, the Chamber decided on 27 November 1903, at Jaurès's instigation, to vote 50,000 francs to a committee with the special task of preparing the publication of "archival documents relating to the economic life of the French Revolution." The man in charge was the ubiquitous Aulard, who patronized Revolution studies much as Thierry had fostered studies of the third estate during the July Monarchy. Aulard's powerful position naturally aroused fierce opposition (as had Thierry's), with good reason, but no one could deny that Aulard was an efficient and hardworking man. The enterprise turned into an organized collective venture in a

specific historical field. Strict instructions were issued to streamline the opera-
tions and to standardize the procedure. The Paris committee wanted to see
committees set up in every department, staffed by an inspector of education,
the departmental archivist, and other qualified persons, who were to keep in
touch with Paris while doing research and making suggestions about future
publications. This succeeded better in some departments than in others. A bul-
letin was published from 1906 on. In 1913 a general meeting was held in Paris
at which all active departmental committees were represented. The *Collection de
documents inédits sur l'histoire économique de la Révolution française* turned into a
most impressive series, and what is more, it did so in record time. In the eleven
years from 1903 to 1914 more than fifty volumes were published, including
many *cahiers de doléance* but also decrees on the sale of property, on the care of
the poor, on agrarian problems, and so on.[225]

During the "Combist" period (1902–5) a network of provincial correspond-
ents was set up to study the economic history of the Revolution. With the
financial backing of the government it was possible to bring out a large number
of publications, which, needless to say, were received with very mixed feelings
by Catholic and conservative historians. It looked very much as if, with the
collaboration of the education inspectorate and directors of the departmental
archives, the fourth estate was being mobilized to revive the revolutionary pe-
riod officially, for purposes of reflection and remembrance. Could this not be
viewed as a parallel to the policy of Guizot, Salvandy, and other Orleanist min-
isters of galvanizing the third Estate, to which only the notables and the upper
middle class were thought to belong, with the help of local societies? One great
difference, however, from conditions in the July Monarchy was that at the be-
ginning of the twentieth century a respectable network of expert departmental
archivists had spread to all parts of France. Whereas Guizot and his staff had
been forced to wallow in the departmental mud, Aulard and his collaborators
could follow an orderly path through the archival material.

Cataloguing the Archives of the Revolution

The ministerial circular of 11 November 1874 called for an inventory of the
series L and Q (covering the period of the Revolution).[226] Of course a minister
can demand a great deal, and the staff, most of whom had been expertly trained
at the Ecole des chartes, seemed ready to tackle the task. Eugène de Rozière
played an important part, both as general inspector of departmental archives
and also as a member of the Conseil de perfectionnement of the Ecole des
Chartes, in getting the period of the Revolution included in the sphere of the
archivist and the *chartiste*. That took some diplomacy, for the subject was still of
burning topical interest—the grandchildren, if not the children, of the guillo-
tiners and the guillotined still faced one another. Being immersed in the study
of the Revolution inevitably meant being assigned to one or the other of the two
camps. Even so, some people tried to pursue the study of the Revolution under
the banner of "hard" epistemological positivism (which is not necessarily the

same thing as ideological positivism, the latter being more closely bound up with free thought).

What was demanded was the study of "revolutionary facts susceptible to treatment by documents" without "preconceived opinions shaped in advance by sentiment, rancur, or self-interest."[227] Not doctrines but unbiased explanations were needed. Rozière was successful; even the cautious Ecole des chartes extended its course on institutional history to the "year VIII." Second-year students were henceforth examined on the revolutionary institutions, and in 1892 the first thesis on the subject was presented at the Ecole des chartes. By then the whole issue had been settled, although the insatiable Aulard was far from satisfied with the attention *chartistes* were paying the Revolution.[228] In the opinion of many provincial conservatives, on the other hand, they were spending much too much time on it. When Augustin Cochin did his research in the provinces, he came up against the usual suspicions, especially in Brittany; being a Parisian *chartiste*, he was mistaken for a radical. Within a few days, however, he was able to gain the confidence of the locals, and then he was showered with complaints about members of the Bloc républicain and the excesses of "Combism." Conservative circles in the provinces were on their guard. The progovernment Aulard and his men had stooges everywhere, generally some *fonctionnaire* or another, even in Brittany, as Cochin himself observed. "Even here there is a teacher at the *lycée* with a finger in my pie," he wrote irately in September 1905.[229]

Encouragement by the Paris City Council

This is not the place to examine the influence of local authorities in general, that is, of departments and municipalities, on the study of history, an extensive and patchy field that merits detailed examination. On the whole, though, this influence did not extend beyond the local boundaries except in Paris, especially when it came to the study of the French Revolution. From the middle of the 1880s to the end of the nineteenth century the Paris city council was radical; most of its members were more left-wing than the central government. To encourage the study of the Revolution, Paris lavished money on commemorations, statues, monuments, source publications, and even a full university professorship. The effects of such financial support went far beyond the field of local history and made themselves felt at the national level.

Republicans felt outraged by the fact that statues of kings and emperors could be found all over Paris but the great pioneers of the Revolution and the "founding fathers of liberty" had not been thus immortalized. In 1879 it was decided to hold a competition for the design of statues to Etienne Marcel and Voltaire. Rousseau followed in 1882, Diderot in 1884, and in 1886, with the centenary of the Revolution not far away, there was an extensive plan for a large monument to the Revolution in the Tuileries, between the Pavillon de Flore and the Pavillon de Marsan, on the remains of the royal palace. The strength of the Republic did not, of course, depend on the impact of architectural design: what

mattered was the celebration of the courage and the good sense of the *citoyens*. It was important to "make a striking appeal to popular emotion, to kindle fruitful enthusiasm," and to provide a permanent reminder to the nation, on a symbolic site, of the final victory of the Republic over the monarchy. The monumental building would have to house a museum and a library of writings on the Revolution: "It will be a holy shrine, the very heart, the enduring conscience of 1789 in external and plastic form." The Revolution needed a sanctuary, a temple. Education was not enough. The hope was to elicit an international response, an inflow of "precious souvenirs" from abroad—"so many votive offerings to this altar of the unknown god born in our midst and continuing to grow for the good of the human race."[230]

Emotions ran high when, in 1887, the city council was presented with a motion that the *chapelle expiatoire* put up during the Restoration in expiation of the murder of Louis XVI be dismantled and a statue to Danton erected in its place. Some members thought this was no more than the due of a man credited (at a time when France was under attack by foreign monarchs) with having inspired the popular masses of Paris with the words "Let's fling them a royal head as a challenge." That may have been a rather tasteless remark, but then passions had been inflamed. On the left too voices were raised against this "statuomania"; would it not be far better to spend all that money on bread for the poor? In the event, the *chapelle expiatoire* remained intact and Danton was given a place on the carrefour de l'Odéon, to the echo of violent protest.[231]

The parliamentary decision in 1880 to declare the Quatorze Juillet a national holiday struck dyed-in-the-wool radical republicans as a tasteless compromise. In their view, 10 August 1792 ought to have been declared the spring festival of the Republic—had it not been celebrated as early as 1793 in honor of the unity and indivisibility of the Republic? Had not Consul Bonaparte banned this celebration in 1800 because he was opposed to a "national feast reminding the people that they could be masters whenever they chose"? The tenth of August stood not only for the victory of the people but also for the salvation of France: "The victory of the little man, of the poor, of those who clung closest to *la patrie* because they had no other possessions."[232] A proletarian owned nothing but his country! At the beginning of 1892 the sum of 200,000 francs was requested for this centenary, supported by petitions from democratic-radical and social-radical committees.

The dramatics and the semireligious fervor notwithstanding, the Paris city council did a great deal to foster a more objective historical study of the Revolution, especially in 1885–1900, not least through an impressive series of publication and the founding of a university chair. Forty-five volumes in the *Collection rouge (de documents relatifs à l'histoire de Paris pendant la Révolution française)* came out in 1888–1914, including six volumes by Aulard on the Club des Jacobins, five volumes on the "public spirit" of Paris during the Thermidor reaction and the Directory, also edited by Aulard, and sixteen monumental volumes of *Actes de la Commune de Paris*, edited by Sigismund Lacroix.[233] Yet another series, also published at municipal expense, included the great bibli-

ography of Paris during the Revolution by Maurice Tourneux (5 vols., 1890–1913) and the impressive annotated list of written sources on the Revolution in Paris by Alexandre Tuetey (11 vols., 1890–1914).[234]

The objectives of these publications were clearly set out in a program presented in the form of a thesis in 1887. The aim was not to provide a general history of the Revolution, a chronicle of events, or a "picturesque history of customs and arts, of life in the street and of the domestic hearth," which were the province of commercially viable historical works attractive enough to authors, publishers, and readers not to need outside assistance. The publications sponsored by the authorities took a more profound look at the Revolution, that is, at the "efforts made by the representatives of the people of Paris to establish a new regime based on liberty and equality."[235] In other words, these publications were political first and foremost. The time under review was relatively brief, usually confined to the years 1789–95. But what the authors provided was decidedly not a list of events; their concern was not with (political) incidents but with state policy, with government plans and their implementation, and with the executive personnel. The aim was to commemorate and to provide inspiration for contemporary representatives and executive staff of the Third Republic. The Revolution was studied from an institutional angle, from the angle of turbulent assembly halls and dusty offices (in this case in Paris), though political subjects were by no means the only ones to which attention was paid. It was an essential characteristic of the Republic that a number of areas previously considered to be private, such as education and relief for the poor, were taken under the wing of the state. There was an essential difference between this approach and the more liberally inspired "academic" study of history, which was more elitist and aimed exclusively at the top of the political pyramid. In a Republic with universal (manhood) suffrage it was essential to enjoy the support of the majority of *citoyens*. That explains why republican historiography was more democratic than the "academic" variety and why (through the political institutions) it was interested in the nation as a whole.

Another investment by the city council in the study of the Revolution was the abovementioned creation in the Paris arts faculty of a chair in the history of the Revolution. Several reforms had helped to increase the independence of the faculty and to empower the city council to spend money on the creation of new chairs. Alphonse Aulard was invited to lecture on the Revolution at an annual salary of 12,000 francs. Until then he had been a teacher at the Lycée Janson de Sailly in Paris, having previously held several posts at provincial universities. Under the pseudonym Santhonax, he also wrote a weekly column, "Les Lundis révolutionnaires," in *La Justice*, Clemenceau's paper. Aulard, who was a member of the Radical Party, had not been trained at a German university (which rather endeared him to Jacobin circles) and was more of a literary than a historical scholar. He had taken his doctorate with a thesis on Leopardi and also used a literary approach to the Revolution—which was still more or less taboo at the faculties—in writings on parliamentary eloquence and on the orators in the Constituent Assembly.

The decision by the Paris city council to fund a new chair and Aulard's

inaugural address in March 1886 caused a furor.[236] All colors of the political spectrum were involved. The reactions ranged from personal abuse and hostility in *Le Gaulois*, *Le Moniteur* ("Tell me who pays you?"), and *Le Figaro*, to polite doubts about the intentions of his financial backers in the *Journal des débats* and approval in *La Justice* and *Rappel*, to derision by the extreme Left in *La France libre*. Aulard's left-wing critics thought the creation of a chair was an excellent idea, but after they heard Aulard they feared that administrative routine had already gained the upper hand. Aulard was accused of having written no more than a dull bibliography, of having attacked Michelet and Louis Blanc ("dry as dust"), of having "scalped" the Revolution, of having undressed her the better to dish her up "in documentary form." "Documentary! We know that refrain. It is fashionable. It is equally pleasing to the incompetent and to the able, to contemporary double dealing. . . . Documents as such . . . are easy science, petty science, science without a conscience."[237] That was sonorously put and partly true. It was a prelude to the criticism voiced at the end of the century by Charles Péguy and later by Lucien Febvre against the cult of documents, but it was unfair to the often useful and sometimes astute contributions of the publishers of source material. It goes without saying that their work, however helpful, must yield pride of place to original historical research, but during this phase in the study of the Revolution that work was of essential importance. Despite all the sharp differences in the 1880s between the "opportunists" in the government of the Republic and the "radicals" in the Paris city council, both were agreed on one thing: the best way to celebrate the centenary of the Revolution was "to dispel the legends, to reestablish the historical truth by drawing it from the sources,"[238], and that meant publishing the authentic words and deeds of the men of the Revolution. Aulard himself, incidentally, did much more than merely publish source material. The publications he launched with the help of assistants who enjoyed many facilities (but did not always set to work with sufficient care) were only a part of his many activities.

In 1891 the government endorsed the initiative of the city council and Aulard's chair was given the seal of national approval. That ensured its continued existence—the bright red color of the city council was beginning to fade, and who knew what might have happened to Aulard's 12,000 francs. In 1902 the municipal subsidy of 5,000 francs per annum to Aulard's journal, *La Révolution française*, was withdrawn; after that the subsidy was provided by the Ministry of Education.[239]

As for the source publications, it must be pointed out that the city council took no fresh initiatives after 1900, though it did publish sequels to the current projects. After the First World War, however, it called a definite halt to its subsidies for the study of the Revolution.

CONCLUSIONS

How did government subsidies affect the number of paid jobs in the study of history from the Restoration to the First World War? It is impossible to give a

TABLE 14

Estimated number of Professional Historians in Public Service in 1910

Profession	No. of Historians		
	Total	*Paris*	*Provinces*
Higher education (history)	120	80	40
Secondary education (history)	620	50	570
Archives	150	50	100
Libraries	120	70	50
Museums	35	25	10
Total	1,045	275	770

Note: The estimates for higher history education are equivalent to one-third of all arts posts at faculties, the Collège de France, the Ecole pratique des hautes études, and the Ecole des chartes. On secondary history education see chapter 3. the estimates for archives are based on figures for the Archives Nationales, various ministry archives, the archive inspectorate, departmental archives, and several large municipal archives. The estimates for libraries are equivalent to one-third of the total library posts (in Paris far from all of them were historians). Museum posts (except at the Louvre) were still very small in number, and then only in a few large towns outside Paris.

precise answer because unspecified numbers of persons were working as professional historians in a variety of institutions. For that reason the figures in table 14 are based partly on estimates, although they do give a good indication of the actual state of affairs. The figures have been rounded off and divided between Paris and the provinces. The conclusion is clear: with more than a thousand jobs, the pursuit of historical studies had become a true profession at the beginning of the twentieth century.

Nearly a century earlier, at the start of the Restoration, the situation had been quite different. Then there were no specialist history teachers in intermediate schools, departmental archivists were as good as unknown, and there were at most twenty posts for historians in institutions of higher education in Paris. The total number of professional historians at the beginning of the Restoration was certainly no greater than seventy-five—sixty in Paris and fifteen in the provinces. In the course of just under a hundred years there had been a fourteenfold increase in the number of posts for these men. Particularly in the provinces, where professional historians had been very few and far between, they had become familiar figures. We might with equal success have approached this process of professional expansion (in the strict sense of increases in the number of professionals) by looking not at general figures but at individual choice of profession. For instance, successive issues of vocational guides might be used to make the same point.

Vocational guides were a nineteenth-century innovation, typical of a society in which the choice of profession had widened in the wake of economic expansion and the division of labor. These guides must not be confused with the craft descriptions given by so many moralistic writers. One of the first works in the modern vein was the *Guide pour le choix d'un état ou dictionnaire des professions* (1842), by Edouard Charton. Charton, editor-in-chief of the *Magazine pitto-*

resque, was a *quarante-huitard*, a forty-eighter, full of the new educational ideals and active in many educational associations. In his guide he carefully specified the "time and money needed to enter the various professions, the studies to be pursued, the curriculums of the special schools, the examinations that had to be taken, the aptitudes and faculties needed for success, the resources of the various educational establishments, the prospects of advancement or success, and the duties."[240]

In principle, historical studies involved three distinct activities: writing, teaching, and administration. Research might be added as a fourth activity, but it generally led to publications or was done as part of teaching or administrative activities.

Under the heading *homme de lettre* (professional writer) no special provision was made for writers of historical works, and not until the 1880 edition did Charton have a separate listing for journalists, although he did not really list it as a proper profession because it required no special training. Scribbling was no passport to riches. Most journalists earned between 2,000 and 6,000 francs a year. Best paid were the playwrights; authors of five-act plays normally received 10 percent of the takings. From Charton's 1880 edition it appears that writing plays was a veritable industry, with good prospects for a popular *vaudevilliste*. Writing historical works, as I have said, was not classified as a separate profession, and although some histories proved spectacular successes, such as Lamartine's *Histoire des Girondins* and Taine's *Les Origines de la France contemporaine*, they were the exception.[241] Michelet was forced to publish his *Histoire de la Révolution* at his own expense,[242] and when he lost his post at the Collège de France and had to live on his publications, he turned his hand to such natural-science books as *L'Oiseau* (1856), *L'Insecte* (1857), *L'Amour* (1858), *La Femme* (1860), and *La Mer* (1861), which sold much better than his historical writings. Taine put it conclusively in 1864 in a letter to Gabriel Monod, then a young *normalien*, who had asked for his advice. "A historian cannot live by his pen," he told him.[243]

The profession of teacher (*professeur*) was discussed at length in the vocational guides. Teaching did not have brilliant prospects; it paid little but also entailed few risks. A simple *maître d'études* (schoolmaster) was paid, over and above his free board and lodging, a minimum of 600 francs a year, a sum guaranteed by parliamentary decree in 1839; a history teacher at a minor secondary school was paid 1,600 francs, but a fully qualified teacher at one of the larger Parisian *lycées* could count on up to 7,500 francs in 1880, more than the basic pay of 6,000 francs of a professor at a provincial university. The magnetism of Paris thus had a financial aspect as well, but then life in the capital was, of course, more expensive than life in the provinces.

Charton realized that few young people liked to stand up before a class. Students were full of great hopes when they finished school, and young people who loved literature preferred to be writers. But, Charton warned, few authors achieved glory and an independent position; most ended up in a *position nécessiteuse*, dependent on the favors of publishers, booksellers, newspaper editors, or

theater managers. As teachers, they might well have a mediocre existence, but at least it would be "assured and . . . honorable." Another vocational guide observed with regret that not everyone appreciated the honorable nature of the teaching profession.[244]

In general, young people who took to teaching were not from well-to-do families. For anyone with a classical education, becoming a teacher was the cheapest way to enter a profession. Law and medicine were expensive to study and took long to qualify in, but one could become a *maître d'études* just as soon as one had taken the *baccalauréat*; all the later exams could be sat while one was employed as a pupil-teacher. Only a small number of carefully chosen students were able to prepare for their examination at the Ecole normale supérieure on a state grant, and it was not until the 1880s, with the reforms of the arts faculties, that this situation was gradually changed.

Nineteenth-century vocational guides treated all teaching as a single profession; the teaching of history was mentioned but not discussed separately, although it did become a special career in the course of the nineteenth century (see chapter 3). The vocational guides dealt chiefly with career prospects; as far as they were concerned, a division of teaching based on different subjects was irrelevant.

The clearest expression of the expansion of professional posts for historians was reflected in archives, libraries, and museums. In the mid–nineteenth century the entries under "archivist" in the vocational guides usually included a statement such as "these posts offer no fixed employment" or "this type of post offers little work and is very badly paid." In the 1880s and 1890s the archivist's post was given greater prominence, although it was still thought necessary to add that this kind of employment held few financial prospects. "Departmental archivist" had by then become a real profession, and the vocational guide for 1880 observed that no departmental archivist earned less than 2,000 francs, that most were paid 3,000 and a few even 5,000 per year. Moreover, in quite a few places archivists were given free lodging, and the inspection of records in localities scattered over a department provided attractive extra remuneration. In several places the departmental archivist's career was advantageously combined with a post in a municipal archive, library, or museum. Even so, it was no gold mine. In about 1900 Pierre Caron insisted that the position of departmental archivist deserved better pay as well as a graduated salary scale with periodic rises, as one might expect from any decent career.[245] Departmental archivists gradually became members of a recognized profession, but town archivists continued, especially in smaller towns, to be employed only part-time. That explains why in 1912 the archive in Lunel remained closed on Saturdays, the incumbent being too busy cutting his customers' hair.[246]

Much the same was true in the case of librarians. There was a marked difference between the entries in Charton's 1851 edition and the 1880 edition. In 1851 Charton reported that careers in public libraries were often doled out as personal favors, despite efforts by the authorities to regularize appointments and advancement. The 1880 tells us that although "favors no doubt preside

over appointments," strong recommendations were needed for even modest posts. Charton added that in the past there had been many abuses in the library system, the librarian's job being generally considered a sinecure. Just as for archivists, the posts in Paris, especially in the Bibliothèque Nationale, were the most sought after and the most highly paid, the *administrateur-général* of the Bibliothèque Nationale earning 15,000 francs, the four *conservateurs* 10,000 francs each, and a general assistant 2,000 to 3,000 francs a year. The last figure was more or less the same as the pay of the heads of the most important municipal libraries outside Paris (2,500 francs). Here too the appeal of Paris was partly financial. In education as well as in administration the center was sharply set off from the periphery. This was aggravated by the bureaucratization that went hand in hand with the extension of archives and libraries. A new administrative level emerged in Paris interposed between the minister and the provincial institutions, the so-called services généraux des bibliothèques et des archives, with a number of key posts. In 1910 there were three general inspectors in this service, with an annual salary of 10,000 francs each.[247]

Finally, there was the post of museum curator. Charton did not even list that post in his 1851 edition. The 1880 edition tells us that thanks to recent decisions about the organization of the national museums (1874) and the recruitment of staff (1879), it was now possible to speak of a career in this field, although the number of posts was severely restricted. More than ten years later, in 1891, Jacquemart's guide gave much greater space to this post. In 1882 the Ecole du Louvre was founded for the training of museum staff; it was modeled on Ecole des chartes's role in the training of archivists. It was soberly noted that in 1891 not a single graduate of the Ecole du Louvre had yet found employment in a museum. Most of the posts in the national museums went to students from the French schools in Athens or Rome or from the Ecole des hautes études. The Ecole du Louvre was recommended to young people wishing to become curators of museums, but they were urged to collect further qualifications elsewhere.[248]

The provincial museums continued to rely on private initiative. Appointments were made by local associations, although the salaries came out of the municipal budget. Nowhere in the provinces did a curator earn more than 2,000 francs annually. The job only became attractive when it was combined, for instance, with a career in the local académie des beaux arts; sometimes the pay was not intended to be more than an extra pension to a local artist.

The entries in editions of the vocational guides published during the second half of the nineteenth century confirm the picture we have drawn on the basis of financial allocations to the administrative sector (archives, libraries, or museums). They also confirm that one could not earn a living from the writing of historical works. It is now time for us to direct our attention to the largest group of professional historians, to those who constituted, as it were, the broad base of a growing trade: the teachers of history.

History at School

ON 18 MAY 1818 the Committee for Public Education (Commission de l'enseignement publique) decided that history and geography lessons in the municipal and royal colleges would henceforth be entrusted to specialist teachers,[1] each taking five two-hour special classes a week. By opening up a small but regular job market for historians, that decision helped to turn history into a profession. The teaching of history became a way of earning a living.

The subject of teaching history as a special subject had first been broached in the eighteenth century, but only indirectly.[2] In 1796 a chair of Hebrew at the Collège de France had been changed to one of history,[3] and at Douai the establishment of a chair of history had been considered as early as 1749.[4] But it was only in Napoleon's arts faculties that a special history chair became a regular feature. In general, history chairs came to the faculties well before history-teaching posts were introduced in *lycées* and *collèges*. The institutionalization of history teaching thus began at the top, that is, with higher education. Even so, the number of faculty posts was very small, numbering no more than seventeen in the whole of France in 1865.[5] The faculties had a great deal of influence on the general level of history instruction and on the examinations (see chapter 4).

In respect of jobs for historians, secondary education was of course much more important than the faculties, the appointment of specialist history teachers in the former being a crucial step in history education. It led to an increase in the number of hours devoted to history in the schedule, to greater concern about the contents and the intellectual and didactic level of the lessons, and ensured continuity. In short, the appointment of specialist teachers helped to institutionalize the teaching of history.

A FABULOUSLY LONG SPELL

The position of history in the traditional school system was an example of what Braudel has called "quasi-immobile history." The *ratio studiorum* in this field seems to have had a durability that could bear comparison with the geographical background and put up as least as stiff a resistance to change as any social or economic structure. The inertia of the traditional system of education was legendary.

From the beginnings of the Western educational tradition, which can be traced back to ancient Greece, the teaching of history had had to make do with an ancillary role. Except for some striking exceptions, it was not until the nineteenth century that history education acquired a firm and independent place in

France and in various other countries. For more than two millennia it had been conspicuous by its absence.

The explanation must be sought in the resistance of the traditional curriculum to innovations in general and to the introduction of history in particular. The need, however, had been sharply felt, and during the eighteenth century many voices were raised in France insisting that schools pay greater attention history and especially to French history.[6] Away from school, interest in French history was keen, but pedagogical reluctance to it continued to be buttressed by four interrelated factors: the saturated syllabus, the traditionalist attitude of teachers, the role of Latin, and the hegemony of rhetoric.[7]

The fourth factor in particular was responsible for the ancillary position of history. The raison d'être of classical education was knowledge of Latin grammar (*grammatica*) and of its crown, Latin rhetoric (*rhetorica*). The highest class was called the *classe de rhétorique*. Since the fourth century B.C., when the rhetorical technique was first formalized by the school principals of the Greek *poleis*, rhetoric had continued, thanks largely to the Roman educationists who took over so much from the Greeks, and also to the resurrection of the Greek heritage by the Renaissance and by humanism, to hold sway in the traditional system of education of many countries. In France it was only after the educational reforms of 1880 that rhetoric lost its dominant role.

The term *rhetoric* has a pejorative sound to modern ears. It seems bound up with external and superficial factors. But rhetoric used to be much more than that. In one nineteenth-century handbook it was defined as "intelligible discourse," of which the art of reasoning (*logica*) and grammar (*grammatica*) were essential parts.[8] Great social and political changes could lead to the development of different forms of rhetoric, and new emphases were introduced into the various categories.[9] Much as Aristotle had distinguished between demonstrative, deliberative, and forensic rhetoric, so this nineteenth-century handbook distinguished between pulpit, legal, and political rhetoric, in addition to an "indefinite" kind.[10] The centralization of political power usually led to greater emphasis of the literary and artistic aspects of rhetoric. All in all, there were many modifications, but the practice of rhetoric continued to hold a central place.

History was subservient to rhetoric. Monumental, influential works such as those by Cicero and Quintilian codified the position of history. They emphatically recommended the reading of historical writings even though such writings were thought to have but two purposes as far as rhetoric was concerned: as stylistic models and as paradigms, memorable facts and sayings one ought to have at his or her fingertips for use on appropriate occasions.[11]

Under the influence of humanism, the traditional, ancillary position of history was reaffirmed. Hence it is not surprising that in the definitive version of the Jesuit curriculum (1599), which served as a model to friend and foe alike, history was not listed as an independent subject.[12] However, during the compilation of the *ratio studiorum* voices were raised asking that more space be assigned to history. German Jesuits in particular pressed this point, for obvious reasons: they wanted to use history to fight Protestantism, which used history to

good effect in discrediting the Catholic Church. But the resistance of the classicists, reinforced by the humanists, proved too great. In the lower classes history a such was not taught at all, and in the higher classes it was taught in the form of commentaries on such writers as Caesar, Sallust, Quintus Curtius Rufus, Justinus, and, with some moral reservations, Tacitus. In the highest class the Jesuits might allow their pupils to read a historian (Livy in particular) *in their free time*, each pupil being left to digest the work on his own. Moreover, on Saturdays an hour might be set aside for *eruditio* (erudition), in which such subjects as the Roman senate, the Greek popular assemblies, or the army might be discussed. However, the *ratio* of the Jesuits did not encourage this practice: every mention of *eruditio* was coupled with appeals to the teacher's sobriety.[13] Good education could not be dispensed along byways of education, which far too often led the teacher into the thickets of pedantry.

The Reformation and the Counter-Reformation gave rise to historical polemics that were followed with keen interest. Calls for more education in the vernacular often went hand in hand with demands for more information about the history of one's country. In general, however, until the eighteenth century the reading of history books (apart from the classical historians who served as literary models) in traditional educational institutions remained confined to the faculties. Only in the German-speaking world was there a significant number of exceptions to this general rule. For reasons that need not detain us here, Germany enjoyed a marked lead in fostering the independence of history education.[14] Nothing of the sort occurred in France, not even in Protestant schools (save for one exception). A study of school exercise books has shown that in practice the regulations of the *ratio studiorum* were more or less closely observed.[15] In the seventeenth century, history was taught exclusively through the works of classical historians or, very occasionally, other writers. No such analysis has been made for the eighteenth century, but we know that many voices were by then clamoring for the inclusion of French history in the school curriculum.[16] Some *collèges* advertised history teaching as a special attraction.[17] In their free time many pupils did indeed read history, and in private schools too some attention was being paid to the subject. Outside school there was growing interest in national history.[18] But despite these influences, instruction in history was not a normal feature of traditional school education; France made no official provision for them until the beginning of the nineteenth century.

The Moral Benefits of History

Educationists had few doubts about the moral usefulness of familiarity with the past. Countless were the praises of history, invariably embroidered with obligatory quotations from Cicero's *De Oratore* and such standard catch phrases as *historia testis temporum, lux veritatis, vita memoriae,* and *nuncia vetustatis.* Although the truthfulness of historical works was occasionally questioned, the moral value of history was widely acknowledged. History, understood as the study of the classical historians, served as a behavioral science par excellence, countless

teachers preferring the instructive examples embedded in the writings of classical historians to the abstract doctrines of moral philosophy. Morality, it was felt, was more graphically brought home to students by example than by exhortation.

Not all classical historians, however, could be presented as models of morality and virtue.[19] It behooved the modern historian to distinguish good from evil; hence the repeated admonition to be wary of historians who failed to preach moral sermons, for instance of Herodotus and Tacitus, and hence also the popularity of such moralizing authors as Livy and Plutarch. Classical historians not only provided material for exercises in grammar and rhetoric but were upheld as great models. Whenever the teacher, after analyzing a text from the literary angle, underlined its edifying character and if necessary explained it, he was playing the part of the true *historicus* as well as being an *interpres*.[20]

Of course objections were made to this pragmatic use of history. Descartes wrote a well-known attack on the humanistic training he had been given and highlighted the dangers of "exemplary history."[21] The skeptical Descartes distrusted even the most reliable history books, contending that even when historians refrained from embellishing their subject matter they were wont to gloss over the less edifying circumstances. According to Descartes, people who allowed their behavior to be guided by historical models ran the risk of falling prey to extravagance and making plans far beyond their powers. Historical skeptics were to voice these objections to the instructive value of history more and more often and more and more stridently. During the Enlightenment even such reform-minded philosophers as Jean-Baptiste d'Alembert joined in this chorus,[22] though they were never able to drown the unctuous choir eulogizing the moral function of history.

In the nineteenth and twentieth centuries the moral objective remained enthroned long after the teaching of history had been institutionalized, no matter how much the emphasis may have been changed. *Historia magistra vitae* remained the device of history teachers.[23]

The Biographical Approach

Whenever educationists paid the least attention to history, they tended to turn the past into a collection of famous biographies. As a rule, these personal accounts were removed from their time or historical context. All sensible teachers agreed that chronological references had to be kept to the minimum. "The date of the destruction of Carthage was less important than the moral actions of Hannibal and Scipio; the date of Marcellus's death was far less important than the knowledge of why he was unworthy of his task," Montaigne tells us.[24] Cardinal Fleury argued in his influential textbook that although a pupil must of course be familiar with the general periods of the history of God's people and of the great empires, there was no need to burden him with a mass of dates.[25] The famous *Traité des études*, by Charles Rollin, rector of the University of Paris, which was still being reprinted in the nineteenth century, did not mention a single date before the Punic Wars.[26]

Thus, chronology did not play an important role in traditional education—history was cut up into timeless *exempla*. The addition of dates may be considered a nineteenth-century aberration. Mnemonics had helped to imprint the absolute essentials since olden times, and of course one had to learn the dates of French kings, but the leading educationists all agreed that chronology, the battleground of polemicists and apologists, did not need to be made much of at school.[27]

The idea of historical development, enshrined in the historiographic contributions of the Enlightenment, was not part of traditional education in the humanist mold. Christianity, which according to the leading experts presupposed the concept of temporality and hence a linear philosophy of history,[28] reinforced the moralizing function of profane history education, which was essentially (implicitly) based on a cyclical approach: models were useful and meaningful precisely because the situations and role patterns were repetitive. The teaching of biblical history had a similar biographical tendency.[29] The ultimate interpretation of the meaning of life on earth and the belief in the finite nature of this world, in man's redemption, and in the hereafter could of course be considered the expression of a linear philosophy of history, but that certainly does not mean that the past was considered to be a *process*.

The Christian division of world history into such periods as the six *aetates* or the four *regna* was in accordance with an age-old scheme. In this classification of world history it was possible to use a growth metaphor or to compare history to human life (empires rise, dazzle, and decline), but this could hardly be called a fundamental idea of historical development.[30] The historical nature of man and society may have been hinted at, but the moralizing practice of the Christian type of humanistic education kept the door of historical understanding firmly shut.

The Church taught that Adam was the first man, whom all of us resemble. Man has remained essentially unchanged. The apple of knowledge did not contain the pith of historical understanding. Humanism provided a pedagogical program, steeped in historical references and grounded in antiquity. The identification with the classics was so great that there was little room for the kind of detachment that is the sine qua non of a genuine conception of historical development.[31]

The Select Audience

Traditional history education had never been meant for the masses. The select target group automatically influenced the content of the curriculum. This was particularly true of the dramatis personae of history, who were presented to the student as a company of illustrious princes, generals, and magistrates whose actions constituted so many collector's pieces of traditional historiography. Pragmatic history was elitist history; the benefits of reading historical works were thought to vary with the social status of the pupils. At the end of the seventeenth century Cardinal Fleury left no doubt on that point in his educational handbook, which was reprinted throughout the eighteenth century: "A

man of mediocre status needs very little history; those who play some part in public affairs need a great deal more; and a Prince cannot have too much."[32]

In that respect there was a great difference between classical historians and biblical history. Elementary notions from the Bible ought, in principle, to be inculcated into all Christians. Even those who could not read could be taught these notions by a set of questions and answers. For that very purpose, Cardinal Fleury, like many others, wrote a *catéchisme historique*; Fleury's *catéchism* was widely used, especially in the religious training of young children. Similarly, Charles Rollin, whom we have already met, distinguished in his textbook between the writings of the classical historians, who provided models for the exclusive use of "great men," and God's Word, which established rules and examples "for all sorts and conditions."[33] The Bible was beneficial to all, including simple people, husbands, fathers, mothers, children, and the poor, whereas the writings of Plutarch, Polybius, and other classical writers were of interest to (future) leaders only.

It was remarkable that Rollin should still have identified the teaching of history with the reading of classical historians, which he thought was predominantly of interest to "all those who wield any authority over others." Rollin's target group, however, was rather broader than Fleury's, for Rollin mentioned not only princes and conquerors but also civil servants, officers, magistrates, intendants, prelates, leading secular and regular members of the clergy, as well as fathers and mothers, masters and mistresses of their households. But Rollin too recommended historical works especially to people in positions of leadership as good training in humility and a mirror of duties. Such persons would do well to appreciate that their subjects were not there for the rulers' benefit; rather, the rulers were there for the benefit of those over whom they ruled.[34]

No more so than traditional education in general was history education intended for the masses. In the eighteenth century, when there was a growing call for the teaching of French history alongside the study of ancient and biblical history, a call that was of course linked to the process of nation building, the need first arose for history books that would set a good example to persons in all sectors of society. When the inculcation of patriotic ideas, something called for by all citizens, became a dominant part of history education—a process that, incidentally, was not completed until the nineteenth century—it was no longer enough to "denationalize" Plutarch and make him into a *Plutarque français*, full of "historical praises to [French] generals and military leaders, ministers of state, and the chief magistrates of the nation."[35] The aim was not simply to replace the classical protagonists with French counterparts: the true national portrait gallery had also to have a democratic look.

THE BACKGROUND OF INSTITUTIONALIZATION

The 1818 decision did not come out of the blue. "The state of society and family aspirations" call for a broad education in history, we read in the preamble to that decision.[36] The resistance of the traditional education program had

finally been overcome by a complex combination of factors. It is possible to distinguish between general causes and a concrete impetus. In chapter 1 I named four reasons for the growth of historical writing (1) changes in taste; (2) the historicization of the worldview; (3) the emergence of political polemics in the form of historical treatises; and (4) growing interest in national history as part of the process of nation building. In addition to these general factors, there was also a concrete political motive for the institutionalization of history instruction, which of course was not independent of the general factors.

Changes in Taste

In the history of historiography it is usual to emphasize changes in intellectual taste, especially at the beginning of the nineteenth century. History became the *dernier cri* in trendsetting circles. This may have been the result of a sentimental revolution, a "new cosmic awareness," "the resurrection of lyricism and dreams," a "new susceptibility to historical processes," in which emotion took charge of the intellect, including its view of the past. Johan Huizinga put it very well: "The entire attitude to the past was transformed: the past no longer served as a model, as an example, as an oratorical arsenal, or a lumber room crammed with curios, but it now filled the mind with a longing for distant and foreign things, with a longing to relive what had once been. The historical sense was replete with nostalgia and haunting memories."[37]

Historiography became suffused with a burning romantic streak—we need only recall the famous autobiographical passages in which young Michelet recalled the emotions he felt when he first saw the sepulchral monuments assembled by Alexandre Lenoir during the Revolution or the eager enthusiasm of Thierry when he first read Chateaubriand at the age of fifteen.[38] Historical novels and paintings fueled the imagination of future authors of "serious" historical works,[39] and their style was influenced by the Romantic Movement.[40] As the reading public also discovered the charm of old chronicles, historians would henceforth have to have an eye for the picturesque and for local color.[41] This change in taste and revolution in sentiment had an unmistakable influence on the mental outlook of the French intellectual elite at the beginning of the nineteenth century, and there is little doubt that the great popularity of history was behind this development, although it left few direct traces on the institutionalization of history teaching.

The Historicization of the Worldview

It is most unlikely that history would ever have become an independent part of the school curriculum without the historicization of the worldview. That fundamental change in intellectual outlook forced leading French circles to take a fresh look at the political and social realities. The process involved so many nuances, distinctions, and even contradictions that its careful analysis would require a separate study. Here we shall simply confine ourselves to drawing an

overall picture of a mental revolution that culminated in the toppling of a century-old hierarchy of learned disciplines and bestowed upon history an unprecedented epistemological status and immense pretensions. The historical approach seemed to undermine the eternal truths of philosophy, theology, and rhetoric. There had been many portents of this development in earlier times. Thus it can be shown that French Renaissance historiography,[42] the *Querelle des anciens et des modernes*, the idea of progress, revolutionary theory, and literary and artistic "pre-Romanticism" all contained elements that foreshadowed the destruction of both the old epistemological ideal and classicism.[43] However, it was not until the nineteenth century that history began to pretend that it could proffer a comprehensive interpretation, and, what is more, on an unprecedented scale. Man and society were not timeless phenomena but products of historical developments, and changes were not just so many recurring phases in a repetitive circular process but stages in an irreversible process of development.

Earlier I referred to the difference between historicization and historicism (chapter 1). Historicization, I said, is an enriching way of thinking, a window on the world, whereas historicism is a closed system, an ideology. During the second half of the nineteenth century, and especially toward its close, historicism played the useful role of putting up a methodological barrier to the prevailing, positivist ideal of knowledge. It then became common practice to contrast France, which had succumbed to the Enlightenment and to positivism and had turned into a hotbed of political utopias with revolutionary upheavals as their disastrous consequence, with Germany, the soil of Romanticism and historicism, filled with respect for evolutionary processes and hence possessed of a sense of reality and embarked upon a steady course of political development. After the Second World War this contrast was emphasized in many studies, if only to drive home the point that the balance had tilted the other way and to emphasize the ethical and political dangers inherent in historicism.[44]

Of the two, historicization entailed a less antagonistic worldview. Thus, whereas historicism was a defiant form of antipositivism and defensive in essence, historicization entailed a new global way of looking at the world. It had a diffuse but compelling character. Again, whereas historicism was an exclusively German creation, historicization was also embraced by leading scholars in other Western European countries. Historicization was behind the introduction of history as an independent school subject; historicism was at most a useful contributor to its consolidation. Historicization was the achievement of an intellectual vanguard and pioneered an epistemological breakthrough; historicism was the waste product of methodological rearguard skirmishes fought largely by philosophers of science.

The historicization of the worldview, which can be very briefly described as a genetic historical approach involving such concepts as development, growth, and process, was a blend of a complex combination of ideas that were, of course, connected with other topics as well. I have tried to distinguish three elements of historicization: an epistemological reevaluation of history; the so-

cialization of the view of man; and an increase in the scale of historiography. Each of these elements merits a brief discussion.

At the beginning of the nineteenth century philosophical writers referred to an epistemological reevaluation of history. Now, philosophers had always been suspicious of history, Descartes's skepticism having found its way, for example, into Arnould and Nicole's very successful textbook of logic.[45] The unreliability of historical knowledge was a standard theme of philosophers. However, at the beginning of the nineteenth century some philosophers who, incidentally, had begun to publish their work much earlier gained great popularity with systems in which historical knowledge held pride of place. This new trend became known as anti-Cartesianism. Giambattista Vico played an important role in this epistemological reevaluation. *Verum factum* replaced *cogito ergo sum*.

In the philosophical climate prevailing in France at the beginning of the nineteenth century Vico's views made a considerable impact, though not before the 1820s.[46] The way for Vico's ideas had been prepared by the popularization of the Scottish common-sense philosophy of Thomas Reid, among others.[47] It was thanks largely to Royer Collard, appointed to the chair of the history of philosophy at the Sorbonne in 1810, and to Victor Cousin, his substitute and at the same time lecturer at the Ecole normale, that Scottish philosophy gained ground in France during the second decade of the nineteenth century. Royer Collard was later turned into an immortal figure of fun by Taine.[48] But however puny the philosophical merit of Royer Collard may have been, there can be no doubt about his influence. He may be considered the father of French history education since, as president of the Committee of Public Education, he was responsible for the 1818 decision. Young Cousin was undoubtedly the better philosopher of the two—during the July Monarchy he was to become the *Pontifex Maximus* of French philosophy, to the dismay of many of his colleagues.[49] Cousin formulated his ideas so colorfully and with such facility that the depth of his contribution came to be questioned in the long run. But that point had not yet been reached; in the second decade of the nineteenth century Cousin was the fastest-rising star in the Parisian philosophical firmament.

Cousin's contribution provided a good illustration of the reevaluation of history by leading philosophers. Cousin proclaimed the dawn of a new philosophical era following the reign of Locke and Condillac, the heirs to Descartes.[50] They had derived all man's qualities and ideas from sensation, understood as the action of the brain under the influence of impressions on the sense organs. Man was a machine and "the study of man a branch of physiology."[51] Cousin realized that Laromiguière and Maine de Biran had diverged from Condillac in many important respects, but it was Royer Collard who had turned him and his fellow students at the Ecole normale from "Condillac's beaten track" in 1812, leading them onto the path of Scottish philosophy, "now so well-trodden but then so arduous and unfrequented."[52]

Common sense, a subject on which Descartes had been highly sarcastic, had obtained an epistemological status in philosophy comparable to that of demonstrable truths. Philosophers began to admit into their pantheon a historical truth

endowed with no more than probability. "I am as certain of the existence of the city of Rome as I am of the truth of Euclid's first proposition," wrote Reid, "although it is the result of probability reasoning and not of logical proof."[53] The rehabilitation of common sense was, of course, much more than an element of the historicization of philosophy; it led to the upgrading of the place of historical knowledge in philosophy. It is worth noting, by the way, that this victory over the historical skepticism of philosophers, who rarely had the patience to read the works of historians, was the result not only of the improvement and intensification of source criticism, as the traditional view would have us believe, but also of a philosophical reorientation.

The influence of Kant and of German idealism, known in France mainly thanks to Cousin's lectures, made itself felt somewhat later. Cousin himself mentioned 1816 as the first year in which he had become acquainted with these ideas, but it was above all during his first visits to Germany, in 1817 and 1818, that he discovered the work of Schelling and met Hegel, a man whose reputation, according to Cousin, still rested on his being a well-known pupil of Schelling. Cousin's lectures caused quite a stir, and the influence of German philosophy on them was unmistakable, particularly in the courses he gave in 1819–20.[54]

The assassination of the duc de Berry, heir to the throne, on 13 February 1820 produced a fierce reaction. The reigning ultras ordered Royer Collard to stop using Cousin as his substitute, Cousin being considered a progressive and known to have expressed pantheistic and liberal views. Needless to say, Cousin's reputation among liberals was reinforced by these repressive measures. More generally, the reaction also had repercussions on the institutionalization of history teaching, but that takes us to the subject of political motivation, which we will examine later. Here we need merely stress that the 1818 decision to appoint specialist history teachers was not yet influenced by the prestige of German philosophers, who attached such great importance to history, for it was not until the 1820s that the writings of such German philosophers as Herder became more widely known in France.[55] By then the German influence naturally provided extra support for the champions of the further expansion of history education. The traditional philosophical refusal to grant that history was a form of knowledge fell (temporarily) out of step with the times. Malebranche was held up as a model of the old-fashioned philosopher, one who grew angry when he came upon a pupil reading Thucydides and reproached him with "merely seeking amusement for his imagination, of paying heed to accidental facts like a child instead of being concerned with himself, with man, with man's destiny, with God, in short with ideas and with philosophy." Cousin was dismayed; in his view the study of history was "an essentially philosophic task."[56]

The epistemological reevaluation of history applied first and foremost to philosophy, the second factor in the historicization of the worldview, the treatment of man as a social being, was felt in a wider sphere. It was much more than a facet of historicization, and in this the French intellectual tradition was much less dependent on foreign intellectual influences. An impressive series of French thinkers had made it clear that man was shaped largely by the society of which

he was a part. Man's real nature could not be discovered if he was viewed apart from society, as the classical moralists had done. According to Cousin, "The true nature of man cannot be found in his consciousness or in the display of his passions, but must be sought in his social relationships."[57] Psychology must start with man's social instinct, and so must political theory.

Such enlightened thinkers as Montesquieu, Voltaire, Turgot, Condorcet, Duclos, and Condillac played a leading role in driving home the importance of social influences. Their contributions are part of the prehistory of sociology. The emergence of sociology as an independent discipline at the beginning of the nineteenth century has been presented as a counterrevolutionary phenomenon, as a way of stressing the importance of society and collective institutions after the disintegration that followed the Revolution, which had rashly preached the liberty and equality of the individual citizen.[58] But it was forgotten that fraternity too had been emblazoned on the revolutionary banner and that community spirit (conviviality) had been a favorite theme of enlightened thinkers. The foundations of a broad sociology had been laid as early as the eighteenth century.

Although the French tradition was rich in this field, the influence of Scottish philosophers at the beginning of the nineteenth century cannot be ignored even here. Thomas Reid and Dugald Stewart, in particular, had attacked the ideas of Hobbes, whose influential reflections on the state and society had begun with the individual. In this area too the Scottish ideas were propagated in France by Royard Collard and by Cousin.[59] Cousin was bitterly opposed to Hobbes's view that human beings only associated by chance or for selfish reasons. Cousin countered with the "principle of sociability": though people chose society for the advantages it offered them, that was not the whole story. "The liking of society is instinctive and solitude is mortal to the life of the moral being; man's destiny is wholly social."[60]

The third factor of historicization was the increase in the scale of historiography. The effective agents of the past were no longer identified with the actors as such, as they had been in the pragmatic, humanistic approach. History became "debiographized." The past seemed shaped by such supra-individual entities as progress, nation, people, institutions. Metaphysical ideas often served as a secularized conception of God. There were all sorts of affinities between God's providence and, for instance, the explication of historical events by the idea of progress. The past was subjected to a supra-individual order; individuals became tools in one of God's plans, or in the progress of reason and civilization, or in the salvation of the nation. Remarkably, it was in this area that Cousin expressed his appreciation of Bossuet's view of general history—"this lofty manner of treating heroes and empires, this inflexible advance toward a fixed goal, right through everything that deflects and distracts ordinary historians."[61] Moreover, certainly in Cousin's day, and before that during the Enlightenment, people were wont to look upon progress as God's work. God's providence could, however, also manifest itself in unique, isolated events and exemplary persons; God could intervene to reverse the course of history. The belief in progress, or

more generally the habit of thinking in terms of development and processes, did not have to conflict with the Christian faith, though it was not necessarily bound up with it.[62]

The search for supra-individual entities in the past meant not only a widening of historiography, as a result of which its intellectual attraction increased, but also the treatment of these large-scale entities as the driving forces of the past and hence an extension of the concept of historical causality. The search for historical explanations implied a search for deeper causes and broader developments. Once historians had come to consider it their task to analyze progress, they ceased to be satisfied with Cleopatra's nose as an explanation of the course of history.

It must be added that the increase in scale was not the result of generalizations based on a large number of data or statistics, as would happen with twentieth-century historiography; the increase in scale was effected above all by the introduction of general ideas and symbols. Cousin and his intellectual friends, including Michelet (who was nicknamed Monsieur Symbole) were wont to see ideas or symbols behind almost every historical fact. The number of historical data as such therefore had little bearing on what we have called the increase in the scale of historiography.

History as Political Polemics

The third reason for the popularity of history was the liking for historical reflections in political polemics. The break with tradition, the turbulent events, and the chaotic succession of political regimes were so many catalysts in the transformation of the intellectual climate. The historicization of the worldview was stimulated by major political crises. Other times of crisis also have witnessed an increase in historical polemics;[63] uncertainty seems to call for historical legitimization supported by precedents. The study of the past has since time immemorial been a way of coping with the present. However, at the beginning of the nineteenth century, the assimilation of shocking experiences was not based primarily on historical precedent. Under the influence of historicization it became customary to explain and mitigate the severity of traumatic events by treating them as necessary developments.

One of the earliest professional teachers of history expressed the prevailing attitude as follows: "Faced with the spectacle of the greatest of all social revolutions . . . we found it impossible to fathom this terrible, solitary drama set in the midst of the centuries without seeing its prologue in the past or its dénouement in the future."[64] Thierry referred to "a new understanding of history," which appeared "the moment the great series of political reversals was completed."[65] Cousin put it more elegantly: "We have seen so many empires, sects, opinions collapse . . . we (moderns) are weary of this ceaselessly changing face of the world. . . . And it is only natural that we should end up wondering about the meaning of these games that cause us so much pain; asking ourselves whether human destiny remains unchanged, advances, or recoils in the midst of

these world-shaking revolutions; why there are revolutions . . . if they have any purpose at all, if there is anything serious behind all this turmoil and the general destiny of mankind." Cousin maintained that such questions were almost unknown in antiquity and that they had not begun to "trouble the soul and to perturb all thinking people" until his own day and age.[66] If history was to play a "therapeutic" role, then historians must write history in a specific "philosophical" way, and once they did that, they became directly involved in historical arguments about the ultimate justification of the break with tradition. For what was involved was not the description of "disjointed events" or of "fortuitous and arbitrary phenomena produced by chance and destroyed by chance." The true historian's task was to discover the "real order of these arbitrary events, connecting them and explaining them by fitting them into a higher order." All this was clearly linked to what I have called the increase in scale and to the search for supra-individual entities, that is, to a search for a cohesive view of the past, the better to determine what role civilizations have played and what higher idea they represented in the "economy of universal life."[67]

Leading thinkers were aware of "this new view of history," in which "everything hinged on everything else, each event having, quite apart from its own appearance, another and wider aspect, so that it must be viewed in its relations with the whole of which it is a part and in which it has been assigned a place." Sismondi, Guizot, and Thierry were held up as models of historians who had demonstrated "the unity presiding over the long life of nations."[68]

This new philosophical historiography was an outstanding means not only of engaging in political polemics but also of consolidating one's own ideals. The association of philosophical reflections with historical accounts, the study of history from a philosophical angle, was a legacy from the Enlightenment, and one that was very much in vogue during the Restoration. Thanks to it, the Romantic changes in sentiment and style could be given full sway at the same time that the options of the Enlightenment were retained. Historiography during the Restoration was not just a flight into the past and a turning away from one's own time; it was at least as often a means of participating in intense political arguments and taking a stand in the current political struggle. In France, for one, there was no such thing as a split between the historiography of the Enlightenment and that of the Romantic Movement. The distinction between a purely descriptive and a demonstrative (reflective) historiography has a pejorative aim. It was used with emphasis by historians who offered repeated assurances that they wanted to confine themselves exclusively to descriptions, in contrast to those (objectionable) colleagues who put demonstrations first.

In France a very serious gulf between historians was opened up by Chateaubriand. This champion of French Romanticism spoke of two hostile schools into which he claimed French historians were divided. The first tended to believe in the writing of history "without reflections," in "the simple telling of events and depiction of manners"; the historian's true task was to present "a simple, variable picture filled with episodes," it being left to the reader, "according to his mental makeup . . . to draw conclusion, arrive at principles, and to

infer general from particular truths." In short, the first school was that of descriptive historians, not of philosophical historians prominent in the previous century.

The other school was concerned not with details but with general facts; it concentrated on the history of the species rather than on the history of the individual. The hallmark of this school (in patent contrast to that of the first) was "to remain impassive before vice and virtue and also before the most tragic catastrophes." According to Chateaubriand, this was a form of "fatalistic history, or of fatalism applied to history."[69]

Fatalism—the word was out. Later, it was to make way for a different term, *historical determinism*. Since the publication in 1824 of Mignet's and Thiers's first volumes on the history of the French Revolution a fierce discussion on the subject had been raging.[70] For Mignet and Thiers, the Revolution had not been a conspiracy but an expression of the "necessity of things." That sort of explanation was not original—De Maistre, Mallet du Pan, Madame de Staël, and others had come up with similar interpretations[71]—but the way in which Mignet and Thiers demonstrated the inevitability of the Revolution by means of the history of institutions (and that too was what Chateaubriand meant by general facts) appealed to a wide audience. The political message was crystal clear: it provided a justification for the Revolution; or at least it dwelled on its good side.

Although the term *fatalism* may thus have cropped up in the middle of the 1820s, mainly for use in polemics about the most harrowing past, that is, about the Revolution, this particular way of writing history and polemicizing had been popular even earlier. In December 1812 Guizot had delivered his inaugural lecture at the Sorbonne from the brand-new chair for modern history. He said that he was mainly concerned with the broad outlines and with general developments. We shall make it our task, Guizot explained, to unravel for every century and for every estate "the general principles that have caused the fortune or misfortune of generations subject to their constraints, and that thereafter shaped the fate of later generations."[72] Guizot's subsequent lectures on the representative system in France and Europe and his history of the English revolution were models of institutional history (of Chateaubriand's history of species) trying to prove the "necessity of things"—with the unmistakable objective of contributing to the fight for a political system grounded in the constitution.[73]

Fatalistic historiography was out to prove that history must needs lead to the progress of culture and of political institutions. It was largely rooted in ideas of the Enlightenment. The genetic approach to history, so often considered a typical feature of Romanticism, was in a sense a retrospective complement to the belief in progress, or at least in the reversibility of the historical process. Chateaubriand's split was not generally applicable. The Romantic style could also be used by "fatalists." As for the so-called descriptive school, it would perhaps have been more correct to accuse it of obscuring or even of disguising the historian's real objectives. Have we not learned to be suspicious of historians who proclaim the wish to hide behind the historical sources or "to let the past speak for itself"?

Of course France too experienced something like Weltschmerz and nostalgia. The old chronicles had a picturesque local color. It was possible to wallow in the past. Even so, nearly every bit of descriptive history with any appeal did have an objective and alluded (indirectly) to the contemporary world. If it failed to do that, then it was nothing but scissors-and-paste history or a paraphrase of some ancient chronicle, possibly with a deliberate use of archaic terms to make the atmosphere seem even more authentic.

A clear example of the links between descriptive and demonstrative historiography was mentioned by Augustin Thierry, who relates that in 1817 he looked in historical works for demonstrations and arguments to underpin his political opinions. (The political ideals of Thierry and his allies, who were known as the constitutionalists and whose number included Guizot, Cousin, and Royer Collard, will be discussed when we come to the political motivation of the institutionalization of history teaching. Here we are more concerned with the general background.) Thierry tells us how much pleasure he felt in reading the old chronicles and how, when the political wind started to blow from a different corner and the ultraroyalists came to power, he found the serious study of the past a means of calming his youthful ardor. He did not stifle his longing for liberty, but his patience was strengthened by the knowledge that "the work of this world is done slowly; and that each passing generation does no more than leave one stone for the construction of that edifice of which fervent spirits keep dreaming."[74] However, this patience and deliberate abstention from explicit philosophical digressions did not mean in the least that in his picturesque work Thierry left the reader to draw his own conclusions. His historical writings derived their strength precisely from their aura of reliability and authenticity. From his *Histoire de la conquête de l'Angleterre par les Normands* (1825) to his *Essai sur la formation et des progrès du Tiers Etat* (1855), fatalism remained the mainspring of his historical imagination and a key to his stupendous *oeuvre*. The most elegant description often served as the best proof.

Historiography during this period of Romanticism and the Restoration was more than ever politically motivated. It was the continuation of the political struggle by other means.

The Consolidation of National Consciousness

The fourth factor in the confused intellectual background to the institutionalization of history education was the consolidation of the national consciousness. In Chapter 1 I pointed to the growing prominence of national history in the intellectual output during the second half of the eighteenth century. National consciousness was in a sense the concrete expression of the abstract socialization of man and the increase in the scale of historiography. The nation become the model social form in which man's destiny was enshrined.

The "objective" process of nation building, which was based on economic, social, and political factors and was greatly stimulated by Revolution and Empire, had a "subjective" intellectual counterpart. The political thinking of the

elite was electrified by "national" ideas, their view of art and literature being overwhelmed with notions of national genius and national character. Historians did not invent national consciousness; on the contrary, as happens so often, historiography proved to be a derivative, intellectual genre. Only when new ideas are accepted in a given period do they apparently lend themselves to the study of the past. Most historians are anything but intellectual pioneers or inventors of new concepts. In eighteenth-century books on French history it was of course possible to discover certain elements derived from the prehistory of national consciousness: attachment to the dynasty, the idea of geographical unity, animosity to hostile powers, opposition to interference by the pope, "French pride"[75] Thierry, that mainspring behind the gigantic operation involved in the rewriting of French history, may have exaggerated a bit when he described the books of his predecessors as "rather pompous narratives in which a small number of privileged persons monopolize the historical scene and in which the broad mass of the nation disappears under the mantle of the court,"[76] but there was no doubt that national consciousness had to become a firm element of political sensibility before it began to dominate French historiography during the second decade of the nineteenth century.

The strengthening of the national consciousness led to the growing acceptance by authoritative circles, as a *communis opinio*, that schoolchildren must be inculcated with patriotism. The firm place history gained in the school curriculum during the nineteenth century was certainly due in part to this development. Thus, the stress laid by nineteenth-century educationists on the language, geography, and history of the French motherland was in striking contrast to the subordinate position of French and the almost total absence of references to France in the traditional humanist approach that had prevailed in education during part of the eighteenth century.

To better understand this contrast we can do no better than to look at Rollin's previously mentioned educational handbook, which enjoyed great popularity in the eighteenth century. No map of France was found in the geographical section, though maps of the world, the Roman Empire, Greece, and Asia Minor were included. Geography was essentially confined to what had been mentioned by the classical authors. The campaigns of Hannibal, Scipio, Pompey, Caesar, and Alexander the Great (the order is Rollin's) offered many opportunities for acquainting pupils with "all the memorable places in the universe, the sequence of events, and the location of towns."[77] The illustrious pedagogue was so much ahead of his time that he did indeed consider modern geography of some use. He recommended that pupils be made "now and then" to read a few pages of the newspaper *en famille* and that the places mentioned there be pointed out to them on the map of the world.

In his survey of the moral examples set by the truly famous and great Rollin did mention some French names, but these were still squeezed rather uncomfortably into the classical frame. That was understandable, because Rollin was unable to avail himself of any relevant work fashioned by the rules of rhetoric. "French history" was primarily the province of compilers and chroniclers. Rollin

drew his French examples from funeral orations (especially by Fléchier, Mas-caron, and Bossuet) and from academic eulogies (especially by Fontenelle). Thus Rollin commended the simplicity and piety of Turenne, the heroic auster-ity of Cardinal Ossat, and the modesty of the wife of de Thou, president of the parliament of Paris. Louis XIV was even praised for cutting the costs of army meals.[78] The spirit of self-sacrifice shown by the six citizens of Calais who vol-unteered to deliver their persons to the king of England in an attempt to pre-vent the destruction of their city was cited as another example.[79] But model characters culled from Greek and Roman antiquity overshadowed all these. Only in the course of the nineteenth century would history teachers be able to make use of a crowded gallery of national heroes and heroines. It is striking that Rollin was rather ashamed of his fractured knowledge of French history, but it is nevertheless highly significant that he should have ended his pedagogical recommendations for history teachers with the warning that in any case French history must not be taught at the cost of Greek and especially not at the cost of Latin.[80]

The strengthening of the national consciousness by the Revolution and the Empire also caused a wide circle of educationists to frown on the fact that the teaching of national history was not institutionalized. In this respect there was a clear link between nation building and the historicization of the worldview. In principle, nation building could have gone hand in hand with historical legitim-ization based exclusively on precedent. During many changes in political power and past crises it had become clear how quickly historical precedent could be used to justify contemporary developments. However, the kind of historical legitimization that went hand in hand with nation building differed from the old pattern of cyclical thinking in terms of precedents and (real or assumed) time-honored conditions. Never before had there been such clear references to legitimization by (once again real or assumed) historical developments. The argument derived its strength not from the fact that things had been the same in the past but from the fact that they had developed in the same way. The emerg-ing nation-state became the leitmotif of education in French history education. That this particular perspective introduced all sorts of anachronisms and im-peded a more profound historic consciousness is something we have come to know only too well. However, it remains true that the genetic perspective of patriotic history teaching in the nineteenth and twentieth centuries differed rad-ically from the traditional, often dynastic process of legitimization by precedent so characteristic of the *histoires de France* written during the ancien régime.

The compelling perspective of the emerging nation did not entail the rejec-tion of the pedagogical practice of holding up great personalities from the past as examples. By *debiographization* people simply meant that the actions of great personalities were no longer considered the favorite explanatory category they had been in the pragmatic conception of historiography. The historicization of the worldview, the increase in scale, the emphasis of irreversible developments, generally in the form of Progress—all these in no way impeded the use of heroes from the French past as examples. The two pedagogical objectives of

history education (demonstrating the growth of the nation and putting forward examples) could flourish in peaceful coexistence. The demonstration of developments was added as a new factor without any sacrifice of the century-old and tested didactic objective of citing historical examples. It would therefore be wrong to argue, as an eminent historian of ideas has done, that *historia magistra vitae* lost its popularity under the influence of the new thinking in terms of processes and developments.[81] Logically that might have been expected to happen. Thus, history education can be paradoxical, and it is not ruled by logic. In fact it would seem that in nineteenth-century education more emphasis was laid on the exemplary value of historical heroes than ever before. The real innovation was the democratization of the gallery of heroes, together with a gradual adaptation of the moral tenor to the changed social function of education.

History Teaching as the Creation of the *Constitutionnels*

The political motives behind the 1818 decision cannot of course be divorced from its background (change of taste, historicization, political polemics, and national consciousness). The decision was a concrete expression of the political polemics rife at the beginning of the Restoration. Royer Collard may be called the father of history teaching in France because it was thanks to him, as president of the Committee of Public Education, that specialist history teachers were first appointed.[82]

Royer Collard was the doyen of a liberal circle that also included Guizot, Cousin, Thierry, Constant, and Barante among many other upholders of the Charter as the foundation of the political order. In the 1820s they were called *doctrinaires* by their opponents, the ultraroyalists, who accused them of dispensing doctrines for every occasion. *Doctrinaire* was thus a term of abuse, used much as *philosophe* was used during the Enlightenment, or as *intellectuel* was used at the end of the nineteenth century. In accordance with a not uncommon process, this pejorative title was then converted into an honorable one. Guizot later described the attitude of the *doctrinaires* as "this mixture of philosophical exaltation and political moderation, this rational respect for rights and facts, these doctrines both new and conservative, antirevolutionary without being retrograde, and basically modest though often lofty in expression."[83] It was this circle of early-nineteenth-century liberals that during the Restoration looked for historical arguments with which to uphold the constitution as the "logical" outcome of historical developments. People from this circle rocked the cradle of the French history teacher, and the great majority of the first batch of these teachers was of their political stamp. In the 1820s, when the Restoration became "reactionary" and the "government of the congregation" seized the reins of power, the leaders of the *doctrinaires* were swept aside. They bided their time until 1830, when the revolution returned power into their hands. But that point had not yet been reached.

In 1818 a petition was addressed to the Chambers asking for the appoint-

ment of history teachers at the *collèges*. The petition, itself a new and "eminently national" right, was drafted by J. J. A. Darmaing, a member of the liberal circle's radical wing.[84] A *normalien*, he had graduated in 1812 and then become a history teacher at St. Cyr's, the prestigious French military academy. In 1818 he had founded *Le Surveillant politique et littéraire*, in which he hotly championed liberal ideas, thus getting the paper banned very soon after it was launched. *Le Surveillant* let it be known, *inter alia*, that *normaliens* fervently hoped education might fall into line with "the progress of the century and of the shining lights."[85] *Normaliens* were not afraid of Rousseau and Voltaire. The paper also greeted the lectures of the young Cousin, Royer Collard's substitute in the very important chair of philosophy at the Sorbonne, as a brilliant success. As a lecturer at the Ecole normale, Cousin was also the teacher of nine out of the ten first history teachers. This greatly admired man did not sway young minds with appeals for a value-free or relativizing historical approach, but with a committed approach: "Any who interrogate [history] must keep the present and the future in view. . . . We believe that progress is a law governing everything, matter and spirit . . . the true principle of progress is a concatenation of disparate facts that succeed one another as do successive generations in the life of mankind."[86]

The *Surveillant* gave the ultras short shrift for treating the Charter not as a contract but as a concession, as "a free gift that the King, perhaps in an excess of generosity, had graciously granted the French people . . . the alleged rights of the people exist in the Charter alone." Darmaing was furious. In his view the Charter had dethroned despotism and was a monument "upholding for all times the power of reality, the influence of the Enlightenment, and the ascendancy of the people."[87] Needless to say, after this broadside Darmaing could not go on teaching history to future officers at St. Cyr. He became the parliamentary correspondent of *Le Constitutionnel*.

Royer Collard himself was older and more circumspect than either Darmaing or Cousin. Nevertheless, the ultras made him the butt of bitter attacks, especially in the area of education, where he championed the Université, that state education monopoly, which was a thorn in the flesh of the clerical party.[88] Royer Collard was also a declared opponent of the return of the ancien régime, so dear to the ultras. Let us listen to the address he delivered in 1817 on the occasion of the annual awarding of prizes to the best pupils of the Parisian *collèges*. "Love it, then, this noble country, whose reverses even proclaim her glory . . . love those institutions that summon all of you to serve them. . . . Love this august race that has protected your ancestors for so many centuries, that has brought them out of barbarism and restored them to civil life and to the liberties they had lost." With this last phrase, which no ultra would have endorsed, Royer Collard duly paid his respects to the monarchy. But then he plainly distanced himself from the reactionaries: "What was once fitting no longer suffices." In a sense he also distanced himself from pragmatic historiography: "Blind imitation of the past frustrates the hope of shaping the future." After decades of revolutionary convulsion and turbulent events, it was time for historical reflection. "Now the great spectacle of the past lies uncovered before your

eyes . . . all the experiences of the human race have been assembled, crowded into the circle of your studies." Hence it was all the more essential, Royer Collard contended, to match education and teachers to the demands of their own age and to the "new destiny" of France.[89]

At a similar festive occasion one year later Royer Collard was able to report results. At the side of classical letters, that "abundant source of beauty and truth . . . there has appeared special history education, the necessary complement to a classical education, which must nowadays embrace, together with an understanding of the world we live in, the fate of human generations through the ages." [90]

Once it was accepted that the ancien régime had gone forever and that the good old days would never return, history education became something more than a depository of "timeless" model behavior patterns. According to the *constitutionnels*, too much had happened to allow one to count on a replay of the past. History education could not remain a collection of isolated and undated biographies. Chronology had to be more than just a list of dates. The *constitutionnels* felt that without the idea of historical development it was impossible to understand the world in which one lived. One's own age and the Charter had to be seen as logical sequels to what had gone before and possibly—so the most progressive believed—as a stage on the road to a better and more open future. The eternally revolving wheel of time had to make way for the upward paths of history.

The First Ten History Teachers

In accordance with the decree of 15 May 1818 ten specialist history teachers were appointed to five elegant Parisian schools in September and October 1820.[91] For a time the history teacher continued to be a purely Parisian phenomenon. The royal *collèges* Louis le Grand, Henry IV, Saint Louis, Bourbon, and Charlemagne each added two history teachers to their staffs. All but one were *normaliens* and had therefore been influenced by Cousin. Six were aged twenty-five or younger, two were twenty-seven, one was twenty-nine, and one was thirty. None of them had had special training in history for the simple reason that no such training existed.

Who were these first ten men? The oldest, and the only non-*normalien* among them, was Charles Durozoir (b. 1790).[92] He was also the only one who was a declared supporter of the Restoration monarchy at the time of his appointment. On 31 March 1814 Durozoir had helped to organize an uprising and had been arrested. During the Hundred Days he was active in the Maison du Roi at Beauvais and glorified the return of the Bourbons in the *Gazette de France*. He was a member of the book-censorship committee (1817–22) and the author of such eulogies to the crown as *Le Dauphin fils de Louis XV* and also of a *Chronologie des Rois de France* (1821). In 1823 he became Lacretelle's substitute in the chair for ancient history at the Sorbonne.

Durozoir was the odd man out. Of the other nine, five did not reveal their

political opinions and four gradually turned into outspoken Orleanists. In the first group, Auguste Poirson (b. 1795) seemed to be a born teacher; he had a most successful career both at Saint Louis and later at Charlemagne (1837–53) and was the author of popular school textbooks.[93] Jean-François Gail *fils* (b. 1795) was more of a scholar than a teacher. He was really a Hellenist and later substituted for his father as professor at the Collège de France. His personal file contains a letter his father wrote from his deathbed in which he pleaded with the minister to appoint his son as his successor.[94] The unworldly Jarry de Mancy (b. 1796) was not suited to giving lessons: he was too gentle, had constant disciplinary problems, and suffered from laryngitis, that scourge of the teaching profession. He also taught at the Ecole des beaux arts and was, *inter alia*, the author of synoptic tables that, following in the footsteps of Lesage's famous atlas, tried to summarize history in tabular form. The only disadvantage of this excellent method was thought to be "the great ease it affords the indolent pupil."[95] Eduard Dumont (b. 1791) also was not a successful teacher; he proved unable to keep his classes in order and suffered from poor health. By 1834 he was completely worn out, and in 1839 he was granted permanent sick leave. He was, however, a fairly successful writer of textbooks.[96] The files do not contain any relevant details about the career of Jacques Dominique (Touchard de) Boismilon (b. 1795).[97]

Four of the ten were to become supporters of the July Monarchy and had problems after the 1848 revolution. Ovide Chrysaultre Desmichels (b. 1793), the son of a baker from Digne, was appointed rector of the Aix academy in 1831 and of the Rouen academy in 1838. According to the *Dictionnaire de biographie française*, his failure to do adequate documentary research and his lack of critical acumen made him one of the most harmful historians of his day. In any case, he was so politically tainted that Lazare Hippolyte Carnot, the republican minister of education, pensioned him off in 1848.[98]

Charles Cayx (b. 1793) refused to accept an appointment as *censeur royal* in 1827 and in any case declared himself a liberal after 1830. In 1837 he became Letronne's substitute at the Collège de France and was appointed inspector of the Paris academy. He also aspired to a political career. In 1840 and again in 1842 he was elected as a liberal member of parliament for Cahors; in 1845 he lost his seat but was appointed *inspecteur général* of education. In January 1849 he was put on the nonactive list, but he staged a comeback in September 1850 with a temporary appointment, followed in March 1851 by a permanent appointment as rector of the Seine academy. His career was crowned with the vice-rectorship of the Paris academy in 1854, a very senior post under the direct control of the minister of education. That academy was by far the most important of all, with the minister serving as its ex-officio rector. Cayx was the only one of the quartet of politically minded history teachers to carry on successfully after 1848.[99]

François Ragon (b. 1795) was appointed inspector of the Paris academy in 1838. He was considered an outspoken Orleanist. In 1848 anonymous letters were sent to the *citoyen ministre* denouncing Ragon as a "hyperbolic eulogist" of

the Orléans dynasty. The letters were studded with excerpts from Ragon's *Histoire de France*. He was pensioned off in 1849.[100]

The most committed and not the least of these men was Auguste Trognon (b. 1795). In 1822 he became Guizot's substitute at the Sorbonne; he was editor of the *Globe* and the author of several historical novels in the vein of Walter Scott. In 1825 the duc d'Orléans charged him with the education of the prince de Joinville; later he became secretary to the prince. After the February revolution Trognon remained loyal to the prince; he followed him to Claremont and acted as secretary to former queen Marie-Amélie. The French history that Trognon taught to the banished royal children became the basis of his *Histoire de France* (5 vols., 1863–65), for which he was awarded the Prix Gobert on Guizot's recommendation in 1865.[101]

The Reaction during the 1820s

What with the liberal views of the pioneers of history education and the political line adopted by a great many among the first batch of history teachers, it is not particularly surprising that the ultraroyalists had such strong reservations about the institutionalization of history education. When the Restoration turned reactionary in the 1820s things did not bode well for history. For years there was no increase in the number of history teachers, and the place of history in the curriculum slid downwards in the course of the decade.

And yet no ultra could have taken exception to the official instructions accompanying the decree of 1818. The future teachers of French history were enjoined to impress upon the memory of their pupils "the succession of kings, the most striking events during their reign, the wars, the treaties, the names of the leading personages associated with main epochs of the monarchy."[102] The undisguised official objective was to legitimize the crown—the monarchy provided the weft of patriotic history. These strict guidelines must be viewed against the background of the traumatic break with tradition. The circulars of 7 and 31 December 1818 stressed once more—there was obviously good reason for repeating it—that the aim was to reinforce love for the reigning dynasty. At the same time, however, there was also a reference to the gratitude for the institutions that France owed to her monarchy, a reference that was open to a variety of interpretations. To safeguard the future of history education, the instructions included an emphatic injunction to teachers to avoid everything that was connected with politics or gave occasion to partisan discussion.[103] History education must first and foremost serve moral ends.

Yet all these official instructions and circulars concerning the depoliticization of history education were not enough to dispel the ultras' suspicions. The *constitutionnels* had a bad name and *normaliens* had a liberal reputation. The reactionary government was afraid that "those ideas of progress and social advance, many of which make one fear that the youth in our schools might be infected," would be spread in the form of "observations and arguments."[104]

Much later, in quite different circumstances, when the Catholic leaders

pressed remorselessly for greater influence in public education, their then spokesman, Monseigneur Dupanloup, was only too conscious of the "congenital defect" of history education: "Almost on the very day that it was first included in the public education curriculum, history discredited itself by its own excesses."[105] Voices were raised urging the abolition of history education in many of the schools where it had only just been introduced. Just as God immediately recognizes his own, so the bishop unfailingly recognized his foes.

INSTITUTIONAL DEVELOPMENTS

The 1820s reaction made way for a consolidation and extension of history education during the further course of the nineteenth century. We shall confine ourselves to just a few aspects of this development, which still awaits an in-depth study. It is possible to distinguish between the formal, the substantive, and the philosophical aspects of history education. The formal aspect is not difficult to quantify, at least in part. It concerns the number of teachers and their share in the curriculum and in its general expansion, including the struggle over the introduction of contemporary history. The substantive aspect concerns the contents of school textbooks, the didactic guidelines, the great inquiry of 1871, and the reform movements of 1880, 1890, and 1902. There are good reasons for dating the birth of professional history teaching to 1890. The third aspect concerns the morality of history education and particularly of its politicization at the beginning of the twentieth century.

The Growing Number of Teachers

In 1828 a mere 12 history teachers were employed in French state schools. In 1911 that number had risen to 618. For a clearer picture of this considerable increase the reader is referred to table 15, which gives the relevant figures at intervals of twenty to twenty-two years for Paris and for the rest of France and distinguishes between state *lycées* and municipal *collèges* for the latter. As I have said, following the decree of 1818 the appointment of history teachers stagnated in the 1820s—only during the July Monarchy did it become customary to appoint specialist history teachers in the most important schools, even outside Paris. A marked increase in prestige and remuneration (and hence in appeal) came in 1830 with the creation of a special competitive examination (*concours d'agrégation*) for history teachers, thanks to which, just as had happened with philosophy in 1827, a prestigious elite of *agrégés* was produced. The advantages and disadvantages of the history *agrégation* are discussed in chapter 4. Here I shall merely point out that although the study of history received a great boost from the special *agrégation*, the salary and chances of promotion of history teachers continued to lag behind those of general arts faculty graduates. In 1844 the Chamber was petitioned to grant equal treatment and pay to history teachers. It had decided to extend such treatment to teachers of mathematics in

TABLE 15
History Teachers at *lycées* and *collèges* for Boys, 1828–1911

| Year | Paris Lycées *and* Collèges | Province | | Total |
		Lycées	Collèges	
1828	10	2	0	12
1848	20	130	0	150
1870	22	86	0	108
1890	44	145	181	370
1911	81	293	244	618

Sources: Almanach de l'Université royale de France, 1828; *Almanach de l'Université, République française*, 1848; *Annuaire de l' instruction publique*, 1870, 1890, 1911.

Note: The figures refer only to the *enseignement classique* for boys; not included are the *enseignement spécial* and education for girls. *Suppléants* are included, but not *chargés*. Unfortunately, there is a lack of reliable information on the subject of private education. For related problems see Isambert-Jamati, *Crises de la société, crises de l'enseignement*, 375.

1840 and to teachers of natural science in 1841.[106] According to the petitioners, the trust placed in history *agrégés* by charging them to teach the "national history of the French people" to the highest class justified their financial equality with other *agrégés*. The Chamber agreed.[107]

The Second Empire witnessed an appreciable decline in the number of history teachers at the provincial *lycées*. The total number of history teachers decreased by nearly one-third, from 150 to 108, in the period 1848–70 (see table 15). History of course felt the repercussions of the general pressure on state education, but it was also subjected to special cuts. In 1852 it was decided to abolish the *agrégation* for historians. According to Fortoul, the then minister of education, the competition had degenerated into an eloquence contest for pedantic *normaliens* (the usual whipping boys) and served no purpose other than the diversion of the snobbish Parisian public. "Their impassioned arguments" merely "twisted the ideas and falsified the true feelings of the contenders," and this led to the "stubborn defense of peculiar notions," Fortoul wrote in his report to the emperor.[108] This was during the heyday of the Bonapartist clampdown on potential hotbeds of liberal ideas. Fortoul wanted none but humble and tested teachers. For the time being, there would be just one general arts *agrégation*, to which candidates were admitted only after working in education for five years. Eight years later, however, in 1860, the separate *agrégation* for historians was brought back and the highly selective and hence highly sought recruitment of history teachers was thus resuscitated.

During the Third Republic history teaching made great strides. In 1890 the number of teaching posts in Paris was twice the number in 1870, and in the provincial *lycées* the number was greater than it had been in 1848. Moreover, for the first time history teachers were given a permanent place in municipal *collèges*. In the period 1890–1911 the number of history teachers in Parisian and provincial *lycées* doubled and the number of history teachers at the munici-

pal *collèges* rose by 35 percent. The increase in the total number of history teachers from 108 in 1870 to 618 in 1911 could be called spectacular (see table 15). But in relative terms too historians' presence in the teaching professions was growing. In the *lycées* alone their share rose from 10.6 percent of the total number of teaching posts in 1870 to 12.2 percent in 1890 and to as much as 16.2 percent in 1910.[109] History education was clearly on the ascendant.

History's Share in the Curriculum

In 1843, when minister Villemain outlined the state of education in his famous *Rapport au Roi*, the number of history and geography lessons from the lowest to the highest class accounted for 11 out of a total of 121 lessons a week. In other words, history (with geography) made up 9.1 percent of the curriculum.[110] During the second half of the nineteenth century the share of history (and geography) in the weekly schedule of the classical section was computed on a different basis, with the results shown in table 16.

In 1880 the syllabus was suddenly modernized, a step from which history was able to profit. We shall return to the substance of the reforms, but from the numerical data alone it would seem that in 1890 there was a reaction against, and, moreover, fierce criticism of, the dispensing of encyclopedic knowledge and the overtaxing of pupils. The total duration of lessons was reduced from 22.2 hours a week in 1880 to 18.5 hours in 1890. The share of Greek, Latin, and French increased (from 52% to 58.3%); the sciences suffered a small cutback (from 16% to 15.4%); and modern (foreign) languages were the greatest losers (from 11.5% to 7.3%). Against that background the damage to history (and geography) was not too grave (from 15% to 13.8%).

The reforms of 1902 ushered in the absolute and relative heyday of history in the curriculum of classical *lycées*. At more than 3.5 hours per week, history and geography took up 17 percent of the total number of school hours, a share never to be equaled. The reforms of 1925 limited history to three hours and ten minutes, or 15 percent of the curriculum, and in 1962 the share was still nearly the same.

In addition to education in classical *lycées*, the 1860s saw the rise of *enseignement special*, a form of special teaching that could be considered the forerunner of a modern *lycée* division. Here too history was given a permanent place and taught by specialist teachers. Among other innovations, the pupils were taught the history of industrial inventions. In the 1880 came the introduction of cultural history,[111] which was also considered a suitable subject for the education of girls, to which serious attention was being paid at the time.

The increase in the number of teachers and the growing share of history in the curriculum were the two firm pillars of the institutional development of history education. A (small) job market was being opened up. Teaching history became a way of earning a living. This was the infrastructure of history as a profession.

TABLE 16
Times Allocated and Share of History (and Geography) in the Weekly Schedule of the
Classical Sector of *lycées*, 1852–1902

Year	Time Allocated for History (and Georgraphy)	% of Total Weekly Schedule
1852	2 hours 35 minutes	13.0
1864	2 hours 35 minutes	12.5
1880	3 hours 25 minutes	15.0
1890	2 hours 30 minutes	13.8
1902	3 hours 35 minutes	17.0

Source: Isambert-jamati, *Crises de la société*, 380.

The Expansion of the Curriculum, 1818–1902

Nineteenth-century education too was plagued by attempts at reorganization. There is no need to produce here a detailed list of all the relevant decrees and instructions, but three items demand our special attention: the age groups of the school population to whom history was taught; the way the material was distributed among successive classes; and the struggle round the introduction of lessons in contemporary history.

Before looking at the first item, I should point out that I shall be referring to classes according to the French system. The 1818 curriculum, our starting point, looked as follows. In the sixth class (= 5th grade) and the lower preparatory classes no secular history was taught; instead the pupils were taught biblical history, and not, of course, by specialist history teachers. In the fifth class (i.e., the sixth grade) a start was made with ancient history. The pupils were taught the most important events and introduced to the most famous persons, and they were expected to be able to point out historical sites on a map. In the fourth class (seventh grade) the teaching of ancient history was continued up to battle of Actium (31 B.C.). In the third class (eighth grade) the pupils were taught Roman history, followed by medieval history as far as Charlemagne. The top class, called the *classe rhétorique*, was taught French history.[112]

In the 1820s the traditional sphere of the history teacher was considerably curtailed. It was decided to stop the teaching of history to the *rhétorique* in 1821 and to the second class as well in 1826. The whole of history was now squeezed into the fifth, fourth, and third classes. By successive decrees issued in 1829 and 1830 the situation prevailing in 1818 was restored, and during the further course of the nineteenth century the traditional sphere of the history teacher was extended further. In 1833 it was decided to teach history to the sixth class as well. In 1865 history scored further successes at the very bottom and the very top of the school system: henceforth history would be taught to the preparatory class (the seventh in the French system) and also to the class following the *rhétorique* (the *classe de philosophie*, which prepared pupils for the arduous entrance examinations to the *grandes écoles*). The final hurdle was cleared in

Table 17
History Education in Various Classes, 1818–1902

Class/Year	1818	1821	1826	1830	1833	1865	1880	1902
8							■	■
7						■	■	■
6					■	■	■	■
5	■	■	■	■	■	■	■	■
4	■	■	■	■	■	■	■	■
3	■	■	■	■	■	■	■	■
2	■	■		■	■	■	■	■
Rhétorique	■			■	■	■	■	■
Philosophie						■	■	■

1880 when biblical history made way for secular history even in the lowest preparatory class (the eighth). The realm of the history teacher was now at its widest (see table 17).[113]

Regarding our second item, the distribution of the subject matter over the years, it should be noted that until the 1852 reforms the teaching of history had always started with ancient history and that French history was not introduced until the final year. Thanks to the intervention of Minister Fortoul, an authoritarian Bonapartist (who abolished the *agrégation en histoire*), the old chronological sequence was dropped and French history was taught to the sixth, fifth, and fourth classes, ancient history coming later.[114] In 1865 French history had to take a few steps backwards in the classical division of the *lycée*, but there was no going back on the principle that French history must be taught before any other. In 1880 French history was extended further, at the expense of biblical history, into the lowest classes.

In 1880 the syllabus looked as follows. During the two preparatory years French history was taught in its broadest outlines. In the sixth, fifth, and fourth classes came the history of the Near East, Greece, and Rome, respectively, which were taught for two hours a week. From the third class on, history was taught for three hours a week. The third class learned European history and especially French history from 395 to 1270; the second class was taught about the period 1270–1610, the *rhétorique* about the period 1610–1789, and the *classe de philosophie* about the period after 1789.

In 1902 there came an important teaching innovation, associated with a wider choice of subjects for the pupils in the highest classes. It led to what we now call the concentric method. From the sixth up to and including the third class (what the French call the first *cycle*) pupils were first taken through the whole of history; the highest classes were treated to a second, more searching course in post-1498 developments.[115]

Generally it was not until the second half of the nineteenth century that the stress in the classical division of the *lycée* shifted from general ancient (and medieval) history to French history. This was later than one might have been

led to expect by the patriotic phrases with which the introduction and expansion of history teaching was championed even during the first half of the nineteenth century. Was it the resistance of the classical tradition that kept educational attention so firmly focused on antiquity? Or was the real reason French educators' fear of the politicization of history teaching? In view of how much dust the introduction of contemporary (French) history kicked up, the temptation is to plump for the second alternative.

The Struggle for Contemporary History

Although the highest class was taught modern history, the lessons did not go beyond Louis XIV until 1830. In the course of the 1830s, 1789 became the new terminus. In 1848 the government of the Second Republic wished to include the French Revolution and the Empire in the curriculum; at the instigation of Minister Carnot it was decided on 8 October 1848 that henceforth fifteen lessons in the *rhétorique* had to be devoted to the period 1789–1815, teachers being enjoined to refrain from "moral and political appraisals of the men of 1789."[116] In 1852, when French history was introduced into the lower classes, 1815 still remained the final date.

Truly contemporary history, that is, history including the past fifty years, was first taught in 1865. Fierce press campaigns and heated discussions in the Chamber accompanied this revolutionary decision, published in the name of Victor Duruy, the *grand ministre* mentioned in chapter 2. In 1862, when he started to teach history at the Ecole polytechnique—one year before he was appointed minister—Duruy had first called for the teaching of contemporary history. He considered it no more and no less than a eulogy to the achievements of one's own age.

Duruy referred to the din of the factories as the "cry of pain of matter forced into submission"; science had "consecrated man king over nature subdued."[117] By guaranteeing liberty, the modern state had ensured that the economy could flourish (the free-trade treaty of 1860 was dubbed "an economic 1789"); hospitals and schools had made sensational progress. Criminal law had been reformed—criminals were no longer considered enemies of society but sick people in need of treatment—and with success: in 1859 there were 550 fewer recidivists than in 1858 and only 21 executions in the whole empire (that number previously had been typical of Paris alone). Alas, criminality had not yet declined appreciably, but the causes were clear: 84 percent of those brought before the courts could barely read and write or were totally illiterate. "Ignorance, there is the enemy!" Locomotives and the electric telegraph bridged space and time. The steamship braved winds and waves. Contemporary history must, according to Duruy, radiate confidence in science and progress.

Pupils who left the *lycée*, Duruy argued, were sent out into the world better prepared for life in ancient Rome, Athens, Sparta, or Babylon than for life in Paris. They were not being trained for their own society. "Steeped in the past, they are keen on the present and take it where they find it, in partial and

truncated pamphlets or essays." These pupils were not given a correct picture of the "organization, the needs, the aims and the laws governing our society or of the spirit of justice that is its inspiration."[118] Duruy believed that the teaching of modern history must help the pupil to find his way in the world.

That objective was particularly associated with the *enseignement secondaire spécial*, in which contemporary history was assigned a very important place. This *enseignement spécial* was meant to replace Fortoul's *bifurcation*, which, incidentally, was flourishing.[119] Fortoul, inspired as he was by Saint-Simon, had established, within the classical *lycée*, a less classical packet of options designed to equip the sons of the bourgeoisie for life in modern society. Now the classically minded teaching fraternity turned out by the Université had put up a great deal of resistance to Fortoul's *bifurcation*.[120] Duruy opted for a separate, shorter, and less prestigious form of "special" education in addition to that provided by the classical *lycée*. Duruy's predecessor, Rouland, incidentally, had already prepared the way for this solution, though Duruy's memoirs do not give that impression. In any case, the growing number of pupils taking *enseignement secondaire spécial* were in a hurry to start professional work and could not afford "prolonged contact for seven or eight years with the finest minds of Greece, Rome, and France."[121] For them contemporary history was a godsend.

The introduction of contemporary history, presented as a "course in patriotism and social education," led to fierce attacks on the minister by both clerical and republican circles. Duruy was accused of trying to make Bonapartist propaganda, and in fact his conception of contemporary history did lay him open to that charge. Moreover, a popular school textbook written by one of his sympathizers seemed to suggest that the Second Empire was the fulfillment of all promises. Not surprisingly, the critics were sardonic: "History lessons will, no doubt, henceforth have to run from Adam to Napoleon III and from the expulsion from Paradise to the French exodus from Mexico."[122]

Of course Catholic objections to the introduction of contemporary history into the syllabus had much greater political weight at that time than the protests of what was a small group of republicans. Considered on their own, the objections by leading churchmen to Duruy's contemporary history were valid in several respects. There was no doubt that it served as government propaganda, though reproaches of "bias" sounded a bit hollow in the mouth of Catholic spokesmen. Long before the introduction of contemporary history into French schools Catholic schoolmasters had been teaching contemporary history, if not in their history lessons then at least during religious instruction.

An anonymous pamphlet published in 1864 casts some light on how Catholic educators conveyed a picture of their own period to their pupils well before the state introduction of contemporary history. In connection with the Ten Commandments the pupils were reminded that "the Revolution is, therefore, the denial of God's Rights for the sake of human license in the three social spheres where these Rights ought to prevail: the domestic, the civil, and the religious. That amounts to the deification of man. It is nothing but the sin of the rebellious angels."[123] And it was in this light that the history of the preceding

fifty years ought to be taught. In 1814 Louis XVIII had "fatally" served the interests of the Revolution with the Charter. As a result, the writings of Voltaire and Rousseau had been reprinted, and in 1830 all hell had been let loose again. The revolution of 1830, "striking at the throne and above all at the Church," had led to the sacking of cathedrals and churches, the smashing of altars, and the persecution of bishops and priests. Ever since, the road had been wide open for "insolent doctrinal systems," such as those of Saint-Simon, Pierre Leroux, and Fourier. In 1848 these doctrines, which were at one in their hatred of the three manifestations of divine authority—the church, the state, and the family—were being taught in public. The Catholic Church was being assailed with pantheistic doctrines and with the denial of the fundamental dogma of the Fall, the state was being dismissed as an artificial creation, and the family was being pushed to one side by the denial of property and of the principle of heredity.[124]

Duruy's conception of contemporary history, as I have said, not unbiased, but it was certainly less divisive than Catholic education as seen by our anonymous author. Was he exaggerating, perhaps? The general tenor of his pamphlet is temperate, far from fiercely anticlerical, and not at all antireligious. The pamphlet ends with the wish that, as part of "our religious practice," pupils might be taught respect for all that was "noble" in the aspirations and the needs of France. It was wrong to teach history simply "to inculcate hatred and a false view of one's own age."[125] And there was no doubt that the ideological polarization of French society was reflected in the antagonistic interpretations of contemporary history.

In connection with the institutional development of history education, it should also be stressed that Duruy's conception involved the introduction of new subject matter. He not only drew a new chronological boundary but also widened the scope of historical inquiry. His conception *was* a worldview, and as such it embraced contemporary subjects: industry, electricity, steam, agriculture, the reduction of poverty and criminality, and greater welfare provisions. Duruy did not reap the praises of classical arts-orientated educators, who believed that a history of import and export duties was taught at the expense of lessons in morality.[126] But no matter what Duruy's secret (secondary) motives may have been, he helped to extend the independence and competence of history teachers in 1865 by the inclusion of contemporary history lessons in the *classe de philosophie*. Not only would history teachers henceforth teach the top class but they would teach topics that had never been broached before.

After the fall of the Second Empire contemporary history continued to be taught to the highest class, but the pupils were not taken beyond 1848. The Second Empire, it was felt, had best be ignored. In 1880, however, ultracontemporary history was reintroduced. Henceforth the highest class was taught French history with a special emphasis on the period from 1789 to the "constitution" of 1875. The instructions issued in 1880 even specified that the highest class ought to be treated to free discussion of "historical facts that might be open to controversy or to different interpretations." It was thought that this "type of historical and moral argument" would help to complete the intellectual

training of pupils in the highest classes. That sounded nice and tolerant, but in a polarized society in which the Republic continued to encounter bitter opposition and in which there was keen rivalry between public and special education it could of course never have been the intention of the republican government to leave any doubt about the legitimacy of the (republican) institutions.

Small wonder, then, that Gabriel Monod, writing in the *Revue historique*, a journal of unimpeachable but moderate republican sympathies, voiced reservations about instructions that threatened to politicize history education and to change it into a "republican or moral course of lectures." Naturally, the same strictures applied to the treatment of burning questions from earlier periods—the St. Bartholomew's Day Massacre, the revocation of the Edict of Nantes, the execution of Louis XVI . . . The differences in opinion regarding these matters arose from differences in political and religious outlook, Monod explained, and "introducing regular discussions of such matters would threaten to transform the classroom into a battlefield of impassioned and irksome disputes." Monod was afraid that it might encourage doctrinaire attitudes or else give rise to mere gossip. He wanted to keep history education as "scientific" as possible so that its conclusions might be "nothing but generalizations based on the attentive and impartial study of the facts." "Let us refrain," Monod continued, "from adding to the philosophical orthodoxy of the *lycées* a historical orthodoxy, which might result from obligatory discussions of the morality of events."[127] Monod's scruples were ignored; Ferry and his circle introduced the type of education they thought the country needed.

During later reforms the boundaries of contemporary history were moved forward. In 1902 the year 1889 (the centenary of the Revolution) was chosen as the last date on the history syllabus.

SUBSTANTIVE DEVELOPMENTS

Early School Textbooks and Didactic Guidelines

Adopting a program is one thing, implementing it quite another. The decree of 1818 simply included the didactic guideline "that the teacher shall establish by frequent questioning . . . whether his pupils have grasped and retained what he has taught them." However, no textbooks were available as yet. The Committee for Public Education promised to that a list of such works would be issued at the end of the year. For biblical history and mythology the recommendations included Fleury's traditional *Catéchisme historique* and the just as indestructible *Appendix de Diis*. As further teaching aids the committee suggested a map of the world, a map of the Holy Land, lists of dates, and special maps for the teaching of history. Geography remained subordinate to history. The committee also wanted to take a pupil's history marks into account when deciding on promotion to a higher class. That was a big enticement, and to make it even more appealing a history prize was established in 1819 (in accordance with the tried pedagogical principle of *emulatio*).[128]

Besides these summary recommendations, the authorities confined their efforts for a time to the official endorsement of textbooks, which, once the syllabus had been agreed upon, began to appear regularly and in a variety of shapes and sizes in the 1820s. Their authors included a great many of the earliest history teachers. Successive changes in the syllabus necessitated adaptations and revisions of these early readers. Teachers were eager to write new textbooks or to revise the old ones because the income meant an addition, sometimes even a sizable one, to the wage packet.

It is possible to distinguish three generations of history books. The first generation began to appear in the 1820s; the second in the 1850s, partly under the influence of a drastic revision of the syllabus; the third in the 1880s. From then on history education made rapid strides. Not only revisions but also new teaching methods helped to outdate textbooks more and more quickly and even led to the publication of a spate of them from the 1890s on. Moreover, at about the turn of the century bitter public ideological conflicts led to a veritable "handbook war."

The retrospective assessment of the value of the first generation of textbooks, or *précis*, was somewhat scathing. They were referred to as "jumbles of facts," a "stock list of proper names and dates linked by uniform formulas," and were accused of turning history into no more than a "series of wars, treaties, reforms, and revolutions that differed only in the names of nations, princes, battlefields, and dates."[129] This harsh view was not altogether fair in the circumstances; besides the classical historians whose writings were studied during Greek and Latin lessons, there were only too few decent history books that pupils could read outside the classroom and "particularly at home."[130] The institutionalization (and hence the standard treatment) of history accentuated the hopelessly unsuitable character of the thoughtlessly truncated masterpieces used for optional reading in the eighteenth century. Compared with such eighteenth-century *abrégés*, the early-nineteenth-century *précis* certainly constituted a great step forward.

Thus authors from the first batch of specialist history teachers, such as Poirson, Cayx, Ragon, and Michelet, were aware of the shortcomings and limitations of their *précis*, but they knew that their books were better than the old *abrégés* in three respects.[131] First, they incorporated the results of new studies; second, they conveyed a clearer picture of the subject matter; and third, they aimed at "dramatic unity." And in presenting their subject matter, alongside wars, treaties, and alliances, they regularly assigned a (modest) place to a "survey of the political institutions, of the nature of the legislation, of manners, of literature, and of the sciences."[132]

Needless to say, the first generation of textbooks also included many less effective products. Among the more successful *précis*, however, several were snatched up by adults who had not been taught history in their youth. Michelet's *Précis de l'histoire moderne*, in particular, the first edition of which was published in 1827, was praised for its originality and vision by the great Sismondi himself.[133] All in all, these textbooks were remarkable for their qualities rather than for their failings.

The greatest objection to them was that they had not really been written for children, that they had not taken the child's intellectual level and way of life into account (which partly explains their success with adults). On top of that, the *précis* were crammed with dates, which many teachers, often out of sheer indolence, considered to be of paramount importance. Learning by rote may well be described as the original sin of history education, but it could not really be blamed on the *précis*. On the contrary, it was thanks to them that, as many qualified critics were quick to remark, "observation and argument" were given a place in education, and that represented a "veritable revolution in teaching."[134]

The authors of the *précis* certainly considered history to be more than memory training. What mattered was not just "the quick recital of all the relevant facts" but also "the elucidations and reflections" needed by anyone about to "subject the facts to discussion and to deduce their consequences."[135] There was not the least doubt that the philosophy of history Cousin had in mind made its entry into education with the help of these early textbooks. The wish to turn history education into more than memory training was formulated as follows: "What we look for in the facts is their interrelationship and their spirit . . . we do not look upon the history of facts as our way; our true aim is the history of ideas. We propose to trace that history through the centuries in order to arrive at the general law constituting its center and true importance."[136] And in his *précis* Michelet explained that he had tried to "represent all the intervening ideas, not by abstract expressions but by characteristic facts that can capture the imagination of the young."[137] One may of course mock this idealistic approach to history, in which without the least hesitation certain "facts" were considered to bear out cherished ideas, ideas thought to be built on unshakable foundations. But no matter what the objections, it was largely thanks to these *précis*, even if on a limited scale and in tentative form, that "philosophical" ideas— ideas that had been adding luster to the study of history outside the classroom for a considerable time—were introduced into history classes.

History textbooks proved of considerable help to schoolmasters. It should be recalled that these expensive innovations were at the time meant primarily for the teacher, not for the pupil, to whom the contents were normally dictated. Beyond that, we have very little and only indirect knowledge about the way history was taught.

A typical handbook for teachers was the *Manuel des maîtres d'études ou conseils sur l'éducation dans les collèges de l'université*, by P. Henry, rector of the Angers academy, first published in 1842.[138] The attention Henry paid to history as a school subject was remarkable in itself: it reflected a growing concern of educationists.

Henry began with the sober observation that the time allocated to history in the schedule was inadequate for the students to gain detailed knowledge of the set curriculum. The history teacher must therefore make sure that his pupils learned the rest outside of school hours. To keep some check on this part of their work, the teacher must now and then look into his pupils' exercise books to ascertain whether they had done the requisite homework. This was not advo-

cated on the basis of any educational principle, but was dictated purely by lack of time, much as it had been in the eighteenth century, as we know, for instance, from Rollin's instructions. The history teacher was therefore, in Henry's words, "a director of historical studies,"who mapped out the lessons, explained how to classify and evaluate events, and taught his pupils to see the facts in the round and to determine their nature. The teacher must also assess the historical worth of the various writers of textbooks and be on his guard against "systems." During lessons he should confine himself to generalities; for detailed knowledge the pupil had to rely on his own reading.

Normally a lesson lasted for two hours. At the time, educationists did not yet make allowances for the fidgeting and growing lack of concentration of schoolchildren. (Only at the end of the nineteenth century were lessons cut to one and a half hours, and not without fierce resistance.) According to Henry, these two hours had to be divided as follows: thirty minutes for tests of what had been taught at the last lesson; fifteen minutes for checking the pupil's notes on his independent reading; thirty minutes for a discussion by the teacher of the homework set last time; thirty minutes for the new lesson dictated by the teacher; and finally, during the last fifteen minutes, a summary by the best pupils of the new material. Hence no more than 25 percent of the lesson was devoted to ex cathedra lectures by the teacher, and 75 percent to testing, correcting, and summarizing. The pupil's exercise book played a central role in all this. The expensive school textbooks were, as I have said, largely intended for the teacher's own use. Loose-sheet exercise books were considered preferable to bound ones. At the end of the year the corrected loose sheets could be numbered and bound, together with a list of dates and an alphabetical index. Geography, as already mentioned, was treated as a subsidiary subject.

Whereas, as a qualified observer put it, the task of the history teacher in the 1820s and 1830s had by and large been to keep order in the classroom and give out the numbers of the pages to be read by the pupils,[139] in the 1840s, as Henry's educational instructions make clear, rather more was expected of the history teacher.

The Instructions of 1854 and the Second Generation of School Textbooks

The next phase in history education started at the beginning of the 1850s with an incisive revision of the syllabus, accompanied by instructions by Minister Fortoul. French and modern history were assigned a larger place at the expense of ancient history. Education became regimented and standardized. Henceforth there was little opportunity for straying from the official path; those who did could expect sharp reprimands from the dreaded inspectorate. The minister of education's ideal, according to Taine's sally, was to be able to tell precisely, whenever he looked at his watch, what subject was being taught at that very moment in every single classroom in France. The Bonapartist authorities' distrust of teachers, who in 1848 had proved so susceptible to liberal, pantheist, deist, indeed even atheist ideas, played an important part in their determination

to exert strict control. A greater place was assigned to religious instruction than had been usual in public education. All in all, though, Fortoul's instructions cannot be called purely repressive.[140]

No one can deny that the instructions of 1854 represented an attempt to adapt education to the needs of the times and to the educational level of the child. The classical tradition in education was anything but sacrosanct to the authoritarian Fortoul, a man inspired by Saint-Simon. He ordered that much more attention would have to be paid to the French language—"à la langue nationale sa juste prépondérance"[141]—and to French history. The instructions concerning history in particular were infused with a fresh spirit. In 1852 Fortoul charged Victor Duruy, then still a teacher, with revising the history curriculum.[142] It is difficult to determine the Duruy's precise contribution from documents signed by the minister alone, but there is good reason, in respect of the teaching of history at least, to speak of the Fortoul-Duruy instructions of 1854. The vilification of Fortoul and the adulation of Duruy, both of which are part of the canon of prorepublican historians, seem to be totally unjustified as far as history teaching is concerned.

The Fortoul-Duruy instructions, which were considered to be binding until 1880, sharply condemned the "original sin of history instruction," namely, the ramming down of dates and the learning by heart of a surfeit of facts, "this sterile abundance . . . this chaotic prodigality of reminiscences."[143] Instead, general developments should be emphasized, and the history teacher was enjoined to appeal to the pupil's mind rather than to his memory.

According to the binding Fortoul-Duruy instructions, a model lesson had to be organized as follows: fifteen minutes for going over and outlining the last lesson; fifteen minutes for questions on the last lesson; twenty minutes for the dictation of a summary of the new lesson; forty-five minutes for the actual ex cathedra lesson; and twenty-five minute for checking the homework.[144] These instructions differed in several striking ways from Henry's proposals. To begin with, the time set aside for the teacher's spoken lesson had been increased by a quarter, to nearly 40 percent of the lesson. This was a reflection of the history teacher's increased prestige and competence. Second, all pupils were henceforth given the same standard dictation, summarizing the lesson the teacher was about to deliver. The subject matter was therefore standardized, and pupils were able to follow the major historical developments more easily. Third, the pupil's independent reading was abandoned. As homework, besides learning the last lesson, the pupils were frequently asked to write an essay on a historical subject, the so-called *composition historique*. That essay was really more of a literary exercise and was recommended as such. At the end of the nineteenth century the reformers of history education fulminated against these *rédactions*, which, they agreed, might well fulfill a useful literary function but which gave rise to the most ridiculous history compositions.

Although the Fortoul-Duruy instructions cut the teacher's freedom to a minimum, they did not lead to a general deterioration of the quality of history instruction. Quite apart form the fact that quite a few changes were improve-

ments and the likelihood that standardization raised the average level of knowledge and understanding, strict regimentation implied a firm commitment to history in schools that had previously neglected that subject. The instructions were thus two-edged—while reflecting the wish for modernization and for better adaption to contemporary conditions, they were also antiliberal and repressive. In short, they were a characteristic product of the Second Empire.

Victor Duruy also played a leading role as publisher and author of the second generation of textbooks.[145] He wrote versions adapted to the needs of every class, from biblical history for the lowest to contemporary history for the highest. Duruy was able to hold the interest of pupils because he presented them with much more lively accounts than the first *précis* had done. In his *Histoire grecque* (1851) he set democratic Athens above aristocratic Sparta. That earned him a reprimand from the education authorities, who charged him with committing "audacious temerities."[146] His *Histoire de France*, which became a great success and was translated into German, English, Spanish, Italian, and Slavonic, was attacked in the 1850s for its "regrettable outbursts." Expert critics in the early seventies considered Duruy's textbooks the best available at the time, "less because of their accuracy than thanks to the flow of the narrative."[147] It was not until the eighties, under Ernest Lavisse, who revised parts of Duruy's writings and later succeeded him as the semiofficial editor in chief of history textbooks at Hachette's, that the third generation of history textbooks was ushered in. But amidst the stream of new books Duruy's continued to be used until the beginning of the twentieth century.

Apart from Duruy's books, teachers of contemporary history also made great use of the textbooks written by G. Ducoudray (also published by Hachette), C. A. Dauban (published by Delagrave), and L. D. Brissaud (published by Belin). In the *enseignement spécial* the most widely used textbooks were those by G. Hubault, E. Marguerin, and H. Pigeonneau (published by Belin).[148] Needless to say, there were also less successful products. In general, we can say that in the fifties and sixties several series of textbooks saw the light of day, all of them more lively than their predecessors and adapted to the prescribed curriculum of every class and all designed to help the history teacher comply with the strict new directives.

The Inquiry, 1871

Many French people saw the military defeat of 1870 as an intellectual defeat as well, the result of inferior education. Much as their defeat by Napoleon some seventy-five years earlier had acted as a catalyst for the Germans, so this defeat proved an enormous stimulus for French educational inquiries and reform plans. After the Franco-Prussian War Nietzsche had had good reason to warn his compatriots against letting down their guard.

Now it has to be said that reform plans had been drafted by special committees even before 1870, but those had invariably been tucked away in drawers and no reform movement had ever taken a real stand. The reformers' arguments

only struck home after the French debacle, the German challenge having its most incisive effect on French higher and elementary education. The reforms of the arts faculties are discussed in chapter 4; those of elementary education under the laws of Jules Ferry around the year 1880 are not of particular interest here, seeing that there were no specialist history teachers in primary schools.

Secondary education was less affected than elementary and higher education. It was the only educational level with a rich tradition, and one that it is generally agreed could stand comparison with Germany. True, there were critical voices and various reforms were introduced, but it was not until the turn of the century that the great parliamentary inquiry into secondary education under Ribot was to take place. The underlying motive then was not the German challenge but the internal political situation, the object being to find an explanation for the success of private, confessional secondary schools. The Dreyfus affair had demonstrated the strength of the enemies of the Republic, men who had enjoyed a Catholic education. Only at this point were the state *lycées* subjected to scrutiny.

But though a *general* investigation was not to be held until nearly thirty years later, certain school subjects were found to be in need of urgent repair immediately after the French defeat. In particular, it turned out that French soldiers' knowledge of geography was deplorable. French officers were unable to read topographic maps, and this in sharp contrast to their well-trained German counterparts.[149] Better geography instruction seemed the obvious remedy, and a great inquiry into the matter was launched. Seeing that geography was linked to history like a Siamese twin, and that the two were also taught by the same masters, the inquiry naturally included history teaching.[150]

By far the greatest attention in the final report was paid to secondary education. The most important item in the report on the faculties was the final *lycée* examination set by university professors. The examiners complained bitterly about the candidates' standard of knowledge: "In history the answers of the candidates are inadequate . . . in geography they know next to nothing." The examiners went on to express the wish that history and geography be assigned a more important place in the assessment of the pupils' general standard and that the period on which pupils were examined no longer be confined to events after 1643 but include the time before 1643 as well. It is remarkable that nothing at all was said about the special training teachers received in these subjects from the faculties. In chapter 4 we shall look more closely at the creation of training colleges for teachers in higher education beginning in 1880. In 1871 the *rapporteurs* did not yet call for such training: their attention was focused on secondary education.

The inquiry covered twelve of the seventeen academies into which French education was geographically divided. Because of conditions resulting from the war, the inspectors did not visit the academies of Strasbourg, Nancy, Caen, and Lille, nor did they visit the academy of Paris since enough was known about it as it was. Because the general situation in Paris and in the northeastern prov-

inces was better than it was in the southern and western provinces, it seems likely that the picture drawn by the *rapporteurs* was too negative.

Of the fifty-five members of the elite corps of specialist history teachers in these twelve academies fifty-three were seen by the inspectors. Fewer than half (24) were *agrégés d'histoire* and just one was a *docteur*. The greatest number of history lessons in secondary schools in about 1870 were not given by specialist teachers. In the lower classes of the *lycées* the subject was taught by the *professeur de grammaire*; neither in the *enseignement spécial* nor in the *collèges* were there specialist history teachers at the time. In general the state of history teaching in schools without specialist teachers was bad. We are even told of a teacher whose results in other subjects were quite respectable but who did not bother about history at all because there had been no inspection for ten years and he was therefore under the impression that history and geography had been scrapped. In the *petits collèges* of small towns it was customary to combine two years into a single history class and to teach them side by side, which did not help the pupils' education. Apart from one positive exception, the *rapporteurs* made only negative comments about the competence of nonspecialist teachers.

The report had little to say about the best teaching methods or the best way of organizing the lessons. Almost without exception the specialist teacher dictated a summary of the lesson he was about to give, and the pupils were expected to learn the summary for next time in accordance with the Fortoul-Duruy directives. Then the teacher would deliver his lesson in full while the pupils took notes, to be produced at the next lesson. After marking the homework, the teacher spent some (unspecified) amount of time on questioning the pupils. This was an educational innovation; such oral examinations were still far from usual, and according to the *rapporteurs*, few teachers appreciated their importance. Teachers were warmly enjoined henceforth to devote half an hour of each lesson to this new educational technique, whose purpose it was to put an end to the pupil's passive role. At the same time teachers were warned against the danger of letting their pupils take too many notes of the lesson, as this might lead them to repeat like parrots what they had not really taken in. According to the *rapporteurs*, although most nonspecialist teachers organized their lessons in much the same way, it had happened more than once that a teacher gave no oral lessons at all and dictated, or had the pupils read, from a book. In striking contrast to Fortoul's advice to keep strict discipline and to his general directives, the *rapporteurs* advised that teachers be given greater freedom in organizing their lessons and in the choice of teaching methods.

As for geography, the original reason for the inquiry, it was without exception treated worse than history and often not taught at all. The *rapporteurs* were particularly scathing about conditions in the *enseignement spécial*. "In conventional education, history is given pride of place, and that it is how it ought to be, but in the *enseignement spécial* it is particularly important to impart practical knowledge, and therefore it matters more to the pupils to know about the production of goods in Belgium and about trade in New York than about the

details of the War of the Spanish Succession," the report stated. It was proposed that henceforth two of the weekly three hours should be devoted to geography and only one to history.

To the dismay of the *rapporteurs*, the pupils at *lycées* and *collèges* were found to lag behind those at the training colleges for teachers in their knowledge of French history and geography. This was only to be expected from the conventional school system, but the *rapporteurs* apparently failed to realize that and thus were incensed. To demonstrate how poor *lycée* pupils' knowledge of France really was, the *rapporteurs* revealed that only one out of twenty in the top class seemed to know the capitals of the various departments. Fortunately, the teachers of the future were better prepared. Again, in the third *lycée* class not a single pupil knew the names of the first four Capetians, and pupils in the second class of several big *lycées* were unable to name the Valois kings. It is odd that this should have been considered a measure of historical knowledge in the early years of the Third Republic.

The report ended with a series of recommendations. An attempt must be made to have all classes from the third on be taught by specialist teachers. In the higher classes at least one lesson every two weeks must be devoted wholly to geography. In the top class ultracontemporary history (i.e., history after 1848) ought to be dropped and replaced with the general revision of history up to 1815, history from 1815 to 1848, and the "geographical study" of the territorial, political, and national changes in the world since 1848. Apparently, ultracontemporary history had become identified with eulogies to the Second Empire and had therefore to make way for more "geographical" knowledge of the contemporary world.

Reports were also made on the teaching of history and geography in primary schools. Even though the inspection of this educational stratum was less thorough because of its vast size, it became clear that most elementary schools still failed to teach any history at all, despite the fact that history lessons had been made compulsory in 1867. All training schools for teachers were inspected and the conclusion was that the quality of the lecturers at these schools left much to be desired, their basic knowledge was greater and more solid than that of teachers in secondary schools. The inspectors expressed the hope that these training schools and their turnout of better prepared teachers would eventually result in a higher level of history teaching in elementary schools.

In highlighting the less than rosy state of history teaching and the deplorable state of geography teaching the report provided a useful antidote to the "theoretical" development of programs, instructions, and guidelines. Moreover, the report seemed more reliable than Michel Bréal's comments on history instruction, made at about the same time, in his influential and authoritative work on French public education. Bréal contended that by and large history was being taught well. He did note, however, that too much attention was being paid to dates and details and wondered whether there was a professional historian anywhere in the world who had as many events from French history at his fingertips as the French pupil preparing for his final examinations.[151] Bréal's opinion

was based largely on conditions in Paris (and Paris had been left out of the report). As an intimate of Jules Simon, the then minister of education, and a member of Simon's semiofficial advisory council, which met every Saturday,[152] Bréal ought to have been more familiar with the situation in the rest of France.

For the rest, Bréal's work included a great deal of sensible advice and remained an inspiration to educational reformers for a long time, not least because of its powerful attack on the customary routine methods. When it came to history instruction, Bréal was an early champion of the concentric method, which was not to be adopted until thirty years later, in 1902. However, one piece of advice he gave, had it been followed, would have been a serious blow to the hard-won independence of history teaching. In keeping with the age-old arts tradition, which reflected his philological preoccupations, he believed that history teaching should be based more fully on the reading of the great historians. "What matters is not so much the incidents of the Peloponnesian War or of the struggle between Louis XI and Charles the Bold; far better to have the pupils read Thucydides or Comines."[153] This approach entailed the great danger that history would again be taught as part of literature by teachers versed in that subject. History would then have been forced back into the ancillary position it had held for so long.

The Educational Reforms of 1880

An important wave of educational reforms was launched by Jules Ferry, who on 18 December 1879 took office as minister of education in the Freycinet cabinet, which had set itself the task of consolidating the republican victory. Elementary education was improved by major educational laws, and higher education too was reorganized. Although the organization of secondary education was least affected by the reforms, there was a drastic modernization of the *contents* of the conventional education curriculum in accordance with wishes previously expressed, for instance, in the famous circular issued by Minister Jules Simon in 1872 and strongly inspired by Michel Bréal.[154]

The main result of the 1880 reforms was that French was assigned a much greater place in standard education, at the expense of Latin. The composition of Latin verse was abolished and the Latin oral exam, that century-old stumbling block and most important aspect of the final examinations, was replaced by a French commentary on the text. The fabulously long reign of rhetoric in conventional education was broken in 1880. This is not the place to evaluate these incisive changes, except to point out that history teachers were henceforth forced to brave competition from other "modern" subjects. The reformers unleashed a veritable quarrel between the ancients and the moderns in the *lycées*, which was decided in their favor; there followed a reaction that did not really come to an end until 1902, when the range of options open to pupils in the higher classes was expanded.

The reformers' aim was the replacement of the "lesson of words" with the "lesson of things." The reforms themselves were formulated as follows: "Substi-

tuting the development of the child's own judgment and initiative for the exclusive cultivation of the memory, and preferring the experimental method, which proceeds from the concrete to the abstract and deduces exemplary rules, to a priori procedures and the abuse of abstract laws."[155] History was on the march; like geography, it was being treated as an important modern subject to which more school time had to be devoted. The ministerial directive called for systematic instruction in geography, a subject to which no previous ministerial decree had devoted so much space.[156] Even physical training was paid less attention, and this even though the pronounced intellectual bias of education was being challenged by progressive circles.

The educational guidelines for history teachers, published on 12 August 1880, did not include any revolutionary recommendations. They advised that there be greater emphasis in the higher classes on the study of institutions, customs, and manners rather than on "minor events" or the "details of military campaigns." French history ought to highlight "the general development of the institutions from which modern French society has sprung" and fill pupils with "respect for, and loyalty to, the principles on which this society is based."[157] Neither the warning against learning about minor events, especially those of military campaigns, nor the wish to legitimize the existing institutions was original. Sanctioning the status quo had been a structural element of almost every form of history teaching under the various political regimes. However, this type of institutional history assumed an unprecedented polemical character in the polarized atmosphere in which the young and fiercely attacked Republic tried to find its feet.

The most striking aspect was what the reformers left out. For example, they paid no attention to the industrial and economic developments so strongly emphasized by Fortoul and Duruy, two Second Empire education ministers of Saint-Simonian inspiration. But fairly soon afterwards, in the course of the 1880s, attention to these nonpolitical subjects was nevertheless paid (as part of "cultural history") in the *enseignement spécial* and in the expanding field of education for girls.[158] In 1880, however, it seemed that the Ministry of Education was putting everything second to engraving the importance of republican institutions on the child mind. Oddly enough, the directive issued by Cumont, minister of education in the conservative Cussey cabinet during the heyday of the Ordre Moral (1874), a man whom later republican historians accused of having ushered in a "pedagogical counterrevolution," sounds more modern, what with its recommendation that teachers devote more time to "civilization, the arts, the sciences, commerce, and industrial labor and also to the role of institutions."[159]

Several didactic directives were linked to the recommendation of the 1871 report, namely, greater emphasis on oral examinations and less time for the written revision of notes. As mentioned earlier, the recommendations also included the discussion of controversial historical events. Not everyone was convinced of the minister's genuine wish to use this device simply to foster greater interest among pupils.

As for the guidelines for history teachers, in 1880 there were merely minor changes; it was only in the course of the 1880s that major reforms were ushered in, to be codified in 1890. In 1880 the young but already authoritative *Revue historique* published Gabriel Monod's view that all existing school textbooks were antiquated.[160] The third generation of textbooks was about to be born.

1890: The Birth of Historical Pedagogy

In the seemingly endless list of new curriculums and instructions 1890 marked a particularly significant year for history education.[161] The most important general institutional change in secondary education introduced by Minister Léon Bourgeois in 1890 was the abolition of the independent status of the *enseignement spécial*. It was replaced with an equivalent modern department of the prestigious *lycée*. At the same time, the reforms of 1890 meant a partial restoration of the status of the humanities, that is, of the traditional arts and letters, after the losses they had suffered in 1880. Languages were able to regain part of their old position once the "lesson of things" had been made a guideline. More so than even in 1880, emphasis was laid on textual commentaries (instead of translation exercises and compositions), in which greater attention was henceforth paid to content than to style. "There was too strong an attachment to fine words, and not enough to the expression of truth and goodness." The humanities discovered a fitting answer to the modern challenge: "formal education made way for substantive education, the mind being taught to think for itself and at the same time being enriched with the wonderful ideas of which language is the depository."[162] In this comeback of the humanities, history education was able to hold its own (see table 16). Of great importance was the fact that it was now being appreciably strengthened by an influential and expertly framed set of didactic instructions.

A report by a subcommittee to the great reform committee of 1890 may be considered a codification of the didactic guidelines for history education and merits our detailed consideration. The compiler of this report was Ernest Lavisse, who knew more about education than most people. He had begun his career as an assistant to Victor Duruy, the *grand ministre*, after which he had been Fustel de Coulanges's successor at the Ecole normale and then, successively, a professor at the Sorbonne, founder of the new arts faculties, Duruy's successor as publisher, and author of school textbooks and of monumental series of history books at Hachette's. In short, he was the pope of the university guild of historians and even managed to be elected a member of the Académie française, an achievement that was (and still is) most unusual for a faculty professor. We shall return to Lavisse's varied activities in chapter 5; here we shall merely discuss his report, which was the mature fruit of more than twenty years of teaching experience.

Lavisse's instructions were in two parts.[163] The first dealt with the role of history teaching in intellectual and moral education. This part was a product of its time and will be discussed when we come to the morality of history educa-

tion. The second part dealt with the theory and practice of history teaching; it was less time-bound and would continue to set the tone until well after the First World War.

In general, quite a few elements in the report could also be found in earlier instructions, but now, for the first time, they were presented as a coherent whole, in manageable form and in a style that was crystal clear. Four general didactic guidelines were spelled out. First, the subject matter had to be adapted to the child's intellectual level. Much progress had been made since the first *précis*, but much had still to be done. The main thing was to keep "differences in time and place" constantly before the child's mind, since otherwise history was turned into an "unwieldy platitude." The child has no inherent understanding that the past is "other" than his own period. As an example of this "education in historical discernment" Lavisse mentioned lessons on modern means of communication, which had no parallel in the past.

Second, the teacher had to carefully select the facts and persons he presented to his pupils. As in so many older instructions, there was a warning against the temptation to make the pupils learn strings of dates by rote. "Wars in particular pose a threat to the history teacher." Examples were given, something that had not happened before. Thus, in dealing with the Thirty Years' War the teacher must avoid "the formidable boredom of names, dates, and strategies" lest he gloss over the difference between Wallenstein's "bands" and Gustavus Adolphus's "national army" (the actual significance of this distinction apparently called for no further explanation). Another example was the custom of covering the Merovingian period by presenting a useless list of kings, treaties, and quarrels instead of conveying some idea of how the Merovingian princes lived and ruled.

Third, a history lesson had to make some point. The teacher must indicate its main trend and leading themes. The instruction spoke of the "general course of events." It all reflected the "philosophical" presumptions of the first crop of history teachers, albeit shorn of much of their metaphysical and idealistic overtones. A case in point was the suggested treatment of the period 1270–1610 (which, according to the 1890 dispensation, was taught in the fifth class). Lavisse outlined the main developments as follows: The Middle waned Ages in the wake of the definitive decline of the universal powers, the empire having previously been wrecked by the papacy; the papacy in its turn was weakened by the Great Schism and restricted by the power of the kings. The Crusades came to an end, and the Infidel established himself in Constantinople. England and France discovered their respective identities in a war that lasted for a hundred years; Spain was about to be united. In Germany and Italy, by contrast, anarchy was rife as organized states turned these two countries into battlefields. The decline of Germany and Italy was still part of the waning of the Middle Ages, the end of that long period in which both countries had been dominant thanks to the imperial crown and the papacy. At about that time there also emerged the first signs of a new attitude: the striving for church reforms, the beginning

of the Renaissance, the great discoveries and inventions, and so on. So much for Lavisse's outline.

The outline was imbued with the schoolbook wisdom of an age we have left far behind. It all seems old-fashioned nowadays.[164] The outline revolved about political power and particularly about the rise of the nation-state. Nineteenth-century preoccupations were projected back into the past. But despite anachronistic elements and the differences in opinion on the essential developments of that period, it cannot be denied that the pupils were given a clearer overview of it. The brush strokes used to depict and structure the material were excellent and clear and introduced "dramatic unity" into the historical picture. After 1890 the teacher who dished up a hotchpotch of facts to his pupils—which of course continued to happen—could henceforth be told that he ought to know better. The stress on the political aspects, incidentally, was not frowned upon; according to the directives, there was no way to separate politics from history.[165] In the higher classes the teacher had to pay particular attention to the present because the pupils would soon be entitled to cast their votes.

Fourth and finally, the teacher was enjoined to use the *méthode pittoresque* to underpin the *méthode démonstrative*. Especially in the lower classes it was important to bring home to the pupils the various aspects of Greek and Roman history in a concrete way, by "localization, so to speak, and by dramatization and by avoidance of aesthetic and political abstractions. . . ; by the description of scenes and of carefully chosen backgrounds. . . , by presenting the main types of soldier, diplomat, parliamentarian, man of letters and scholar."

In addition to these guidelines, the part of the report devoted to teaching methods also made a plea, heard before but never elaborated, for assigning a more active role to the pupil. The aim of the so-called *méthode active* was to combat the pupil's passivity, which was particularly noticeable in history (and also in philosophy). There was a great danger that the teacher might just stand before the class spouting away, his high-flown language going straight over the pupils' heads. The pupils' active involvement was presented as an innovation, although it had been the custom much earlier, when pupils had been expected to read history books at home.[166]

Indispensable for the introduction of the *méthode active*, according to Lavisse, was a new working aid to be used in addition to the *manuel*, as it was customary to call school textbooks at the time (the terms *abrégés* and *précis* had been dropped from the titles). That new aid was a reader listing major events, customs, institutions, and biographies of leading personalities, corresponding to the subject matter of the general outline covered by the *manuel*. The reader would have to be the work of specialists working together (which was unusual enough in itself) and ought not to contain transcriptions of documents but only direct reports in everyday language, stripped of philological and other impediments.[167]

Lavisse urged teachers not to drop the customary dictation of summaries of their lessons: "such résumés must map out, that is, present the order of events,

together with the most important dates and a conclusion." He wanted to prevent at all costs the innovations associated with the *méthode active* from being achieved at the cost of an overall understanding. He was more cautious than many later educational methodologists.

Lavisse was particularly averse to the then still very common practice of *rédaction*, that is, neatly copying the notes taken in class or reproducing sections of the textbook. That was a purely mechanical activity. "The poor pupil has learned the secret of copying without taking in what he writes, and as far as the good pupil is concerned, *rédaction* merely spoils his hand." Poor style was a characteristic feature of this practice, which, Lavisse urged, must be scrapped.

Other common practices, by contrast, were considered to be very useful as long as they were varied and not too long, for instance, writing a composition on a given theme, evaluating a person, or setting out the views and impressions elicited by the subject matter of a particular lesson. However, the teacher must be careful about encouraging his pupils to harangue the class. Only in the higher classes was this practice acceptable, provided it bore on small, well-defined topics, and then not until the teacher had first made sure that the pupils were well prepared. To have a pupil from a lower class lecture on a wide-ranging subject such as the Gracchi, which had been customary, was a ludicrous idea, Lavisse contended. Asking oral questions was recommended as one of the best ways of reaching the pupil, but the questioning must not be too rigorous or associated with threats of punishment. It had to be well prepared by the teacher and must follow clear lines. In general, the teacher ought to be free to use the didactic method of his choice in the fight against the "enemy to be overcome, namely, inertia."

The report was widely praised. Writing in the *Revue historique*, Gabriel Monod claimed that no better or clearer guidelines could be found anywhere. The straitlaced Monod could not refrain from observing that Lavisse had gone too far in banishing genealogy and chronology, and he also regretted the reduction of history lessons to one and a half hours from the usual two. Monod believed that no less than four hours of history a week were needed, but that was impossible at a time when the general feeling was precisely that pupils were being overstretched. As far as that was concerned, Monod had his own views. "Luckily, football and cricket will not be scrapped," he quipped caustically.[168]

The Reforms of 1902 and the Leçon Magistrale

One of the last reforms of secondary education before the First World War was introduced in 1902. It was preceded by a major parliamentary inquiry under Ribot, which must be seen as part of the *Défense républicaine*, as a reaction to the Dreyfus affair and not to the German challenge. Numerous salutary changes were introduced in order to help secondary education compete with religious instruction and to adapt it better to the process of social modernization. The two most drastic general changes were that elementary and secondary education ceased to be completely independent *cycles* and became parts of a consecutive

system and that pupils were offered a wider choice of subjects.[169] The first change meant a clear breach with the age-old "apartheid" of elementary and secondary education, which had simply been a reflection of existing social divisions. Before 1902 many lycées had run their own preparatory classes, and many elementary schools had failed to prepare their pupils for secondary schools. The other change introduced a clear differentiation in the type of education children were offered. After 1902 pupils in the sixth and fifth class could decide whether or not to study Latin, and pupils in the fourth and third classes could choose to have both Latin and Greek, Latin only, or no ancient languages. Pupils in the second and first classes could choose to have Latin or Greek; Latin and two modern languages; Latin, one modern language, science, and mathematics; or two modern languages, science, and mathematics. The monolithic, traditional system that had for centuries determined the character of "secondary" education had definitely been overthrown.

The curriculum was designed in such a way that pupils could leave school at the end of the fourth class with a rounded education. That was the so-called first cycle. The new system had direct repercussions on the teaching of history to the various classes: the entire subject had henceforth to be completely revised at the end of the fourth class. This gave a fresh impetus to the concentric method, which had been advocated earlier but had not yet been adopted.[170]

The 1902 reforms were imbued with the spirit of the Défense républicaine and hence differed even in political and ideological respects from the previous reforms. There were, however, no reforms of the actual teaching practices. Even Charles Seignobos, who drafted the 1902 education program, used the 1890 directives as his didactic guidelines.[171] In fact, as Lavisse's colleague, Seignobos had been intimately involved in drawing up these directives. Lavisse and Seignobos differed more in political attitude and temperament than in their views on teaching methodology.

In the years that followed, the méthode active became the hot potato of teaching methodology. In 1907 a conference on history teaching held in the Musée pédagogiqe heard a passionate plea for improved methods, followed by a stormy discussion. The mere fact that such a conference had been called reflected growing interest in the teaching of history and in its development.

Louis Gallouédec, the champion of the méthode active, even went so far as to call for the replacement of the leçon magistrale, the teacher's lecture, with readings from the manuel and from a historical reader.[172] According to him, the teacher's task was to set the course, parcel out the material, interpret difficult points, and question the pupils to ascertain whether they had grasped what they had been taught. Giving leçons magistrales, that is, standing before the class and lecturing, was monotonous and dull, encouraged passivity and ignorance, and repelled the pupils.

There were bound to be critical voices. One educationist in particular, writing in the Revue historique, spoke up warmly in defense of the leçon magistrale. What did history teaching have to gain by abolishing the cours ("that French and typically academic method") and replacing it with a manual? According to

this critic, Gallouédec had caricaturized the history teacher, depicting him as a man who did no preparation after his early years and for the rest of his life rattled off one and the same lesson in a mechanical and sterile way. Those were the bad exceptions. The average teacher "dictates little, does not hold forth, but speaks, expounds, discusses, recounts, comments, varies the basis and form of his teaching"; in short, the teacher was a "living book." Turning textbooks into the pivot of education meant presenting the pupil with a "dead teacher." "The best manual is never as good as a well-presented lesson."

Clearly, the able educationist to whom the *Revue historique* had opened its columns took this matter very seriously. Abolishing the *leçon magistrale* in the teaching of history meant flying in the face of every French tradition, of "our national instinct," abrogating the most precious duties and interests of the university and the country. Abolition would spell a national disaster: "the harm would be . . . irreparable."[173]

Strangely enough, the implementation of Gallouédec's ideas would have returned education to the situation prevailing at the beginning of the nineteenth century, when books also held pride of place in history education and *leçons magistrales* had not yet been introduced. The circle of methodological guidelines would then have been closed. But it must be added that by the beginning of the twentieth century the teaching material had been drastically improved and was incomparably better than the inappropriate reading material presented to schoolchildren at the beginning of the nineteenth century. Beginning in the 1880s, schoolbooks of sound educational quality and scholarship became freely. They represented what we have called the third generation of history textbooks for schools. The first *manuel* able to stand up to the pitiless critique of the *Revue historique* in the 1880s was Jallifier and Vast's.[174] But the journal did not let its many successors pass without critical comment. Only later, especially after the 1902 reforms, did several *manuels* earn the unreserved praise of the *Revue historique*.

Publishers did much to encourage the authors of history textbooks. The market had become lucrative from the time every pupil was expected to work from his own copy instead of borrowing the teacher's. Alcan brought out a collective work under the editorship of Monod; Delagrave published a concise and lucid textbook by Nouvel and Bouniol; Colin published Seignobos's series, with Métin as its coauthor; Hachette published Albert Malet's *manuel*, which is remarkable for its typography and illustrations.[175] Malet's book, expanded and revised by Jules Isaac, was to prove the most long-lived and successful of this third generation of textbooks. "Malet-Isaac" in revised form was still being used in the 1960s, and in 1981 it was even reprinted in pocketbook form for the general public (and hence not for school use) as a general cultural guide.[176] We may take it that the standard of these leading *manuels* was higher than that of the average *leçon magistrale*, which was of course completely dependent on the quality of the teacher. In that respect, Gallouédec cannot be faulted. Yet the question remains whether education would have benefited from the complete abolition of all spoken lessons.

These calls for reform were meanwhile no more than the noises of extremists. In any case, the *leçon magistrale* retained its key position in education. A self-confident generation of history teachers who had enjoyed a good education and considered themselves better qualified than their predecessors were simply not prepared to let go of this master key. The *leçon magistrale* was considered the pièce de résistance of the lesson, something to be proud of, no matter how keen the teacher was to have his pupils play a more active role.

The educational conference of 1907 did reach agreement on the benefits flowing from a detailed explanation of the various methods, and everyone agreed that the teacher should have more freedom in adapting the methods he deemed the best. The teachers themselves had to decide how to treat the prescribed material.

The desire for greater freedom was in keeping with the 1890 instructions. All in all, 1890 seems to have been a general end point in the drawing up of methodological guidelines. The final wording of the instructions might be considered a ministerial vote of confidence in history teachers. It was the result of, as well as a spur to, the self-confidence and independence of teachers. The spirit of the 1890 instructions put an end to the previous ministerial suspicions and to the insistence on rigid discipline, designed to foster docility and to prevent the teacher from exercising his independence of mind. There was thus good reason for referring to the instructions as "the 1890 Charter."[177]

THE MORALS OF HISTORY EDUCATION

History had of old been considered a training school for morals and virtue. That view remained unchanged in the nineteenth century. In a sense the institutionalization of history teaching was a sign of growing confidence in its moral role. Two important factors in assigning a larger place to history in the moral training of *lycée* pupils were the wish to kindle patriotism and implant national consciousness and the decline of subjects that had traditionally been the pillars of moral education, namely, religion and classical languages. The rise of nation-states and the secularization and far-reaching consequences of socio-economic developments were important reasons for growing dissatisfaction with, and arguments about, the morals of religion and the classics. During the period leading up to the First World War—and, by the way, well beyond that—the champions of history education hammered away at the moralizing role of their subject.

This role might have seemed to be unquestionable and even have been allowed to grow had sharp differences of opinion not emerged in the course of the nineteenth century about the nature and scope of the norms and values to be inculcated. A report by Minister Villemain in 1843 expressed the traditional view of history education. "On every possible occasion, pupils must be reminded of what they owe to God, their parents, their king, and their country."[178] But by that time the traditional view had long since been under fire. In the

further course of the nineteenth century the philosophical and political polar-
ization of France would give rise to fierce arguments about the moral aims of
history education. We have already seen to what bitter controversies the intro-
duction of contemporary history had led in the 1860s. That conflict had flared
up with particular intensity in the years following the defeat of 1870–71.

The Catholic and royalist press was quick to blame state education for that
debacle. At the time, numerous pamphlets, such as *Les crimes de l'éducation
française* (1871), appeared asserting that the Napoleonic Université had turned
France into a "skeptical, scoffing, ignorant, anti-Christian, in short, atheist na-
tion, one that is ungovernable, that is, delivered up to either anarchy or despo-
tism."[179] Republicans and Bonapartists were tarred with the same brush. Publica-
tions such as *Le Correspondant*, the *Revue de l'enseignement chrétien*, and the
most vituperative and rudest of them all, *L'Univers*, reopened the offensive
against state education, which had never been accepted by the church.[180]

In this heated struggle history education was not spared. Monseigneur Félix
Dupanloup, the influential Catholic spokesman on education and a man who
could not be ignored, even published a special work on this subject, the *Con-
seils aux jeunes gens sur l'étude d'histoire* (1872), in which he did not mince
words. He drew attention to the "innate flaw" of history education and thought
the present situation particularly alarming. The majority of those who had made
it their business to write or to teach history these days "are cut off from our
faith by prejudice or error, most of them being bad Catholics, Catholics in
name and nonbelievers in fact." They were camp followers, to whom history
was nothing but "corroboration of their own opinions, men who knew next to
nothing about the very religion on which they kept making dogmatic pronoun-
cements."[181]

The incensed prelate, incidentally, did not think the solution was to remove
history from the school curriculum. History education could be very beneficial
provided it had a sound basis and was presented in accordance with sound
principles. In that case, history was "a manly school, worthy of being recom-
mended to the citizens of a nation anxious to get back on its feet, a school
capable of strengthening spirit and character," and one that could give France
something she had been missing very badly and without which her revival was
impossible: real men.[182]

Dupanloup's views were widely shared during the years following the defeat:
the time-honored moral function of history would help in the reconstruction of
the motherland (and the Revanche). Never before had the inculcation of the
national ideal and the fulfillment of national duties played so central a role.
These objectives were adopted by all groups of the political spectrum after the
defeat, albeit every party had its own cherished view of the regenerated mother-
land. Each one had a particular form of government in mind and they thought
quite differently about the role of the church; each one saw itself as the incarna-
tion of the "true" France and reserved the label "true national sentiments" for its
own political ambitions, to the exclusion of those of all who thought otherwise.
Every group at the time was nationalistic, but each understood something dif-

ferent by that term. This situation did not change until the 1890s, when pacifist ideas gained ground among teachers and voices were raised calling for greater reserve in fostering national fervor.[183]

When talking about the theoretical foundations of history education Dupanloup's choice of words was markedly modern, "positivist." History, he said, provided "knowledge of man, taught the science of life, and finally shed light on the present and the future," since "in a sense, what has been will be, because the same causes will always produce more or less the same effects." The serious and attractive approach to the study of history was "*philosophical* and I would say *religious*—because in it God is ever-present and visible."[184] God's Providence, according to this highly influential bishop-educationist, ruled supreme in the field of learning and science.

The thought that God revealed himself in history and that good was rewarded and evil punished even during man's life on earth was one of the basic assumptions underpinning the moral value of traditional history education. This assumption was not, however, the only possible one for a Christian. There was also another rich tradition, inspired by St. Augustine, which looked upon man's time on earth as a pilgrimage full of hardships, taken into account in the hereafter and not before.[185] The first assumption had practical pedagogical applications. Historical examples gained in clarity and power of expression once one could assure children that villains came to a bad end and virtue was rewarded here on earth. The crassest formulation of this pedagogical tradition came from the pen of the liberal minister Duruy. To him history was "a great form of moral education and I wished it were given its proper name: the record of expiations and rewards. In it you will not find one lapse, one error, one crime that has not been punished."[186] Duruy qualified this by adding that it did not always apply to individuals but applied "unfailingly" to the community at large. During his ministry Duruy was very much at odds with the clergy; in particular, the criteria for judging persons and communities that he used in his textbooks differed widely from those used by the church. Even so, the freethinker Duruy and Catholic educators were agreed about one thing: that history has a built-in reward structure.

It was not until Lavisse's report in 1890 that this ancient educational premise was abandoned. The report asserted that the teacher could not possibly present history as a "school of morality" since far too often crimes went unpunished and good deeds unrewarded. "The wrongs . . . are not expiated either by the men or by the generations who have committed them."[187] Never before had a government directive so explicitly turned its back on the educational tradition. The directive did not, incidentally, mean that no moral role at all was assigned to history education. On the contrary, Lavisse elaborated this aspect more so than any of his predecessors had done.

History was said to be first and foremost a search for the truth, and it was the teacher's duty to judge the past without prejudice. For this reason alone, each history lesson was "a lesson in morals." And even though historians might hold different views about one and the same person, not one of them ever extolled

cowardice and all of them exalted good deeds. That there was general agreement on these points was something Lavisse never doubted. Nor did he refrain from alluding to the fact that the educative value of this universal, "lay" moral judgment made it a worthy successor to Christian morality: "In judging the moral worth of human beings, we have a priceless universal consensus, and this at a time when the metaphysical foundations of morality are under review."[188]

In another respect too history education had a moral side. Whereas the arts and sciences turned pupils into "decent and cultured men," history helped to make them good citizens. *Education civique* entailed preparation for participation in public life "at a given date and under given circumstances." That was framed much more shrewdly and less offensively than the directive of 1880, which had emphasized the inculcation of respect for the institutions and principles on which the contemporary French Republic had been founded.[189]

According to the 1890 instructions, the crux of *éducation civique* was the fostering of a sense of duty. Now, educationists had never failed to use history instruction to drive home the pupils' duties. What was new was that the mirror of public duties was now held up to all French citizens, not merely to their leaders. In addition to the duties of all people at all times, the directive also mentioned certain duties that differed from generation to generation.[190] Once again Lavisse's formulation was unobjectionable, but if Catholic educators read between the lines, they discovered that theirs was quite a different idea of duty—in their book man's duties did not change from one generation to the next.

In addition to inculcating a sense of duty, history education was also expected to strengthen self-confidence and to foster resolution. "Arousing a taste for action" was needed more than ever as a counter to the growing *fin-de-siècle* skepticism. Moreover, children reared in a country weakened by political and religious conflict must be taught tolerance and freedom of expression. And finally, history lessons had to strengthen the pupils' national sentiment now that France was under threat from without. But in this connection Lavisse stressed that national sentiment must not fly in the face of world history: "It is part of our Frenchness that we love and serve humanity."

It is interesting to note the resemblance between the moralizing tone of the 1890 directive and the findings of Viviane Isambert-Jamati, who made a detailed study of the school speech-day addresses delivered in 1896–1905. This serial study was intended to probe the opinions and attitudes of teachers. It is of course much more difficult to pronounce on education in practice than on the theory behind the official prescriptions.

According to Isambert-Jamati, in their addresses delivered in 1896–1905 teachers once again made a strong appeal to their pupils' sense of duty. Only in the course of the twentieth century did this approach give way to such psychological themes as mental hygiene and mental balance.[191] Before that, however, there was good reason to speak of a generation of "dutiful men" inspired by Kantian morals (championed in French educational circles primarily by Re-

nouvier).[192] These men advocated the secularization of France and wanted to replace the Ten Commandments with the categorical imperative.

Another important theme in these addresses was the view that schools must prepare their pupils for making a contribution to the "transformation of the world." The *lycée* had to prime its students for action. This agreed with Lavisse's praise of vigor and drive. The idea of progress dominated the addresses, and secularism was held up as an important part of the great work of creating a better society. Work was increasingly considered a communal task, rather than the personal virtue it had been in the previous period (1860–70).[193]

Disinterested, nonpractical, cultural training as a contribution to individual happiness, which was to become *the* moral value propagated in addresses during the next period (1906–30), still scored very low around the turn of the century. The 1890 directive passed over it in silence. Meanwhile, "an active petty bourgeoisie" expected that in the wake of the 1890 reforms the *lycées* would prepare their sons as well to take advantage of the latest social developments.[194] But no matter what the expectations of the parents may have been— no study of this subject has yet been published—what is certain is that the teaching fraternity in general, according to these addresses at least, felt comfortable with the moral precepts laid down in the 1890 instructions for history education.

In this connection it is interesting to note how much these addresses stressed training in intellectual competence. The directive itself also dwelled on this subject. Lavisse distinguished four functions in the intellectual training provided by history education: training the memory; feeding the imagination with real objects from the past; developing a critical appreciation of facts, persons, ideas, periods, and countries; and developing the ability to place intellectual facts, literature, and art in their political and social context. The last point in particular was said to be a necessary complement to literature: "History, paying the ransom for the disinterested approach of literary studies, must put the scholar in touch with the modern world."[195] In respect of this aspect of intellectual training too, which was not mentioned explicitly in earlier directives, Lavisse's views agreed with those expressed in addresses delivered on speech days around the turn of the century. Even his repeated appeal to "facts" was in keeping with the positivist and scientistic attitude voiced in these speeches.[196]

History enjoyed unprecedented popularity in the speech-day addresses delivered in 1896–1905. On average, 28 percent of them were devoted to this subject, compared with not more than 9 percent in the previous period investigated (1876–85).[197] It seems reasonable to assume that the popularity of history on these solemn occasions of school life was largely due to the thoughtful 1890 directive, which not only spelled out the methodology of history but also reflected the moral and intellectual ideals cherished by teachers at the time. Below we shall see that the moral tenor of the instructions of 1902 did not agree quite so well with the ideals dominant in the addresses delivered during the next period.

Politicization and Reaction

The 1902 education program was written by Charles Seignobos. As far as the actual teaching of history was concerned, it largely followed on what had gone before, but its moral approach represented a clear ideological break with that of the 1890 report. In particular the 1902 reforms were a product of the Défense républicaine, which had sprung up in the wake of the Dreyfus affair and preceded the government of the Bloc républicain (1902–5). Moreover, Seignobos was quite a different man from his teacher, Lavisse, who was twelve years his senior. As a colleague of Minister Duruy, Lavisse had had a compromising Bonapartist past, which made it necessary for him to step very cautiously in politics for the rest of his life. Seignobos, by contrast, was an active political animal who had been steeped in political life since childhood.[198] In 1849 his grandfather has been a member of the Legislative Assembly, and his father had joined the Chamber (*centre gauche*) after 1871. Whatever views Seignobos himself may have held earlier, and no matter how critical and independent his political judgment may have been, at the turn of the century he was closest to the social radicals, though he never became a real party man.

To Seignobos, history education was an "instrument de culture sociale."[199] The pupil had to be familiarized with the most important social phenomena, customs, and institutions. Historical comparisons helped to bring out differences and similarities. The study of events and developments taught the pupil about the continuous changes to which human affairs are subject and protected him from "irrational fears of social change."[200] This was an astonishing thing for the architect of an official education program to say. History education, Seignobos believed, not only prepared the pupil for participation in public life but was an indispensable element of any democratic society.

There were four clear differences between Seignobos's views and the views expressed in the report Lavisse had published twelve years earlier.[201] First, the inculcation of a sense of duty had ceased to be an educational objective. Instead the pupils' awareness of social and political developments was to be raised. The emphasis on vigorous and purposeful action made way for information about impersonal institutions and developments. It might be added as an aside that even the textbooks written by Seignobos reflected his impersonal and hence somewhat colorless treatment of history.

Second, Seignobos stressed the importance of arriving at carefully considered political judgments, and though his political objectives were not left unexpressed, they were highly covert. Whereas Lavisse had spoken cautiously of *éducation civique* in preparation for the exercise of the franchise, Seignobos used the term *éducation politique* as a means of strengthening democracy and opposing conservatism. For Seignobos, history education was *the* antidote to conservatism. This view of public mental health was of course an incredible "transvaluation" of the traditional practice of teaching history for the purpose of inculcating established values.

Third, in 1890 there had been no references whatsoever to social questions. The greatest danger in moral education, according to Lavisse, came from indifference, skepticism, lack of self-confidence, and the idea that a mere individual had little influence on events.[202] For Seignobos, who had been a committed supporter of the republican mobilization campaign during the Dreyfus affair, the greatest danger came from enemies of the Republic: right-wing France was trying to poison the country's youth.

Finally, Seignobos deliberately eschewed the least trace of nationalism. In 1897 he had observed with distaste that 80 percent of the candidates sitting for the final examination had answered, when asked about the purpose of history education: "To stoke up patriotism."[203] Seignobos did add that quite possibly the candidates were not really speaking their mind but simply giving the reply they thought the examiners wanted to hear. History education must not be misused to glorify the fatherland, as was happening in Germany. That was a perversion of history and simply pandered to the prejudices of every nation and every party.

On this point in particular Seignobos was speaking for a different generation from Lavisse's. In the 1890s, "the heroic period . . . of university antimilitarism,"[204] pacifism, internationalism, and socialism had been gaining ground among younger recruits to the educational world. The Dreyfus affair had acted as a catalyst, especially in arts faculties and among teachers. At the beginning of the twentieth century these left-wing currents grew increasingly militant. Radical pacifism exerted a strong pull especially on teachers, and this became very evident not only at educational congresses but also in the new school textbooks.[205] It provoked a violent "nationalistic" reaction. A case in point was E. Bocquillon's *La crise du patriotisme à l'école* (1905), a well-documented book with an index of names that denounced those responsible for burying French education under a flood of pacifism, antimilitarism, and internationalism. The flawed professors at the Sorbonne were pilloried.[206]

This opposition to the left-wing current, which was not of course confined to education, though it flourished there, was christened the "nationalist revival of France" just before the outbreak of the First World War.[207] It is claimed that this right-wing reaction gained much ground both in the press and also in literature. The views expressed were found appealing by a great many people, not only because of to the literary standing of some the authors but also because they reflected ideas that seemed exciting and challenging inasmuch as they were confrontational and oppositional. After all, the republican order had held sway since 1902, and a growing number of people now considered it dull and boring to support the government.

Agathon's famous inquiry (1913) was considered important evidence for the popularity of right-wing, nationalist, and vitalistic sentiments among school children. It demonstrated the predominance of anti-intellectualism, patriotism, support for universal conscription, and a desire for war. It seems likely that the investigators were not entirely devoid of wishful thinking, but in any case the picture emerged of teachers and professors, men who judged wars by moral and

legal standards, facing a class of pupils for whom wars were glorious displays of strength, energy, action, and heroism.[208]

It is tempting to describe a similar contrast of attitudes with respect to Seignobos's ideas. If we did, we could refer to the educational program of 1902 as the culmination of a current that swelled in the 1890s, crystallized into a social-radical political morality following the Dreyfus affair, but quickly receded at the beginning of the twentieth century thanks to the rise of right-wing ideas to which schoolchildren proved highly susceptible. It is safer, though, to leave schoolchildren out of our discussion (as an uncertain aspect of historical studies yet to be done) and to confine ourselves to noting a contrast between teachers and professors in the arts faculties, on the one hand, and influential *littérateurs*, on the other.

The *Belle Epoque* was a period of sharp polarization and bitter divisions in a nervous and touchy society. Several more or less institutionalized (and therefore clearly defined) sectors of this overheated society found themselves at odds with one another. In the absence of a dominant spirit of the age we may perhaps refer to this phenomenon as the "synchronism of anachronisms." Educators and *littérateurs* lived in two different worlds.

It is remarkable that the tenor of the 1902 program differed in several respects from what appeared to be the teachers' preoccupations based on the speech-day addresses given during the following period. Whereas the instructions reflected a clear utilitarian attitude and stressed the direct and practical uses of history as a means of political education,[209] the most frequently expressed ideal in the addresses delivered after 1906 was disinterested cultural training.[210] This contrast between the instructions and the speeches was reflected not only in the teaching of history but also in attitudes toward other school subjects.[211]

The consensus on the idealistic approach, the stress of *culture générale*, and opposition to materialistic considerations and immediate practical benefits all were absent from the new directive. The explanation was the reaction of teachers to the consequences of the 1902 reforms, which can be considered the crown of all the attempts to adapt secondary education to social changes, and to the modernization of society, which most teachers had supported in the previous period. When that goal had been attained and the modern section had been admitted as an equal partner to the classical curriculum, and many pupils had opted for more practical subjects, the defensive, "anti-utilitarian" reaction set in.

Self-justification played a part in this reassessment of cultural education, which was no longer seen as a path to social adaptation.[212] Teachers and lecturers wanted to train a cultural elite of disinterested citizens, and they certainly did not want to go on supplying cultural luggage to self-seeking people, to the sons of the entrenched upper class, or to potential careerists, as they had in the 1890s. They clearly failed to appreciate that their ideal of "cultural leisure" was not within the reach of broad strata of the population. And their ideals obvi-

ously did not extend to bringing secondary education within the compass of these strata. It was no accident that their approach coincided with a long freeze in the number of secondary school pupils (193).

Secularism, which during the 1902 reforms and especially under the *camisard* and rabid antipapist Seignobos had still been considered a matter of urgent concern, was no longer referred to in addresses given after 1906. It looked very much as if Combes's success in restricting confessional education and the secular enthusiasm that had filled teachers employed in the public sector had been dissipated within just a few years. To take this as proof that secularism was more of a negative than a positive factor would be going to far (200). For had the brusque approach of Combism not brought the ideal into discredit? Was it really appropriate to use a festive occasion such as a speech day for raising matters that drew teachers and parents directly into this rather shabby and embarrassing episode in the French school struggle?

The belief in progress also was far less often voiced in speech-day addresses, especially after 1910. The idea that schools prepared their pupils for action and provided them with tools for changing the world had lost its popularity. Nature study too seemed to have few attractions. By contrast, the humanities triumphed as the most important school subjects and regained the traditional, dominant prestige they had enjoyed before the 1880s. Knowledge of the "eternal man" scored high among the objectives of education. The tenor of addresses by history teachers, which were examined separately, differed in no significant way from the general tenor. True, history teachers showed less appreciation for disinterested cultural training, but it remained the dominant objective. Henceforth it became particularly popular to sing the praises of a critical approach. Historical characters from the past were eulogized above contemporary personages, and the idea of the "eternal man" apparently held a more than average attraction for historians (218).

Judging by the speech-day addresses delivered after 1906, the extraordinary prestige history education had enjoyed in 1896–1905 had waned. The share of history in the addresses had decreased from 28 percent to 16 percent, which was still quite a respectable figure. Geography accounted for no more than 2 percent. The big winners after 1906 were the humanities, supplying the texts of more than half (53%) of the addresses (214–15, 271).

There are good reasons to trust the results of this thorough investigation. Needless to say, teachers tended to be less magniloquent in class than they were on such solemn occasions. Even so, it is hard to avoid the conclusion that the 1902 reforms was out of tune with the ideas and ideals rife among teachers a few years later.

Against the background of the so-called nationalist revival of France, so noisy during the decade before the outbreak of the First World War, talented *littérateurs* attacked a great many of those professional historians who wielded considerable influence on the teaching of history for allegedly holding false ideas and ideals. Thus Seignobos was one of their targets, and so were the

irreproachable Gabriel Monod (who had voiced his approval of the 1902 re-
forms in carefully chosen words in the *Revue historique*)[213] and the much more
politically committed Alphonse Aulard.

It is odd to recall that at the time of the fiercest attacks on professional
historians *from without*, by, for instance, such contributors to the *Action française*
as Maurras and Lasserre, the ideas enshrined in the 1902 instructions, that is,
ideas that must be considered the apotheosis of the social-radical morality of
history education, had already been rejected *from within* by teachers themselves.

The attacks by the *littérateurs* were explicit, personal, shameless, and often
unjustified, inspired by nationalistic, vitalistic, and martial sentiments, by their
very nature antirepublican in kind and tenor. The rejection of the 1902 instruc-
tions by the majority of teachers was not accompanied by an explicit disavowal
of the associated reforms or with hard criticism of the educational popes but
represented a more implicit and covert shift of ideals. It was an antiutilitarian,
idealistic reaction and reflected growing support for disinterested cultural edu-
cation. French teachers were swayed not so much by right-wing nationalism,
militarism, or antirepublicanism as by a lack of interest in social and political
question.

Not all teachers were guilty of *trahison des clercs*.

The vicissitudes of the moral aspects of history education failed to undermine
the unusually strong hold history had been able to gain on secondary education
thanks to the growth in the number of teachers and the expansion of the curric-
ulum. The ground had been prepared for history's steady advance into the
realm of higher education.

History and Higher Education

HIGHER EDUCATION provided a less significant job market for professional histo-
rians than did secondary education. In 1910 there were 620 persons teaching
history in schools but only 120 historians in higher education.[1] Not only was
the number of posts in secondary schools five times as great but the call for
secondary-school teachers was also the moving force behind the expansion of
history education in the arts faculties from the final quarter of the nineteenth
century on.

Historians in the arts faculties increasingly performed two functions, namely,
the training of history teachers and the encouragement and evaluation of re-
search. Both functions were innovations. Before 1880 arts faculties had made no
provision for preparing candidates for the teacher's certificate; only at the end of
the nineteenth century was the *thèse*, judged by a panel of university professors,
transformed from a largely rhetorical exercise into a genuine historical disserta-
tion. In the long run, the *thèse* even became the pièce de résistance of historical
writing. At the beginning of the twentieth century these new functions led to
changes in what had been expected of history professors for three-quarters of
the nineteenth century.[2] The arts faculties increasingly set the tone for teachers
and researchers (often one and the same person). The attitude and habits of
faculty staff were transformed, and so was the status of history professors.

Nowadays we take it for granted that a professor not only delivers lectures
but also does research. This was by no means the rule in France before 1880,
and the difference was clearly reflected in the training of university history
teachers. The inclusion of history in the faculty curriculum therefore meant
more than the professionalization of the historian's job. That is, it did more
than increase the number of professional historians: it enhanced the influence of
the faculties on history education and research.

THE GERMAN MIRACLE AND THE FRENCH SHORTFALL

The academic adoption of history was an international phenomenon. In the
German-speaking world, which was remarkable for its precocious creation of
independent history chairs,[3] the philosophical faculties had begun to play a
paradigmatic role in historical research as early as the first half of the nineteenth
century. They became obligatory stopping places for future secondary-school
teachers. The academic incorporation of history was part of a wider develop-
ment that assigned the universities a more prominent place in scientific research
and in training students for certain professions.

The modern university is a German invention. Throughout the nineteenth century and part of the twentieth—until the 1930s—German universities were looked upon as model academic institutions with a magnetic appeal. Thanks to them, Germany became the mecca of academic scholarship and exercised great influence on France, Britain, the United States, and many other countries. The rise of the American academic model, which, unlike the more selective and bourgeois German model, set out to provide "mass" education, was a postwar welfare phenomenon.

We can roughly distinguish three episodes in French attempts to reform higher education along German lines. The 1860s, and particularly the time when Duruy was minister of education and called for an extensive statistical survey,[4] saw the preparation of a host of inventories and led to a growing realization of just how far France had fallen behind Germany. For some time, however, the necessary reforms did not go beyond the drafting of ministerial plans. The flow of money remained shut off, and the most successful initiatives came from outside the faculties.

After the military defeat, which was generally considered a moral and intellectual one, the previously isolated champions of reforms in higher education were given a fresh boost: higher education became a political issue in the 1870s. More money was made available for professorial chairs, and bursaries were made available. However, the legal provisions for higher education were bogged down in the fierce struggle round the freedom of (Catholic) higher education. The reform of education as such was largely forgotten.

The third period started in the 1880s. Political issues having continued to hold the upper hand during the first half of that decade (and Jules Ferry and others having frustrated the possible resuscitation of Catholic education by introducing a state monopoly in examinations), the second half brought reforms that, for the first time, had been initiated and were widely supported by the faculty staff. During the preceding two periods the reform plans had come from without, from the "educational ceiling" of ministers, civil servants, and politicians. In this, the last and successful period, by contrast, the initiative came from within, from the "educational floor" of professors and lecturers. The money flowed less freely than it had in the 1870s and the funds of the faculties swelled less rapidly,[5] but the increase in the number of students and the results of the educational reforms were unmistakable. In the 1890s the contents of the most important examinations were drastically revised, and the legal status of French universities was firmly laid down.

How far did France actually lag behind its German rival, the envy of the French reformers? During the years 1871–76 the number of registered students in the twenty universities of the German Reich averaged more than 16,000 a year.[6] The corresponding number at French universities was 10,000–11,000.[7] A number of technical problems complicate the computation of these figures, but there is no doubt that the German Reich had many more university students than France. In about 1870 the difference between the total populations of Germany and France was not very great: Germany had 39 million and France,

36 million. It has been calculated that at the end of the 1880s the German Reich had an average of 57 students per 100,000 inhabitants and France had only 43 students per 100,000 inhabitants.[8]

Much more striking were the differences in the number of the academic staff. In 1880 the number of professors ordinary and extraordinary in Germany was 1380,[9] where the total academic staff in France came to no more than 503.[10] If we add the 459 *Privatdozenten* (outside lecturers eligible for a professorship) at German universities—and a proper comparison demands that we do—we find that the number of German academic staff was about three and a half times as large as that of the French.

The intellectual hegemony of the German universities in a number of disciplines during the second half of the nineteenth century and at the beginning of the twentieth was therefore based on solid numerical foundations. A sizable academic staff does not guarantee high-quality academic scholarship, but it nevertheless provides favorable conditions for it. Thus, if the selection of academic staff in both countries had been based on comparable qualitative criteria, then a much larger number of scholars would naturally have held out a much greater promise of intellectual success and influence.

At the Chicago World Exposition in 1893 the "university exhibition" was dominated by the Germans. In the collective work on German universities written after that occasion Friedrich Paulsen commented on the historic reversal of roles between Germany and France. Thus, whereas in the Middle Ages the Germans had had their empire and the French their studies, by the nineteenth century the Germans had long since been fated as a nation of poets and philosophers, while the French had been able to boast two empires. But all that had changed again since 1870–71. Paulsen saw a causal nexus between Germany's lack of political power and economic progress during the first part of the nineteenth century and the dominant role of the German universities at that time. "The energies of the German people were directed inward, and it was in the intellectual world that they sought compensation for their low ranking in the external world. . . . The German people had no center of national life other than learning and literature."[11]

According to Paulsen, then, political power and economic progress were inversely proportional to academic commitment. In recent studies we can find similar views, if expressed in rather more circumspect form. Thus the impressive German educational system has been contrasted with the pitiful system of higher education with which England was burdened during the first part of the nineteenth century.[12] England had been a pioneer of industrialization, her political power was great, and political democracy had made an early debut, but English higher education kept its medieval features longer than her neighbors did. In particular, English education retained its traditional clerical and corporative basis. In 1870 England had 5,500 students in five universities. At that time English higher education lagged patently behind even that of France; the gap between it and the economically so much less developed and politically more conservative Prussia was immensely greater yet.

In his important book on the German academic community Fritz Ringer could only explain the exceptional prestige of German professors and the renown of German universities in the nineteenth century by reference to the vacuum left by the collapse of the traditional class-ridden society, the slow pace of industrialization, and the associated social developments. Ringer spoke of "German mandarins," alluding to Max Weber's account of the status of Chinese literati during more than two millennia.[13] The high standing of German universities and the extraordinary prestige of the professor were, however, peculiarly German phenomena, and the results of a unique historical interlude. Around the turn of the century the German mandarins were able to put up increasingly virulent resistance to modern culture and the associated socio-economic developments and to cling more and more grimly to a form of idealism in which *Bildung* (a generic term for culture, breeding, and learning) was considered to be the sole aim of higher education. In the end the fate of the German mandarins was sealed by twentieth-century economic and social developments. For the German universities too were forced during the twentieth century to turn out *Fachleute*, experts with specialized knowledge, instead of concentrating exclusively on *Bildung*.[14]

For France, the miracle of the German universities served as a spur to self-examination. In the second half of the nineteenth century most advocates of the reform of French higher education less interested in discovering why the German universities were flourishing than with discovering why France lagged so far behind. Paramount, though generally unexpressed, was the view that the development of a modern society must needs involve an extension of higher education.[15] That view was therefore diametrically opposed to Paulsen's. Most French reformers were convinced that there was a direct functional link between political power and economic development, on the one hand, and the spread of higher education, on the other. France was a political superpower with a well-developed bureaucracy, a country in which an unstable political system went hand in hand with a relatively high degree of democratic control. In terms of industrialization, France admittedly lagged far behind Britain in about 1870, but was well ahead of Germany.[16] France was, moreover, considered to be the home of culture. *Culture générale* (the equivalent of *Bildung*) was essential for entering certain professions, but France's prestigious general education was presided over by the secondary schools, the *lycées* and *collèges*, and not, as in Germany, by the universities. French inferiority, according to the reformers, was due to defective organization, to flaws in the structure of French higher education, which was generally blamed on Napoleon. With improved organization the number of French students would "automatically" become "normal," that is, it would catch up with the number in Germany.

A number of sociology books proffered comparable views on the functional links between "modernization" and "educational mobilization."[17] The higher the degree of economic development, the greater the number of students in higher education. Apart from drawing attention to the organizational shortcomings of France, many authors insisted that there was an overall functional connection.

TABLE 18
Number of Registered Students in German and
French Universities, 1871–1911

Year	Germany	France
1871–76	16,000	10,000–11,000
1886–91	29,000	17,000
1910–11	63,000	41,000

Sources: For France, Ministère de l'économie nationale,
Annuaire statistique de la France 56 (1940–45): "Résumé ré-
trospectif"; for Germany in 1871–76 and 1886–91, Conrad,
"Allgemeine Statistik" and in 1910–11, Statistisches jahrbuch
für das deutsche Reich 32 (1911), 330–31.
Note: Figures are rounded off to the nearest thousand.
The German figures for 1871–76 and 1886–91 are annual
averages.

From the growth in the number of students in Germany and France before
the First World War we cannot deduce either a negative or a positive link
between modernization and the development of higher education. In Germany
as in France the total number of students quadrupled in forty years (see table
18). The forty-year period from the French defeat until the First World War
saw incredibly fast economic developments in Germany. The German Reich
overtook the French Republic as the leading power on the European continent.
To use the traditional terminology, Germany changed from an object into a
subject of European politics,[18] something Germany had not been since the six-
teenth century. Now, from Paulsen's theory of an inversely proportional rela-
tionship between the attractive power of universities and economic develop-
ments, one would have expected a declining number of German students, but
in fact quite the opposite took place. The French expansion also seemed spec-
tacular. The reformers attributed it to organizational improvements, and it filled
republican civil servants with pride. In comparison with the German academic
expansion, in absolute figures the French increase may seem less stunning, but
if one considers the much smaller French population increase during this pe-
riod, then the French figures look considerably better. More specifically, the
French population grew from 36 million in 1870 to 39 million in 1910, while
the German population rose from 39 million to 65 million. In both countries
there were rather more than 100 students per 100,000 inhabitants in 1910 (i.e.,
just over 0.1%). Comparisons of the populations of eighteen- to twenty-five-
year-olds during this period are hampered by a number of technical problems,
so that the results of computations differ widely.

The periods 1870–90 and 1890–1910 both witnessed increases in the number
of students. From the beginning of the 1870s to the middle of the 1890s the
European economy suffered a general depression, followed by a sharp upturn.[19]
The increase in the number of students in Germany and France did not, therefore,
seem to depend very markedly on the general economic climate. All we can say is

that both in absolute figures and also in percentage terms the increase in 1890–1910 in both countries was greater than it had been in 1870–90.

This general picture of the positive or negative functional links between modernization and the number of students provides a useful first approximation but proves unsatisfactory on closer examination. The same is true of the sociopolitical explanation of the increase in the number of students, namely, that the wish to prolong adolescence (itself a late-nineteenth-century concept) that was then rife among broad strata of the European middle class was the moving force behind the extension of (higher) education to eighteen- to twenty-five-year-olds.[20] It is an interesting interpretation that can hardly be confirmed or refuted, but it does add a new dimension to the discussion of the growth of higher education.

Comprehensive higher education must be generally available and socially desirable. The economic development of a society probably limits the expansion of higher education but does not explain the actual levels attained. And university attendance must of course also fit in with the social and cultural aspirations of parents and adolescents in certain population groups.

To go beyond these general pronouncements and to cast more light on the specific situation of French arts faculties, we must first determine the total number of students in the various faculties and determine the social functions of the faculties.

Differences between Faculties

Complaints about a surfeit of academics were centuries-old, the leaders of traditional societies having regularly voiced their fears of having too many "overeducated" people.[21] This attitude was reminiscent of the objections to the mendicant orders: that they were nothing short of parasites. There was no need for more than a very small number of intellectuals. Any excess of people working with their brains had to be paid for with the manual labor of the productive part of the population. Cardinal Richelieu had already warned against the temptations of the intellectual professions, which damaged the true sources of a society's wealth, agriculture and trade.[22]

During the first half of the nineteenth century there was a near consensus about the deplorable superabundance of academics. And did 1848, "the revolution of the intellectuals,"[23] not demonstrate how harmful the consequences of such an excess were to social stability? At the end of the nineteenth century too, when the extension of higher education was being energetically propagated by the government, a great many influential people kept harping on the harmful consequences of too many academics, pointing particularly at the social tensions that an intellectual proletariat doomed to unemployment is bound to set up.[24]

The number of students in higher-education establishments, incidentally, was still very small in the nineteenth century and at the beginning of the twentieth. Contemporary calculations put the figure at roughly 50 students per 100,000 inhabitants (0.05%) in 1890 in both France and Germany. Twenty years later

the relative number had doubled in both countries to 100 students per 100,000 inhabitants (0.1%).[25] Calculations of the percentage of students per age group were still rather unreliable in the nineteenth century. For the beginning of the twentieth century (1911) Bourdieu and Passeron have estimated that a mere 0.7 percent of French people between the ages of nineteen and twenty-four attended a university.[26] Higher education for the many still lay in the future. If we take 10 percent of nineteen- to twenty-four-year-olds as the limit above which we may speak of higher education for the many, then no European country had crossed that threshold before the Second World War. In the 1930s the United States was the only country where more than 10 percent of all twenty- to twenty-four-year-olds received higher education. Recent calculations have shown that the proportion in the United States exceeded 11 percent during the 1930s, while in France, Britain, and Germany the corresponding proportions ranged from 1.4 percent to 2.6 percent.[27]

Two conditions had to exist before the 10 percent threshold of higher education for the many could be crossed. First, there had to be greater prosperity, and second, university education had to be drastically augmented with the adoption of all sorts of subjects traditionally lacking in academic status. University education had to become far less exclusive, and broader strata of the population had to be offered the opportunity of extending their studies by several years while earning nothing for their labors. In 1963, on the eve of the explosive expansion of the number of French students, only 5 percent of French nineteen- to twenty-four-year-olds attended a university.[28]

Since olden times just three faculties in the traditionally narrow field of higher education had been entitled to issue professional qualifications: the theological, the legal, and the medical faculty. The church needed educated servants; in the West the university has clerical origins. The secular authorities, for their part, needed lawyers following the advent of constitutional government. And concern about physical health ensured that physicians trained at the university could earn their living from their professional pursuits, though they could not, of course, count on the solid support of church and state, which provided a steady job market for graduates in the first two categories. In the traditional system the arts faculty—in Germany the philosophical faculty—had served mainly to provide a foundation course for the other three faculties; it was not until the middle of the nineteenth century that school teaching provided a fixed and large labor market for arts graduates from the philosophical faculties. In France the (independent) arts faculties were granted the right to issue professional qualifications at the end of the nineteenth century. There seems to have been a cyclical fluctuation in the percentage of students attending the various faculties,[29] but here we are concerned only with the general trend from the beginning of the nineteenth century to the beginning of the twentieth. A comparison with the German faculties highlights the very different situation of the French arts faculties. The German lead seems to have been based chiefly on the totally different position of the theological and philosophical faculties. The theological faculties, both Protestant and Catholic, accounted for more than half the total number of students at the beginning of the nineteenth century. In 1831–

36 the theological faculties were still the largest, but their share of the students had dropped to just over one-third (34%). In 1851–56 this share had dropped further, to just over a quarter. After 1870 the theological faculties' share of the students was never more than 20 percent. By 1910it had sunk to well below 10 percent.

However, although there were sharp fluctuations in the *absolute* number of students enrolled in theology, there was no sharp decline. In 1831–36 a total of just over 4,400 students (3,102 Protestants and 1,310 Catholics) were enrolled in theology; in 1910 the figure was still more than 4,350 (2,492 Protestants and 1,861 Catholics).[30]

In France, the position of the theological faculties differed radically. During the Revolution the old-style universities—together with the guilds and corporations—were abolished as symbols of the hated feudal system. The new theological faculties set up by the authorities would never again succeed in overcoming the distrust of the Catholic Church. The Catholic Church now preferred to entrust the education of French clerics to special seminaries, free of any state influence. Attempts at reconciliation, such as those initiated by the Restoration authorities and attempts in the 1870s during the Ordre Moral, remained fruitless. The enrollment of theology students at the faculties was negligible. For a variety of reasons the number of registered students is difficult to ascertain, but the number of diplomas issued speaks volumes. From 1850 to 1880 number of *licences en théologie* issued each year averaged fewer than five. In 1905 the theological faculties were abolished as part of the complete separation of church and state.[31]

Another reason for the German lead in the number of students was the number of enrollments in the philosophical faculty. In earlier times that faculty had prepared students for the other three faculties, but in the 1830s the share of those who did not simultaneously register for another faculty was 18 percent. By 1841–51 that share had increased to more than 25 percent. In 1861–86 the rate was consistently more than a third of the total number of students. In 1876–81 it rose to more than 41 percent, to be followed by a drastic reduction to 28 percent in 1886–91. The rate continued to fluctuate sharply but did not drop to below 25 percent. In 1900 it was 37 percent, and in 1910 it was more than 46 percent. The German philosophical faculty was rather a mixed bag. More subjects were taught there than in the French arts and science faculties combined. During the period under review the German philosophical faculty offered, *inter alia*, pharmacology, dentistry, and political economy (*Kameralia*). A realistic estimate put the proportion of philologists and historians (which is comparable to the number of single enrollments in the French arts faculties) at about one-half until 1880. In 1881 the figure was 53 percent (4,546 students), but it dropped during the rest of that decade. At the beginning of the 1890s it was 38 percent (more than 2,800 students), but in 1910 it was back to 49 percent (more than 12,000).[32]

In France the position of the arts faculties was quite different and remained so for a long time. Because these faculties had practically no students (for reasons examined below), in 1852 law students were directed to enroll not only in

the law faculty but in an arts faculty as well. From that moment on, the number of registered arts students rose by leaps and bounds, but this was not of course an expansion of the arts faculties as such. The number of registered students is misleading. The following example may serve to illustrate this point. In 1865 the number of enrollments in the Paris arts faculty came to 10,409 and the number in the provincial arts faculties came to 8000, making a total of more than 18,000. However, since every student was obliged to register four times, the actual number of students was 4,500. Of this respectable number no more than a fraction proposed to take an examination in an arts subject. The number of *licences ès lettres* (arts degrees) received that same year gives us a good idea of the actual state of affairs: 40 were received in Paris, and 77 in the provinces, making a total of fewer than 120. Since roughly one-half of the candidates passed their examination, we can safely say that in 1865 no more than 250 students attempted to obtain an arts degree.[33]

If we count only single-faculty enrollments, then the number of students in the arts and science faculties seems relatively small. In France the faculties of law and medicine had the largest number of students by far. In 1876 they accounted for more than 94 percent of the total number of students; the theological faculty accounted for 1 percent, and the arts and science faculties for 5 percent. In Germany in 1876–81 the legal and medical faculties jointly accounted for less than half (47%) of the total number of students, the theological faculties accounted for 16 percent, and the philosophical faculties for 37 percent.[34]

The large differences between the total number of students in Germany and France did not reflect a rush by French students to study law and medicine but were signs of the strength of the German theological and philosophical faculties. This was still the case in 1890. Although by then the proportion of law and medical students in France had dropped to 80 percent and that of arts and science students had risen to 19.5 percent (the theological faculty accounting for a mere 0.5%), these percentages still differed appreciably from the German figures for 1886–91, when law and medicine accounted jointly for 52 percent, theology for 20 percent, and the philosophical faculty for 28 percent of the total number of students.

At the beginning of the twentieth century these differences became smaller, the German theological faculties now accounting for less than 10 percent of the number of students, whereas the share of the French arts and science faculties increased sharply, to 30 percent, in 1910 (15% of which was accounted for by the arts). But even then the proportion of law and medical students in France remained relatively much higher than the proportion in Germany (70% in France compared with 43% in Germany).[35]

THE STAGNATION OF THE ARTS FACULTIES

Until the 1880s the arts faculties were relatively unimportant. In 1876 the number of single-faculty enrollments came to 238, which represented 2.1 percent of

the total number of students. This percentage did not increase markedly until the 1880s. In 1890 the arts faculties accounted for 11 percent (1,834 students) of the total student population, and in 1910 it accounted for 15.5 percent (6,363 students).[36] Before we look at the educational reforms introduced at the end of the nineteenth century, which provided the institutional framework for the academic adoption of history, we must first try to explain the deplorable state of the French arts faculties during three-quarters of the nineteenth century.

First of all, it should be noted that demand for teachers as such played no significant role in the development of these faculties. The French *lycées* also needed trained teachers, of course, but until the end of the nineteenth century the French arts faculties had played a subordinate role in the training of teachers. In contrast, as early as the beginning of the nineteenth century the German philosophical faculties had played a crucial part in this field, as obligatory halfway houses for future high-school (*Gymnasium*) teachers. The demand for teachers was thus a necessary condition for faculty development but apparently not a sufficient one.

In answer to the complex question why the arts faculties had played a marginal role in the French system of higher education, we might mention external rivals as well as internal weaknesses. The external rivals were the *lycées*, which provided education up to the *baccalauréat*, and the Ecole normale supérieure, which provided higher education quite independently. The internal weaknesses included a lack of intellectual curiosity and such general institutional shortcomings as the lack of local autonomy by, and the lumping together of, faculties; lack of competition between the various institutions; and the lack of academic freedom. A brief digression on these subjects may help to throw some light on the stagnation of the French arts faculties and on the problems the educational reformers had to solve.

The Prestige of the Baccalauréat

Because it was proof of a sound classical education, the *baccalauréat* (high-school diploma) was esteemed as a status symbol. It was a voucher for the intellectual luggage that made a cultured person stand out from the crowd. The *baccalauréat* served as an external barrier for the "higher" strata of society and also helped to safeguard internal standards.[37] This protective function of the *baccalauréat*, and more generally of classical education, has been discussed at some length by many socially conscious pedagogues and also by others. "The bourgeoisie needs a type of education that is beyond the reach of the rest of the population," we can read in an influential sociological study published in 1925. The American sociologist Thorstein Veblen even went so far as to explain the inclusion of classical languages in the curriculum as a whim of a "leisure class" anxious to distinguish itself from the rest by conspicuously wasting its time on the learning of dead languages.[38]

Of course it was inevitable that the inequalities besetting society would be reflected in the divisions of the educational system. In the nineteenth century

few people felt the need to disguise this fact. Thus, Monseigneur Dupanloup expressed a generally accepted view when he defended a strict form of "apartheid" between popular education, professional education, and classical education, each befitting the distinct social prospects of those concerned.[39]

However, classical education was certainly more than the legitimization of social inequality. The *baccalauréat* also helped to maintain (internal) standards, as was demonstrated year after year by the high percentage of failures. Whether the criteria used during the examination were educationally sound is irrelevant here; what is certain is that whether a candidate passed or failed the *baccalauréat* could not be directly related to the social position of his or her parents.

Needless to say, social reality proved that the much-vaunted ideal of careers open to anyone with talent was an illusion; not everyone had an equal chance of being admitted to a *lycée*. Nevertheless, it is possible to argue that classical education was a civilized way of mitigating, rather than accentuating, social inequality. The extent to which social inequality was "tempered" by the *lycée*, or at least challenged by scholastic achievements, thus seems a more suitable measure of the social function of the *lycée* than the constantly repeated allegation that recruitment to it was socially restricted, especially so during this period, and that hardly any workers' children enjoyed the benefit of secondary education.

The *baccalauréat* was an indispensable means of entering the legal and medical faculties, and in the course of the nineteenth century it gradually became a sine qua non of appointment of all senior civil servants. In much earlier times, the arts faculty had served as a foundation course for the other faculties, but in France the actual preparation for the *baccalauréat ès arts* had "slipped down" into the *collèges* even before the Revolution. The universities of the ancien régime were only able to cling to the right of conferring degrees as a financially lucrative relic of their medieval heritage. The arts faculties introduced by Napoleon regained the ancient privilege of setting the *baccalauréat* examinations, but the training for them was left to *lycées* and *collèges*.

In German-speaking territories the philosophical faculty lost its propaedeutic function. In the nineteenth century the German *Gymnasium*, like the French *lycée*, provided a thorough classical education. But whereas in France the *baccalauréat* was considered to be the seal of *culture générale*, in Germany the *Abitur* served as a qualifying examination for admission to universities and hence to higher *Bildung*. The *baccalauréat* was a much more widely recognized professional qualification than the *Abitur*. The leading role of the *lycée* in the French educational system, which was partly owing to the prestige of the *baccalauréat*, was fittingly described by Lucien Febvre as the "stranglehold of the middle" (i.e., of secondary education on primary and higher education).[40]

The System of the Grandes Ecoles—the Ecole normale supérieure

The higher general education expected of those who mattered in society, or *culture générale*, did not of course render higher professional qualifications su-

perfluous. In the Napoleonic view of higher education, which could in many respects be traced back to the ideas of the Enlightenment and also included several ephemeral additions from the revolutionary period, higher professional education was assigned to specialized schools. The Napoleonic Order was not created *ex nihilo*. Its models were the military academies for artillery officers and engineers founded as early as the first half of the eighteenth century and also the schools for civil engineers (1775) and mining engineers (1778). The Convention founded two *grandes écoles*—originally under different names—which were to remain the formidable rivals of French science and arts faculties, namely, the Ecole polytechnique (1793) and the Ecole normale supérieure (1795).

In Germany and in other countries as well, similar professional high schools were founded for the purpose of purveying "useful" knowledge. Typical of the situation in nineteenth-century France, however, was the fact that the Ecole polytechnique and the Ecole mormale supérieure enjoyed a de facto monopoly in the training of arts and science students. Until the 1880s these *grandes écoles* had no rivals in the sphere of full-time education. The arts and science faculties of the universities contented themselves with the setting of examinations. This was in sharp contrast with what happened at the philosophical faculties in Germany, which, for instance, in early nineteenth-century Prussia, prepared students for the *Gymnasium* teachers' examinations.[41] Having no professional rivals, the German philosophical faculties acquired a strategic monopoly in the training of (*Gymnasium*) teachers.

In France it was not until well into the nineteenth century that it occurred to anyone to delegate the training of teachers to the faculties. The reputation of the Ecole normale rose to unprecedented heights at the start of the Third Republic. Only at the beginning of the twentieth century could the Parisian arts faculty get rid of its redoubtable rival by absorbing the teaching staff of the Ecole normale.

The system of the *grandes écoles* and especially of the Ecole normale differed in two ways from faculty education. First, the Ecole normale was a boarding school, and second the number of students was restricted and there was a careful selection system. Since olden times boarding schools had been a way of avoiding time-consuming and expensive journeys and of coping with the small number of local schools. But the boarding school also enabled the authorities to keep the pupils under their thumb. The uniform not only betrayed a semimilitary style but was considered a guarantee of good behavior, the more so as the fear of being recognized prevented pupils from "frequenting places that it behooved them to shun."[42]

But boarding schools were not chosen merely because they obviated long journeys and facilitated repressive measures. When more and more voices were raised berating these institutions for their failure to foster independence and originality, many influential educationists leapt to their defense. Not everyone considered the family home the best setting for moral education. The boarding school not only provided better protection from bad influences but also had

"positive" advantages. Family life was only too apt to encourage egoism. Henri Marion, who ran a course of lectures on pedagogy at the Paris arts faculty in 1883, had no doubts that boarding schools were the future of education. After all, a "liberal democracy" had less need to encourage individualism than to foster discipline, social responsibility, and human solidarity.[43] But his and similar pleas fell on deaf ears, and by the end of the nineteenth century the number of boarding schools providing secondary education had begun to decline. Until the 1880s more than 40 percent of all *lycée* pupils were boarders; in 1920 that figure had fallen to 19 percent.[44] Parents and children alike increasingly preferred the warmth of family life to the cold comforts of the boarding school.

Camaraderie, originally a military slang expression, had become a proverbial attribute of boarding schools.[45] At the Ecole normale students forged the notorious *camaraderie normalienne*, which often survived fierce political differences. There was sharp rivalry (encouraged by the educational principle of *emulatio*) within the elite body of *normaliens*, but outwardly the *normaliens*, no less than the *polytechniciens*, exhibited a haughty esprit de corps. The faculties also boasted some arrogant students of course, but the boarding schools were so many hothouses in which the exclusive spirit could come into full flower. On top of that, the intellectual standard of the Ecole normale was unmistakably high. Preselection was extremely strict, and after admission, with board and lodging paid for by the state, the training was extremely demanding. The examination results bore this out.

The Ecole normale experienced several ups and downs under the various political regimes.[46] During the Restoration the school was even closed for a time, but during the July Monarchy its position was greatly strengthened, especially under Victor Cousin (1835–40). During this period the school moved into the building in the rue d'Ulm. Its liberal image was stamped during the Second Empire. At the beginning of the Third Republic the school gained unprecedented prestige, with a number of graduates playing a leading role in national politics. The *république des ducs* of the 1870s seemed to be making way for a *république des professeurs*, and the *normaliens* took an important part in that process.[47] The political atmosphere at the Ecole normale changed at the end of the nineteenth century thanks to the spread of socialist ideas, but there was still a place for those who thought otherwise. The intolerance came rather from without, from a government egged on by the press, whether on the left or on the right. The Ecole normale was a (relative) oasis of tolerance in the polarized atmosphere of the *Belle Epoque*.

The prestige of the Ecole normale continued to grow, though the number of students barely rose. From 1810 to 1870, 30 pupils on average were admitted every year. After 1870 this figure rose to 40 each year. The number of students at the Ecole polytechnique was a good five times as large (from 1850 to 1870, 130–80 pupils were admitted every year, and later that figure rose to about 200).[48] It is no wonder that the *normaliens* formed a small elite among the teaching profession. As the number of teachers increased, the proportion of *normaliens* kept decreasing. In 1842 half the senior posts in the *collèges royaux*

(the *lycées*) were held by *normaliens*; in 1865 their share had fallen to a quarter.[49] However, an increasing number of *normaliens* found attractive positions outside secondary education, so much so that the Ecole normale could meet the need for qualified teachers less and less. In the 1880s, when the arts faculties also were preparing students for the teacher's examinations, the Ecole normale remained the most prestigious and attractive training center, taking the best of the students from the faculties. To the champions of faculty education, the Ecole normale was thus not only an anomaly but a thorn in the flesh. Then, after a great deal of bickering, the staff of the Ecole normale was absorbed into the Paris arts faculty at the beginning of the twentieth century, and the Ecole normale lost its autonomy.[50] Even so, the building in the rue d'Ulm continued to provide housing for privileged students.

The Research Ethos

The arts faculties experienced great internal difficulties. Until well into the nineteenth century the division of labor between those faculties "whose task was *vulgariser de la science faite*, to popularize acquired knowledge, and the *établissements scientifiques*, whose job was *faire de la science*," to do research, was rarely challenged.[51] The fact that professors at arts faculties did research and belonged to a learned society in Paris or in the provinces did not alter the institutional separation between education and research. In sharp contrast, the German philosophical faculties had turned into outstanding research centers, centers in which "fundamental" research was done as early as the eighteenth century. Not only did they not content themselves with providing foundation courses for the old and established "higher" faculties but they even claimed to be more important than the latter. The emancipation of the German philosophical faculty found its *locus classicus* in Kant's essay "Der Streit der Fakultäten" (The struggle of the faculties), in which he wrote with some disdain about the professional education provided by the "higher" faculties. Their subject matter was no more than tradition committed to paper. The theological faculty was concerned with the Bible and not with reason; the legal faculty, with law books and not with natural law; and the medical faculty, with medical rules and regulations and not with the workings of the human body. As soon as a clergyman, lawyer, or physician added an appeal to reason, he challenged the commanding authority of the prevailing system and ventured into the realm of philosophy, or so Kant contended.[52]

It is of little importance to our discussion whether this approach was consistent with the everyday reality of faculty life or whether sophistry was indeed more rife at the philosophical faculty than it was at others. Here we are more concerned with the enormous pretensions of German philosophers during the Enlightenment and with the fact that the French *philosophes* were at least as presumptuous as their German colleagues. In general, the French Enlightenment was marked by a fiercer attitude toward the clergy, by sharper opposition to the prevailing feudal system of law, and by greater sarcasm about the profes-

sional profundities of the medical fraternity. In other words, French *philosophes* as a whole were more scathing in their critique of the existing order and of traditional ideas. But of crucial importance was the fact that French Enlightenment "philosophy" was formulated not within the university system but without. No university chair had been set aside for Voltaire, Diderot, d'Alembert, or Rousseau—they presented their work in *salons*.

In eighteenth-century France the university was still a clerical corporation, one of which the French Revolution would make short shrift. In German-speaking parts the oldest universities also were of clerical origin, and after the Reformation the theological faculties had played a dominant role in Protestant regions. However, such young and trendsetting universities as Halle (1694) and Göttingen (1737) had opened their gates to "rational ideas," and their philosophical faculties had developed wider pretensions that in due course were evidenced elsewhere as well.[53] Enlightenment philosophy was, to a large extent, propagated in German-speaking lands from university chairs, in the form of lecture notes later published in book form. Christian Wolff and Kant were typical exponents of a form of *Kathedervernünftigkeit*, academic rationality, whose style differed markedly from that of the *salonfähige esprit*, the presentable wit, of the French *philosophes*.

In the new University of Berlin, founded in 1809 to compensate the Prussians for the loss of Halle after the peace of Tilsit, the pretensions of the enlightened German professors of the preceding period found a firm institutional anchorage in a brand-new philosophical faculty. The new philosophical faculty soon attained a dominant position and shed most of its propaedeutic role.[54] Its founders built on an Enlightenment tradition even though they distanced themselves from the Enlightenment in a great many respects, adopting ideas that would later be associated with idealism or historicism.

In 1810 a special examination for *Gymnasium* teachers, the *examen pro facultate docendi*, was introduced in Prussia.[55] All candidates had to have attended a university for three years. At about the same time, Wilhelm von Humboldt specified that scientific research was the primary task of the brand-new University of Berlin, and especially of the philosophical faculty.[56] This stress on research was one of the most striking innovations of the so-called German *Idee* of a university.[57] Needless to say, the blueprint was one thing, the realization another; in the event, institutional developments would have failed had they not kept up with the growing research ethos of the professors.

All in all, it was far from obvious that the philosophical faculties, which became compulsory training centers for *Gymnasium* teachers, did more than teach mere textbook wisdom. At first their doing so seemed strange. The research task became so dominant that the philosophical faculty turned into a training school for savants rather than for teachers. What the university taught had little bearing on what was expected of a future high-school teacher, so that separate pedagogical courses had to be taught to prepare students for the teaching profession.[58] This combination of scientific research with teacher training, which seemed so inappropriate at first, gave the German philosophical faculties

three advantages over the French arts faculties during the first three quarters of the nineteenth century. First, the German faculties gained enormous prestige. Second, since research could be extended at will, the foundations were laid for a drastic expansion of the academic staff. Third, future teachers were inculcated with a research ethos that in many cases became a habit, which had a refreshing effect and may well have been the only way of preventing education from growing rusty.

Of course there were disadvantages as well. German teachers were often far too learned for their own good, and people spoke of a decline in the teaching craft. The research ethos often gave rise to pedantic behavior. The German lead was also reflected in what was (at the time) undisputed mastery in abstruse donnishness. But for a time the advantages outweighed the disadvantages.

Institutional Shortcomings

Just as a new university was being founded in Berlin, France was given a higher-education system that perpetuated the weak institutional position of the faculties.[59] A lack of local autonomy and of inter-institutional competition went hand in hand with a lack of academic freedom. Moreover, in France no less so than in Germany the same traditional terms were applied to institutions with completely different functions, terms that often reflected their medieval origins.

The Napoleonic Université, established by the decree of 17 March 1808, was not a seat of higher learning but a lay corporation of teachers and inspectors of education. On the model of the Jesuit order, a public organization had been created out of fragments of the older institutions, with a staff predominantly engaged in "secondary" education. The faculties were a part of the Napoleonic Université, but they constituted no more than a small section of the corporation as a whole. In other words, the Université was a national, public organization rather than a local amalgamation of faculties.

The various faculties in a given town did not constitute a collaborating unit but were independent parts of the educational system of a given geographical area, the *académies*. All public secondary schools in the area also fell under the same academy. The academy also exercised control over private schools. In 1910 France had seventeen academies (including 1 Algerian), of which the Parisian was by far the most important. These administrative academies must not be confused with such prestigious bodies as the Académie française and the AIBL or with regional learned societies, many of which were also known as *académies*.

The head of an administrative academy was its *recteur*, assisted by a corps of (feared) peripatetic inspectors. These senior officials wielded great power in the educational system. They were appointed by the head of the Université, the *grand maître*, and later by the minister of education. France had no *rectores magnifici*, that is, elected heads of universities who represented all the faculties to the world outside. The deans of the faculties, the *doyens*, were appointed by the central authority and had no superiors other than the rector of the academy and the minister.

French state education was highly centralized. The arts faculties enjoyed no autonomy whatsoever. The amalgamation of different faculties into an independent, strong and self-confident local university was frowned upon.

Within the various German states, competition between universities continued after the unification of Germany. Needless to say, the authorities of the German Reich also had a strong hold on higher education, but, following a long tradition, the system was never so extravagantly centralized as it was in France, where, however changeable the political system, the strict Napoleonic educational order was maintained through most of the nineteenth century. In that hypercentralized French system there was no room for rivalry between the various arts faculties. Instead, there was a clear-cut hierarchy. The Parisian faculty topped the list. In the provinces the sense of belonging and loyalty to their own institution was extremely tenuous. Paris had no rivals.

Another striking difference was, as I have said, the lack of "academic freedom" in the French system. Even the term was missing from the French language! The Germans, by contrast, greatly prized the *Lehrfreiheit* (freedom to teach) of their universities. Paulsen thought that this freedom was intimately linked to the intellectual freedom he considered to be a characteristic feature of German life.[60] A correlate of the lecturers' *Lehrfreiheit* was their students' *Lernfreiheit* (freedom to learn). The lecturers were free in their choice and treatment of subject matter, and the students were free in their choice of lectures. The only thing that was absolutely fixed was the length of university attendance. Hence, no matter what academic restrictions may have existed in Germany in practice, the atmosphere was more liberal than it was in France, where the syllabus was precisely spelled out and the lectures were subject to frequent inspections. The *venia legendi* (permission to lecture) in France was for a long time reserved for officially approved professors; there was no place for *Privatdozenten*. French arts faculties did not have these underprivileged and legally underprotected lecturers and potential professors. In Germany, the presence of *Privatdozenten* ensured the rich diversity of German university life and stood in the way of fossilization.

The Traditional Tasks

Stripped of their propaedeutic function, stripped of students by the Ecole normale supérieure, having no research objective, and in an institutionally weak position, the Napoleonic arts faculties were doomed to stagnation. For what real task was left for them? In the Napoleonic view, arts-faculty professors had but two clearly defined duties: setting examinations and purveying knowledge to the general public.

Dressed in red gowns, supplied with black and white balls to cast their votes for examinees, for several long, fatiguing days at fixed times of the year the professors made sure that the high standard of the *baccalauréat*, the secondary schools' final examination, was maintained. The examination fees of the many candidates constituted a welcome complement to these professors' meager sal-

aries. Apart from the *baccalauréat*, they also set the *licence ès lettres*, the examination for the bachelor's degree in arts, and finally they attended the hour-long *soutenances*, or vivas, at which every candidate had to defend two theses, one in Latin and one in French.

The chosen means of purveying knowledge to the general public was the formal lecture. The success of a faculty professor's *cours* was measured by the size of his audience. During the annual inspections the relevant figures were meticulously recorded by the inspectors. The number of interested listeners was of course subject to seasonal fluctuations; in the summer, for example, the heat drove potential listeners out of town to country resorts, so that attendance dropped dramatically. In general the audience consisted of rheumatic *rentiers*, pensioned officers, and even the occasional lady, the latter running the risk of being denied admittance on the grounds that she posed a threat to moral standards.[61]

A professor's way of speaking was one measure of his competence. Diction was important, as was rhetorical presentation, but of course the content mattered as well. A lecture was expected to reflect broad knowledge and to bear witness to wide reading; individual contributions were valued, but a deliberate striving for originality was usually considered to be an impediment to tried-and-true forms of education. The discussion of specialized subjects was eyed very suspiciously and generally interpreted as reflecting a lack of more general knowledge. Sparkling displays of erudition were considered to be quite out of place in a lecture by a French professor at a traditional arts faculty.[62]

It would be quite wrong to take a purely negative view of the role of that kind of "people's university," one whose appeal and comprehensibility to outsiders was constantly being checked and one in which specialists were treated with suspicion; there is no doubt, however, that it did not encourage a spirit of research and hampered "normal" scholarship. A few faculty professors did succeed in writing brilliant books based on scrupulous research and yet accessible to the public at large. As far as the historians among them were concerned, one need only recall Guizot's *Essais sur l'histoire de France* (1823) and Fustel de Coulanges's *La Cité antique* (1864), both of which were first presented in lecture form. However, these were striking exceptions.

The arts faculties did not prepare students for examinations. The lectures did not cover the examination syllabus. There were no seminars of the kind found in German universities, where this small-scale and intensive way of teaching was made possible by the *Lehr- und Lernfreiheit*, two mainsprings of the research ethos and habit. Hence there were no students in French arts faculties—they had no business there. The enrollment fees of potential examination candidates were simply treated as an advance on the examination fees.

How, then, did the French *lycées* come by their teachers? The Ecole normale supplied far too. The demand was met in a simple and cheap way: students who had obtained the *baccalauréat* were entitled to stand up before a class, straight out of school as it were. After all, the *baccalauréat* was the crown of a classical arts education and certainly qualified any *bacheliers* who wanted to try

their hand at it to work without further ado in the lowest classes. Teaching was the cheapest way for a person with a classical background to start a career; it was also the least lucrative,[63] so it was all too often entered into as a last resort. Boarding schools provided *bacheliers* with free board and lodging, including free heating, but the pay was meager, the discipline strict, the comfort minimal, and there was little fresh air within the walls of the dungeonlike school buildings.[64]

Those who wanted to advance in the educational sphere had to acquire diplomas by studying on their own after work. Apart from a small number of *normaliens*, who were released to prepare for the higher examinations, all the rest were working students. The rigorous demands of these further examinations, together with the harsh conditions under which the candidates had to prepare for them, explain the large proportion of failures. The first hurdle to be crossed after the *baccalauréat* was the *licence ès lettres*, the general arts degree, a kind of super-*baccalauréat*, which was failed by half the candidates in the first half of the nineteenth century and by more than 60 percent in the 1870s.[65] Once they had passed the *licence*, they could go on to the backbreaking *agrégation*, the annual competition (and hence not strictly an examination) for the highest educational qualification, which called for a staggering amount of general knowledge. The *doctorat ès lettres* was not considered much of a professional qualification and therefore was less sought after than the *agrégation*. It appealed to only five to nine amateurs a year during the first half of the nineteenth century. The numbers increased slightly later in the century, averaging twelve a year in 1867–77;[66] at the same time, the character of the theses changed as well, as we shall see in chapter 6. Here I shall merely observe that one could not expect a faculty lacking a clear research objective to elicit theses meeting the highest standards of academic research.

The arts faculties had close administrative as well as material links with secondary education. The professors set the final secondary-school examinations, and hardly a head of a faculty was without wide experience in secondary education (sheltered university positions continued to be a German monopoly for some time). In keeping with this "integration" of secondary and higher education, the French title *professeur* lacked the exclusiveness and luster of the German *Herr Professor*. *Professeur* was the title of all qualified teachers in *lycées* and *collèges*, no less than in the faculties.

In arts-faculty appointments teaching experience was a very important consideration. The manner in which a teacher discharged his duties mattered less than his length of service. In a great many cases a poor service record in secondary education, with inspectors' reports referring year after year to a failure to maintain discipline in class and educational qualities, was no impediment to a faculty appointment provided the candidate had successfully defended his theses. Social considerations could tilt the scales when it came to appointments to arts faculties. The work there was physically far less demanding than teaching at lower levels. An appointment to a faculty chair was therefore a kind of part-time job or early retirement, and in a sense the key to a system of social benefits, especially in the provinces. At the end of the nineteenth century, by

which time the situation had changed, a critic called the traditional arts faculties "anterooms to a pension."[67] Scholarship was not well served by such self-serving social arrangements, which illustrate once again how glaringly the pretensions, prestige, and functions of French arts faculties France differed from those of the philosophical faculties in Germany.

MODERNIZATION, 1877–1914

Students

The first problem for those who wanted to breathe new life into the arts faculties was the lack of students. There were examination candidates and there were public audiences, but there were no real students to teach. As long as this target group was absent the professors in the arts faculties could not impart genuine higher learning. Therefore, the primary objective of the ablest competent reformers was therefore to attract students into the faculties.[68]

After the first phase of the 1860s reforms, the main features of which, as I have said, were greater historical awareness, inventory taking, and the drawing up of blueprints, the second phase, during which the political wind was favorable after the defeat of France and more money was released for the faculties, also had tangible results that helped in the fight for more students. The most effective means of attracting students, needless to say, was by providing bursaries. In 1877 William Waddington, the then minister of education, introduced *bourses de licence*, which were followed in 1880 by the *bourses d'agrégation*, created by his successor, Jules Ferry. In 1883 a total of 560,000 francs was allocated to some 450 persons, of whom 400 were students at the arts and natural science faculties. The introduction of these bursaries was essential for bringing about a change in the academic climate, which, incidentally, occurred very slowly in some provincial faculties. The habits of the established faculty staff did not change as if by magic; some professors objected to the new role, which meant extra (unpaid) work for them. However, the educational needs of the scholarship students led to the introduction of a new system of lectures that attracted other students as well. In addition, those participating in the *agrégation* were no longer first required to teach school for more than five years—a measure introduced during the Second Empire by Minister Fortoul, who wanted to reserve this competition for experienced teachers.[69] This proved to be an obstacle to uninterrupted and intensive study at the faculties.

The number of (single-faculty) arts students shot up from 120 in 1879–80 to 492 in 1881–82, 762 in 1883–84, and 928 in 1885–86. Thereafter the number of students kept rising steadily until the First World War. In 1891–95 an average of 2,800 students enrolled every year; that figure rose in 1896–1900 to just under 3400, in 1901–5 to more than 4,100, and in 1906–10 to almost 5,900.[70] The founders of the modernized arts faculties were understandably proud of these figures, enshrined in all sorts of statistics. Ministers of education kept patting themselves on the back. Senior civil servants (whose influence was inor-

dinately great as a result of ministerial instability) such as Louis Liard, director of higher education from 1884 to 1902, and Octave Gréard, *vice-recteur* of the Paris academy (of which the minister was the ex-officio rector) from 1879 to 1902, and such educational popes as Ernest Lavisse let no public occasion pass without triumphant references to these numerical achievements. Higher public education, which was able to ward off the competition of the free (Catholic) universities, was a hobbyhorse of the republican regime, be it for opportunist or radical reasons.

But figures can be misleading precisely because of their apparent accuracy. On closer examination we find that the authorities made deliberate attempts to exaggerate them. True, the figures did indeed cover single-faculty enrollments only, but everything and everybody was included: foreign visitors, people attending occasional lectures, and many who were students on paper only and did not prepare for any examinations. The number of genuine students was difficult to determine. One indication is the number of diplomas issued.[71] In the period 1866–70, an average of 114 *licences ès lettres* were issued annually; forty years later, in 1906–10, the annual average was 537. The figure had thus multiplied nearly five times, but that rise was less spectacular than the increase in the number of students enrolled in the arts faculty, which, according to the official figures, rose from the 120 attending lectures in 1879–80 to 6,363 in 1910–11 (more than fifty times as many). The republican authorities manipulated the official figures ever so slightly.

The real increases, however, were unmistakable. It became more and more common to continue with arts courses instead stopping once one obtained *baccalauréat ès lettres*. While the number of *baccalauréats ès lettres* rose by 37.5 percent from 1877 to 1910 (in absolute figures from 3,373 in 1878 to 4,638 in 1910), the number of *licences ès lettres* rose by 273.5 percent (in absolute figures from 151 to 564).[72]

In another respect too the arts faculties scored a considerable success: at the beginning of the twentieth century the Paris arts faculty swallowed up its prestigious rival, the Ecole normale supérieure. The death sentence on the latter as an autonomous institution was passed when Ernest Lavisse, one of the leading architects of the modernized faculties, became director of the Ecole normale. Its teaching staff was absorbed into the Paris arts faculty, although boarders were left were they were. No other faculty succeeded in ridding itself of a competing *grande école*, such as the Ecole polytechnique or the Ecole des sciences politiques. In any case, all *normaliens* were channeled into the Paris arts faculty. The plan to turn the Ecole normale into a pedagogical institute for all final-year arts students preparing for a teaching career was never implemented.

The growing number of students in no way stilled the hunger of the reformers. At the beginning of the twentieth century there was even an ambitious plan to make attendance at an arts faculty, as an *établissement de science théorique*, compulsory for all pupils leaving secondary school and intending to apply for admission to such professional training establishments as the law faculty. In a sense this would have been a resurrection of the old propaedeutic function.

The political motive behind this plan, presented by Charles Seignobos, was obvious: academic studies at an arts faculty were "logically" bound to inculcate a democratic spirit. Learning and democracy were after all inseparably bound up in the progressive pretensions underlying the politics of higher education of which Seignobos was a renowned champion. That was also the reason why women students were being welcomed. "France has good cause to draw women away from the foes of democracy and learning."[73] Here the anticlerical Seignobos was directly attacking the Catholic Church, which was thought to have a strong influence on the female part of the population. But other enemies of the Republic, who considered the Republic a dangerous threat, lay in wait abroad. That is why foreign students also were bid a hearty welcome. Anyone who has studied in France remains a lifelong friend of France, and French democracy could not have friends enough to counter the continuous subversion of the enemies of *la patrie* and of democracy; after all, foreign supporters of the ancien régime were very active in "decrying contemporary France under the guise of describing her."[74]

Seignobos's political objectives were not disguised. He was a sincere democrat but also enough of a politician to play on the feelings of those in government circles who did not ignore the possibility of an antirepublican coup. At the beginning of the century there were in fact quite a few disturbances in the Quartier Latin. Law students in particular had remained susceptible to virulent right-wing ideas. It seemed that the more plainly the government used left-wing republican phrases and the more anticlerical its actions became, the more the most vociferous (law) student society shifted to the right.[75] Incidentally, Seignobos's plans to immunize the "right-wing" faculties came to nothing.

When we look behind the facade of the breezy official documents and addresses, we are struck by the pronounced frustration of lecturers faced with the average arts student's lack of interest and dedication. Attendance at lectures was not obligatory, and absenteeism was rife among students, many of whom had taken on schoolteaching assignments. What lectures they attended were rendered less enjoyable by the ominous cloud of the pending examinations.

In general, we can say that French university life had a free and easy, rather unstructured character. That was true first of all of the teaching: there was hardly a sense of working for a common purpose; the relationship between students and lecturers was very loose and impersonal.[76] This was also true of the students' life outside of class. The Association générale des étudiants de Paris, founded in about 1883, was quite unlike the traditional student organization in countries with an old university tradition, such as Germany or the Netherlands. Students probably found Paris's many diversions much more attractive than arts-faculty dinners, get-togethers at (political) cafés, and editorial meetings at the offices of one of the countless ephemeral small publications. But in provincial towns too there was no traditional student social life; there is no French equivalent for "university town." Nor did the term *étudiant* have the same connotation as "student" had elsewhere at the time; in France one was a *bachelier* or a *licencié* and one hoped to become an *agrégé*. "Student days" was not a term

used in France; there was no student identity. What did exist was *cameraderie normalienne*. As a *normalien* one was someone to be reckoned with; one bore a kind of title, was filled with esprit de corps. Arts faculties had little to offer in its place.

At about the turn of the century, when the atmosphere at the Ecole normale became polarized and socialism as well as pacifism gained in influence by the side of republicanism, students at the arts faculties did not constitute an equally identifiable and vociferous subculture.[77] The Dreyfus affair was an important catalyst in the polarization and politicization of the intellectual climate of the Ecole normale; the large number of intellectuals (a term that originated during that period) of Jewish origin made it difficult to adopt a neutral stance. Intense intellectual exchanges fostered political commitment, physical isolation from outside society notwithstanding.[78] It is perhaps exaggerated to claim that the *trahison des clercs* (as such political commitment was later labeled by Julien Benda)[79] was invented in the Ecole normale, but there is no doubt that at the arts faculties, where there was no physical isolation from society at large, and where the atmosphere was more anonymous and less constricting, the students did less to force one another to take a social and political stand. The heated discussions of the *normaliens*, incidentally, had a rather theoretical character given the privileged social position they held.

Since many students at the arts faculties had to pay their own way by becoming teachers soon after gaining their *baccalauréat*, those who looked upon the growing number of students as young people out to delay shouldering social responsibilities were clearly being unfair. Admittedly, there was some truth in the contrast between the sons of the bourgeoisie engaged in a life of play and pleasure at academic establishments and working-class boys who had to earn money at the very earliest opportunity.[80] Some historians have even argued that "adolescence" first became a concept and a problem when a growing number of bourgeois youngsters started to pour into the universities.[81] As far as the arts faculties were concerned, this facile interpretation is not very plausible. The students in these faculties found themselves in a different position from that of students in the legal and medical faculties, a distinction that stemmed partly from their more ambiguous future. In intellectual respects, a teacher was part of the top layer of society, charged with looking after the sons of the well-to-do. But his own lifestyle was rather cramped. His economic position was fairly safe but not very spectacular and in any case hardly held out prospects comparable to those of lawyers and physicians. It is little wonder, then, that teachers were called *demi-bourgeois*.[82]

With their many working and scholarship students, and hence few *héritiers* (heirs) the arts faculties practiced the most liberal social recruitment policy; similarly, the Ecole normale supérieure recruited fewer upper-class students than the Ecole polytechnique or the Ecole des sciences politiques.[83] Even so, students and teachers did not have to work with their hands. There was thus a cultural gulf between them and the working class in the expanding industrial towns, while centuries of alienation divided them from agrarian society.

The Statutory Provisions

By the law of 1896 the French faculties were joined together into "genuine" universities. That law was therefore the birth certificate of the French universities, and the culmination of a long series of legal changes.[84] One of the mainsprings of the reform movement was the wish to increase the autonomy and the influence of higher education.

The first objective was greater autonomy in the supervision of the teaching staff. State education, said Jules Ferry, the minister of education, in 1880, had to be transformed from an *administration* into a *corporation vivante*. The old Université had to be emancipated and secularized. The first step in that direction was the removal from the minister's most important advisory body, the Conseil supérieur de l'instruction publique, of all persons not associated with educational institutions. In particular that meant the exclusion of a large number of clerical members.[85] At the opening of the first session of this powerful committee Ferry spoke of the creation of a new "States General" of education.[86] The foundations were laid for a university ambience that became increasingly self-confident. For the first time in French history the universities were given a clear and individual voice and became a factor of public opinion. Similarly, beginning in 1880 most educational reforms were launched by people engaged in education. Before that time much of the talking and arguing had been done by dignitaries of state and church over the heads of teachers and lecturers.

The next step was to grant the faculties greater independence. In 1885 they were accorded corporate rights; henceforth they were authorized to accept donations and subsidies from local authorities and private individuals. A faculty *assemblée*, made up of all lecturers, was established and charged with drawing up the curriculum. Also established was a *conseil* made up (exclusively) of heads of departments in which financial matters were discussed and appointments considered. The dean was to be chosen by the minister from between two candidates, one proposed by the *assemblée* and one proposed by the *conseil*. Although the reformers were far from satisfied, these changes introduced a greater measure of liberalization and decentralization. The faculties had come of age, were given a say, and even had some influence on decisions about higher education.

Prior to the foundation of "genuine" universities, comparable to the German ones, a *conseil général des facultés* had been set up in some academies, made up of the rector of the academy, the deans, and two professors elected from each faculty. Some ten years later the law of 10 July 1896 formally established universities.[87] The number of universities and their locations agreed more or less with the Napoleonic provisions, but the formal amalgamation of faculties into universities was something quite new. Even so, many reformers were disappointed by the way the new universities functioned. The young universities were born with two innate flaws. First, there were too many; in the prevailing circumstances there was little prospect of creating fifteen (Strasbourg had been

lost in 1870) flourishing centers of higher education. In smaller towns the new universities, as mergers of poorly attended faculties, remained doomed to a vegetative existence.[88] Second, by the time the law was passed (1896), the power of the separate faculties had grown too great.[89] In addition to the powers already mentioned, they enjoyed further privileges, including control over their finances. The nerve centers of French higher education were loath to shelter under the umbrella of universities that were awkwardly trying to find their feet in the Napoleonic system handed down to them. The faculties were autochthonous elements that had been able to wrest in the 1880s what powers the reformers, including Louis Liard, the influential director of higher education, had meant to reserve for the new universities. Yet, when it came to ceding rights once acquired, the faculties refused to budge and remained the hub of higher education. The law of 1896 changed that very little.

And yet it did more than produce a new label; the change in name also had a psychological effect. Many of those concerned felt a sense of deep satisfaction. At long last France seemed to have caught up with the rest of the world.[90] The new law increased the appeal of French higher education to foreign students, and that meant a lot in the context of bitter rivalry with Germany. (One of the disadvantages of the system of the *grandes écoles* had been their inability to attract foreign students.)

Moreover, the law was one further step toward the greater autonomy of higher education. The exalted ideas about unity of knowledge and decentralization inspired by the reform movement were not, of course, realized by the mere establishment of universities. That required more than new legal provisions. The disappointment felt was largely the result of inflated expectations.

The Growth in Academic Staff

In the original Napoleonic plan every arts faculty was meant to have five chairs: philosophy, classical languages, French literature, history, and foreign languages, which might be English, German, Italian, Spanish, or a combination of these. As mentioned earlier, history chairs were founded well before history was taught as a special subject in the *lycées*. At the end of the Second Empire the Napoleonic system of chairs remained unchanged in fifteen of the sixteen arts faculties, Paris being the exception: in 1865 the Paris arts faculty boasted eleven chairs, that is, more than twice the usual number. In addition to the chair of philosophy, there was also a chair of the history of philosophy; the chair of classical languages had been split into three, one for Greek and two for Latin (rhetoric and poetry); the chair of history had been split into ancient and modern history, and there was a separate chair of geography. The total number of chairs in French arts faculties came to eighty-six in 1865.

Forty-five years later, in 1910, the number of chairs had more than doubled even though Strasbourg had meanwhile been lost. Table 19 shows the increase in the number of chairs both in Paris and in the provincial faculties. It is remarkable that even though Paris had a headstart, it nevertheless profited most

TABLE 19
Increase in the Number of Chairs at Arts Faculties, 1865–1910

Faculty	1865	1878	1888	1899	1910
Paris	11	13	20	22	33
Provinces	75	82	98	122	142
Total	86	95	118	144	175

Sources: Figures are based on the most careful registration, found in successive issues of the *Statistique de l'enseignement supérieur* (1869, 1879, 1889, 1899). For 1910 I consulted the budget, and for the situation in Paris I referred to Guigue, *La Faculté des lettres.*

from the expansion. In Paris the number of professors tripled, whereas in the provinces the number less than doubled. As a result, the proportion of Parisian chairs rose from 12.8 percent in 1865 to 18.9 percent in 1910.

There were also considerable differences among the provincial faculties themselves. In 1910 four provincial faculties had more than ten chairs each, namely, Bordeaux and Lyon, with eighteen chairs each; Toulouse, with fifteen; and Lille, with thirteen. The rest had to content themselves with a much smaller number and hardly expanded.

Alongside the increase in the number of chairs, a new position was introduced in the 1880s, namely, that of *maître de conference*, or university lecturer, a person who was employed full- or part-time to run a *cours complémentaire* or a *conférence*. The familiar *suppléant* who, under the old system, had often acted as substitute for the titular head of the department (perhaps on study leave) year after year, and for a small part of the latter's salary, became an unusual sight, although he did not disappear altogether.

Initially the staff expansion followed a fixed pattern. First, separate chairs were created for Greek and Latin, and in some cases such features as "institutions" and "philology" were explicitly added to the teaching assignment. Next, the expansion came to benefit history, often culminating in the creation of three separate chairs of history, in accordance with the humanistic triplet: ancient, medieval, and modern.

Geography, for which Paris alone used to have a separate chair, was split off from history, with which, however, it continued to be inseparably linked. In any case, several independent chairs of geography emerged in the provinces.

Beginning in 1885 the faculties had the right to create separate chairs with money that was not supplied by the Ministry of Education. As a consequence of this "liberalization" and "decentralization" Paris acquired a very hotly disputed chair for the study of the French Revolution,[91] and chairs of local and regional history were established in several provincial universities.

The Share of History

History, including art history and archeology, accounted for a remarkably large share of the growing number of chairs in the arts faculties. Table 20 lists the

TABLE 20

Increase in the Number of History Chairs (including Geography) at Arts Faculties, 1865–1910

Faculty	1865	1878	1888	1899	1910
Paris	3	4	6	8	16
Others	14	21	26	37	41
Total	17	25	32	45	57

Sources: Figures are based on the most careful registration, found in successive issues of the *Statistique de l'enseignement supérieur* (1869, 1879, 1889, 1899).

number of chairs in various historical subjects, including geography. In 1865, 20 percent of all chairs in the arts faculties went to history (including geography); in 1910 the figure was 32.6 percent. Particularly striking is the doubling of the number of history chairs in Paris during the first decade of the twentieth century. For a long time there had been three such chairs in Paris, in ancient history, modern history, and geography. Five new chairs were added at the end of the nineteenth century: in archeology (1876), medieval history (1878), modern and contemporary history (1883), history of the French Revolution (first a *cours* but converted into a chair in 1891), and art history (1899). In 1910 this figure had risen from eight to sixteen, thanks to the establishment of chairs in Roman history, history of medieval civilization and institutions, modern political and diplomatic history, and history of social economics (all four in 1904), history of Christianity in modern times (1906), historical method, and Byzantine history (both in 1907), and geography and topography (1909).

The number of history lecturers grew quickly as well. There was just one in 1878, but there were twenty-six in 1888, twenty-seven in 1899, and some fifty in the various arts faculties by 1910.[92] Because of this expansion French historical scholarship may be said to have made considerable strides at the beginning of the twentieth century. Moreover, a number of philology and literature departments had started to lay greater stress on the historical components of their respective disciplines. Thus, the study of classical languages was sometimes complemented with the study of institutions and *antiquités*; in 1910 a chair in the history of the French language was established. In addition, men with a strong historical bias were appointed to various chairs of philology and literature: Gebhart and later Jeanroy for southern European languages and literature; Ernest Lichtenberger and later Charles Andler for German language and literature; and Gustave Lanson for French rhetoric. Lanson's name, in particular, was associated with a purely historical approach to the study of literature. He headed a school of historians of literature who did excellent work, which, however, has been overshadowed (and sometimes discredited) by the dramatic rise of the postwar "antihistorical" school built on structuralist and allied theoretical foundations.[93]

It is possible to speak without exaggeration of the genuine "historicization" of the Paris arts faculty at the end of the nineteenth century and the beginning of

the twentieth. There was not only greater interest in historical subjects but also a marked preference for the historical method (see chapter 6). As mentioned above, in 1907 Paris was even given a chair in historical method.[94] Of the eleven new chairs created in the Paris arts faculty in the years 1900–1910 eight were reserved for historians.

This preponderance of historians casts a sharp light on the discrepancy between the intellectual success and the institutional failure of sociology in the arts faculties. No matter how original and inspiring Durkheim's ideas were found to be, no matter how influential the *Année sociologique*, a journal founded in 1898, was, no matter how much Durkheimian sociology appealed to the most gifted students, sociologists barely gained a foothold in the arts faculties. Until the end of the First World War there were only two posts, one in Bordeaux and one in Paris, both of which were the result of *ad hominem* appointments made by Durkheim himself. In 1887 Louis Liard, the director of higher education, who saw a lot of Durkheim, had called Durkheim to Bordeaux.[95] In 1902 Durkheim, who had by then published his most important sociological works—*De la division du travail social* (1893) and *Le Suicide* (1897), together with the theoretical *Règles de la méthode sociologique* (1895)—had been appointed substitute for Ferdinand Buisson in the chair for the *science de l'éducation*, established in 1877. In 1906 he became the titular head of that department. It was, incidentally, not until 1913 that "sociology" was officially taught by the side of "pedagogy."[96]

To these two posts we can add a third, the special chair for the history of social economy, established in 1904 and reserved in 1907 for a sociologist (in the event C. Bouglé).[97] The rise of sociology under Durkheim and his associates, practically all of whom had had a philosophical education, did not succeed in breaking the institutional grip of historians, despite the many doubts created by the destructive criticisms of, and fierce polemics against, the hegemony of the historical method.[98]

After the First World War several great historical works, no less than the *Annales d'histoire economique et sociale* (1929), that dynamic historical journal, were clearly and profoundly inspired by Durkheim and more especially by his *Année sociologique*. In a sense, French historians may even be said to have turned into intellectual parasites of sociologists: they were only able to maintain their strong institutional position by exploiting sociology. What interdisciplinary cooperation began to develop between French historians and sociologists clearly benefited the historians. There was no teaching of sociology as such. In 1920 sociology became an obligatory but subordinate part of the philosophy course.

The case of French sociology shows that intellectual influence is no guarantee of institutional success;[99] institutional power does not always go hand in hand with intellectual achievement. Ideas can circulate and change more freely and more quickly than institutions, which put up a tough resistance to radical reforms and generally develop along fixed paths.

It is not easy to explain the institutional success of the historical disciplines

around 1900. The most important prerequisite was the prior institutionalization of history in secondary education (see chapter 3). With some delay, the marked advances of history as a school subject made themselves felt in higher education as well. Sociology, by contrast, had an Achilles heel: it provided few jobs—in secondary education or elsewhere. True, students at the Paris arts faculty were compelled to attend Durkheim's lectures on pedagogy, and sociology was made a compulsory subject in teacher-training colleges, but all attempts to turn sociology into a compulsory school subject came to nothing.[100] Only as a subdivision of philosophy could sociology be taught in the *lycées*.

In short, there were at least three factors favoring the hegemony of history in the arts faculties. The historians at the young universities produced academic results, had the political wind in their sails, and enjoyed an institutional headstart.

In respect of the first point, it was easy to show that the excellent academic results sprang from the application of the historical method. The quantity and quality of academic history publications had been appreciably improved. The historical method was almost synonymous with thoroughness and reliability, for all the criticisms that could be leveled at its assumptions and structural principles (see chapter 6).

Was it an accident that the great increase in the number of history chairs in Paris was achieved while the radicals were in power—first under the reign of the Bloc républicain, that mammoth alliance of social radicals and socialists led by the implacably anticlerical Combes (1902–5), and later during the reign of the Concentration républicaine, the union of social-radical, radical, and moderate republicans, to the exclusion of the socialists, under the leadership of Georges Clemenceau, known as the "strikebreaker" and "France's number one cop" (1906–9)? Money for the new chairs had to be found somewhere, and when it came to establishing them, it was the government that called the tune. This did not necessarily mean that political criteria alone determined which professors would be nominated. The smear campaign of the opposition press, depicting a maffia of progovernment historians milling about in the rue de Grenelle, where the Ministry of Education was housed, the better to help political comrades obtain attractive posts, was greatly exaggerated. The unimpeachable integrity and the scruples of some professors did not save them from the jibes of the gutter press. Most historians did not sell their principles for political advantage, though they might flirt with politics now and then and entertain prospects of gaining some money. That, incidentally, applied also to those sociologists who, in that climate of virulent anticlericalism and "Combism," allowed themselves to be presented as the social leaders of the future and as heralds of a "secular morality," proffered as a sound alternative to the Christian vision of the good society and to Catholic morality.[101]

A third factor in the institutional *succès fou* of historians during the first decade of the twentieth century was the strong position from which they had set out. In accordance with the biblical saying "whosoever hath to him shall be given," the position of the mightiest grew mightier still, and they were able to

take the fullest advantage of the expansion in academic staff. The historians thus benefited from an institutional snowball effect.

REFORMING THE EXAMINATIONS

In the 1890s a rising tide of inquiries, reports, books, and articles reflected intense interest in the reorganization of the examination system. Next to the statutory provisions, the examination question took up more and more space in the *Revue internationale de l'enseignement*, the influential journal of the reformers.[102]

There were tangible results. Before the turn of the century the nature of the *licence* and the *agrégation* were changed, and a completely new examination, the *diplôme d'études supérieures*, was introduced. The *baccalauréat* proved the most resistant to the reformers' onslaught; until 1902 it remained an unassailable bulwark behind which the old educational tradition fought a rearguard action.[103] But then, the *baccalauréat* examination was part of secondary education.

Before we look at the examination changes, I should stress that examinations used to be much more important than they are in modern universities. Their role, in fact, casts some light on the nature of education. They sealed the student's fate all at once, since there were no preliminary or oral examinations. The day of the examination was thus the "supreme moment" of the student's career, its alpha and omega, with crucial repercussions on appointments and salaries. Examinations set the rhythm of academic life. Their results were not affected by preliminary tests taken over the years or by essays rewarded with so-called pass sheets. Pass sheets are so important nowadays that university finals have turned into pure ceremony, determined survivors of the storms of the 1860s.

The pass-sheet system not only eases the burden of the examinations but is of course also a way of ensuring regular attendance at lectures. Not surprisingly, therefore, it was favored by many lecturers in the period under review, although it was introduced on only a limited scale. By and large, things remained as they had been. "The examination is the master, the rule, the discipline." Not education but examinations mattered; the whole thing was topsy-turvy, as Lavisse put it in 1892.[104]

Yet, after a modest start in 1877, in the course of the 1880s all arts faculties introduced tutorials to prepare students for the *licence* and the *agrégation*. Paris led the way, but the larger provincial universities followed soon afterwards, and the smaller faculties eventually adapted themselves warily and with bad grace to this Parisian innovation. For lecturers it meant a great deal more work. The *cours public* (public lecture), which often required long preparation and proved a sore trial for less eloquent professors, was retained. Added to it now, were two *cours fermés* (closed courses), one as a preparation for the *licence* and the other leading to the *agrégation*, both being open to examination candidates only. The *cours public* remained optional and often resembled a correspondence course since many candidates had already started on a teaching career and could not

afford the expense of traveling to the nearest faculty once a week. It was also with an eye to "working students" that the *cours fermé* was held at night.[105]

The examination questions were set from on high and hence left little choice to lecturer or student. No allowance was made for the special interests of the teacher, if indeed he had any. In that respect the tutorials were a time-consuming chore that curtailed the hours a lecturer could devote to research. For this reason alone it would be utterly misleading to liken the French *cours fermés* to the German *Seminare*. At French arts faculties there was no *Lehrfreiheit* (freedom to teach) nor any freedom to do research. The teaching associated with the *cours fermé* was exclusively based on the prescribed examination syllabus, which retained its general character for a long time and was closely linked to what students had been taught in secondary school.

The Licence ès Lettres

By and large, the *licence ès lettres* was a kind of super-*baccalauréat*.[106] All the training for it too was given in secondary school; it differed from the *baccalauréat* only in its greater degree of difficulty. The *licence ès lettres* required, among other things, a Latin essay, a French essay, a Latin verse composition, and a Greek translation exercise. The first change came in 1880: students could opt to be examined on literature, philosophy, or history, and from 1886 also on modern languages. The scope of this form of specialization has, however, been exaggerated. The specialized area was relatively small; the *licence ès letters* remained a general diploma. Many experts agreed that when all was said and done very little indeed had been altered. Seignobos contended in 1904 that "every lecturer who had to correct written work for the *licence* realized how little it differed in kind from the *copies du baccalauréat*."[107] In contrast to official expressions of satisfaction, reflected in later studies of the subject, many experts considered the *licence*, for all the changes, the greatest obstacle to the (re-)organization of historical studies at the faculties.

In 1907, at long last, after prolonged pressure by, among others, such leading historians as Seignobos, the *licence* was split into four clearly distinct types. However, Latin translations were demanded in all four (until 1920) and continued to be a major stumbling block. There was no fundamental change in the subject matter, which, as of old, remained linked to the secondary-school syllabus. The *licence* in no way prepared students for academic research. There were, for instance, no exercises involving problems posed by an academic controversy and no discussions of the *état des questions* (the stage things have reached); nor was there a review of data, arguments, and material other than those presented in the prescribed text. No provision was made for familiarizing students with academic methods, for teaching them to use bibliographies or keep up with the latest literature, or for pointing out gaps in the prevailing state of knowledge.[108] In short, there was a failure to give education an academic orientation.

Latin translation remained the centerpiece of the *licence*. After 1880 there was

some shift in favor of French, just as in secondary education, but the students were still left with exercises in language and style, as so many relics of the old rhetoric, that pièce de résistance of every licentiate in the arts faculty, including those in the history stream.

All in all, the *licence ès lettres* was an arduous examination. At first some 50 percent of all candidates failed it; after the 1870s this percentage tended to rise even further.[109]

The Agrégation d'Histoire

Although the *licence* may have been a difficult examination, it was a mere trifle compared with the *agrégation*. The *agrégation* was not, strictly speaking, an examination but a competition. Every year a fixed number of places were reserved for the very best students; the rest of the candidates fell by the wayside. The *agrégation* was a veritable Minotaur.[110]

In essence, it was a certificate of educational competence dating back to the eighteenth century (1766). This particular method of selecting teachers had been instituted to fill the gap created by the expulsion of the Jesuits in 1762. In time it acquired a dual function: in addition to safeguarding the high quality of teachers, it also provided a means of regulating their number. The oral part of this annual competition marked a red-letter day in university life. The *agrégation* was considered a gauge of the state of education. The press published lengthy reports.

The competition was organized by the central authorities and was held in Paris in the middle of August. Faculty professors manned the powerful *agrégation* jury, though the competition as such was not a faculty affair.

Eighty to 90 percent of candidates failed the examination.[111] Those who succeeded in passing it enjoyed considerable privileges: higher pay, fewer hours, and the allocation of higher classes. *Agrégés* constituted a small elite among secondary teachers. Their number, incidentally, continued to grow, increasing from 9.5 percent in 1842 to 19.6 percent in 1898.[112] Beginning in the second half of the nineteenth century, teachers tended increasingly to seek higher qualifications; on the other hand, there was a "Malthusian" effect, which kept the annual recruitment of *agrégés* in check.[113]

In order to better understand the development of history teaching in the arts faculties we must look at the makeup of the *agrégation d'histoire*. Although there had been an *agrégation* since 1830, it was not until 1907 that a special *licence* for historians was introduced, a logical consequence of the institutionalization of history teaching in the *lycées*. Not only can the changes in the requirements for the *agrégation d'histoire* thus be examined over a relatively long period but the *agrégation* also provides one of the few criteria for assessing the development of history teaching in the not yet differentiated arts faculty. The *agrégation d'histoire* was a crucial and characteristic factor of this development.

The jury assessed the candidate's ability on the basis of his presentation and knowledge. The two prerequisites of success were rhetorical ability and ready

knowledge: an *agrégé* had to be eloquent and possessed of a good memory. During the second half of the nineteenth century specific academic demands were added, and these were finally entrenched in 1894 in the form of a separate examination that had to be passed before a candidate was admitted to the actual *agrégation* competition.

We can distinguish the following periods. From 1831 to 1852 the old order prevailed. From 1852 to 1860 there was no special *agrégation* for historians. From 1860 to 1885 new "academic" demands were added; though the old forms were preserved, the subject matter was subjected to philological and specialist revision, particularly thanks to the contributions of Fustel de Coulanges in the 1870s. In 1885, at the instigation of Ernest Lavisse, a break was made with the traditional form: the *disputatio* between the candidates (the tournament) on a subject chosen by the jury was replaced with an (oral) examination based on the candidate's own extended essay. The academic demands were increased. At the same time, more attention was paid to geography. In 1894 a new era was ushered in: before being admitted to the *concours*, candidates had to prove their academic ability, to which end a special diploma was introduced. Training for this diploma was provided at the arts faculties, whose raison d'être was strengthened as a result. The *agrégation* was now relieved of its "academic" part. In the new order of 1894 the testing of pedagogical skills was an important issue.

But no matter what the changes and what new demands were added, without the gift of rhetoric and ready knowledge no candidate could hope to become an *agrégé*. And who would argue that a history teacher could do without either of these?

1831–1852: THE OLD ORDER

Initially the *concours* took the form of three tests, one written and two oral.[114] The written test came first: it consisted of a six-hour-long essay. Beginning in 1837 candidates had to write three essays, one each in ancient history, modern history, and geography, to which was added a fourth, in medieval history, in 1861. The set topics could come from any part of the secondary-school syllabus, and the training, not surprisingly, consisted in endless drills of schoolbook truisms. These were referred to as *repasser*. After the written test, the first sifting of the candidates took place and the preliminary list of *admissibles* was compiled.

The second hurdle was an oral examination, known as the *thèse d'agrégation*, as distinct from the *thèse de doctorat*, the doctoral thesis. Three months before the *concours* the jury published the six to eight subjects of the *thèse d'agrégation*. Twenty-four hours before the examination, candidates were told on which subject they would have to deliver an address. After delivering the address, the candidate was questioned for one hour by two fellow candidates—his *argumentatio* being thus followed by a *disputatio*. It was not until 1885 that this practice was dropped. To give the candidates more time for preparation, the examination subjects were published nine to twelve months before the competition.

Moreover, the same subjects were used for several years in succession so that those who had failed could revise their earlier addresses. For all that, it remained next to impossible to absorb all the essential data in the short time at the candidates' disposal.

The following six questions set in 1831 may convey an impression of the demands made on the hapless students:

1. How was the Roman Senate reformed, and what powers did the Senate have during various periods of the Republic and during the first century of the Empire?

2. Which were the frontiers, the most important towns, the customs, and the culture of the Roman province of Africa in the sixth century A.D.?

3. What can be inferred from Ennodius's eulogy of Theodoric?

4. Which were the great territorial divisions, the most important towns, and the political structure of Germany in the eleventh century?

5. What is the origin, and which were the distinct meanings, of the terms Guelph and Ghibelline during different periods?

6. Which were the Portuguese settlements in India in the fifteenth century? Pay particular attention to the talent and deeds of Alphonso d'Albuquerque.

This list of questions for the *thèse d'agrégation* was concluded with the recommendation that they be answered by reference to original documents. A great many candidates studied just one or two subjects thoroughly in the hope that luck would be with them. If it was not, and they had to improvise at top speed an answer to a question they had not prepared properly, then their chances of passing were poor, although verve and a cool head might still get them through. The fact that the competition was invariably held in Paris was a considerable disadvantage for students from the provinces. In the crucial twenty-four hours before the examination those candidates who knew their way about the capital had a considerable edge on the rest. Moreover, Parisian students had better local connections, and these could prove helpful to them. True, it was strictly forbidden to consult others, but that ban was hard to enforce.

The large number of failures did not persuade the jury to lower their requirements for the *thèse d'agrégation*. The subjects continued to be very broad. Thus, in 1839 one of the questions was, "Trace the history of Cardinal Richelieu's administration," the students being expected to discuss at the very least the cardinal's domestic and foreign policies, including finance, the law, the army, the fleet, the colonies, agriculture, industry, literature, and art. The geographical questions, too, were very broad. A question in 1834 read: "Sketch the geography of Europe following her great natural divisions and state precisely all the political changes that have taken place on European territory in the composition and frontiers of the various states from the disintegration of Charlemagne's empire to 1789."

The questions thus continued to range over a large field, and the demands on the candidates seemed to become increasingly strict. The report of the 1847 jury stated clearly that the *thèse d'agrégation* did not call for a *discours* but for a "dissertation de critique historique," that is, a reasoned discussion of the *travail*

érudit, the student's academic research.[115] The arguments had to be shored up with references to authoritative sources, and contradictions in the latter had to be carefully explained. In view of the wide-ranging character of the questions, however, the required scholarly approach could not possibly be deployed. After this second test the final list of *admissibles* was drawn up.

Finally, the remaining group of candidates was set the last test, once again oral, the *leçon*. It consisted of a lecture by the candidate lasting half an hour, followed by half an hours's questioning by the jury. The subject of the *leçon* was chosen one day earlier by lot. In theory it was meant to test the candidate's ability to convey the set subject matter to his pupils, his didactic skill ("always sober, grave, and circumspect in its appeal"), but in practice what mattered was its appeal to the professors who made up the jury. In other words, the demands were substantial and intellectual rather than didactic.

In view of the jury's severity, we should not be surprised to learn that in 1843, by which date the *concours* had been held twelve times, a mere thirty-three *agrégés d'histoire* were employed in education,[116] and that in 1847, for example, a mere three candidates passed the test, the jury adding that the *thèse d'agrégation* of each one of these had had serious shortcomings. The jury was of course aware that most of the candidates had to prepare for the examination while working as schoolteachers, which meant that they had to devote a great deal of time to correcting homework. In 1847 the jury concluded its report with a balm for wounded feelings, a sincere expression of their profound "esteem and regard for so much courage and intellectual effort, and that for no other end and ambition than making a modest and hard-earned living."[117]

1852–1860: AN INTERLUDE

From 1852 to 1860 no special history *concours* was held. According to Fortoul, the Bonapartist minister of education, a general *agrégation* competition had to cover all arts subjects.[118] Specialization merely led to a "stubborn clinging to peculiar ideas." A Saint-Simonian, he had a poor opinion of "impassioned disputations" based on the old "scholastic battles." The *concours* had overreached itself. Instead of testing didactic and pedagogical skills, it had degenerated into a platform on which priggish students could parade their subtleties and indulge in displays of pedantry. The *concours*, to which the press paid so much attention, simply turned the winners' heads.

To encourage the candidates' practical skills, a new entrance qualification for the general arts *concours* was added: all candidates were henceforth expected to have had several years' experience in education. Without saying it in so many words, this measure was pointedly aimed at *normaliens*, a select, noisy, and politically recalcitrant group who were exempted from teaching duties while they prepared for the *concours* and hence were the most successful candidates.

Fortoul's measure was thus designed not only to increase the practical skills of the *agrégés*; it also had a repressive objective. University circles objected strongly to it. It took until 1860 for the tradition to be restored. Fortoul's inter-

vention was therefore no more than an interlude. The specialization of teachers, including history lecturers, could not be halted for good.

When the old *concours* was restored, an important change was made: the *thèses d'agrégation* were replaced with three (oral) text interpretations. Every candidate had to give a commentary on one Greek, one Latin, and one French text from a list published several months earlier. This change was in keeping with a general tendency in history education that we might call the "philologization" of history. In the first place, it reflected the wish to make classical authors more widely known among historians and hence to prevent a separation between the teaching of history and the teaching of arts subjects in general; letters must benefit from "contact with the great historians."[119] The set texts were much too long for critical study, let alone for any serious discussion of recent contributions. The questions were often posed in such a way that the text interpretations resembled the old *thèse d'agrégation*.

In time, however, scientific (philological) source analysis gained in importance. It became essential to use the best edition of the texts to be analyzed, and recourse to the original sources became a habit of history teachers at the faculties. There was a clear difference between assignments characteristic of the old *concours*, such as "Outline the political role of Demosthenes in his struggle against Macedonia," and such new assignments as "Demosthenes' *Philippica*" or "Plutarch's *Life of Demosthenes*"; or to take another example, between the old-style assignment "Outline the relations between the Carolingians and the Holy See" and the new-style assignment to discuss an extract from the *Monumenta Carolina*. In short, the source had replaced the presentation as the central issue.

After the passage of several years, textual analysis alone was no longer considered a sufficient test of the candidate's historical knowledge. For that reason the then minister, Victor Duruy, reintroduced the *thèse d'agrégation*. but now with more pointed questions. Textual analysis as such, which generally was considered a very useful exercise, was retained. The *concours* was, therefore, not rendered any easier.

To gain some idea of the demands made by textual analysis and the *thèse d'agrégation*, let us now look at the 1872 examination syllabus: two Greek texts (Plutarch's *Life of Agesilaus* and Xenophon's *Hellenica*, books 3–5); two Latin texts (Sallust's *Catalina* and Cicero's *Epistolae ad diversos*, books 1–8), and two French texts (chosen from Joinville and Monstrelet's *Chroniques* [1400–1422], book 1). In addition, there were five *thèses* in which the abovementioned texts played an important role:

1. Discuss and compare the expeditions of the Ten Thousand, of Agesilaus, and of Alexander the Great in Asia from the historical and geographical viewpoints.

2. Discuss the situation of the Roman Republic and of Roman society from the end of the War of the Allies to the beginning of Augustus's principate.

3. Discuss the Roman equestrian order from the time of the Gracchi to the decline of the Empire.

4. Discuss the Latin kingdom of Jerusalem.

5. Discuss the domestic history and constitution of England under the house of Lancaster.

The candidates had nine months in which to prepare. A year later, in 1873, modern history had its turn. The French textual analysis included one volume of the *Mémoires* by the (duc de) Saint Simon, and one of the theses had to deal with the relations between France and Spain during the reign of Louis XIV. There was even a thesis on nineteenth-century political history: "The treaties of 1815."

In the second half of the 1870s this sort of assignment came to be considered far to broad. Not only were fewer subjects set for the theses from 1877 on but the same subjects were used for several years in succession to help those students who had to retake the examination. Moreover, the set texts were shortened, and the subjects became more specialized under the *système des questions étroites*, the narrow-questions system. It was introduced not so much to make the *concours* easier as to help students attain the required standard. Because the subjects set for the thesis were less wide-ranging, general knowledge and general book learning became less essential than the study of monographs and detailed knowledge of specific problems. The old type of *concours* was thus adapted to the specialization of the prospective *agrégés*. Rhetorical gifts and an exceptional memory remained important, but they no longer sufficed those aspiring to become *agrégés*.

In 1894, for instance, the assignment for students of modern history was as follows: "With the help of original documents, discuss the most important treaties signed by France in 1713 and in 1714." The subject had been announced a year earlier. Twenty-four hours before the actual examination students were told which of the following questions (*sous-thèses*) they had to be answer:

1. Discuss the repercussions of the treaties and diplomatic conventions of 1713 on trade, the fleet, and the colonies of France and England.

2. Specify the part of the German Reich and the house of Hapsburg in the negotiations, treaties, and diplomatic conventions of 1713 and 1714.

3. What was the role of Holland in the negotiations of 1713 and 1714, and what did Holland achieve through the treaties entered into during this period?

4. Define the role of the house of Savoy in the negotiations and treaties of 1713 and 1714.

5. Discuss the political and dynastic relations of France and Spain in the negotiations of 1713 and 1714.

Such purely diplomatic topics were popular with the jury in those years. As a result, there was a change in the character of the sources to be consulted. The

introduction of textual analysis in 1860 may have been largely based on literary motives and may originally have centered exclusively on the elegant prose of famous historians. However, in the course of the 1870s nonliterary sources too were expressly included, something little short of a revolutionary innovation. Nonnarrative, "involuntary" sources of a legal or diplomatic kind (treaties, laws, charters, etc.) had never before been studied on so large a scale in any *arts* faculty. When it came to history, the study of which was still largely governed by rhetoric, arts faculties had of old concentrated on literary and hence on narrative texts. The change in the type of source chosen for study was naturally bound up with growing interest in some subjects.

To round off the picture, it should be added that in 1884 the diplomatic scene of 1713–14 constituted the only modern-history question. That same year students were also asked to discuss the following ancient-history topic with the help of original documents: the tribunal of the heliastae at Athens to the end of the Peloponnesian War. They were also asked to discuss the following medieval problems, again "with the help of original documents from the West and the East": the events leading to the establishment of the Latin empire of the East in Constantinople from the beginning of the Fourth Crusade until the election of Baldwin, and the division of the empire. Each of these subjects gave rise to several difficult *sous-thèses*. A year later, in 1885, the number of subjects covered by the *thèse* was reduced to two. The subjects themselves remained mainly institutional: the agrarian laws in Rome and the relations between the French crown and the towns (1180–1314).

What is called philologization and specialization was the result of a deliberate attempt to reform history teaching in the still very traditional Université. The *agrégation* assignment was considered the regulator of history education both at the *lycée*, where history had already been "institutionalized," and also at the faculty, where a form of higher history education was gradually being developed. The aim, as Fustel de Coulanges, the highly influential member of the jury put it in 1875, was to check the most prevalent evil of French history education, namely, the "abuse of generalizations."[120] According to Fustel, there was "a habit of declamatory and senseless generalizations and a certain indifference to the serious search for the truth." Fustel was not happy about the "rounded view" of things, which some mistook for "a detached view of history" or for a "philosophy of history." In his opinion, what was needed instead was to study "the facts closely and in some detail . . . the analytic method must take precedence over the synthetic method."[121]

We might say that the century-old methodological wisdom preferred by historians, namely, recourse to, and critical scrutiny of, the original sources, was rendered "operational" in the 1870s in at least part of the *agrégation* competition. Fustel recommended the study of sources as a cure for "the generalization mania"—and that is what it turned out to be. Beginning in the mid-1870s there was a clear change in what was demanded of an *agrégé*. An *agrégé* was henceforth expected to acquire greater knowledge of a relatively small subject; he ought to study authentic sources and show critical acumen in dealing with

them; he ought to be much more circumspect about making general statements. General knowledge continued to be demanded, but the new guidelines stipulated "a feeling for detail, a critical mind, and familiarity with the texts." The *agrégation* became less attuned to the secondary-school curriculum; the detailed studies demanded were not geared to the needs of school pupils but indispensable for filling history teachers with the right ethos and for teaching them better habits.

In 1885 the old-style *thèse* was abolished in keeping with the growing specialization trend. Henceforth the candidates were no longer set the same subject, followed by an *argumentatio* or *disputatio* between the candidates themselves on the various *sous-thèses*. Instead, every candidate had to write an extended essay on a subject he himself had chosen, and this was followed by an oral examination. The *thèse* became more of a real examination than a competition. The new system has been compared to what was customary at the Ecole des chartes. But it clearly differed from the latter in two respects: the choice of subject was not completely free, as the candidates had to choose from an (admittedly wide) list drawn up by the jury; and candidates were not allowed to use unpublished source material, as the jury had no means of checking it.

Critics of this reform spoke of a premature "bastard doctorate" grafted onto the *agrégation*. It meant a clear break between secondary and higher education. According to those anxious to preserve the old system, a viva was a much more powerful analytical tool than a written presentation. Oral improvisation after a long period of preparation was the "best spur to self-revelation" because it forced the candidate to "reveal himself totally, just as he is and just as he will be," spontaneously and using all his fundamental qualities.[122] According to Auguste Geffroy, professor of ancient history at the Sorbonne, president of the jury in 1885, and a member of the committee for the reform of the *agrégation*, the jury had lost its best testing device. But his was a voice from the past. At the urging of Ernest Lavisse, the majority of the committee members voted in favor of a change in the *thèse d'agrégation*.[123]

At the end of the 1880s and in the 1890s there were two innovations in the *agrégation*. First, subjects culled from contemporary history (that is, history from 1789) were added with increasing frequency. Since the history teacher had the job of preparing his pupils for "national life" and for his role as voter, he would have to discuss the most important problems of "contemporary civilization." Urgently needed was a rational analysis of revolutions and changes of various kinds experienced by France, Europe, and all mankind, Lavisse wrote at the beginning of the 1890s.[124] In keeping with the prevailing preoccupations, attention was focused on relations between church and state during the French Revolution. In 1892 the set subject for a paper was "Religious politics in France during the Revolution and before the signing of the Concordat."

Second, greater emphasis was placed on geography. At the beginning of the 1890s Lavisse noted clear progress in the geographical knowledge of *agrégés*.[125]

Geography had from the outset been inseparably bound up with history in the teaching assignments, but for a long time it had been reduced to a subordinate form of historical geography. Geography now began to stand on its own feet and changed from a derivative and auxiliary discipline into the equal of history. In 1892 (ten years before the birth of Ferdinand Braudel) one set subject was "The Mediterranean: an examination of its physical geography." The foundations were laid for a mutually beneficial cross-fertilization between geography and history. Not until 1942 was this bond broken and geography assigned a competitive examination of its own. Geography contributed in an important way to the growth of interest in the economic dimension of the past. In 1905, for instance, the set essay was "Cotton: the growing and the manufacturing countries."[126] Through geography, therefore, historians were introduced to many subjects that had a modern ring.

For all the reforms, it should not be forgotten that the jury's final decision was based on the candidate's *oral* presentation. The textual interpretation was oral, and the thesis or extended essay had to be defended orally. Rhetorical skill remained a prerequisite of passing the *agrégation*. Ready knowledge was essential. The candidate had to have a large store of quotations at his fingertips. Because the jury did not always find it easy to check on references, the poise of a self-possessed candidate could mislead and impress them. Such poise might also stand the candidate in good stead in the classroom. However, it still remained to be seen whether a candidate who could impress a most learned jury could also keep order in class and speak on a level that his pupils could understand.

The most serious objection raised by leading historians was that the oral tests were actually in conflict with the academic approach expected of the prospective *agrégé*. An oral discussion was not the best way to familiarize history students with heuristics, source criticism, scrupulous research, and verifiable argumentation. Many historians felt that the spoken word was an "outstanding instrument of popularization" but that a true scholar ought to provide "written evidence" of his ability.[127] The meticulous Charles-Victor Langlois, who came first in the *agrégation* of 1885, contended that at the beginning of the 1890s all a candidate needed for the *thèse d'agrégation* and the associated textual analysis was a good memory, an ability to compile material, and eloquence, none of which guaranteed that the candidate was also possessed of "original erudition" or that he had a scientific approach.

Once specialization was introduced and students were offered a wider choice, they started to ask for even more. Individual research seemed most desirable; the research ethos became compelling. The *agrégation* was increasingly felt to be an impediment to further specialization and to individual research. The subjects of textual analysis were chosen by others. The tutorials for the *agrégation* were based on the same subject in all the arts faculties. Lecturers were not allowed to help their students prepare the extended essay on the grounds that it would interfere with the competitive nature of the examination. The student was not entirely free in the choice of subject for his essay, and the lecturer was debarred

from contributing the results of his own research and special knowledge. The French arts faculties were still unable to match the German *Seminare*. In Germany the lecturer had a free hand in the choice of subject; education and research reinforced each other. In the French arts faculties the tutorials focused exclusively on the examinations, and the lecturer's classwork was done at the expense of his research. Leading historians argued that the *agrégation* would have to be changed still more radically if it was to cease being an obstacle to thorough specialization and to individual research.

The Diplôme d'Etudes Supérieures

As so often in France, it seemed easier to create something new than to reform the old. The persistent demand of leading historians for the modernization of the *agrégation* led to the creation of a new diploma. The year of its creation, 1886, is not as important as the year in which that diploma became obligatory for everyone taking the *agrégation*, 1894.[128]

The decision had two important consequences. First, it introduced a clear distinction between academic and purely professional requirements. The *diplôme d'études supérieures* was a certificate of satisfactory academic achievement, and the *concours d'agrégation* was relieved of this task. Instead, it became a test of a teacher's practical abilities. Second, training for the *diplôme d'études supérieures* meant a genuine expansion of the job market provided by arts faculties. The *diplôme* led to the greater independence of higher education, so much so that its opponents looked upon it as an artifice designed to divorce secondary from higher education.

The *diplôme d'études supérieures* was open to all who held the *licence*. Besides several other tests, such as a textual analysis and an exercise in an auxiliary discipline, its most important element was the extended essay. This so-called *mémoire* had to be based on independent academic research. A professor was now allowed to give students the benefit of his special skills and interests. The students themselves could choose the subject of their paper, which was meant to prove competence in historical research. This was a novel step at French arts faculties.

For the first time students were allowed to use unpublished source material, something that had previously been barred for the simple reason that the jury had no means of checking such material on the spot. The uniform character of French arts faculties disappeared because students were now given the chance of specializing in regional studies; regional history based on archive research was no longer taboo in arts faculties, which could now develop into genuine schools of history. Preparation of the *mémoires* contributed to the emergence of tutorials on the model of the German *Seminare*. The tutorials were also open to those who were seriously interested in the subjects under discussion but did not intend to become teachers, as well as to foreign students. The initial lack of interest in these so-called *conférences de diplôme* does not detract from the fact that they had considerable long-term effects.

Within a few years of its introduction, there was satisfaction all round with the *diplôme d'études supérieures*; even the extremely critical Charles-Victor Langlois could not but express his approval of its high academic quality.[129]

The New Order after 1894

Making the *diplôme d'études supérieures* a compulsory examination had considerable repercussions on the choice of subjects for the *agrégation* competition. The *agrégation* was officially relieved of its academic features and devoted to professional requirements in the strict sense, that is, to the fostering of pedagogical and didactic competence.

The new-style *agrégation* was structured as follows: First there were four written questions, one on ancient history, one on the Middle Ages, one on modern history, and one on contemporary history with geography. These were followed by a viva.[130] The subject of the *thèse* was henceforth related to that of the *mémoire*. The candidate's address lasted for three-quarters of an hour and was followed by questions put by the jury. Next the student had to deliver three trial lectures on subjects made known twenty-four hours earlier. These *leçons* were not allowed to cover the same period as the *mémoire*. In other words, a candidate who had written a paper on a medieval subject had to give his trial lesson on ancient, modern, or contemporary history and geography. This rule was introduced to prevent a possible decline in general knowledge; the *agrégé* had to remain a generalist. The trial lessons were followed by pedagogical and didactic questions. To counter unfair competition between Parisian and provincial students, the old custom of making the subjects known twenty-four hours before the examination was abolished. In the new dispensation the subjects were made known five hours before the examination, and the preparations had to be made in a closed room.

From the second half of the 1890s on, there was thus an unmistakable change in favor of pedagogical and didactic skills, whose scope had, moreover, been widened. Pedagogy had become a burning question not only in education but also in politics. Dissatisfaction was rife. To begin with, there was disagreement about the kind of "ready historical knowledge" students were expected to have. Second, there was dissatisfaction with the prevailing methods of testing pedagogical and didactic skills.[131] The *leçons* were delivered in an artificial setting, before a jury of professors who, no matter what their pedagogical insight, were no substitute for schoolchildren. The *leçon* were a "dry run" in front of one's peers. Notwithstanding the reforms, the adjudication thus retained much of its traditional character. An outstanding memory and rhetorical gifts remained the prerequisites of success at the *concours*.

The title *agrégé d'histoire* continued to be bestowed on a small elite, the *agrégation* remaining by far the hardest of all French examinations. But the advantages—more pay, fewer hours, and higher classes—and the prestige were such that many were brave enough year after year to strain their mental powers to the breaking point. In 1874–83, 95 historians became *agrégés d'histoire*; in

1884–93, 130; in 1894–1903, 117; and in 1904–13, 137.[132] There was a general, though fluctuating, numerical increase. The figure for 1904–13 represents a 44 percent increase over that for 1874–83. This increase was not in proportion to the explosive rise in the total number of registered students, and was also much, much smaller than the increase in the number of students who had taken their *licence ès lettres*—five times as many in 1906–10 as in 1866–70. The total number of *agrégés* was fixed annually by the authorities. If there was a large number of candidates in a given year, than the demands made on them were usually stepped up.

Remarkably, even in this context it is possible to speak of the relative success of history (including geography) compared with other subjects. The number of historians among the total number of registered *agrégés* in the arts faculties increased from 14.2 percent in 1874–83 to 18.5 percent in 1904–13.[133] The percentage of history chairs in the arts faculties—20 percent in 1865 and 32.5 percent in 1910—was much higher than the percentage of registered *agrégés d'histoire*. The demand for *agrégés* remained less elastic than that for chairs of history, and yet in the competition between arts subjects for a share of the job market represented by secondary education history was more than able to hold its own.

It is not fashionable to take a positive view of the *agrégation*. After starting it in 1922, when he was twenty years old, Fernand Braudel, who sat on the jury in the 1950s, spoke scathingly about it more than once.[134] The cramming demanded from candidates who were, on average, twenty-three to twenty-four years old was not only a total waste of time but could cause positive harm by fostering work habits that rendered young people unfit for academic research.

The final verdict on the *agrégation*, at least for the period before the First World War, must be less negative than that. First, during the second half of the nineteenth century the *agrégation* helped to introduce academic features into the rhetorical approach to history, so common in the traditional Université. Second, thanks to its admittedly debatable but in any case severe demands and the many failures, an exceptional standard for assessing teachers was maintained, and this greatly influenced the quality and the prestige of history education in French secondary schools. Was it pure chance that in a country saddled with that accursed hyperselective competition history teaching enjoyed greater renown and was of a higher standard than in countries that had nothing but a certificate of good teaching performance, which often was considered no more than a mere formality and which no one could fail to obtain?

France Compared with Germany

The increase in the number of students, the establishment of genuine universities, the expansion of the academic staff, and the reforms of the examinations were made much of in government reports and in speeches by government representatives. The early champions could rest on their laurels. Louis Liard,

director of higher education, published a rose-colored historical survey, and Ernest Lavisse became a specialist in delivering self-satisfied occasional addresses and optimistic obituaries celebrating high officials who had contributed to the reform of higher education, among them Albert Dumont (d. 1884), Victor Duruy (d. 1894), and Louis Liard (d. 1917).[135]

There were many good reasons for using buoyant phrases. To begin with, optimistic opinions helped to bolster national pride. France was rising from her ashes. The development of university education was considered a means of strengthening the nation. Intellectual work was held to be the continuation of war by other means. When Lavisse spoke of constructing a system of education for historians, he called it "fighting the Germans." In the 1870s French historians had not yet issued a challenge to their German counterparts, but in the 1890s they felt free to do so.[136]

People also voiced optimistic opinions lest they play into the hands of the enemies of the republican system, men who seized every opportunity to show up the government's shortcomings. People were optimistic lest they discourage the reform movement and, last but not least, because they were convinced that things were fast moving in the right direction.

It was Ferdinand Lot, one of the most talented of the young medievalists, born in 1866 and hence not part of the first generation of reformers (Lavisse was born in 1842), who dared throw down a remorseless challenge to the more or less official raptures. Lot published a number of studies to show how much French arts education still lagged behind the German. Such a stand took a great deal of nerve. The university establishment was anything but grateful to Lot, and after all, his career depended on them. Moreover, people were quick to accuse him of pro-German bias. After the uncritical admiration evinced by the reformers in the 1870s, it had become the done thing to dwell on the failings and blemishes of German university life.

Lot published his first critique as an angry young man in 1892. It was entitled "French Higher Education: What It Is and What It Ought to Be,"[137] and received unexpected support in the *Journal des débats*, by Gaston Paris, the grand old man of philology, who had been closely involved in the reform plans for the past thirty years but was politically less "integrated" than, for instance, Lavisse. Gaston Paris was closely acquainted with German university life, something Lot had compared favorably with the French. True, Paris objected to Lot's virulent tone, but he shared his impatience with the French shortcomings. Views endorsed by so magisterial a source could not, of course, be allowed to go unchallenged. Lavisse reacted at once. He dismissed Paris's criticism as mere wailing and insisted proudly on how much had been achieved during the last few decades.[138]

Not only at the beginning of the 1890s, when many reforms were still waiting to be implemented, but also years later Lot was able to demonstrate by well-documented comparisons that in respect of academic staff no less than of academic results the French arts faculties lagged badly behind the comparable sectors of the German philosophical faculties.

In 1903, for instance, as Lot pointed out, there were 836 teachers of philoso-

phy, pedagogy, sociology, psychology, classical studies, history, art history, geography, modern languages, comparative linguistics, Sanskrit, Oriental philology, and allied subjects in the German philosophical faculties. At the same time, the French literary faculties, the Collège de France, the Ecole pratique des hautes études, the Ecole des chartes, the Ecole du Louvre, along with several similar institutions in which comparable subjects were taught, mustered a total staff of only 354 persons (professors and lecturers, 138 of whom worked in Paris and 216 in the provinces).[139] Six years later, in 1909, Lot counted a total of 885 such persons in Germany. The increase was largely the result of the establishment of thirty new ordinary and special chairs of classical philology, modern languages, and Oriental philology (the number of lecturers in classical studies had remained static or even declined). Most "disconcerting," as Lot termed it, was the state of philosophy, medieval and modern history, and modern art. According to Lot, during this very period (1903–9) little progress had been made in increasing the number of persons teaching these subjects in France.[140] Though that claim was justifiably challenged,[141] there certainly was no sign of France's closing the gap. The French academic staff in the subjects under consideration was less than half the size of the German staff.

In 1910 Lot tried to compare the academic achievements of the French arts faculties with the corresponding achievements of the German philosophical faculties. It was not easy to arrive at an acceptable conclusion. In particular, Lot was unable to rely on the number of students because the enrollment criteria and the type of education offered differed too radically. The German universities used a certificate system that involved attending lectures and tutorials for six semesters and handing in papers at set intervals; the French faculties, in contrast, did not have compulsory lecture attendance and tested their students' knowledge by examinations. The two systems were incomparable in many other respects as well. The *licence* had largely remained a general arts examination, and the *agrégation* had no German equivalent. The best way of determining the respective level of academic achievement, therefore, was to compare the *mémoires* needed for the *diplôme d'études supérieures* with the German *Dissertationen*. According to experts, the academic level of both papers was comparable. The fact that *mémoires* were submitted in manuscript form and *Dissertationen* in printed form did not affect the issue. Lot arrived at the figures shown in table 21. The French (academic) contributions were thus embarrassingly fewer in number than the German. In 1908–9 the number of *mémoires* amounted to just 28 percent of the number of *Dissertationen* in philosophy, history, philology, and comparable subjects taught in the philosophical faculty. Neither the lower population figures (39 million compared with 65 million in 1910), nor the smaller number of universities (15 compared with 21), nor even the smaller number of students taking arts subjects (just over 6,000 compared with just over 10,000 in 1908) could explain the enormous French backlog. Thus, despite the smaller number of registered students, the number of French *mémoires* would have had to be twice as large as it was to bear comparison with the number of German *Dissertationen*.

TABLE 21
Number of *Dissertationen* and *Mémoires*, 1906–1907 to
1908–1909

Academic Year	Dissertationen	Mémoires
1906–7	681	186
1907–8	740	237
1908–9	816	230

Source: Lot, *Diplômes d'études et dissertations inaugurales.*

The reason for the poor French showing was that whereas the *Dissertation* was the normal conclusion to three years of university studies in Germany, most French arts students dropped their studies once they had taken their *licence*. Thus, in Paris 60 percent of the *licenciés* did not go on to study for the *diplôme d'études supérieures*, and in the provinces this percentage was higher still (66%). Two-thirds of all French students gave up their studies as soon as their course became "academic," that is, the moment it ceased to be based on book learning alone and was expected to include research.

Lot attributed the small number of candidates sitting for the *diplôme d'études supérieures* to the absence of genuine *Seminare* on the German model. According to Lot, the so-called *conférence de diplôme* was not very different in practice from a chat with one or two students. Lot did not deny that the students were given good advice and that the *conférence* was more useful than a lecture, but he did not think there was anything like shared research between teacher and class. The only exception, if on a small scale, he said, could be found at the Ecole pratique des hautes études.[142] Lot's criticism, however, was too one-sided; it was aimed at the supply side alone. In fact, quite a few lecturers ran tutorials in true *Seminar* style, but these were not often frequented by French students. Thus, Gaston Paris recalled that some of his courses on Romance philology were not followed by a single Frenchman, the majority of his audience consisting of foreigners, who came from far and wide, attracted by his fame.[143] In all fairness, therefore, it must be said that French students were anything but keen on such tutorials. At the very least, there was an interaction between the short supply of *conférences de diplôme* and the small demand for them by students.

Causes of the Lack of Interest in Academic Work

Reliable observers have attributed the marked difference in the zest for academic work shown by French and German arts students to more than just the defective organization of the French arts faculties. Moralistic critics also mentioned various general circumstances and vices said to be typical of French society at the time and to constitute so many obstacles to academic studies. Three of these were political polarization, the Parisian atmosphere, and materialism.

The sharp political polarization France had known since the Revolution is

said to have been a particular stumbling block to academic pursuits. In France people generally took sides, at a very early age and under the influence of the social circles in which they grew up, in the fatal struggle between free thought and Catholicism, opting for or against the dogmas of the contending parties. Frenchmen were thus rendered unfit for academic pursuits, a characteristic of which is that the results of an investigation cannot be known in advance, as Gaston Paris and Gabriel Monod, two thoughtful observers, kept stressing.[144] As a variation on this theme, *Le Rouge et le Noir*, later renamed *les Deux France*, stressed that the conflict between the aristocratic and the democratic spirit militated viciously against a flourishing academic culture.[145] In France people were simply out to gain knowledge that could be exploited as quickly as possible in the social struggle. The idea of unprejudiced and time-consuming research struck them as quite pointless. Academic study was paralyzed by the fear that it might be lacking in social relevance.

At the beginning of the 1870s such advocates of the reform of higher education as Gabriel Monod extolled the faculties as future centers where young people could meet, get to know one another, and forge bonds of friendship for the rest of their lives, "where youth could become used to forgetting differences of province, family, party, religion, class, and learn to subordinate everything to scholarship and patriotism."[146] This picture was much too rosy: social polarization was too strong to allow the emergence of a training center dedicated to the fostering of a consensus for the sake of unprejudiced scholarship and greater patriotism. After the Dreyfus affair, in which so many intellectuals took sides, even kindly old Monod abandoned his idealistic views about the soothing of ruffled spirits. Only the dire threat from without could lead to the rise of a Union Sacré during the First World War and help to unite *les deux France* for as long as the war continued. To what precise extent the unmistakable social polarization, so rife at the beginning of the twentieth century, impeded academic developments is impossible to say.

Another reason for the lack of enthusiasm for academic work was said to be the sensual and frivolous literary and intellectual atmosphere for which Paris was so renowned. The serious-minded Gaston Paris deplored the fact that young people acquired the much sought-after *notoriété parisienne* with facile newspaper articles, novels, and quite particularly with plays rather than with serious study. A prerequisite of success was never to assume that one's public was more intelligent than it was—one had to write in such a way that even the concierge could understand. Sensationalism was an end in itself, "amusing people with saucy remarks or shaking them up with paradoxes" in a style that had to be "bold, disturbing, and cruel." The Parisian public would only attend lectures that promised to titillate them as a *chanson* might.[147] The Parisian atmosphere sketched by Gaston Paris and others was not without a kernel of truth. Certainly during the *Belle Epoque* Paris was a sink of iniquity. Even when the institutional reforms opened wide the doors to higher arts education, it remained very difficult to devote oneself wholeheartedly to academic pursuits in Paris. Yet in provincial towns with arts faculties, where there were fewer distrac-

tions (not to say, where one might be bored to death), the chances of acquiring an academic education were seized even less often during this period.[148]

A third reason was said to be the materialistic bent of the French. For a young man there was an urgent need to make his way in life quickly because "the ranks were serried, life dear, and pleasure-seeking a fine art."[149] That was undoubtedly true, and particularly so during the nineteenth century, with its growing (but unevenly shared and still relatively limited) prosperity and rising expectations. But did the French really differ so much from the Germans in their materialistic attitude?

Without wishing to brush the abovementioned moral causes entirely to one side, one is more inclined to blame the unsatisfactory French academic attitude and achievements on the French institutional inheritance. During the greater part of the nineteenth century the French arts faculties had been in a state suspended animation; when a start was made with the reforms in the last quarter of that century, it took France a long time to catch up with the German philosophical faculties. During the first decade of the twentieth century the French position seemed to have improved appreciably, but French arts education still lagged a considerable way behind that provided by the German universities. In any case, until the First World War the French arts faculties failed to shake off their ties with secondary education. For although the faculties did manage to gain greater independence in terms of staff, as we shall see in chapter 5, the old links remained very strong.

As for the examinations, there was indeed a change. A brand-new examination was introduced to test academic ability. Changes were introduced in the old *licence* and in the *agrégation*, and yet the subject matter of the examination remained largely attuned to the secondary-school curriculum. The prestigious *agrégation* continued, in fact, to be a hyperselective recruiting mechanism for secondary schools (no matter whether or not the *agrégé* ended up in the teaching profession). It would still be decades before French universities gained enough autonomy for academic research to become a dominant factor in the education of students, as it had become in Germany as early as the nineteenth century, with all the pros and cons. In some respects, the creation of the sixth section of the Ecole pratique des hautes études after the Second World War must be considered an attempt to escape from the "all-powerful grip of the middle" on the arts faculties.

At first it seems strange that in a country such as France, where the secondary education offered by the *lycées* was so renowned, the higher education provided by the arts faculties was so unremarkable. On closer examination this paradox proves to have a causal explanation: the *lycée* stood in the way of the arts faculty.

The Results

Although the reforms of the arts faculties did not meet the exaggerated expectations so many people had for them, it would be wrong to call them a total

failure. In comparison with the deplorable situation that previously had prevailed, many tangible results were recorded in the four decades beginning with the 1870s. Let us recapitulate. First, France could now boast genuine university students, albeit fewer than the official statistics made out, and a relatively small number were engaged in full-time study. Second, the academic staff had gained a measure of independence, and the position of higher education had been strengthened by the establishment of real universities. Third, the staff of the arts faculties had been considerably augmented. Fourth, the examinations now provided tests of academic competence. This was a reflection of a growing research ethos and of procedures associated with it. Ferdinand' Lot's fierce criticism was an illustration of the changed expectations for the role of arts faculties.

The study of history, in particular, could boast respectable achievements. The position of French academic historians was relatively stronger than that of their German counterparts. In France one-third of the arts faculty posts in 1910 were held by historians (120 out of a total of 360 posts). The proportion of history chairs at the arts faculties also was roughly one-third of the total. In German universities historians had to make do with a quarter of the total number of posts in the comparable departments during the first decade of the twentieth century.[150]

Comparisons of the academic output of history students also put the French in a favorable light. On average, the number of *mémoires* for the *diplôme d'études supérieures* came to just a over a quarter of the comparable number of German *Dissertationen*. The number of *mémoires* in ancient history was admittedly below that average (15%), and the number of *mémoires* in medieval history (including those submitted in the Ecole des chartes) was close to the average (25%), but the number of *mémoires* in modern and contemporary history was relatively high, nearly half the number of the German *Dissertationen* in this field.[151]

If ever the growing influence of faculties was a normative factor in education and research, then it certainly happened with history. After the successful institutionalization of history teaching in secondary education historians gained the upper hand in the reformed arts faculties. This institutional *succès fou* was reflected in the drastic increase in the percentage of university chairs reserved for historians and in the relatively high output of academic papers by history students. The intellectual success was evident from the paradigmatic function of the *méthode historique*. The historical approach became highly popular with other departments in the arts faculty.

The foundations for the miraculous French lead in historical research were laid in the arts faculties, and well before the First World War.

The Old Professors and the New

INSTITUTIONAL DEVELOPMENTS led to new demands on history chairs. But was there an appropriate response from the average professor? Needless to say, the dictum *individuum est ineffabile* also applies to arts-faculty historians. Every professor had his own idiosyncrasies, qualities, and shortcomings. There were bright men and dunces, workhorses and idlers, fusspots and bunglers, specialists and eclectics, precocious geniuses and late bloomers. The life and work of professors can of course be judged on individual merit, but our aim is not to write biographies capturing the uniqueness of each one but to show, by overall comparisons of their life and work, to what extent a new type of professor came to the fore under the influence of the professionalization and academic adoption of history.

To that end, we shall examine two imaginary processions, one dating back to 1870 and the other to 1910. The aim is to compare the typical professor before the reforms of the arts faculties (and of the Ecole normale supérieure) with the typical professor after the reforms, that is forty years later.

GENERAL SURVEY

Our 1870 procession is made up of twenty persons, the 1910 procession of thirty-seven.[1] In 1870 fifteen taught at provincial faculties and five in Paris (at the arts faculty and Ecole normale, including one substitute professor). In 1910 twenty-seven taught at provincial faculties and ten in Paris. Not included are professors exclusively engaged in the teaching of geography, the history of art, archeology, and the history of Christianity. Also excluded are assistant professors.

The most striking difference between the career profiles of the 1870 professors and those who followed forty years later was that the second group was less closely connected with secondary education: in 1870 all twenty professors had taught at secondary schools; in 1910 fourteen of the thirty-seven, that is, more than one-third, were university-bred men with no experience in secondary education. The average professor in 1870 had taught school for more than 12 years, whereas the average professor in 1910 had taught for only 5.7 years. If we leave aside those without any schoolteaching experience, then we find that average schoolteaching experience of the remaining twenty-three was 9.2 years.[2] This fall in secondary-school experience was part of the growing separation of arts faculties from the *lycées*. The institutional developments discussed in chapter 4 were reflected in the collective biography of history professors.

The professorial corps neither aged nor grew any younger. The average age in 1870 was just under fifty-three (52.85) years, and forty years later the figure was almost the same (52.86 years). However, there was an appreciable change in their training background. Thus, while *normaliens* continued to account for more than half the total number of history professors, their percentage dropped from 70 percent in 1870 (14 out of the 20) to 59 percent in 1910 (22 out of the 37). This breach of the near monopoly enjoyed by *normaliens* was largely due to the rise in the number of scholarship students. The *boursier de faculté*, confined mainly to Paris, was a recent phenomenon, dating back to 1877 and 1880. These students were popularly known as Lavisse's boys, for Lavisse had been one of the architects of the faculty reforms. In 1870 the arts faculties had no students in the proper sense of the word; by 1910 almost a third of all history professors (12 out of 37) had been trained at faculties. The Lavisse innovation had proved a resounding success.

In 1910 few of the professors' curricula vitae showed any signs of the hoped-for exchanges between different institutions of higher learning. Just one of the faculty scholars was also a *normalien*, and another had also attended the Ecole des chartes. The absorption of the teaching staff of the Ecole normale supérieure into the faculty of Paris in 1904 rendered the standard of education more uniform, the effects of which did not, of course, make themselves felt in the training of professors until later. Although the faculty and the Ecole des chartes were brought under one roof at the Sorbonne, a clear distinction continued to exist, symbolized by two separate entrances. In 1870 just one of the professors was a *chartiste*, and in 1910 there was still just one. The Ecole des chartes and the arts faculty continued to run on separate tracks. That there was hardly any exchange of students, did not, incidentally, imply that there was no exchange of ideas. The Ecole des chartes unmistakably served as a methodological model for the arts-faculty examination reforms.

Part of the professors' training took the form of prolonged study abroad, be it to work on a thesis or otherwise. In 1870 three-quarters of the professorial corps had not studied abroad; in 1910 the figure was two-thirds. A remarkable fact was their change of destination. In 1870, two of the five who did not stay at home went to the Ecole française d'Athènes, one went to Italy, one to Scandinavia, and just one to Germany. In 1910 a good five of the thirteen travelers made a pilgrimage to a German university. Visits to the French institutions in Athens and Rome also became more common. Seven professors, especially of ancient history, were able to visit Greece and Italy during their years of study. One professor had spent several years doing special research in Prague. Oddly enough, the losers of the 1870 war seemed only too happy to take lessons from the victors. A growing number of students from other countries also attended German universities. Germany had become the mecca of academic learning.

The average age at which the 1910 crop of professors took their doctoral degree was thirty-one. The class of 1870 had been slightly older—just over thirty-two. Very early and very late promotions were not uncommon among the 1870 group. Three took their doctorates at the age of twenty-three, and three

took theirs when they were over forty, the oldest being forty-seven. Of the 1910 class of professors the youngest was twenty-four and the oldest forty. In 1870, 75 percent had taken their doctorate before the age of thirty-five; in 1910 that percentage had risen to 81. All in all, the age differences at the *soutenance* (defense of the doctoral thesis) were not very marked.

The interval between the *soutenance* and the appointment to a faculty post was shorter in 1910 (7.7 years) than it had been in 1870 (9 years). A striking difference was that in 1910 as many as fifteen of the thirty-seven had been employed by a faculty even before they took their doctoral examination. In 1870 just one had joined a faculty before his promotion—an intriguing exception.

Although the doctoral examination was taken at a younger age in 1910, and appointments to a faculty also came sooner, posts in Paris were by no means acquired at an earlier age. Thus whereas in 1870 a few lucky candidates had been appointed in Paris soon after their promotions, this had become a rarity by 1910; normally, no one could expect a Paris appointment until twenty years or more after gaining the doctorate. Lavisse, who was appointed to the Ecole normale supérieure three years after submitting his thesis and went on to become a *professeur titulaire* at the Sorbonne, was a lone exception to the rule. There were no young professors in Paris; the old had the roost all to themselves.

Of the twenty professors in the 1870 procession three went on to hold high office—two became rectors, and one became a general inspector. Among the 1910 crop just one left his university chair for a senior government post.[3] Had a professorship become so specialized a function by 1910 as to be an obstacle to holding administrative office, or had there been a change in professorial ambition? Had the 1910 professors come to prefer their own jobs to an exalted administrative position? In any case, a university chair had become the peak of most of their careers, which had not been the case forty years earlier.

There was a clear difference in the representation of minority groups on the 1870 and 1910 teams. The 1870 group included not a single professor of Jewish descent and just one Protestant.[4] In 1910 there were three professors of Jewish descent and as many as seven Protestants.[5] Jews and Protestants were strongly overrepresented on the 1910 professorial team, judged, that is, by these minority groups' representation in the general population. Protestants made up no more than 2 percent of the population in 1910[6] but more than 19 percent of the history professors at the beginning of the century; and Jews made up approximately 0.2 percent of the population[7] but more than 8 percent of the history professors. Protestants and Jews jointly made up more than a quarter of the 1910 team, while accounting for no more than 2.2 percent of the population.

The secular, anticlerical approach of the Third Republic clearly proved a boon to the Protestant and Jewish minorities. The large number of professors of Protestant and Jewish descent was just one facet of the emancipation of the minorities reflected in republican state appointments. Not only ideological differences but also envy of this social success prepared the ground for that per-

nicious bestseller of the 1880s, *La France juive*, a book written by the poisonous publicist Edouard Drumont, for the many pamphlets decrying *Le Péril protestant*, and for the grim wit enshrined in the commentaries of Charles Maurras and others in the *Action française* and similar hate sheets.[8]

THE 1870 PROCESSION

Et l'homme dans tout cela? Averages are abstract generalizations. Is it possible, with the help of a broad classification and brief characterizations, to picture the professorial corps of 1870 and in 1910 and to indicate differences in the type of professor appointed following the professionalization and academic adoption of history education? If we let the 1870 team file past us in review we can distinguish three groups of professors: lightweights, successful teachers, and heavyweights. This classification is based partly on the views of contemporaries—inspectors of education—and partly on later opinions. Minor differences notwithstanding, all contemporaries took a negative view of eight of the twenty professors of 1870. Their appointment was generally deplored; moreover, successive inspectors of education generally took the same view. Indeed, though the criteria differed from ours, largely because changes in the function of arts faculties (before 1880), I have been unable to discover a single underrated historian among these eight. As for the remaining twelve, I have distinguished between those who exerted some intellectual influence and produced work of lasting value and those who did not; that is, between six heavyweights and six successful teachers. Their positive assessment by successive inspectors of education does, however, need some qualification: this group of twelve included some who seem overrated when judged by present-day standards. The inspectors clearly tended to overrate rather than go to the opposite extreme.

Our tripartite classification thus involves two assessment levels: contemporary inspectors' judgment of the professors' success or failure in their work in the old-style arts faculties; and the determination of their "surplus value" in the form of intellectual influence and work of lasting value, which by its very nature can only be established in retrospect.

The Lightweights

Benjamin Nicolas (1815–70) was appointed professor in Poitiers in 1867.[9] He published an unusually small number of titles after taking his doctorate in 1861 with a dissertation on the letters of Servat Loup, the ninth-century abbot of Ferrières. Nicolas died in 1870 after been very ill for several years. The inspector was quite outspoken about him: "Nothing original."

Eugène Morin (1814–76) was appointed *titulaire* (professor with tenor) at Rennes in 1851.[10] He had taken his doctorate in 1847 with a study of the life and work of Symmachus. He played some part in Breton learned societies and opposed the exaggerations of the ultra-Breton school "in the name of common

sense and true criticism." Morin did not publish a great deal. His lectures, which took in a host of detail, attracted little attention.

Félix Robiou (1818–94) was a scholar who had strayed into education.[11] The inspectors' reports were very negative: "Quite apart from his lack of energy, he has a weak brain, and it is said that there were cases of mental illness in his family." The inspector was being impertinent, but then that was part of the job. The inspectorate became upset when Robiou decided to take up Egyptology. At the time that sort of specialization was frowned upon by good educationists.

Robiou was really a classical historian who had taken his doctorate in 1852 with a paper on the influence of Stoicism. He was the author of handbooks on Roman and Greek institutions, among other writings. In 1870 he was appointed successor in Strasbourg to Fustel de Coulanges, who had gone to the Ecole normale in Paris. After the war and after several intermediate stops, Robiou ended up in Rennes, where he became tenured in history in 1877 and professor of Greek in 1881. In the 1880s the inspectors still complained that he was unable to get his message across to his students because his presentation lacked lucidity. Robiou was said to be a scholarly recluse: "He neither is nor ever was a teacher," was one inspector's frank opinion. In earlier times it had been customary to turn such "invalids of the teaching profession" into librarians. A charitable but despairing inspector wondered if the same might not be done even now. We are entitled to ask if the very negative view of the inspectorate stands in need of correction. After all, it was based on old-style faculty criteria, according to which specialization was suspect, certainly when it went hand in hand with a lack of didactic and rhetorical skills. Robiou's publications were numerous and regarded quite highly by a small circle of scholars. However, in view of his peculiarities and utter lack of verbal skills, we are bound to conclude, even in retrospect, that his appointment had been a mistake. While Robiou continued to occupy his chair historical education was "held in suspense," and his handful of listeners did not turn up "very eagerly." Robiou may not have been a misfit as an author, but as a professor he was undoubtedly a lightweight.

François Combes (1816–90), who took his doctorate in 1858 with a fat tome on the princesse des Ursins (568 pages), was appointed to a professorship in Bordeaux in 1864.[12] Combes was a prolific writer with hefty volumes on a variety of subjects—on Suger, on German invasions through the ages (1873), on European diplomacy in the early modern period, on a nineteenth-century cardinal, and on Madame de Sévigné. Thick tomes one and all, full of juicy anecdotes, but superficial and uncritical. His lectures were well attended, something the inspector considered further proof of the poor taste of the citizens of Bordeaux. At least that opinion showed that the inspectors did not base their reports exclusively on the size of audiences and the entertainment of an enthralled public but also paid careful attention to content and critical acumen. The inspectors also made allowances for Combes's private difficulties—Combes had to share his home with a tyrannical mother-in-law—but ultimately their damning verdict was, "Much bad taste and little real history." Combes's success

with the public was taken as a confirmation of the poor quality of the faculty of Bordeaux in about 1870.

Alfred Barry (1809–79) was appointed professor in Toulouse in 1840.[13] He had taken his doctorate in 1832 with a superficial dissertation on the development of the Robin Hood cycle. He was also the author of schoolbooks that were so many condensations of a *histoire générale philosophique* in the style of Guizot. A conspicuous political dimension crept into a report dated 1870 when an inspector put a question mark after the negative notes on Barry for the preceding years, suggesting that these notes merely reflected the Bonapartist rectors' dislike of Barry's moderate views. Even so, the inspectors' reports did not become much more favorable after 1870. For all that, Barry did good work in local archeology. He provided the annotations for the reissue of the Gallo-Roman part of the large history of Languedoc by Devic and Vaissette, wrote various archeological articles, and was involved in the establishment of a provincial museum. Was it due to the wear and tear of his long professorship that the zeal he displayed in later life must be called inordinately modest? In any case, Barry not only managed to frighten off his public by concentrating exclusively on local archeology but particularly alienated the young. When he retired in 1874, no one regretted his departure; his undeniable achievements in local archeology did not make up for his failings as a teacher.

Alfred Duméril (1825–97) succeeded Barry in Toulouse in 1874 and was equally unsuccessful at his post.[14] In 1862, he had been appointed a professor with tenure in Dijon. His departure for Toulouse had been politically motivated: in the wake of the "small white terror" rife in some provincial towns, whose solid citizens were still haunted by fear of the Commune, Duméril had been accused of being a red. The rector had put up a most curious defense; Duméril, he agreed, was apt to make silly remarks, for which his poor health and good-natured character might be considered mitigating circumstances, but he simply could not be a *communard* because he was a moneyed man (an unearned income of 15,000 francs was specified). The atmosphere in Dijon was unpropitious, but Duméril also ran into trouble in Toulouse. It so happened that lectures in general were increasingly being turned into occasions for political agitation, be it right- or left-wing, and sometimes there was little a professor could do about it. But Duméril was careless, and that made him the butt of special attacks. His emphasis on the negative aspects of the reign of Louis XIV led to noisy protests, catcalls, and a fracas. And years later, in 1889, when tempers were very heated by the centenary demonstrations, Duméril's attitude gave rise to a flood of press reactions in which the entire political spectrum, from infrared to ultraviolet, was involved. The staid arts faculty seemed to have turned into a frenzied political club, bulging with "brawling locals, hired hoodlums, officials, and a few unfortunate women teachers who thought it incumbent upon them to accept the invitation of the assistant mayor," as the venomous commentary in a Bonapartist paper put it. Another antirepublican paper called Duméril's a "course in pornography and not in history."

It redounds to the credit of the (republican) inspectors that they did not cover Duméril's failings with the mantle of political love. They made a distinction between his person ("decent, honest, and loyal") and his professorial work ("he may have students but does not teach a single one of them"). His lectures were said to have more "moral uplift" than method or critical acumen. After his thesis in 1856 on Charles V, Duméril published little more for the rest of his long career. In 1890, two years before his retirement, it was alleged that, largely because of him, the Toulouse arts faculty, of which he was then the dean, had failed to join in the reforms ushered in during the previous century. "Duméril's unfitness to run the faculty increases by the year, and as a professor he has no appeal whatsoever to the students," the inspector reported regretfully but honestly.

Jean Hippolyte Dansin (1824–72) took his doctorate in 1856 with a book on the reign of Charles VII, which he published two years later in an expanded edition numbering 439 pages.[15] He did not publish much more than that. In 1860 he was appointed to a professorship in Caen. His lectures were praised for their punctiliousness, the elegant use of language, and the combination of factual argument with high moral reflection, but they did not attract large audiences. The inspector took Dansin under his wing, attributing the lack of public interest to the "business preoccupations and self-interest" of this particular section of the Norman population. It was a common complaint that only material questions mattered in the provinces and that there was a general lack of intellectual curiosity—the proverbial narrow-mindedness of the self-satisfied provincial middle classes. Dansin, incidentally, was very much accepted by the good citizens of Caen ("the best homes are happy to receive him") and was even elected to the municipal council in 1871. He fervently hoped to be made a dean, and when that job eluded him, he resigned his chair at the age of forty-seven. After a very promising start, Dansin's professorial career thus came to a disappointing conclusion. The inspectors' opinion was certainly not unreservedly negative; Dansin's unsuccessful professorial career was also blamed on his touchiness.

The last of our lightweights was Théophile Alphonse Desdevises Dudézert (1822–91).[16] An autodidact, he had acquired all his wisdom from books, and, as he himself explained, had gone into education against the wishes of his family. After teaching at secondary schools for twenty-four years, he joined the faculty of Clermont-Ferrand in 1868 and was made a professor two years later. He had therefore proven himself as a teacher but was a late addition to the team of 1870. In 1873, following the intercession of local notables, he returned to his native region as a professor in Caen. At the age of sixty-seven he promised to give up his job provided his son was appointed to the faculty. What is more, the inspector felt that this request should be granted in the interest of higher education.

Desdevises had had political difficulties. In 1851 he had argued that "a professor's duties differ from the historian's"; those teaching history, he said, must "dwell on such developments as can be commended to subjects of a Catholic

state." At the time such views may have seemed sensible, but decades later, when political power had shifted, opponents who had kept records for use in more appropriate times used them against him. These "odious attacks" even reached the Parisian press. Desdevises defended himself in 1885 in a letter to the director of higher education, explaining that these views had been common held in the circles in which he grew up but that he had long since ceased hold them.

The mainly negative opinion of the inspectors was not dictated by political motives. Desdevises, they contended, was knowledgeable but lacked direction and hence lost himself in details, had a poor vocabulary, and lacked judgment. After his thesis on the historical geography of Macedonia, he had gone on to publish a fair number of articles, mainly on geographical topics, but none had made a great impression. Liard put his tolerant opinion in a few words: "A hard-working professor with a somewhat narrow approach." At the end of the 1880s, though he was clearly exhausted, Desdevises insisted on continuing a long career during which he had invariably faced the generally negative opinions of his activities with good cheer.

The Successful Teachers

My distinction between lightweights and successful teachers is based mainly on the inspectors' views. Most of their reports on the second group were full of praise, but none of these six was singled out for having any intellectual influence or for producing work of lasting value. The only reason why they were considered successful teachers was that at the time the professionalization of university history teaching had not yet progressed very far and the inspectors' criteria were still based on the ethos and habits of the old-style arts faculty.

Macé de Lépinay (1812–91) was a teacher for twelve years, in Paris among other places, before he presented a long thesis (567 pages) on Roman agrarian law in 1846 and was given a chair in Grenobles in 1849.[17] In 1850 he unexpectedly incensed traditional Catholics by placing question marks after the many legends about Saint Léger, the bishop of Autun in Merovingian times (something that had been done much earlier as well, and for good reasons). "Faculty chairs have not, after all, been created to challenge our religious principles. If history is taught in that way, then it had best not be taught at all," wrote L'Ami de l'Ordre, a regional paper of a fiery Catholic persuasion. Macé must have been a man of courage: in 1851 he was temporarily suspended for joining a political demonstration against the Bonapartist system. However, he came round soon afterwards and was then considered a devotee of the new regime. After his thesis, his main publications were schoolbooks and travel guides for the French railways. His lectures were widely appreciated, and he was a member of the mighty agrégation jury for several years in succession. In that capacity, incidentally, he was reproached (by the only dissonant note in a chorus of eulogies) with having an obsession for dates and with imposing a veritable chronological tyranny. That, in any case, was the view of Nisard, a fellow jury member, who

was notoriously easy-going and probably could not bear a fusspot by his side. In the 1870s Macé's lectures still attracted a large public. He was then appointed dean of the faculty and did not retire until he was over seventy, after a successful career that, alas, has left few traces.

Much the same was also true of Martin Henri Chotard (1821–1904), who "without being brilliant" was nevertheless considered "a distinguished professor," one who more than satisfied the demands made in Besançon, where he was appointed substitute professor in 1866.[18] He had taken his doctorate in 1860 with a 240-page thesis in historical geography on Arrian's circumnavigation of the Black Sea. He did not publish a great deal: several geography textbooks and later in life a book on fortifications in northern France based on unpublished letters by Louvois. His lectures, however, were held in high esteem. When he started his professorship, the inspectors had cautioned him to curb his passion for "historical curiosities." In 1867 he lectured on Joan of Arc but failed to pay sufficient attention to "her truly heroic side," preferring to dwell instead on "details about the antechamber and dining room." Accounts of clothing and food were thought to be more suited to a "special book" than to the lecture hall. His descriptions of everyday life were so down-to-earth as to detract from the Maid's heroic feats. However, the inspector added with clear satisfaction, Chotard worked hard and did his utmost not to be common. His lectures were informative, crammed with facts, and distinguished by outstanding summaries. "Speaking easily, clearly, and soberly, he does not hanker after rhetorical or declamatory effect. He has the tone and approach truly befitting a professor." Chotard too was made a dean, and like Mace, managed to stay in office until after his seventieth birthday. In 1874 he left his chair in Besançon for one in Clermont-Ferrand, where he succeeded the lightweight Desdevises and again was appointed dean. It was not until 1892 that he retired. After an uneventful and unruffled career his name was completely forgotten.

François Ouvré (1824–90) published less than any of the other successful professors and had the most rewarding official career of all.[19] While still a schoolteacher he wrote a study of Aubéry du Maurier, minister of France at The Hague, covering the history of France and the Netherlands from 1566 to 1636. He submitted the 355-page study as his thesis in 1853. In 1860 he was offered a chair in Aix-en-Provence, where he was very successful and considered to be the best professor in the whole faculty. If his lectures were not too well attended, it was usually because the heat tended to drive *bonne société* out of the sweltering town. Ouvré was related to a well-situated family in Marseille, was a home-loving man, was cautious in his political views, and was acquainted with the latest advances in history—all reasons for the inspectors to be satisfied with him. He was a meticulous historian. After he had lectured on the reign of Louis XIV for two years in succession, the inspectors saw fit to warn him against his tendency to become too deeply immersed in a particular period (specialists, as I have said, were frowned upon in the old-style faculties). The inspectors also regretted Ouvré's apparent "horror of going into print," the more so as his lectures deserved to be known better. Ouvré's delivery was flawed, and the

inspectors' reports dwelled at some length on what could be a terrible handicap in a lecturer's career. Apparently Ouvré's "correct delivery, unforced, well modulated, and with a slightly husky timbre [that] is a little too hoarse, something to which one becomes accustomed," was under threat from that scourge of the teacher's life, laryngitis. Yet, afflicted though he may have been by it, he was appointed rector of the academy of Clermont-Ferrand in 1876. He held the same high official post for fourteen years in various academies until his death in 1890. After a successful academic and official career, he too fell into (not undeserved) oblivion.

The three successful teachers discussed so far, two of whom were made deans and one of whom became a rector, had one thing in common: they published little of importance after their theses. The remaining three in our procession of successful professors did have a large list of publications to their credit, but none of them was able to inspire the intellectual respect that might have turned him into a heavyweight. The first was too immersed in his local speciality, the second displayed extreme ideological prejudice, and the third showed a patent lack of critical acumen.

André Alexandre Germain (1809–87) took his doctorate in 1840 with a study of the life and work of Sidonius and became professor at Montpellier a year later.[20] He threw himself into the study of local history, writing several books on the general history of Montpellier and more particularly on trade in earlier times and also publishing countless articles. Germain knew how to breathe life into local history, a subject that had been treated with some suspicion by the old faculties. Public interest in his lectures was considerable. Not only was he able to come up with striking facts culled from local and unpublished sources, but he was also able (a gift most local historians lacked) to "dress up a lecture, to rejuvenate it when it has dated . . . his forte is the public lecture." In the 1880s, when the inspectors' heads were filled with the reforms, it became clear to them that Germain was not up to the new demands. However, until 1886 (when he was nearly seventy-five) he was allowed to continue his popular lectures, the inspectors considering it "impolitic and inhuman" to deprive him of his chair. They realized that Germain was a successful professor in the old-fashioned style, one who unfortunately did not fit into the reformed faculties. His many publications on the local history of Montpellier were meritorious but did not have a wide enough range, one inspector observed.

Louis Lacroix (1817–81) was the apple of Monseigneur Dupanloup's eye.[21] After leaving the Ecole normale and teaching for five years, he submitted his thesis, *La Religion des Romains d'après les Fastes d'Ovide* (287 pages), which earned him a two-year stay at the French school in Athens. Soon afterwards he published a two-part history of ancient Italy and a large book on the Greek islands (644 pages), whereupon he was given a chair in Nancy. In the 1870s he was appointed substitute for Henri Wallon, a heavyweight in the Paris arts faculty (see below). Unable to obtain a permanent post in Paris, Lacroix resigned in 1880. He was undeniably a talented historian, and his lectures were carefully prepared and much appreciated, but the inspectors disliked his reli-

gious fervor and rigid views. "What has made Lacroix abandon the spirit of wisdom and temperance which can be expected of members of the Université?" wondered inspector Maggiolo with some concern. And a year later, in 1869, when the Empire had turned "liberal," Lacroix was even said to be stricken with "religious exaltation." The inspector, however, did not consider taking steps against Lacroix, for that would have added fuel to the flames of the ultras, who were hostile enough as it was to the Napoleonic Université. Lacroix had powerful friends among outspoken Catholic opponents of public education, but, the inspector claimed, he exerted a moderating influence on the most extreme of the ultras.

Lacroix had the fervor of the convert and would not suffer a single drop of water in his sacramental wine. In the preface to his 1865 book containing his lectures over the past ten years, he explained that he had confined himself to the teachings of Augustine and Bossuet because despite the wider attention that was being paid to world history these days, their work revealed "the supreme reason of the events of the past."[22] The Christian view of history was the only correct one and provided a clear explanation of the relationship between God, man, and the world. The Revolution had been God's work, a chastisement facilitating new life. Had not Bossuet written that "pain corrects confusion"? What mattered most in the teaching of history was to judge events by the fixed principles of good and evil and to show which human actions were good and which were bad. Influential Catholic circles were full of praise for Lacroix. The inspectors, for their part, kept silent about his work as a substitute professor at the Sorbonne. Were they, though well used to the ways of the Ordre Moral, nevertheless embarrassed by Lacroix's uncompromising ultra-Catholicism, by the polemical fervor hiding under his elegant presentation? At any rate, neither the lectures nor the voluminous writings of this maverick ultraroyalist left a lasting impression.

The last in our series of successful teachers was also the oldest in our imaginary 1870 procession. Rosseeuw Saint-Hilaire (1802–89) came to teaching relatively late in life; he had first studied law, worked in a bank, and published a number of historical novels.[23] In 1828 he took his *agrégation* (*ès lettres*) and was given a teaching post in Paris. Ten years later, in 1838, he was appointed Lacretelle's substitute as professor of ancient history at the Sorbonne, a post he retained for many years; in 1853 he was made *chargé* (junior lecturer), and in 1855, *titulaire* of this chair. Beginning in 1864 he allowed Auguste Geffroy (discussed below) to substitute for him. Rosseeuw did not retire until 1872, when he was seventy, by which time he had barely taken any part in teaching for eight years. The inspectors' reports therefore referred to the earlier period (the 1850s and early 1860s) of his career.

Rosseeuw was a skillful writer and a good lecturer. He held the only chair of ancient history at the time, though he was anything but a specialist in that field. His intellectual interests ranged far afield, reflecting "a liking for comparisons." In 1856 he gave a lecture on the role of the monarchy in ancient Greece in which he did not flinch from comparisons with Arab tribes and Scottish clans.

His was the "philosophical" history so fashionable at the time at the ASMP, to which he was elected in 1872. Rosseeuw was able to attract large audiences, but despite his respect for the man, the inspector could not refrain from observing (in 1862) that he would have liked him to use "a stricter method." Rosseeuw published a great deal; in addition to his literary work, he wrote more than a hundred leaflets, so-called *Feuillets de propagande protestante*, many about historical personages. His dissertations, incidentally, were rather flimsy—his French thesis on the origins of the Spanish language ran to just thirty-three pages and his Latin thesis on beauty in art to just fifteen—and they bore the hallmarks of the old-style theses. However, Rosseeuw also published solid and substantial books on a number of subjects. His magnum opus was a monumental history of Spain, from its origins to the death of Ferdinand VII (1833). In 1837, a few years before the first version of Rosseeuw's history of Spain appeared in five volumes (1844–79), Thiers had sent Rosseeuw to Spain to gather information and to acquire books for the Bibliothèque Nationale and the Bibliothèque de l'Institut. The style of Rosseeuw's history was a mixture of that of Guizot's institutional history and that of Michelet's metaphysical-cum-idealistic history. Characteristic of the liberal Protestantism of this seventy-seven-year-old writer was his final wish that the Spanish might "ever remain a religious nation even while becoming a free people," with which words he concluded the last volume.[24] Rosseeuw was professor in Paris and yet no heavyweight. His work left no traces. The *Revue historique*, the journal of the Young Turks, devoted just one line to his obituary in 1889: "The author of a voluminous history of Spain, which was not devoid of talent, though far too often lacking in critical spirit."[25]

The Heavyweights

Finally, there were the professors whom the inspectors considered successful and whose work had lasting intellectual influence. These six were spoken of with respect by the generation that followed, for a variety of reasons. Two (Desjardins and Dareste) produced sound work that could muster reasonably well long after they had gone; three (Zeller, Geffroy, and Wallon) made a very substantial contribution that, even though it was open to methodological criticism, nevertheless broke new ground. The last, Fustel de Coulanges, was the only truly great historian among them, the Benjamin of the 1870 class of history professors, and an acknowledged intellectual leader.

Abel Desjardins (1814–86), the son of a head clerk in the Ministry of War, did not gain a post in public education until 1843, having first studied law and then been a private tutor in Paris for many years.[26] Following his 212-page thesis on the emperor Julian in 1845, he was appointed a professor at Dijon in 1847. The young professor was not to the taste of the local priests. In a Sunday sermon the faithful gathered for prayer in the cathedral were warned against his lectures, "to which the crowd is attracted by frivolity rather than by love of learning" and which, to the dismay of the leaders of the (private, Catholic) educational institutions, were attended by many women and even by house-

wives and their daughters. In 1848 Desjardins had been a staunch republican, and that had not been forgotten. In 1855, after an unholy row, Desjardins's republican antecedents were pilloried in the right-wing press. A year later he was transferred to Caen. That transfer must not, however, be taken to mean that he was out of favor; it was a tried method of the state inspectorate for cooling excited tempers and avoiding confrontations in incensed Catholic towns. The inspectors thought that Desjardins was an exemplary teacher. Although there were no students in the modern sense of the word, Desjardins's lectures were "a meeting place for the studious, for serious-minded people, for magistrates, for the finest young doctors." Desjardins was an important man, a member of both the *agrégation* jury and the admissions board of the Ecole normale supérieure. In 1858 he was called to Douai and immediately installed as dean. He worked there for twenty-eight years, until his death in 1886. During his last years age started to take its toll, and the inspectors' reports were not entirely uncritical. Desjardins was said to revel in his success, to be vain, and to be unsuited for work in the new faculties. He was "too paternal" and also failed to keep the brand-new scholarship boys on their toes. The inspectors, who had become slightly more radical in the 1880s, also reproached the well-seasoned Desjardins with having lost his militancy and having become too conciliatory, in short, too "opportunistic." In November 1882 the mudslinging *L'Univers*, which loved to fish in troubled waters, even reported that Desjardins had spoken approvingly of the comte de Chambord. In his reply Desjardins declared solemnly that he felt a new restoration would be a misfortune for France.

Desjardins did not leave an unusually large body of published work. His most successful book was a 388-page biography of Joan of Arc, first published in 1854 and reprinted several times (a fourth edition appeared in 1889). His most lasting work was a source publication, the *Négociations diplomatiques de la France avec la Toscane* (6 vols., 1859–86). Desjardins visited Florence on several occasions in order to do archival research and discovered a great deal of unknown material. Source publications constitute a subsidiary but, provided they are well done, lasting historiographic genre. Desjardins's was not only well done but of historical importance. It was still appreciated by the next generation of historians.

Cléophas Dareste (1820–82), who must not be confused with his brother, the jurist Rodolphe Dareste (1824–1911), was the only *chartiste* among the 1870 crop of professors.[27] He too had studied law, and he had gone on to become an *agrégé d'histoire*. After six years in secondary education, the last two at the prestigious collège Stanislas in Paris, he became a professor at Grenoble in 1847, at the age of twenty-seven, and two years later he became a professor at the relatively important faculty of Lyon. In 1865 he was appointed dean, and later he was also elected to the Lyon municipal council. In 1871 he was made rector of Nancy, and in 1873 he returned to Lyon in that capacity. Dareste was possessed of natural authority, which earned him high positions at a very early age. He was a level-headed and reserved man with conservative views. Political circumstances put an early stop to his career: he incensed republicans by at-

tending the opening of the Catholic faculty in Lyon. He was made out to be an "ultramontane rector," and even moderate papers criticized him harshly for having "seen fit to wear the robe, take the money, receive the homage of those who are only too happy to welcome any who have deserted from us. We no more want a Université without academics than we do a republic without republicans." Even moderate liberals found it hard to swallow Dareste's behavior. Students caused disturbances, shouting in unison, "No rector, no Jesuits!" and calling for the dismissal of Monsieur Dareste. It was December 1878, the time of the republican seizure of power and of reprisals for the punitive measures of the Ordre Moral. Tit for tat. Minister Bardoux blamed Dareste for the disturbances and dismissed him (at full pay).

Dareste produced an impressive body of historical writings. His 1843 thesis was admittedly insubstantial and unimportant, but in 1848 he published his *Histoire de l'administration en France et des progrès du pouvoir royal depuis le règne de Philippe Auguste jusqu'à la mort de Louis XIV*, in two hefty volumes, which, though dated, had not yet been superseded more than thirty years after their publication. His *Histoire des classes agricoles en France depuis Saint-Louis jusqu'à Louis XVI* (first published in 1854 [327 pages] followed by a greatly expanded second edition in 1858 [556 pages]) was awarded a prize by the ASMP. Although it was not his most enduring, certainly his most successful work, and in his own day the most useful, was his *Histoire de France depuis les origines jusqu'à nos jours*, which first appeared in nine volumes from 1865 to 1879 and saw a third edition in 1884–85, a few years after his rather early death in 1882. The hypercritical *Revue historique* considered it the best and "most factually accurate" general history of France.[28] It was not until the turn of the century that the great collective history of France edited by Lavisse robbed Dareste of his leading place. In the very summary obituary that appeared in the *Revue historique* Dareste was called one of the most thorough and well-informed historians of his day.

Jules Zeller (1819–1900) does not owe his place among the heavyweights to the lasting quality of his writings.[29] He was a pioneer, opening the eyes of a whole generation to the history of Germany and Italy, particularly during the eighteen years of his lectureship the Ecole normale supérieure (1858–76). In his youth Zeller had been a *quarante-huitard*, a forty-eighter. He had gone on to study law, had spent some time in Germany, and had taken his *agrégation d'histoire* in 1844. In 1845 he had become a teacher in Rennes. Zeller was no coward; even in turbulent times he stood up for his political opinions in Catholic Brittany. But the Université was a glass house, and the inspector reported that although Zeller was highly regarded as a teacher, he had thrown himself into politics since the events of 1848 with "a little more passion than one would have wished from a professor." In particular, Zeller apparently had spoken in various clubs in language that the majority of persons present considered incautious and immoderate. Zeller was also the leading light of a local paper that, the inspectors added, had the support of the prefect of Ille-et-Vilaine. The inspectors felt that the attention Zeller attracted was not easy to reconcile with "the

strict proprieties, the grave and modest duties imposed on those to whom families entrust the education of their children." This opinion shows clearly the precariousness of the position of those engaged in state education at that time in regions dominated by the clergy. Zeller was asked to be less outspoken, but by then he had made too many enemies among people with influence in Rennes. In 1849, when the political tide turned, the clergy and some of the notables did their utmost to get rid of him, and the inspectors advised that he be transferred for the sake of peace. Admittedly, Zeller had allowed himself to fall under the sway of the previous state commissioner, but he was nevertheless a good lecturer. In 1850 he became a teacher in the Strasbourg *lycée*, which represented a promotion rather than a punishment. In fact the inspectors took no steps against him, not only because they wanted to avoid any possible conflicts but also because they were anxious to look after Zeller's interests. In 1853 he became a professor with tenure in Strasbourg; three years later he was made a lecturer a the Ecole normale supérieure in Paris, but that appointment was revoked immediately after the fall of the city in 1870. In 1876 he became general inspector of higher education. Zeller retired in 1888 and died twelve years later.

Zeller was a general historian, a versatile man, and a talented writer. In 1849 he took his doctorate with a thesis on Ulrich von Hutten (244 pages), and a few years later he published a voluminous history of Italy (672 pages) as part of the series *Histoire universelle*, edited by Duruy. His most frequently reprinted work comprised portraits of Roman emperors (5th ed., 1883, 544 pages), and he also wrote the medieval-history section in the long report on the progress of the arts and the sciences compiled, at the behest of Minister Duruy, on the occasion of the International Exhibition (1867).[30] Next he wrote an ultracontemporary history of Italy, *Pie IX et Victor Emmanuel, 1846–1878* (1879, 572 pages). Zeller's carefully prepared lectures were so renowned that the princess Mathilde invited him to deliver a series of addresses to a select audience, and these were subsequently published as *Entretiens*. Zeller's largest book was a history of Germany from its beginnings to Luther (7 vols., 1872–91), which may be considered to mark the debut of German history at the Université, coming as it did even before the work of Ernest Lavisse. Gabriel Monod, who, like Lavisse, had attended Zeller's lectures at the Ecole normale, did not conceal his view that there were many flaws in Zeller's writings and that in more than one respect methodological objections could be raised against them, but he granted that Zeller nevertheless opened windows onto Germany and Italy that previously had been largely closed to *normaliens*.[31]

A role comparable to Zeller's was played by Auguste Geffroy (1820–95), whose importance is due less not so much to the lasting quality of his writings as to his pioneering work.[32] His books lacked Zeller's elegant style; he patently had less facility. In the 1860s Geffroy made great efforts to overcome the reluctance of *normaliens* to be seen as men of learning and appealed to them not to bury their scholarship in their papers, which had been the golden rule at the Ecole normale supérieure. As a member of the *agrégation* jury Geffroy was an

early champion of the philological approach and of specialization, though later on, in the 1880s, he defended the old (oral) forms of this competitive examination;[33] the changes introduced in the 1880s were obviously too sudden for the man who had advocated reforms in the 1860s and 1870s. At the end of his life, Geffroy, like Zeller, was rather looked down on by the younger generation, who did not always remember that these two men had introduced refreshing new attitudes and developments that had borne such rich fruit in university history education, so much so, in fact, as to render their own publications out of date. In a sense Geffroy may thus be said to have fallen victim to his own success.

Auguste Geffroy, having taught in the provinces for several years, became a teacher in Paris in 1846. In 1848 he defended a thesis on Milton's politics and religious pamphlets (295 pages). In 1851 he published a history of the Scandinavian countries as part of Duruy's Histoire universelle. In 1852 he became a lecturer, and in 1854 a professor at Bordeaux, where he earned many plaudits. "He creates a certain intellectual stir," the inspector noted. In the 1850s and 1860s Geffroy was sent on several missions to Scandinavia. There he not only did valuable research work but also acted as a kind of intelligence agent. In 1861 he visited Copenhagen for the third time under cover of a "very low-key" literary mission. He wrote well-informed political bulletins for the Moniteur universel on the Danish question, in which the Second Empire was very interested. At the beginning of the 1860s this historian-cum-spy-cum-diplomat began to resent being made to serve two masters; he was tired and wanted to be back in Paris for good. He wrote home to explain that he had been very useful to France, especially during the Crimean War, and asked the minister of the interior and the minister of foreign affairs to tell the minister of education of the many ways he had done his duty in delicate circumstances. He was duly rewarded: in 1862 he succeeded Duruy as lecturer at the Ecole normale supérieure. From 1864 to 1872 he served as Rosseeuw St. Hilaire' substitute, although he lacked proper qualifications in ancient history, and later he even became a regular professor of ancient history at the Sorbonne. From 1875 to 1894 (with a break of several years) he was director of the Ecole française in Rome. In the tense atmosphere following the Franco-Prussian War Geffroy was able to patch up several clashes between bragging German scholars and touchy Frenchmen, which he did with diplomatic finesse.

Like Zeller, Geffroy was a general historian with an exceptionally broad international outlook. His work was very varied. He contributed the section on ancient history to the large report on the progress of arts and science published in 1867.[34] Only after his appointment as professor to what was then the only chair in France devoted exclusively to ancient history did Geffroy earn his spurs in that field with studies of Roman archeology. Geffroy was one of the few French historians familiar with the history of northern Europe, and, as already mentioned, he was the author of a history of the Scandinavian countries (1851). In 1855 he brought out a substantial volume (512 pages), the Notices et extraits, about manuscripts on French literature and history kept in Swedish, Danish, and Norwegian libraries and archives. Thirty years later he followed this up

with a volume on Sweden from the Peace of Westphalia to the French Revolution, with an introduction of more than one hundred pages, in the *Recueil des instructions données aux ambassadeurs et ministres de France* (1885, cii + 516 pages). Soon after his death a volume by him devoted to Denmark was published in the same series (1896). In the expert opinion of Gabriel Monod, Geffroy's best work was *Gustave III et la cour de France* (2 vols, 1867), in which he made use of unpublished letters of Marie Antoinette and Louis XVI.[35]

In the 1860s Geffroy presided over the birth of the new methodological scruples increasingly being voiced at the Ecole normale and the University of Paris. In that sense he was a pioneer of a process that became increasingly evident during the 1870s under the leadership of Fustel de Coulanges, the most important of our 1870 team of history professors. Although Fustel's work gradually overshadowed Geffroy's, not all young *normaliens* would forget how much they had profited from the international contacts and broad outlook of the modest, helpful, and efficient older man. No one less than Gabriel Monod called himself Geffroy's pupil, and not simply out of kindness but also in order to give credit where credit was due.

The fifth heavyweight in the 1870 team, Henri Wallon (1812–1904), was a very important political figure during the first decade of the Third Republic.[36] A devout Catholic and at the same time a staunch republican, he was elected a member of the Legislative Assembly for the Nord department in 1849; he resigned in 1850 following the curtailment of the general franchise and held no further political office until 1871, when he stood for, and was elected to, the National Assembly. Wallon was called the "father of the Republic" because of his amendment that made it possible for the republican form of government to be ushered in through the back door in 1875. He became minister of education (1875–76) in the Buffet government and, at the same time, a *sénateur inamovible*. But here we are interested in his contribution as a professor of history rather than as a politician.

Henri Wallon studied under Michelet at the Ecole normale. A bright and alert student, he was in no danger of being relegated to the provinces. For a time Wallon was Michelet's assistant, then stood in for him, and later, when Michelet was called to the Collège de France, became his successor at the Ecole normale. In 1846 Wallon was appointed Guizot's substitute as professor of modern history in the Paris arts faculty. He had taken his doctorate in 1837 with a thesis on the right of asylum (112 pages) and had then worked for ten years on what was to become his most important historical book, a three-volume history of slavery in antiquity (1847) that is still considered a classic and, in any case, had an important social dimension.[37] As an introduction he wrote a comprehensive study of slavery in the colonies. A year later (in 1848) he joined the staff of Minister Schoelcher and became secretary of the committee for the abolition of slavery in the colonies.

Because of his work and his role, Wallon was not penalized during the 1848 revolution even though he had been the detested Guizot's substitute. He even raised strong objections to the appointment of Henri Martin, a writer of histori-

cal books and the darling of the *quarante-huitards*, as successor at the Sorbonne to the fugitive Guizot on the grounds that Martin was not an *agrégé d'histoire*. In December 1849, at the age of thirty-seven, Wallon, whose most important publication was devoted to ancient history, became professor of modern history at the Sorbonne. He was to occupy Guizot's chair for nearly forty years, until 1887. From 1876 to 1881 he also served as dean. It has to be said that, what with all his political appointments, his professorship from 1871 to 1887 was partly nominal, for in these sixteen years he invariably had a deputy, including the ultra-Catholic Lacroix.

Wallon left a voluminous body of writings, including, quite apart from his long catalogue of political publications and academic papers (in his capacity as permanent secretary of the ASMP), a popular biography of Joan of Arc (2 vols., 1860), which saw numerous reprints and abridged versions; a biography of Jesus, which was also reprinted a great many times and was meant to serve as a refutation of Renan's demythologizing *Vie de Jésus*; and a book on Louis IX (Saint Louis) and his time (1871).

The inspectors reported most favorably on Wallon's lectures in the 1850s and 1860s. He was described as a champion of Catholicism but also tolerant of other views, "precise and temperate, (presenting) factual accounts drawn from the best sources, and (evincing) sound judgment" (1866). Wallon's course of lectures may not have been a brilliant public success, but it imparted a "taste for scholarly historical research and evinced a healthy historical approach."

Wallon's studies of the French Revolution were noteworthy. In the 1870s he was the first to pioneer these studies at the Sorbonne. That was long before the creation of a special chair for the study of the Revolution in 1886. Wallon wrote books on the Terror (1873), on the history of the Parisian revolutionary tribunal (6 vols., 1880–82), on the people's representatives *en mission* and on revolutionary justice in the departments in 1793–94 (5 vols., 1889–90). With this work he intended to pinpoint the excesses of the revolutionary regime as a deterrent for his contemporaries. Against this background, Aulard's appointment in 1886 must be considered a countermove by radicals anxious to revise the study of the Revolution at the Sorbonne.

Wallon had obvious political and religious preoccupations. In some respects his writings were prejudiced, but he was anything but a narrow partisan. "Too honest a man to bend history to his views," wrote Monod in his obituary.[38] True, Monod described most of Wallon's work as "high-class popularization," as lacking in the best critical qualities, originality, and depth, but he expressly exempted Wallon's history of slavery from these charges. As a historian Wallon did not have much influence at the Université; his long absences due to his political and other commitments led to his marginalization as a history professor in the 1870s, by which time he had practically ceased to have any students. However, he left more to posterity than a great many others: an *oeuvre* of impressive scope and breadth, including several popular successes and one classic.

Fustel de Coulanges: An Intellectual Leader

Numa Denis Fustel de Coulanges (1830–89) was the youngest and the greatest historian in our imaginary procession.[39] He was forty years old when he came to the Ecole normale from the faculty of Strasbourg to act as Geffroy substitute in 1870, teaching ancient history to the crème de la crème of the French *lycées*. "Good things come quickly," as a popular saying has it, and that saying certainly applied to Fustel. After leaving the Ecole normale he went on to study at the Ecole française d'Athènes, taught school for a few years in Amiens, took his doctorate in 1858, and accepted a post in the Paris *lycée*. In 1860 he joined the faculty at Strasbourg, where, in 1862 at the age of thirty-two, he became a professor. In 1864 he published his masterpiece, *La Cité antique*, a study of Greek and Roman religion, law, and institutions in the style of Montesquieu. In the 1870s he continued his *cursus honorum* in Paris, first at the Ecole normale, in 1875 as substitute professor of ancient history and in 1878 as *titulaire* in the brand-new chair of medieval history. In 1875 the first volume of what was to become his magnum opus, namely ,the *Histoire des institutions politiques de la France ancienne*, appeared. This work was never completed; Volume 4 was published soon after his death. In 1880 Fustel also become director of the Ecole normale, a post he had never sought. In 1883 he asked to be relieved of this onerous duty because his health was failing: in the time left to him he wanted to devote all his energies to his *Histoire des institutions politiques*. Unsparingly, Fustel literally worked himself into his grave. He died in 1889, not yet sixty, after a life in the service of learning.

Fustel was a diffident lecturer. "He is as shy as a young girl," wrote the inspector in 1859. He exerted no power by handing out posts or through a bevy of hangers-on. He shied away from personal contacts with his students.[40] Fustel's position was based on intellectual strength, not on institutional might.

That strength stemmed from his books, his ideas, and his principles. He never wrote a methodological discourse or any other theoretical (methodological) handbook, but he conveyed methodology *in actu*, through guidelines scattered throughout his writings. His work was paradigmatic in the literal sense of the word. And surely that is the only approach for anyone who is anxious to be taken seriously by professional colleagues (to be) and to exert a lasting influence. Fustel's intellectual contribution was not confined to history but extended well beyond the frontiers of that discipline, which, incidentally, were not sharply drawn until later. Emile Durkheim was one of his students, so that Fustel can be considered a vital link in the development of the classical, "broad" sociological approach à la Montesquieu and Auguste Comte into the modern, "formal" or "hard" sociology à la Durkheim. Durkheim's Latin thesis on Montesquieu's contribution to the rise of the political and social sciences (1893) was dedicated to Fustel.[41]

Fustel made no distinction between history and sociology: he saw history not as a motley collection of past events but as a science of human societies. History

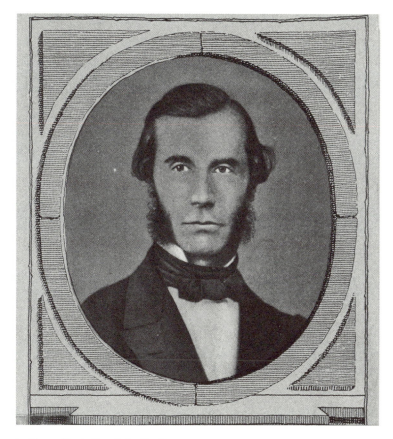

3. Numa Denis Fustel de Coulanges

studies the organs of a society, that is, its laws, economics, "mental and material habits," in short, the entire spectrum of existence. The new term *sociologie* therefore had the same meaning as *histoire*, "at least for those who understand it properly," Fustel added dryly. And a passage he wrote at the end of his life in his introduction to a volume of the *Histoire des institutions politiques* ended with this epigram: "History is the science of social facts, that is, sociology itself."[42] Fustel left an intellectual heritage that had fruitful effects on the study of history as well as on sociology.

Various biographies have been devoted to Fustel, the best among them a biography written by his pupil Paul Guiraud,[43] and he was the only historian in our procession whose collected works were thought worthy of publication, a task undertaken most scrupulously by his pupil Camille Jullian. Fustel's *La Cité antique*, in particular, gave rise to a flood of exegeses and polemics.[44] In the limited frame of these miniature portraits it is impossible to do full justice to Fustel's work. Therefore I shall confine my discussion to three areas in which

Fustel's influence was of capital importance, namely, method, subject matter, and style.

With respect to the method, Fustel was a fervent advocate of methodological doubt (which is something quite other than systematic doubt). In a letter on the approach he used in *La Cité antique* he explained that he had "acted like Descartes, forgetting everything he had learned and reading nothing but the ancient writers themselves. . . . I made it a rule to read nothing modern authors have written."[45] It was a kind of ascesis: to eschew all secondary literature and go straight to the fountain. Fustel applied this ancient precept of the historico-critical method in a highly creative way. He summed up his own procedure in three rules: "Study the texts and nothing but the texts in the smallest detail; do not believe save what these texts demonstrate; and then radically root out from the history of the past any modern ideas that false methods have instilled into it."[46] Fustel genuinely believed that it was possible to study the past without any preconceptions. He was an epistemological positivist. Such men are often called naive, but Fustel's case proves in any case that naivete in epistemology need not stand in the way of sound historiography based on an unequaled ability to select the material, great resourcefulness, and a nose for synthesis. Fustel realized that he had broken the rules of "traditional semi-erudition" and that he was an embarrassment to the system builders, but that was a price a scholar had to pay. "History is a science: it does not imagine; it simply sees, and in order to see clearly it needs reliable documents."[47]

With regard to subject matter, for Fustel the true subjects of historical research were not the reconstruction of events or deliberate human actions but institutions. In studying society the historian must be less concerned with plumbing the depths of the human psyche than with observing social forms and habits.[48] The raison d'être of Fustel's anti-individualistic historiography was to track down institutions from incidental data embedded in the sources. A case in point was his treatment of the Merovingian period: Fustel believed that the relevant documents threw more light on the history of Merovingian institutions than they did on the actual events.

> The series of events known to us is very incomplete. Often we do not know the date of a king's death, and not even the sequence of kings can be given with compete certainty. The same is true of the wars. Facts that contemporaries may well have thought to be of capital importance are completely lost to us. . . . But that is not the case with the institutions. The institutions can be retraced from a host of different sources, from accounts whose authors describe matters "quite naturally and almost without thinking about them," including laws . . . charters. . . . There are numerous data explicating the nature of kingship, the power of the kings . . . taxes, legal procedures, and criminal law, the relations between church and state.[49]

Fustel was thus far less interested in the testimony of contemporary witnesses than he was in "the continuity of facts and institutions." A Braudelian before Braudel, he preferred the analysis of what was more durable.[50]

Finally, and perhaps most important of all, was the matter of style. Fustel

admired the classical prose of Racine, Bossuet, Molière, Pascal, which was sober in form and compact in content. His own prose was lucid, concise, impersonal yet not dry, without the least show of donnishness. We can legitimately speak of Fustelian clarity. Fustel stood out sharply from such Romantic writers as Michelet, with his high-flown metaphors. A historian's task was not to write "charming accounts or profound dissertations but . . . to state the facts, to analyze them, to get close to them, and to bring out the connections between them."[51] The best historians, according to Fustel, keep closest to the texts, interpret them as best they can, "do not write or even think except in accordance with them."[52] No brilliant metaphors, no hyperbole, none of the "cut and thrust" style of authors who sweep their readers along more quickly than grammar or syntax permits. Fustel's prose was a model of order and repose, in short, of clarté française.

Fustel was a positivist, but not of the dry-facts variety. Restraint and temperance rendered him all the more productive and creative. La Cité antique was a highly original reconstruction based on "facts" that had previously gone unobserved. This is not the place to enter into the correctness of Fustel's reconstruction, the debatable nature of his argumentation, or the inner contradictions it reflects; for these the reader is referred elsewhere.[53] All we can hope to do here is briefly mention some general methodological objections to Fustel's work and approach. Quite early on, Fustel was accused of carrying systematics too far. In 1866 the inspectors said that his only fault was "a pronounced tendency to pursue systematic ideas."[54] However, in 1869 they noted reassuringly that "despite his systematic approach, he is not the man to sacrifice scientific probity to the systematic spirit." In this connection Fustel has often been accused of a lack of psychological insight. His pupil Charles Seignobos put it like this: "Fustel was unrivaled when it came to the interpretation of texts and had the gift of extracting the correct information from them, but he was not nearly as good in his observations of social reality."[55]

Fustel was also reproached for a lack of chronological precision, a matter to which French academic historians paid particular attention at the end of the nineteenth century and the beginning of the twentieth. In particular, they were wont to study political institutions in small chronological slices. Other weak points in Fustel's contribution, such as his inadequate knowledge of philology and a lack of archeological and epigraphic material, are of less importance in this context.

Fustel's Influence

In method, subject matter, and style, especially the last two, Fustel influenced the academic study of history for a long time. As early as the 1880s the young Charles Seignobos disassociated himself from Fustel's view that history was an "observational science." In widely discussed articles in the Revue philosophique Seignobos argued that all historical reconstructions necessarily involve a subjective and a psychological element.[56] Thus, although the leaders of the younger

generation of historians, Seignobos among them, could no longer be called naïve epistemological positivists (as they continue to be described in the secondary literature), the ascetic attitude toward documents remained deeply ingrained in French academic historians at the turn of the century. "No documents, no history" was the first maxim of the historians' credo.[57] And in respect of style also, what I have called "Fustelian clarity" kept resounding as a clarion call: aversion to metaphor and hyperbole, ungrammatical expressions, and personal associations was the rule. The prose of French historians around the turn of the century was sober, precise, impersonal, and methodical.

As for subject matter, after Fustel there was a clear tendency to engage in investigations that were more limited in scope, both in time and in space. First, there was a sharp delimitation and reduction of chronological boundaries in the study of political institutions (e.g., the growth of the monarchical system). Secondly, the comparative method Fustel had applied so refreshingly (albeit speculatively) was temporarily discarded by university historians as being too hazardous. It was French sociologists who, rather recklessly, usurped this element of Fustel's legacy for a time. French university historians, for their part, confined themselves increasingly to smaller slices of time and space. This was a form of specialization in historical research, the intellectual pendant to the social process reflected in the professionalization of historians and the growing importance of history as an academic subject.

A proper assessment of Fustel's intellectual legacy must include the machinations of certain political polemicists. In 1905 shrewd right-wing agitators used the occasion of what would have been Fustel's seventy-fifth birthday to appropriate his memory. *La Bagarre de Fustel* may, in fact, be called the birth certificate of the *Action française*.[58] Its pros and cons, which hinged on Fustel's political opinions, cannot be discussed here.[59] Still, two comments are in order. First, that they picked on Fustel, of all people, bears witness to the sharp nose of Maurras and company. Maurras wanted to rob the young, predominantly republican French universities of an intellectual leader, a *maître à penser*, and thus injure them to the quick. Second, the right-wing activists succeeded in permanently discrediting Fustel; explicit references to Fustel were henceforth eschewed in republican university circles. Fustel's legacy had been sullied. He had been turned into a *maître à penser* with a bad political smell.

THE 1910 PROCESSION

Let us now move forty years on and look at the occupants of history chairs in 1910. The first problem is classification: they do not lend themselves to a tripartition into lightweights, successful professors, and heavyweights. We can, however, divide them into professorial misfits and successful men. This division is largely based on the inspectors' reports. But we must remember that the inspectors' criteria had changed during those forty years: they now placed less emphasis on general knowledge and on oral as distinct from written presenta-

tion. There had been a clean break between the old and the new demands. Professors considered to be old-fashioned and inadequate in 1910 might well have been called successful in 1870.

Another striking fact is that in 1910 a very much smaller number of professors were found to be inadequate. In 1870 eight out of our twenty had fallen short of the inspectors' expectations, but in 1910 that proportion had shrunk to a mere five out of thirty-nine. Had the inspectors lowered their demands, or had the quality of the professors improved? The answer is probably a little of each. To start with the second alternative, the quality certainly seems to have risen at the lower end inasmuch as fewer professors turned out to be dunces in 1910. That, of course, tell us little about the average quality and nothing at all about the merits of the upper echelon. What we can say, in any case, is that in 1910 the standards were being more carefully controlled. The inspectors' demands were now being framed in a nascent university setting, one in which people knew one another better, protected one another, and weighed their opinions more carefully. Even more fundamental were the effects of specialization. Professors were no longer quite so vulnerable to the views of outsiders (i.e., the inspectors), and they found it easier to turn out work of more lasting value. The inspectors were aware of these changes. Thus in his comments on the local-history thesis of one of the 1910 team of professors an inspector wrote: "With that approach, even men of mediocre talent can produce useful results."[60] In 1910 a greater number of professors made the most of their talents, for which the inspectors rewarded them with lenient verdicts.

The most striking difference between the intellectual approaches of the professors of 1910 and that of the professors of 1870 was their degree of specialization in space and time: within forty years period specialists and regional historians had become common among history professors. What had been the exception in 1870, and had been frowned upon by the inspectors at the time, had become the rule in 1910. Specialization was proceeding apace, although it was still relatively insignificant when compared with developments during the further course of the twentieth century: by virtue of his training, the 1910 specialist was considerably less specialized than his successor in 1980. The process of specialization is unending by definition. Compared with the degree of specialization in 1870, however, and that is what matters here, the specialization recorded in 1910 was considerable.

Of the thirty-four professors who were given positive assessments (thirty-nine minus the five found to be wanting) twenty-one were specialists on a particular period or region. Of these twenty-one, twelve were period specialists: five were ancient historians, five were medievalists (including two Byzantinists), one was a sixteenth-century expert, and one was a historian of the French Revolution. There were nine regional specialists, at least three of whom had also published work on nonregional topics, but few of these contributions were particularly profound or of lasting importance.

Of course, one specialist is not necessarily like another. The specialists in our group differed markedly in the breadth of their outlook. Some were myopic

specialists; others were specialists with the gift of fitting their small part into the great whole; there were specialists with or without an overview. In principle it is of course possible to produce a detailed study so brilliant that the whole universe is reflected in it. We can accordingly speak of minor and major specialists.

In general, short-sightedness was thought to pose a greater threat to regional and local historians than it did to period specialists. Thus an inspector said apropos of a *soutenance* that local-history presentations usually lacked sparkle, rarely went beyond purely regional concerns, and were generally replete with references to unpublished sources bearing on "facts of a material kind." A great deal of talent was needed to arrive at generalizations from these detailed facts (at the time the simplest form of generalization, quantification, was not yet widely accepted). "There are but few with the talent of a Quicherat," sighed the weary inspector.[61] In any case, the regional historians in our 1910 procession included no great specialists. The heyday of professors with brilliant theses on *géo-histoire* was still to come.

Of the twelve period specialists nine may be called minor specialists and three were specialists of greater merit. Our classification of the 1870 team was based on two criteria: intellectual influence and the lasting importance of their published material. Thanks to specialization, the second criterion had lost in importance; specialization, after all, means a longer shelf life. The classification of our 1910 professorial team is accordingly based on three criteria: widening of the historical horizon, pioneering work, and intellectual leadership.

Three of the twelve period specialists and thirteen others, that is, a total of sixteen professors, were men of exceptional merit. Four of them widened the historical horizon by looking beyond the French frontiers and making substantial contributions in the fields of German, Czech, and diplomatic history, in addition to their publications on French history. In certain respects we can refer to these men too as regional specialists, but of a very distinct kind.

Six of these meritorious professors were pioneers. Some of them may also be called specialists, although the pioneering nature of their published work merits a special designation. One, Charles Diehl, the founder of French *byzantinologie*, was a "great" period specialist; four were pioneers in socio-economic history; and one was a pioneer in the history of ideas. All injected new subject matter into what were predominantly literary and political studies of history.

Six, finally, were *patrons*, a relatively new title. *Patrons* were the direct result of the institutionalization and academic adoption of history. The characteristic of a *patron* was that he wielded power in the form of influence on appointments, in the supervision of theses, and in getting articles placed in prestigious journals. *Patrons* came in different shapes and sizes: some had a marked, and some a less pronounced, intellectual influence; some had numerous students and others had only a few; there were standard *patrons* and just one *superpatron*.

The most powerful of them all was Ernest Lavisse. Two period specialists were also *patrons*: the medievalist Charles-Victor Langlois and Alphonse Aulard, who was an expert on the revolutionary period. Another *patron*, Charles Seig-

nobos, was charged with teaching the historical method. In principle he thus covered the entire historical field; in practice, however, his work was mainly devoted to nineteenth- and twentieth-century political history. Two *patrons*, Gabriel Monod and Henri Berr, were chief editors of the most influential general-history journals of the day, the *Revue historique* and the *Revue de synthèse historique*. Strictly speaking, neither Monod nor Berr should be included in our 1910 procession. Admittedly, Monod was at the time a professor in the Collège de France and president of the fourth section of the Ecole pratique des hautes études but not a professor at the arts faculty. Henri Berr, the least powerful among the *patrons*, a philosopher by training, was a teacher in Paris and would never be offered a university chair. However, Berr behaved like a *patron* and exerted considerable influence through his "salon," the editorial offices in the rue Sainte Anne. In any case, our picture of the 1910 history *patrons* would be distorted were we to omit Monod and Berr from our procession.

Professorial Misfits

Of the five history professors who received negative assessments three were *normaliens* and two had studied law.

Jacques de Crozals (1848–1915) was the son of a man in the educational world, who bombarded the ministry with letters of recommendation designed to further his son's career.[62] Jacques was admitted to the Ecole normale in 1868, took his *agrégation* in 1872, was a teacher in various *lycées*, and gained his doctorate with a thesis on Lanfranc, the archbishop of Canterbury installed by William the Conqueror (1877, 270 pages). He was appointed a lecturer at Rennes. In 1880 he became a lecturer at the college of higher education in Algiers; in 1881 he was made a lecturer in Grenoble, and he became a professor there in 1884. Judged by the criteria of the old Université, which continued to prevail in Grenoble, Crozals was not really a professorial misfit; indeed, he was even made dean of this unimportant faculty. His work was varied but superficial: he published an ethnological study on the Fulani (1883, 271 pages); various biographies, including the lives of Plutarch (1888, 239 pages), Saint-Simon (1891, 235 pages), and Guizot (1894, 239 pages); and also a few short comedies and translations from the Italian. All in all, however, his *oeuvre* was rather slight.

The second of our *normaliens* was Paul Gaffarel (1843–1920), whose work was found in retrospect to be rather better than the inspectors thought at the time.[63] Gaffarel worked in secondary education from 1865 to 1873. He took his doctorate in 1869 with a thesis on pre-Columbian contacts between America and the Old World (346 pages). In 1874 he became a professor at Dijon after first serving as a substitute professor. The indiscreet inspectors raised serious objections to his private life. In 1870 he had married into a moneyed but otherwise not very desirable family. In 1888 Gaffarel, who had meanwhile been divorced, appeared at a student party "dressed in black, his face covered up, flanked by two scantily dressed and notorious women," one of whom (La Ga-

limare) had been found guilty of keeping a house of ill repute. (Seignobos was right: Paris was the only place in all France without any *censura morum*.)[64]

The inspectors had not a single good word for Gaffarel's work. They called him a charlatan who wrote a great deal but nothing of any importance. They did not allow their sympathy with his disappointments and domestic misfortunes to color their opinion of his work. In 1901 Gaffarel was transferred to Aix-en-Provence (against the wishes of the faculty there). He retired in 1913. In both Dijon and Aix-en-Provence he also held political office, for which the inspectors did not thank him: he was called a careerist who had first flirted with the socialists and then, when that had not paid off, had stood as a candidate for the clerical monarchists. Gaffarel was a prolific writer and certainly turned out more than mere botch. He published a great deal on colonial history, including a lengthy history of Algeria (1883, 708 pages); a few books on the campaigns fought during the Revolution and the Empire, some of which were reprinted several times; several school textbooks, which proved less successful; as well as articles in the prestigious *Revue historique* and in local journals. The latest edition of the great *Dictionnaire de biographie française* takes a positive view of Gaffarel's work, although that entry is accompanied by no explanation or acknowledgment and was perhaps posthumous compensation for the tide of negative opinions circulating during Gaffarel's life.[65] All in all, Gaffarel failed to meet the modern demands that were being made even on provincial professors. On his departure most people were glad to see the back of him.

The third *normalien* to be considered too slight by the inspectors was Léonce Pingaud (1841–1923), who after a few years in secondary education took his doctorate in 1872 with a study of the policy of Gregory the Great (310 pages).[66] A year later he joined first the faculty at Clermont-Ferrand and then the faculty at Besançon, where he became professor in 1875. Pingaud was a model of a Catholic *universitaire*; "highly esteemed by that part of Besançon society which mixes little with republican officials, he remained close to his old teachers in the Catholic college." During the first few years of his professorship the inspectors were satisfied with him, but in 1889, when he spoke once too often about "the errors of the Revolution," he had gone too far. In 1890 the inspector noted ironically that no "republic, however attractive," could have gained his allegiance. He was described as "a *universitaire* in name rather than in attitude . . . utterly devoted to local works that gratify his political and religious sentiments." A clear break followed in 1901: Pingaud no longer attended faculty meetings, nor did he have any students. Instead he took an increasingly active part in local learned societies, most of which were politically reactionary and Catholic in persuasion. He published a large number of well-documented papers on the history of Franche-Comté, in addition to several books, including one on Bernadotte (1901, 452 pages; reprinted in 1933). In 1907 the inspector described him as "a conscientious professor, but one who might as well not exist as far as the university is concerned."

Louis Stouff (1859–1936) was Swiss by birth and a lawyer by training.[67] Even so, he took his doctorate in 1890 in the arts faculty with a thesis on secular power and civic authority in the bishopric of Basel prior to the Reformation (3

vols., including 2 with source references, notes, and appendixes). The jury reproached him with being too much of a jurist and with subordinating history to the law. He was also said to have generalized "to excess," "a shocking abuse of the legal method, the sense of historical life being stifled by abstractions."[68] The jury did not, however, dismiss Stouff as a trivial intellect and were most appreciative of his archival discoveries. In any case, a short time later, partly on the recommendation of his father, who sat in the Senate, Stouff was appointed lecturer at the faculty of Dijon, and in 1903 he became professor of ancient and medieval history there. Though he was admired for his legal mind and his detective work in the archives, his appointment was generally considered a mistake. After his thesis, his main publications were articles on the history of Burgundy. Partly because he was hard of hearing, he became increasingly withdrawn. Although the inspector still gave him the benefit of the doubt in 1890 ("he is rather naive, but then he is . . . Swiss"), the official view had become frankly critical by 1900: "wide-ranging erudition but a fairly narrow mind with outdated ideas." Stouff, incidentally, kept his chair until 1929. The inspectors' opinion did not improve with the passage of time.

The last of our professorial misfits was Georges Desdevises du Dézert (1854–1942), son of Théophile Alphonse, the lightweight in our 1870 procession.[69] In the case of these two we can speak of a dynasty of lightweights, with the rider that the son would undoubtedly have been a successful professor had he been judged by the criteria of 1870. He was a fine orator whose suggestive if somewhat shallow and unmethodical approach used to fill the lecture halls. He was already engaged in secondary education when (in 1883–84) he received a scholarship to prepare for the *agrégation*. He flung himself into the history of Spain, lived and traveled in that country at his own expense for five months, and claimed to have collected six thousand historical records there. Earlier Lavisse had returned the manuscript of his thesis with the advice that he spend a few months more in the archive and the library in order to render his work more academic. In due course Desdevises defended his thesis on Don Carlos of Aragon, a study of northern Spain in the fifteenth century (1888, 455 pages), with the skill of a "brilliant and subtle advocate, but not as an acute critic of the sources, one with solid knowledge of the literature."[70] He also wrote a three-volume history of Spain (1897–1904) and numerous other books and articles, some of which were published in the *Revue historique* and the *Revue de synthèse historique*. He was greatly liked by Clermont society, "in which he perhaps took too much pleasure." Desdevises was very popular, and the inspector had to acknowledge his oratorical mastery. But because of the new demands being made on professors, the junior Desdevises du Dézert was considered out of date in 1910. His lectures were said to be "moral rather than learned."

The Regional Specialists

Of the thirty-four professors whom the inspectors considered to be successful—which, incidentally, did not mean that they were beyond reproach—there were nine who, on the basis of their most important publications, could be called

regional historians. Six of these were in fact appointed to teach regional history, while the remaining three taught general history. All could be considered "minor" specialists: their publications were expert enough, but they did not generally extend to beyond their own region or town.

Michel Clerc (1857–1931) went from the Ecole normale to the Ecole française d'Athènes.[71] From 1880 to 1883 he participated in several excavations, on Samos among other places, and immediately upon his return to France he was given a lectureship in Aix-en-Provence. In 1893 he took his doctorate with a substantial work, *Les Métèques athéniens* (476 pages), in which he examined the legal status and the socio-economic role of foreigners in Athens. The inspector's opinion was not very positive: the author was not on top of his subject and did not draw any general conclusions; moreover, his source material was rather tenuous. The inspector, who did not seem to have too high an opinion of epigraphers, blamed this last shortcoming on the subject as well as on the author: "These theses by stone-shifters are rarely attractive."[72] Even so, Clerc's work did not displease everybody. His good points were accuracy and thoroughness. In 1894 he was appointed the first professor of Provençal history in Aix. From that time on he published little else besides books on local history, including a two-volume history of Marseille, together with studies and articles published mainly in regional journals.

Paul Courteault (1867–1950), brother of Henri Courteault, the *chartiste* and director of the Archives Nationales, was a teacher for many years after leaving the Ecole normale in 1890.[73] In 1894 he was given a post at the Bordeaux *lycée* and was also appointed curator of the city museum. In 1899 he became director of the Archives historiques de la Gironde. He was a great student of local history and a fine lecturer. In 1907 he became an assistant professor, and in 1910 a regular professor, of the history of Bordeaux and southwestern France. To gain an appointment to the faculty (as successor to Camille Jullian, who had moved to the Collège de France) he had taken his doctorate shortly before with a book on Geoffroy de Malvyn (1545?–1617), a local magistrate and humanist (1907, 211 pages). Nearly all Courteault's publications had to do with the history of Bordeaux and were highly appreciated as fine contributions to local history.

Charles Molinier (1843–1911) became a teacher in 1865 after leaving the Ecole normale.[74] In 1873 he was given a teaching post at the Toulouse *lycée*, and in 1880 he took his doctorate with a thesis entitled *L'Inquisition dans le Midi de la France au XIIIe et au XIVe siècles* (476 pages). it was an important book, more valuable as a study of sources than as a history of the Inquisition. Wallon, the dean and at the same time president of the jury, contended that Molinier had approached the work more as a librarian and archivist than as a historian. Wallon was also annoyed that Molinier had looked back with regret to the old civilization of southern France. The candidate seemed to be complaining about "the policies to which we owe the unity of our country."[75] And inspector Perrens noted that Molinier had abandoned his "exaggerated" circumspection when giving his assessment of the Inquisition, the better to parade a form of separa-

tism. The inspector could see him as a future professor, but Molinier's fast and furious oratory made the inspector doubt whether he was suited to lecturing anywhere but in the south. With his scrupulous attention to detail, Molinier was the ideal man to work in an archive, but he still had to prove that he was also a historian, and he still had to learn to write.[76] All these critical comments notwithstanding, Molinier was appointed a lecturer at the faculty of Toulouse in 1881, soon after his *soutenance*. Two years later he became a professor in Besançon, and in 1886 he returned to Toulouse as professor of the history of southern France, a post he held until his death in 1911.

Molinier never managed to fill his lecture halls; he seemed to be lecturing for his own benefit rather than for that of his sparse audiences. He did, however, play an eminent role as a sleuth and critic. He was more familiar than anyone else with the unusually rich archives of the Inquisition. It was Molinier who, on an academic mission to Italy, extracted the *Registre* of Jacques Fournier, bishop of Pamiers and later pope in Avignon, from a pile of dusty papers in the Vatican.[77] Almost a century later, in 1975, Emmanuel Le Roy Ladurie was able to base his world-famous *Montaillou—Cathars and Catholics in a French village (1294–1324)* on this very find. Molinier's meticulous studies of heretics and inquisitors are still consulted today. His publications were few in number but of lasting importance even if he was unable to rise above his special interests.

Henri Prentout (1867–1933) was a Norman born and bred.[78] Born in Le Havre, as a scholarship student he took his *licence* at the faculty of Caen, received a scholarship to prepare for his *agrégation* in Paris, and went on to teach in Tourcoing for two years. He returned to Caen in 1894, clearly delighted to be home. He took his doctorate in 1901, and immediately thereafter he was invited to give a course of lectures on Norman history. In 1904 he was made professor in the same field. He died in 1933. His thesis was a brilliant biography of Decaen, a Norman nobleman who had played an important role in the colonial policies of the Consulate and the Empire. That thesis bore witness to thorough archival work in Caen, where Decaen's private archives were kept, and elsewhere. Prentout was esteemed as a "singularly valuable link between the indigenous and the university element." He was a leading member of many local societies and also wrote surveys of Norman history in such academic journals as the *Revue de synthèse historique* and the *Revue d'histoire moderne et contemporaine*. He published a three-volume history of the provincial states of Normandy. In view of the historical background of that work, it is not surprising that he was also familiar with English history, so much so that after the First World War he wrote a history of that country. However, it was mainly as a regionalist that Prentout was esteemed at the university.

Robert Parisot (1860–1930) first chose a military career, but when he was stationed in the garrison of his native Nancy he became so captivated by the past of the region that he left the army for history.[79] He took the *agrégation* in 1888 and became a teacher in Bar-le-Duc. Ten years later, in 1898, he defended an 820-page thesis on the kingdom of Lorraine under the Carolingians (843–923), for which he was awarded a prize by the AIBL. In 1902 he was offered

the chair of the history of eastern France at the faculty of Nancy. Most of his written contributions appeared in local journals. After the First World War he published a three-volume history of Lorraine from its origins to his own times. He died in 1930.

Prosper Boissonnade (1862–1935) was a scholarship student at the faculty of Toulouse. He took his *agrégation* in 1884 and then became a teacher.[80] He obtained his doctorate in 1893 with a thesis entitled *Histoire de la réunion de Navarre à la Castille: Essai sur les relations des Princes de Foix-Albret avec la France et l'Espagne, 1479–1521* (1893, 685 pages). This was a useful contribution to diplomatic and military history, and one that broke fresh ground. His precision and erudition were singled out for praise. The dean (Himly) called Boissonnade "un naif" because of his appearance. Neither his mustache nor his spectacles could disguise his exceedingly youthful looks; "with his close-cropped hair and shaven face except for the lip, he looks like a seminarist." But according to the inspector, Boissonnade was well on the way to becoming a true scholar. He had combed libraries and archives even in that "horribly sweltering village of Simancas," and though he had not given a sparkling performance at his *soutenance*, he had nevertheless given proof of solid scholarship.[81] In addition to his thesis, Boissonnade had also written several contributions to the history of Angoumois and Angoulême (where he had been a teacher from 1886) by the time he became a lecturer in Poitiers (1895). In 1897 he was appointed professor of the history of Poitou in the same town.

Boissonnade was more than a regional historian. In a sense he was also a pioneer of economic history, especially thanks to his two-volume *Essai sur l'organisation du travail en Poitou depuis le XIe siècle jusqu'à la Révolution* (1899–1900). However, unlike Henri Sée and Henri Hauser, who wrote about the history of labor organization at about the same time, Boissonnade failed to make it into the ranks of professors of exceptional merit. This indefatigable scholar piled up record upon record and published book after book. His lectures were thought to be solid though by no means brilliant or crowd-catching. "A desk-worker who would rather please himself than make himself useful or agreeable," the rather critical inspector wrote in his report (1892–93). But there were also more positive voices. In 1907 Boissonnade was described as a very productive professor who might well be called to the Sorbonne one day. That proved to be a mistaken view. Boissonnade's work was wide-ranging rather than profound. He was a pioneer in going back to the sources in economic history, but his approach was derivative and not well considered. It was with good reason that Lucien Febvre used one of Boissonnade's last works (on Colbert) to demonstrate how economic history ought *not* to be written. Febvre described this attack as constructive criticism of *histoire-tableau* in the economic field. Much as, with the deadly touch of the practiced matador, he had previously attacked medievalists for making it seem that peasants had not so much tilled the land as drawn up cartularies, he now reproached Boissonnade with presenting an academic Colbert and ignoring the real problems of economic life.[82] Febvre's criticism proved fatal, as usual. (It was more justified in the case of Boissonnade's

economic historiography than in that of Seignobos's political historiography, to which we shall return.) The attack on Boissonnade was not part of the fight for intellectual leadership among Parisian historians, but it was very much to the point and basically constructive.

For the rest, Boissonnade did certainly not go unappreciated. His sizable *oeuvre* was rewarded with prizes on more than one occasion; he was a member of numerous committees, sat on the *agrégation* jury (1905–6), and in 1921 was appointed dean at Poitiers, a post he held until he retired in 1932. He was valued by a great many people.

In addition to these professors of local history, the 1910 procession also included three professors of general history who did their most important work in the regional field. The clearest example was set by Paul Gachon (1854–1929),[83] one of Fustel's outstanding pupils at the Ecole normale. He became a teacher and then, in 1883, a lecturer at Montpellier. In 1888, immediately after taking his doctorate, he was made a professor there; he retired in 1924 and died five years later. Gachon was one of the few doctoral candidates whose Latin thesis was not only well rounded but thought to be of some importance. It was devoted to the Spartan ephors (1888, 119 pages), bore the stamp of Fustel, and was a model of institutional history (which would later be considered part of social history) applied to the well-plowed field of ancient history. According to Gachon, the ephors embodied the social and economic resistance of the military and landed aristocracy to the Spartan kings. His French thesis, *Les Etats de Languedoc et l'édit de Béziers, 1632* (1887, 301 pages) was also judged to be useful, but in the view of the dean who presided over the jury it paid too little attention to the general background and took too much for granted. Even so, the inspector was tolerably satisfied and remarked that Gachon's *thèse* was proof of the superiority of the *méthode universitaire* to that of the Ecole des chartes. "Ever since *normaliens* have been taught respect and love for exact science, their work has been much better than that of *chartistes* because *normaliens* have preserved the art of composing and writing, which *chartistes* happen to lack, save for such exceptions as Quicherat and Delisle."[84] Most publications by Gachon, a clergyman's son, related to the history of Protestantism in the Languedoc. His *oeuvre* was not very extensive but specialized and of considerable quality.

François Dumas (1861–48) was the only one in our 1910 procession to leave his professorial chair for a senior government post.[85] A scholarship student at the Bordeaux faculty (i.e., not a *normalien*), he took his *agrégation* in 1884 and then taught for ten years in Tours while preparing his thesis. His subject was the *généralité* of Tours under the intendant du Cluzel (1766–83). That thesis (1894, 437 pages), based on material drawn from the town archives, was judged to be a useful contribution, the inspector adding that it was less boring than other local-history dissertations. The jury, which of course was unfamiliar with the documents, put up little if any opposition to his doctoral promotion.[86] In 1896, Dumas became a lecturer, and in 1898 he became a professor of modern and contemporary history at Toulouse. His *oeuvre* was not very large.

Apart from writing regional studies, he was the coauthor of a history of the Franco-Prussian War (1896) that was reprinted four times and a study of the commercial treaty of 1786 between England and France (Toulouse 1904, 197 pages). In 1907 he was made a dean, and he distinguished himself by running a sound and thrifty administration. From 1917 until his retirement in 1931 he was rector of the academies of Besançon, Grenoble, and Bordeaux, in that order. Even after his retirement Dumas continued to do administrative work, *inter alia* as director of the French Institute for Spanish Studies in Madrid, a post he held until the Spanish Civil War forced him leave. Dumas chose to end his career with an official post. He did not publish much in later life, and although some of his writings bear witness to his broad interests, the most important of them were devoted to local and regional history.

Henri Carré (1850–1939) was a working student who obtained his *licence* in 1872 while teaching in Aurillac and did not obtain his *agrégation* until 1881, having meanwhile taught in Alençon and Carcassonne.[87] Directly afterwards he joined the teaching staff at the *lycée* in Rennes, and a little while later he started to also lecture at the local faculty. His lectures were highly appreciated. Although his private fortune made him a man of independent means, he loved to teach and was good at it, as the omniscient and indiscreet inspector put it in 1885. Carré took his doctorate in 1888 with a thesis on regional institutions, *Essai sur le fonctionnement du Parlement de Bretagne après la Ligue (1598–1661)*, (1888, 569 pages). He had sifted through thousands of unpublished documents with scholarly scruple, but the period he examined was very brief, and he failed to say anything about its antecedents or to make any comparisons. In short, his useful and learned monograph lacked a wider context. It adduced a host of original data but dwelled at too great a length on unpublished material and was badly written. The inspector considered it a helpful contribution to local history, and its author a "hard-working man," if lacking in wit and finesse. "Though he smiles now and then, he does not make one smile." Not surprisingly, the jury had but few comments to make on Carré's finds in the previously unexplored archives of Rennes. To kill time, they asked Carré to explain what he had written.[88]

Carré was found to be suited to work in higher education, but the inspector wondered whether he would be brave enough to accept a post outside Rennes if the need arose. He was, in fact, not doing justice to Carré's thirst for adventure. Immediately after taking his doctorate, Carré was given a lectureship at Poitiers, where he became a professor one year later (in 1889). He developed into a general historian. Lavisse was able to recruit him for writing the parts in his great *Histoire de France* devoted to the Regency and to Louis XV and Louis XVI (1715–89), a period on which Carré had produced popular writings before. He was also a regular contributor of articles on the revolutionary period. Carré was greatly esteemed in academic circles: he was made dean at Poitiers, and "being a man of the world and having a practical approach," he was widely expected to become the rector of the faculty. With Prosper Boissonnade, a specialist on the history of the Poitou, at his side in Poitiers, Carré felt free to withdraw from the

lecture theater and devote himself instead to the writing of general-history books. The plaudits these earned him, however, including the volumes in Lavisse's *Histoire de France*, were on the whole less fulsome than those he received for his regional work. His thesis, which he defended relatively late in life, at the age of thirty-nine, remained his most lasting and important scholarly contribution.

The Period Specialists

Of the twelve professors we have called period specialists two were *patrons* (Langlois in medieval studies and Aulard in the history of the Revolution), and one was a pioneer (Diehl, the father of French Byzantine studies). These three are discussed below. First we will look at the remaining nine.

Their number included five professors of ancient history, a discipline for which French universities lacked a real *patron* around 1910; Professors Bouché-Leclercq and Gustave Bloch did write important works in this field, but neither had the style of a *patron*. The formidable Camille Jullian taught at the Collège de France. After Fustel, who had died in 1889, and before the appointment of Gustave Glotz in 1913,[89] the teaching of ancient history at French universities lacked a clear direction.

The most original ancient historian in our 1910 procession was Bouché-Leclercq (1842–1923), who succeeded Geffroy in the Parisian chair.[90] Bouché-Leclercq was more or less self-taught. He had left the seminary because of philosophical qualms, traveled in Italy and Germany, and given private lessons. In 1871 he presented himself, an unknown figure with a very good thesis, *Les Pontifes de l'ancienne Rome* (1871, 439 pages). Geffroy read the manuscript and wanted to know more about its author. He looked him up in his student quarters and, as he put it, came upon one "still young, of very independent character and spirit, a little diffident, but sincere and serious," surrounded by the best German books his impecunious circumstances had allowed him to acquire.[91] Bouché-Leclercq was not an *agrégé* and had had no teaching experience in state schools, but on Geffroy's recommendation he was nevertheless offered a lectureship in Montpellier in 1873 followed by a professorship in 1875. In 1878 Geffroy, who was director of the Ecole française de Rome, made Bouché-Leclercq his substitute in Paris. The inspectors' opinion was not entirely favorable. In a report of 1876 Bouché-Leclercq was said to lack charm and finesse, not to have digested all his book learning, and to be an insipid lecturer. "It is hard not to take him for a provincial schoolteacher who has not yet been fully civilized in Paris." With the incorrigible high-brow superiority of the Parisian, the inspector added that Bouché-Leclercq was still "no more than a doctor." Later too the inspectors were not wildly enthusiastic about him. Only old people, in particular very old women, were said to attend his lectures, the professor himself being the youngest in the hall. But no one could deny that Bouché-Leclercq knew his stuff.

Bouché-Leclercq wrote various large and important books, including a four-

volume *Histoire de la divination dans l'antiquité* (1879–82), which is still considered a standard text. He also wrote a handbook on Roman institutions (1886, 654 pages), a study of Greek astrology (1899, 658 pages), and many other works. In addition, he translated Ernst Curtius's *History of Greece* and Droysen's *History of Hellenism*. All in all, Bouché-Leclercq was considered an important professor of ancient history. For thirty-one years, from 1887 to 1918, he was a professor at the Sorbonne, but he failed to turn into a genuine *patron*. The reason must probably be his character, which Geffroy described as "self-doubting, sometimes downright gloomy."

The second Parisian professor among our period specialists was Gustave Bloch (1848–1923), the father of the famous Marc Bloch.[92] After leaving the Ecole normale he worked in secondary education for a short time, and in 1873 he was called to the recently opened Ecole française de Rome. After his return, with a strong recommendation from Albert Dumont, the director of that school, Bloch was offered a lectureship at the faculty of Lyon (1876). There he worked on his dissertation, which he defended in 1884. That same year he became professor at Lyon. Four years later he was called to Paris to teach at the Ecole normale. In 1904, upon its merger with the Sorbonne, he was made a professor of Roman history. He retired in 1919.

Bloch had studied under Fustel, whose influence was clearly reflected in the subject and approach of Bloch's thesis. *Les Origines du sénat romain: Recherches sur la formation et la dissolution du sénat patricien* (1884, 334 pages) was praised in the dean's report for having overturned "all the postulates that were customarily used as substitutes for the texts." It was, however, pointed out that the thesis was primarily concerned with validating the method itself. This highlighted an important aspect of professional writing: the method had become an end in itself. The inspector's report described Bloch—"this fat, dark-skinned, and bearded little man, rather thick-set and squat but remarkably self-assured and vigorous"—as one of the most mature and best *docteurs* of the French Université. He might just as well have sat on the jury as face it as a candidate, the inspector added. His thesis was almost as precise as a mathematical demonstration. The only flaw the inspector could discover was a lack of ease and flexibility.[93] At the Ecole normale Bloch, nicknamed "Mega" because of his large head, was held in high regard. His best-known work was the volume on independent and on Roman Gaul (1900, 456 pages) in Lavisse's collective work, the *Histoire de France*. His obituary in the *Revue historique* described him as the undisputed master of Roman history.[94] However, Bloch applied his mastery to a limited field, thus failing to lend his weight to the academic study of Roman history at large and to turn his professorship into a real *patronat*.

Charles Lecrivain (1860–1942) also went from the Ecole normale to the Ecole française in Rome, whence he returned to a lectureship at the faculty of Rennes in 1885.[95] In 1886 he was appointed a lecturer in Toulouse, and in 1888 he took his doctorate with a thesis that not only bore a strong resemblance to Gustave Bloch's but also reflected the marked influence of Fustel: *Le Sénat romain depuis Dioclétien, à Rome et à Constantinople* (1888, 243 pages). The

work had considerable character and was a model of precision; its style was sober and disciplined, shorn of all superfluous detail: "Everything has been condensed in these compact pages, sometimes to a core from which nothing can be taken away." Once again the jury had been presented with an institutional history that was in fact a social history. Lecrivain described the gradual rise of a political institution under the late Roman Empire and of the aristocratic class associated with it. Like Fustel before him, he was reproached with showing "excessive determination to arrive at his findings unaided, without regard for prior work." Lecrivain was twenty-eight years old, scholarly, and dry, and as he took pleasure in dull things, he did not feel the least need to render his subject matter attractive to the public. The inspector, who, incidentally, had found Lecrivain's *soutenance* deadly boring, opined that Lecrivain was not a man to make many mistakes, that he would turn out to be a good teacher, and that he would certainly become a professor.[96] In 1893 Lecrivain was duly offered a professorship in Toulouse, a post he held until his retirement in 1930. He published numerous specialist articles, mostly on Roman history. His teaching methods were judged to be useful, but he was said to find it hard to inspire his students, so much so that after a time he gave up lecturing altogether. In 1870 Lecrivain would have been considered a professorial failure; in 1910, despite his shortcomings, he was esteemed for his methodical and specialist approach.

Georges Radet (1859–1941) was also given a faculty appointment before he took his doctorate.[97] From the Ecole normale he went to Athens (1884–87); then, after a few months at the Algiers *lycée*, he became a lecturer in Bordeaux in 1888. In 1892 he took his doctorate with *La Lydie et le monde grec au temps de Mermnades, 687–546* (1892, 327 pages), which earned him paeans of praise from his teacher, Perrot, the director of the Ecole normale and an ancient historian, but made less of an impression on the rest of those present during its presentation, including the inspector. In 1895 Radet was appointed a professor of ancient history in Bordeaux. He was the typical guild historian, for whom there was really no such thing as a dunce teaching ancient history. He admired his predecessors and his colleagues, and he could count on their goodwill in return. He wrote the commemoration volume of the Ecole française d'Athènes with deep respect (1901, 492 pages), was a faithful contributor to a number of Festschriften, and duly received his own *Mélanges* (1940). He was the indefatigable editor of the *Revue des études anciennes* and the author of various books and numerous papers.

Maurice Besnier (1873–1933) was the youngest of the five professors of ancient history. He too received a faculty appointment before his *soutenance* and hence did not have to labor in secondary education.[98] He specialized in Roman archeology and epigraphy. In 1896, having left the Ecole normale, he went on to Rome, where he started work on a thesis about the Tiber Island in antiquity, which he defended in 1902 (357 pages). This thesis was judged to be a solid and accurate piece of archeological research. Besnier, who had also been on digs in Algeria, was appointed to the faculty at Caen as early as 1898 and was made a professor there in 1906. He was a specialist and a brilliant lecturer to boot. In

1906–7 the inspector anticipated that Besnier was likely to be called to Paris. In addition to his contribution to Roman archeology and epigraphy, Bernier wrote two highly praised general works, a *Lexique de géographie ancienne* (1914, more than 800 pages), and the volume dealing with the Roman Empire at the time of the Severi (192–321) in the *Histoire générale*, edited by Gustave Glotz and published after Besnier's death (1937).

The period specialists also included five medievalists. Two of these, the *patron* Charles-Victor Langlois and the pioneer Charles Diehl, will be discussed later. The remaining three were successful period specialists pure and simple, although there are reasons why one of them, Christian Pfister, should be considered a *patron* and another, Louis Bréhier, as a pioneer who contributed to the foundations of French *byzantinologie*.

Christian Pfister (1857–1933) was an authoritative and respected medievalist.[99] After serving as Gabriel Monod's deputy at the Ecole normale from 1902 to 1905, he served as a professor at the Sorbonne from 1906 to 1919. Beginning in 1913 he was also editor of the prestigious *Revue historique*. In 1910 Pfister was intellectually overshadowed by Langlois, the other professor of medieval history at the Sorbonne,[100] but because Langlois was rather unapproachable and not prepared to lecture to any but a very select company, most students had to deal with Pfister. In 1913, when Langlois became director of the Archives Nationales, Pfister had the field all to himself—Ferdinand Lot being no more than a senior lecturer at the time, and one, moreover, who had to be reappointed annually.[101] Pfister's monopoly was, however, of short duration. The First World War disorganized the academic world, and in 1919 Pfister chose to take a leading part in the *reconquista* of his beloved Alsace, becoming a professor (of Alsatian history) and dean of the brand-new faculty of Strasbourg. Henceforth he published little more than work on the history of Alsace. However, he remained a leading authority on French medieval studies and was respected in the historical world at large, not least because of his editorship of the *Revue historique*. Nevertheless, the most stimulating and original ideas during the interwar years came not from Pfister but from Ferdinand Lot, his successor at the Sorbonne, and from Marc Bloch.

After taking his *agrégation*, Christian Pfister had been allowed to remain a boarder at the Ecole normale in order to attend lectures at the Ecole des chartes and to write his thesis. Pfister also did not have to work in secondary education but went straight on to the faculty at Besançon (in 1882). In 1884 he became a lecturer in Nancy; in 1885 he took his doctorate, and in 1887 he became a professor of history and geography in Nancy. In 1892 he was put in charge of teaching the history of eastern France. Ten years later, he went to Paris, but he decided to transfer to Strasbourg after the First World War. From 1927 to 1931 he was rector of the Strasbourg academy. He retired in 1931 and died two years later.

Although as a *normalien* Pfister had been introduced to medieval history by Gabriel Monod, he was strongly influenced by Fustel, who predicted a great

career for him while Pfister was only in his first year at the Ecole normale (1881). Pfister's thesis marked a new departure. Never before had an arts-faculty thesis, submitted by a *normalien* and an *agrégé*, so clearly reflected the influence of the Ecole des chartes. Pfister's *Etudes sur le règne de Robert le Pieux, 996–1031* (1885, lxxxvi + 424 pages) set out the life of the king, the king's powers, and events at home and abroad. The strict chronological approach of this institutional and factual study meant a clear break with Fustel's own work. Although the jury, which included Fustel himself and Achille Luchaire, found fault with several details, it was more impressed by the work than the inspector, who thought Pfister's was a mediocre composition written in careless style and embellished with Alsatian idiosyncrasies.[102]

Pfister never became a great stylist, but he was always a hard worker. He wrote many books and articles on general subjects and worked on the *Histoire de France* under Lavisse, yet his main work bore on regional history, including a monumental history of Nancy that was certainly more than a narrowly conceived urban study.

Pfister was an exceptionally good lecturer. In Nancy his *cours* were packed with three to four hundred listeners, and his seminars were extremely instructive. He introduced a course on paleography and maintained a host of contacts with local societies. In Paris the notoriously stuck-up *normaliens* also appreciate the meticulously prepared lectures of this "lay Benedictine." His conscientious approach was praised by no one less than Marc Bloch in an exceptional *hommage*, though Bloch also suggested, at the risk of being accused of ingratitude, that Pfister's educational exertions, constrained by the uninspiring traditional forms, had an intellectually fossilizing effect and had been bought at the cost of Pfister's own research.[103]

The second medievalist was the Byzantinist Louis Bréhier (1868–1951), a lone and modest man who gained his reputation as a specialist in the shadow of Charles Diehl.[104] From 1890 to 1892 Bréhier was a scholarship student at the Paris faculty, and thereafter he was a schoolteacher for seven years. Upon gaining his doctorate with a dissertation entitled *Le Schisme oriental du XIe siècle* (1899, 312 pages), he was given a lectureship in Clermont-Ferrand, where from 1903 until his retirement in 1938 he was a professor of ancient and medieval history there. The inspectors praised Bréhier as a thorough and hard worker. "Not brilliant but possessed of all the other qualities," an inspector noted in 1910.

Bréhier's *oeuvre* was extensive and constituted a genuine contribution to Byzantine research. In addition to detailed studies, he contributed a three-volume synthetic work to Henri Berr's series *L'Evolution de l'humanité* and several general works on Christian and Byzantine art. He contributed many substantial literary surveys to the *Revue historique*. His work was also appreciated abroad. However, as a Byzantinist, Bréhier found himself too isolated in Clermont-Ferrand. What few students he had received methodical and excellent instruction, but he had no doctoral candidates. Many of the most essential reference books could not be found in the inadequate library of this small provincial university.

Like Bréhier, Arthur Kleinclausz (1869–1947) was a faculty scholarship student (1888–90).[105] After working for several years in secondary education, and before taking his doctorate, he became a lecturer in the history of Burgundy at the faculty of Dijon (1897). He took his doctorate in 1902 with a voluminous thesis on the Carolingian empire (1902, 611 pages), which was praised for its clarity and factual understanding, although the jury also found that he had failed to study certain topics thoroughly enough, that some of his formulations were too sweeping, and that he had left a number of questions unanswered.[106] All in all, however, the jury thought that his thesis qualified Kleinclausz for a professorship. In 1903 he was promoted from lecturer to professor of Burgundian history and Burgundian art. A year later he moved to the chair of medieval history and antiquities in the much larger faculty of Lyon. His classes for *agrégation* candidates were singled out for praise. In 1931 he was made a dean, and in 1939 he retired.

Kleinclausz's most important publications concerned the history of Burgundy, including the history of Burgundian art, and also the Carolingians. He wrote the Carolingian section of Lavisse's *Histoire de France*, a contribution that was less favorably received than his magnum opus, *Charlemagne* (1934, 420 pages), the fruit of many years of research.

Besides these three medievalists, our list of period specialists also included a *seizièmiste*, an expert on early modern European history. Jean-Hippolyte Mariéjol (1855–1934) was a scholarship student at the faculty of Aix-en-Provence, where he duly obtained his *licence*, but failed the entrance examination to the Ecole normale.[107] He was poor and had to support his mother and sister by teaching school. Nevertheless, by 1882 he had obtained his *agrégation*, and a year later he became a lecturer in Dijon.

In 1887 Mariéjol took his doctorate with a biographical study entitled *Un Lettré italien à la cour d'Espagne (1488–1526): Pierre Martyr d'Anghera, sa vie et ses oeuvres* (1887, 239 pages). The inspector was enthusiastic. The candidate had written a spirited account of a man known to only a few. He was obviously well-read, a "writer possessed of Attic wit," and one of the most remarkable candidates the inspector had come across for a long time, "a fine figure of a man," well-spoken and without any of that southern exuberance. The thesis, the inspector continued, had been written by a master, perhaps a little too soberly. He thought that Mariéjol was one of the best of the new generation of academics, men who probably had a more extensive and solid knowledge of things outside their speciality than the previous generation.[108] In 1891 Mariéjol was given a lectureship in Nancy, and in 1892 a professorship in Rennes. A year later, at his own request, he was appointed a lecturer at the much more important provincial faculty of Lyon, where he became a professor in 1896. He retired almost thirty years later, in 1925.

Mariéjol wrote a number of school textbooks and revised one of the volumes in the Hachette series edited by Duruy. He also wrote a history of Spain under Ferdinand and Isabella (1892, 359 pages), contributed two volumes to Lavisse's *Histoire de France* (covering the years 1559 to 1643), and published biographies

of Catherine de Medici and Marguerite de Valois. He was considered a great expert who could write well but lacked penetration. The young Seignobos had this to say in a letter to his friend Langlois soon after Mariéjol was awarded his doctorate: "Mariéjol is very naive . . . it is that type of man who makes the best narrative historian."[109]

The Horizon Expanders

Four of the exceptionally gifted sixteen professors in our 1910 procession were horizon expanders, men of wide-ranging knowledge who made substantial contributions to modern non-French history. Most had fixed their eyes on France's eastern neighbor at a time when the French intellectual climate was largely dominated by the "German crisis."[110] True, the history taught at the universities was not wholly dominated by a thirst for revenge, but in some respects it was indeed a "historiography of the vanquished." The losers were fascinated by the victors, and many had made it a point to attend a German university. The number of experts on German history in this group would have been larger still had Ernest Lavisse, whose views on German history were highly influential, been included. But Lavisse was a *patron* and will therefore be treated separately. In a sense some of our horizon expanders may be called regional specialists, although they were distinct from the specialists in French regional or local history.

Every one of our four horizon expanders had more than just one string to his bow. At the outbreak of the First World War Ernest Denis was probably the greatest French expert on central Europe. He is known not only for his work on German history but also for bringing the Czech people to the notice of France. Albert Waddington was not only an authority on early Prussian history but well versed in the history of the Dutch Republic and in seventeenth-century diplomatic history. Georges Pariset was *the* French specialist on eighteenth-century Prussia and also one of the greatest authorities on the period spanning the French Revolution, the Consulate, and the Empire. Finally, Emile Bourgeois was the author of *the* handbook on French diplomatic history and at the same time the director of a porcelain works in Sèvres.

Ernest Denis (1849–1920), the oldest of our four horizon expanders, was a militant man born in Nîmes to a Protestant family.[111] In 1867 he was admitted to the Ecole normale, and in 1870 he joined the army as a volunteer. In 1871 he became a teacher in Bastia, and in 1872 he obtained the *agrégation d'histoire* and applied for a travel scholarship to Prague. He supported his application by stressing that next to Moscow, Prague was the most important city of the Slavs, "that race so badly known among us, but which may well be called upon to play an important role." The history of Bohemia was a history of resistance to the Germans. Denis wanted to study Huss, whom previous historians had treated exclusively as a religious reformer and not as a champion of Czech nationhood.[112] Denis not only was awarded a scholarship (2,000 francs per annum) but had it extended for two more years, the authorities taking his point

that the Slavs of Bohemia were France's natural allies. The circumstances had been drastically changed by France's defeat, but Denis's association of historical studies with foreign policy was reminiscent of Geffroy's endeavors in Denmark in the 1860s. Denis's historical work had a political weight that kept increasing under the influence of twentieth-century developments.

After his return to France, Denis worked in secondary education for four years. The *ordre moral* still prevailed, and the inspectors were rather at a loss what to do with the passionately republican Denis. In Angoulême (1877) Denis told his class that the sanctity of Saint Louis "could nowadays do little but make one laugh," that Louis XVI had deserved his death sentence, and that Louis Blanc was a fine historian. His remark that the sale of church property at the time of the Revolution had been justified was the straw that broke the camel's back. Alarmed and incensed parents informed the bishop. Rumor had it that the Jesuits might be instructed to open a Catholic school in Angoulême. The headmaster of the *lycée* found that Denis and his naively expressed radical ideas posed a threat to the continued existence of his school and wanted to see Denis swiftly transferred to a faculty, where he could "pursue his career amidst the liberties and irresponsibility of higher education." Secondary public education was, in fact, much more vulnerable to outside pressure than higher public education. The inspector (1878) knew only too well that more cautious teachers were demanded in this moderate region. The *lycée* was prosperous and the Catholics had not (yet) managed to open a school of their own precisely because public education was "wise and temperate" and gave no offense to any religious faith. "Although the complaints against Denis are probably exaggerated," the inspector wrote, "we must ensure his speedy transfer to a faculty." As so often, the inspectors were being circumspect but did not cave in under "social pressure."

In 1878 Denis took his doctorate, and a year later he became a lecturer in Bordeaux. In 1881 he moved to Grenoble as a lecturer, and in 1882 he became a professor of foreign languages and literature there. In 1886 he became professor of history in Bordeaux. His *cursus honorum* continued: he went on to Paris, where from 1895 to 1901 he substituted for Alfred Rambaud (1842–1905), a professor of contemporary history (who was made a senator in 1895 before becoming minister of education in the Méline cabinet from 29 April 1896 to 28 June 1898). In 1901 Denis was appointed a *professeur adjoint* at the Sorbonne and in 1906 a full professor of modern and contemporary history. He died in 1921.

Together with Palacky, who received him in Prague, Denis was declared a "national" Czech historian, and as such he was showered with honors that rarely fall to a simple professor of history: he was immortalized on a monument, and a station in Prague was named after him.

The thesis with which Denis took his doctorate in 1878, *Huss et la guerre des Hussites* (1878, 506 pages), did not entirely please the tolerant Catholic dean, Henri Wallon, who said that Denis "has turned himself into a Czech, into a Hussite, a Taborite, and treats the Germans, the Catholic Church, and even the

moderate Hussites as only a sectarian would." For all that, the jury as a whole was full of praise. The thesis was described as a serious work based on original sources, scrupulous when dealing with church politics, well composed, and sprinkled with lively stories and well-drawn portraits.[113]

Denis was at home in republican circles and on familiar terms with Albert Dumont, director of higher education, as we know from a candid letter in which Denis asked for a transfer to Grenoble, a city with a less developed system of higher education but where he could quickly become a professor. Moreover, Grenoble was "republican enough not to make one who has always been a bit of a heretic fear that he is shocking people." Back in Bordeaux, but now as a professor of history, Denis also became a member of the town council. He shored up his renown as a leading "national" historian of the Czechs with two books: *Fin de l'indépendance bohême* (2 vols., 1890, 996 pages), and *La Bohême depuis la Montagne Blanche* (2 vols., 1903, 1319 pages). In addition, he wrote two volumes on the history of Germany in the late eighteenth century and the first half of the nineteenth (1896–98, 346 and 312 pages), followed by a third volume on the consolidation of the German empire (1852–71) (1906, 528 pages). These writings were less original than his books on Bohemia but were nevertheless praised as the best general writings on German unification published by a Frenchman.

Denis's work was rooted in the present and revolved about persons and events. He was not ashamed of that. "It is perfectly obvious that our retrospective deductions are arbitrary . . . the past only exists in its relationship to us. . . . A man of genius does not exist save for his admirers, a victory loses its importance the day its effects are no longer felt."[114] Denis was out to record the *histoire événementielle* of great men and battles. In the opinion of many, his was an old-fashioned approach, but it undoubtedly filled a need for those in search of a Czech national identity, and it had considerable political and diplomatic weight. Denis was received by Masaryk after the First World War, after which he was treated with incredible respect. His *histoire événementielle* had an obvious social function.

Albert Waddington (1861–1926), son of a professor at the Protestant seminary in Strasbourg (and later in Paris), was a scholarship student of the faculty of Paris.[115] He went on to study in Germany for two years (1884–86) and on his return was immediately offered a post at the faculty of Lyon. Two years later, in 1888, he took his doctorate; in 1896 he became a professor at Lyon, a post he held for thirty years, until his death in 1926. His thesis, *L'Acquisition de la couronne royale de Prusse par les Hohenzollern* (1888, 453 pages), was written along Lavissian lines and immediately made him the greatest French expert on early Prussian history. Waddington had been hard at work in the archives, and his book combined accuracy with fine composition and style—a combination rarely found in German writers, as the inspector stressed.[116] The work was a highly objective account of the purposeful policy pursued by the Elector Frederic III in his efforts to gain the crown at the end of the seventeenth and the beginning of the eighteenth centuries. Waddington, we are told, fully deserved

his post at what, after the loss of Strasbourg, was France's leading provincial university.

Waddington's most important publications dealt with seventeenth-century Prussian and Dutch history. His *La République des Provinces-Unies: La France et les Pays-Bas espagnols de 1630 à 1659* (2 vols., 1895–97, 887 pages) was based largely on his study of archives in The Hague, Paris, and Brussels. He also started on a major history of Prussia, publishing a preliminary study of the subject under the title *Le Grand Electeur Frédéric Guillaume de Brandenbourg, sa politique extérieure, 1640–1688* (2 vols., 1905–8, 1,128 pages). In 1911 he brought out the first volume of his history of Prussia, from its origins to the death of the Great Elector, and in 1922 he brought out the second volume. He died before the other three volumes he had planned could be published.

In the 1890s the inspector voiced his misgivings at Waddington's having put his academic work before his teaching duties. In addition, as the envious petit-bourgeois rector remarked tartly, thanks to a rich marriage Waddington was in with Lyon society and kept company with aristocratic bankers and financiers.

Waddington's work was greatly appreciated abroad, especially by German scholars. Such appreciation fell to few Frenchmen venturing into the field of German history. Waddington was one of the very few French historians whose academic contribution was left unscathed by the First World War. Yet Waddington had lost two sons at the front and himself had an excellent service record as a volunteer interpreter and translator attached to the staff of the Tenth Cavalry Division "in direct contact with the enemy." "But," as he explained in the introduction to the second volume of his history of Prussia (1922), "I have stifled my inner resentment as a Frenchman and father in order to let nothing be heard but the voice of the impartial historian."[117]

Georges Pariset (1865–1927), of Alsatian origin, was, like Albert Waddington, no *normalien*.[118] He received a grant from the faculty to prepare for his *agrégation* and in 1888 shared first place with the *normalien* and pioneer Henri Hauser (see below). Next he received a travel grant that took him to Germany for three years, during which time he wrote highly praised articles on Germany in the prestigious *Le Temps*. On his return to France he taught school for a month before being appointed a lecturer at the faculty of Nancy (1891). Pariset took his doctorate in 1897 and became a professor in 1901. When war was declared, he stayed at his post until the French authorities closed the university in 1917 and he had to make for Paris. After the armistice he was asked to join the new French university at Strasbourg, where he served as a professor from 1919 until his death in 1927. In 1923 he was approached about becoming Aulard's successor in the chair of the history of the French Revolution, but Pariset was one of the rare historians who did not succumb to the siren call of Paris.

Pariset excelled in two fields: German history and the history of the Revolution. In his thesis Pariset, like Waddington, following in the footsteps of Ernest Lavisse, covered a brief phase in the history of Prussia. A substantial thesis running to nearly a thousand pages, it dealt with the position of state and

church under the soldier king Frederic William, that is, during the first half of the eighteenth century: *L'Etat et les églises en Prusse sous Frédéric-Guillaume Ier, 1713–1740* (1897, 990 pages). The jury thought the book unnecessarily long but added that although its author could have been briefer, he had certainly treated the subject exhaustively.[119] Not only had he introduced "all the legislative and administrative documents" but he had included biographical data and had made a thorough study of the intellectual climate, popular beliefs, and theological ideas. And because the church was closely linked to the state, the reader also learned about the Prussian monarchy prior to the reign of Frederick the Great. As the jury put it appreciatively, "Pariset goes on searching where many would have stopped." True, there was some criticism of the introduction and of the conclusion, in which Pariset delivered himself of obscure predictions about the future based on clichés and scholastic arguments. On the whole, the inspector was rather less enthusiastic than the jury. Not only did he consider the thesis too long but he accused Pariset of having "a Germanic turn of mind, a completely Germanic approach, even a tendency to show that while France is superior politically . . . Germany is superior in intellectual respects." The inspector noted with satisfaction that Lavisse's objections to this approach during a *soutenance* lasting many hours was warmly applauded from the public gallery. Even so, the Germanophobic inspector ungrudgingly acknowledged Pariset's distinction and thought it self-evident that Pariset would shortly be offered a professorship.

Even Pariset's Latin thesis (on a medieval subject) was a serious and learned affair. It was called a "véritable phénomène," not least because most candidates made light of their Latin theses. It was almost incredible, as the inspector put it, that the hypercritical Langlois could find no fault with it. Clearly, history did not always have to be a matter for interminable discussions.

Next to German history, Pariset's *oeuvre* was devoted to the Revolution. He had already published several studies and contributed surveys to the *Cambridge Modern History* when Lavisse asked him to cover the period 1792–1815 for his *Histoire de France contemporaine*. For seven years, from 1907 to 1914, Pariset wrote hardly anything else. At the start of the war the long manuscript of this solid and conscientious worker was not yet finished, whereas the parts on the Restoration and the July Monarchy (contributed by A. M. Charléty) were ready to go to press. Pariset finished his manuscript after the war, but it was thought to be much too long. Lucien Herr, the enigmatic librarian of the Ecole normale, and a member of Lavisse's editorial board, made sizable cuts in Pariset's two volumes, which came out in 1920 and 1921 under the titles *La Révolution, 1792–1799* (429 pages) and *Le Consulat et l'Empire, 1799–1815* (444 pages). They are still considered to be valuable syntheses. The author was, however, reproached with having an excessive political bias. Thus, the better to stress the originality of Albert Mathiez's *La Vie chère et le mouvement social sous la Terreur* (1927, containing articles published since 1915), Georges Lefebvre, the great expert on the history of the Revolution, pointed out that Pariset, for his part, had had little to say about money and food supplies and that although he had

mentioned the setting of a ceiling on prices, he had added little more about the economic policy of the Comité de salut public. Of course Lefebvre knew perfectly well that Pariset had referred to these topics in his original manuscript, but "was it not typical that Pariset should have omitted just these passages when he had to abridge his work?"[120] This argument was unfair. The bias of Lavisse's series was not due to Pariset, and the abridgments had been ordered by Lucien Herr (admittedly, with the author's knowledge). From the items not included in the *Histoire de France contemporaine* but published later we can tell that Pariset certainly had not ignored the economic history of the Revolution and that he had indeed, as was his custom, supplied a fully documented and concisely formulated account of it.[121]

Emile Bourgeois (1857–1934) is one of the few native Parisians in our procession.[122] After attending the Ecole normale in 1877–80, he worked as a schoolteacher for a very short spell and then spent some time in Germany before accepting a lectureship at the Caen arts faculty. While still one of Monod's students he wrote the thesis with which he took his doctorate in 1885, *Le Capitulaire de Kiersy-sur-Oise, 877: Etude sur l'état et le régime politique de la société carolingienne à la fin du IXe siècle, d'après la législation de Charles le Chauve* (1885, 315 pages). The thesis was well received, but by then Bourgeois had decided to abandon medieval studies in favor of diplomatic history. Two years later, having been appointed a lecturer at Lyon, he published a well-researched study of early-eighteenth-century Prussian foreign policy, in particular Prussian attempts to acquire a power base between the Rhine and the Rhone, entitled *Neuchâtel et la politique prussienne en Franche-Comté de 1702 à 1713* (1887, 261 pages), in which he used unpublished documents he had unearthed in archives in Berlin, Paris, and Neuchâtel to disclose a sinister Prussian plot to conquer Franche-Comté, with the ultimate aim of dismembering France. Bourgeois was older than Waddington and Pariset and also less familiar with the internal history of Prussia; his work was done under the stark impact of French suffering and German aggression. That same year (1877) Bourgeois became a professor at Lyon. In 1893 he was called to the Ecole normale, and in 1904, after the Ecole normale was fused with the Paris arts faculty, he was appointed a professor of modern political and diplomatic history. Since 1897, as Albert Sorel's successor, he had also been associated with the Ecole des sciences politiques. Bourgeois was a *cumulard*, a holder of more than one paid job: besides being a professor, he was also a director of a porcelain works in Sèvres, a town in which he had previously done research in the archives and had prepared a catalogue. In 1921 Bourgeois succeeded Ernest Denis as professor of modern and contemporary history. He retired in 1932 and died two years later.

Bourgeois's name is inseparably bound up with his widely used *Manuel historique de politique étrangère*, the first volume of which, covering the years 1610–1789, was published in 1892 (10th ed., 1928, 604 pages), followed by the second volume, covering the years 1789–1830, in 1879 (10th ed., 1929, 806 pages), and the third volume, covering the years 1830–78, in 1905 (9th ed., 1931, 836 pages). It was *the* handbook for budding diplomats and other pupils

of the Ecole des sciences politiques. Several generations of students, their horizons largely confined to the French hexagon, made their first acquaintance with the outside world through the informative *Manuel*. It was a useful and far from bookish compilation, a compact diplomatic history but one lacking in breadth, a history without *forces profondes*, filled with accounts of persons, treaties, missions, events, and diplomatic dispatches. It is little wonder, then, that Lucien Febvre, who as a *normalien* (who received his doctorate in 1898) was taught by Bourgeois, said later that the *Manuel* had robbed history of all its attraction for him.[123] The book lacked inspiration and enthusiasm. It was a "pragmatic" historiography centered on the deliberate actions of emperors, kings, and diplomats. Febvre was right to complain about its exceedingly narrow conception of foreign relations and its failure to grasp the importance of historical change. For the rest, the *Manuel* unmistakably filled a need and was, perhaps partly as a result of its "unhistorically" pragmatic approach, a most successful textbook. In 1925 Bourgeois added a fourth volume: *La Politique mondiale (1878–1919)* (836 pages).

Encouraged by the response to his *Manuel* and well-liked in moderate republican circles, Bourgeois decided to stand for the Senate. Unfortunately for him, familiarity with diplomatic matters did not prove to be a passport to political success. But no matter what criticism one may level at Bourgeois's work, it has to be granted that he contributed his mite to the study of foreign affairs and hence helped to stretch the horizon of many a student and of a sizable section of the general public.

The Pioneers

Of our six pioneers one was a Byzantinist, one was a historian of ideas, and four were socio-economic historians. All six left an impressive *oeuvre*.

Charles Diehl (1859–1944) was the founder of French academic *byzantinologie*.[124] After attending the Ecole normale he came first in the *agrégation* competition of 1881 and then spent several years continuing his studies at the French schools in Rome and Athens. In 1888 he defended his thesis on Byzantine institutions, still virgin ground in France at the time. Entitled *Etudes sur l'administration byzantine dans l'exarchat de Ravenne* (1888, 412 pages), it proved to be a milestone in French historiography, even though the versatile Alfred Rambaud (1842–1905) had preceded him in 1870 with a thesis on the Greek empire during the tenth century. As mentioned above, Louis Bréhier was not to take his doctorate until 1899. Diehl, who had published important papers even before his thesis, did not have to do his stint in secondary education but was offered a lectureship in Nancy in 1888. In the 1890s he joined archeological digs in North Africa (1892–93), as a result of which he published, *inter alia*, *L'Afrique byzantine: Histoire de la domination byzantine en Afrique (533–709)* (1896, 644 pages). In 1899 Diehl was called to Paris, where a lectureship in Byzantine history was created specially for him, something quite unprecedented at French universities. Diehl was a prolific writer, and his books were excel-

MINISTÈRE DE L'INSTRUCTION PUBLIQUE.

ACADÉMIE d

ENSEIGNEMENT SUPÉRIEUR.

RENSEIGNEMENTS CONFIDENTIELS.

Nom et prénoms du fonctionnaire. *Diehl, Charles*

Fonctions. *professeur d'Histoire*

Caractère, conduite et habitudes sociales. Rapports avec ses chefs, les autorités et le public. *Homme du monde, aimable et ponctuel.*

Sagacité et jugement. Fermeté. *très bien*

Exactitude et zèle. *très bien*

Élocution. *Précise, élégante, très soignée.*

Son enseignement a-t-il la gravité et la profondeur indispensables aux cours de Faculté? *Oui.*

Indiquer l'objet de cet enseignement pour la présente année. *Les antiquités de l'Algérie.*

Nombre et heures des conférences ou manipulations par semaine. *trois.*

Nombre des élèves inscrits aux conférences ou manipulations. *dix*

Composition de l'auditoire de la leçon publique. *Étudiants, gens du monde, membres de sociétés savantes, professeurs*

Convient-il ou conviendrai-il aux fonctions administratives? *Oui.*

Se livre-t-il à des travaux étrangers à ses fonctions? *non.*

Travaux et publications pendant la présente année.

A-t-il droit à l'avancement? *Vient d'être nommé t. Valaire.*

VOIR AU VERSO.

4. Inspector's report on Charles Diehl (recto)

OBSERVATIONS GÉNÉRALES.

Nota. Sous ce titre d'Observations générales, développer, expliquer tout ce que la précision des réponses de l'autre part n'a pas permis d'exposer avec les distinctions et les nuances nécessaires.

Professeur distingué, très consciencieux, apprécié du public : met beaucoup de soin et) exactitude et de correction à tout ce qu'il fait.

Le Recteur

5. Inspector's report on Charles Diehl (verso)

lently documented and distinguished in style. His publications included a splendid work on Justinian and Byzantine civilization in the sixth century (1901, 695 pages). In 1907 Diehl was made a full professor of Byzantine history, a post he held with distinction until he retired in 1934.

His many fine publications earned him various honorary doctorates abroad, where he was considered one of the showpieces of French scholarship. Before Diehl's arrival France had barely counted in Byzantine studies, a field dominated by German scholars.

Of the four socio-economic pioneers, Marcel Marion (1857–1940) was the oldest.[125] After studying at the the Ecole normale (1877–80) he worked for more than ten years in secondary education. In 1892 he took his doctorate and then became a lecturer in the arts faculty of Toulouse. The opinion expressed by Fustel de Coulanges, director of the Ecole normale, was largely borne out by Marion's subsequent career: "a very keen nose for historical research, a critical and methodical mind, one who knows the importance of detail." Marion, he went on to say, was sure to make an excellent researcher and also a good teacher even though "he was a little timid and uncertain." In the event, Marion seemed unable to keep discipline in his class, and his appointment to a post in higher education came as a genuine relief. Marion's thesis was an original and searching study of the eighteenth-century financial administration of France: *Machault d'Arnouville: Etude sur l'histoire du contrôle général des finances de 1749 à 1754* (1891, 463 pages). Several members of the jury questioned Marion's inter-

pretation, but in the end the jury was full of praise. The inspector thought the book was too long. He pitied the hapless band of historians if the study of a single ministry could confront them with so voluminous a work. But there was absolutely no doubt that the candidate—"of almost comically ugly appearance, but with a look of great candor, calm, and earnestness"—would become a professor to be reckoned with.[126] In 1896 Marion went to Bordeaux, where he succeeded Ernest Denis as professor in 1904.

Marion wrote important studies about the famine of 1747–48 in Guyenne and on the taxation system in the eighteenth century, again mainly in Guyenne (1901, 247 pages). His *La Vente des biens nationaux, avec étude spéciale des ventes dans le département de la Gironde et du Cher* (1908, 448 pages) was a milestone in the historical study of the French Revolution. With it Marion put a stop to a great many futile polemics and pointed the way to fruitful research. Only regional studies, he insisted, could provide decisive answers to the delicate question of the sale of nationalized effects. Marion himself took regional soundings, without, however, providing a statistical survey of the types of property sold; he was mainly interested in the financial aspects of the matter. At about the same time the Russian scholar Loutchisky, who, partly in connection with the agrarian problems in his own country, dealt with the sale of nationalized property as a question of large-scale versus small-scale land ownership and tried to arrive at quantitative results.[127]

Marion was highly regarded as both a meticulous scholar and one of the best-informed historians of the Revolution, but one inspector's report was very negative: "Marion is cut out to become an archivist; he proffers an interminable bibliography, unnecessary details, and little interpretation." The inspector regretted his having had to pass this judgment on so diligent a man, who had rendered such useful service. That negative opinion was, however, exceptional and probably inspired by political motives. Marion was anything but a progressive republican, and the inspector's critical voice undoubtedly played a part in the deliberations at the faculty meeting called in Paris in 1907 to appoint a substitute for Espinas (a professor of the history of social economics). The historians present expressed the view, through Ernest Denis, that the vacancy was of a *philosophical* kind and therefore no historian could be considered for the post. Bouglé, the candidate proposed by Durkheim, was offered the job with a sizable majority. Marion received even fewer votes than Henri Hauser, the candidate proposed by Espinas himself.[128]

Even so, Marion succeeded in getting to Paris, where he was anxious to work partly for personal reasons.[129] In 1912 he was appointed to the Collège de France as successor to Emile Levasseur, who had occupied the chair in the history of economic doctrines for forty years. This time Marion's liberal-conservative views did anything but impede his candidature, which enjoyed the support of Camille Jullian, his former colleague from Bordeaux. The most serious competitor was the "pink" François Simiand, proposed by Georges Renard, professor of the history of labor, a chair established in 1907 by the Paris city

council. After three rounds of voting Marion finally defeated the strong but small Simiand clan.[130]

In Paris Marion began his monumental *Histoire financière de la France depuis 1715*; the first volume, covering the years1715–85, appeared in 1914, and the sixth and final volume, covering 1875–1914, appeared in 1931. At the same time Marion was also working on his widely used *Dictionnaire des institutions de France aux XVIIe et XVIIIe siècles* (1923, 564 pages).

Many flaws have been found in Marion's pioneering contribution. Among other things, his great history of state finances revealed him to be a staunch liberal dismayed at the gigantic budget increases introduced especially at the end of the nineteenth century and the beginning of the twentieth while failing to take the rises in national income into account. Ernest Labrousse, who worked with Léon Blum at the time of the Popular Front and who, like so many other socialists, was not terribly worried about national deficits and favored greater state participation in the economic life of the nation, pointed to Marion's liberal blinkers in an obituary in the *Revue historique*. His pioneering socio-economic studies, Labrousse contended, stamped Marion as an institutional historian first and foremost, much more interested in the legal structure and workings of institutions than in the underlying and decisive economic factors: "Marion is a lawyer rather than an economist."[131] This authoritative critique applied to much of the socio-economic historiography produced at the time. For all that, these institutional studies constituted an extremely useful, indeed indispensable springboard for a closer theoretical study of economic life in the past. Marion's legal-institutional approach was concrete, factual, and based on research into the sources. It represented an unmistakable advance over the abstract and doctrinaire treatment of history by most nineteenth-century French economists.

Philippe Sagnac (1868–1954), Marion's junior by eleven years, was also a *normalien* (1891–94).[132] The son of a lawyer, he first studied law but gave that up, partly for health reasons. After his *agrégation* the Paris arts faculty provided him with a two-year scholarship to prepare for his doctorate. In 1898 he took the latter with a Latin and a French thesis, both of which were original and important contributions to the social history of the Revolution. His Latin thesis dealt with the seigniorial reaction under Louis XVI and was for some time the only work on the growth of seigniorial rights in the prerevolutionary period. The French thesis, *La Législation civile de la Révolution française, 1789–1804* (1898, 446 pages) bore the subtitle *Essai d'histoire sociale*. Sagnac set out to explain the reasons for the legislation introduced by the Revolution, particularly in respect of the old and new conditions of landownership. He examined this legislation in the light of the history of the "rural classes" at the time of the Revolution. It was a new and difficult subject. Not surprisingly, therefore, Sagnac did not write the definitive work on it; all the same, he had picked a very promising subject, discovered a host of documents, and displayed sound critical judgment. True, his general theories were open to question and sometimes even contradictory, but his work would henceforth be obligatory reading for anyone

interested in the social history of the Revolution—as the jury concluded after listening to Sagnac's brilliant *soutenance*.[133] Sagnac, who did not seek a career in secondary education for health reasons, fully merited his posts in higher education. In 1899 he became a lecturer at Lille and in 1905 a professor.

Sagnac had a very methodical mind, a great talent for organization, and a liking for systematic catalogues. With Pierre Caron he founded the Société d'histoire moderne, which began to publish the *Revue d'histoire moderne et contemporaine* in 1899. He wrote (again in collaboration with Caron) a survey of the results and shortcomings of modern historical studies and played an important role in the Commission chargée de rechercher et de publier les documents d'archives relatifs à la vie économique de la Révolution, founded by Jaurès. He also contributed several chapters on the eighteenth century to volumes 8 and 9 of Lavisse's *Histoire de France* and wrote the first part (on the early years of the Revolution, i.e., until 20 September 1792) of Lavisse's *Histoire de France contemporaine*, published in 1920 (but written earlier) and still considered a standard work. During the interwar years Sagnac turned into a Parisian *patron*. In 1923 he succeeded Aulard in the chair for the history of the French Revolution and in numerous other functions as well. In 1932 he founded the center for the study of the French Revolution at the Sorbonne. In the mid-1920s he and the medievalist Louis Halphen presided over the publication of a major general series, *Peuples et civilizations*, the less French-oriented and more Europe-centered successor to Lavisse and Rambaud's *Histoire générale*.

In 1910 Aulard was still the unchallenged *patron* of all university studies of the Revolution. Sagnac was as yet no more than the pupil who, with the agreement of the aging Aulard, led the investigation onto new paths. Before the publication of Jaurès's *Histoire socialiste*, before the various publications of the Committee for the publication of sources relating to economic life in the Revolution, and before Albert Mathiez, who, following in the footsteps of Aulard, was primarily interested in the political and religious history of the Revolution, Sagnac had done pioneering work on the socio-economic and agrarian history of the Revolution. Georges Lefebvre, author of a sensational thesis (1924) on the peasants of northern France at the time of the Revolution and, in 1937, Sagnac's undisputed successor to Aulard's chair, was ungrudging in his opinion of Sagnac, having discovered in Sagnac's *oeuvre* the first signs of "current preoccupations that, we must hope, will renew our conception of history." True, Sagnac did not break with the old approach, and still told a "story," but that story was no longer a recital of events, and his explanations were no longer exclusively based on politics, on the war, and on the psychology of the leading protagonists, as had been the custom in Sagnac's youth. Other factors were involved as well, including economic ones. Nor did Sagnac turn his back on Labrousse's statistical method. Moreover, "attached as he was to bourgeois liberalism, Sagnac admittedly did not subscribe to a wholly Marxist interpretation of the Revolution, and yet one of the chapters he contributed to Lavisse's *Histoire de France* was entitled 'the class struggle.'"[134]

Compared with the contribution of Albert Mathiez, who enjoys a much

greater reputation in the historiography of the Revolution, Sagnac's work was less obviously marked by traditional political ideas. Mathiez was hypnotized by the reputations, justified or not, of such great men as Robespierre and Danton. As a result, Mathiez must be considered outdated, while Sagnac, with his studies of such subjects as the distribution of landed property, seigniorial rights, the sale of nationalized property, and agriculture in the eighteenth century, can be said to have pointed the way to modern historical studies of the Revolution.

The pioneering work of the next two professors, Henri Sée and Henri Hauser, bore mainly on the agrarian and economic history of the early modern period. They also wrote numerous books on completely different subjects and periods. Both had the great merit of interesting younger historians in economic historiography. Their work and influence have, however, been somewhat overshadowed by the memorable concentration of French historiography around Lucien Febvre, Marc Bloch, Ernest Labrousse, and Fernand Braudel.

Henri Sée (1864–1936) lacked Hauser's brilliance but was at least as indefatigable.[135] His large *oeuvre* comprised various less weighty publications, but his studies of the agrarian history of Brittany were innovative and his two-volume economic history of France was for a long time the only handbook on the subject. Sée was not a *normalien* but a scholar of the Paris arts faculty (1885–87) who, after working in secondary education for a year, was granted a two-year scholarship (1888–90) to prepare his doctoral thesis. He went back to teaching for another few years, took his doctorate in 1892, and became a lecture in Rennes a year later.

Sée's thesis, *Louis XI et les villes* (1891, 426 pages) earned him a devastating comment from the inspector: "His ground has still to be covered."[136] The inspector conceded that the thesis contained useful data but regretted that it had been written much too soon. "Apart from a few quotations from Commines and Michelet, it does not even include a portrait of Louis XI." According to the inspector, Sée's thesis highlighted the gulf between the education of faculty scholars and that of *normaliens*. Even so, the inspector recognized Sée's diligence and oral skills, adding that Sée might do well in higher education one day. The jury, though much more positive, also criticized the thesis for its poor composition, monotony, repetitions, and excessive subdivisions. Once appointed at Rennes, Sée quickly published a regional political study as a sequel to his dissertation, *Les Etats de Bretagne au XVIe siècle* (1895), and two regional studies in medieval agrarian history, *Etudes sur les classes serviles en Champagne du XIe au XIVe siècle* (1895) and *Etudes sur les classes rurales en Bretagne au Moyen Age* (1896). By 1901 he had produced a voluminous national synthesis, *Les Classes rurales et le régime domanial en France au Moyen Age* (638 pages), which left a great deal to be desired but proved useful as a provisional summary. In 1897 Sée was offered a chair, which he kept until his early retirement in 1919 at the age of fifty-five for health reasons; his bad health did not, however, stop him from publishing a great deal for another seventeen years, until his death in 1936.

Agrarian history remained the most original part of Sée's contribution. His attention gradually shifted to modern history. He wrote a very substantial monograph, *Les Classes rurales en Bretagne du XVe siècle à la Révolution* (1906, 544 pages); collaborated with André Lesort, the departmental archivist, on a four-volume *Cahiers de doléances de la sénéchaussée de Rennes* (1909–13); and edited a critical edition of Arthur Young's famous travelogues. Sée also received critical acclaim for his various synthetic works on economic history, of which the most useful and most impressive was the *Französische Wirtschaftsgeschichte* (2 vols., 1930), which was first published in German and did not appear in French until after his death. Less successful were Sée's contributions to the history of political ideas in the seventeenth and eighteenth centuries (1923 and 1925), most of them articles written before the First World War. Sée was also one of the very few French historians who dared to tackle the philosophy of history, but his articles, however meritorious in filling the void in French studies in the philosophy of history before Raymond Aron's *Essai sur la théorie de l'histoire dans l'Allemagne contemporaine* (1938, 321 pages) and *Introduction à la philosophie de l'histoire* (1938, 353 pages), were referential and not very profound.

The inspectors' reports were full of praise for Sée's lectures, which they said were "in the line of Fustel's, precise and devoid of small talk" (1897) and attracted a considerable student following. Sée was most influential in the field of agrarian history. His writings were highly descriptive and grounded in critical studies of archive material. His weakest point was a tendency to make generalizations based on very special cases.[137] Sée did not use statistics, though figures would have been particularly helpful in his attempts to arrive at generalizations, especially in agrarian history. The great upsurge of regional agrarian research in France following Marc Bloch's innovative *Les Caractères originaux de l'histoire rurale française* (1931) has caused Sée's pioneering work to fall into desuetude.

Henri Hauser (1866–1946) was a versatile and remarkably expeditious historian.[138] A brilliant *normalien*, the inspiration behind an anti-Boulangist manifesto for which he was attacked by the right-wing press, a student who shared first place with Pariset in the *agrégation* competition, a man who married young and immediately afterwards became a provincial teacher, Hauser took his doctorate when he was twenty-six with a biography of François de la Noue, the sixteenth-century French Huguenot leader (1892, 336 pages). The thesis was not greeted with acclaim. Hauser had made quite a few mistakes, had dug up too much unpublished material, and had not consulted the literature as much as he should have done. Because of his literary inclinations, he considered it bad taste to be too emphatic, preferring to drop hints instead. His book was very readable, however; it was based on interesting unpublished documents and reflected a keen insight into psychological problems. The inspector thought Hauser much too young. He would have done better to brush up his general knowledge by continuing as a schoolteacher for another few years. "This Algerian Jew" (Hauser had been born in Oran, where his parents had moved for health reasons, but had been brought up in Paris) was talented enough but had failed to

ask the right questions, the rattled inspector alleged. Surprisingly, he added that Hauser ought to be offered a post in higher education, and fairly soon at that, because then he would have more time to study. Hauser's thesis was the model of a very lively but far from impeccable piece of writing. It was quite unlike Pariset's well-considered and lengthy thesis, but then Pariset had taken five years longer to produce it, had been able to devote himself totally to research for three years, and had never had to take a teaching post.[139]

In 1893, shortly after taking his doctorate, Hauser was appointed lecturer in Clermont-Ferrand, and a few years later, in 1897, he was made a professor there. Meanwhile he published several articles in which he raised original and stimulating questions about the socio-economic reasons for the success of the Reformation and about the conditions and organization of industrial workers in the fifteenth and sixteenth centuries. Hauser was also the first French historian to use the word *capitalism* in the title of a book and the first to treat it as an operational concept (in a 1901 lecture). Many of these studies, which had a fairly fragmentary character, were later reprinted in such collections as *Ouvriers du temps passé* (1899), *Etudes sur la Réforme* (1909), and *Travailleurs et marchands dans l'ancienne France* (1920).

Hauser, who was not afraid to speak his mind, ran into trouble in Clermont-Ferrand.[140] The Dreyfus affair set off a powder keg. The Clermont *jeunesse dorée* disrupted his lectures following the provocative claim of a clerical paper that Hauser's lectures were so many Dreyfusard demonstrations. Inflammatory articles also alleged that Hauser intended to lecture on the "blessings of the guillotine," and a local left-wing newspaper published a scathing report on the cancellation of Hauser's evening lectures "to avoid clashes," pointing out that the lecture hall could easily have been "sanitized" by the proven means of admission tickets. The cause of the disturbances, which were not very important as such but did reflect the general atmosphere, was the disclosure that Hauser had signed petitions asking for a revision of the Dreyfus case. The press blew the matter up, and right-wing colleagues simply loved to fish in these troubled waters. In any case, Hauser was prevented from continuing his lectures, and several months later, in June 1899, he observed that although the situation had apparently calmed down, no one had really forgiven or forgotten anything. "Outside the small circle of three or four students, there is little I can do, and I am therefore unable to render the university the services I had thought I could." In 1901, having been on the nonactive list for close on two years, he became a lecturer in Dijon at his own request, and just over a year later, in January 1903, he was made a professor there.

In addition to further studies of the organization of labor under the ancien régime, including *Les Compagnonnages d'arts et métiers à Dijon aux XVIIe et XVIIIe siècles* (1907, 520 pages), Hauser gave evidence of his versatility with an extremely informative survey of social-science education, accompanied by several methodological recommendations (*L'Enseignement des sciences sociales* 1903, 467 pages). He also produced an impressive edition of narrative sources relating to sixteenth-century French history, the *Sources de l'histoire de France, XVIe siècle*

(1494–1610) (4 vols., 1906–15). Hauser was exceptionally knowledgeable about a wide range of subjects. He attached great importance to source criticism but considered knowledge of other disciplines, including geography in particular, indispensable to the historian. He was second to none when it came to digging up sixteenth-century archival documents and manuscripts, but he was also glad to dip into other sources. Apart from his work as a *seizièmiste*, Hauser had, even before the First World War, written various books on such contemporary economic subjects as German colonization (1900, 141 pages) and American imperialism (1905, 128 pages). During the war, while working for Clémentel, minister of trade in the Clemenceau government, he concentrated all his attention on current problems, and even after the war, when he returned to his beloved sixteenth century, he continued to write on current, ultracontemporary history.

In 1919 Hauser a became lecturer in economic history at the Sorbonne, in 1921 a *professeur sans chaire*, and in 1927, at the age of sixty-one, he was offered the first chair in economic history at a French university. Hauser was by now a leading light among French and international historians. He became the wise old man on many a journal's editorial board and of several international organisations. In particular, he was generous enough to join the editorial board of the still rather shaky *Annales d'histoire économique et sociale*. He was a convinced internationalist, spoke several languages, and played an important role on the stimulating international committee for research into the history of banking and price fluctuations. Hauser's sober introduction to the *Recherches et documents sur l'histoire des prix en France, 1500–1800* (1936) still makes useful reading, along with the somewhat speculative studies of François Simiand and the scrupulous work of Ernest Labrousse. Hauser retired in 1936 and found a worthy successor in Marc Bloch.

Hauser showed the full measure of his historical ability in his syntheses for the series *Peuples et civilisations*. With Augustin Renaudet he wrote *Les Débuts de l'âge moderne* (1929, 654 pages), and unassisted he added the sequel, *La Prépondérance espagnole, 1599–1660* (1933, 594 pages). One may well balk at the Eurocentrism of the series and at the old habit, as Hauser himself put it, "of marking (time intervals) with *prépondérances* that wane away and others that wax," but *La Prépondérance espagnole* was rightly considered a masterly and original synthesis. Wide-ranging, concisely constructed, extremely informative, grippingly written, and incorporating many fresh viewpoints, the book was deemed worthy of another reprint in 1973, forty years after the first edition, this time accompanied with a eulogy by Pierre Chaunu, one of the leading figures of the Nouvelle Histoire.[141] The pioneer of economic history had developed into an all-round historian.

The sixth and last of our pioneers was a historian of ideas. Georges Weill (1865–1944), the son of an Alsatian chief rabbi and a *normalien* (1883–86), took his doctorate, like Hauser, at an early age, though he had had to go into teaching immediately after his *agrégation* (1886), first in Orléans and later in Dijon.[142] Weill's thesis, *Les Théories sur le pouvoir en France pendant les guerres de*

religion (1892, 318 pages), dealt with sixteenth-century political ideas. The jury expressed some reservations about the bibliographical shortcomings, but Weill's defense of his thesis was brilliant. The inspector thought that Weill was still too young yet conceded that he was suited to a future career in higher education. The inspector realized that it would have been impossible for a Jew, "a marked Semitic type," even one as talented as Weill, to obtain a chair in the Second Empire.[143] In 1894 Weill was given a teaching post at a Paris *lycée*, and until 1906 he went on teaching at various schools in Paris. During these twenty years as a schoolteacher he published, in addition to his dissertation, numerous books and articles, most of which were devoted to the history of nineteenth-century ideas. In addition to studies on Saint-Simon (1894, 253 pages) and Saint-Simonism (1896, 319 pages), he wrote a lengthy *Histoire du parti républicain en France de 1814 à 1870* (1900, 553 pages) and a *Histoire du mouvement social en France, 1852–1902* (1904, 494 pages), both of which served for a long time as standard works in a previously unexplored field. He also had numerous other works to his credit. When a faculty lectureship fell vacant in Caen in 1906, the inspector recommended Weill in preference to two other candidates, including Albert Mathiez, who was then a teacher in Caen. To justify his choice, he pointed out that although Weill's thesis had been indifferent, he had published a great deal since. Weill was a teacher of remarkable erudition: "Monsieur Weill is worth a whole library." Weill was thus given a lectureship at long last, became a professor in 1910, and remained at this post until his retirement in 1935.

Besides well-informed and crisply written books on French intellectual history, on the history of French liberal Catholicism (1909, 312 pages), on French secondary education from 1802 to 1920 (1921, 255 pages), and a *Histoire de l'idée laïque en France au XIXe siècle* (1925, 376 pages), Weill cooperated in the publication, after the First World War, of two major general history series, the strictly chronological *Peuples et civilisations* and the more thematic *L'Evolution de l'humanité*. His contribution to *Peuples et civilisations*, which covered the first half of the nineteenth century, *L'Eveil des nationalités et le mouvement libéral, 1815–1848* (1930, 592 pages), was considered to be a rather superficial compilation.[144] But the two volumes he contributed to *L'Evolution de l'humanité*—one on the history of the press, *Le Journal: Origines, évolution et rôle de la presse périodique* (1934, 451 pages), and the other on national movements in the nineteenth century, *L'Europe du XIXe siècle et l'idée de nationalité* (1938, 480 pages)—commanded respect for their broad international approach and outstanding documentation.

Weill may not have been a profound analyst, but he was unquestionably an intelligent and lively narrator, one who opened up the virgin territory of the history of nineteenth-century ideas. In some respects his work may have been superseded by more penetrating research; however, as introductory works, Weill's various studies of subjects bound up with the intellectual history of the nineteenth century still have not been bettered.

THE *PATRONS*

Of the six *patrons* who, in the nature of things, worked in Paris three were older than sixty in 1910 (Lavisse was 68, Monod 66, and Aulard 61), two were under fifty (Langlois and Berr were both 47), and one was in his middle fifties (Seignobos was 56). Two were "period *patrons*" (Aulard on the French Revolution and Langlois on the Middle Ages) and made little impression outside their special fields. The other four wielded a wider influence, the older two (Lavisse and Monod) thanks to their broad approach and the younger two (Seignobos and Berr), who were less versatile, thanks partly to their methodological reputation and to their renown as philosophers of history.

Lavisse was the most powerful and the most intelligent of them all, and also the most gifted writer. Monod was the most effective, the most scholarly, and the one with the broadest outlook. Lavisse, for his part, exerted a considerable social influence, not only on all the sectors of education using his books but also on a fairly wide educated public, whom, in the 1870s and 1880s, he familiarized with German history and for whom he edited the multivolume *Histoire de France*, a work unexcelled in many respects, and also wrote his masterly book on Louis XIV. Monod's influence, by contrast, was felt most by professional historians. As an indefatigable lecturer and editor of more than a hundred volumes of the *Revue historique* (from 1876 on), he did much to raise the standard of French historical studies. He was second to none in devoting himself to the service of the younger generation of historians, even at the expense of his own work, which, though voluminous, had a rather diffuse and fragmentary character.

Lavisse and Monod belonged to the generation of master builders. In a sense that was also true of the much more limited Aulard, who sat back in his chair for the study of the Revolution, built a bastion around it, and forced university studies of the Revolution into a straitjacket. Aulard published his own journal, *La Révolution française* (from 1887) and his own source editions. Perfectly integrated into the political life of his day, he raised a small empire that helped to foster the study of the Revolution and at the same time strengthened his own position. The influence of Lavisse and Monod was less direct and less compelling. Monod was extremely generous and not concerned about his own prestige or power. Lavisse was less self-effacing. He did enjoy his many posts but kept to himself more than Aulard and was more discreet and discriminating in his use of other people. The intellectual weight of Lavisse and Monod was patent; Aulard's was not. In particular, the position of strength enjoyed by Lavisse and Monod had developed naturally and was rarely challenged (at least not in university circles), whereas Aulard had gained his position almost overnight, thanks to a political decision, and so he had to wage a constant struggle to assert himself.

The younger three *patrons* belonged to the next generation and could therefore carry on where their predecessors had left off. In particular, they could

afford the luxury of criticizing the institutional studies of their elders. Seignobos and Langlois, both of whom considered themselves Lavisse's pupils, had a smaller sphere of intellectual influence than their master but wrote well-founded and hence lasting historical studies. The volumes they contributed to Lavisse's *Histoire de France*—Langlois on the years 1226–1328 and Seignobos on the years 1848–1914—remain unexcelled contributions to political history. Neither Seignobos nor Langlois was an empire builder. Seignobos had the ear of republican politicians and presided over a salon that was claimed to make ministers, yet he was a staunch individualist, the "perfect radical," who wanted no disciples and was averse to academic honors. Langlois, who was a close friend of Seignobos's and had collaborated with him on the famous *Introduction aux études historiques* (1897), was a difficult man to approach. His writings were much esteemed, abroad as well as at home, and his opinions had great weight, but he did not really feel at home in education and was awkward in dealing with students. He was a misanthropic *patron* who abandoned his professorship in 1913 to become director of the Archives Nationales.

Henri Berr was not a historian but a philosopher, but he influenced historians as the founder of the *Revue de synthèse historique* (1900) and as editor of a thematic general history series, *L'Evolution de l'humanité*, conceived before the First World War. Berr, who was never to become a professor, must be ranked a *patron* thanks to his journal and his series, but he played no part at all in making academic appointments. He stimulated others and was a good listener. *Le grand naïf*, as he was called,[145] was the precise opposite of those *patrons* who make use of people. Berr was a model impressario *patron*, launching such younger historians as Lucien Febvre while keeping out of the limelight himself.

Ernest Lavisse

Ernest Lavisse (1842–1922) came from a simple petit-bourgeois background and would not have been able to pursue an academic career had his striking achievements not earned him a scholarship.[146] At the Ecole normale (1862–65) he had such classmates as Monod and Albert Duruy, the son of Victor Duruy, the *grand ministre*. It was undoubtedly through Albert Duruy that Lavisse came into contact with the father, who made a great impression on him. Victor Duruy had been a very successful history teacher, the author of widely used textbooks, the editor of a large series of works on general history, a man who, shortly after a brief lectureship at the Ecole normale (1861–62), had started on a meteoric career that culminated in his appointment as minister of education in 1863. He had an eye for talent and took to his son's bosom friend. As soon as Lavisse had passed his *agrégation*, he was offered a teaching appointment at the prestigious Lycée Henri IV in Paris, along with the post of private secretary to the minister of education. He was thus directly involved in the great education inquiries and in the new educational plans. It was also with the help of Victor Duruy that Lavisse was appointed tutor to the *prince impérial* in 1868.

When the Empire fell Lavisse not only lost a lucrative and influential position

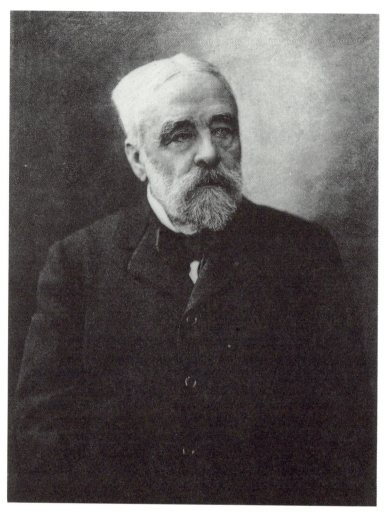

6. Ernest Lavisse (Photo BN)

but had to bear the stigma of having been the teacher of a once future emperor. Lavisse was twenty-eight at the time. He decided to accept a meager grant of 500 francs and to spend a few years in Germany (1872–74). There he studied medieval history under the great Georg Waitz, wrote acclaimed articles on current questions in the prestigious *Journal des débats* and *Revue des deux mondes*, and secretly paid several visits to Arenenberg in Switzerland, to which the imperial family had retired (1874). From Lavisse's letters to Albert Duruy one gets the impression that Lavisse paid these visits under pressure from the imperial family, but not too reluctantly, in an effort to help prepare the way for a Bonapartist restoration.[147] Lavisse's ex-pupil was to be groomed as the leader of the Bonapartist party under the name of Napoleon IV and had to be rescued from

the influence of his domineering mother. It must be remembered that at the time (1874) the republican form of government had not yet been consolidated and that a strict Catholic *ordre moral* prevailed, which was certainly not to the liking of the freethinking anticlericalist Lavisse.[148] Lavisse, incidentally, suspected that his correspondence was being intercepted; he therefore had his letters forwarded by intermediaries and asked that they be burned as soon as they had been read (a request that was ignored).

In his free time Lavisse worked on his dissertation. Once he returned to teaching at the Lycée Henri IV, it did not take him long to obtain his doctorate with a thesis on medieval Prussia: *Etude sur l'une des origines de la monarchie prussienne ou la marche de Brandenbourg sous la dynastie ascanienne* (1875, 268 pages). The book was to become a milestone in the "historiography of the vanquished"; it was a study meant to plumb the secret of the victor's success.[149] Lavisse unfailingly chose the right subject (in contrast to his much more learned, thorough, and hesitant colleague Monod, who kept changing tack). Lavisse set out to define the nature of the Prussian margrave's authority and to show it at work at the very time when a new state was being founded on the right bank of the Elbe. German historians tried to trace the roots of Prussian greatness as far back into the past as possible, the better to demonstrate the solidity of Prussia's glory. Lavisse was not concerned with that aspect, but he felt that it was essential to acquaint his compatriots with the history of Prussia, and he thought the best way of doing that was by familiarizing them with Prussia's origins. He warned against "retrospective hatred." "We have a duty to acquire a considered and philosophical understanding. . . . One cannot understand a history about whose beginnings one knows nothing."[150] "From Albert the Bear, margrave of Brandenburg, to the current sovereign of Prussia there is a continuous tradition," argued the self-confident doctoral candidate, appealing for the attention of all French people. Lavisse's academic approach was not noncommittal. Moreover, he was averse to the least display of donnishness, and he certainly was not infected with the historian's fever of searching for fresh documents. For him, the "difficulties and strains" of research into the past were well worth tackling because that research held the answers to burning current questions. Lavisse concluded that Brandenburg had not been pursuing any "Christian or German mission" but merely the mission imposed by life under difficult circumstances. "The soldier has always been the leading character over there." Lavisse ended by quoting a statement made a century earlier by Mirabeau: "War is Prussia's national industry."[151]

Lavisse made his name. His thesis was crowned with a prize by the Académie française. Many of the views he expressed would help to shape the French picture of Prussia and would influence much subsequent historical research, not least by Emile Bourgeois, Albert Waddington, Georges Pariset, and Georges Pagès.[152] Lavisse combined several of the articles he had contributed to the *Revue des deux mondes* in his *Etudes sur l'histoire de Prusse* (1879, 327 pages; 6th ed., 1912), which also was distinguished with a prize from the Académie française. Among the generation that came after Fustel, Lavisse was the only history

professor to be renowned as a stylist. His prose was anything but pedantic, full of pithy formulations, elegant and simple, and interspersed with crisp summaries. One can describe his approach, which was more versatile and colorful than Fustel's, as epigrammatic historiography. The climax of his work on Prussian history was *La Jeunesse du Grand Frédéric* (1891). Based for its factual information on the enormous work of Johann Gustav Droysen's pupil Reinhold Koser, it was a masterly and original psychological characterization of Frederick William I, the coarse and tyrannical father, and Frederick the Great, his levelheaded and intellectually superior son. By the time the sequel, *Le Grand Frédéric avant l'avènement* (1893), came out, Lavisse had been included among the immortals of the Académie française (1892).

Yet Lavisse did not confine himself to the history of ancient Prussia. He also wrote stylish, intelligent articles on contemporary Germany that were reprinted in two widely read collections, the *Essais sur l'Allemagne impériale* (1887) and the *Trois Empereurs de l'Allemagne* (1888). In addition, his calls for educational reform also came out as collected essays. He also wrote many successful school textbooks and a frequently reprinted *Vue générale de l'histoire politique de l'Europe* (1890).

Lavisse had a meteoric career. In 1876, soon after his *soutenance*, he became a lecturer at the Ecole normale. As one of the architects of the new arts faculties he moved across to the Sorbonne, where he was first a substitute professor and then, in 1883, "director of historical studies." In 1888 he was appointed successor to Henri Wallon in Guizot's chair of modern history. Lavisse was forty-five at the time, and he would stay at this post for thirty years, until 1919. After the republican "seizure of power" and the vigorous steps taken by Jules Ferry, the minister of education, Lavisse became reconciled to the republican system. His old bosom friend Albert Duruy reproached him bitterly. In a highly confidential reply to Albert in 1882 Lavisse put up a spirited and frank defense. Under the fire of the first educational reforms he had felt very sad, his outward show of gladness notwithstanding. The deaths of the *prince impérial* (1879) and of his own father (in wretched circumstances, which he had hidden from his son and which Ernest now reproached himself for having failed to notice) had made him "gloomy, sad, and indifferent." "All your misfortunes have made me cry, and their memory constantly mingles with the memory of my own. . . . Your father's serene and noble old age is one of my rare joys." "Yes," he continued, "I am completely wrapped up in my work, because I have always been devoted to work and it is my sole refuge at the moment: I work as others drink absinthe."[153] Do we have to doubt this self-analysis and dismiss it as disingenuous? Such shrewd observers as Romain Rolland and Charles Benoist were struck by Lavisse's remarkable detachment and by his "curious sense of balance and sadness."[154]

In the 1880s rumor had it that he was about to be appointed ambassador to Berlin, but Lavisse had no diplomatic ambitions.[155] As he put it in a letter to Albert Duruy, he felt that "his life's work was . . . to train professors of history capable of teaching the love of France."[156] He was able to discharge that self-

imposed duty in brilliant style. As the reader may have gathered from earlier chapters, Lavisse exerted a strong influence on history education at the higher, secondary, and primary levels, thanks largely to his reforms of the examinations, his textbooks, his educational guidelines, and his choice of the best teachers.

Lavisse was the most powerful man at the New Sorbonne; no appointments could be made without his consent. But no matter how great his intellectual, artistic, and literary powers, Lavisse was not an intellectual leader. His work was admired, but it was too literary and too personal to be imitated. He was not the theorist but the organizer and editor of French university historiography before the First World War.

In particular, Lavisse was the editor of three monumental series. The twelve-volume *Histoire générale du IVe siècle à nos jours* (1893–1901) received less praise than the eighteen-volume *Histoire de France* (1900–1911), covering the Gallo-Roman period to the French Revolution, and the nine-volume *Histoire de France contemporaine*, which did not appear until after the First World War but had been planned and partly written before. In addition to contributing several minor chapters, Lavisse himself wrote two volumes on the first forty years of the reign of Louis XIV (1643–85), published in 1905 and 1906. Many historians consider them the culmination of Lavisse's late *oeuvre*.

Not all the twenty-seven volumes devoted to French history were of the same standard. Lavisse's editorial work, done with the help of Lucien Herr, was not even. More editorial work was done on the volumes that appeared before 1789 than on those published after that date. However, thanks to its pronounced political orientation and its division into narrow chronological slices, the *Histoire de France* remains unexcelled in a number of respects.

Lavisse did not accept the republican system until the 1880s, when he came to consider it the least divisive system for the French nation, and moved slightly to the left of many young intellectuals in the 1890s, largely influenced by socialism and pacifism. Even so, he was cautious enough not to take sides publicly during the Dreyfus affair. As chief editor (since 1894) of the influential *Revue de Paris*, the competitor of the more fashionable and right-wing *Revue des deux mondes*, Lavisse avoided any allusion to the affair in the heat of the struggle. In January 1899 he came out with an *Appel à l'Union*, in which, as a "friend of legality and public peace," he tried carefully to toe the middle line. He had become a very cautious man and was careful not to burn his fingers a second time.[157]

When war broke out in 1914 Lavisse was over seventy. Fierce right-wing nationalists such as Maurras made jubilant claims about a "Lavisse regained" when the old man spoke up for the "Union sacré" and wrote rabidly anti-German articles. Had they really doubted Lavisse's patriotism, or had they merely been sorry that had listened to the left-wing views of those around him?

The embittered Lavisse lived to see the victory of the Allies at a ripe old age. By then, however, his creativity had been extinguished. He died in 1922 at the age of seventy-nine and was buried in his birthplace, the small village of Nou-

vion-en-Thiérache, which had been overrun by the Germans twice in his life-time.

Gabriel Monod

Gabriel Monod (1844–1912) was descended from a family of Huguenot clergy-men and scholars who, as a result of the Protestant exodus from France follow-ing the revocation of the Edict of Nantes, found themselves scattered across many western European countries.[158] Gabriel's father was not a cleric but a merchant in Le Havre, and his mother came from Alsace. Young Gabriel was brought up in a cosmopolitan atmosphere. Unlike the scholarship student Lavisse, he was heir to a small family fortune. Although not exceptionally rich, the Monods were well-to-do bourgeois intellectuals. In Gabriel's own intellec-tual background the idealism of the *quarante-huitards* was wedded to the open-mindedness of liberal Protestantism. The Bonapartist regime was held in con-tempt. In 1861 Monod wrote in his diary that he liked his history teacher, Tommy Perrens, the author of a vindication of Etienne Marcel and later an inspector of higher education, because "Monsieur Perrens is a red republican like myself."[159]

After the Ecole normale (1862–65), where he made friends with Ernest Lavisse, Monod was given a post in secondary education but was granted study leave for three years in succession. He went to Florence, recently proclaimed the capital of the young Italian kingdom. Perrens had preceded him there, tak-ing his doctorate in 1853 with a book on the "Republican monk Savonarola." Monod himself was preparing a thesis on the Florentine guilds. While working on his thesis, Monod came into contact with the impressive Malwida von Meysenbug, one of the "romantic exiles" who had taken it upon themselves to see to the education of Olga, the daughter of the great Russian revolutionary, Alexander Herzen. In 1873 Monod was married to Olga, having overcome Mal-wida's initial opposition. According to the not improbable romantic version of the story, when Monod, hopelessly in love, had first been turned down, he had gone to Germany to drown his sorrow by immersing himself in the rules of scientific historical criticism, a subject not taught in France.[160] Monod kept in touch with Malwida, and it was in her impressive circle of acquaintances that he met Mazzini and became one of the first Frenchmen to be familiar with Wag-ner's music and Nietzsche's philosophy.[161]

Monod studied in Berlin and in Göttingen. In the summer semester of 1868 he was impressed with the seminar run by Waitz, who, apart from being a great scholar, was also a remarkable and generous lecturer.[162] It was largely thanks to Waitz that Monod made it his life's work to prepare his students for two gigan-tic tasks, namely, the critical elaboration of historical sources and the rewriting of French medieval history in the light of the historical criticism taught at Ger-man universities and forsaken by France after the abolishment of the Maurists and the other studious orders.

On 1 January 1869, at the age of twenty-four, Monod, partly with the help of

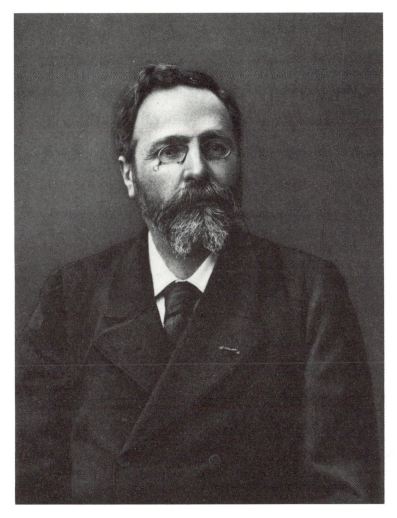

7. Gabriel Monod

Lavisse, who was very close to the minister of education, was appointed a history *répétiteur* (tutor) at the brand-new Ecole pratique des hautes études. He could have earned much more as a schoolteacher, but here, after an initial clash with his superior, Alfred Maury, who was completely unfamiliar with the seminar system, he was eventually allowed to introduce the tutorial approach into the teaching of medieval French history and thus to establish a typically academic system of history instruction.[163] Years later Lavisse recalled that Monod's tutorial system had struck him as the model for a new form of French higher education.[164]

The Franco-Prussian War put a sudden stop to this work. Although as a teacher he was exempted from military service, Monod became a volunteer

medical orderly. The pamphlet *Allemands et Français* (1871), in which he re-
counts his experiences at Metz and Sedan and then on the Loire, was sur-
prisingly free of bias. After the crushing of the Commune, Monod returned to
his work at the Ecole pratique des hautes études. Was it on his advice that the
disorientated Lavisse decided to train under Waitz?

Monod made his name as a medievalist with several studies of Merovingian
sources, but he never took his doctorate. He had a host of plans to pursue
various medieval topics, but for a number of reasons he failed to implement any
of them. "I keep wondering if I have not failed in my duty by attending to too
many things, by becoming a jack of all trades, by yielding with rather epicurean
indulgence to the pleasure of reading everything, of seeing everything, of under-
standing everything, of loving everything," Monod mused in a letter in 1894.[165]
He wrote a great deal on a number of subjects, ranging from early medieval
history to the latest historical developments, but his *oeuvre* was fragmentary. Yet
more than any other historian of his generation he helped to raise French histo-
riography to a more academic and international (i.e., German) level through his
teaching at the Ecole pratique des hautes études for thirty-five years (1869–
1905) and at the Ecole normale for twenty-five years (1880–1905, as successor
to Lavisse, who had gone over to the Sorbonne) but most of all thanks to the
Revue historique, a journal he founded in 1875. Starting with the first issue in
1876, he presided over the publication of more than a hundred further issues
over the following thirty-five years, making an unparalleled contribution to the
widening and deepening of the approach of French academic historians. The
Revue historique became the best-informed general historical journal in the
world during the last quarter of the nineteenth century—with a broader inter-
national approach than its German elder sister, the *Historische Zeitschrift*[166]—
thanks to the tremendous exertion, the international contacts, and the immense
range of intellectual activities of Gabriel Monod. The editorial work he did on
the hundred or so issues of the *Revue* was much more time-consuming than
Lavisse's work on the twenty-seven volumes of the *Histoire de France*. Lavisse
finished up with a splendid and rounded historiographic edifice, to which he
had contributed two elegant volumes in his own name. Monod's periodical was
by definition incomplete, and his own contributions had a fragmentary and
occasional character and now lay hidden in bulletins, discussions, and reports.
And yet Monod's influence through the *Revue historique* may well have been
more fruitful and lasting, at least for professional historians, than Lavisse's
"high-class popularizations." We might say that Lavisse could only reap because
Monod had sown.

Most French historians consider it only fitting that the unselfish and modest
Monod was given a special chair at the Collège de France after his exhausting
stint at the Ecole normale and the Hautes études and a very short pro forma
appointment at the Sorbonne. During the last few years of his life Monod was
enabled, thanks to a grant from the marquise Arconati Visconti, a republican
benefactress, to occupy a chair of "general history and historical method."[167]
Monod, who combined extreme systematic precision with a profound knowl-

edge of the philosophy of history, wrote a very modern and open-minded trea-
tise on the theory of history[168] but invested most of his efforts in his great
biography of Michelet, to whom he had already devoted a great many detailed
studies and whose large collection of papers, arranged in complicated sets, he
had been handed by Michelet's widow. His posthumously published *La Vie et la
pensée de Jules Michelet* (1923, 650 pages) only dealt with the period ending in
1852. As for the later Michelet, we still need a critical but respectful biography
carefully placed in a broad framework, much as Monod did for the earlier
period.

Monod's bibliography comprised 215 entries.[169] This figure does not include
his many articles in daily and weekly newspapers published at home and
abroad or his hundreds of reviews. Apart from publications on medieval
sources, Michelet studies, articles on educational policy, schoolbooks, and pub-
lications on the history of religion (including a weighty introduction to his
translation of H. Boehmer's study of the Jesuits, published in French as *Les
Jésuites*, 1910) and foreign history (including a substantial introduction to the
translation of J. R. Green's *Short History of the English People*, published in
French as *Histoire du peuple anglais*, 1888), the greatest number of entries in his
bibliography were biographical articles, including numerous obituaries of histo-
rians. Some of these outstanding and balanced contributions were reprinted in
two anthologies, *Les Maîtres de l'histoire: Renan, Taine , Michelet* (1894; 3rd ed.,
1896) and *Portraits et souvenirs* (1897). In addition to his published work,
Monod kept a diary, the known extracts of which are exceptionally interesting,[170]
and was a prolific correspondent (according to Lavisse, any business using as
many postage stamps as Monod did could count itself an extremely active con-
cern).[171]

Whence did Monod draw his enormous energy, which he largely placed in
the service of others? The cosmopolitan and ecumenical Monod was as devoted
as Lavisse to the "national" task of training teachers and lecturers capable of
kindling patriotic feelings in their charges. For Monod the study of history was
a vital instrument for improving the world through the eradication of political,
social, and international prejudice. "The true historian is he who, rising above
all impassioned and narrow prejudice, and reconciling all that is legitimate in
the conservative spirit with the irresistible demands of movement and progress
. . . , of revolutions . . . helps to extirpate superstitious respect and blind ven-
eration, even while making it clear how much of its strength and vitality a
nation loses when it breaks violently with its past," Monod wrote in the famous
introductory manifesto to his *Revue historique*.[172] If it is to improve the psycho-
logical health of the nation, the study of history must be a great healer of
all social wounds, in France as well as abroad. For Lavisse, France's "na-
tional teacher," history was a patriotic mission; for Monod, France's "scientific
teacher," it was a categorical imperative.

Because of his lofty view of the social function of historians, the Dreyfus affair
proved a traumatic experience for Monod. He gave moving proof of his scru-
pulous stand and unshakable commitment.[173] He was one of the first to com-

pare the *bordereau* (the anonymous letter abstracted from the German embassy and allegedly written by Dreyfus), published on 10 November 1896 in *Le Matin*, with a facsimile of Dreyfus's handwriting, which he had obtained from Bernard Lazare, his ex-pupil at the Hautes études and an early protester of Dreyfus's innocence. Monod showed that the two were dissimilar, and he asked Lazare to obtain expert opinions. He made representations to Auguste Scheurer-Kestner, vice-president of the Senate, and also appealed to two influential journalists, Ranc and Humbert. It was Humbert who mentioned Monod by name in the October 1897 issue of *L'Eclair*. Monod was in Rome at the time. On the train back home he wrote a first open letter, which he tore up; a second appeared on 5 November 1897 in *Le Temps* and *Les Débats*. Dreyfus's tribulations had turned into an affair.

Because of his Protestant background, Monod would have preferred not to add fuel to the flames, in the hope that moderation would win the day. However, "my moderation has done me no good; the newspapers have abused and vilified me, and I have received anonymous death threats." The study of history, which for Monod was more a method of attaining deeper understanding than a "science," was unable to make headway in the polarized and diseased atmosphere of *La Belle Epoque*. "In what a country for cowardly sheep we live! How much we have learned these past few months! Ochlocracy is perhaps the most odious and certainly the most stupid of all tyrannies," he wrote to Romain Rolland on 13 June 1898. "I find it very hard to keep believing in civilization . . . clericals, anticlericals, moderates, socialists, all seem so superficial to me, so unjust, so unreasonable," he wrote on 16 November 1899. "In general, rich Catholics are stupid and Protestants petty and narrow" (May 8, 1898).[174]

But Monod would not have been Monod if, after the bitter storm the Dreyfus affair had blown up, his natural goodness and simplicity had not regained the upper hand. He wrote in 1909 that those who had been touched by the affair had been afforded a glimpse of "the tragedy of life at the heart of all things and all souls." But the good had won out in the end. "Politics . . . is far from being a farcical display of egoism and cupidity . . . the social work of this rotten parliament . . . the partly anonymous work it was compelled to accomplish by the force of circumstances, impelled by the soul of France, which, deep down, is ever reasonable and generous."[175]

Monod died in 1912, incorruptible and with a sorely tried but unbroken faith in a future in which reason and human solidarity have the final say. He was spared the pain of witnessing the outbreak of the First World War.

Alphonse Aulard

Alphonse Aulard (1849–1928), unlike the versatile Lavisse and Monod, was *patron* of a limited field.[176] From the mid-1880s he was the grand old man of academic studies of the French Revolution, and he continued to be just that for nearly forty years. History was not Aulard's first choice as a profession. A *normalien* who joined the Ecole normale in 1867, together with, *inter alia*, Louis

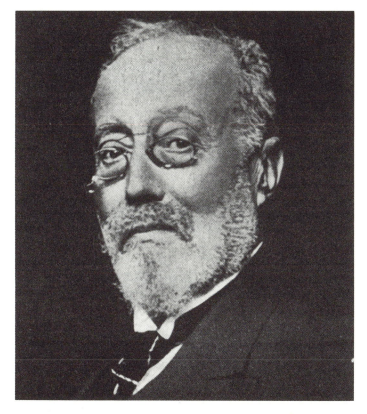

8. Alphonse Aulard

Liard and Ernest Denis, five years after Lavisse and Monod, Aulard first decided on a literary career. Exempted from military service as a *normalien*, he nevertheless fought as a volunteer in 1870–71; in 1871 he took the *agrégation ès lettres* and became a teacher in Nîmes. Because he had chosen literature, he saw no need to study in Germany, as so many young historians were doing. (He was the only one of our *patrons* in 1910 not to know German.) Although Aulard taught French literature, his interests were not confined to his own country. His special field was literary criticism, and he took his doctorate with a thesis on the great Italian poet Leopardi (1798–1837). Aulard, who had meanwhile accepted a teaching post at Nice, refused an appointment to the faculty of Clermont-Ferrand on the ground that the climate there was too harsh for his delicate health. In fact, he came down with acute laryngitis with complications and was granted sick leave for two years, during which he received protracted thermal therapy. It was at this time that he took his doctorate (in 1877). In 1878, on his doctor's advice and upon the intercession of his father, an inspector of education, he was appointed a lecturer in southern European languages and literature at the arts faculty of Aix-en-Provence, a post that it was said would tax his voice

less severely. He then changed faculties three times within two years (Montpellier, Dijon, Poitiers), finally to be appointed professor of French literature at Poitiers.

It was at about that time that Aulard, who was by then past thirty, started to apply himself to the history of the Revolution. His first important publication on the subject, blending literature and history, was devoted to parliamentary eloquence at the time of the great upheaval: *Les Orateurs de l'Assemblée Constituante* (1882). A few years later he published sequels dealing with revolutionary speakers in the Legislative Assembly and the Convention (1885–86). Aulard, who received outstanding inspectors' reports—"a solid mind, abundant learning, erudition without dryness, an excellent teaching technique"—chose, after an intense conflict with the dean, to accept another appointment in secondary education, this time in Paris. He assured the authorities that his voice no longer troubled him. In September 1884 he was made a *professeur de rhétorique* at the Lycée Janson de Sailly. Aulard became closely involved with radical-republican circles in the capital. He used a pseudonym to run a notorious column, "Les Lundis révolutionnaires," in *La Justice*, Clemenceau's paper. Aulard and many like him were incensed at the opportunistic behavior of the official republicans. The self-same Gambetta who had defended his country when it was in mortal danger and had been hailed in 1870 by prorepublican youth as a reborn (if less successful) Carnot, had proved to be a disappointment to Aulard. "The policy of bargaining, of compromise, may be inevitable but saddens us deeply." And after Gambetta's death (1882): "This opportunist policy has survived him and strikes us as being baser and more nauseating than ever." Aulard expressed the feelings and thinking of a generation of passionate republicans with the sigh, "How beautiful the republic was under the Empire!"[177]

His political connections stood Aulard in good stead. In 1885 the radical-republican municipal council of Paris funded a special lecturing post at the Sorbonne in the "history of the French Revolution."[178] In February 1886 Aulard's appointment to the post was approved (with a salary of 12,000 francs, double his pay as a professor in Poitiers), and in March 1891 his lectureship was converted into a full professorship. Aulard's energy now proved to be boundless. He may have had to thank political friends for his appointment, but the radicals, for their part, had reason to be grateful as well, for Aulard had a tremendous capacity for hard work and a ready wit.

Looking ahead to the centenary of the French Revolution, staunch republicans thought it was high time justice was done to the "founding fathers." The supporters of the Revolution had been driven onto the defensive, not least because of the spectacular success of the brilliant Taine, who, after a volume on the ancien régime in which he rapped the royalists' knuckles, had gone on to write three volumes on the Revolution (1878–84) in which he portrayed the Jacobins as blithering idiots. (In 1886, he was to draw a portrait of Napoleon that earned him the undying hatred of the Bonapartists.) Taine was no university historian, but even in the universities what few scholars devoted themselves to the study of the Revolution were wont to enlarge on the ugly aspects and

excesses of this extremely tempestuous period. Henri Wallon had preceded Aulard with studies and source publications on the Terror and revolutionary justice.[179] Aulard now carried on with the publication of documents—proffered as "irrefutable" proof—on two leading revolutionary bodies, the Comité du Salut Public and the Jacobin Club in Paris.[180]

Critics of Aulard's editorial activities were far from gentle. The *Recueil des Actes du Comité du Salut Public avec la correspondance officielle des représentants en mission et le registre du Conseil exécutif provisoire*, of which nineteen volumes were published in twenty years (1889–1909), was in fact much too sweeping in design. In 1888, when it was first planned, nobody had anticipated that. The series, however unsatisfactory, was nevertheless an indispensable aid to the study of the revolutionary government. *La Société des Jacobins: Recueil des documents* (6 vols., 1889–97), by contrast, could have done with a broader approach and with more extensive documentation, but it continues to be an extremely useful reference work. In addition to these two great series, a number of other source publications were launched under Aulard's editorship. For these Aulard made use of a host of assistants, not all of whom were equally meticulous, the less so as they were not carefully supervised.[181] Aulard worked quickly but not conscientiously enough. For all that, the claim that these source publications served only the greater glory of Aulard himself and of the revolutionary administrators is quite unfounded.[182] To begin with, these publications helped to provide greater insight into the actions and motives of the revolutionary authorities, and that constituted some advance in knowledge. Second, Aulard's publishing collective built a bridge between faculties and archives, an unusual approach in the study of contemporary history.[183]

As befitted a true *patron*, Aulard also published a journal. In 1887 he became secretary of *La Révolution française*, which had been founded a few years earlier; although it was not the only journal in this field, it was by far the most balanced and important. Aulard's own *oeuvre* was large in volume but relatively small in compass. Apart from school textbooks, it mostly covered a period of twenty-five years of turbulent French history (1789–1814). He published, *inter alia*, a popular biography of Danton (1886), whom he helped to return to popular favor; a short contribution to religious history, *Le Culte de la raison et le culte de l'Etre suprême, 1793–1794* (1892); a solid history of institutional education, *Napoléon Ier et le monopole universitaire* (1911); a social study with a surprising economic slant, *La Révolution française et le régime féodal* (1919, but in proof as early as 1914); and seven collected *Etudes et leçons sur la Révolution française* (1893–1913). But Aulard's magnum opus was his *Histoire politique de la Révolution française: Origines et développements de la République, 1789–1804* (1901, 816 pages).

With it Aulard intended to provide a carefully documented study of the conception and adaptation of two essential principles of political organization, the (equal) rights of man and national sovereignty, which, in his view, found their logical expression in democracy and the Republic. He presented this study as a monograph and not as a synthesis. It is therefore mistaken to accuse him of too

strong a political bias and quite misleading to call his work *histoire événemen-tielle*.[184] Aulard did not describe events as such but dwelled on political ideas. He used a mainly chronological approach when dealing with the period 1789–92 but not for later years. That, in his view, would have meant "introducing into the account the confusion rife in the actual events."[185]

Many of Aulard's supporters and opponents had one thing in common: they were staunch upholders of democratic and republican ideas. The idea of political organization preoccupied his colleague Seignobos no less than it did Maurras. The slogan "Politics first" was on many lips. It was the time of the Défense republicaine (1899–1902) and the Bloc des Gauches (1902–5), in which the modern party lines were first drawn. Political parties, which until recently had been little more than political factions, now developed political tentacles in the form of local committees spread all over the country. At the same time, Paris saw the publication of Ostrogorski's famous *La Démocratie et l'organisation des partis politiques* (2 vols., 1903), based on the experience in the United States and Great Britain. In keeping with the social-radical spirit of the age, Aulard attached great importance in his studies of the Revolution and to the role of the organized (Jacobin) political factions. "It is a mistake to say that the French Revolution was made by a few distinguished individuals, by a few heroes . . . the full story of the years 1789–99 makes it clear that no individual directed the events."[186] The true hero of the Revolution was the French nation, though not "en masse but in the form of organized factions." To stop the Revolution, Bonaparte had dissolved the factions, "leaving no *citoyens*, only individuals,"—a phrase by which Aulard articulated the credo of the "republic of committees."[187]

The influence of Danton worship, of Aulard's so-called *dantonisme*, has been greatly exaggerated as a result of Albert Mathiez's reevaluation of Robespierre.[188] For Aulard, the Jacobin organization as a whole was the prime mover and bearer of the republican ideals. In essence he agreed on this point with his more conservative opponent, Augustin Cochin, who is considered the founder of the sociology of Jacobinism (Taine having previously provided a psychology of Jacobinism).[189] The difference between Aulard and Cochin lay in their attitude toward the Jacobin network. Aulard saw it as the true face of France; Cochin saw it as the country's usurpation.

Aulard's *Histoire politique* proved to be a successful book. The third edition appeared in 1907, the sixth edition in 1926. For all that, Aulard's most important work was quickly considered outdated. To a younger generation the general (male) franchise was a matter of course, and national sovereignty no longer meant a radical break with the old class-ridden society but an obstacle to international solidarity, the cause of the arms race and of war, a cover for vested interests. The political ideals of Aulard and those around him were now presented, in a tempting but rather unsubtle hypothesis, as so many diversionary maneuvers intended to maintain economic privilege.

No matter how irritating Aulard's political attitude may have seemed to his successors, and despite the shortcomings of his *oeuvre*, the unqualified denigra-

tion of his history of political ideas backfires on the critics. The French Revolution must remain completely incomprehensible to anyone who underestimates the persuasive power of slogans as potent as *liberté, égalité, fraternité*. Aulard, who continued to believe in the ideals of democracy and the republic, was closer to the mentality of the Jacobins than many of his critics.

Charles Seignobos

Charles Seignobos (1854–1942) was Lavisse's student, and for a long time his right-hand man;[190] Lavisse made use of him, but he also gave him all the space he needed. Seignobos was considerably to the left of Lavisse. He was a republican, a democrat, an outspoken freethinker, and not afraid of doing battle with his political opponents. Although he was more independent than Aulard and never a party man, he became the whipping boy of the right-wing press. In the 1930s Seignobos, then nearly eighty, was intellectually slaughtered as a historian by the pitiless and brilliant Lucien Febvre, almost a quarter of a century his junior. Seignobos may lay claim to the questionable title of France's worst-treated historian.

Charles Seignobos was born in Lamastre, a small town in the Ardèche, to an old Huguenot family that had been professing the "positive religion" for a generation. In 1871 his father was elected to the Chamber, and he remained there for ten years, representing *le centre gauche*. After several years' absence from the Chamber, the senior Seignobos lost the 1899 election to a right-wing candidate, who inveighed against the revolutionary policies that "have driven the monks from their homes, the magistrates from their benches, religion from the schools, and the princes out of the army and out of their motherland."[191] The election was declared void after an investigation proved that there had been misrepresentation, threats, and corruption. By a nose, Seignobos *père* was reelected in his department in 1890. The old man, born in 1822, had by then become rather inactive for health reasons and died two years later, in 1892. All in all, the future political historian may be said to have been to the manner born.

Charles briefly studied law in Paris but did not find it to his taste. He returned to the *lycée* (Louis le Grand) while preparing for the Ecole normale, to which he was admitted in 1874. There he came under the influence of Fustel and, from 1876, of Lavisse (Monod was not to become a lecturer there until later). After his *agrégation* (1877), Seignobos went to Germany, taking in Göttingen, Berlin (where he heard Ranke and Sybel), Leipzig, Munich, and Heidelberg.[192] On his return he published a startling report about the study of history at German universities. Unlike Monod and Lavisse, he was largely unimpressed by it, and he squarely attacked the purely technical and sterile nature of many German historical seminars. German training led to the accumulation of masses of critically elaborated source material that no one knew what to do with. The method had become an end in itself. "Historians had gone on digging even though there was no gold left in the mine."[193] German professors were afraid of amateurs, and they tried to keep outsiders at bay by erecting huge technical

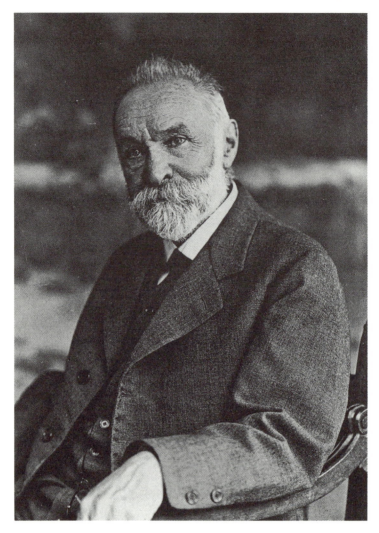

9. Charles Seignobos

barriers. Behind this dry form of technical instruction there lay, notwithstanding the apparent objectivity and infallibility, strong political convictions—"a mixture of philology and politics, the philology for the students attending the seminars, the politics for the rest."[194]

From Munich, in April 1879 Seignobos applied for the post of *maître de conférences*—"the new institution of assistant professors"—at a provincial faculty.[195] Because of the planned reforms he deliberately opted for higher education. That same year he was given a post at Dijon and received good reports. Perhaps he talked a little too openly to his students, but he worked very hard. He also kept rather aloof from his colleagues; the inspector in 1881 said that

"his colleagues do not consider him very good at what is called sociability and the social graces." Seignobos took his doctorate in 1882 with a regional study that clearly reflected Fustel's socio-institutional approach: *Le Régime féodal en Bourgogne jusqu'en 1360: Essai sur la société et les institutions d'une province française au Moyen-Age* (1882, 417 pages). The inspector was sorry to discover that this candidate from the south spoke so quickly and indistinctly (a complaint that was still to be voiced fifty years later) and that he was too quick to systematize: "a rigorous mind, methodical to excess, one who puts a degree of precision into things that do not always warrant it."[196] Very apposite, and still true of Seignobos in his later days, was the observation that "he defends himself with nervous energy even when he is wrong and does not always accept compliments even when they are justified." However, the inspector had no doubt that Seignobos was a serious and original worker. Seignobos had not come up with a string of "factual" events but had defined the general characteristics of feudal society and institutions in Burgundy, partly based on divergent archive material. The jury found that although the candidate hazarded daring "conjectures" about the origin and development of the feudal system, his method was original, his ideas fresh, his explanation of details ingenious, and his general approach remarkable.

The relationship between the young doctor with good Parisian connections and the sleepy and politically conservative provincial faculty of Dijon was strained. In the heat of the battle around the reform of higher education, in which Seignobos was closely involved as a pupil and adjutant of Lavisse, he snapped at an older professor who opposed the changes, telling him to expect a sharp note from the minister. For the rest, Seignobos could not find a proper outlet for his energy in Dijon, and Lavisse needed his help in his education and publishing plans. For three years in succession (1883–86) Seignobos was therefore given (poorly paid) leave before becoming a kind of *Privatdozent*. In 1890 he was offered a lectureship at the Sorbonne (where Lavisse had been appointed a professor in 1888), first in the "pedagogy of historical science" and later in general history. Not until seventeen years later, in 1907, after the publication of three remarkable works—a political history of Europe in the nineteenth century and two theoretical publications—was Seignobos offered a chair expressly devoted to the historical method. In 1921, when Emile Bourgeois succeeded Ernest Denis as professor of modern and contemporary history, Seignobos's chair became the chair of modern and contemporary political history. His three volumes, covering the period 1848–1914, in Lavisse's *Histoire de France contemporaine* came out at about the same time. In 1925, at the age of seventy, Seignobos retired, but he continued to deliver lectures to packed halls. He also published several books, including the often reprinted *Histoire sincère de la nation française* (1933; 7th ed., 1969), which Lucien Febvre attacked in an effort to blacken the professional reputation of an old man who enjoyed such great success with the public at large.[197] Physically, Seignobos survived the attack for another few years. He died in 1942.

After a promising start, Seignobos had decided to turn his back on medieval

history. In a confidential letter to his young friend, the medievalist Langlois, he explained that he was no scholar and had no wish to vie with other medievalists. "My only skills are a quick eye and the writing of clear outlines, I need a field with no detailed problems to solve, in which teachers, not research workers, are wanted, where what matters is to shake up ideas and to discover the formulas behind the facts." He did not wish to work in an archive, he continued, nor would he get to the Collège de France, but he would perhaps be rewarded with the feeling that he had contributed to "rendering intelligible to coming generations the society in which they live. For me that is the sole justification of history."[198] Seignobos became an educationist, a methodologist, and a political *contemporainiste*.

His role in establishing the official guidelines for the teaching of history in secondary schools is mentioned in chapter 3. As author of a number of school textbooks, including a history of civilization, Seignobos was less successful than Lavisse. Seignobos's role as a methodologist and theorist has been misrepresented, sometimes deliberately. Seignobos never was the document fetishist that Lucien Febvre, Henri-Irenée Marrou, and many of their followers tried to make him out to have been.[199] As early as 1881 he wrote: "Documents do not speak by themselves. The traces left by men and societies are dead letters to those lacking the skill to interpret them . . . the skill of taking advantage of documents consists in knowing how to ask certain questions."[200] Nor was Seignobos ever the "naive" epistemological positivist he has been called. He published remarkable articles in the *Revue philosophique* (1887) on the "psychological conditions of historical knowledge," in one of which he distanced himself from Fustel by defining the study of history not as an "observational science" but as a "rational science" and by specifying the psychological and subjective dimensions of historical knowledge.[201] Seignobos confided in Langlois that he was extremely happy with what he had written even though the style of his article was so terse that many historians might not be able to follow him. Lavisse had praised it, but Seignobos was not sure that Lavisse had really read the article.[202]

Together with Langlois, Seignobos wrote the famous *Introduction aux études historiques* (1897; 5th ed., 1924, 308 pages), which was widely attacked for its opening sentence (written by Langlois), which reads, "History is made with documents"; but for anyone who takes the trouble to read on, it continues to be an intelligent and sober introduction to the subject. The parts written by Langlois, on prior knowledge and external criticism, are somewhat dry and pedantic—more positivist in approach, if you like—unlike the parts dealing with internal criticism and the synthetic method written by Seignobos. In its way, the *Introduction* is much more effective than Ernst Bernheim's more informative but less analytic *Lehrbuch der historischen Methode* (1889). Seignobos's second great methodological work was *La Méthode historique appliquée aux sciences sociales* (1901), which, for all its shortcomings, not only was a useful corrective to the abstract vagueness and facile comparative approach characteristic of the young science of sociology but also provided a stimulus, which, sadly, is now forgotten, for the study of social history. Seignobos's "methodological imperialism,"

which asserted that all the social sciences ought to adopt the historical method, incensed François Simiand, one of Durkheim's assistants (see chapter 6 and the conclusion). In Seignobos's discussion with the sociologists two things became clear. First, Seignobos adhered to his psychological conception of history and was fiercely opposed to a reifying sociological approach.[203] Second, although he had started out as an institutional historian of Fustel's school, he had come to attach great importance to coincidences in his later years. Chance events could make and break institutions, the skeptical Seignobos contended.[204]

Seignobos was respected most as a political historian of the nineteenth century. His *Histoire politique de l'Europe contemporaine: Evolution des partis et des formes politiques, 1814–1896* (1897, 814 pages) was in fact a remarkable book that succeeded in presenting the chaotic events and developments marking the political history of contemporary Europe clearly and in well-documented form. The work had no equal anywhere in the world and was reprinted and translated many times. Seignobos ended his great survey in a highly polemical manner, by positing that historians have a natural but mistaken inclination to suppose that great changes must be the result of great causes. Historians tend to explain political developments as they might explain geological developments, "by profound and continuous forces, greater than the actions of individual."[205] But except for England, Norway, and Switzerland, which had experienced gradual political change as the result of an uninterrupted process of internal development, the rest of Europe had been exposed to "sudden crises in the wake of sudden events." The revolution of 1830 had smashed the Holy Alliance against the Revolution, had led to the victory of the parliamentary system in the West, and had helped to incubate the Catholic and socialist parties. The revolution of 1848 had led to universal suffrage, had kindled the desire for national unity in central Europe, and had encouraged the emergence of well-organized Catholic and socialist parties. The Franco-Prussian War had created a German Reich with a dominant position in Europe, had destroyed the secular power of the pope, had changed the character of war, and had consolidated a system of armed peace. The revolution of 1830 had been the work of an obscure republican group, helped by the inexperience of Charles X; the revolution of 1848 the work of a few democratic and socialist agitators helped by the sudden demoralization of Louis-Philippe; the war of 1870 had been the personal work of Bismarck, the ground having been prepared by the personal policies of Napoleon III. Seignobos concluded, "In these three unforeseen facts one cannot discern any general cause reflecting intellectual, political, or economic conditions on the European continent. Three accidents have thus determined the political development of contemporary Europe."[206]

Seignobos's argument was reminiscent of Pascal's concerning Cleopatra's nose, and also of Voltaire's sallies. He would have done better to adopt a middle position between "profound forces" on the one hand and "events" as explanatory categories on the other.[207] But then Seignobos was never a sedate middle-of-the-roader; he was a polemicist who liked to shock.

Seignobos's most lasting contributions were the three volumes he contributed

to Lavisse's *Histoire de la France contemporaine*, namely, *La Révolution de 1848: Le Second Empire, 1848–1859; Le Déclin de l'Empire et l'établissement de la 3e République, 1859–1875*, and *L'Evolution de la Troisième République, 1875–1914* (all three published in 1921 and running to a total of 1,364 pages). They constitute an impressive, original, and still unexcelled exposition of internal political developments in France. Seignobos was a political animal. He was preoccupied with contemporary history and provided a lucid analysis of the confusing facets of political life, a telling description of the history of political power. But that was also his weakness. He was fiercely anticlerical and quite unable to see the church as anything but a powerbroker. Seignobos was utterly lacking in sympathy for genuine religious sentiment or devotion. He was a rationalist heart and soul, and a skeptic who found it hard to understand that there could be more things between heaven and earth than his philosophy conceded.

His style was terse, lucid, and precise. He eschewed metaphor, which he said "dazzles without illuminating."[208] He avoided such abstract nouns as "royalty, the Church, elements, tendencies, all of which change too easily into mystical forces." When he described the acts or ideas of a group of human beings, he always referred to that group "by the name of a people, party, or class, or by a collective noun (government, ministry, clergy), in such a manner that, behind the name, the reader can see the men who have acted or thought."[209] In his general vocabulary too Seignobos was almost obsessive in the pursuit of concrete terms. He abhorred pomposity and shoptalk. He confessed to spending a great deal of time finding the simplest formulations, invariably sacrificing elegance for clarity. His prose was dry as dust and cautious rather than elegant.

Before 1914 Seignobos undoubtedly wielded great influence as an educationist, methodologist, and *contemporainiste*, not least thanks to his books, lectures, articles, and newspaper interviews. But he himself edited no journal, published no serial works, was no teacher with a school of followers. Seignobos was a hyperindividualist and desired no disciples. True, before 1914 he would keep open house for close friends and his best students every Wednesday night.[210] A few of them would sit down to dinner, and the rest would turn up (uninvited) later on. They had little patience with those who thought it beneath their dignity to talk about their work, and there were heated discussions about history and politics. Seignobos would often inveigh against recently presented dissertations and the work of colleagues: "That's quite absurd . . . he's an imbecile . . ." He was an arch-heretic who loathed mutual adoration, polite phrases, and academic reverence. He could not and would not flatter—he never gained the title *membre de l'Institut*. He refused absolutely to tie students to his person—he threw his reputation to the wolves. Seignobos's *oeuvre* had its limitations, but he did not deserve the disparagement that was to be his lot.

Charles-Victor Langlois

Charles-Victor Langlois (1863–1929) was a generation younger than Lavisse, Monod, and Aulard.[211] However, because he completed his studies very quickly,

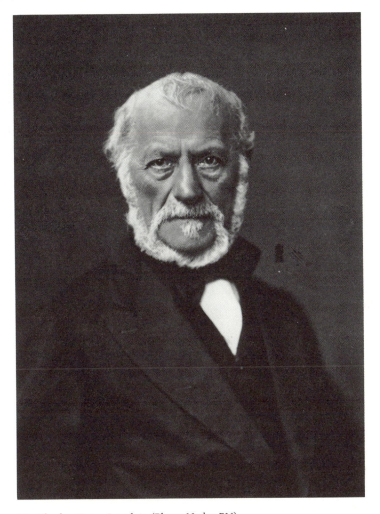

10. Charles-Victor Langlois (Photo Nadar BN)

he almost drew level with his old friend Seignobos, nine years his senior. Langlois was the only one of our *patrons* not to have been a *normalien*. He combined his studies at the highly respected Ecole des chartes (1881–84) with attendance at the reformed Paris arts faculty. At the Ecole des chartes he was greatly impressed with Paul Meyer (Roman philology); as a faculty scholar he was also studied under Lavisse. Fustel's intellectual influence was reflected in Langlois's thesis. In 1885, immediately following his brilliant success at the *agrégation*, Langlois was appointed to the faculty of Douai. A short time later he was transferred to Montpellier. He took his doctorate in 1887, at the age of twenty-four, with an institutional study of the reign of Philip III ("Philip the Bold," 1270–85), to whom, sandwiched as he was between Louis IX ("Saint Louis") and

Philip the Fair, little attention had been paid until then. *Le Règne de Philippe III le Hardi* (1887) was not based on thirteenth-century chronicles, which were little short of being a "list of martial or diplomatic adventures" but said nothing about the institutions Langlois wished to describe, namely, "the progress of royalty, the administrative organization, the attitude of the central authority to the leaders of feudal society, so many topics ignored by the chroniclers of the time."[212] In line with Fustel's institutional history, Langlois focused less on the actual experiences of Philip's subjects than he did on "structural," unconscious institutional developments. The historian's attention, according to young Langlois, who had grown up during the years of the struggle for the Republic ought to be centered on "governments that, not content with merely carrying on, hand down durable institutions to the future."[213] The main difference between Fustel and Langlois was that Langlois shortened the time period covered. Fustel thought a "vast time span" was essential if gross errors were to be avoided;[214] Langlois, by contrast, considered a very brief period a sine qua non of thorough archival research.[215] Langlois concluded that during the reign of Louis the Pious's weak son various monarchic institutions were nevertheless strengthened by the king's servants, who, often of lowly origin but having had meteoric careers (often with an equally abrupt end), had become deeply attached to the monarchy.

At the same time, Langlois did original research into the parliament of Paris (to which, *inter alia,* his Latin thesis was devoted) and, later, into the state of the financial administration and the chancellery during the thirteenth century.

In 1890 (at the same time that Seignobos's position was being regularized) Lavisse fetched Langlois to the Sorbonne as a lecturer in auxiliary historical sciences. Partly as the result of his new appointment, Langlois published three important aids to historical research in archives and libraries, all written within three years of his arrival at the Sorbonne. In collaboration with H. Stein he brought out *Les Archives de l'histoire de France* (1891, 1,000 pages), which replaced the pioneering work of Henri Bordier;[216] with Charles Seignobos he wrote the *Introduction aux études historiques* (1897, 308 pages); and on his own he wrote a *Manuel de bibliographie historique* (1896–1904, 619 pages), consisting of two parts: "Bibliographical instruments" and "History and organization of historical studies."

In the volume he contributed to Lavisse's *Histoire de France* Langlois showed the full measure of his skill as an institutional historian. *Saint Louis, Philippe le Bel, les derniers Capétiens directs, 1226–1328* (1901, 434 pages) was a brilliant synthesis based on the premise that the most important aspect of French history during this period was the "continuous perfection of the monarchical institutions." In a crystal-clear presentation of the events interlarded with telling portraits of the political protagonists Langlois explained to his fellow citizens in the Third Republic why France had not been a free country in the thirteenth century. Having grown up during the struggle for the secularization of French society, he paid exclusive attention to the conflict between the French king and the pope. And since he lived at a time when the Republic was being racked by

scandals and *affaires*, he devoted a chapter to what had been considered causes célèbres in about 1300. The central problem at the time was the question of blame, and Langlois had clear views on that subject. The Templars were not guilty—their trial was "a blatant denial of justice." Langlois was fully aware that the case records were so many treasures of cultural history, but he was far more interested in the guilt or innocence of the unfortunate victims. This chapter remains unsurpassed as a critical study of the examination of witnesses and their testimony. Langlois refused to forget the injustice committed centuries before, to "anthropologize" the archives of the repression into some garden-variety history of everyday life.[217]

In addition to his concern with political institutions, Langlois also developed a marked interest in cultural history. Because of the structure of the *Histoire de France*, he was unable to give much space to the cultural aspect, but the independent publications he devoted to it—*La Société française au XIIIe siècle d'après dix romans d'aventure* (1903), *La Vie en France au Moyen Age d'après quelques moralistes du temps* (1908), and the *Connaissance de la nature et du monde au Moyen Age* (1911)—were acclaimed, adapted, and reprinted several times. In these writings Langlois used a method that sprang directly from his abovementioned dictum "History is made with documents," the opening phrase of his hypercritical contribution to the *Introduction aux études historiques*. He described his procedure as follows: "Rather than cobble together fragments of various texts cut up into small bits and pieces, we shall reel off before the reader, like so many films, a number of carefully dated and reliable documents, adding appropriate notes, so that he . . . may obtain . . . fresh and direct impressions, whose authenticity is not marred by any interposed material."[218] Langlois's procedure must not be dismissed as a neurotic chase after objectivity, nor should it be derided as "scissors-and-paste" history.[219] He used it most successfully to bring medieval culture home to twentieth-century readers, to convey a vivid picture reflecting not the usual hyper-religious sentiments but fiercely anticlerical ones. In a sense this approach, which Langlois did not, of course, consider the only possible one, might be considered a sign of his modesty.

Langlois took a keen interest in educational matters and wrote a number of terse essays on vexed questions in that field.[220] He was deeply interested in the "responsible popularization" of historical knowledge, wrote many successful popular texts, and even became a director of the Musée pédagogique. Like so many other intellectuals, he felt the need for popularization to counter the mass mobilization of the *anti-dreyfusards*. However, the hypersensitive and rather inaccessible Langlois was not suited to teaching orally. He was a recluse and put off his students; as soon as their number exceeded that of the fingers of one hand, he would ask some of them to leave.

His work and reputation made Langlois the obvious successor in Fustel's chair to Achille Luchaire, who had been professor of medieval history at the Sorbonne from 1889 to 1908. Langlois was duly appointed in 1909, but only four years later he decided to change his chair for the directorship of the Archives Nationales.[221] In the world of medievalists this move from a university to

the Archives Nationales was anything but a demotion; even so, his decision was partly dictated by his failings as a teacher. Ferdinand Lot, who was on close terms with Langlois, nevertheless chose to take his doctorate under Pfister in Nancy rather than under Langlois in Paris because of the kind of "character quirk" that caused Langlois quite unexpectedly to come out with "bitter attacks that threatened to put a strain on our friendship."[222]

During his tenure as director of the National Archives, and later when he was president of the AIBL (beginning in 1925), Langlois's authority among medievalists certainly did not diminish, but his formative intellectual influence on the academic world was small. Where Seignobos, who, unlike Langlois, was a skillful debater and a sociable man, described his friend as one of those rare persons who combine intelligence with honesty,[223] twenty years later one of the younger generation of talented medievalists called him "a misanthrope with a solitary and troubled soul."[224] In 1910 Langlois was a *patron*, but one without a following.

Henri Berr

The last *patron* in our procession is Henri Berr, who in 1910 was "only" a teacher of philosophy in the highest class of the prestigious Parisian Lycée Henri IV. He deserves the title *patron* for his role as the founder and director of the challenging *Revue de synthèse historique* (from 1900). Berr's career was not very spectacular—he remained a secondary-school teacher for forty years—but in compensation he acquired a fine reputation in historiography. Berr was placed on the top rung of the historiographic ladder—ahead of Lavisse, Monod, Aulard, Seignobos, and Langlois—by virtue of his being regarded by Lucien Febvre as the forefather of the *Annales*.[225]

Berr (1863–1954) was a *normalien* (1881–84). After taking his *agrégation* in letters he became a teacher, first in Tours, next in Douai (1886), where he also lectured at the faculty, and then in Paris (in 1888).[226] As a teacher of the highest class at the Lycée Lakanal, a *professeur de rhétorique*, he taught for six hours a week; after 1902 he had to teach for two hours a week more. His task was therefore not very onerous or much more taxing than that of a university lecturer. The reports on Berr's lessons were not altogether favorable. In 1889 Liard wrote that Berr "has not been quite able to take the measure of his class," but he added that Berr was a "most worthy humanist." At the end of Berr's teaching career (1925) it was noted that his pupils had only paid him attention from time to time. Berr, who had some private means, asked for early retirement at the age of sixty-two so that he could devote himself wholly to his academic research. According to the inspector, there was no reason to regret that decision: "Monsieur Berr . . . is not worth as a teacher what he is worth as a writer or a scholar."

Berr's "logistic" activities, the founding of his journal, the planning of a new historical series, the *Evolution de l'humanité*, and afterwards the organization of congresses, of the so-called "weeks," must be viewed in the light of Berr's ideals,

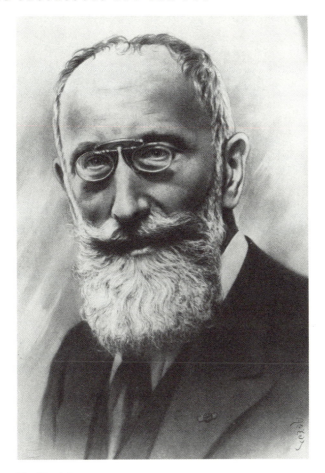

11. Henri Berr

which he set out in two major publications, namely, his thesis, *La Synthèse des connaissances et l'histoire: Essai sur l'avenir de la philosophie* (1898, 512 pages), and his *La Synthèse en histoire: Essai critique et théorique* (1911, 272 pages).

The thesis was long and fairly vague in scope. Berr himself explained that he had worked on this rather hybrid book since 1892. It had a pronounced philosophical orientation, was not very succinctly written, and was full of deep anxieties about the malaise and crisis-ridden feelings of contemporary youth. These *fin-de-siècle* neuroses were reflected in the tension between "life" and "knowledge" and the feeling that "modern life consists of pieces that do not fit together."[227] Berr tried to reconcile unbridgeable opposites in an attempt to improve the future of mankind, as the heading of his conclusion declares. There was a need to "understand and to combine everything . . . philosophy, science, and religion." "Instead of wanting to be ourselves, we must force ourselves to be all" (4).

The thesis contained various useful ideas that, thanks largely to famous articles by Lucien Febvre, would one day become the common property of French historians, for instance, the social character of man and of human knowledge. For Berr sociology was a point of view: the individual exists by the grace of his environment but must not be reduced to a small component of it. A careful reading of Claude Bernard's *Introduction à l'étude de la médecine expérimentale* (1865) had convinced him of the unity of theory and facts, or rather of the context-bound nature of facts, of the need for creative hypotheses, and of the importance of asking the right questions and posing the right problems.

Berr's methodological ideas did not take pride of place in his thesis. His first concern was to improve society with the assistance of the state but without coercion. "It is persuasion above all, the subtle and profound influence of ideas, the slow but sure contagion of new beliefs, that can transform the life of mankind—and thus hasten progress" (489–90). Much as Monod had tried twenty years earlier to bring unity into polarized French society through the study of history, so Berr now asked that the problems of democracy and the role of the aristocracy be put to one side to allow the state to seize the initiative in the development of "this Office of Synthesis, this College turned toward the future" (492). Berr's ideas were a peculiar mixture of idealism and positivism.

Berr's book written in 1911 seems more modern than his dissertation written thirteen years earlier. It is less traditionally philosophical and more strictly historical. Thanks to his long stint at the editorial desk, Berr was now better informed about the work of historians. He proffered fewer speculations about future society and concentrated on the future of historical studies. His attention was focused on "synthesis and history" or on "historical synthesis." What did he mean by that? The concept had little to do with the synthesis of Hegelian dialectics, that is, with the resolution of thesis and antithesis. Nor was there a conceptual affinity between his ideas and "chemical synthesis" as taught by Berthelot, that is, the art of combining elements as a method of arriving at new discoveries.[228] By 1911 Berr, partly under the influence of Paul Lacombe, had come to look upon historical synthesis as little more than *histoire-science*. Lacombe, a regular visitor to the editorial offices of the *Revue de synthèse*, had written a well-argued plea (*De l'histoire considerée comme science* [1894]) to make the study of history more "scientific," that is, more positivist, as distinct from *histoire événementielle*, a concept he himself had coined. But no matter who or what may have been the cause, Berr had unquestionably veered toward positivism.

Essential for Berr was the distinction between "erudite" and "scientific" synthesis. In most syntheses (he was undoubtedly thinking of Lavisse's *Histoire de France*) the main preoccupation had been "the quality of the established and mustered facts rather than the way in which they were combined."[229] Berr objected to the introduction of empirical and artificial contexts, and he quoted Langlois in support of his argument: "The theoretical study of contexts, that is, of the more or less legitimate and fruitful ways of combining . . . data is a capital part and . . . one of the least developed, of historical methodology."[230]

Berr, a courteous man and certainly, unlike Lucien Febvre, no polemicist, would have been the last to deny the importance of erudite syntheses, particularly in education. He approvingly cited Seignobos's dictum that this kind of historical knowledge is "indispensable for anyone wishing to be a complete man of his time, a citizen of his country and of the world." Erudite synthesis, "this empirical reconstruction of a vanished reality, essential while science has not yet matured, is unlikely to have become superfluous, even when science has definitely come into its own."[231] Much as geographical descriptions remain important alongside scientific geography, so, according to Berr, traditional and pedagogical history (in the style of Seignobos) must continue because they satisfy a deep human instinct and are a practical necessity.

However, valuable though erudite syntheses (as distinct from works of popularization) were, it was important to remember that they were not scientific syntheses. Whereas erudite syntheses had a preparatory and limited function, "science" must react to erudition, penetrating and regulating it. Erudite synthesis had the task of "combining the facts in accordance with apparent affinities, without preconceived ideas about their inner relations, or their scientific connections." In addition, "science" must exert control, dissolve artificial combinations and consolidate legitimate ones, and deepen and correct spontaneous interpretations. Erudite synthesis "tries to reproduce life"; *histoire-science* tried to explain it. The ultimate aim of the "science of past human facts" was, according to Berr's positivist line of thought, "power rather than prediction."[232]

Berr's role in advancing the logistics of science was impressive. The importance of the *Revue de synthèse historique* is examined in the next chapter. Here we can say that a cardinal point in Berr's attempts to organize "scientific history" was openness to other sciences. Gabriel Monod had been more cosmopolitan, and his historical knowledge more profound, but his approach had been predominantly historical, whereas Berr's was interdisciplinary. Like Monod, Berr was most generous to younger historians. Berr's writings were not startling and his *oeuvre* was neither widely read nor widely quoted and was less impressive than that of the other *patrons*. He stimulated others and was a great listener ("He listened marvelously," wrote Fernand Braudel respectfully but not without a touch of irony). Berr's enthusiasm, simplicity, and optimism attracted talented young historians, in contrast to the haughty self-assurance or skepticism of Lavisse, Aulard, and Seignobos, which repelled them. Berr wrote countless introductions to the books of others, published in his series *Evolution de l'humanité*.

Lucien Febvre was the intellectual heir to Henri Berr. Febvre was unquestionably the greater historian, more creative, possessed of a greater historical imagination, more style, and an altogether different temperament. Febvre was egoistic, radical, and controversial. His historical philosophy was more materialistic and hence less idealistic than Berr's, but there was a large measure of methodological and theoretical agreement between the two. Berr's best ideas have been handed down to us through Febvre, whose striking success served to seal Berr's fate.

We have allowed this colorful procession of twenty history professors from the class of 1870 and seventeen from the class of 1910 to pass us in review. These two series of individual lives reflect a global reorientation in the historical activities of French university professors. The jack-of-all-trades had made way for the specialist. Is it possible to find a reflection of these changes in the written work of these men?

Changes in Professional Writing

FEW PROFESSIONAL HISTORIANS are prolific writers, generally no more so than ama-
teur historians. In chapter 1 we saw that professionalization, in the sense of the
increase in the number of professional historians, did little to expand the vol-
ume of historical writing. It did, however, have a considerable effect on its
character. So far we have dwelled on the influence of professionalization on
history teaching at schools and faculties and on the classification of historical
material in archives, libraries, and museums. In this last chapter we shall look at
changes in the character of historical publications associated with the social
process represented by the increase in the number of professionals and with the
institutional process thanks to which the faculties increased their influence on
historical investigations.

From the large number of publications by professional historians I have cho-
sen three types: dissertations, journals, and general surveys. The first type, dis-
sertations, is clearly defined. The second type, journals, is heterogeneous, being
more of a medium than a type. A journal contains articles, source publications,
and reviews. Although the editors have some say over the copy, theirs is not an
academic exercise, unlike the assessment of a dissertation. The journal of French
professional historians during the last quarter of the nineteenth century was the
Revue historique, but at the beginning of the twentieth century, as a result of
continuing professionalization and specialization, after twenty-five impressive
and influential years of publication, the *Revue* found it increasingly difficult to
continue as a general professional mouthpiece. There now appeared more and
more highly specialized professional journals, which in turn produced a reac-
tion in the form of a new periodical, the *Revue de synthèse historique*. Last but
not least, we shall be looking at general historical surveys. By and large, profes-
sional historians addressed these to a small number of professional colleagues,
but one such survey, the *Histoire de France*, managed to reach a wider public.
Edited by Ernest Lavisse, it came out in 1901–11 and ran to eighteen volumes.
It was an impressive result of the collaboration of university historians and a
successful example of "high-level popularization."

DISSERTATIONS: SOME FIGURES

During the hundred years from 1810 to 1910 French arts faculties produced
1,333 successful doctoral students. This period in fact saw a marked increase in
arts doctorates, as the survey of annual averages during successive decades con-
tained in table 22 shows. The distribution of these candidates over the various

TABLE 22

Average Number of Doctoral Candidates per annum at Arts Faculties,
1810–1819 to 1900–1909

Decade	Yearly average
1810–19	5
1820–29	5
1830–39	8
1840–49	9
1850–59	12
1860–69	9
1870–79	14
1880–89	18
1890–99	24
1900–1909	30

Sources: Maire, *Répertoire alphabétique des thèses ès lettres*; *Catalogue des thèses et des écrits académiques*.

Note: Not included is the *doctorat d'université*, which could be taken from 1897 on (see *Annuaire des docteurs [lettres] de l'Université de Paris*). In Paris 136 *thèses d'université* and in the provinces 63 were defended from 1899 to 1914. For the annual averages see also Condamin, *Le Centenaire du doctorate ès lettres*, 21.

French arts faculties was uneven. The Paris arts faculty enjoyed a formidable lead. From 1810 to 1880 three-quarters of all theses (492 out of a total of 654) were defended in Paris. The provincial leader was Strasbourg, with 31 *soutenances* over sixty years (in 1870 France lost Strasbourg to the Germans). Among the more active faculties were Caen, with 24; Dijon, with 22; and Lyon, with 20 *soutenances* in seventy years. The middle range included Toulouse, with 13, and Montpellier and Rennes, with 11 *soutenances* each in 1810–80. The eight remaining arts faculties saw very few *soutenances*.

In 1881–1900, two decades of feverish activity in higher education, the Sorbonne increased its lead even further. The proportion of doctoral students in provincial arts faculties was halved, to 12.5 percent. During these twenty years the doctoral degree was conferred in Paris 382 times and in the provinces a mere 55 times. After the loss of Strasbourg the new provincial leader was Bordeaux, with 10, followed by Lyon and Aix-en-Provence, with 8 each, and Nancy, with 7. The middle range was made up of Clermont-Ferrand, Rennes, and Toulouse, each bestowing 4 doctoral degrees in these twenty years. The remaining seven provincial faculties constituted an academic desert, with just 1 or 2 doctoral degrees in this period.

Doctorates were less common in arts faculties than they were in the faculties of law and medicine. At the beginning of the twentieth century there were ten times as many law doctorates (and even more in medicine) as there were arts doctorates. Much lower demands were made on students submitting theses in the law and medical faculties. In the faculty of law a large proportion of all

theses were devoted to legal history. Thus, in the academic year 1909–10, 46 explicitly historical subjects were covered in a total of 271 dissertations (i.e., 17%) defended at provincial law faculties.[1] Most dealt with narrowly defined, minor subjects that demanded only limited technical knowledge of historical processes. As provincial lawyers or notaries such doctors at law might turn into pillars of their local history societies, but they did not earn their living from historical studies and thus were not professional historians.

The Choice of Subjects

From 1810 to 1900 classical antiquity was the favorite period of study among doctoral students in the arts faculties. Subjects and persons taken from classical antiquity were by no means the exclusive province of history students, however; they appealed even more strongly to students of philosophy and literature. The three figures chosen most often by doctoral candidates were Aristotle, Plato, and Cicero, whose names cropped up 46, 39, and 33 times, respectively, in the 1,091 titles of theses defended from 1810 to 1900.[2] Both Aristotle and Plato were more popular than Descartes (17), Kant (15), and Hegel (3) taken together. The great theologians Saint Thomas Aquinas (16), Saint Augustine (16), and Bossuet (19) were not badly represented but came far behind Aristotle, Plato, and Cicero.

Greek playwrights (Aeschylus, Euripides, and Aristophanes, with a combined score of 28) won out over the French (Racine, Corneille, and Molière, with 17). Among the poets, Homer (20), Virgil (12), Ovid (8), and Horace (6) were preferred to Ronsard (3). There were hardly any theses on modern historians, but a respectable number were devoted to classical historians, among whom Plutarch (9), Tacitus (8), and Xenophon (7) did rather well. Greece and Rome jointly were mentioned twice as many times in the titles (46) as France (21). A notable exception to the rule was Louis XIV, with 13 mentions compared with Caesar's 4 and Alexander the Great's 3.

Classical antiquity thus dominated the choice of doctoral subjects. Needless to say, not only the candidate but also his supervisor played an important role in the dogged persistence of the classical tradition. Close on its heels followed the seventeenth-century French classics. Not until the second half of the nineteenth century did the Renaissance enter the fray, particularly so in the persons of Erasmus (4) and Vives (3).[3] With one exception, it was also not until the second half of the nineteenth century that subjects and persons associated with the Enlightenment, such as Voltaire (4) and Rousseau (5), were included.[4] Romantic writers entered the doctoral lists even later and on a modest scale in the persons of Chateaubriand (2) and Sir Walter Scott (1).[5]

There was also a transfer of interest from some arts subjects to others. The end of the nineteenth century witnessed a marked increase in the proportion of historical theses, from 31.1 percent of all theses in 1860–79 to 33.4 percent in 1880–99. The losers were philosophy and French literature. The proportion of philosophy theses decreased from 19.2 percent in 1860–79 to 14.7 percent in

1880–99, and the decrease in literature theses was from 29.9 percent to 27.8 percent. History was the great winner, but modern (foreign) languages also made gains (from 10.7% to 11.2%), and French language (and grammar) was able to increase its relatively small share quite considerably (from 5.1% to 6.5%).[6] Another striking phenomenon was the increasing diversity of subjects. The category "others"—that is, other than history, literature, philosophy, French, and other modern languages—kept expanding. The growing interest of candidates and their supervisors in sociology, psychology, and geography (all of which are largely taught in arts faculties in France) would become noticeable, particularly at the beginning of the twentieth century, though the process had started at the end of the nineteenth.

The Character of the Theses

The *thèse de doctorat* was derived from a century-old oral educational tradition—in days gone by the candidate had been expected to simply state and defend a few propositions. The *thèse* was less a thesis than a program for a public disputation, the medieval origins of the university still much in evidence. Comparisons have been made between chivalrous tournaments and the verbal sparring matches of medieval intellectuals.[7] But no matter what the origins of this academic practice, at the beginning of the nineteenth century, that is, from 1810 to 1830, the length of arts theses was modest and the subject matter often stale.

During these two decades (1810–30) the average thesis comprised fifteen to twenty quarto pages, occasionally thirty and rarely to more than forty. Thus Michelet's 1819 French thesis on Plutarch ran to fifteen pages.[8] Favorite subjects were apologetics, epics, odes, the existence of God, the human soul, truth, memory, methods, ethics, liberty, voluntary death . . . After 1830 the character of the theses slowly began to change slowly, beginning in Paris. A leading part in this process is attributed to Joseph-Victor Leclerc, a professor of Latin rhetoric (from 1824) and dean (1832–65).[9] While he was dean Paris ceased to accept a few pages on some commonplace in philosophy, ethics, or literary criticism as suitable thesis material.[10] Henceforth doctoral candidates were expected to deal with unanswered or open questions. Scholarship made its timid debut in academic dissertations. The rule that every candidate had to defend two theses, one in French and one in Latin, on different subjects taught in the faculty concerned, was given a wider interpretation, though not until the middle of the 1870s. However, decades earlier, the *thèse* in the form of a short discussion paper had been replaced by presentations of the results of more or less independent investigations of traditional academic subjects.

At the beginning of the nineteenth century the *soutenance* was described as a series of witty professorial deliberations on a candidate's thesis while the candidate himself listened and did not open his mouth.[11] In other words, the learned members of the jury crossed swords with one another rather than with the doctor-to-be. The whole thing was a spectacle, an intellectual fireworks display

run by professors and open to the public. In time this changed. True, the show element did not disappear, but the display was now also expected to give proof of the professional expertise of the candidate himself, who was given a greater say. The *thèse* began to assume the form of a dissertation. The demands on the candidate were stepped up and his academic skill was put to the test.

The doctorate became an increasingly difficult hurdle to clear. Before 1860 it happened quite often that the *thèse* was defended even before the candidate had become an *agrégé*. By the end of the nineteenth century that was no longer the case. Dissertations now were considered the crown of university education, *the* measure of scholarly attainment.

The dissertations kept increasing in length and in range of subject matter. In the 1870s the average number of pages was more than three hundred;[12] at about the same time the educational compass of the arts faculty became so wide as to include almost any subject. That, incidentally, did not mean that candidates and their supervisors went out of their way to pick original topics. Many remained attached to the traditionally hallowed academic subjects—for the time being at least. The almost inconceivable tenacity of the tradition was also reflected in the fact that throughout the nineteenth century students were still expected to write one of their two theses in Latin. The most peculiar artifices were sometimes needed to translate modern concepts and technical terms into a language designed for other ideas and another civilization.[13] Many a benevolent academic pitied the French doctoral candidate, who remained condemned to write in a dead language. And it was not until 1903 that the obligatory Latin *thèse* was abolished and replaced with a second French dissertation.

COMPARISON OF HISTORICAL THESES

We shall now put the counting frame to one side and take out a microscope. General counts and observations are bound to be vague. For a more reliable analysis of the changes in history theses we shall now proceed to a comparison of, on the one hand, a limited number of dissertations defended in Paris in 1875, on the eve of the reform of higher education—that is, before historical studies became an academic profession—and, on the other hand, dissertations defended more than thirty-five years later, during the academic year 1911–12, by which time the institutionalization of history had made steady progress.[14]

The 1875 Theses

Theses can be analyzed according to their subject matter, documentation, and method. In respect of subject matter, the distinction between historical and literary theses was vague. Seven of the 1875 history theses had a biographical basis, many of them being about authors of literary works. These authors were no picked from the pantheon of classical antiquity; most had made their mark more recently: Cardinal de Retz, Bourdaloue, Grotius, Barclai, J. Saurin, Ron-

sard, and Herder. Even so, the candidates realized that they were submitting historical studies, not contributions to the history of literature or rhetoric. In the case of Cardinal de Retz, as one candidate explained, the last part of his life, from 1662 to 1679, when he was no longer an archbishop and his great political and religious career was over, really was not part of "history proper" but of "literary biography and history."[15] Two theses on general subjects made works of literature their starting point. Bourdaloue's sermons were used as a springboard for the portrayal of seventeenth-century life and customs. This was very narrow cultural history presented in a high moral tone. Bourdaloue was presented as a "doctor of souls keen to correct social injustice and to sanctify morals."[16] The result was a "moral essay" celebrating Bourdaloue's eloquent pleas from the pulpit in the cause of moral uplift. The second essay in cultural history concerned the position of women in Athenian families during the fifth and fourth centuries B.C., again on the basis of literary texts, though not by any particular author.[17]

The 1875 dissertations gave the impression that the university was self-absorbed, that it had set itself up as the guardian of fine writing and used dissertations to encourage literature. It would, however, be misleading to call the university an ivory tower for that reason. The university was no Lady Bountiful. A literary thesis was no ticket to the fleshpots. Cultivating *bonae litterae* was a way of gaining psychological satisfaction, and an essential constituent of intellectual life in what was still a highly traditional society. There was some interest in cultural history, but it could only be expressed through the literary sources with which one was familiar. Only one thesis constituted a notable exception to this rule. The subject was deliberately not one of traditional academic interest, and the treatment was a milestone in the "historiography of the vanquished," aiming to fathom the secret of the victor's success. This thesis was by Ernest Lavisse and dealt with the medieval origins of Prussia.[18]

As for the second factor, documentation, no archive was researched for any of our nine theses. With a single exception, no unpublished sources were consulted either; the thesis on Cardinal de Retz was the only one to introduce unpublished manuscripts from various libraries. This exceptionally well documented contribution of a thirty-one-year-old candidate, Gazier by name, quickly earned him an appointment at the Sorbonne, where he became *the* specialist on seventeenth-century literary and religious history and *the* expert on Port-Royal, a man whose house was called a "veritable Jansenist museum."[19]

Among the remaining dissertations just one was distinguished by extensive (published) documentation, namely, that of the forty-six-year-old Charles Joret on Herder and the literary renaissance of Germany in the eighteenth century, a work begun long before the Franco-Prussian War.[20] It was a literary study with a strong historical bias. Soon afterwards Joret became a professor of foreign languages at Aix-en-Provence, though history clearly remained his "master science." The other seven dissertation were sparsely documented. It must, however, be stressed that there was a clear distinction between, say, a lightweight dissertation on Ronsard[21] and Lavisse's intelligent *thèse*, which, elegant in design

and eschewing the least show of pedantry, was based on a great deal of thought and proffered astounding insights. The quality of documentation is not, of course, the same thing as the quantity of annotations.

The 1875 theses were mainly based on a small number of books. Most of the candidates, moreover, were stay-at-homes. Lavisse, who had studied in Germany for a time, was the exception. A candidate could do almost all he needed without stirring abroad. He rarely needed to work in a library, and visiting an archive was something that apparently never even occurred to most.

Explicit attention was rarely paid to our third analytical factor, method, which seemed to matter much less than the moral tenor of a thesis. Gazier argued that even though Cardinal de Retz lacked the moral stature of the abbé de Rancé, he deserved full credit for his penitence. The candidate also respected Retz as an author but added that "the writer does not make one respect the man."[22] Gazier was trying to vindicate this arch-intriguer and incorrigible *frondeur*, who showed remorse in his later years and became a pious man. A thesis on Saurin was allegedly based on the premise that "it is their heart that renders men eloquent."[23]

One of the candidates employed what may be called scissors-and-paste objectivity, convinced that using the greatest possible number of quotations was tantamount to "effacing oneself."[24] Candidate Gazier, with his profusion of documents, was full of the typical conceits of the *érudit*, asserting that "the positive facts advanced . . . will not one day be gainsaid by new revelations."[25] This was an approach quite different from that of the "thoughtful and philosophical understanding" Lavisse had in mind when he tried to help his contemporaries to a clearer grasp of burning topical questions by means of historical demonstrations in which historical research was no end in itself.[26] Lavisse practiced "philosophical history" in the great style of Guizot, Mignet, and Thiers, yet he made no explicit appeal to methodology.

The 1911–1912 Theses: Subject and Documentation

The subjects chosen for the 1911–12 theses reflect a growing determination to uncouple history from literature. The predominantly literary line of approach had lost its attraction. Just two of the sixteen dissertations were of the life-and-work-of-the-author type: a thesis on the abbé de Saint Pierre, which portrayed him as a contemporary of the candidate who had strayed into the eighteenth century, and not as a Utopian dreamer; and a thesis on Sébastien Zamet, archbishop of Langres, peer of France (1588–1655), a fierce opponent of Jansenism.[27] The thesis on Zamet betrayed the hand of Gazier, a candidate in 1875 but now a supervisor. In general, we can say that the influence of supervisors had increased as a result of the institutionalization and academic adoption of history. As we pointed out in chapter 5, a new type of professor, the *patron*, had taken the stage. In 1875 there had been hardly any connection between the candidate's choice of subject and the supervisor's particular competence. The growing influence of supervisors was a consequence of not only growing specializa-

tion but also a hierarchical process that could culminate in the establishment of schools—or clans, if one prefers to describe academic pursuits in anthropological terms.

None of the other historical theses was based exclusively on literary sources. (Purely literary dissertations are not being considered in this context.) Of the remaining fourteen dissertations, four dealt with diplomatic history, one with the revolution of 1848, four with institutional history, three with local or regional history, and three with the history of art. None of these subjects had been covered in 1875.

The diplomatic theses covered fairly long periods with clearly defined chronological limits. Emile Bourgeois's influence was evident in all four.[28] Three dealt with French foreign policy—one with the relations between France and England during a few years of the Regency (1723–26); another, running to nearly a pages, with foreign policy during the four years of the Directory (1795–99); and the third with the final phase of the Egyptian expedition (1799–1801).[29] The fourth diplomatic thesis dealt with the relations between Russia and China at the time of Peter the Great.[30]

One thesis took more than five hundred pages to cover the events of four days in 1848. It was a rigorously critical study based on the principle of *autopsy* (seeing with one's own eyes) of the revolutionary days of 21–24 February. This painstaking study of the "February events" had been supervised by Seignobos.[31]

Of the four institutional theses, one dealt with ancient history, namely, the Egyptian military installations under the Ptolemies, largely based on the evidence of Greek papyri.[32] The candidate had worked at the French institute in Cairo. The thesis was not dedicated to the candidate's rather unapproachable and hypochondriacal professor, A. Bouché-Leclercq, the author of a four-volume *Histoire des Lagides* (1903–7),[33] but to Gustave Bloch. Two institutional theses were submitted by candidates with access to special archives: the assistant archivist of the public poor-relief administration defended a thesis on the administration of the Paris Almshouse in the seventeenth and eighteenth centuries, and the secretary of the archbishopric of Auch defended a thesis on church law and church finances from 1300 to 1600, having consulted, among others, the Vatican archives.[34] The fourth, on the reign of Philip I, king of France (1060–1108), was a typical medieval institutional thesis.[35] It described the life of the king, his authority, and his relations with the feudal lords and with the church. This thesis was dedicated to Pfister, but the subject, the institutional aspect of regal power during a particular period of the king's reign, was fully in line with Langlois's ideas.[36] Was this another case of a candidate's shunning a difficult professor?

The three local or regional dissertations all tried to present a more or less integral "social history" from a specific angle. One, on the Reformed Church in Paris at the time of Henry IV, reflecting impressive erudition but sparsely annotated,, covered the most divergent aspects of the Protestant subculture.[37] Another dealt with economic conditions in Languedoc at the end of the ancien régime.[38] "It is no longer true to say that history is exclusively about brilliant

actions and distinguished personalities . . . we have long since passed the time when agriculture, industry, and trade, being the everyday pursuits of persons of low birth, were not deemed proper subjects for historical research," the candidate maintained. He granted the importance of the analysis of social classes in Languedoc, but in his book of almost a thousand pages he focused exclusively on the economic output. The third regional study—*Philippe II et la Franche-Comté*, by the thirty-three-year-old Lucien Febvre—was the most elegant of all.[39] The crisis of 1576 was the starting point of this splendid political, religious, and socio-historical study of Franche-Comté in the sixteenth century, dedicated to Gabriel Monod. None of these local or regional dissertations relied on a chronological sequence for its design or composition; all three were synchronic rather than diachronic in approach. I shall have more to say about chronological order.

Finally, there were two art-historical theses, both written by students of the Ecole française de Rome.[40] One, in folio format, dealt with the architectural history of the Lateran palace. It was not an analysis of architectural styles but a comprehensive collection of archeological data and historical documents set out in strict chronological order. The second thesis, whose creative character was beyond any doubt, examined the influence of Rome on the revival of interest in antiquity reflected in late-eighteenth-century art and literature. Once again, the candidate did not proffer art criticism based on stylistic criteria but viewed the Roman influence in the light of contemporary developments. Remarkably, in an attempt to draw a representative picture he paid more attention to the average artist than to the odd genius.

With regard to documentation, there was a striking difference between the 1911–12 theses and those written thirty-five years earlier: the space devoted to both documentation and historically reliable evidence had been considerably augmented. The thesis had been transformed into a deluge of unpublished sources. In 1875 just one thesis had included unpublished manuscripts. In 1911–12 practically every thesis was partly based on archival research. One candidate even boasted that he had made the least possible use of published material.[41] This almost pathological fixation on archives obviously was considered a methodological virtue by those concerned. It was an extreme illustration of the changed attitude to documentation. Needless to say, it reflected the fact that recent archival inventories had opened up a host of new sources, a sine qua non of the changed outlook of candidates and supervisors alike.

The 1911–1912 Theses: The Historical Method

In time the method of research came slowly but steadily to be considered more important than the results. The deification of the method may be seen as one of the most important consequences of the professionalization, institutionalization, and academic adoption of history. What one did no longer mattered nearly as much as how one did it. The study of history was beginning to be "methodologized." As late as 1875 the method had never or only rarely been mentioned explicitly; what had mattered then was the moral tenor.

Our 1911–12 candidates, by contrast, were greatly influenced by the histori-
cal method, especially when it came to source criticism and the organization of
their material.[47] The historical reliability of the sources was repeatedly put to the
test. The thesis on the four days in February 1848 was based as far as possible
on eyewitness reports; the thesis on the Lateran place contained no "hypotheti-
cal reconstructions" but was made up entirely of "contemporary testimony"; the
thesis on classical influences at the end of the eighteenth century set out to
present nothing but the opinions of contemporaries. Similarly, the four theses
devoted to diplomatic history were based mainly on contemporary archival ma-
terial. Since diplomacy was considered to be a tissue of lies, historians were
particularly on their guard when venturing into this field. With the four institu-
tional theses too the guiding principle was the contemporaneity of the sources.
Since these were largely of an involuntary, non-narrative character, the guiding
critical principle could not be "autopsy." Nor, for that matter, could it be the
sincerity of the witnesses. The same was true of the three local or regional
studies.

When it came to the organization of the material, there was a clear preference
for chronological order, for "following the passage of time as much as possible."[43]
This was a striking feature of the two art-historical dissertations. They were
excellent reference works, but both failed to do justice to their subject. The
thesis on the Lateran palace in particular was an architectural chronicle rather
than an architectural study.

Closely connected with the liking for chronological order was the predilec-
tion for relatively short periods, and when the documents being dealt with were
particularly numerous the periods could be very short indeed. Three of the four
diplomatic theses covered no more than a few years each. One thesis, as men-
tioned above, was confined to just four turbulent days. Several others even had
very fine chronological subdivisions. With some subjects strict chronological
order proved a suitable compositional device, and in any case, the choice of a
short interval could turn out to be an inspiration, rendering a subject more
approachable and providing profound insights. The mechanical use of immuta-
ble chronological sequences and the strict limitation of the time interval may,
however, impede historical insight into certain subjects. Many historical phe-
nomena must be considered over a longer term if one wants to gain an impres-
sion of what really happened, and not fall victim to the illusions of the day.

If we ignore the two biographical dissertations and the three specifically legal-
institutional dissertations among the sixteen theses presented in 1911–12, then
we find that eight of the remaining eleven theses were by and large constructed
along chronological lines. Of these eight, four dealt with diplomatic history in
the style of Emile Bourgeois. Fascinated by discoveries in foreign archives, their
authors painstakingly chronicled events, arguments, and negotiations over sev-
eral years in great detail. In retrospect, one might say that by applying this
particular historical method they ignored the "underlying forces" and reduced
diplomatic history to the story of a vain game played by diplomats. The author
of the thesis on the four days in February 1848 was so preoccupied with the

question of what precisely had happened that he never got round to looking at the causal factors, not so much because of his choice of subject as because of the way he treated it. A study of turbulent events can often serve to lay bare the underlying social structures, but as far as our candidate was concerned, the question of the precise sequence of events during these four days took precedence over all other historical considerations.

The thesis on Philip I (1060–1108) also covered a very short time interval. In keeping with a historiographic tradition, to which we shall be returning, the king's life served as a time frame for a politico-institutional analysis of regal power and of the relationship between the crown, the feudal lords, and the church. Of course, the king's personal influence could not be entirely neglected, but for the analysis of the political institutions the duration of the king's reign provided an artificial demarcation that was defended for purely practical reasons.

The two art-historical dissertations also followed the chronological order of the documents in painstaking detail. In neither case did this approach enhance the artistic insight into, and the historical understanding of, the subject. Whatever its uses, the strict application of the chronological order failed to do justice to the subject.

For the three local or regional theses the chronological plan was not a straitjacket but an operational principle rendering an unwieldy subject more manageable. The delimitations that had to be introduced willy-nilly to facilitate research were first of all spatial in character. In the case of the thesis on the Protestant church in Paris the time limits were reflected in the title—"at the time of Henri IV"—but the author did not keep strictly to that specification. Instead, he launched into a broad discussion of the relations between church and state, the public and private lives of Protestants, their intellectual and artistic contributions, and their role in Parisian society and trade. In the thesis on Franche-Comté the 1567 crisis was the occasion for presenting a sweeping panorama of a regional society in the sixteenth century, with the bourgeoisie and the aristocracy holding the stage.[44] The economic history outlined in the thesis on Languedoc at the end of the ancien régime set out to analyze the economic activity of various sectors. The authors of these three theses were concerned less with temporal developments than with particular conditions. All three used the synchronic approach.

The Interdisciplinary Approach and Quantification

Whereas some of the 1875 historical theses were barely distinguishable from literary dissertations, thirty-five years later, in 1911–12, there was no doubt which candidate was a pure historian and which a man of letters. There had been a process of growing disciplinary independence: literature and history had gone their separate ways. The history of art, however, had not yet gained its independence: art-historical dissertations continued to be looked upon as the work of historians who had specialized in a particular field.

Regarding historians' relations with other disciplines we can only say that their recently acquired disciplinary autonomy did not incline them to join in interdisciplinary collaboration. We get the impression that the majority of our candidates wanted to apply the historical method to the full and what the results were before consulting other disciplines. It should be remembered that strict source criticism, chronological organization, and focusing on a brief time period had produced good results. Although the disadvantages of this approach were recognized by some historians, in general satisfaction with the gain in accuracy and detail prevailed.

The striking exception to this general trend of shutting oneself away in one's own field was the candidate with the most promising future, Lucien Febvre. A born historian, an irrepressible romantic, and one possessed of a graphic historical imagination, Febvre was greatly attracted by geography, a subject that had begun to gain academic independence during the first decade of the twentieth century. In the *agrégation* geography remained tied to history until 1942, but in dissertations a clear distinction was being introduced. Febvre was strongly influenced by the geographer Paul Vidal de la Blache, his teacher at the Ecole normale, and he was a close friend of the slightly older Albert Demangeon, who had taken his doctorate in 1905 with an impressive study of Picardy, and also of Jules Sion, a comrade from the Ecole normale who had obtained his doctorate in 1909 with a fine study of the peasants of eastern Normandy.[45] Even before his *soutenance* Febvre, having first approached Jules Sion and consulted Vidal de la Blache, had agreed to contribute a book to Henri Berr's series, *La Terre et l'histoire*, which because of the war did not appear until 1922 under the new title *La Terre et l'évolution humaine*. The fact that Sion and Vidal both advised Febvre to write this book shows that he was not considered a "monodisciplinary" historian. Neither of these two geographers, incidentally, was an anxious guardian of his own field or a petty academic sectarian. "They were not the kind of men to organize the protectorate of the slipper against the cobbler's trade," as Febvre put it.[46]

The second exception to the trend of shutting oneself off in one's own professional field was Léon Dutil, whose thesis drew an overall picture of economic activity in Languedoc at the end of the ancien régime. Here too geography served as an intellectual sparring partner. Hundreds of pages were devoted to a detailed discussion of agricultural output, industry, and the circulation of products. In contrast to Febvre's thesis, Dutil's proffered no analysis of social classes.

None of these theses relied significantly on quantitative data, let alone on "sophisticated" computations. Academic history was still in the prequantitative stage. True, figures were cited in the regional study of Languedoc and (to a lesser extent) in the study of Franche-Comté, but there was no attempt to introduce statistical tables or graphs.[47] Quantification provides the obvious solution to the problem of selecting, reducing, and generalizing the enormous mass of published or unpublished source material,. Counting is often the simplest form of generalization. Quantitative methods were developed by historians in the interwar years, especially (but not exclusively) as a way to deal with price fluc-

tuations, but it did not become an indispensable part of French history theses until after the Second World War. Then there was a development comparable to what we have seen in connection with methodology at large: quantification changed from a means into an end, so much so that the reliability of quantitative techniques seemed more important than the research findings. Nowadays, technical accuracy and sophisticated methods of computation are considered to be the ultimate objective of specialist investigations. In the history theses of 1911–12 there was still very little quantification on the whole; when figures were mentioned the influence of geography was paramount.

Febvre versus Lavisse

No matter how valuable and useful most of the 1911–12 theses may have been in bringing to light, compiling, and providing critical analyses of documents— and that was a major way in which they differed from the 1875 theses—only Lucien Febvre's broke new ground in university history studies. It served as a source of inspiration, if not as a paradigm, for broadly based social, structural, and regional-history studies. In this context the historical inaccuracies in Febvre's monograph are no more important than his compositional imperfections, which were the result of his wavering between portraying a synchronic state and describing the course of events.[48] Verifiability matters less here than originality and a fruitful effect on future historical research. A thesis like Febvre's solves problems or removes blind spots in established research patterns. A masterly thesis leads to a reorientation and can become a model for future theses. Febvre's thesis was just that; the other theses simply added to the store of established knowledge.

The thesis of the most talented of the 1875 candidates, by contrast, had had a signaling rather than a paradigmatic function. Like Lucien Febvre, Ernest Lavisse was thirty-three years old when he took his doctorate, but he could look back on a much more turbulent past. Having been the intimate of Victor Duruy, the *grand ministre*, at an early age and a tutor to the *prince impérial*, he had fled, confused and destitute, into academic exile in Berlin after the fall of the Empire, to return home an expert on the history of contemporary Prussia and the German Reich. In his thesis Lavisse had tried to retrace the origins of a country that had robbed France, undeniably and in humiliating fashion, of its leading position on the European continent. The orientation of Febvre's thesis was patently less *engagé*. His description of the region with which he had been familiar since childhood was devoid of the least political dimension. Febvre was able to work much longer on his dissertation than Lavisse, and in greater peace. Lavisse's thesis expressed several ideas on Prussia that were to have a marked effect on the French public at large, no less so than on his students. Many subsequent theses on Prussian history were to elaborate ideas that Lavisse first propounded in his thesis and later expanded in numerous articles and books. Citizens and professional historians of a conquered nation anxious to come to grips with the conqueror were able to turn to Lavisse. Thus not only was his work widely

influential but it was fairly soon superseded by more extensive research. Feb-vre's thesis did not become known outside the circle of his fellow historians; here, however, it came to be considered a model social study in regional his-tory, one that was emulated by many doctoral candidates, particularly after the Second World War. Almost sixty year later it was republished in a pocket edi-tion. Febvre's readership was very much smaller than Lavisse's, but in the con-fined circle of professional historians his influence was deeper and more lasting. Must that not be considered a direct intellectual consequence of the profession-alization and academic absorption of history? The most talented historians of two generations, each with a fascinating style of his own, were sharply divided by a gulf created by the professionalization of history—Lavisse the historian admired by an educated public, Febvre the adulated historians' historian.

Oddly enough, although Lavisse was not a professional historian by training or career, he was nevertheless able to advance the professionalization and aca-demic adoption of history through the professorial appointments he was able to make (for it was Lavisse who pulled the strings of higher education for de-cades). Febvre, by contrast, although a professional historian by training and career, tried to break out of the narrow professional circle through inter-disciplinary cooperation. The monument Lavisse left behind was his *Histoire de France*, Febvre's was the *Annales*. Lucien Febvre never reached a wide, educated public. His dicta on life and man; his exhortations "Live first . . . immerse yourself in life"; and his protests against the parochial spirit of the specialists were carved into almost tragic relief by the inevitable growth of specialization. Febvre was a professional historian, but the narrow constraints of professional-ism went against his grain.

TWO NEW DISCIPLINES: SOCIOLOGY AND GEOGRAPHY

The theses defended in arts faculties at the end of the nineteenth century and at the beginning of the twentieth century reflect the rise of two new disciplines with a direct bearing on academic history teaching and research. The addition to the list of suitable subjects for doctoral theses of sociology in the 1890s and geography a decade later faced historians not only with institutional competitors but also with intellectual rivals challenging the hegemony of the historical method. As far as the institutional competition was concerned, historians had nothing to worry about. For a long time university posts for sociologists could be counted on the fingers of one hand, and as sociology was not included in the secondary-school curriculum there was no job market for sociologists to speak of. In respect of training and examinations sociology had remained stuck in the institutional framework of philosophy.

Geographers fared better when it came to university posts. In due course every arts faculty was able to boast a special chair of geography. Paris even had three after 1909: one established as early as 1812, in which Himly (1863–98) was succeeded by Paul Vidal de la Blache (1898–1914); a separate chair of

colonial geography, financed by the Colonial Ministry; and a chair of "geography and topography," founded in 1909 and entrusted to Lucien Gallois.[49] In other faculties, however, posts for geographers remained few and far between. Historians were content with this clearly defined but modest place for geographers; some of them were only too glad to leave the preparations for the examinations to geographical specialists. In the *agrégation* history and geography were amalgamated; specialization was left for the doctoral examination. Whereas institutionalization turned out to be somewhat of a disaster for sociology, the term *semi-failure* being a euphemism for what really happened,[50] geography managed to find a small but firm institutional niche in the arts faculties.

Sociological theses were unknown before 1890, with one notable exception: a dissertation by the original and independent Alfred Espinas entitled *Des sociétés animales* (1877, 389 pages). Because the term *sociologie* was not yet in common use, the dissertation was subtitled *Etude de psychologie comparé*. Following in the footsteps of Comte, and influenced by the evolutionism of Herbert Spencer in particular, Espinas treated social organization as a biological phenomenon.[51] In the 1890s six dissertations were defended that authors and readers alike considered to be sociological in character, and they were openly described as such. The first was Durkheim's *De la division du travail social: Etude sur l'organisation des sociétés supérieures* (1893, 471 pages).[52] Two were by candidates who, at least at the time, were part of Durkheim's circle, namely, Gaston Richard, who had taken his doctorate one year before Durkheim with a study of the sociology of law, and one by the younger Célestin Bouglé, who took his doctorate in 1899 with *Les Idées égalitaires: Etude sociologique* (1899, 251 pages).[53] Two other sociological theses were defended by rivals of Durkheim, both of whom were fighting for power and influence in the new sociological realm. The eclectic Jean Izoulet caused a stir with his bulky thesis *La Cité moderne et la métaphysique de la sociologie* (1894, 691 pages; 11th ed., 1910) and was appointed to the chair of social philosophy at the Collège de France in 1897, a few years after taking his doctorate.[54] René Worms, who had previously taken his doctorate in law, obtained his arts doctorate with *Organisme et société* (1895, 406 pages). In 1893 Worms had founded the *Revue internationale de sociologie*, which counted renowned scholars among its contributors.[55] (The first issue of Durkheim's *Année sociologique* did not appear until a few years later.) Finally, in 1899 another doctoral candidate presented a "historical and critical study" of Comte's sociology.[56]

During the first decade of the twentieth century there were just four theses that can be described as "sociological," all four submitted by candidates from Durkheims's circle: Adolphe Landry (1901), Paul Lapie (1902), Hubert Bourgin (1905) and Octave Hamelin (1907).[57] Durkheim's influence also made itself felt in other dissertations, for instance, in that of the classical historian Gustave Glotz, although Glotz's *La Solidarité de la famille dans le droit criminel en Grèce* (1904, 621 pages) was primarily historical in character.

While there was a decline in the number of sociological theses from the 1890s to the beginning of the twentieth century, there was a marked increase in

the number of geographical theses. Before 1890 no purely geographical theses were defended. Vidal de la Blache, the future *auctor intellectualis* and *grand patron* of university geography, had taken his own doctorate in 1872 with a thesis on the life of Herodes Atticus (1872, 184 pages).[58] There were also a few somewhat skimpy theses in historical geography: one on the geographical ideas of Saint Gregory of Tours (1858), another on the topography of the Attic demes (1853), and one on Arrian's voyage around the Black Sea (1860).[59] Autonomous geographical theses, that is, theses in which a geographical subject was not exclusively examined in the light of historical sources, first appeared in the 1890s. Although Lucien Gallois was still forced "by the tyrannical influence of Himly, dean of the Sorbonne,"[60] to choose a historico-geographical subject, namely, *Les Géographes allemands de la Renaissance* (1890, 266 pages), and Paul Camena d'Almeida's thesis, *Les Pyrénées: Développement de la connaissance géographique de la chaîne* (1893, 328 pages), was also bound up with history, there were now two purely geographical theses, one on the Sahara (1893, 443 pages) and one on the archipelago of New Caledonia, in which the candidate, incidentally, had never set foot (1895, 548 pages).

During the first decade of the twentieth century eleven purely geographical theses were defended in Paris.[61] Of these, seven covered French regional geography. The first regional-geographical thesis, which would serve as a model study or paradigm, was Albert Demangeon's thesis on Picardy, *La Plaine picarde: Picardie, Artois, Cambrésis, Beauvaisis. Etude de géographie sur les plaines de craie du Nord de la France* (1905, 496 pages). Emile Chantriot followed quickly with a thesis on Champagne (1905, 316 pages); Camille Vallaux with one on Lower Brittany (1907, 320 pages); Raoul de Félice with one on Lower Normandy (1907, 590 pages); Antoine Vacher with one on Berry (1908, 548 pages); Charles Passerat with one on the plains of Poitou (1909, 238 pages); and Jules Sion with one on the peasants of Eastern Normandy, a thesis with the subtitle *Etude géographique sur les populations rurales de Caux et du Bray, du Vexin normand et de la vallée de la Seine* (1908, 544 pages).[62] Not only the last thesis, which mentions it explicitly in the title, but other regional studies as well reflect considerable interest in the interplay of physical circumstances and human activity. Thus various titles include the term *géographie humaine*. The first to use it in the title of his dissertation was Jean Brunhes in his *Etude de géographie humaine: L'irrigation, ses conditions géographiques, ses modes et son organisation dans la péninsule ibérique et dans l'Afrique du Nord* (1902, 518 pages). Introduced in various publications by Vidal de la Blanche and later elaborated by Demangeon in academic circles, *géographie humaine* became current usage through the brilliant contributions of Brunhes, who was appointed to a chair by that name at the Collège de France in 1912.[63] Apart from Brunhes's, there were another three such theses on countries other than France: one on Madagascar (1902, 428 pages), one on Walachia (1902, 385 pages), and one on French Guinea (1905, 326 pages).

Durkheim and his circle found it hard to accept geography as an independent discipline. In the 1890s sociologists had ridden high in the confident belief that

their discipline was destined to become *the* all-embracing social science. Durkheim had produced exemplary studies and established the appropriate methodological rules, but unlike the regional geographers, he had failed to develop a clear-cut research program. He himself had come to appreciate this shortcoming: even before French *géographie humaine* had been properly developed, he had insisted in several of his reviews of publications by Friedrich Ratzel, the founder of *Anthropogeographie*, that while the geographical factor casts no fresh light on sociology, it can only be understood with the help of the latter. Durkheim accordingly advocated the inclusion of geography in a "morphologie sociale."[64] François Simiand, a methodological fanatic, who had tried to show historians the error of their ways even earlier, launched an attack on regional-geographical theses in *L'Année sociologique* (1906–9). He considered these theses useful compendia, comparable to lists of historical dates or dictionaries, but without *scientific* value because of their failure to adduce an "explicative nexus."[65] Simiand's was a rigid positivist, causal interpretation: what could not be subsumed under laws was not real knowledge. Admittedly there was some truth in Simiand's reproach that "confining oneself to such small regions meant eschewing the only means of distinguishing between chance or irrelevant coincidence and true correlations," but his alternative, namely, to start, as in any other science, with "the analysis of simple, general relations,"[66] was inapplicable, and reflected a failure to appreciate the full complexity of the relations between man and his environment. Geographical fieldworkers must have looked askance when they heard about Simiand's refusal to study a region "in all its complex individuality" until a "science of social morphology" had first come up with general explanations and established the necessary relations.

While historians and geographers contracted a *mariage de raison* on the institutional plane, respected each other on the intellectual plane, and sometimes collaborated fruitfully with one another,[67] sociologists, who looked down with omniscient superiority on historians and geographers alike, failed to find firm moorings in French academic institutions. Despite their unmistakable intellectual influence and prestige, the sociologists, who kept execrating or squabbling among themselves, went away empty-handed. The various interdisciplinary contacts between historians and geographers, by contrast, and particularly their interaction in the arts faculties, had more than a purely institutional impact. Nor can they be reduced to chance personal relations in a small academic world. There was, it would appear, also a marked difference in academic habits. An offshoot of philosophy, or at least applied by people who had enjoyed a philosophical education, French academic sociology had a pronounced theoretical and abstracting bias and used a deductive approach. French university sociologists thought little of fieldwork. Historians and geographers, for their part, had a predominantly practical attitude and adopted the empirico-inductive approach: they preferred to concentrate on a limited period of time or on a limited area. Theoretical treatises did not enjoy first priority among them. The approach of historians and geographers was of a piece, that of sociologists all their own.

THE SOCIAL DIMENSION OF THE THESES

On 7 August 1852 Monseigneur Sibour, archbishop of Paris, spent two hours at the *soutenance* of the abbé Joseph Leblanc, who was taking his doctorate with a thesis on profane literature during the early centuries of the consolidation of the church.[68] The prelate's presence reflected the social importance attached to the occasion. The abbé Gaume's *Le Paganisme dans l'éducation* (1851), with its fervent plea for the removal of the heathen classics from the school curriculum, had unleashed fierce arguments.[69] The classics, "that canker of modern society," he had pleaded, should be replaced with the fathers of the church. The 1850s witnessed strong Catholic pressure on public education and the spectacular growth of denominational schools. The abbé Leblanc's thesis was thus of burning topical interest.

On 20 June 1897 the conferment of the doctoral degree upon Charles Andler was graced by the presence of the socialist deputy and renowned orator Jean Jaurès, a leading parliamentarian. Andler took his doctorate with a dissertation on the origins of German state socialism, having made a thorough study of the writings of German philosophers and theorists (such as Hegel, Savigny, Gans, and especially Rodbertus, von Thünen, and Lasalle) on law, property and expropriation, economics in general, the organization of labor, and the distribution of incomes.[70] The press paid a great deal of attention to this particular *soutenance*. Thus the respected *Journal des débats* published a reasonably sympathetic report under the heading "Socialism at the Sorbonne" stating that one had only to listen to Andler for a few moments to feel "the terrifying power of his imagination, the probity and refinement of his conscience." *Le Temps* carried a less friendly report, accusing Andler of upholding pure collectivism, which, according to the journalist, could only lead to despotism and barbarism, when nature herself presided over man's inequality. One member of the jury, the philosopher Emile Boutroux, stressed the ugly face of socialism, upholding instead the "splendor of the pure idea, the protests of the mysterious but divine essence of the universe against the feeble revolts of the presumptuous." It should be pointed out, by the way, that Andler was anything but a collectivist; he merely wished to curb shameless self-seeking and to break the taboo on the least infringement of private property rights. Here we are less concerned with Andler's thesis, however, than with the reactions to it.

The most virulent was Charles Maurras's attack in *Le Soleil* (2 July 1897). Democratic anarchism and collectivist organization were, according to Maurras, antagonistic in appearance only; actually they were impelled by the "same egalitarian passion" that sprang, not from idealism, but from envy and impotence or laziness. It was bad tactics merely to insist that these systems were ruinous. It was not enough to show that such ideas were chimerical. One must also show up their ugliness and base nature. "Collectivism must be knocked on the head," and that, according to Maurras, was something the moderate papers, with the exception of *Le Temps*, had failed to do. "They have admired his [Andler's] ideas, have praised his religious gravity." Many readers may have come to think

that collectivism had now found its philosopher, having previously found its rhetor in Jaurès. If that view became rooted in public opinion, it would pose a greater threat than thirty or forty socialist deputies in the Chamber, Maurras observed bitterly.[71] According to Maurras, great dangers lurked behind such theses as Andler's. The candidate's pretense of propounding *scientific* socialism may not have taken in some of the jury members, but the mere fact of their providing him with an academic platform aided the public respectability of socialism as a general and personal philosophy.

The presence of the archbishop in 1852 and of a famous socialist parliamentarian in 1897 highlights the social involvement of the candidates concerned. Not only did the theses presented reflect the influence of the professionalization, academic adoption, and specialization of history but they could be palpably affected by social factors. Academic development is not a laboratory phenomenon.

The Academic Adoption of Socialism

In the 1890s socialism began to gather strength in France. The 1893 elections spelled success for socialist groups of various plumage, and particularly for the independent socialists, who took fifteen seats in the Chamber. At that point, Millerand, not Jaurès, was still their leader. The municipal council elections of 1896 also proved the strength of the socialists. Various left-wing groups entertained the hope that in the near future socialists would come to power by legal means, through the ballot box. Side by side with left-wing political organizations, the trade union movement also grew in strength.[72] Whereas the Paris Commune had scared the wits out of the academic world, and the number of academics involved in the uprising had been negligible, in the 1890s there was a marked rise in the number of those holding more or less socialist ideas in Parisian university circles. Various theses submitted in the arts faculty gave evidence of the previously unknown attraction of socialist and related views.

Before 1890 not a single thesis on any aspect of the socialist movement was defended at French arts faculties. In the 1890s three dissertations had the word *socialism* in their titles. Jaurès himself had been the first, with a brief Latin dissertation on the origins of German socialism in 1891.[73] Remarkably, he dealt with such "idealists" as Luther, Kant, Fichte, and Hegel but ignored the materialism of the Young Hegelians as well as modern economic developments. Andler's 1897 contribution was of a completely different caliber,[74] yet for all the differences between them, it was significant that both Jaurès and Andler chose German socialism as their subject. Theirs was no longer—as it had been with Lavisse and other historians during the decades following the defeat of 1871—"the eastward look of the vanquished" but a search for explanations of the success of the socialist party in Germany and the undeniable achievements of the German Reich in the field of social legislation. How was it possible that in the "reactionary" German empire the position of the socialists was so much stronger, and the legislation so much more "progressive," than in republican France, the country with a great left-wing tradition?

The third thesis submitted in the 1890s bearing the word *socialism* in its title was by a historian. (Both Jaurès and Andler had been trained as philosophers, although Andler, after repeated experiences with the jury of the *agrégation philo* had finally decided to end his education with an *agrégation* in German.)[75] This lengthy dissertation, by André Lichtenberger, dealt with the socialist ideas of eighteenth-century French writers. Lichtenberger gave socialism a very broad definition, treating as a socialist any writer who, on the basis of egalitarian or communist ideas, especially about the state, criticized the traditional organization of property and the distribution of wealth and wanted to change society.[76] Tommy Perrens, the inspector of higher education, a "red republican" of the old school (of 1848), found Lichtenberger's thesis most interesting: "Nowadays socialism is very much in our thoughts and its antecedents are therefore of importance." The candidate, who had dedicated his thesis to Aulard and Lavisse, appeared before the jury dressed in a black suit with silk or satin revers (old Perrens could not tell the difference), "a finely pleated shirt, and lacquered buttons." Perrens, who had seen him a year earlier by the seaside "dressed like the perfect gentleman," described him as "a bit of a poseur, a man who fancies himself . . . but a keen mind for all that." Perrens was clearly sympathetic to the candidate's viewpoint. "From the confused ideas and the torrent of abrasive language it can be discerned, by and large, that the principle of private property no longer enjoys the superstitious respect inculcated in the generation to which I had the misfortune of belonging."[77]

With these three "socialist" theses the Parisian arts faculty played a pioneering role. If we ignore two minor theses on the links between socialism and Christianity, defended at the theological faculty at Montauban, then the Paris arts faculty may be said to have rung in the academic adoption of socialism.[78] Not surprisingly, it was widely considered to be more left-wing not only than the provincial arts faculties but also than the other faculties in Paris. Whereas in the 1890s the arts faculty had merely tolerated junior lecturers bent on rendering socialism more scientific, at the beginning of the twentieth century it added men with known socialist convictions to its "scientific" staff.

Does that entitle us to speak of the "politicization" of university life, especially in Paris? The right-wing, antirepublican press kept firing broadsides at the Sorbonne. With great indignation and often with great literary skill, it alleged that the Sorbonne was hand in glove with the republican government and inveighed against the nepotism and careerism to which it alleged academic pursuits had fallen prey. At the drop of a hat disturbances were set off in and around the lecture halls. With every fresh appointment came attempts to provoke some sort of scandal. That was one direct result of the growing political polarization. In the 1920s Julien Benda described the turn of the century, in his notorious *Trahison des clercs*, as a time in which "scholars started to play the game of political passions."[79] In saying that, incidentally, Benda was referring more to the nationalism of Barrès, Maurras, and their circle than to the armchair socialism of the Parisian professors.

The phrase "politicization of university life" is in any case misleading inas-

much as most university professors had clear reservations about the political parties. Some, such as Aulard, were party members, but they were the exception. Much more typical was Durkheim, who did turn up at lectures with *L'Humanité*, the Communist paper, under his arm, but insisted on preserving his independence.[80] Party political propaganda went against the grain of most French professors.

The younger generation of academics gave politics less wide a berth. Charles Andler has described how in about 1890 he, together with Lucien Herr, the influential librarian of the Ecole normale supérieure, became a member of Jean Allemane's socialist party, which had a purely "proletarian" membership and subscribed to the then novel doctrine of the general strike. "We felt," Andler explained,

> as if we had stepped into the shoes of "those great *universitaires* who had been republicans at the time of the Empire." . . . We promised ourselves to give the Republic all the professional devotion of which we were capable. Our aim was to make ourselves indispensable by our scholarship. . . . We were very discreet. It would have been a terrible blunder to preach socialist ideas openly in the educational world, for that would only have provoked opposition. The students were left to discover their own truths. . . . All they expected from their teachers was technical skill. . . . Our task was to serve them as irreproachable technicians.[81]

There is no reason to doubt the sincerity of this testimony of one of the most highly "politicized" academics of the time. Even such staunch party members as Andler and Herr were convinced that they could best serve the advent of the "Social Republic" by providing "technically perfect" scholarship. Andler and Herr were conscientious enough to draw a clear distinction between the latter and political activity. The critical theory of the *Frankfurter Schule* had not yet ruffled the conscience of left-wing academics.

Perhaps it would be more accurate to speak of these developments as representing the interpenetration of university and society rather than the politicization of university culture. In any case, there was a clearly discernible "socialization" of the subjects chosen for theses in the arts faculty. Before 1890 classical orators and poets, philosophers, and theologians were the most popular subjects. In the course of the nineteenth century fifteen theses on Christianity and the church were defended in the arts faculty but not a single one on socialism or collectivism before 1890. Similarly, fifteen theses dealt with the concept of God and the proof of God's existence, but there was not a single one on Marx. There were nineteen theses on Bossuet but not one on Proudhon, Fourier, or Louis Blanc. The first thesis on Saint-Simonism was defended during the second half of the 1890s.[82] The use of the term *socialism* and the choice of socialist thinkers as fit subjects were not the only signs of the "socialization" of academic dissertations;[83] the trend was also reflected in the emergence of specifically sociological theses. For is it not true to say that in the 1890s quite a few people came to look upon sociology as the science of society, whose scientific methods would be able to solve most social problems? For many people there was little

difference between scientific socialism and sociology.[84] Tommy Perrens, the seasoned inspector of higher education, considered Andler's *soutenance*, coming as it did after the theses of Worms, Izoulet, Basch, and Durkheim, a sign of "the new science at which our parents would have been no less surprised than Louis XIV would have been by railways." That science was sociology.[85]

There was a clear difference in the way sociologists and historians expressed the "socialization" in their doctoral theses. In keeping with the previously mentioned differences in scientific attitude, the philosophically trained and prosocialist young sociologists were mainly concerned with the study of principles and theories. Bouglé took his doctorate in 1899 with *Les Idées égalitaires: Etude sociologique* (219 pages), and Adolphe Landry took his in 1901 with *L'Utilité sociale de la propriété individuelle* (510 pages). Prosocialist young historians, for their part, preferred empirical studies based on historical documents culled from economic history. Thus Paul Mantoux took his doctorate in 1905 with *La Révolution industrielle au XVIIIe siècle: Essai sur les commencements de la grande industrie en Angleterre* (543 pages), and Camille Bloch took his in 1908 with *L'Assistance et l'état en France à la veille de la Révolution (généralités de Paris, Rouen, Alençon, Orléans, Châlons, Soissons, Amiens, 1764–1790)* (568 pages).

In an interview in *Le Temps* (5 September 1900) Gabriel Monod, the teacher of the young generation of historians and the moral conscience of university history studies, defined young historians' attitude toward the social question as follows: "Of course, they rather lean toward socialist politics, but they [the young historians] are less doctrinaire than their philosophical (and sociological) comrades. These historians want no more and no less than the introduction of the historical method into the study of social questions."[86]

THE HISTORIANS' JOURNAL: THE *REVUE HISTORIQUE*

In the spring of 1875 the thirty-year-old Gabriel Monod asked the publisher Germer Baillière to join him in founding the *Revue historique*.[87] At that moment France lacked a strictly academic and independent history journal, Monod explained. There were of course such general journals as the prestigious *Revue des deux mondes* and *Le Correspondant*, both of which gave much space to historical articles and reviews. There were also hundreds of local periodicals in which regional and local historiography was discussed. In 1839 there appeared the *Bibliothèque de l'Ecole des chartes*, the *BEC*, in a sense the oldest French journal having the four characteristics of a professional historians' journal: historical studies, critical source publications, book reviews, and an informative column with varied reports, including obituaries. The *BEC* was not, however, a general journal for historians but the official organ of current and former students of the Ecole des chartes, devoted almost exclusively to the history of the Middle Ages in France. Since 1866 there had also been a general journal with the above-named four characteristics but without temporal or geographic limitations, namely, the *Revue des questions historiques*. It was an offshoot of the *Revue*

du monde catholique, founded in 1861 to provide a Catholic counterweight to the *Revue des deux mondes*, whose influence had been expanding, especially since the 1850s. People suspected that the Jesuits were behind the founders of the *Revue du monde catholique*, an uncompromising ultramontane journal. The *Revue des questions historiques* was really the independent version of the historical column of the *Revue du monde catholique*. In the middle of the 1870s, at the same time that Monod made his proposal to Baillière, the republican government was still anything but firmly in the saddle, and the *Revue des questions historiques* was politically committed to the restoration of the Catholic monarchy.

The young Monod envisaged the *Revue historique* as a journal that would stand above the political parties, publishing unprejudiced, conciliatory, and strictly objective historical studies. However, Monod himself was of Protestant descent and inclined toward free thought and liberalism; he was a cosmopolitan with family ties in many European countries and had married the daughter of the Russian revolutionary Alexander Herzen. Monod had left-wing sympathies and looked forward to the consolidation of a fair and just republican form of government that would reconcile French society, which was then racked by inner dissension. The contributors to the *Revue historique* shared Monod's views, and on that basis Charles-Olivier Carbonell called it a "fighting journal,"[88] the arch-rival of the *Revue des questions historiques*, a journal dominated by Catholic and royalist *chartistes*, many of noble descent. The distinction was not, however, as sharp as all that. The *Revue historique* had a less virulent tone and was less biased and less colorful than the *Revue des questions historiques*. It was not overtly political, and in any case it was more open. Its critical views could be very severe, but its objective was to bridge conflicts, not to fan them.

The *Revue historique* was more of a professional journal than the *Revue des questions historiques*. That, incidentally, had not been Monod's original intention. He had wanted to address not only "those who make a special study of history" but also "anyone interested in intellectual matters."[89] The *Revue historique* succeeded in reaching professional historians from the outset, but its influence never went much further. And although Monod's notes on contemporary history sometimes assumed the form of political commentaries,[90] he was ultimately alive to the fact that the *Revue historique* was a professional journal. Yet, being intensely involved in the problems of his day, and convinced that the study of history was a form of mental hygiene designed to fight fanaticism and spread (historical) understanding and tolerance, Monod, who had preaching in his blood, sought other ways of reaching a wider public. In the 1880s he accordingly founded a Société historique, which, on the model of the Atheneum Club in London, was meant to be a meeting place of intellectuals anxious to resolve the philosophical and political conflicts rife in leading Parisian circles. In 1885 the Société historique counted more than five hundred members, including influential magistrates, advocates, diplomats, parliamentarians, senators, and businessmen, together with men of letters and others engaged in secondary and higher education.[91]

Although the *Revue historique* may not have been successful in the "high-level popularization" of academic history, it proved a resoundingly effective journal for professional historians. Within a few years Monod's journal was considered to be their organ—a "rallying and information center" that contributed greatly to their sense of fellowship. It aimed to show prospective historians how best to apply "the correct historical method" and tried to foster solidarity.[92] By far most of its contributors were involved in higher public education,[93] and the same was probably true of its readers. As for the *BEC*, most of its contributors were archivists, lawyers, or people without a profession ("leisured historians") most of whom had been educated at the Ecole des chartes, where much emphasis was laid on the auxiliary sciences associated with medieval studies. The *BEC* was a typical *revue d'érudition*, crammed with source publications and critical glosses and devoted almost exclusively to French medieval history. The book reviews too were mainly concerned with French writings.[94] The *Revue historique*, with annual volumes that were twice as thick, devoted far less space to source publications and much more space to unrivaled book reviews. Hundreds of books were discussed in authoritative, thorough, and balanced articles. Extensive information was provided on historical work done not only in France but in the rest of the world as well. The reason why the *Revue historique* was considered *the* authoritative French historical journal must be sought first and foremost in the range and quality of its book reviews. For the rest, it satisfied the need of professional historians for wide-ranging and carefully verified information.

The *Revue des questions historiques* made the same overall claims as the *Revue historique* but was in fact much more restricted in scope. In the chaotic 1870s, when it was still unclear which political regime would gain control, its tone was apologetic. As mentioned above, its aim was the restoration of the Catholic monarchy, and it addressed itself to a broad public. Its leading contributors were *chartistes* and a few clerical writers. In response to what were often crude attacks on the Catholic Church's role in the past, the *Revue des questions historiques* became the leader of a historiographic counteroffensive. Hundreds of pages were devoted to attacks on anti-Catholic historians. Between 1870 and 1876 more than half of its pages—articles no less than book reviews—were devoted to the history of Christianity.[95] In the *Revue historique*, by contrast, the share of religious history was a mere 11 percent.[96]

Such general journals as the *Revue des deux mondes* and *Le Correspondant* also allotted a great deal of space to history, and the quality of their articles was often outstanding. It was anything but easy to have your work published in a prestigious general journal; historical studies as such were not of particular interest to them, but were included for the information or amusement of a broad public and had to be well written. Political bias was more pronounced in general journals than it was in the *Revue historique*. Thus historical articles were considered a respectable means of shoring up the ideological profile of, say, the liberal-conservative *Revue des deux mondes* or the Catholic *Correspondant*. It is no wonder, then, that so many controversial articles saw the light of day not in the *Revue historique* but elsewhere. While the *Revue historique* tried to foster the

solidarity of professional historians, general journals based their appeal to collaborators and readers on philosophical, social, or political grounds.

In their book reviews the general journals were highly selective. Whereas the *Revue historique* tried to cover international writing as systematically and fully as possible, the general journals based their book reviews on the social relevance of the material or on the editor's personal preferences. Reviews of historical works carried by general journals were often more important than the reviews published in the *Revue historique*, but if a professional historian wanted to keep up with developments in his own field he needed only to read the latter.

Preferences

It is difficult to summarize the contents of the *Revue historique*.[97] The articles no less than the countless book reviews differed considerably in kind, which was what the editors intended. The *normalien* Monod deliberately chose a *chartiste*, Gustave Fagniez, as a fellow editor. In his very time-consuming secretarial work Monod was assisted by his pupil Charles Bémont, who succeeded Fagniez on the editorial board during the early 1880s. For twenty-five years, until 1909, the *Revue historique* retained this two-man editorial team, with Monod clearly in command. The editors were the guarantors of the soundness of the articles, and, by and large, they acted as quality controllers rather than chorus leaders. The *Revue historique* aimed to be a broadly based mouthpiece of "scientific" historical studies. The subject matter mattered less than the reliability of the findings and the "correctness" of the method. Compared with the general journals, the *Revue historique* was thus a model of what we have called the "methodologization" of history.

Subjects and Periods

Alain Corbin has left us a quantitative classification of the articles published in the *Revue historique*. Despite all the complications and imperfections this kind of approach entails, it does seem useful to measure the results of Corbin's computations against the general output of historical writings in about 1900. To that end, a comparison of the contents of the *Revue historique* with that of writings on post-1500 French history is presented in table 23. This comparison of articles published by a journal, on the one hand, with general writings covering a wide field, on the other, may cast some light on the differing preferences of professional historians and nonprofessional historical writers.

Table 23 bears out the claims of those who have argued that professional historians at the time under review paid too much attention to political history in general and to foreign politics in particular. (I noted in chapter 1 that diplomatic history was attracting growing attention.) This trend was very pronounced among professional historians. Another striking fact was the attention paid to socio-economic history, another trend to which we have drawn attention. For professional historians this was merely the consolidation of a general

TABLE 23

Subjects of Articles in the *Revue historique*, 1876–1900 and of Publications in the
Répertoire méthodique (Systematic Catalogue) 1901

Subject	% of All Subjects	
	RH	RM
Domestic politics	21.3	17.9
Foreign politics and colonial history	15.8	6.0
Socio-economic history	12.3	10.9
Religious history	11.4	14.1
Military history	9.6	14.6
Total	70.4	63.5
Others subjects[a]	29.6	36.5
Total	100.0	100.0

Note: For a classification of articles in the *Revue historique* based on contents see Corbin, "Maté-
riaux pour un centenaire," 202; for details about the *Répertoire méthodique* see table 5.
[a]In heterogeneous groups

tendency. Almost 90 percent of the economic articles in the *Revue historique*
were devoted to commerce, transport, banking, the credit system, and public
finance; the economic aspects of agriculture and industry accounted for only 10
percent.[98]

Unlike political and socio-economic history, religious and especially military
history were much less popular with professional historians than they were with
historical writers in general. The growth of interest in these two fields was thus
clearly less pronounced in professional circles.[99]

The *Revue historique* seemed to lay particular emphasis on the eighteenth and
nineteenth centuries. Random samples covering the period 1893–1913 show
that 45 percent of the articles published in the *Revue historique* dealt with these
two centuries, more than half of them covering the Revolution and the Empire
(23%).[100] In fact these eventful twenty-six years received as much attention in
the *Revue historique* as did a thousand years of medieval history (also 23% in the
random samples for 1893–1913). In keeping with editorial policy at the time,
ancient history was barely considered. Early modern history was well repre-
sented, with 32 percent; interest in the sixteenth and seventeenth centuries was
evenly divided (16% each).

The exceptional interest in the Revolution and the Empire taken by the *Revue
historique* was in line with the interest in this period reflected in historical writ-
ing at large. Despite the inauguration of special journals for the study of the
history of the Revolution (about which more below), the *Revue historique* con-
tinued to show a predilection for this turbulent span. Does this perhaps indicate
that the editors of the *Revue historique* thought that these events steeped in

legend and myth provided the best demonstration of how the unprejudiced "scientific" method based on authentic sources could be successfully applied?

Geographical Coverage

When discussing its geographical coverage, Corbin reproached the *Revue historique* for its Franco- and Eurocentrism.[101] However, he only took account of the articles and not the book reviews. Two-thirds of the articles published in the *Revue historique* in 1876–1900 did indeed concern France, so that just one-third was devoted to the rest of the world, which was still a sizable proportion. However, the international outlook of the *Revue historique* was reflected mainly in its review columns. During the last quarter of the nineteenth century Monod's many international contacts, his varied interests, and his considerable exertions made the *Revue historique* the world's best-informed general journal for professional historians. Its international outlook was broader not only than that of other French journals; it was even broader than that of its venerable German sister, the *Historische Zeitschrift*.[102] In addition to separate discussions of foreign books, the *Revue historique* also published collective reviews of works published in particular countries. These *bulletins*, often sent in by extremely competent foreign contributors, were a feature unique to the *Revue historique*.

A very large amount of space was devoted to German history, but Italy and Great Britain also received considerable attention. Spain, Austria-Hungary, and Russia were regularly included, and the smaller European countries were not ignored. Monod was able to attract a large number of foreign scholars; in fact the *Revue historique* probably had more foreign contributors than any other historical journal in the world.[103]

The charge of Eurocentrism was more justified than that of Francocentrism. The *Revue historique* was a child of its age. Even so, non-European countries were not completely overlooked. Thus, the percentage of reviews devoted to books on non-European history came to 3–4 percent in 1891–1910.[104] That may have been a small percentage, but it nevertheless covered a relatively large number of books. In 1906–10, for instance, 210 works concerned with non-European history were reviewed (out of a total of 5,723 book reviews). Compared with other journals published at the time, the *Revue historique* thus provided a relatively large amount of space to the history of regions outside the old continent.

Time Span and Social Groups

Corbin's computations show that 63 percent of the articles published in the *Revue historique* in 1876–1900 covered a span of thirty years or less.[105] This predilection for short periods was also characteristic of the theses presented at the time. Biography was very popular. According to Corbin, more than a quarter (26%) of the articles published in 1876–1900 were biographical; random samples of the articles published in 1893–1913 gave a figure as high as 32

percent, that is, just under one-third of all the articles published.[106] Attention was thus focused on personalities rather than on groups. Corbin concluded that in nearly half of the articles (49%) the individual (man or woman) was treated as an independent person rather than as part of a larger body. In more than half the articles, however, the man (or woman) was considered as part of a group. The most common of these were social groups in the strict sense (11%), but political or religious groups were also taken into consideration (7% and 5%, respectively). The study of man as an inhabitant of a particular town or region was as common as the study of man as member of a nation-state (6% in both cases).[107]

The predilection for short periods, the popularity of biography, and the individualistic approach did not mean that the study of longer periods (more than thirty years) and of groups of people was being ignored. Remarkably, the preference for political history did *not* go hand in hand with a preference for the study of man as a national subject. Whenever man was treated as a part of a collective, it was mainly as a member of a social group or class.

Documents and Figures

Until the First World War, articles in the *Revue historique* were not accompanied by graphics; only occasionally was a map or diagram included. Statistical data were not completely lacking, however. Thus, 4 percent of the articles published in 1876–1900 included interpretations of figures, though there had not yet been the least attempt at "sophisticated" representations. On the other hand, nearly one-quarter (23%) of the articles published in 1876–1900 had one or more documents appended to them.[108] For the rest, the number of source publications decreased steadily.[109] In that respect the *Revue historique* differed from such typical *revues d'érudition* as the *BEC* and also from various local-history journals, which seem to have adopted the device of "no documents, no historical reviews."

The notes accompanying articles in the *Revue historique* were much more copious than those found in journals addressed to the general public but not excessive in comparison with other professional journals or with later footnote developments. In only 12 percent of the articles published during the first twenty-five years did notes account for a quarter or more of the space.[110]

Relations with Other Disciplines

The contributors to the *Revue historique* were historians almost to a man. In assessing the journal's interest in other disciplines, however, we wrong the *Revue historique* if we look at the main articles alone because its admirable book reviews gave generous cover to other disciplines. Particular attention was paid to religious (including non-Christian) history, legal history, educational history, and the history of literature and art, the *Revue* retaining its internationalist approach even in these fields. It also carried extensive reports on new work in the auxiliary historical sciences. Not only in dealing with numismatics, epigraphy,

genealogy, heraldry, philately, paleography, diplomacy, chronology, bibliography, librarianship, and archival research but also in discussions of archeology and linguistics the journal attempted to fit these auxiliary disciplines into a fairly consistent, overriding historical-research framework.

A special column was devoted to geography, attention being paid not only to the history of geography and to voyages of discovery but also to descriptive geography, ethnography, and *Anthropogeographie* were systematically covered (from 1896 to 1905 the journal reviewed no fewer than three books by Friedrich Ratzel).[111]

The column on the history of science was a mixed bag but highly informative and interesting for all that. The largest section was devoted to the political and economic sciences, to which the index for 1901–5 added "socialism and sociology" in fraternal combination.[112] Among scores of other books the attention of professional historians was drawn, during these five years, to the writings of the political scientist M. Ostrogorski, the jurist Anton Menger, the economist Karl Bücher, and such sociologists as Guillaume de Greef and Célestin Bouglé.[113] French translations of the writings of Karl Marx were also reviewed.[114] There were sections devoted to the history of the exact sciences, of philosophy, of medicine, of hygiene, of criminality, of witchcraft, and of magic. The 1901 index introduced a section devoted to "folklore," drawing the readers' intention, *inter alia*, to the French translation of James Frazer's *The Golden Bough*.[115]

These examples perhaps make clear that the review columns of the *Revue historique* reflected wide and varied interest in other disciplines. Books dealing with the history of these disciplines were emphasized, but more theoretical works were not debarred. Many disciplines were considered to be auxiliary historical sciences; others were thought to supply complementary data needed by historians. There was, however, no suggestion that the concepts and methods of other disciplines should be borrowed to enrich the historian's craft. The *Revue historique* radiated self-confidence, self-assurance, and indeed often self-satisfaction as well. It took a great deal of interest in work done in other fields but left no doubt that it considered the historical method paramount. In that sense there was a world of difference between the *Revue historique* and Henri Berr's *Revue de synthèse historique*, which first came out in 1900. Henri Berr, who was not a historian but a philosopher by training, approached historians as well as nonhistorians for contributions to his journal. The *Revue de synthèse historique* was keen to borrow concepts and procedures from other disciplines; the atmosphere round Berr was more adventurous and less contained, so that even the limitations of the historical method were thought a fit subject for discussion.

The Appeal of Specialization and the Search for Syntheses

The great increase in the number of publications and the growing specialization of professional historians made it increasingly difficult for the *Revue historique* to continue playing the part of a general historical review in the original sense. Around the turn of the century there were even serious doubts about the useful-

ness of a professional history journal with such universal and comprehensive objectives. Although the *Revue historique* was credited with having played a cardinal role in making the study of history a scientific pursuit, it came to be seen as a victim of its own success.[116] Division of labor and specialization had become the new watchwords of young professional historians.

Toward the end of the nineteenth century numerous historical journals were founded, each specializing in a particular period or in some branch of history. Thus *La Révolution française* was launched in 1881. Beginning in 1887 it was edited by Aulard, who shaped its characteristic form and provided its radical-republican inspiration. As a reaction, the *Revue de la Révolution française* was brought out as early as 1883 by Charles d'Héricault and Gustave Bord. Its tenor was unmistakably counterrevolutionary. In 1888 *Le Moyen Age* made its debut, carrying nothing but reviews and bibliographies on medieval topics until 1897, when, twice as thick as before, it turned into a genuine professional journal. In 1899 came the *Revue des études anciennes*, devoted to ancient history and, by way of an exception, published not in Paris but in Bordeaux, where the indefatigable Georges Radet headed the editorial board,[117] ably assisted by Camille Jullian, a lecturer in Bordeaux until his appointment to the Collège de France in 1905. The year 1899 also saw the emergence of the *Revue d'histoire moderne et contemporaine* (*RHMC*), with Pierre Caron and Philippe Sagnac as its mainsprings. It was their aim to introduce a systematic research program into national and local (exclusively) French history from 1500 on.

Not only specific periods but also certain subjects related to mainstream history were graced with professional journals of their own. In 1887 the *Revue d'histoire diplomatique* saw the light of day. Military history even boasted more than one journal. Students of socio-economic history could turn to the *Revue des doctrines économiques et sociales*, founded in 1908 and renamed *Revue d'histoire économique et sociale* in 1913. In 1910 the *Revue de l'église de France* was launched, in a sense as a pendant to the respected *Bulletin de la société de l'histoire du protestantisme français*, founded in 1851. In 1912 the *Revue des études napoléoniennes* was born in Paris, a continuation of a similar journal published in Turin since 1901. There was also a *Revue Bossuet* (since 1900), published by the Bossuet Memorial Committee; a *Revue Bourdaloue* (since 1902); a *Revue des études rabelaisiennes* (since 1903), later continued as the *Revue du seizième siècle*; and last but not least the *Annales révolutionnaires* (since 1908). published by the Society for Robespierrean Studies under the formidable Albert Mathiez, who bore his former teacher a grudge and disliked the latter's *Révolution française*, the mouthpiece of the republican establishment.

These journals, as well as others not mentioned here,[118] must be considered a logical consequence of growing specialization. That does not mean that they laced a political inspiration or a philosophical dimension. It simply means that under the influence of specialization and the consequent need for more detailed discussions the demand for general reviews had declined.

Until the end of the century the leading role of the *Revue historique*, though eroded by specialized journals, was rarely questioned. A direct challenge to it,

as we saw, came with the founding of the *Revue de synthèse historique* in 1900. For much the same reason that the *Revue des questions historiques* had rightly accused Monod's *Revue historique* a quarter-century earlier of "pretending to do things differently and better than we do them,"[119] the *Revue historique* in its turn now had cause to feel affronted. That feeling, incidentally, never led to an open clash between the *Revue historique* and the *Revue de synthèse historique*. There was no real antagonism, just a clear difference in their respective conceptions of the structure and function of a general history journal. At the time, the *Revue de synthèse historique* represented the most serious attempt to stem the alarming increase in the number of publications and the growing specialization of professional historians. History journals too had a dialectic of their own. The irresistible process of specialization provoked a reaction; specialization may have been the dominant trend in the professional study of history, but it was also a seedbed for the new craving for syntheses.

The Interdisciplinary Alternative: The *Revue de synthèse historique*

Essential to an understanding of Henri Berr's venture is the distinction he made between erudite and scientific syntheses. What Berr considered true of historical studies in general also applied to his journal.[120] A journal dedicated to erudite rather than scientific syntheses was there to draw attention to, and to pass critical judgment on, historical writings. Articles were accepted and discussed on the basis of their professional merit. The *Revue historique* was authoritative. The inclusion of an article and a favorable review in it set an official seal of approval on one's work. However, according to Berr, the journal had an empirical and artificial structure. Its articles were lumped together by country, by period, and by subsidiary or associated disciplines. Berr, for his part, advocated in his journal no less than in his books a thorough clarification of the structural principles. A journal of erudite syntheses such as the *Revue historique* aimed to "reproduce" established knowledge; a journal of scientific syntheses aimed to "elucidate" it.

The articles in the *Revue de synthèse historique* were published under two headings, "Theory and Organization of Synthesis" and "Attempts at Synthesis." This was a more pretentious classification than the empirical one used by the *Revue historique*, with its "general," "ancient," "medieval" and "modern history"; "Revolution and Empire"; "contemporary history"—an adaptation of the scholastic trivium.

During the first few years of its existence the *Revue de synthèse historique* paid a great deal of attention to the theory of history and methodology (57 of the 154 articles published in 1900 to 1910, during which time the *Revue historique* failed to publish a single comparable article).[121] Over time, however, the number of theoretical contributions to the *Revue de synthèse historique* decreased. Did this reflect a law of diminishing returns in the spinning of theories? In any case, they had made a resounding start, with articles by the Romanian historian Alex-

andru Xénopol, Paul Lacombe, Benedetto Croce, Giovanni Gentile, Heinrich Rickert, and Karl Lamprecht. Simiand had published his famous diatribe on the historian's idols in the *Revue de synthèse historique*; and Durkheim had supplied a preview of his preface to the second edition of the *Rules of Sociological Method* under the heading "On the Objective Method in Sociology."

A striking feature of Berr's journal was its openness to other disciplines. The *Revue historique* took note of other disciplines in its review columns but never in its articles. Its interdisciplinary approach made the *Revue de synthèse historique* a forerunner of Febvre and Bloch's *Annales d'histoire économique et sociale*. Not only such sociologists as Durkheim, Simiand, Bouglé, and Gaston Richard but also such geographers as Vidal de la Blache and Pierre Foncin, such philosophers as Emile Boutroux and Frédéric Rauh, the psychologist S. Jankélevitch, and many others were persuaded by Berr to contribute articles to his journal. At times it looked as if the journal might turn into a ragbag, but then it was hard work begging authors with an established reputation for a contribution when there was a plethora of professional journals covering every field.

Berr distanced himself clearly from such historians as Seignobos, who wanted to foist the historical method on anyone involved in the social sciences. However, Berr was equally opposed to the "sociological method" of Durkheim and his circle. He gave a great deal of space to sociology and to sociologists but nevertheless stuck firmly to a psychological view of the role of his *Synthèse*.[122] Berr's conception of science during this period was strongly influenced by positivism, and although he paid some attention to historical materialism,[123] he always remained an idealistic philosopher. In essence, the great difference between the *Revue de synthèse historique* and the *Annales d'histoire économique et sociale* in the 1930s was the increasing influence of the Marxist, or rather of the materialist, conception of history on the *Annales*.

The *Revue de synthèse historique* had an active editorial policy. As a young journal it was out to discover a niche amidst a host of other periodicals. Berr organized special issues (about Germany, England, and Belgium), ran a series of comprehensive articles entitled "The Regions of France," and gave space to inquiries and polemics. These were aspects of journalism unknown to the *Revue historique*. The *Revue de synthèse historique* discussed far fewer books than the *Revue historique* (during the first ten years it reviewed 1,473 works while the *Revue historique* covered 9,610). However, Henri Berr introduced a new feature, the collective book review, whose aim it was to strike a temporary balance on a given subject, to indicate new lines of research, and to present "work done and work still to be done." A characteristic feature was the series on regional French history. During the first ten years of the journal's existence it covered Gascony, Lyon, Burgundy, Franche-Comté (by Lucien Febvre), Velay, Roussilon, and Normandy.[124] The *Revue historique*, too, gave space to local historiography (and not for France alone), important local-historical publications being regularly mentioned. But Henri Berr was particularly keen on regional surveys. These made the *Revue de synthèse historique* more appealing than the *Revue historique*, which overwhelmed its readers with a chronicle of necessarily fragmented infor-

mation on an enormous number of new books. The *Revue de synthèse historique* filtered and balanced its information and put it into perspective, thus involving the reader more directly. It was much more selective than the *Revue historique*. A subscription to Henri Berr's journal certainly did not save professional readers the trouble of reading the *Revue historique*.

There was also a to-and-fro of contributors between the two journals. However, the articles they published in the two journals differed in type. A numerical analysis of the contributors to both journals does not reveal striking differences between the two.[125] In fact, these two general historical journals complemented rather than competed with each other. The interdisciplinary escapades of the *Revue de synthèse historique* were made possible because the *Revue historique* kept guard over the institutional bastion. Would the advances have been quite as stimulating had no one done the donkey work?

The existence of two so different journals devoted to general history is clear evidence of the rich variety of professional history research at the beginning of the twentieth century.

Lavisse's *Histoire de France*

Writing a history of France is a traditional and respectable activity demanding broad knowledge and literary skill. For centuries this type of historical work was the domain of compilers, adapters, abstracters, and updaters.[126] An almost inexhaustible source of literary variations on early themes was the *Grandes Chroniques*, kept by monks of the royal abbey of Saint-Denis, which appeared in print at the end of the fifteenth century, translated, adapted, and brought up to date. In general there was a sharp division between those who had set themselves the task of writing a history of France and those engaged on original research. Adapted to the taste and fashion of the day, a history of France might be reprinted many times without the least allowance for learned findings known only to a very small circle. A successful history of France might have an amazingly long life, some being reprinted time and again over the course of a hundred years. In principle, a history of France was not out of date until a new history appeared that sold better, no matter what criticism learned or even less learned men may have leveled against the first in its heyday. Within the "history of France" genre the law of inertia held remorseless sway. The work by Nicole de Gilles, with its pronounced medieval flavor, was reprinted time and again until the beginning of the seventeenth century (the sixteenth impression appeared in 1617). Mézeray's abridged *Histoire de France*, first published in the mid–seventeenth century, retained its popularity for a century (its sixteenth impression appearing in 1755) before it had to make way for the enlightened abbé Velly's elegant history (1st ed., 1755–86), which in its turn enjoyed great popularity throughout the first two decades of the nineteenth century.[127]

In about 1820, not least thanks to the efforts of Augustin Thierry, the demands made on a national history changed radically. Although the gulf between

historiography and historical research was not completely closed, there was nevertheless an unmistakable striving for authenticity (local color) and a desire to keep close to the historical sources. A history of France remained a general survey by definition, and its authors were necessarily forced to consult the work of other historians, but there was a growing awareness of sources among them. At first that awareness was largely confined to published sources, but it very quickly came to embrace unpublished sources as well. Michelet claimed that he was the first author of a general history of France to have consulted unpublished material. It was the first time, he declared in the third volume of his *Histoire de France*, that "history had been placed on serious foundations" (1837).[128] The growing awareness of sources went hand in hand with a much broader conception of a national history. Thierry denounced earlier works that "for lack of something better, we grace with the title History of France," works in which the nation is hidden from view under the courtier's cloak. "Our provinces, our towns, everything each one of us holds dear as our *patrie* should be shown to us in every century of its existence; in its stead we are offered nothing but the domestic annals of the reigning family, births, marriages, deaths, palace intrigues, wars . . ."[129] The king's family chronicles may have made way for a history of the governments and political institutions of the French nation, but this novel and broader conception of national history remained political history first and foremost. "No account has been taken of all that accompanies, explains, and partly underlies this political history, the social, economic, and industrial circumstances, the state of literature or ideas," according, once more, to the highly original and self-assured Michelet, who, more than any other historian, galvanized the writing of histories of France with his historical imagination, his associations, his fantasies, and his familiarity with the sources.[130]

In the 1830s, after Thierry, Barante, Guizot, Mignet, Thiers, and Sismondi, each recounting and philosophizing, depicting and reflecting in his own way, had sharply denounced the lack of color, the poor documentation, and the meanderings of the existing national histories, two great new works began to appear, both of which were still being reprinted at the beginning of the twentieth century. One was by the professional historian Jules Michelet, the other by the fluent penman and jurist Henri Martin. The two were completely different in quality and appeal. Michelet's was original and well documented, Martin's unoriginal and superficial. Michelet fully realized that he was doing spadework. Martin had no aim beyond summarizing the work of others and rendering it accessible to the widest possible public. When it came to early history, for example, Martin was quite prepared to swallow and repeat the most fantastic tales about the Druids and the Gauls.

Michelet's *Histoire de France* was the work of a lifetime. He was thirty-five years old when the first volume appeared in 1833 and almost seventy when he completed the work in 1867. After six volumes on the Middle Ages (1833–44), he devoted seven volumes to the history of the French Revolution (1845–53) before completing, late in life, his seven volumes on modern history (1855–67). Henri Martin took less time. He was not yet thirty when he published an early

and rather flawed version of his work; a second, considerably modified version in nineteen volumes was finished before he was forty-five (1837–54). Both works were reprinted a number of times. Martin's also appeared in a successful popular edition beginning in 1867. A cheap, unabridged version of Michelet's *Histoire de France* was published in 1900.

In the course of the nineteenth century many other authors tried their hand at writing histories of France. It was an intellectual challenge, and lucrative at that. Moreover, at a time of nation building and of consolidating the national idea writing the history of one's own people struck many budding authors as the raison d'être of all historiography. The legion of political commentators of varied plumage included a large number of professional historians. Even graduates of the anything but publicity-seeking Ecole des chartes tried their hand at popularization. Henri Bordier and Edouard Charton wrote a two-volume *Histoire de France* "based on original documents and artistic monuments of every period" (1859–60), which was reprinted twelve times, a further edition appearing as late as 1900.[131] University historians also joined the race and were more or less successful. I mentioned Auguste Trognon and Cléophas Dareste earlier in a different context.[132] The work of the second of these in particular (9 vols., 1865–79; 3rd ed., 1884–85) was highly regarded by professional colleagues.

No work, however, equaled the writings of Michelet and Martin in size or in the public esteem they enjoyed, each in its own way. This explains why, at the turn of the century, Hachette made great play in its catalogue of the fact that these two famous works were about to be superseded. "A tremendous job of work has been done on our provinces and towns, reigns and institutions, personalities and events. The time has come to summarize the results of half a century of study, and to combine the results of this incomparable inquiry in a general work."[133] This great enterprise would, of course, be directed by an all-round historian who at the same time, the publisher insisted, had to be man of letters. The right man for the job was none other than Ernest Lavisse, who for years had enjoyed close relations with Hachette and who, with the collaboration of Alfred Rambaud, was on the point of finishing just such a multivolume work on general French history.[134] However important the role of the publishers may have been—they may even have taken the initiative—in the end the conception and arrangement of the work were Lavisse's own. He chose his assistants from "teachers at our own universities." Lavisse's *Histoire de France* (1901–11)—nine parts in eighteen volumes of approximately 450 pages each, making a total of more than 8,000 pages and involving sixteen authors—can be considered the result of the first phase of the professionalization, institutionalization, and academic adoption of history. It was an ambitious attempt at a synthesis in a well-trodden field. A first generation of historians whose work was characterized by specialization had agreed to collaborate and address a wide readership of non-historians.

General Characteristics

The first striking difference from earlier works was the division of labor. Never before had fifteen historians and one geographer collaborated in the writing of a single work. Every author was responsible for his own text, though Lavisse himself drew up the general plan, set the guidelines, and more or less edited the final version. In the sequel, the *Histoire de France contemporaine*, which did not come out until after the First World War (1920–22) but parts of which had been made ready for publication earlier, Lavisse left much of the editorial work to Lucien Herr (the librarian at the Ecole normale supérieure, of which Lavisse himself was the director) and Charles Seignobos, who had taken responsibility for three of the nine parts.[135] In the first series, with which we are here concerned, Lavisse's hand, though always discreet, was more obvious. We know nothing about Lavisse's personal contribution. None of the authors ever complained about lack of freedom, and there was one grateful acknowledgment of Lavisse's suggestions and improvements (Petit-Dutaillis testified that Lavisse had gone over his manuscript "coolly," line by line, and discussed it with him at home).[136] But no matter what the precise relationship between Lavisse's editorial labors and the manuscripts of each of his collaborators may have been, in France his *Histoire* represented the first large-scale and successful allocation of distinct tasks in the writing of a historical work meant to constitute one great whole rather than a series of independent volumes. (In Germany this approach had already been used.)

The second remarkable feature was the way the division of labor was actually applied. There was a strict chronological apportionment of the work. Apart from the first volume, which was a widely praised geographical introduction, every volume had sharply defined chronological demarcations. Following Vidal de la Blache's *Tableau géographique* (volume 1), the prehistory of independent and Roman Gaul by Gustave Bloch (volume 2), and a volume on Christianity, Merovingians, and Carolingians by C. Bayet, Pfister, and Kleinclausz (volume 3), all subsequent volumes bore precise dates and referred to the reigning prince or house: volume 4, on the first Capetians (987–1137), and volume 5, on Louis VII, Philip Augustus, and Louis VIII (1137–1226), both by Achille Luchaire; volume 6, on Louis IX (Saint Louis), Philip the Fair, and the last direct Capetians (1226–1328), by Langlois; volume 7, on the first of the Valois kings and the Hundred Years' War (1328–1422), by A. Coville; vol. 8, on Charles VII, Louis XI, and the early reign of Charles VIII (1422–92), by Charles Petit-Dutaillis; volumes 11 and 12, on the years 1492–1559, by Mariéjol; volumes 13 and 14, on the early reign of Louis XIV (1643–85), by Lavisse; volume 15, on the later reign of Louis XIV (1685–1715), by A. de Saint-Léger, A. Rebelliau, Sagnac, and Lavisse; volume 16, on the Regency and Louis XV (1715–74), by Henri Carré; volume 17, on Louis XVI (1774–89), by Carré, Sagnac, and Lavisse; and volume 18 was devoted to indexes and so on.

Excluding the first three volumes and the final one, eight centuries (987–

1789) are spread over fourteen volumes devoted to increasingly brief periods. Thus, while Luchaire covered 150 years, Lavisse took two volumes to cover a period of just over 40 years. The diminishing chronological scale reflects the dominant trend of university history studies at the time. This approach was thought to be an obvious and sensible way of applying the division of labor. The reigns of princes often determined the beginning and end of chronological divisions. This "royalist" chronology did not, however, mean that court and dynasty were thought to be of paramount importance. The real subject of the analysis was "the political and social transformations of France, the development of customs and ideas, and the relations between our people and foreign countries." "Battle history" was explicitly eschewed. Thus, in the examination of the reign of Louis XIV more attention was paid to "Colbert's attempt to reform French society and to turn France into the great workshop and the great marketplace of the world than to the diplomatic and military history of the Dutch War. . . . The reader will, therefore, not be surprised to discover that Colbert takes up considerably more space in this account than Lionne or Louvois—and that," the Hachette prospectus boasted, "is just one example out of many."[137]

It was, moreover, perfectly clear that small chronological divisions and a "royalist" chronology provided a too compact framework for the treatment of some more enduring subjects, or of those quite unconnected with the change of rulers. Within the time limits of each volume, the course of important events and the actions of influential persons were reported in the context of general developments. There were diachronic and synchronic chapters. By and large, the chosen chronological order and the royal framework proved more useful for dealing with *histoire événementielle* than for dealing with political institutions, social groups, economic circumstances, ideas, and the cultural scene.

The third striking characteristic of Lavisse's series was its clear, matter-of-fact style. "Fustelian clarity" was the ambitious goal.[138] The writing was sober and precise. There was a world of difference between it and the romantic evocations and lyrical tones of Michelet, who had described his relationship with history as a love affair: "In what close union have I not spent forty years (ten centuries) with you! What passionate, noble, austere hours we have shared, often in the midst of winter, before dawn. . . . I have worked for you, going, coming, searching, writing. I gave my everything every day, perhaps even more. The morning after, finding you on my desk, I felt that I was like you, filled with your life's strength and your eternal youth."[139] Lavisse and his collaborators, by contrast, tried as much as possible to exclude their own feelings. Personal attitudes and enervating identifications with one's subject, so characteristic of romantic historiography, had made way for the impersonal and detached style of late-nineteenth-century scientism. The history of France had become an *object* of historical research. In the notes the reader was constantly reminded that all the sources had not yet been examined, that historical knowledge had gaps that might never be closed, and that the whole account had a temporary character.

Source awareness and the idea of progress were not equally pronounced in every volume, but they were absent from none. In about 1900, under the influence of professionalization and specialization, the ethos and habits of university historians had come to differ radically from those of the heroic generation of pioneers such as Thierry, Guizot, Barante, and later Michelet. The difference was not unlike that between explorers and cartographers. The sense of responsibility, the notion of insufficient historical knowledge, and the continuous demand for detailed research kept impeding the pace and vigor of the presentation. For all that, the volumes were generally written in meticulous style, unadorned if uninspired. Only the brilliantly written volumes contributed by Lavisse himself were of appreciable literary merit. It is no wonder, then, that Lavisse was the only one of these university historians to be included amongst the "immortals" of the Académie française.

The fourth and last striking characteristic was self-satisfaction coupled with a progovernment attitude. There was no wallowing in the past, the debunking of *grande histoire* being a typical trait. "We have come so wonderfully far" was the message written between the lines. The political inspiration of the authors was predominantly republican and anticlerical. The leitmotif was the growth of national unity and of durable political institutions, in which the monarchy had played a vital role. This was anything but antimonarchist historiography. Arguments between champions and enemies of the Revolution were dismissed as "childish."[140] It was important not to condemn the ancien régime but to describe it as accurately as possible. Unmistakably, however, the writers' own times and form of government were considered the logical result of what had gone before. In that respect the attitude of Lavisse and those around him seemed "fatalistic"; they apparently embraced the doctrine of historical necessity with which Mignet and his followers had been reproached.[141] But the actual aim was to depolarize French public opinion and arrive at a republican synthesis.

Lavisse and company set to work, in their own words, "without passion or prejudice," but they fully realized that a historian cannot help being influenced by the age and country in which he lives. The idea of progress held them in its grip. Their own times knew many abuses, but was it not as plain as a pikestaff that things had been much worse in the past? It would be cheap to reduce Lavisse's attitude to the natural response of a paid servant of the republican state. The vigilant educational inspectors were able to make the life of hostile teachers unpleasant, but there was no censorship. Historians in the service of the republican government were given a great deal of leeway. Was the real explanation not that Lavisse and his collaborators—not least because of the course of the Dreyfus affair and the successful mammoth alliance of radicals, social-radicals, and socialists in the Bloc républicain under the leadership of the rigidly anticlerical Emile Combes (1902–5)—saw French history as a preparation for *La France radicale*?

But enough generalities. Let us now look at the volumes written by Langlois and Lavisse, which were the most successful contributions.[142]

Langlois's Volume (1226–1328)

Volume 6, by Langlois, which appeared in 1901, was by and large *histoire évé-nementielle*. Three-quarters of the contents (319 of the 429 pages) bore the title "Political Events," while just over a hundred pages were devoted to "Institutions and Culture."

The volume begins with the unexpected death of Louis VIII, who bequeathed a "heritage of hatred," accumulated over thirty years of royal conquest, to a twelve-year-old child in November 1226. Following an account of the regency of Blanche de Castile, of her supporters and opponents, Langlois goes on to consider Saint-Louis and his entourage and devotes several chapters to domestic and foreign policy from 1235 to 1270, the first part being concluded with an account of the reign of Philip III (1270–85).

Part 2 covers a shorter period (1286–1328) but is almost twice as long. Once again Langlois starts with a monarch, Philip the Fair, and his entourage and ends with foreign policy. Considerable attention is paid to the uneasy relations between the monarchy and the popes and to the trial of the Templars. One chapter is devoted to the causes célèbres that agitated France at the beginning of the fourteenth century, to the excesses committed against the Jews of Lombardy, to the confiscations, and to the whittling down of coins by the authorities. It is obvious that Langlois's historical concerns were influenced by the problems of his own day. In about 1900 the relationship between church and state was a burning issue, rumors and revelations of scandals were rife, and the Dreyfus affair poisoned the atmosphere and demonstrated the virulence of anti-Semitism. In not so many words, Langlois remorselessly drove home to his readers that the prevailing republican form of government, with all its failings, was greatly to be preferred to the bloody vagaries and barefaced cunning of the French kings. Thus a chapter entitled "King and Nation" ended with the question "Why is France not a free country?" The answer was that when it came to the crunch, there was no entente between the nation's estates, whose "class egoism had, in fact, helped to isolate them."[143] As the nation could not unite and the upper classes were driven on by ultraconservative instincts, it had been left to the kings to bring the nation's estates together in general assemblies. But no matter what the cause, before the accession of the Valois kings it had become customary to consult the nation, so that the "the possibility of representative institutions and of the habit of liberty taking root was not completely lost." The rest of the book would show "how things have turned out" (282). Langlois managed to keep his readers on tenterhooks, but the conclusion his beloved republican citizens were expected to draw was plain: under the ancien régime France had lacked a fair and democratic system of government.

Part 3, "Institutions and Culture," covered the entire period of rather more than a century and was synchronic rather than diachronic in conception. It began with a masterfully concise summary of the royal system of central and local institutions. In this field Langlois had done highly original research and knew the administrative archives as no other. He started out by arguing that the

most important feature of French history during this period was the "continuous improvement of the monarchic institutions" (321). His conclusion, following a lively and well-argued analysis, was that these institutional improvements had resulted less from a deliberate policy by the central authority than from the "secular actions of thousands of obscure little tyrants," namely, the king's local servants and emissaries with their specific instructions and powers. These royal officials behaved like petty dictators. But what else could be expected from "people with little culture, recruited without having to give proof of their reliability, holding undefined powers, and enjoying almost perfect impunity?" (352).

The last three chapters dealt with manners, ideas, and art. Langlois dispensed with a chapter on "social institutions" because these had been covered in the preceding volume, written by Luchaire. Langlois's way of tackling the history of manners was remarkable.[144] According to him, the best method, "in the present circumstances" and for lack of "synthetic and overall knowledge . . . which no one has ever possessed and, no doubt, never will," as he added in measured tones, was to present the reader with a few characteristic documents. There followed well-chosen short sketches, culled from literary sources, of the life of the clergy and of the nobility. *Fabliaux* (comic verse tales), alas mostly undated, served to mirror life in urban streets and in the countryside. Remarkably, when writing this chapter Langlois expressly eschewed the best relevant sources, that is, judicial inquiries and the dossiers relating to the sanctification of Louis IX. These contained almost word-for-word reports of interrogation and conversations, "life itself recorded and laid down."[145] Langlois had used these very sources when relating earlier incidents or describing personalities, and the reader was explicitly referred back to them. His choice of this type of *histoire événementielle* and biographical arrangement of the richest source material was quite deliberate.

Langlois gave the history of ideas and the history of art cavalier and not very inspired treatment. In keeping with the method he had advocated for dealing with such "vague" subjects, he paid extensive attention to selected documents, in this case, needless to say, Villard de Honnecourt's sketchbook of architectural drawings and instructions.

Lavisse's Two Volumes

The two volumes contributed by Lavisse himself, which appeared in 1905 and 1906, were masterly. Written in brilliant style and elegantly composed, they were also surprisingly many-sided, steeped in profound discussions of historical problems, and replete with balanced judgments. Like all the volumes in the series, they were also outstandingly well documented. Lavisse himself, unlike Langlois, did no extensive archival research, relying, as evil tongues had it, largely on the assistance of the erudite Edmond Esmonin. But whatever the truth of that story, Lavisse was unquestionably in control and his bibliography was exemplary. The work is unequaled in its psychological portrayals and rich in striking formulations.

Lavisse's approach in these two volumes was synchronic and thematic rather than diachronic or focused on events. Whereas three-quarters of Langlois's volume was devoted to political events, Lavisse accorded no more than a quarter of his eight hundred pages to them.

Lavisse ushers the reader first into the death chamber of Louis XIII. The age of Mazarin was about to dawn. This first section (117 pages) has a clear chronological structure. The turning point is the Fronde (January 1649–July 1653), "all those events, the levying of troops, and those negotiations with the enemy, which would be treated as crimes today but did not surprise anyone at the time."[146] This chaotic situation is blamed on the imperfections of the state. The period ends with the death of Cardinal Mazarin, who breathed his last in 1661, Christ's name on his lips.

After this first section, which may be considered a prelude, the arrangement is thematic rather than chronological. It begins with the following description of the king:

> Possessed of beauty, vigor, grace, good nature, fairness and a sense of justice, a love of his calling, a noble idea of his duty and devotion to that duty; but almost no intellectual training, a poor and corrupt education; then and above all that religion, that love of glory, that pride, that legacy of the past weighing down on what was after all an ordinary man unable to counterbalance his powerful and pressing fate; that person in danger of being perverted: by the danger of egoism turning into self-adulation, by the sense of justice and fairness being blinded, by love of one's calling and devotion to duty being turned away from serious and noble objectives to the satisfaction of sheer pride, by prudence being reduced to precautions and artifices to prepare or repair rash acts, by the danger of conduct and policies being chosen with an eye to dithyrambs and triumphal arches,—that is how, charming but disturbing, he who would be called the great King made his entry. (1:137)

This account was what one might have expected from one who had been charged with the education of a *prince impérial*. The portrait of the king is followed by sketches of his leading ministers (Fouquet, Le Tellier, Lionne, and Colbert) and a survey of the "political machinery" and the various bodies serving the government at the central and the local level. This section ends with a chapter on Colbert's advice that pride of place be given to the increase in wealth. "This advice was petty, proffered as it was to a country so great and to a prince so glorious, but then Colbert had gone on to explain: 'Only an abundance of money in its coffers makes a State great and powerful'" (1:169). The tension between Colbert's proposals and the actions of Louis XIV determines the structure of Lavisse's work. In the end he finds that Louis XIV does not measure up to the qualities of a great mercantilist prince.

The next section (90 pages) is devoted to economic matters. Government finances, agriculture and industry, commerce, and the colonies are discussed on the basis of Colbert's inquiries, ideas, and plans. All in all, one does not get the impression that the state exerted great influence on the economy. Lavisse carefully sets out the obstacles and resistance to Colbert's economic plans.

The section after that deals briefly (on 50 pages) with "political rule." It shows how the press was muzzled and autonomous activity was squashed. An account is given of a number of genuine attempts to improve legislation, jurisdiction, and the police, the reader being left in no doubt about how radically the crude reality differed from the fine theory.

In a labored attempt to maintain the symmetry of his presentation Lavisse goes on to discuss social groups, religion, literature, the arts, and sciences in chapters titled "The Government of Society" (80 pages), "The Government of Religion" (80 pages), and "The Government of Intelligence" (100 pages). Lavisse deplored the lack of knowledge of everyday life that was swept under the spectacular carpet of Versailles (1:323); in view of the prevailing ignorance, his treatment is certainly justified. After a discussion of artisans and peasants against a background of general and persistent destitution, he gives a superlative summary of the "revolt of the small man," half a century before Boris Porchnev's great monograph *Les Soulèvements populaires en France de 1623 à 1648.*[147] His description of the nobility leads Lavisse to formulate a historical inevitability: "A caste left without work is bound to become perverted."[148] In dealing with the clergy, Lavisse contends that the call of Christ was rarely heeded by the upper estates: "For the sons of the great families God was a last resort" (1:397). At the time, the great masses worked to maintain a small group of privileged people. "To live on the people and to despise them, turning privilege into an honor and the work that maintains the privileged into a matter of shame,"—such, according to Lavisse, was the paradox of that society (1:403).

The discussion of Jansenism starts with a purely political assessment of Louis XIV. Gallicanism and Protestantism too are examined from a predominantly political angle. Although anticlerical and a freethinker from childhood, Lavisse nevertheless kept an open mind even in this sphere. "To neglect seventeenth-century religious concerns, or to play them down, is tantamount to misunderstanding the history of that century, to being out of touch with it" (1:88). That was something most of his spirited young collaborators, including Langlois, found rather hard to swallow. Lavisse even went so far as to argue that it was more important to come to grips with Pascal than, for instance, to plumb the character of a minister, even if his name was Colbert.

Literature, art, and science are approached from Colbert's view that since there was only one court, there ought to be just one patron of the arts, patronage redounding "to the king's greater honor and glory." However, according to Lavisse, the "true grandeur" of the seventeenth century was the revolution in mathematics, which paved the way for the advance of natural science, "the two infinities, the infinitely large and the infinitely small, having been laid bare to man's eye and intellect." Only a handful of people appreciated the true grandeur of the age. "It takes time for the dust to settle, and for the noise of the superficial events satisfying our superficial curiosity to abate" (2:184). Braudel himself could not have put it in a more Braudelian manner.

The last subject to be dealt with is foreign policy. Lavisse begins by proffering a survey of other European powers (45 pages) and of the state and organization

of the army and the navy (35 pages). Next comes a chronologically arranged discussion of the fortunes of war and diplomacy (100 pages).

Lavisse concludes with a somber account of the situation in France in 1685, the year in which Colbert died without a successor of mark. Court life was at a low ebb. The king was increasingly reminded of his own mortality by illness and infirmity. Without taking back a single word of his harsh judgment, Lavisse ends compassionately on a tragic note: "The entire body had grown heavy; but even though the grace had fled, the majesty endured, to go on to the end, to wax and become superb amidst the approaching sadness and ruin" (2:142).

Shortcomings

Lucien Febvre made short shrift of Lavisse's *Histoire de France*. In 1933, more than twenty years after the completion of the last volume, he called Lavisse's coproduction "a work lacking a unity of conception, and thus devoid of life—a collection of volumes with the limited aim of providing . . . useful bits of information." Febvre admitted that the series had given rise to an authentic masterpiece, the *Tableau géographique* by Vidal de la Blache, and that the publication as a whole had been a commercial success. But he added that the public had bought the many volumes under a misapprehension. "They provided poor answers to true pragmatic inquiries and proved incapable of eliciting new ones, of enlarging the horizon of cultured readers by acquainting them with the labors the best workers pursue in silence, far from the places where people talk too much."[149]

Lucien Febvre was a brilliant polemicist. According to him, historians fell into two camps: those using the right approach to historical studies and those using the wrong approach. For his *Combats* Febvre tried to enlist "allies and support" against "a form of history that is not for us." To Febvre, historical research was a battlefield of friends and foes. It ought to be treated as a historical subject in its own right, one to which Febvre's maxim should be applied: "History is not judgment but understanding and—getting others to understand. We must not tire of repeating that."[150]

For all that, it is not hard to tell in what respects Lavisse's *Histoire de France* was better than any previous survey of French history. There simply was no other work of such scope and meticulous care, no work in which not only the political events but the political institutions were paid such detailed attention. Lavisse's *Histoire de France* was no literary masterpiece. It was less stimulating than Michelet's *Histoire de France*; not one of the authors in Lavisse's work could lay claim to the flashes of insight that made Michelet a historical genius. However, all the volumes—even the less successful ones—were reliable, balanced, and clear. Does that refute Febvre's criticism? Perhaps the merit of Lavisse's enterprise should be gauged not by comparisons with earlier surveys but by an overall assessment based on our present-day standards of historical knowledge. Can we, three-quarters of a century later, after a great deal of intensive and inspired historical research, arrive at a balanced historiographic assess-

ment? To determine the lasting merit of the volumes written by Langlois and Lavisse, we need to consider the gain in knowledge, the enrichment of the conceptual apparatus, and improvements in method and technique.

The Gain in Knowledge

In the course of the twentieth century there has been an indisputable gain in knowledge of economic history, agrarian history, and historical demography. Langlois was unable to consult Henri Sée's comprehensive (preliminary) survey *Les Classes rurales et le régime domanial en France au Moyen Age* (1901) or Pirenne's innovative study of cities and economic growth. Neither Langlois nor Lavisse made it clear that they were writing about a predominantly agrarian society. Perhaps that fact was still too obvious to need stressing at the beginning of the twentieth century. After all, the milestone in the conception of French history as the history of an agrarian society was not erected until drastic changes in the social landscape appeared after the First World War: it was not until 1931 that Marc Bloch presented historians with a new approach in his *Les Caractères originaux de l'histoire rurale française*. Did not what Lavisse had written of Colbert—"born in a shop and spending all day in an office . . . the vagaries of nature, now continuous rain, now drought, a year of plenty and another of scarcity—disconcerted this methodical man, who did not know what to do make of that vague peasant mass scattered over the king's domain and over thousands of small seigneuries. He placed greater hopes in the workshops"—also apply to Lavisse himself?[151]

The history of price movements also was not studied seriously before the First World War. The stability of the gold franc was so self-evident in the nineteenth century and at the beginning of the twentieth that there was a tendency in France not to consider the history of price fluctuations a matter of great importance. However, in the 1930s, under the influence of the economic crisis, that attitude changed. For Langlois's period, the thirteenth and fourteenth centuries, this particular aspect remained extremely uncertain because of a lack of data, but for the seventeenth century, though to a lesser extent than for the eighteenth century, historical research into price movements did produce some results. Uncertain though the figures continued to be, certainly in attempts to reconstruct the purchasing power of the currency, the study of price fluctuations did bring to light the periodic character of "subsistence crises."[152] Until the first half of the eighteenth century sharp rises in the price of grain resulted in more than the normal number of deaths, fewer marriages, and fewer births.

The greatest gain in knowledge probably has been in historical demography, though only after the Second World War. It too hardly affected the picture drawn by Langlois because there are no demographic documents for the thirteenth and fourteenth centuries. "We must resign ourselves not to pose such questions" since no source can provide us with the least answer, wrote Pierre Goubert, who wanted to make historical demography the starting point of the

study of history.[153] Things were different for the seventeenth century, full of gaps and uncertainties though the data may have been in comparison with those available for the second half of the eighteenth century. Pierre Goubert's *Beauvais et le Beauvaisis de 1600 à 1730: Contribution à l'histoire sociale de la France*, prepared in solitude with dogged application in 1944–56 and defended as a thesis in 1958, was a milestone in the demographic study of the ancien régime. Naturally, the massive child mortality and the short life expectancy had also been known to Lavisse and his collaborators from incidental descriptions, but the systematic reconstruction of family life in cold figures makes devastating reading. Death had a firm hold on daily life. In 1966 Goubert used this demographic study to write a general survey accessible to a large public, *Louis XIV et vingt millions de Français*.

One of the more specific areas in which there was a clear gain in knowledge was Colbert's background. As Colbert played a central role in Goubert's study, as his views were invariably quoted and his plans rarely questioned, this was no matter of secondary importance. Colbert's origins appear to have been less humble than Lavisse assumed; he gained his position in a less seemly way and knew how to line his purse with speed. Moreover, Colbert's "mercantilist" ideas were much less original than Lavisse made them appear to be, as Henri Hauser had already pointed out in a review.[154] For the rest, Lavisse appreciated that "Colbert died too rich." But instead of being as indignant about it as Goubert and others were,[155] Lavisse took a "structural" view of the matter, playing his grave accusation down with the statement, "The question of how the ministers became so rich is well worth studying."[156]

Missing Words

The use of new words does not imply a richer conceptual apparatus. Nowadays historians use a host of new words borrowed from other disciplines. In that respect they differ radically from Lavisse, whose sober prose was devoid of all scientific jargon. A distinction must be made between empty, harmful, and illuminating concepts. The verbiage with which sociology, in particular, encumbered itself also ruined the prose of many a historian. This sort of jargon alienated the general reader and was unnecessarily ponderous but otherwise had no harmful repercussions on the study of history. Things were different in the case of some concepts borrowed from disciplines having few if any historical dimensions. Various modern concepts act as so many blinkers to historical research. A case in point is "purchasing power," which, when applied to periods before the mid–eighteenth century, prevented a clear view of an economy that was characterized by barter and self-sufficiency in important sectors.[157] Another example is applying the modern concept of "social stratification" to a predominantly agrarian society with little division of labor, a great many seasonal activities, and quite distinct economic functions.[158]

It is not true, however, that every "anachronistic" concept is by definition an

obstacle to historical understanding. Thus the concept of the class struggle has been a catalyst in the study of past social conflicts. As far as that is concerned, incidentally, Lavisse, surrounded as he was by young intellectuals filled with socialist ideas, was not blinded by appearances. Later experts viewed his chapter on the "revolt of the small people" as an excellent contribution to the subject.[159] Another "anachronistic" key concept borrowed from the Marxists and acting as a catalyst in economic history was capitalism.[160] From the fundamental article written in 1902 by Henri Hauser, the first French historian to use the term *capitalism* in a title and to examine the usefulness of the concept, to Braudel's second magnum opus, in which the concept was placed in an original theoretical frame and given a different content, it has stimulated a great deal of thinking in economic history.[161]

Another illuminating concept missing from Lavisse's intellectual equipment was *conjoncture*.[162] For all his vagueness and abstraction, François Simiand, the "patriarch of price movements," must be credited with being the first to use it, in about 1930, in order to fit a period of several centuries into a single conceptual frame. According to Simiand, in *conjoncture* phase A, a period of expansion, with prices and wages rising in the wake of the inflow of precious metals, is followed by phase B, a period of recession characterized by "monetary famine," declining prices, and a fall in wages. The fat years of the sixteenth and early seventeenth centuries were followed by the lean years stretching from about 1630 to about 1730. The seventeenth century became one of crises—the *Grand Siècle* proved to be a century of depression, and Colbert appeared in a new light: "He is no longer seen as the top-ranking civil servant from whose hands all the kingdom's manufactures flowed in full spate. He now appears to have been the ferocious ruler of deflation," wrote Le Roy Ladurie at the end of the 1960s.[163] In fact Simiand's division of *conjoncture* into two phases—A and B— has been severely criticized. On closer examination there appeared to be enormous regional differences and frequent deviations from Simiand's model.[164] Nowadays a Malthusian model is generally preferred for dealing with seventeenth-century French society, in which the relatively limited chances of increasing food production set fatal limits to population growth. The *conjoncture* concept seems to have lost its fascination for historians interested in economic trends prior to the early eighteenth century.

Over the twentieth century the general view of social conditions has increasingly been influenced by economists. Various terms from the economists' vocabulary have become part and parcel of everyday speech, and hence of historical argumentation as well. In the absence of reliable quantitative data, often the prerequisites of serious discussion, we can only say that before the mid–eighteenth century the the conceptual apparatus of historians was not enlarged very much by the addition of economic concepts. True, these concepts did help to provide clearer insights into some seventeenth-century developments, but when it came to, say, the thirteenth century, the application of some of them amounted to letting off just so much hot air.

The introduction of the concept *mentalité primitive*, by contrast, gave histori-

cal research a strong impetus.[165] As a result the work of, say, Marc Bloch on the Middle Ages is filled with a different spirit from that of Langlois. Under the influence of Lucien Lévy-Bruhl, among others, the prevailing view of man had been radically changed. Thus, if we compare Marc Bloch's 1937–38 lectures on precisely the same period (*La France sous les derniers Capétiens, 1223–1328*) with Langlois's contribution, we discover a cardinal difference: Bloch examines the past with an anthropologist's eye; Langlois ignores possible differences in feeling and thought.[166] Whereas Bloch looks for contrasts, Langlois assumes that medieval man was just like a modern Frenchman. No matter how uncertain the history of human mentality may still have been, questioning the idea of "eternal man" proved to be a stimulus to historical research. Attempts were made to place what had been described as cultural-historical peculiarities into a historico-anthropological context. In this connection it is significant that Langlois tried to reconstruct the "famous trials" the better to settle the question of ultimate guilt. That sort of research, incidentally, took much inventiveness and critical acumen. As a critique of the evidence presented at the time Langlois's work is still valuable. He set out to discover whether the Templars had really been guilty and to expose the crying injustice of the Inquisition. That was historiography with the question of guilt as its centerpiece, historiography at the level of human responsibility. Langlois was aware that the archives of the Inquisition were a treasure trove of cultural history, but because of its lack of a historico-anthropological perspective, this kind of "history of customs and manners" was considered more of a curiosity than a serious contribution to the study of the past. In about 1900, however, it was precisely the workings of the legal machinery and the exercise of political power that struck most committed left-wing intellectuals as being of the utmost social importance.

The *mentalité primitive* concept not only served to highlight contrasts but also had an anti-evolutionary connotation: discontinuities and historical contexts came to be emphasized. The process of drawing long and continuous lines of development from the Middle Ages to the present day—in the event, the growth of national unity and of enduring political institutions—had lost much of its fascination. A synchronic history of mental attitudes is by definition no better than a diachronic history of social developments. In his inaugural address to the Collège de France in 1933, Febvre was exaggerating when he described the history he was taught at about the turn of the century as "deification of the present with the help of the past,"[167] but the most ambitious piece of collective academic writing to come out before the First World War certainly proclaimed that the main course of development of French history had found its culmination in the contemporary French state. For the rest, this so-called Whig interpretation of history[168] formed a much more obvious background to the work of the hypercritical Langlois, who was acquainted with the archives, than to that of the relativizing Lavisse, who, all in all, lacked the patience and temperament needed for detailed source research. In historiographical assessments what matters is not so much a historian's familiarity with historical documents as his personal experience and intellectual capacity.

Figures Instead of Examples

After the Second World War, figures came to the fore in historical research. Although the quantitative approach to the period prior to the mid–eighteenth century had a very hypothetical character and could offer few hard results, a new method emerged even in the study of centuries for which no reliable statistical data were available. It became customary to produce, if not figures, than at least series of comparable data. Lavisse and his colleagues still worked in accordance with the traditional method of handling an unwieldy mass of data with the help of a few characteristic and well-chosen example.[169] After the quantitative revolution in the historians' craft, ushered in particularly by Georges Lefebvre and Ernest Labrousse in due historico-critical manner, statistics became the new approach. Looking for characteristic examples made way for computations. While the representative character of the examples used in the work of Lavisse and his collaborators had always remained open to question, the quantitative approach had an Achilles heel of its own: the unreliability of the sources on which our knowledge of earlier centuries is based.

In some respects the use of quantitative methods results in a reduction of the historical data, but it also has considerable advantages. Quantification demands precision and leads to generalizations that can be verified and altered. Historians lacking synthetic gifts but having some technical equipment can arrive at generalizations through figures. Provided they are carefully handled and justified, figures are exceptionally well suited to collective work. It was no accident that the first case of practical international collaboration in historical research appeared on the testing ground of the quantitative method, namely, the history of price movements.

An approach able to combine a quantitative analysis with the choice of fitting examples, a method involving the computation of averages and case studies, represents clear progress in history without the least sacrifice.

The Shifting Historical Perspective

Apart from all its shortcomings, the most striking difference between Lavisse's approach and that used by contemporary historians is a change in the historical viewpoint. Lavisse looked at history from Colbert's Parisian office; Pierre Goubert took his soundings in the provinces and viewed the century of Louis XIV from the humble home of Jean Cocu, his wife, and three daughters, all of them weavers (the youngest was nine years old), a family in which, because of the dear price of bread, only a widow and one orphan survived in 1694.[170] Lavisse wrote "history seen from on high," Goubert history "seen from below." Lavisse made great use of the enormous files and correspondence of the hardworking and acute Colbert; Goubert relied on the baptismal, marriage, and burial records kept by the parish priest, a notary's records, and the taxman's lists. Lavisse looked out from the center of government, Goubert from the regional periphery.

While Langlois may have given his readers the impression that France had fallen increasingly under the sway of the central authorities, Lavisse expanded on the obstacles in Colbert's path. Lavisse paid much more attention than Langlois to what was behind Colbert's actions and plans. And although Lavisse overestimated Colbert's originality, he took a more sober view of the effects of his actions.[171]

The difference between the historical perspective of Lavisse and that of more recent historians cannot be seen as the difference between the reconstruction of the "living experience" of contemporaries, on the one hand, and the construction of what were once unconscious structures with the help of historical analyses, on the other. Michelet realized that historiography was something other than the writing of contemporary chronicles: "History comes of age as the mistress of the chronicles she controls, refines, and judges. . . . history takes chronicles on her lap as she would a small child, likes to listen, but must constantly punish and contradict."[172] Fustel de Coulanges's institutional history dealt explicitly with subjects of which his contemporaries were barely or not at all aware.[173] For Lavisse and his circle too history comprised more than the perceptions of contemporaries.

There is no way of telling whether the view from on high is more correct than the view from below. The things one sees from the rocky heights are different from the things one sees from the valley. The progress of knowledge can only be gauged from a single perspective. There were no differences of opinion about the somber situation of France during the *Grand Siècle*. Lavisse's bleak vision was in fundamental agreement with the *misérabilisme* with which Goubert has been reproached. Theirs was not so much a difference in viewpoint as a shift in perspective. It seems reasonable to believe that that shift occurred because, in contrast to Lavisse's generation, which saw the influence of the central authority in *La République radicale* spreading into all sorts of spheres, invested emotional capital in that expansion, and placed great expectations in it, the younger generation took government influence for granted and found it so ubiquitous that the reach of the authorities in earlier times seemed negligible by comparison.

As a chronologically organized and politically orientated survey, several volumes of Lavisse's *Histoire de France* remain unsurpassed. Might this valuable university coproduction written at the beginning of the present century at long last be about to gain the recognition it deserves?

BEFORE REACHING a conclusion, we would do well to recapitulate.

With the help of random bibliometric samples I have tried to convey some idea of the share of history books in the general French intellectual output, as well as of the quantitative shifts in historical writing itself. During the nineteenth century the number of publications on French national and local history rose markedly. Religious and military history accounted for a large share of the historical writing produced in about 1900, while socio-economic history enjoyed growing popularity.

In a predominantly agrarian society lacking mass media, modern working conditions, and comprehensive educational facilities there were no more than 1 million potential writers of history in a population of 38 million to 39 million souls. Historiography did not so much reflect the prevailing productive relationships as it did the preoccupations of (at most) the 2.5 percent of the French population whose personal circumstances granted them intellectual predominance. More than one-third of the writers of historical works were members of the first and second estates. Around 1870 the priest, the parson, and the nobleman were responsible for 36 percent of the annual publication of historical writings; by 1900 their share had fallen to 27 percent. The proportion of blue-blooded historiographers had shrunk most markedly of all during that period (from 20% to 7%), while the share of the clergy had increased (from 16% to 20%). The role of the latter was particularly noticeable in writings on local history and archeology, but the clergy also contributed a substantial share of writings on contemporary history. The historiographic output of the nobility had a disparate character.

Around the turn of the century nearly one-quarter of all historical writers were professional historians; that is, they earned their living from teaching history in secondary or higher-educational establishments or from handling historical material in archives, libraries, and museums. Writing history books was never a full-time way of earning a living. Professionalization in the sense of an increase in the number of professionals, moreover, had less influence on the quantity than it did on the quality of historical writing, on the spread of historical knowledge through schools and universities, and on the organization and classification of historical material in archives, libraries, and museums.

Not until the nineteenth century did the state take the study of history under its wing; during earlier centuries no government had ever kept a sizable group of historians on its payroll. Increasing state interest persuaded a growing number of historians to become civil servants. The transformation of history into a matter of national importance occurred in various ways and at different rates. Regimes of different political stamp all invested money in historical research, each in its own manner and for motives of its own. The Restoration, the July

Monarchy, the Second Republic, the Second Empire, and the Third Republic had distinct preferences for particular historical precedents. State investment in history from the Restoration to the First World War had led to the creation of more than a thousand posts for professional historians by about 1910; one century earlier there had been no more than seventy-five. History had become a full-fledged profession.

In 1818 the authorities decided to entrust history education to specialist teachers. By ushering in a small but solid job market for historians, this measure laid the foundations for their professionalization. The appointment of specialist teachers consolidated the institutional basis of the new profession. It contributed to the extension of the number of hours devoted to history in the school curriculum, to greater concern with the subject matter, to intellectual and didactic improvements, and to guaranteed continuity.

For centuries the teaching of history had been subordinated to rhetorical studies. A complex set of factors contributed to its growing independence in the course of the nineteenth century. These included a change in taste, the historicization of the worldview, political polemics, and the growth of national consciousness. In addition to these more structural factors, a political motive also became evident. History education was the child of the liberals, which explains why it became the butt of an ultraroyalist reaction in the 1820s. However, it managed to gain the better of that reaction even before 1830.

The consolidation and spread of history education from 1830 to the beginning of the twentieth century had formal, substantive, and philosophical aspects. Formal institutionalization included increasing the number of history teachers and increasing history's share in the curriculum. It also included expanding the curriculum and particularly the including contemporary history in the curriculum. The second aspect of the consolidation and spread of history education was the improvement of the contents of school textbooks and of the didactic guidelines. The reforms of 1890 marked the birth of truly professional didactics. The third aspect concerned the morality of history teaching. A crucial factor here was its politicization following the 1902 reforms. The republican authorities' desire to turn history teaching into a type of political education elicited an "anti-utilitarian," that is, idealistic, reaction from the teaching profession.

As a job market for historians, higher education played a less important role than did secondary education. Not only were there fewer posts for historians in higher education but the expansion of higher history education depended largely on the need for secondary-school history teachers. Secondary education was the motor of the upsurge of history education in arts faculties from the last quarter of the nineteenth century on. Conversely, the arts faculties, quite independently and increasingly, played two key roles: they trained history teachers and stimulated and evaluated historical research. Both roles were innovative, at least in France. Before 1880 the arts faculties had set the examinations but provided no preparation for them. History studies had not been considered part of a professor's duties. As distinct from the professionalization of history (i.e.,

the increase in the number of professional historians), the growing influence of the faculties on history education and research can be described as the academic adoption of history.

The vegetative existence of the old-style French art faculties (until about 1880) was in striking contrast to the flourishing of the comparable sector of Germany's philosophical faculties. We can mention four causes: the continued prestige of the *baccalauréat*, the system of *grandes écoles* (headed by the Ecole normale supérieure), the lack of a proper research ethos, and institutional shortcomings. The new-style arts faculties, by contrast, attracted more and more students and were given a new legal status. New chairs were introduced, and a new category of academic staff was engaged. The reforms of the examinations were intended to bring about a drastic increase in the academic demands on future teachers.

Impressive results ware recorded, especially in the history departments of the French arts faculties. Following the successful institutionalization of history as a school subject, historians gained the upper hand in the reformed arts faculties. The performance of history students was relatively high; the institutional developments went hand in hand with intellectual achievements that helped to underline the paradigmatic function of the historical method. The historical approach became fashionable even in other sectors of the arts faculty.

The new role of the faculties ensured that the demands made on professors at the beginning of the twentieth century would be quite different from those made during the first seventy-five years of the nineteenth century. The ethos and habits of history professors changed. A new type of professor emerged as a result of the professionalization and the academic adoption of history.

The most striking difference between the intellectual outlook of history professors in 1910 and that of history professors in 1870 was the degree of specialization in terms of time period and region. In 1910 more than half of the thirty-nine professors studied were known as experts on a given period or a given region. In 1870 most professors had been jacks-of-all-trades, specialization being severely frowned upon by the inspectors. In 1910 it was possible to divide the professorial corps into misfits, specialists, and men of "surplus value." The latter could be judged by three criteria: greater range of vision, greater initiative, and leadership. There were professors who widened the horizon with substantial contributions to German, Czech, and diplomatic history. Some professors were pioneers in such fields as Byzantine studies, socio-economic history, and the history of ideas. Finally there were the *patrons*, a relatively new phenomenon appearing in the wake of the institutionalization of university history studies. The hallmark of these new "bosses" was power in the form of influence on appointments, postgraduate training, and the placing of articles in prestigious journals.

To characterize the large quantity of publications by professional historians, we examined three types of publication: theses, professional journals, and general works. At first the thesis, an offshoot of the traditional method of oral education, was no more than a list of topics for public discussion. Later the

number of theses increased, and they also grew more voluminous and became more varied in subject matter and more heavily larded with documents.

A comparison of historical theses defended in 1875 with those defended in 1911–12 leads to the conclusion that in 1911–12 the method of investigation was considered to be more important than the results. The historical method clearly appealed to those taking their doctorates in 1911–12. Historical sources were carefully examined for reliability, and there was a predilection for strict chronological order and investigating short periods. At the same time, however, several local-history theses were defended that described a (synchronic) condition rather than a (diachronic) form of development.

The newly acquired autonomy of university history led academic historians to adopt a lukewarm attitude toward interdisciplinary cooperation. Their attitude toward two new disciplines, sociology and geography, indicated that historians often looked upon the first as a rival and the second as an ally. The mutual interpenetration between the university and society at large made itself felt. However, although socialist ideas had a perceptible influence, there was no real politicization of academic life.

The rich variety of university history studies was reflected in the existence of two excellent general history journals in addition to a host of specialized ones. Gabriel Monod's *Revue historique*, the favorite journal of professional historians, was renowned for its unrivaled and informative review column. Henri Berr's *Revue de synthèse historique*, which appeared later, held the promise of fruitful interdisciplinary studies at a time when most university historians still embraced the historical method.

Finally, a monumental survey of French history was launched under the eagle eye of Ernest Lavisse. It was a successful example of the division of academic labor and used a strictly chronological approach. A closer examination of the volumes written by Langlois and Lavisse himself shows that by present-day standards they fell short in their treatment of economic and agrarian history and of demography. Nor could historians at the turn of the century avail themselves of a host of clarifying concepts borrowed from the vocabulary of the economists; in particular, lacking the concept *mentalité primitive*, they were sometimes led to an unhistorical view of man. A quantitative approach was still a long way off. In its absence, an attempt was made to do justice to the historical reality by adducing characteristic examples. Despite its limitations and shortcomings, however, Lavisse's far-ranging *Histoire de France* is by no means outdated. As a survey of political history several of its volumes may even be described as unsurpassed.

The most striking difference between early-twentieth-century university historians and their present-day successors is a shift in historical perspective. Nowadays it is more usual for historians to view history from below rather than from on high. Prominent modern historians like to focus attention on the daily lives of anonymous peasants and tradesmen. They have a predilection for regional and local studies of "human insects." Lavisse's *Histoire de France*, by contrast, presented history at the governmental level. Lavisse and his circle were

fascinated by the irresistible process of state formation, and their historical perspective was shaped by it. In contrast to the parochial viewpoint of many modern historians, Lavisse's was national.

THE HISTORICAL METHOD: AN ASSESSMENT

The professional study of history is an abstraction. Professional historians are a motley crew, and their writings are most diverse. Historiography is the work of human beings and hence the result of personal quirks and varied preferences. Moreover, the very writings that usher in important advances in historical knowledge and outlook are often considered to be out of step. Historical studies that break new ground have an idiosyncratic character.

Although it is almost impossible to come up with general pronouncements on fundamental innovations, we can to some extent generalize about the broad stream of written contributions to academic history. Although the links are not absolute, historical writing seems to be influenced largely by institutional developments. A case in point is the specialization of professional historians.

To arrive at general conclusions about the study of history during a given period we must do more than analyze theoretical writings, though it would be a mistake to ignore theory altogether. By way of a conclusion, we can do no better than evaluate what was known as the historical method at the beginning of the twentieth century. This is the more important because the poor reputation of university history studies prior to the advent of the *Annales* school is largely based on François Simiand's devastating verdict on the historical method. Simiand passed judgment on it in 1903 in a detailed discussion of a theoretical contribution by Seignobos.[1] Lucien Febvre is said to have been so impressed by Simiand's article that he never penned a purely theoretical paper of his own. In 1960 Fernand Braudel saw fit to reprint Simiand's article, without any changes, in the *Annales*, as a manifesto that had lost none of its topical importance.

In this almost sacrosanct text Simiand attacked the historical method for being an obstacle to the proper pursuit of academic learning. He pilloried historians as worshipers of three false gods: "the political idol, the individual idol, and the chronological idol."

Their political idol caused historians to pay excessive heed to political events. Simiand equated political history with a chronicle of events, but as I have stressed, under the influence of Fustel de Coulanges political historians were, in fact, wont to focus attention on institutional processes.

The causal interpretation of historical events advanced by Seignobos as a provocative reaction to institutional history was quite a different matter. Unforeseen events, Seignobos argued defiantly, could make or break political institutions.[2] According to Simiand, this "accidental" view of historical events was characteristic of the historian's unscientific approach: truly scientific historical research must, in strict keeping with the positivist tradition, aim at the "system-

atic elimination of contingent influences and at the establishment of strict rules and laws."[3] That was, of course, a marvelous ideal but, alas, very difficult to put into practice. Seignobos's view that in the final analysis accident plays a leading role—a view Durkheim thought smacked of nihilism[4]—is certainly a defensible one.

It is, in any case, true to say that at about the turn of the century university historians considered political history extremely important. Lavisse's historical perspective was dictated by the growth of state influence, which he and his circle experienced in person. Moreover, at the time, both rightists and leftists were sounding the battle cry "Politics first." The bitter fight for the consolidation of republican institutions was still fresh in people's minds, and almost daily there were calls for vigilance lest the Republic be overthrown. In the 1920s and the 1930s historians with Communist sympathies pilloried this political trend as a tactic for masking the real social problems.[5] Before the First World War, which put an end to so many illusions, (political) democracy had been considered not only more important than socialist justice but considered its *conditio sine qua non*. It was a question of the right sequence. Those university historians who around the turn of the century had radical, social-radical, or socialist sympathies believed that political institutions must be organized along democratic lines before other social problems could be solved. This was essentially the view expressed by Gambetta as early as 1869, when he said that "the progressive series of social reforms depends absolutely on the regime and on political reforms, and . . . it is axiomatic that in this field the form determines and defines the substance."[6] It was the same conviction that persuaded university historians around the turn of the century to give political history pride of place in their work.

The individual idol was said to be the reason why so many historical writings were organized around a person rather than an institution or a social phenomenon. "The ingrained habit of seeing history as the history of individuals and not as the study of facts" was the way Simiand put it in a peculiar (Durkheimian) phrase. But however well put, this reproach was unjust. At the beginning of the twentieth century dissertations of the life-and-work-of type were no longer popular. Political institutions, diplomatic relations, and regional studies had become the favorite topics.

Another, connected reproach was the psychological view of historical knowledge. At the time, Durkheim, Simiand's *patron*, was involved in a controversy with his fellow sociologist Gabriel Tarde about the external reality of social facts.[7] Like so many others, including the philosophers Henri Berr and Lucien Herr and the writer Remy de Gourmont,[8] historians objected to the (reifying) conception of social facts preached by Durkheim and his followers. Historians who otherwise differed widely, such as Monod, Seignobos, and Hauser, agreed that historical knowledge was ultimately built on psychological foundations. "Intentionally or not, it is always the man inside us whom we project into history," wrote Henri Hauser in defining the "limits of the historical method."[9]

The chronological idol, finally, was said to be the reason why historians pre-

ferred chronological sequences to arrangements based on causal explanations. The latter alone, according to Simiand, were truly scientific, "objectively coherent," and indispensable to "any understanding of true relationships, even of succession." Now, it is true that historians have a predilection for chronological arrangements. Moreover, they prefer dealing with fairly short periods, although of course they also consider larger time spans. A chronological sequence and a short time span as such cannot be faulted on methodological grounds. The value of an arrangement is determined by the historical insight it provides. We must ask whether or not the period chosen is suitable for the discussion of a particular subject. Is the time span imposed from outside or determined by the subject itself (or at least by the historian's view of the subject)? Is the time span artificial and only explicable on practical grounds, or is there an "affinity" between it and the subject, the historical phenomena being treated as having a durable character? In short, is chronology a straitjacket, or is time an attribute of an historical subject?

Actually, neither chronological order nor a short time period is inherent in the application of the historical method. They are not its prerequisites. In essence, the historical method is nothing but a critical approach based on strict internal and external source criticism. Historians were anxious to dispense with what they called a priori opinions, which in the political context of the time often meant dispensing with religious conceptions. The word *facts* was ever on the lips of historians, no less than it was on the lips of sociologists, but actually it meant little more than concrete data. With the help of the historical method, historians aimed not only to turn their backs on metaphysical ideas and religious convictions but also to demonstrate that historical reality is something other than a system of economic doctrines, laws, set rules, and formal institutions. The historical method was meant to serve as a corrective to the formalistic approach of economists and lawyers, who kept constructing dogmatic historical theories in conflict with the data embedded in the sources.

Unlike present-day French historians, according to whom the historical method had a sterilizing influence, their predecessors laid emphasis precisely on the importance of capturing the "sense of life" and on "the need to observe people in action."[10] The historical method entailed a suspicion of government reports. Seignobos, professor of the historical method, thought that every government document was bound to be a piece of propaganda. In his view—and Seignobos knew what he was talking about—government statistics were among the most falsified records. Such sociologists as Simiand, who confidently used government information in their studies of wages and prices, were naively credulous. It is little wonder, then, that historians tended to give greater credence to nonofficial reports. Secret documents, which often had confidential comments in the margin, were generally considered to be highly reliable.[11] In essence, the historical method was no more, but also no less, than thorough internal and external source criticism. Seignobos's appeal to the young social sciences to apply the historical method was therefore little more than sound advice to check the facts before constructing theories.

Around the turn of the century historians did indeed take a skeptical view of comparative sociology. Their skepticism was not, however, necessarily due to their attachment to the *Zusammenhang*, the nexus, or to the kind of functionalism imputed to them by Claude Lévi-Strauss.[12] Their main objection to the form of comparative sociology practiced at the time was that the most grandiose comparative studies often were built on the shifting sand of unverified documents and made little allowance for the time factor. A comparative history of societies was considered to be a sound objective,[13] but what with the then prevailing state of knowledge, comparative history was also thought to be a very difficult subject and hence rarely pursued. However, comparative history as such was never ruled out of court.

The critical attitude of university-trained historians did not entail the belief that they could establish historical facts with complete objectivity. In the *Introduction aux études historiques* (1897), that gospel of university historians, Seignobos turned his back, as he had done earlier, on the epistemological positivism to which Fustel de Coulanges had adhered.[14] A strict, critical approach must be characterized by sober language. In search of concrete historical data, Seignobos and his disciples started to hunt down abstract terms and metaphors in the vocabulary of historians. That chase was taken very seriously by the hunters, who considered the elimination of abstract terms a form of attack on the traditions. In fact most historians of the *Belle Epoque* still subscribed to the old objective of the Association républicaine des écoles: "opposing all opinions based on faith and tradition by the propagation of Science and History."[15] Professionalization clearly had not been able to expel all the old ideals.

Two Classifications within Library Catalogues, 1684 and 1896

Classification by Nicolas Clément of the Bibliothèque du Roi, 1684	Classification by the Département des imprimés of the Bibliothèque Nationale, 1896
A. Biblia et bibliorum interpretes	A. Ecriture Sainte
B. Liturgiae	B. Lithurgie
C. Sancti Patres	C. Pères de l'Eglise
D. Theologi	D. Théologie catholique
E. Concilia et jus canonicum	D^2. Théologie non catholique
F. Jus civile	E. Droit canonique
G. Geographi et chronologi	*E. Droit de la nature et des gens
H. Historia ecclesiastica	F. Jurisprudence
I. Historia graeca et romana	G. Géographie et histoire générale
K. Historia italica	H. Histoire ecclésiastique
L. Historia germanica et belgica	J. Histoire ancienne, etc.
M. Historia gallica	K. Histoire d'Italie
N. Historia anglica	L. Histoire de France
O. Historia hispanica et indica	M. Histoire d'Allemagne
P. Historia miscellanea	N. Histoire de la Grande Bretagne
Q. Bibhothecarii	O. Histoire d'Espagne et de Portugal
R. Philosophi	O^2. Histoire d'Asie
S. Historia naturalis	O^3. Histoire d'Afrique
T. Medici	P. Histoire d'Amérique
V. Mathematici	P^2. Histoire de l'Océanie
X. Grammatici	Q. Bibliographie
Y. Poetae	⊠. Annexe de la division Q
Z. Philologi	R. Sciences philosophiques, morales et physiques
Grands livres de figures	S. Sciences naturelles
	T. Sciences médicales
	Vm. Musique
	X. Linguistique et rhétorique
	Y. Introduction et généralités de la poésie
	Ya. Poésie orientale
	Yb. Poésie grecque
	Yc. Poésie latine
	Yd. Poésie italienne
	Ye. Poésie française
	Yf. Théâtre français
	Yg. Poésie espagnole et portugaise
	Yh. Poésie allemande
	Yi. Poésie néerlandaise

Appendix 1 (*Continued*)

Classification by Nicolas Clément of the Bibliothèque du Roi, 1684	Classification by the Département des imprimés of the Bibliothèque Nationale, 1896
Grands livres de figures	Yk. Poésie anglaise
	Yl. Poésie scandinave
	Ym. Poésie slave
	Yn. Poésie celtique
	Yth. Théatre
	Y^2. Romans
	Z. Polygraphie et mélanges

The Share of History in the *Bibliographie de la France:* Random Samples

Year	Total	History and Related Studies	Percentage of History and Related Studies
1878	12,823	873	6.8
1880	12,414	857	6.9
1883	13,701	1,058	7.7
1885	12,343	900	7.3
1888	12,973	975	7.5
1890	13,643	990	7.3
1893	13,595	1,255	9.2
1895	12,927	1,134	8.8
1898	14,781	1,723	11.7
1900	13,362	1,361	10.2
1903	12,264	1,331	10.8
1905	12,416	1,487	12.0
1907	10,785	1,404	13.0

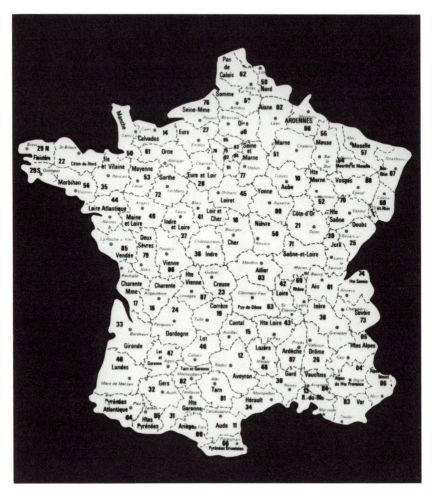

12. Departments of France

Eighty-five Departments Publishing Historical and Archeological Studies, 1885–1900

5 or More Societies		4 Societies
Seine	66	Ain
Nord	13	Charente-Inférieure
Calvados	9	Eure
Seine-Inférieure	9	Isère
Aisne	8	Maine-et-Loire
Rhône	8	Meurthe-et-Moselle
Côte-d'Or	7	Oise
Haute-Garonne	7	Pas-de-Calais
Gironde	7	Basses-Pyrénées
Hérault	6	
Manche	6	
Seine-et-Marne	6	
Seine-et-Oise	6	
Saône-et-Loire	5	
Savoie	5	

3 Societies	2 Societies
Aude	Cher
Bouches-du-Rhône	Drôme
Corrèze	Eure-et-Loire
Côtes-du-Nord	Gers
Doubs	Ille-et-Vilaine
Finistère	Indre-et-Loire
Gard	Jura
Loire-Inférieure	Loir-et-Cher
Loiret	Loire
Marne	Haute-Loire
Haute-Marne	Nièvre
Meuse	Puy-de-Dôme
Haute-Savoie	Hautes-Pyrénées
Somme	Haute-Saône
Vienne	Tarn-et-Garonne
Haute-Vienne	Var
Vosges	Vendée
Yonne	

Note: Twenty-five departments had one society. Ardèche had none.

Departmental Quotient: The Number of Inhabitants per Department in 1896 Divided by the Number of Societies per Department in 1885–1900 (in thousands)

Department	Quotient	Department	Quotient
Less than 100,000		Isère	142
Calvados	46	Marne	147
Seine	50		
Savoie	52	150,000 to 250,000	
Côte-d'Or	53	Drôme	151
Seine-et-Marne	60	Var	154
Haute-Garonne	66	Haute-Loire	158
Haute-Marne	77	Nièvre	167
Manche	83	Indre-et-Loire	168
Eure	85	Cher	174
Ain	88	Somme	181
Charente-Inférieure	89	Côtes-du-Nord	205
Haute-Savoie	89	Pyrénées-Orientales	208
Aisne	93	Loire-Inférieure	215
Seine-Inférieure	93	Ariège	220
Meuse	97	Vendée	221
		Bouches-du-Rhône	225
100,000 to 150,000		Pas-de-Calais	226
Tarn-et-Garonne	100	Cantal	234
Doubs	101	Vaucluse	236
Oise	101	Lot	240
Aude	103	Finistère	247
Hérault	104		
Rhône	105	More than 250,000	
Basses-Pyrénées	106	Aube	251
Sarthe	106	Alpes-Maritimes	265
Corrèze	107	Puy-de-Dôme	277
Hautes-Pyrénées	109	Creuse	279
Seine-et-Oise	111	Lot-et-Garonne	286
Yonne	111	Indre	289
Hautes-Alpes	113	Corse	290
Vienne	113	Landes	293
Gironde	116	Ille-et-Vilaine	311
Meurthe-et-Moselle	116	Loire	312
Basses-Alpes	118	Ardennes	319
Loiret	124	Mayenne	321
Saône-et-Loire	124	Orne	339
Gers	125	Tarn	340
Haute-Vienne	125	Deux-Sèvres	347

Appendix 4 (*Continued*)

Department	Quotient	Department	Quotient
Maine-et-Loire	129	Charente	356
Lozère	132	Aveyron	389
Jura	133	Allier	424
Haute-Saône	136	Dordogne	465
Loir-et-Cher	139	Morbihan	552
Nord	139		
Gard	139		
Vosges	140		

Note: Ardèche, which did not have a society, had a population of 363,000 in 1896.

Urban Quotient: The Number of Inhabitants per Town in 1896 Divided by the
Number of Societies per Town in 1885–1900 (in thousands)

Town	Quotient	Town	Quotient
Towns with More than 4 Societies		Towns with 2 Societies	
Caen (6)	6.5	Annecy	5.5
Montpellier (5)	13.4	Meaux	5.5
Rouen (8)	13.4	Auch	6.0
Toulouse (6)	23.3	Tulle	7.5
Bordeaux (7)	35.3	Le Puy	8.5
Paris (66)	37.6	Saintes	9.0
Lyon (7)	64.1	Arras	10.5
		Epinal	10.5
Towns with 4 Societies		Nevers	12.0
Bourg	3.7	Montauban	12.5
Grenoble	13.5	Carcassonne	13.5
Dijon	15.5	Douai	13.5
Nancy	21.0	Pau	15.0
Lille	51.2	Cherbourg	16.0
		Bourges	18.5
Towns with 3 Societies		Clermont-Ferrand	22.0
Evreux	4.6	Besançon	24.5
Chambéry	5.6	Tours	28.5
Saint-Brieuc	6.0	Rennes	30.5
Poitiers	10.6	Limoges	35.0
Dunkerque	12.6	Nîmes	35.0
Versailles	14.3	Amiens	41.5
Saint-Quentin	15.3		
Le Mans	18.0		
Orléans	19.6		
Angers	23.6		
Nantes	38.3		
Marseille	142.3		

New or Resuscitated Historical and Archeological Societies, 1901–1910

Towns with One or More Previously Existing Societies

Reims	Société des amis du vieux Reims (1909)
	Société archéologique champenoise (1907)
Rouen	Comité de recherche de documents économiques de la Révolution (not connected with the Ministry of Education)
	Assizes scientifiques, littéraires et artistiques
Marseille	Congrès des sociétés savantes de Provence (1906)
	Société archéologique de Provence (1902)
Amiens	Les rosatis picards (publications since 1903)
	Société des amis des arts de la Somme (publications since 1910)
Bourg-en-Bresse	Société Gorini (1903) under the auspices of the bishop of Belley (Abbé Gorini, 1802–1859, was the author of the *Défense de l'Eglise*, a fierce attack on liberal historians)
Grenoble	Société des bibliophiles dauphinois (1905)
Versailles	Conférence des sociétés savantes de Seine-et-Oise (1903)
Nice	Academia Nissarda (1901)
Troyes	Société départementale d'histoire de la Révolution dans l'Aube (1907)
Aix-en-Provence	Société d'études provençales (1903)
Quimper	Commission diocésane d'architecture et d'archéologie du diocèse de Quimper et de Léon (1901) (under the auspices of the bishop)
Beauvais	Société d'études historiques et scientifiques de l'Oise (1904)
Alençon	Les amis du monuments ornais (1904)
Perpignan	Société d'études catelanes

Towns with No Previously Existing Societies

Belley	Société Le Bugey (1909)
Villiers-Cotterets	Société historique de Villiers-Cotterets
Arles	Société des amis du vieil Arles (1903)
Arcachon	Société scientifique d'Arcachon (also publisher of historical studies)
Saint-Malo	Société historique et archéologique de Saint-Malo (1901)
Vienne	Société des amis de Vienne (1904)
Rive de Giers	Société des sciences, lettres et arts de Rive de Giers (1899)
Saumur	Société des lettres, sciences et arts du Saumurois (1910)
Granville	Société d'études historiques et économiques, le Pays de Granville

Appendix 6 (*Continued*)

Towns with No Previously Existing Societies	
Clermont	Société archéologique et historique de Clermont (1902)
Fler	Société historique et archéologique, littéraire, artistique et scientifique, Société du Pays Bas-Normand (1908)
Mortagne	Société Percheronne d'histoire et d'archéologie (1900)
Neuilly	Commission historique et artistique de Neuilly (1902)
Saint-Valéry-sur-Somme	Société d'histoire et d'archéologie du Vimeu (1905)
Bellac	Société archéologique de Bellac, Le Dolmen Club (publications since 1906)

Note: In Paris some twenty new historical and archeological societies were established in 1901–10. Only one of these, the Société historique et archéologique du IVe arondissement de Paris (1902), was a local historical society; all the rest had a national or international appeal.

The Budget of 1835

Services généraux	
Ministère de la justice	18,793,870f
Ministère des affaires étrangères	7,424,700
Ministère de l'instruction publique	12,463,629
Ministère de l'interieur et des cultes	42,009,000
Ministère du commerce et des travaux publics	106,000,000
Ministère de la guerre	257,449,000
Ministère de la marine	65,500,000
Ministère des finances	23,622,700
Total	533,262,899

Ministère de l'instruction publique

Nature des dépenses	Credits demandés pour l'exercice, 1835
1. Administration centrale	655,922f 68c
2. Services généraux	512,000f 00c
3. Administration académique et départementale	819,900f 00c
4. Instruction supérieure, facultés	1,939,106f 00c
5. Instruction secondaire	1,805,600f 00c
6. Instruction primaire	4,600,000f 00c
7. Etablissements scientifques et littéraires	1,627,500f 00c
8. Souscriptions, encouragements, indemnités et secours pour les sciences et pour les lettres	491,600f 00c
9. Dépenses des exercices clos	12,000f 00c
Total	12,463,628f 68c

Source: *Propositions de lois concernants la fixation des budgets de dépenses et de recettes de l'exercice,* 1835 (session 1834), 9, 226.

Budget of Libraries, 1825–1910

Year	Archives Nationales	Bibliothèque Nationale	Bibliothèques publiques[a]
1825	80,000	200,000	105,000
1835	80,000	274,000	111,000
1842	86,000	284,000	167,000
1850	180,000	289,000	207,000
1860	164,000	370,000[b]	203,000
1870	184,000	496,000[b]	209,900
1880	203,000	624,000[b]	299,000
1890	200,000	708,000[c]	263,000
1900	212,000	708,000[d]	226,000
1910	225,000	744,000[d]	211,000

[a]Bibliothèques Mazarine, de l'Arsenal, and Sainte-Geneviève
[b]Plus 50,000 for a catalogue
[c]Plus 80,000 for a catalogue
[d]Plus 100,000 for a catalogue

Percentage of Students in Various Faculties, 1876–1910

Germany

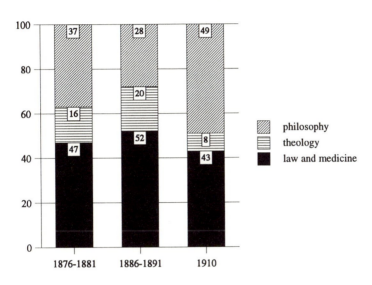

France

Historical Theses, 1875 and 1911–1912

<small>NINE HISTORICAL DISSERTATIONS DEFENDED IN 1875 (ALL ARTS FACULTIES)</small>

Belin, F. *La Société française au XVIIe siècle d'après les sermons de Bourdaloue.* Lyon. 195 pp.

Berthault, E. A. *J. Saurin et la prédication protestante jusqu'à la fin du règne de Louis XIV.* Paris. 332 pp.

Chalandon, G. *Essai sur la vie et les oeuvres de P. de Ronsard.* Lyon. 283 pp.

Dupond, A. *L'Argénis de Barclai: Etude littéraire.* Rennes. 196 pp.

Gazier, A. *Les dernières années du cardinal de Retz, 1655–1679: Etude historique et littéraire.* Paris. 328 pp.

Hély, V. *Etude sur le droit de la guerre de Grotius.* Lyon. 268 pp.

Joret, C. *Herder et la renaissance littéraire en Allemagne.* Paris. 564 pp.

Lallier, R. *De la condition de la femme dans la famille athénienne au Ve et au IVe siècle.* Paris. 299 pp.

Lavisse, E. *Etude sur l'une des origines de la monarchie prussienne ou la marche de Brandenbourg sous la dynastie ascanienne.* Paris. 268 pp.

<small>SIXTEEN HISTORICAL DISSERTATIONS DEFENDED IN THE ACADEMIC YEAR 1911–1912 IN PARIS</small>

Cahen, G. *Histoire des relations de la Russie avec la Chine sous Pierre Le Grand 1689–1730.* 1911. 274 + ccxx pp.

Clergeac, A. *La Curie et les bénéfices consistoriaux: Etude sur les communs et menus services, 1300–1600.* 1911. 316 pp.

Crémieux, A. *La Révolution de février: Etude critique sur les journées des 21, 22, 23 et 24 février 1848.* 1912. 525 pp.

Drouat, J. *L'Abbé de Saint Pierre: L'homme et l'oeuvre.* 1912. 397 pp.

Dureng, J. *Le Duc de Bourbon et l'Angleterre, 1723–1726, d'après des documents inédits des archives du ministère des affaires étrangères à Paris, du British Museum et du Record Office à Londres.* 1911. 548 pp.

Dutil, L. *L'Etat économique du Languedoc à la fin de l'Ancien Régime, 1750–1789.* 1911. 961 pp.

Febvre, L. *Philippe II et la Franche-Comté: La crise de 1567, ses origines et ses conséquences. Etudes d'histoire politique, religieuse et sociale.* 1911. 783 pp.

Fliche, A. *Le Règne de Philippe I, roi de France, 1060–1108.* 1912. 600 pp.

Fosseyeux, M. *Une Administration Parisienne sous l'Ancien Régime: L'Hôtel Dieu au XVIIe et au XVIIIe siècles.* 1912. 437 pp.

Guyot, R. *Le Directoire et la paix de l'Europe des traités de Bâle à la deuxième Coalition, 1795–1799.* 1911. 956 pp.

Hautecoeur, L. *Rome et la renaissance de l'antiquité à la fin du XVIIIe siècle.* 1912. 319 pp.

Lauer, P. *Le Palais de Latran, étude historique et archéologique.* 1911. 644 pp.

Lesquier, J. *Les Institutions militaires de l'Egypte sous les Lagides*. 1911. 383 pp.

Pannier, J. *L'Eglise réformée de Paris sous Henri IV: Rapports de l'église et de l'état. Vie publique et privée des protestants. Leur part dans l'histoire de la capitale, le mouvement des idées, les arts, la société, le commerce*. 1911. 667 pp.

Prunel, L. N. *Sébastien Zamet, evêque de Langres, pair de France, 1588–1655. Sa Vie et ses oeuvres. Les origines du jansénisme*. 1912. 569 pp.

Rigault, G. *Le Général Abdallah Menou et la dernière phase de l'expédition d'Egypte, 1799–1801*. 1911. 403 pp.

NOTES

ABBREVIATIONS

AESC Annales: Economies, sociétés, civilisations
AIBL Académie des Inscriptions et des Belles Lettres
AN Archives Nationales
ASMP Académie des sciences morales et politiques
BEC Bibliothèque de l'Ecole des chartes
BN Bibliothèque Nationale
DBF Dictionnaire de biographie française
EHESS Ecole des hautes études en sciences sociales
TvG Tijdschrift voor Geschiedenis
RHMC Revue d'histoire moderne et contemporaine

PREFACE

1. Merton, *Sociology of Science*; Ben-David, *Scientist's Role in Society*; Solla Price, *Science since Babylon* and *Little Science, Big Science*; Escarpit et al., *Le Littéraire et le social*.

2. Popper, *Logic of Scientific Discovery* and *Conjectures and Refutations*; Kuhn, *Structure of Scientific Revolutions*. For a discussion see, among others, Lakatos and Musgrave, *Criticism and the Growth of Knowledge*.

3. Febvre, "De 1892 à 1933: Examen de conscience d'une histoire et d'un historien" (1933) and "Ni histoire à thèse ni histoire-manuel: Entre Benda et Seignobos" (1933), reprinted in *Combats pour l'histoire*, 3–18, 80–98.

4. Marrou, *De la connaissance historique*, 22; Ariès, *Le Temps de l'histoire*, 209.

5. Bloch, *Apologie pour l'histoire*, 109.

6. For the clearest black-and-white picture see Stoianovich, *French Historical Method*; less extreme are Bourdé and Martin, *Les Ecoles historiques*, and Iggers, *Neue Geschichtswissenschaft*. Also telling is the fact that critics of the "intellocracy" of the *Annales* school have not, by and large, turned their backs on this black-and-white picture; see, e.g., Coutau-Bégarie, *Le Phénomène "nouvelle histoire."*

7. Simiand, "Méthode historique et science sociale."

CHAPTER ONE:
THE CONTOURS OF FRENCH HISTORIOGRAPHY

1. Dupin, *Forces productives et commerciales*, xvi–xx.

2. Daru, *Notions statistiques*. The period under review was 1811–26. Daru is remembered as the author of a history of Venice (see *DBF*).

3. Daru, *Notions statistiques*, 1.

4. Chartier, "Des Livres par milliers."

5. Neuchâtel's role in the propagation of the *Encyclopédie* was brought to light by Robert Darnton in his magnum opus, *The Business of Enlightenment*. On the relative value of various quantitative approaches to eighteenth-century literature see idem, "Reading, Writing and Publishing."

6. Daru used the number of sheets as a unit of measurement. In so doing he therefore

took the print run into consideration (partly on the basis of average estimates). Later investigators confined themselves for the most part to title counts.

7. Furet, "La Librairie du royaume de France," 21; the calculation is based on *permissions publiques*.

8. Morel, "La Production de l'imprimerie française en 1909"; the percentage is based of figures given there.

9. Furet, "La Librairie du royaume de France," 21: 2,285 *permissions publiques* and 2,165 *permissions tacites* in 1780–84.

10. Morel, "La Production de l'imprimerie française en 1909"; less comprehensive but useful comparisons are Morel, "La Production de la librairie française et le Dépôt légal en 1908" and "La Statistique internationale de la production intellectuelle." There is no biography of this intriguing librarian and writer manqué; however, some details about his life can be found in Séché, *Dans la mêlée littéraire*.

11. H. J. Martin, "La Conjoncture intellectuelle française, 1470–1950," in Cain, Escarpit, and Martin, *Le Livre français*, 53–63.

12. Victor Zoltowski has made an attempt to divide book production into periods of economic upswings (A) and downturns (B): A, 1770–1815/17; B, 1817–50; A, 1850–75; B, 1877–1900 (see R. Estivals, "Création, consommation et production intellectuelles," in Escarpit et al., *Le Littéraire et le social*, 194–95). This economic-phase classification is at odds with the production figures and neglects the remarkable growth of the intellectual output in absolute figures.

13. I coined the term *accumulated output* to place the arithmetic approach into some historical relief.

14. L. Delisle, introduction to *Catalogue général*.

15. Carbonell, *Histoire et historiens*, 75.

16. As mentioned, the number of pages and the print run have been discounted in these calculations. See above, n. 6.

17. Morel, "La Production de l'imprimerie française en 1909," 472. The percentages are based on the absolute figures given there.

18. Carbonell, *Histoire et historiens*, 71–73.

19. See appendix 2.

20. Morel, "La Production de l'imprimerie française en 1909," 474. For his analysis Morel made use of the more meticulous *Bulletin mensuel des récentes publications françaises* (1909). Useful for documentation but less critical is Estivals, *La Bibliometrie bibliographique*.

21. In 1970 the heading "history and biography" accounted for approximately 6.9% of the books in the Dépôt légal (1,573 of the total of 22,935 titles) (see M. Troubnikoff, "Les données numériques," in Cain, Escarpit, and Martin, *Le Livre français*, 109–10). As far as historical studies are concerned, there is not the slightest link with the poorly grounded law of the exponential growth curve drawn by Derek de Solla Price, a sociologist of science (see, e.g., his *Little Science, Big Science*, 8, and *Science since Babylon*, 161–95).

22. Chaunu, *De l'histoire à la prospective*, 34.

23. See, e.g., Maigron, *Le Roman historique à l'époque romantique*; and Gerbod, "La Scène parisienne."

24. For a more detailed discussion see chapter 3.

25. Huppert, *Idea of Perfect History*; Kelley, *Foundations of Modern Historical Scholarship*.

26. On historicism see Iggers, "Historicism." Historicism is defined first as the theory

that social and cultural phenomena are determined by history and second as the belief that historical events are governed by law. In this book the term is used in the first sense (the German *Historismus*).

27. For a naive positivist approach that treats the writing of history as the antithesis of tradition see Halbwachs, *La Mémoire collective*, 68–75.

28. See the remarks of the compiler of the systematic index for 1850, written with the 1848 revolution still fresh in memory: R. Merlin, *Bibliographie de la France* (1850), 414–16.

29. Wittram, "Das Interesse an der Geschichte," 2.

30. Martin, "Culture écrite et culture orale," 246–47. In the catalogue of the Bibliothèque bleue, compiled by Alfred Morin, just 0.9% of the 1389 editions fall under the heading "History and travel"; in the inventory of the Garnier family in 1789 only 1.6% of the total of 443,609 items fall under that heading. On the circulation of printed matter in the provinces see Weber, *Peasants into Frenchmen*, 452–70.

31. See, e.g., Bakhtine, *L'Oeuvre de François Rabelais*. The first thoughtful, sober, philosophical interpretation of the Bibliothèque bleue is found in Mandrou, *De la culture populaire*.

32. Nietzsche, "Vom Nutzen und Nachteil der Historie für das Leben," 190.

33. See above, n. 13. That non-French books are included should cause little confusion since these books constitute no more than a fraction of the whole. The carefully compiled register of the Bibliothèque Nationale is more suited to quantification than the careless *Bibliographie de la France*.

34. Furet, "La Librairie du royaume de France," 19.

35. For a more detailed discussion see chapter 3.

36. The percentages are based on absolute figures in Delisle, introduction to *Catalogue général*, xliv. On the restriction applying to provincial and local periodicals see ibid., n. 1.

37. Lelong, *Bibliothèque historique de la France* and *Bibliothèque historique de la France . . . par le feu Jacques Lelong, nouvelle édition*.

38. Monod, *Bibliographie de l'histoire de France*. The headings in the BN catalogue are too unwieldy to use, Brunet's *Manuel du librairie* is full of gaps, and Franklin, *Les Sources de l'histoire de France*, is mainly a list of the most important source editions.

39. Brière, Caron, and Maistre, *Répertoire méthodique de l'histoire moderne et contemporaine*, 1901.

40. Lasteyrie, *Bibliographie générale*. The first edition mentioned the publications from the establishment of each society until 1885 (total 84,000 issues); the bibliography for 1910–40 comprised 124,000 issues, which amounts to a respectable annual average of more than 4,000 issues.

41. For a short description see, e.g., Caron, "L'Organisation des études locales d'histoire moderne."

42. Ibid., 488–89.

43. See Carbonell, *Histoire et historiens*, 79–88, for the computation of the proportion of students of history in the various polymathic societies.

44. Lasteyrie's *Bibliographie* for 1885 lists 407 provincial and 206 Parisian societies, many of which had an ephemeral existence. Because of the loss of Alsace-Lorraine, such places as Strasbourg, Metz, and Mulhouse were no longer included after 1870. Societies whose seats were in the colonies also were not included. An inquiry by the Ministry of Education in 1875–76 produced a list of 151 societies, of which 44 were described as very good and 67 as good and 40 were simply mentioned (AN F^{17} 3023). Also consid-

erably less comprehensive than Lasteyrie is the *Annuaire des sociétés savantes de la France et de l'étranger,* 1866.

45. The calculations for the period 1910–40 give an average of five to six publications per society per annum. The annual average is lower for the longer period because many local journals were short-lived.

46. Dupin, *Forces productives et commerciales,* 1:139, 2:249.

47. See, e.g., Furet and Ozouf, *Lire et écrire,* 37, 121–22.

48. Carbonell, *Histoire et historiens,* 183–84, 208.

49. On the period 1866–75 see ibid., 291–92; on the survey of 1900–1905 see Carbonell, "Historiographie vers 1900." Under the heading "Catholic clergy and pastors," the pastors represented 8% in 1866–75 and 6% in 1900–1905.

50. On the intellectual background to these circles see Girardet's suggestive book *La Société militaire dans la France contemporaine,* 108–10; for a more detailed discussion of intellectual and artistic activities see Serman, *Les Corps des officiers français,* 928–34.

51. S. Freud, "Two Artificial Groups: The Church and the Army," in *The Standard Edition,* 13 (London 1955), 93–99.

52. On this question see Carbonell, *Histoire et historiens,* 215–50: "Persistance des ordres." Carbonell based his work on the survey of 1866–75; I have chosen a more comprehensive approach.

53. Because of their small numerical importance, Protestant pastors have not been included (see above, n. 49). In their own Protestant circles, though, their importance was exceptionally great (see ibid., 221).

54. Boulard, *Essor ou déclin du clergé français?* 112; diagram, 114–15.

55. Dassonville, *Les Belles Familles des religieux français.*

56. Taine, *Les Origines de la France contemporaine: Le régime moderne,* 2:109.

57. Quoted in Boulard, *Essor ou déclin du clergé français?* 125.

58. A rough classification of the social background of the clergy in 1946 shows that peasants (35% of the population) answered 10–15% of the calls; workers (40% of the population), 30% of the calls; the upper and middle classes (25% of the population), 55–60% (see ibid., 136).

59. Ibid., 114–15.

60. Zeldin, *France, 1848–1945,* 2:1010–11. Before 1789 France had an estimated 70,000 monks.

61. Pouthas, "Le Clergé sous la monarchie constitutionelle."

62. Quoted in Lecanuet, *Montalembert,* 3.

63. Pouthas, "Le Clergé sous la monarchie constitutionelle"; Gadille, *La Pensée et l'action politique des évêques français,* 27.

64. Lamennais, "Des Progrès de la Révolution et de la guerre contre l'Eglise," esp. 294–95. The study of history was of great importance in the revival of ultramontanism in France; see, e.g., the selection from the correspondence with Dom Guéranger: Roussel, "Correspondance inédite de Lamennais et de l'abbé Guéranger, 1829–1832."

65. Quoted in Weill, *Histoire du catholicisme libéral,* 52.

66. *Annales de philosophie chrétienne* 3 (1832), 129–30, quoted in Weill, *Histoire du catholicisme libéral,* 57.

67. Lecanuet, *Montalembert,* 51; also quoted in Weill, *Histoire du catholicisme libéral,* 53–54.

68. Montalembert, *Les Moines d'Occident,* introduction.

69. The subtitle of the *Annales* reflected an ambitious programme: "recueil périodique destiné à fair connaître tout ce que les sciences humaines et particulier l'histoire, les

antiquités, l'astronomie, la géologie, l'histoire naturelle, la botanique, la physique, la chimie, l'anatomie, la physiologie, la médecine et la jurisprudence renferment de preuves et de découvertes en faveur du christianisme, par une société d'ecclésiastiques, de littérateurs, de naturalistes, de médécins et de jurisconsultes." A comprehensive prospectus is also bound into the BN copy of the first issue.

70. Weill, *Histoire du catholicisme libéral*, 54–55.

71. *Le Correspondant* was founded in 1829 and after a few years was incorporated in the *Revue européenne*; in 1843 *Le Correspondant* was resuscitated and, under C. Lenormant, became the mouthpiece of liberal Catholicism. The 1850s and 1860s were the heyday of *Le Correspondant*, with the publication of a host of historical articles. For an impression of *Le Correspondant* after its heyday (1871–83) see Crubellier, "Histoire et culture," 4–18.

72. See the prospectus of the Société générale de librairie catholique, successor to Edition Victor Palmé, bound into the Utrecht University Library's copy of *Revue des questions historiques* 20 (1876). On the *Revue des questions historiques* see Carbonell, *Histoire et historiens*, 325–99.

73. Vincent Davin wrote an eight-part critique of Bossuet, summarized in Davin, *Etude critique sur Bossuet*, which elicited a great many reactions (see Gérin, *Recherches sur l'assemblée du clergé de France de 1682*).

74. Darras, *Histoire générale de l'église*.

75. See, e.g., the press review in the third edition of Houtin, *La Controverse*.

76. Cahier, *Caractéristiques des saints dans l'art populaire*, 13. On "popular piety" as a genuine historical source see the introduction in Montalembert, *Histoire de la Sainte Elisabeth de Hongrie*.

77. Rémond, *La Droite en France*, 132–36. P. d'Alzon's *La Croix* became a very popular daily in 1883; alongside it there emerged numerous fanatical regional *Croix*. In 1863 Henri Lasserre, who had been cured at Lourdes, wrote the bestseller *Notre Dame de Lourdes*.

78. On the differences within the Catholic world see Halévy, *La Fin des notables*. A concise survey of the very many national Catholic periodicals is given in Weill, "Le Catholicisme français au XIXe siècle," in which, moreover, the countless local periodicals are not mentioned.

79. For a model of strict historical criticism see Duchesne, *Fastes épiscopaux de l'ancienne Gaule*; for the general context see Marrou, "Philologie et histoire," and the colloquium of the Ecole française de Rome, *Monseigneur L. Duchesne et son temps*.

80. Quoted in A. Armengaud, "Enseignement et langues régionales au XIXe siècle," in Gras and Livet, *Régions et régionalisme*, 266; Certeau, Julia, and Revel, *Une politique de la langue*.

81. Quoted in Armengaud, "Enseignement et langues régionales," in Gras and Livet, *Régions et régionalisme*, 266–67.

82. Tanguy, *Aux Origines du nationalisme breton*, vol. 1.

83. G. Cholvy, "Régionalisme et clergé catholique au XIXe siècle," in Gras and Livet, *Régions et régionalisme*, 187–201.

84. Ibid., 198.

85. On Catholic historiography see the substantial historiographic introduction in Carrière, *Introduction aux études d'histoire ecclésiastique locale*.

86. Carrière's *Introduction* treats the period 1815–70 as one whole and does not recognize 1830 as a *terminus ab quo*. Moreover, he mentions just one publication before 1830 (the abbé Roze on the diocese of Apt, 1820).

87. An exception proving the rule was the conscientious *Histoire de l'abbeye de Fécamp* (Rouen, 1841), by the abbé Fallue, based on his own investigations in Florence and Rome (see Carrière, *Introduction*, 27–28).

88. Carrière, *Introduction*, 27.

89. Montalembert, *Les Moines d'Occident*, and Arbois de Jubainville, *Abbeyes cisterciennes*, were synthetic works of a slightly later date.

90. *Congrès archéologique de France*, 31 (1864), 337.

91. For a brief discussion see, e.g., Montalembert's concluding address to the 1853 session of the Congrès archéologique de France, in *Congrès archéologique de France* (Caen, 1854). See also chapter 2.

92. Aubier, "De la rédaction des chroniques paroissiales," 328.

93. Ibid., 329.

94. Marcilhacy, *Le Diocèse d'Orléans*, is very informative, esp. 134–48.

95. *Congrès archéologique de France*, 31 (1864), 340–41.

96. Commemoration: "Centenaire du service des monuments historiques et de la société française d'archéologie," *Congrès archéologique de France*, 97, 2 vols. (1935).

97. See p. .

98. Aillery, "Quel est le meilleur plan," 292–94.

99. Ibid., 293.

100. Croce, *Zur Theorie und Geschichte der Historiographie*, 9.

101. Carrière, *Introduction*, 36–37.

102. Langlois, "Des études d'histoire ecclésiastique." For a survey of works published since 1870 see Weill, "Le Catholicisme français au XIXe siècle," 335–56.

103. Weill, "Le Catholicisme français au XIXe siècle," 336–41; figures from Langlois, "Des études d'histoire ecclésiastique," 336.

104. Langlois, "Des études d'histoire ecclésiastique," 338–39.

105. On the 1866–75 production see Carbonell, *Histoire et historiens*, 219.

106. On the role of Gabriel Lebras (under the influence of André Siegfried) in this development see Langlois, "Des études d'histoire ecclésiastique," 341. According to Langlois, the importance of Lebras does not, moreover, lie so much in the attention he pays to simple believers or in his use of quantitative methods as in his adoption of the regressive method.

107. Goubert, *L'Ancien Régime*, 1:145–59.

108. For the prefix *de* see Carbonell, *Histoire et historiens*, 229.

109. Goubert, *L'Ancien Régime*, 1:158.

110. Zeldin, *France, 1848–1945*, 1:402. The 15,000 so-called noble families were put at four persons each.

111. For an exaggerated view of the importance of the position of nobles in the general context see Mayer, *Persistence of the the Old Régime*. See also the critical remarks by H. L. Wesseling in *TvG* 97 (1984), 52–56.

112. On a similar situation in 1940 see R. O. Paxton, "Le Retour des notables," in *La France de Vichy*, 232.

113. Halévy, *La Fin des notables*.

114. Tudesq, *Les Grands Notables*, 186.

115. Chaussinand-Nogaret, *La Noblesse au XVIIIe siècle*, 103–5.

116. Ibid., 104.

117. Taine, *Les Origines de la France contemporaine: L'Ancien Régime*, 158.

118. A great deal of research has been done into book ownership, with widely diver-

gent results See, e.g., Meyer, *La Noblesse bretonne au XVIIIe siècle*, 1156–77; cf. Chaussi-
nand-Nogaret, *La Noblesse au XVIIIe siècle*, 105–10.

119. Rémond, *La Droite en France*, 55–56.

120. The list of supporters and visitors of the young duc de Bordeaux in London in
1843 (the pilgrimage to Belgrave Square) is considered the best "inventory" of the legiti-
mists (see Tudesq, *Les Grands Notables*, 201).

121. Ibid., 187.

122. Rémond, *La Droite en France*, 57.

123. Tudesq, *Les Grands Notables*, 187.

124. Caumont, "Histoire de l'Association normande."

125. See, e.g., the extracts from *Mes souvenirs* in the collection *Mélanges de Caumont*);
and Gosselin, "Arcisse de Caumont et la politique." See also F. Bercé, "Arcisse de Cau-
mont et les sociétés savantes," in Nora, *Les Lieux de mémoire*, II, 2:533–67.

126. According to Hubert, "Archéologie médiévale I," in Samaran, *L'Histoire et ses
méthodes*, 294–301. In about 1900 Caumont's *Abécédaire ou rudiment d'archéologie*
(1850–62) was still widely read in the provinces.

127. Gosselin, "La Jeunesse studieuse d'Arcisse de Caumont."

128. *Inauguration dans la ville de Bayeux de la statue de M. Arcisse de Caumont* (Caen,
1877), in *Mélanges de Caumont*.

129. Tudesq, *Les Grands Notables*, 179–80.

130. Ibid., 134–46.

131. Ibid., 146–51.

132. A. de Vigny, *Mémoires inédits*, ed. J. Sangnier (1958), quoted in Tudesq, *Les
Grands Notables*, 197.

133. Tanguy, *Aux Origines du nationalisme breton*, vol. 1, esp. 129ff.

134. *Revue celtique* 2 (1873–75), 131–32.

135. Rémond, *La Droite en France*, 55–56.

136. Tanguy, *Aux Origines du nationalisme breton*, 2:271 n. 440.

137. Seignobos, *L'Evolution de la Troisième République*, 115–17.

138. Cf. Rémond, *La Droite en France*, 143–46, 148–59.

139. Mayeur, *Les Débuts de la Troisième République*, 51–52.

140. Rémond, *La Droite en France*, 147.

141. Carbonell, *Histoire et historiens*, 238; cf. 219.

142. See, e.g., Schlumberger, *Mes Souvenirs*.

143. See chapter 2.

144. Rémond, *La Droite en France*, 106.

145. Orléans, *Histoire des princes de Condé*; see also Carbonell, *Histoire et historiens*,
228.

146. Rémond, *La Droite en France*, 107.

147. For a list of "academic" historians see C. Seignobos, "L'Histoire," in Petit de
Julleville, *Histoire de la langue et de la littérature français*, 297–300.

148. For an apposite characterization see Ariès, *Le Temps de l'histoire*, 209–12.

149. Taken from a lecture by R. Smith in Fritz Ringer's *séminaire* (EHESS, 6 May
1977) and based on the prescribed reading lists for students of Sciences Po, i.e., the
Ecole des sciences politiques. At the Ecole normale, by contrast, Tocqueville was not
widely read.

150. Albert Sorel (1842–1906) was the author of the monumental *L'Europe et la Révo-
lution française*, 8 vols. (1885–1912); on him see Monod, "Albert Sorel." Pierre de la

Gorce (1846–1934) was the author of, among others, the *Histoire du Second Empire*, 7 vols. (1894–1905); see Gorce, *Une Vocation d'historien*. Before the First World War, Gabriel Hanotaux (1853–1944) published, among others, the first two volumes of his *Histoire du Cardinal de Richelieu* (1893, 1896) and a *Histoire de la France contemporaine, 1871–1882*, 4 vols. (1903–8); see Barza et al., *La Vie et l'oeuvre de Gabriel Hanotaux*, and V. S. Vetter, "Gabriel Hanotaux," in Halperin, *Essays in Modern European Historiography*, 91–118.

151. Ariès, *Le Temps de l'histoire*, 211.

152. Armengaud, *La Population française au XIXe siècle*, 63.

153. Fourastié, *Les Trente glorieuses*, 49.

154. "Evolution de la population active," 284; on the flexible use of vocational categories see Seignobos, *L'Evolution de la Troisième République*, 407–8.

155. "Evolution de la population active," 274.

156. For the decline in illiteracy see Furet and Ozouf's exhaustive *Lire et écrire*.

157. Fourastié, *Les Trente glorieuses*, 75.

158. Guillaumin, *La Vie d'un simple*; cf. Halévy, *Visites aux paysans du Centre*.

159. The following figures are taken from a detailed survey in "Evolution de la population active," 246–47 (absolute figures); 249–50 (percentages).

160. Ibid., 269.

161. Ibid., 270.

162. Duroselle, *La France et les Français*, 152–53, says there were 30,000 army and naval officers in 1911; Seignobos, *La Révolution de 1848*, 385 gives the number as 15,000.

163. According to Duroselle, *La France et les Français*, 248, there were 2,100 sitting magistrates, 700 *procureurs*, and 56 members of the Cour de cassation.

164. "Evolution de la population active," 269–70.

165. The proceedings of the inquiry were published in full in *Journal officiel, Chambre des députés, documents parlementaires et annexes*, 1899 session, vol. 2. For a detailed study of this rich source see Isambert-Jamati, "Une Réforme des lycées et des collèges.".

166. Villemain, *Exposé des motifs*.

167. Boulard, *Essor ou déclin du clergé français?* 114–15, puts the number of secular priests at 55,702 and the number of regular priests at 37,000 in 1901.

168. In 1938 the number of nobles, including children, was estimated at 90,000 (see above, n. 110).

169. Duroselle, *La France et les Français*, 85.

170. Febvre, "Travail"; *Geschichtliche Grundbegriffe*, s.v. "Arbeit."

171. Duroselle, *La France et les Français*, 85; Rebérioux, *La France radicale?* 221.

172. This view conflicts with Gramsci's general thesis that every social group fulfilling an essential function in economic production creates one or more strata of intellectuals who see to the group's homogeneity and awareness of their function not only in the economic but also in the social and political fields (see Gramsci, "The Intellectuals," in *Selections from the Prison Notebooks*, 5–23).

173. Furet and Ozouf, *Lire et écrire*, 241, 268.

174. For a survey based on the data in R. de Lasteyrie's bibliography and the number of inhabitants given in the *Annuaire statistique de la France*, 19 (1899; 1896 count), see appendix 5.

175. The five were Privas (Ardèche), Mézières (Ardennes), Ajaccio (Corsica), Mont de Marsan (Landes), and La Rochelle (Charente-Inférieure). La Rochelle had, however, had a historical society in the past.

176. See appendix 5.

177. Societies had their headquarters in the towns for practical, logistic reasons.

178. Quoted in Zeldin, *France, 1848–1945*, 2:33.

179. On the political problems at the local level as well see the discussion in Seignobos, *L'Evolution de la Troisième République*, 103ff.; on republican commemorations and symbols see various articles in Nora, *Les Lieux de mémoire, I*, e.g., R. Girardet on the Tricolor, M. Vovelle on the *Marseillaise*, and C. Amalvi on Bastille Day.

180. See Paul Leuillot's foreword in Thuillier, *Economie et société nivernaises*, 18–19. I am grateful to Guy Thuillier for allowing me to consult his manuscripts on local historians from the Nevers region.

181. These statements are based on several random samples from the *mémoires* of the Académie in Clermont-Ferrand and the *Revue d'Auvergne*. The 131 members of the Société in 1884 did not include a single cleric. In an interview with me in Clermont-Ferrand in June 1977, R. Sève, the local archivist, voiced the suspicion that the Académie numbered more *pétainistes* than *résistants* during the Second World War; the opposite was the case with the Société. The great inventory of local-history studies in Franche-Comté mentions no rival societies in a single town but does refer to differences during the Second Empire between the liberal *Revue littéraire de Franche-Comté* (1863–67) and the Catholic *Annales Franc-Comtoises* (1864–70, 1889–1905). At about the turn of the century the spiritual heir to the liberal journal was *Le Pays Comtois* (1897–1901). See Locatelli et al., *La Franche-Comté à la recherche de son histoire*, 85–96.

182. See appendix 6.

183. For instance, in Montpellier in the sixties (see Le Roy Ladurie, *Paris—Montpellier*, 145–46).

184. Thabault, *Mon Village*. See, e.g., the foreword by André Siegfried, the laudatory review by Lucien Febvre (*Annales d'histoire sociale*, 1947) and the opinion of Eugen Weber, whose *Peasants into Frenchmen* is inspired by Thabault's ideas.

185. Littré, *Dictionnaire de la langue française*: "Néologisme, esprit de région, de localité. Le régionalisme est encore trop enraciné en Italie pour sacrifier ses institutions à l'unité, Joseph de Reinach in: *Journal des débats*, 1875."

186. Cf. J. M. Mayeur, "Démocratie chrétienne et régionalisme," in Gras and Livet, *Région et régionalisme*, 445–60.

187. Newman, *Un Romancier périgordin*.

188. P. Vernois, "Une Ecole littéraire: L'Ecole rustique du Centre," in Gras and Livet, *Régions et régionalisme*, 257–63.

189. Girardet, *Le Nationalisme français*, 12.

190. See chapter 2.

191. Meaux, *Augustin Cochin*, 298.

192. Carrière, *Introduction*, 40–43, lists various societies.

193. See Caron, *Manuel pratique*, 63, 71.

194. Ibid., 71–72.

195. Caron, "L'Organisation des études locales d'histoire moderne," 483.

196. It was characteristic for the appeal to study local history to go hand in hand with a mention of incidental benefits: studying local history was a way of taking an interest in the province into which fate had cast one; it made one feel at home rather than in exile; and it helped to increase one's authority with pupils and their families (for an example see Gabriel Monod's foreword to Lévy, *Le Havre entre trois révolutions*).

CHAPTER TWO
PAYING FOR HISTORY

1. Véron de Forbonnais, *Recherches et considérations*, 2.

2. Marion, *Histoire financière*, 1:468–70.

3. For a classic survey arranged chronologically see Marion, *Histoire financière*. For an economic approach see Bouvier, "Sur les dimensions mesurables du fait financier."

4. Between 1872 and 1907 sixty-five bills calling for income tax were placed before the Senate, only to be turned down. The absence of inflation was another reason for the large number of *rentiers* during this period. On taxation see Zeldin, *France, 1848–1945*, 1:709–12.

5. The French equivalent of the English term *budget* was not used in eighteenth-century France. The great specialist on finances during the Revolution was Victor Braesch (see his *Finances et monnaies révolutionnaires*); for a recent study see Bosher, *French Finances*. See also Goubert, *L'Ancien Régime*, 2:137–38.

6. "Aid to fugitive Dutchmen" was 830,000 livres tourains. The percentages are based on figures in appendix 3 of Marion, *Histoire financière*, 1:468–69.

7. Unless stated otherwise, all data bearing on nineteenth- and early-twentieth-century budgets are taken from BN series 4° Lf156 8.

8. Jardin and Tudesq, *La France des notables*, 21–22.

9. F. Véron de Forbonnais, *Recherches et considérations*, 6.

10. Furet and Ozouf, *Lire et écrire*, 349.

11. Ibid., 175.

12. Bloch, *Les Rois thaumaturges*, 401–5.

13. Fossier, "Le Charge d'historiographe"; idem, "A propos du titre d'historiographe"; Chéruel, *Dictionnaire des institutions*, 547–48.

14. Primi Visconti, *Mémoires sur la cour de Louis XIV*, 246.

15. La Bruyère, *Les Caractères*, 83.

16. Gembicki, "Jacob-Nicolas Moreau."

17. Langlois, *Manuel de bibliographie historique*, 314–16. The book contains references to the studies of L. Delisle and X. Charmes.

18. Napoléon I, *Correspondance*, 15:97.

19. Burton, "L'Enseignement de l'histoire."

20. On the abbé Halma see Gooch, *History and Historians*, 153–54.

21. Jullian, *Extraits des historiens français*, x; Knibiehler, *Naissance des sciences humaines*, 51, 268. For more details on Lemontey see Reisov, *L'Historiographie romantique française*.

22. Baschet, *Histoire du Dépôt*, 449, where the comte d'Hauterive is described as the "rudest and harshest opponent of curiosity about, and historical work on, diplomatic documents."

23. Vauthier, "Chateaubriand," 354–57, mentions just one report to Charles X, written by Vicomte Sosthène de La Rochefoucauld, directeur des beaux-arts, on 19 July 1825. According to F. Fossier, Louis XVIII bestowed the title of royal historiographer for the last time on Chateaubriand, in recognition of his "merits as a diplomat" (see Fossier, "A propos du titre d'historiographe," 370).

24. On the social status of writers in general see Monglond, "La Promotion et le sacerdoce de l'homme de lettres," in *Le Préromantisme français*, 136ff.; and Bénichou, *Le Sacre de l'écrivain*. Jean d'Alembert's "Essai sur la société des gens de lettres et des grands, sur la réputation, sur les mécènes et sur les recompenses littéraires," in *Oeuvres complètes*, 4:337–73, marks an important stage in the emancipation of writers.

25. Maury, *L'Ancienne Académie*.

26. Seznec, *Essais sur Diderot*, 79–96.

27. Gibbon, *Autobiography*, 93.

28. For chronological surveys see Frankeville, *Le Premier siècle de l'Institut de France*; and Dussaud, *La Nouvelle Académie*.

29. For a survey of all editions see Lasteyrie, *Bibliographie générale*.

30. *Budget général, 1825*, 66–67.

31. See Lasteyrie, *Bibliographie générale*. The following works have not been taken into account: the *Table chronologique des diplômes*, resumed in 1836, vol. 4, and *Diplomata, chartae, epistolae et alia documenta ad res francicas spectantia*, resumed in 1832, vols. 1 and 2 (1843–49).

32. See below.

33. On the early history of the Ecole des chartes see Prou's introduction to *Livre du centenaire*.

34. Spiess, *Von Archiven*, 5.

35. According to Chéruel, *Dictionnaire des institutions*, 31, there were 1,225 archival depositories in 1782.

36. A handy survey is Bordier, *Les Archives de la France*.

37. Napoléon I, *Correspondance*, 20:220–21; cf. Bordier, *Les Archives de la France*, 27–28, 392–94.

38. See *DBF*; and Préteux, *A. G. Camus*.

39. Camus, who died in 1804, was succeeded by the industrious Daunou; on the latter see Mignet, *Notices et mémoires historiques*, 197–222. Daunou was dismissed in 1816 but reinstated in 1830. In the intervening years the chevalier de la Rue, a man unhampered by expert knowledge, was put in charge of the archives (see Bordier, *Les Archives de la France*, 21–23).

40. See the extensive catalogue of the exhibition held in the Louvre, *Le Cabinet du Roi*.

41. G. Ouy, "Les Bibliothèques," in Samaran, *L'Histoire et ses méthodes*, 1070.

42. See Courajod, *Alexandre Lenoir*. See also D. Poulot, "Alexandre Lenoir et les musées des monuments français," in Nora, *Les Lieux de mémoire, II*, 2:497–531.

43. Hubert, "Archéologie médiévale I," in Samaran, *L'Histoire et ses méthodes*, 284–85. For a general survey see Chastel, "La Notion du patrimoine," in Nora, *Les Lieux de mémoire, II*, 2:405–50.

44. For 1825, 500,000 francs were requested. By then the costs (since 1810) had run up to more than 4.5 million francs; the total costs were estimated at 8 million francs (*Budget général, 1825*, 72).

45. "Rapport au Roi sur le budget du ministère de l'instruction publique pour l'exercice de 1835," in Guizot, *Mémoires*, 3:398. A. Thierry defined Guizot's objective as follows: "to raise the study of national records and monuments to the rank of a national institution" ("Considérations sur l'histoire de France" [1840], in Jullian, *Extraits des historiens français*, 98).

46. Jardin and Tudesq, *La France des notables*, 125.

47. Guizot, *Mémoires*, 3:33–34.

48. Ibid., 11.

49. See appendix 7.

50. Guizot, *Mémoires*, 3:66–67.

51. Ibid., 140, 159, and passim.

52. Parker, *Cult of Antiquity*.

53. Mellon, *Political Uses of History*; see also Maarsen, *De strijd om de Revolutie*.

54. Furet and Ozouf, "Deux légitimations historiques."

55. Thierry, *Lettres sur l'histoire de France*, 3.

56. For a detailed account of nineteenth-century scholars see Amalvi, "L'Erudition française."

57. Perrens, *Etienne Marcel*; even earlier Jules Quicherat had published a biography of Etienne Marcel in the series *Plutarque français* (1844).

58. For a general study of Guizot see Johnson, *Guizot*; cf. Pouthas, *Guizot*.

59. Guizot, *Mémoires*, 3:171.

60. Jardin and Tudesq, *La France des notables*, 129, 157.

61. Guizot, *Mémoires*, 3:172.

62. Michelet, *Histoire de la Révolution française*; Quinet, *Le Christianisme*; Esquiros, *Les Montagnards*; Blanc, *Histoire de la Révolution française*; Lamartine, *L'Histoire des Girondins*.

63. Michelet, preface (1869) to his *Histoire de France*, cxxxvi.

64. Guizot, *Mémoires*, 3:182.

65. This circular was reprinted, with others, in X. Charmes's detailed and extremely well-documented *Le Comité des travaux historiques et scientifiques*.

66. Knibiehler, *Naissance des sciences humaines*, 261ff.

67. Charmes, *Le Comité des travaux historiques et scientifiques*, 2:6.

68. On the debate in the Chamber see Guizot, *Mémoires*, 3:179.

69. Charmes, *Le Comité des travaux historiques et scientifiques*, 2:21.

70. Carbonell, "Guizot," 226; the question is J. J. Champollion-Figeac's.

71. Ibid., 225, citing the view of Achille Jubinal, a member of the Comité from the beginning.

72. Wailly, *Eléments de paléographie*, v.

73. See Langlois, *Manuel de bibliographie historique*, 357.

74. State grants to the Comité in selected years between 1835 and 1910 were as follows: in 1835, 120,000 francs; in 1842, 150,000; in 1850, 132,000; in 1860, 120,000; in 1870, 120,000; in 1880, 120,000; in 1890, 145,000; in 1900, 162,000 (including a sum for *publications diverses*, the *Journal des savants* among them); and in 1910, 203,000 (including an even greater number of *publications diverses*).

75. The figures are based on Lasteyrie, *Bibliographie générale*.

76. R. H. Bautier, communication to author, 1977; see also Bautier, "Le Comité des travaux historiques." An instructive survey of archives and publications is Antoine, "Un Service pionnier." I am particularly grateful to Mme Antoine for her informative comments.

77. Bernier, *Journal des Etats généraux*.

78. On Guizot's circular see Charmes, *Le Comité des travaux historiques et scientifiques*, 2:19.

79. See, e.g., Giry, "Jules Quicherat."

80. State grants to the Ecole des chartes in selected years from 1850 to 1910 were as follows: in 1850, 35,000 francs; in 1870, 46,000; in 1890, 70,000; and in 1910. 76,000.

81. Prou, introduction to *Livre du centenaire*.

82. Ibid., xxiv.

83. Villemain set up a permanent committee for the administration and supervision of scientific missions subsidized by the Ministry of Education. For reports on its work see *Archives des missions scientifiques et littéraires* (from 1850). It is difficult to give a precise figure of the funds allocated for this work because various ministries had special funds, which were not centralized until 1901 in the Caisse des recherches scientifiques.

84. On Tiran's mission see Knibiehler, *Naissance des sciences humaines*, 276–84.

85. See Radet, *L'Histoire et l'oeuvre de l'école française d'Athènes*, a most informative and respectful work.

86. Selected state grants to the Ecole française d'Athènes from 1847 to 1910 were as follows: in 1847, 61,000 francs; in 1870, 64,500; in 1890, 78,000; and in 1910, 117,700.

87. Quoted in Radet, *L'Histoire et l'oeuvre de l'école française d'Athènes*, 35.

88. Ibid., 56.

89. "Correspondance d'Emmanuel Roux: Les débuts de l'Ecole française d'Athènes," *Bibliothèque des universités du Midi*, fasc. 1 (Bordeaux, 1898), 11.

90. State grants to the Institute de France in selected years from 1825 to 1910 were as follows: in 1825, 425,000 francs; in 1835, 503,000; in 1842, 562,000; in 1850, 571,000; in 1860, 618,000; in 1870, 661,000; in 1875, 667,000; in 1880, 708,000; in 1890, 697,000; in 1900, 687,000; and in 1910, 696,000.

91. Four volumes were published in the series *Notices et extraits des manuscrits de la Bibliothèque du Roi*, four in the series *Histoire littéraire*, two in *Recueil des historiens*, two in *Recueil des ordonnances des rois de France*, two in *Table chronologique des diplômes*, and two in *Diplomata, chartae, epistolae et alia documenta ad res francicas spectantia*.

92. Guizot, *Mémoires*, 3:146–57; see also Mireaux, *Guizot et la renaissance de l'Académie*.

93. Knibiehler, *Naissance des sciences humaines*, 309ff.

94. Ibid., 337–49.

95. See appendix 8.

96. Hubert, "Archéologie médiévale 1," in Samaran, *L'Histoire et ses méthodes*, 283–93. Guizot's work in this field can in a sense be considered as the completion and definition of the initiatives taken by the minister comte de Montalivet during the First Empire upon representations by the archeologist Alexandre de Laborde. For a general survey see Poulot, "Naissance du monument historique"; and Chastel, "La Notion du patrimoine."

97. On government initiatives see Charmes, *Le Comité des travaux historiques et scientifiques*; a general description of the archive, which contains interesting papers, can be found in Antoine, "Un Service pionnier," 23–25.

98. *Projets de loi pour la fixation des recettes et des dépenses de l'exercice 1843*, BN 4° Lf[156] 8 (1842), 170.

99. Lucas-Dubreton, *Le Culte de Napoléon*, 353–87.

100. Gaehtgens, *Versailles*, gives a detailed description of the historical paintings in the Galerie des Batailles.

101. Viardot, *Les Musées de France*, 478–93; *Michelin's Guide de Paris* (1947), 95.

102. Knibiehler, *Naissance des sciences humaines*, 266.

103. Ibid., 267.

104. "Our plan, therefore, is to seize our chance and to extend the benefits of learning to the largest possible number of people," we can read in the prospectus of one of many successful publishing ventures, the "New and complete collection of papers on the history of France from the thirteenth to the end of the eighteenth century, improved with notices, notes, elucidations and comments by MM. Michaud and Poujoulot."

105. The Société de l'histoire de France is the subject of a detailed study to be published in the collection of essays based on the colloquium held in Paris in December 1985 on the 150th anniversary of the Comité des travaux historiques.

106. See chapter 1.

107. The classic form of subsidy was the purchase by the authorities of a certain number of copies (Guizot, *Mémoires*, 3:163). Many have ridiculed the largesse of Sal-

vandy, who preferred to speak from the heart rather than pursue excellence (see Mirecourt, *Salvandy*, 90).

108. Guizot, *Mémoires*, 3:161.

109. Ibid., 159.

110. Ernest Renan was in advance of the *communis opinio* of scholars with his *L'Avenir de la science, pensées de 1848*, which was not published until 1890.

111. Knibiehler, *Naissance des sciences humaines*, 445.

112. Arbois de Jubainville, *Deux manières d'écrire histoire*, 107. Thierry's *Récits des temps mérovingiens* was published as a collection in 1840, accompanied by an introduction, the "Considérations sur l'histoire de France," in which, among other things, Thierry argued that the revolution of 1830 had determined the significance of the preceding revolutions.

113. Aulaunier, *Le Nouveau Louvre de Napoléon III*, 9. For the history of the Louvre see also Hautecoeur, *Histoire du Louvre*.

114. Knibiehler, *Naissance des sciences humaines*, 415–29.

115. Guizot, *Mémoires*, 3:148.

116. For a short survey see Agulhon, *1848*, 144–49. According to Taine, Cousin had exclaimed: "Let us hasten to throw ourselves at the bishops' feet" (Taine, *Les Origines de la France contemporaine: Le régime moderne*, 2:247).

117. Guizot *Mémoires*, 3:149.

118. Arbois de Jubainville, *Deux manières d'écrire l'histoire*, iii; see also *BEC*, 2nd ser., 4 (1847–48), 280, which, incidentally, does not mention this politically motivated text.

119. Quotation from Michelet's manuscript "Soldats de la Révolution," in *Conseil Municipal de Paris, Rapports et documents, année 1886*, no. 80, app. 1.

120. *BEC*, 2nd ser., 4 (1847–48), 360.

121. *Documents divers publiés par les ministres pour l'année 1850, en execution de différentes lois* (1851), 196. On disturbances at republican celebrations see Seignobos, *La Révolution de 1848*, 132.

122. Especially in September, October, and November the *Journal officiel* carried numerous revealing documents culled from the correspondence of the imperial family; the first installment was published on 24 September 1870. With the siege of Paris, other preoccupations became more pressing. See also *Correspondance et papiers de la famille impériale*.

123. For a positive opinion see Dansette, *Naissance de la France moderne*, or, earlier, Boon, *Rêve et réalité*; for general differences in opinion see Gooch, *Napoleon III*.

124. Quoted in Marion, *Histoire financière*, 5:352.

125. Tascher de la Pagerie, *Mon Séjour aux Tuileries*, 108. On Charlemagne see Carette, *Souvenirs intimes de la Cour des Tuileries*, 216; Henri Monnier, whose method of tutoring the prince was described as ponderous and pedantic, was the author of *Alcuin et Charlemagne*.

126. On 1789 see Marion, *Histoire financière*, 1:468–70; the figures for 1825 are based on the *Budget générale des dépenses et des services de l'exercice*, 1825.

127. Marion, *Histoire financière*, 5:232.

128. Ibid., 351.

129. Emerit, *Lettres de Napoléon III à Madame Cornu*, vol. 2, letter 12–15.

130. See Froehner, *Souvenirs*.

131. Jules Soury in *Journal Officiel*, 11 November 1870.

132. On Alésia see Quicherat, *Mélanges*, 468–74.

133. On the part played by Boucher de Perthes see, e.g., "Centenaire de la préhistoire

en Périgord." Edouard Lartet played an active part in the entourage of Napoleon III; see his *Matériaux pour l'histoire positive et philosophique de l'homme*. Between 1865 and 1870, in line with the usage of British archeologists, their French counterparts replaced the term *temps anté-historiques ou anté-diluviens* with *préhistoire* (see *Bulletin de la société historique et archéologique du Périgord* 102 [1975]).

134. Quicherat, *Mélanges*, 71–79, fragment written in 1867.

135. Froehner, *Souvenirs*.

136. Reinach, "Esquisse d'une histoire du musée Campana."

137. Longnon, "A. Maury."

138. "Les Souvenirs d'un homme de lettres par L. F. Alfred Maury," 3,000 pages, seven folio volumes, dictated 1873–77, Bibliothèque de l'Institut; see also Paz, "Alfred Maury."

139. Quoted in Perrot, "Notice sur la vie et les travaux de Auguste-Honoré Longnon," 109–10. Longnon was a technically gifted *érudit* who took an extremely poor view of French history in general (see his one-dimensional royalist political credo written at the time of the centenary celebrations of the Revolution, *De la formation de l'unité française*).

140. *Correspondance et papiers de la famille impériale*, 2:100–102.

141. *Projets de loi pour la fixation des recettes et des dépenses de l'exercice de 1850, 1860,* and *1870.*

142. Knibiehler, *Naissance des sciences humaines*, 439–43; Mireaux, *Le Coup d'état académique*.

143. Quoted in Guizot, *Mémoires*, 3:151.

144. Quoted in Gontard and Raphaël, *Un Ministre de l'instruction publique*, 266. That work contains useful corrections to the sinister picture of Fortoul drawn by republicans.

145. For a report of this episode see Pommier, "Un Témoignage sur Ernest Renan," 42–52, 55–58, 61.

146. See Masson, "Correspondance d'Ernest Renan et du Prince Napoléon," 13–16.

147. See appendix 8.

148. Bordier, *Les Archives de la France*.

149. Despois, *Le Vandalisme révolutionnaire*.

150. Abbé Grégoire, "Rapport sur les destructions opérées par le vandalisme et sur les moyens de le réprimer," in *Convention, Instruction publique, séance du 14 Fructidor, an II;* for the origins and context of the report see the bibliography in Hermant, "Destructions et vandalisme," 717.

151. Despois, *Le Vandalisme révolutionnaire*, 238–39.

152. See Michelet, *Oeuvres complètes*, 3:539–64, and the corresponding entries in Michelet's *Journal*.

153. The 540th departmental archive inventory appeared in 1920.

154. Geyl, *Napoleon*, 69–70.

155. See Ledos, *Histoire des catalogues*; and also Delisle's introduction to the *Catalogue général* (1897).

156. See Perrot, "Léopold Delisle." Delisle's bibliography, compiled by P. Lacombe, runs to more than five hundred pages (1902) and was followed by a supplement (1911). Recollections by Delisle were reprinted in his *Recherches sur la librairie de Charles V*.

157. See Lasteyrie, *Bibliographie générale*.

158. For archival documents see Antoine, "Un service pionnier," 22.

159. See above, n. 74.

160. The figures are from Prou, introduction to *Livre du centenaire*.

161. See table 2.

162. Agulhon, *1848*, 146.

163. See above, n. 144.

164. Gerbod, *La Condition universitaire*, bk. 3, "Captive en Bonapartie."

165. See table 2.

166. See the many details in Furet and Ozouf, *Lire et écrire*. This thesaurus devoted to the teaching of the art of reading and writing wrongly minimizes the political factor.

167. See Lavisse, *Un Ministre: Victor Duruy*, first published in *Revue de Paris* (1895).

168. Duruy, *Notes et souvenirs*, 1:69.

169. Ibid., 80.

170. Duruy, *Les Papes, princes italiens*; see also idem, *Notes et souvenirs*, 1:110–12. On comparable work by Daunou at the request of Napoleon I see Gooch, *History and Historians*, 154–55.

171. *Statistique de l'enseignement supérieur, 1865–1868*. At Duruy's behest, the *Recueil de rapports sur les progrès des lettres et des sciences en France* used the occasion of the world exhibition to publish, among other things, the *Rapports sur les études historiques* (1867), in which A. Geffroy dealt with antiquity; J. Zeller, the Middle Ages; and J. Thiénot, modern history.

172. See Jullian, *Extraits des historiens français*, cxii.

173. Napoléon I, *Correspondance*, 15:102–10.

174. Ghellinck, *Les Exercices pratiques*, 9–38.

175. Duruy, *Notes et souvenirs*, 1:201–324.

176. Ibid., 309.

177. Duruy was the first French minister of education to take the "German challenge" seriously; his predecessors, from Guizot to Rouland, seem to have been less concerned with international rivalry in the educational sphere.

178. On Renier's role see Paris, *Le Haut Enseignement*, 10–11; on Madame Cornu see Emerit, *Lettres de Napoléon III à Madame Cornu*, 1:115–21.

179. AN F[17] 13617, Ecole pratique des hautes études, IVe section, including, among others, a report by Maury (1868).

180. See Gabriel Monod to the director of higher education, 20 March 1869, in ibid. See also several passages from Monod's diary reprinted in Bémont, "Gabriel Monod," 10–11; and Monod's letter to the minister of education, 8 September 1868, in Monod's personal file, AN F[17] 21982.

181. The reports are in AN F[17] 13617.

182. *Rapport sur l'Ecole pratique des hautes études*, 1868 to 1893–94 (BN 8° Z 130); after 1893–94 the *Rapport* was replaced by sectional reports, *IVe Section*, 1894–1937 (BN 8° R 12036).

183. Monod to Albert Duruy, 25 March 1885, Papiers Duruy-Glachant, AN, 114 AP 2, letter following a bitter attack by Duruy on the reforms of higher education, in which he accused his old comrades from the Ecole normale (Monod and Lavisse) of acting for personal gain. See chapter 4 for the reforms of higher education and chapter 5 for the close relationship between Lavisse and the minister's son.

184. *Statistique de l'enseignement supérieure, 1865–1868*, 44.

185. Viollet-le-Duc, *Dictionnaire raisonné du mobilier français* and *Dictionnaire raisonné de l'architecture française*; see Huizinga's view in "Natuurbeeld en historiebeeld in de achttiende eeuw," 403.

186. Hubert, "Archéologie médiévale I," in Samaran, *L'Histoire et ses méthodes*, 305; Abraham, *Viollet-le-Duc*.

187. Quoted in Hubert, "Archéologie médiévale I," in Samaran, *L'Histoire et ses méth-*

odes, 287. For a detailed opinion see B. Foucart, "Viollet-le-Duc et la restauration," in Nora, *Les Lieux de mémoire, II*, 2:613–49.

188. The section "Beaux Arts, conservation d'anciens monuments historiques" was allocated 1.5 million francs in 1880 and 1.7 million in 1910 for monuments belonging to the state, plus 2.7 million francs for the rest. Numerous restoration projects were financed by other means.

189. Data taken from *Annuaire statistique de la France*, 1 (1878): "Etat par catégories des monuments historiques de France (1875)" (278).

190. Note of 11 July 1856, *Correspondance et papiers de la famille impériale*, 2:52–58, Mérimée's copy. Mérimée, who agreed with these plans, was probably not their author.

191. Report of 31 March 1856 by Sainte-Beuve, ibid., 257.

192. Marion, *Histoire financière de la France*, 5:236.

193. Ibid., 6:vi.

194. Ibid., 9. This was a frequently voiced criticism; see, e.g., Cadot, "Le Budget et les fonctionnaires."

195. The funding of elementary education in particular is a complex question; the wealth of the communes mattered more than the departmental data (see the comments by Guizot quoted in Furet and Ozouf, *Lire et écrire*, 185–87).

196. Quoted in Marion, *Histoire financière de la France*, 6:116.

197. The data are from the 1900 and 1910 budgets (BN 4° Lf[156] 8, vol. 3).

198. The figures for secondary education are from Isambert-Jamati, *Crises de la société*, 376; for data on the faculties see below, chapter 4.

199. The income of the faculties has not been taken into account; on this subject see Weisz, *Emergence of Modern Universities in France*, 164–65.

200. Taken from *Statistique de l'enseignement supérieur, 1865–1868, 1869–1876, 1877–1888*, and *1889–1899* (BN 4° Lf[242] 61, 1–4).

201. Radet, *L'Histoire et l'oeuvre de l'école française d'Athènes*, 167.

202. On Albert Dumont see below.

203. Arbois de Jubainville, *Mémoire présenté à l'Académie*.

204. See Lasteyrie, *Bibliographie générale*. In the series *Ordonnances des rois de France*, published under the auspices of the ASMP, ten volumes of the *Catalogues des actes de François I* appeared (1887–1908), with no mention of the editors, as was the custom. The enterprise was directed by the lawyer Georges Picot; his most important assistant was Paul Guérin, and the index was the work of Paul Marichal.

205. The allocation to the fifth section (religious studies), founded after the abolition of the state theological faculties in 1885, came to 32,000 francs in 1899 and 51,000 in 1910 (figures taken from successive issues of the *Statistique de l'enseignement supérieur*; see also table 13. On the position of history see Monod, *A Gabriel Monod en souvenir de son enseignement*; and Lot, "L'Histoire à l'école pratique des hautes études").

206. In R. J. Smith's well-documented *Ecole Normale Supérieure*, 72–75, this change is very much underplayed.

207. In his *Le Régime de l'enseignement supérieur des lettres* Seignobos suggested that the Ecole des chartes be transformed into a postgraduate *institut d'application*, following studies at the arts faculty.

208. In accounts of the motives underlying the reform of French higher education the conservative option is largely ignored, for instance in Prost, *L'Enseignement en France*, and in such studies by non-French authors as Keylor, *Academy and Community*.

209. Renan, *La Réforme intellectuelle et morale*, 81.

210. Ibid., 156. On H. Taine see, for instance, *Sa vie et sa correspondance*, 3:306: "The

general cause of the French Revolution . . . is hurried, poorly done, a priori science . . . the general remedy is well-done, experimental science."

211. The *Revue internationale de l'enseignement* was published annually in two large volumes (totaling 1,300 pages) from 1881 on.

212. Personal file of Armand Dumesnil, AN F^{17} 20658. In 1866 the holder bore the title *chef de la première division*; in 1870, *directeur de l'enseignement supérieur*. On Dumesnil see also *DBF* and Dumesnil, *Aux amis du très regretté Armand Dumesnil*.

213. The personal file of Albert Dumont seems to have gone astray; for an assessment of his work in the educational sphere see Lavisse, "Albert Dumont."

214. Personal file of Louis Liard, AN F^{17} 25839, including a striking characterization of Liard as a pupil at the Ecole normale: "An independent mind . . . reasoning powers . . . speaks with ease and authority, perhaps even with a little too much assurance, whence the complaints about his conduct." For an assessment see Lavisse, "Louis Liard." Liard was succeeded by Charles Bayet (1902–18), on whom see *DBF*.

215. Liard, *L'Enseignement supérieur en France*, 2:368.

216. A. Dumont, *Notes sur l'enseignement supérieur en France*, first published in *Enquêtes et documents relatifs à l'enseignement supérieur* 15 (1884), 29–30.

217. Liard was very outspoken in the introduction to the *Statistiques de l'enseignement supérieur, 1889–1899*, in which he maintained that France had failed to make provisions for "science" for three-quarters of a century because freedom and democracy had been lacking. Liard's commendable *L'Enseignement supérieur en France* was patently a "histoire à thèse," paying disproportionate attention to revolutionary initiatives.

218. Prost was right to take a relative view of the 1896 reforms but wrong to arrive at a negative conclusion (see Prost, *L'Enseignement en France*, 239). On Liard as the architect and tactician of the search for a compromise in the amalgamation of faculties into universities (1896) see Weisz, *Emergence of Modern Universities in France*, 134–62.

219. In this respect Prost was not able to distance himself from Louis Liard's approach. Prost puts the beginnings of the higher-education reforms at no earlier than 1877 and does not even mention Armand Dumesnil.

220. Dumont, "Les Etudes d'érudition en France et en Allemagne," 772.

221. Ibid., 783.

222. Antoine, "Un Service pionnier," 28–30.

223. See the list of publications in Caron, *Manuel pratique*, 24–31.

224. On J. Guillaume see P. Nora, "Le Dictionnaire de pédagogie de Ferdinand Buisson: Cathédrale de l'école primaire," in Nora, *Les Lieux de mémoire, I*, 363–69, which refers the reader to M. Vuilleumier's introduction to Guillaume, *L'Internationale*, 1–57.

225. See the list of publications in Caron, *Manuel pratique*, 31–43.

226. See Prou, introduction to *Livre du centenaire*.

227. Lelong, *C. Port*, 85 (Rozière-Port correspondence).

228. A reaction to Aulard's report was Lot's "Chartistes et archivistes," which mentions that of the 213 theses presented to the Ecole des chartes between 1892 and 1906, 117 covered a medieval subject and only a very small number a subject connected with the Revolution.

229. Meaux, *Augustin Cochin*, 298.

230. *Conseil municipal de Paris, rapports et documents, année 1886*, no. 80, p. 10. See also P. Ory, "Le Centenaire de la Révolution française," in Nora, *Les Lieux de mémoire, I*, 523–60.

231. *Conseil municipal de Paris, procès-verbaux, année 1887, 2e semestre*, 650–56.

232. *Conseil municipal de Paris, rapports et documents, année 1892*, no. 78, p. 8.

233. Aulard, *La Société des Jacobins*; idem, *Paris pendant la Réaction Thermidorienne et sous le Directoire*; Lacroix, *Actes de la Commune de Paris*.

234. On the series *Ville de Paris, publications relatives à la Révolution française et à l'histoire contemporaine* see the list of publications in Caron, *Manuel pratique*, 46–52.

235. J. Cousin, "Rapport de la commission des recherches sur l'histoire de Paris, 31-1-1887," quoted in the introduction to Lacroix, *Actes de la Commune de Paris*, vol. 1.

236. The following quotations are from clippings in Aulard's personal file, AN F^{17} 22600, and Dossier Aulard, in Bibliothèque historique de la ville de Paris, "Documents d'actualité." For further details on Aulard see chapter 5.

237. "Révolution de chaire," signed by Jacques Bonhomme, in *France libre*, 15 March 1886.

238. Goblet, minister of education, in an address at the annual meeting of learned societies, announcing the publication of Carnot's correspondence (*Conseil municipal de Paris, rapports et documents, année 1886*, no. 80, p. 9).

239. On the Senate debate on the subject see *La Révolution française* 42 (1902), 375–78.

240. Charton, *Dictionnaire des professions*. Included is a comparison, by heading, between the second edition of Charton (1851), the third edition of Charton (1880), Doublet's *Dictionnaire universel des professions*, and Jacquemart's *Professions et métiers*.

241. Lamartine's sales figures are in Godechot, *Un Jury pour la Révolution*, 50–52. The first ten volumes of Taine's *Les Origines* had been reprinted an average of sixteen times each by 1901 (see Giraud, *Bibliographie critique de Taine*).

242. Data from Viallaneix, *La Voie royale*; see also Zeldin, *France, 1848–1945*, 2:386–87.

243. Taine, *Sa vie et sa correspondance*, 2:316.

244. Doublet, *Dictionnaire universel des professions*.

245. Caron, "L'Organisation des études locales d'histoire moderne," 501.

246. Meaux, *Augustin Cochin*, 234.

247. *Budget générale, 1910*, chap. 64, 434.

248. Jacquemart, *Professions et métiers*, 685.

CHAPTER THREE
HISTORY AT SCHOOL

1. *Recueil des lois et règlements*, 220–23.

2. See Grosperrin, *La Représentation de l'histoire de France*, 50–69.

3. Monod, "La Chaire d'histoire au Collège de France," offprint, 8–9.

4. Grosperrin, *La Représentation de l'histoire de France*, 54.

5. *Statistique de l'enseignement supérieur, 1865–1868*; in 1844 there were twelve history posts at French arts faculties.

6. For views on the improvement of this situation see Grosperrin, *La Représentation de l'histoire de France*, 29–49.

7. Grosperrin blamed lack of time, gaps in the education of lecturers, the seductive nature and the political dangers of history, and contempt for it. A. Momigliano emphasized the role of Latin in "Introduction of History." The opposition to history on the grounds that it was too "worldly" is mentioned in Snyders, *La Pédagogie en France*, 95.

8. Lulofs, *Nederlandsche Redekunst*, 1.

9. For a brief survey see H. I. Marrou's classic *Histoire de l'éducation dans l'antiquité*, 269ff.

10. Lulofs, *Nederlandsche Redekunst*, 131.

11. Marrou, *Histoire de l'éducation*, 382. The best-known collection of historical material for rhetors, *Facta et dicta memorabilia*, which was used for many centuries, was compiled during the first century *A.D.* by Valerius Maximus.

12. Dainville, "L'Enseignement de l'histoire."

13. Ibid., 142.

14. Momigliano has suggested several reasons in "Introduction of History," 8, 10–13: patriotism, protestantism, and the fact that history was deemed useful in the education of public servants; the German lead might even be due in part to the great difficulty Germans had with Latin.

15. Dainville, "L'Enseignement de l'histoire," 145. Nîmes was the exception that proved the rule (ibid., n. 72).

16. Many of these pleas are mentioned in Grosperrin, *La Représentation de l'histoire de France*.

17. Dainville, "L'Enseignement de l'histoire," 149.

18. See the output figures mentioned in chapter 1.

19. For the detailed opinion of an authoritative eighteenth-century pedagogue see Rollin, *Traité des études*; see also below. There is an extensive literature on the impact of classical historians. A. Momigliano has published such fundamental studies as "The Place of Herodotus in the History of Historiography," reprinted in *Studies in Historiography*, and "The First Political Commentary on Tacitus," in *Essays in Ancient and Modern Historiography*. For a general survey see Burke, "Survey of the Popularity of Ancient Historians."

20. According to Jean Sturm, quoted in Dainville, "L'Enseignement de l'histoire," 131.

21. Descartes, *Discours de la méthode*, 37.

22. Alembert, "Collège," in *Oeuvres complètes*, 4:487.

23. But cf. R. Koselleck, "Historia magistra vitae: Ueber die Auflösung des Topos im Horizont neuzeitlich bewegter Geschichte," reprinted in *Vergangene Zukunft*, 38–66.

24. Montaigne, *Essais*, bk. 1, § 26.

25. Fleury, *Traité du choix*, 137.

26. Nearly a third of Rollin's *Traité des études* was devoted to history.

27. See also Bossuet's challenging *Discours sur l'histoire universelle*, 168.

28. Marrou, *Saint Augustin*, 463–64; Löwith, *Weltgeschichte und Heilsgeschehen*.

29. As far as I know, there is no study of the teaching of biblical history in France.

30. On the problem of the cyclical view of history in Christian thought see Trompf, *The Idea of Recurrence*. Trompf takes issue with the "linear" conceptions of Marrou and Löwith (see above, n. 28).

31. Recent stimulating and polemical studies of humanistic historiography in France have traced the roots of historism back to the sixteenth century see Huppert, *Idea of Perfect History*; and Kelley, *Foundations of Modern Historical Scholarship*. These studies are proof of the wide-ranging character of humanistic historiography but do not convincingly refute the general view.

32. Fleury, *Traité du choix*, 140.

33. Rollin, *Traité des études*, 3:6.

34. Ibid., 13.

35. Turpin, *La France illustre*.

36. *Recueil des lois et règlements*, 220.

37. Huizinga, "Natuurbeeld en historiebeeld," 356.

38. Michelet in the preface to *Le Peuple* and Thierry in the preface to *Récits des temps*

mérovingiens, two well-known passages quoted in, among others, Jullian, *Extraits des historiens français,* xii–xiii.

39. See, e.g., Maigron, *Le Roman historique à l'époque romantique.* Strikingly detailed studies can be found in Haskell, *Rediscoveries in Art.*

40. Also useful to historians is Bruneau, *L'Epoque romantique,* vol. 12 of Brunot's standard work, *Histoire de la langue française.* On Michelet see esp. 347–65; and for a detailed study see Refort, *L'Art de Michelet.*

41. For a careful classification of the uses of this concept see Kamerbeek, *Tenants et aboutissants.*

42. See above, n. 31.

43. W. Krauss, "Der Streit der Altertumsfreunde mit den Anhängern der Moderne und die Entstehung des geschichtlichen Weltbildes," in Krauss and Kortum, *Antike und Moderne,* ix–cxi; for further literature see Voss, *Das Mittelalter,* 165ff.

44. Brands, *Historisme als ideologie;* Iggers, *Deutsche Geschichtswissenschaft.*

45. Arnould and Nicole, *La Logique,* 413–27, "Quelques règles pour bien conduire sa raison dans la créance des événements qui dépendent de la foi humaine."

46. Filangeri, *Oeuvres;* Michelet, *Oeuvres choisis de Vico* and *Principes de la philosophie de l'histoire* (1827), reprinted with an introduction by Paul Viallaneix in Michelet, *Oeuvres complètes,* vol. 1.

47. See Reid, *Inquiry into the Human Mind;* see also the searching analysis of Michelet's intellectual training in Viallaneix, *La Voie royale,* 161–66.

48. Taine, *Les Philosophes classiques;* see also Kossmann, "De doctrinairen."

49. A still useful biography is Janet, *Victor Cousin et son oeuvre;* a famous attack is Leroux, *Réfutation de l'électisme,* 61–276.

50. Cousin, *Oeuvres,* 2:28.

51. Ibid., 151.

52. Ibid., 19.

53. Quoted in Viallaneix, *La Voie royale,* 166.

54. Cousin, *Oeuvres,* 2:19. On *normalien* admiration of Cousin see *Le Surveillant politique et littéraire,* May 1818, 29.

55. Herder, *Idées sur la philosophie,* translated from the German by Edgar Quinet (1827); on Quinet see Valès, *Edgar Quinet,* 49–65. For a more general discussion see Tronchon, *La Fortune intellectuelle de Herder en France.*

56. Quoted in Viallaneix, *La Voie royale,* 161.

57. Ibid., 134.

58. The view of, among others, Nisbet, *Sociological Tradition.*

59. In the 1820s the following translations appeared, among others: Reid, *Essai sur les facultés intellectuelles de l'homme;* and Stewart, *Histoire abrégée des sciences.* An important part in the spread of Scottish philosophy was also played by Gérando (*De la génération des connaissances humaines*); see Viallaneix, *La Voie royale.*

60. Cousin, *Oeuvres,* 2:435.

61. V. Cousin, *Introduction à l'histoire de la philosophie,* quoted in Viallaneix, *La Voie royale,* 177.

62. For an apposite characterization of enlightened Christianity see Huizinga, "Geschiedenis der (Groningse) universiteit,", 88–90, 139–52.

63. Pocock, "Origins of the Study of the Past," reprinted in Blaas, *Geschiedenis als wetenschap.*

64. Trognon, *Etudes sur l'histoire de France,* 6 (originally a book review in *Globe* of Sismondi's *Histoire des Français*).

65. Quoted in Viallaneix, *La Voie royale*, 213.

66. Quoted in ibid.

67. Cousin, *Oeuvres*, 2:84–85.

68. Trognon, *Etudes sur l'histoire de France*, 8.

69. Chateaubriand, *Oeuvres complètes*, 4:xlvii.

70. Knibiehler, *Naissance des sciences humaines*, 27.

71. Ibid.; Viallaneix, *La Voie royale*, 209ff.

72. Quoted in Stadler, *Geschichtsschreibung und historisches Denken*, 104.

73. Guizot, *Histoire des origines du gouvernement représentatif* and *Histoire de la civilisation en Europe*. The second work, which is central to Guizot's historical thinking, has been reprinted by P. Rosavallon, with a preface entitled "Le Gramsci de la bourgeoisie" (1985).

74. Thierry, *Lettres sur l'histoire de France*, 14.

75. Grosperrin, *La Représentation de l'histoire de France*, 839–40.

76. Thierry, *Lettres sur l'histoire de France*, 15.

77. Rollin, *Traité des études*, 4:452.

78. Ibid., 3:60.

79. Ibid., 93–94.

80. Ibid., 15–16.

81. See Koselleck, "Historia magistra vitae."

82. AN F[17] 12823, Procès-verbaux de la Commission de l'instruction publique, minutes, 15-5-1818. Guizot, appointed to the chair of modern history in 1812 and hence a colleague of Royer Collard, who had been appointed to the chair of the history of philosophy in 1810, implies that he was the driving force behind this decision; see Guizot, *Mémoires*, 3:173.

83. Guizot, *Mémoires*, 1:159; also quoted in Stadler, *Geschichts-schreibung und historisches Denken*, 73.

84. I have looked in vain for the original text of the petition in the petition registers AN C 2033 and C 2052. On Darmaing see *DBF*.

85. *Le Surveillant politique et littéraire*, May 1818, 28.

86. Cousin, *Oeuvres*, 2:390.

87. *Le Surveillant politique et littéraire*, May 1818, 25–26.

88. See, e.g., the record of the debate in the Chamber on 25 February 1817, in *Archives parlementaires*, 19:152–56.

89. Quoted in Barante, *La Vie politique de Royer Collard*, 1:330.

90. Ibid., 425.

91. In 1822 the *Almanach de l'Université* mentioned no history teachers in other Parisian schools; it mentioned two outside Paris, at the *collèges royaux* in Strasbourg and in Toulouse.

92. AN F[17] 20686; see also *DBF*.

93. AN F[17] 21521.

94. AN F[17] 20783 (2).

95. AN F[17] 20996.

96. AN F[17] 20659.

97. AN F[17] 20197.

98. AN F[17] 20593; *DBF*.

99. AN F[17] 20362, born in 1793. See also *Revue de l'Instruction publique* 18 (1858), 397; and *DBF*.

100. AN F[17] 21569.

101. AN F^{17} 21811; see also Larousse, *Dictionnaire universel*, s.v. "Trognon."

102. *Recueil des lois et règlements*, 220–23.

103. Quoted in Gerbod, "La Place de l'histoire," 124–25.

104. Rabanis, *Lettre à M. Cousin*, 4.

105. Dupanloup, *Conseils aux jeunes gens*, 9. In 1867, incidentally, his criticism had been more cautious (see idem, *L'Histoire, la philosophie, les sciences*, 93–94).

106. *De la position des professeurs d'histoire dans les collèges de l'université.*

107. Decree of 15 November 1845, *Bulletin universitaire* 14 (1845), 214–16.

108. Fortoul, *Rapport à l'empereur*, 72–73.

109. Estimate in Karady, "Stratégie et hiérarchie des études," 30. According to figures taken from the *Rapport au Roi* (1844) (Villemain, *Exposé des motifs*, 68, the share of *agrégés* in history was already 10% of the total number of *agrégés* (338).

110. The calculation is based on the "plan d'études" in Villemain, *Exposé des motifs*, 68–73.

111. *Revue historique*, no. 33 (1887), 108–11.

112. *Recueil des lois et règlements*, 220–23.

113. This is not an exhaustive survey of the many regulations involved. I have consulted the *Circulaires et instructions officielles relatives*. See also Gréard, *Education et instruction.*

114. Decision of 30 August 1852 (see Fortoul, *Instruction générale*, 24–25).

115. "Programmes d'histoire, 7-6-1902," in *Bulletin administratif de l'instruction publique*, n.s., 71 (1902), 792–803.

116. Gerbod, "La Place de l'histoire," 126.

117. For Duruy's inaugural address, from which these quotations are taken, see Duruy, *Notes et souvenirs*, 1:127–57. The *normalien* G. Ducoudray's *Histoire de France et histoire générale* may be considered a perfect result of Duruy's program (see below).

118. Duruy, *Notes et souvenirs*, 1:121–23.

119. Isambert-Jamati, *Crises de la société*, 71–76, is very cautious about the number of pupils.

120. For a detailed account see Gerbod, *La Condition universitaire*, 288–90, 301–3, 317. On Rouland's plans see Anderson, *Education in France*, 206; see also Isambert-Jamati, *Crises de la société*, 74.

121. Duruy, *Notes et souvenirs*, 1:255.

122. Laprade, *Le Baccalauréat et les études classiques*, 57, quoted in Anderson, *Education in France*, 178.

123. *La Politique et l'histoire contemporaine*, 41.

124. Ibid., 60–61.

125. Ibid., 72.

126. Laprade, *Le Baccalauréat et les études classiques*, 86–89, cited in Anderson, *Education in France*, 179.

127. Monod, "Les Réformes de l'enseignement secondaire," 358–59.

128. *Recueil des lois et règlements*, 220–23.

129. Langlois and Seignobos, *Introduction aux études historiques*, 284.

130. Rollin, *Traité des études*, 4:449; see also his assessment of existing works from a didactic point of view.

131. See, e.g., Poirson and Cayx, *Précis de l'histoire ancienne*; Ragon, *Histoire générale des temps moderne* and *Histoire de France*; and Michelet, *Précis de l'histoire moderne*.

132. Cayx, "Avant-propos," in his *Précis de l'histoire de France.*

133. See Viallaneix's introduction to Michelet's *Précis de l'histoire moderne* in Michelet, *Oeuvres complètes*, 2:20.

134. Rabanis, *Lettre à M. Cousin*, 4.

135. Poirson and Cayx, *Précis de l'histoire ancienne*, preface.

136. Rabanis, *Lettre à M. Cousin*, 12–13.

137. Michelet, *Précis de l'histoire moderne*, preface.

138. Henry, *Manuel des maîtres d'études*.

139. Rabanis, *Lettre à M. Cousin*, 4.

140. Gerbod, the great authority on university life, referred to the period 1852–63 as "l'histoire à l'index" in "La Place de l'histoire," 128–29.

141. Fortoul, *Rapport à l'empereur*, 42.

142. Duruy, *Notes et souvenirs*, 1:79.

143. Fortoul, *Rapport à l'empereur*, 46.

144. Fortoul, *Instruction générale*, 24–25, 39–40.

145. *Histoire universelle publiée par une société de professeurs et de savants sous la direction de V. Duruy* (1853–) comprised a large number of highly respected works, many of which were repeatedly reprinted, among them Maspéro, *Histoire ancienne des peuples de l'Orient*; Maury, *La Terre et les hommes*; A. Geffroy on the history of Scandinavia; A. Rambaud on the history of Russia; and J. Zeller on the history of Italy. Exceptionally successful were Duruy's own books: *Histoire de France*; *Histoire grecque*; *Histoire romaine*; *Histoire du Moyen Age*; and *Histoire des temps modernes*.

146. Duruy, *Notes et souvenirs*, 1:71.

147. Levasseur and Himly, *Rapport général*. See also below, n. 150.

148. For a full list of their works see *Catalogue général des livres imprimés de la Bibliothèque Nationale*.

149. Girardet, *La Société militaire dans la France contemporaine*, 110.

150. Levasseur and Himly, *Rapport général*. Neither author was a "proper" historian. Levasseur, a professor at the Collège de France, was a man of many parts: economist, statistician, demographer, and geographer (see Hauser, "Emile Levasseur"). Himly, the founding father of university geography, for fifty years held the only independent chair of geography in French higher education (at the Paris arts faculty).

151. Bréal, *Quelques mots sur l'instruction*, 256.

152. Hémon, *Bersot et ses amis*, 275.

153. Bréal, *Quelques mots sur l'instruction*, 256. This view was common among advocates of classical education; see, e.g., Spruijt, "Een doctoraat in de geschiedenis," 133.

154. Charles Zévort, director of secondary education, had a part in this development (see Falcucci, *L'Humanisme dans l'enseignement secondaire*, 340).

155. Ibid., 341.

156. See Isambert-Jamati, *Crises de la société*, 132, for a calculation of the share of various subjects in the text of the ministerial instruction. Geography's share increased from 0.4% in 1860–70 to 6% in 1880; in the same period physical training's share increased from 0.7% to 5%.

157. Falcucci, *L'Humanisme dans l'enseignement secondaire*, 354.

158. *Revue historique*, no. 33 (1887), 108–11.

159. Gerbod, *La Condition universitaire*, 530, considered the 1874 syllabus a pedagogical counterrevolution. For a more balanced view see Isambert-Jamati, *Crises de la société*, 107.

160. *Revue historique*, no. 14 (1880), 363.

161. There is little point in going into the precise details of every change in the educational program. In 1884 history had already had to accept a reduction in the number of hours (see *Revue historique*, no. 26 [1884], 94–95).

162. Quoted in Falcucci, *L'Humanisme dans l'enseignement secondaire*, 420–21.

163. The instructions are reprinted in Lavisse, "De l'enseignement de l'histoire," in *A propos de nos écoles*, 77–107. His members of the subcomittee were Inspector Foncin, Professor Henri Lemonnier of the Paris arts faculty, and Jallifier, an exemplary teacher.

164. There is a striking resemblance between this approach and what English historiographers refer to as the Whig interpretation (see Butterfield, *Whig Interpretation of History*; see also Blaas, *Continuity and Anachronism*, and Offringa, "Een whig-interpretatie van de Duitse geschiedenis").

165. Lavisse, *A propos de nos écoles*, 95–96.

166. See above.

167. Lavisse was the editor of the *Album historique*, a series illustrated with many engravings that included, among other writings, Parmentier, *Le Moyen-Age*; on these textbooks see also Altamira, *La Ensenanza de la historia*.

168. *Revue historique*, no. 42 (1890), 363.

169. For an excellent summary see Isambert-Jamati, *Crises de la société*, 177–80.

170. The method had been advocated, for example, by Bréal in *Quelques mots sur l'instruction*, 255, and by Monod in *Revue historique*, no. 14 (1880), 361.

171. The historical committee was presided over by Lavisse; the other members were Inspectors Debidour and Foncin, the teachers Gallouédec, Jallifier, and Albert Petit, and Professors Lemonnier and Seignobos. For Seignobos's writings see *Revue historique*, no. 90 (1906), 447. The archives of the history reform committee are of little interest as they are filled for the most part with correspondence about temporary regulations, AN F^{17} 13947. The *Instructions concernant les programmes de l'enseignement secondaire* (BN 8° 24327) were not published in toto until 1911. The spirit of the 1902 reforms is captured by Seignobos's "L'Enseignement de l'histoire comme instrument d'éducation politique," in *L'Enseignement de l'histoire* (1907), reprinted in Seignobos, *Etudes de politique et d'histoire*, 109–32. For a fuller discussion see below.

172. At the time, Gallouédec (1864–1937) was a teacher at the Lycée Charlemagne in Paris. Gallouédec published mainly works on geograph, and after the First World War he was appointed *inspecteur-général* of education (see *DBF*; see also G. Monod, *Revue historique*, no. 95 [1907], 337–40).

173. L. Bougier, *Revue historique*, no. 95 (1907), 341–45.

174. For reviews of Jallifier and Vast's *manuel* see *Revue historique*, nos. 24 (1884), 460; 29 (1885) 475, and 37 (1888), 235. An analysis of history textbooks for secondary schools remains to be done. For those for primary schools, by contrast, there are several extensive studies: Freyssinet-Dominjon, *Les Manuels d'histoire*; Amalvi, *Les Héros de l'histoire de France*; and idem, "Les Guerres des manuels."

175. For reviews see *Revue historique*, for example, no. 90 (1906), 447; for full titles and various versions and editions see the *Catalogue général des livres imprimés de la Bibliothèque Nationale*. Seignobos wrote a pedagogical and didactic introduction to his series of school textbooks, *L'Histoire dans l'enseignement secondaire* (1906), in which he defined schoolbooks as "dictionnaires de faits" and laid great emphasis on the *méthode active*; for a critical survey see Pagès, "L'Histoire au lycée."

176. On Lavisse's recommendation, Malet (*agrégé* in 1891) was commissioned by the publishers Hachette to write a schoolbook in keeping with the 1902 reforms. Jules Isaac (*agrégé* in 1902) edited, among others, a successful *Résumé, aide-mémoire, l'histoire contemporaine* (1907). Malet was killed in Artois in 1915. "Malet-Isaac" came out after the 1923–25 educational reforms; for its genesis and distinct didactic conception see Gérard, "Origines et caractéristiques du Malet-Isaac."

177. Langlois and Seignobos, *Introduction aux études historiques*, 284–85.

178. Villemain, *Exposé des motifs*.

179. Quoted in Gerbod, *La Condition universitaire*, 524.

180. See ibid., 541–48.

181. Dupanloup, *Conseils aux jeunes gens*, 20. Before 1870–71, before the defeat, before the Commune and the capture of Rome, Dupanloup's tone was less apocalyptic (see above, n. 105).

182. Ibid., iii.

183. Wesseling, *Soldaat en krijger*, 24.

184. Dupanloup, *Conseil aux jeunes gens*, ii.

185. Löwith, *Weltgeschichte und Heilsgeschehen*, 148–59.

186. Duruy, *Notes et souvenirs*, 1:154.

187. Lavisse, "De l'enseignement de l'histoire," reprinted in *A propos de nos écoles*, 78.

188. Ibid., 79.

189. See above.

190. Lavisse, "De l'enseignement de l'histoire," 80; see also above.

191. Isambert-Jamati, *Crises de la société*, 318–19.

192. On Renouvier and Kantianism in France see, e.g., Scott, *Republican Ideas and the Liberal Tradition*; and Milhaud, *La Philosophie de Charles Renouvier*.

193. Isambert-Jamati, *Crises de la société*, 163.

194. Ibid., 175.

195. Lavisse, "De l'enseignement de l'histoire," 84.

196. Isambert-Jamati, *Crises de la société*, 159, 175.

197. Ibid., 170, where the meticulous investigator assures us that this rise was not due to an overrepresentation of historians among the speakers.

198. For a fuller discussion of Seignobos see chapter 5.

199. Langlois and Seignobos, *Introduction aux études historiques*, 289 (in the appendix on secondary education by Seignobos).

200. Ibid.

201. See Seignobos's clear argumentation in "L'Enseignement de l'histoire,"in *L'Enseignement de l'histoire*.

202. Lavisse, "De l'enseignement de l'histoire," 80.

203. Langlois and Seignobos, *Introduction aux études historiques*, 288–89.

204. Quoted in Wesseling, *Soldaat en krijger*, 24.

205. At the congress of the Ligue de l'enseignement in Amiens in 1904 it was suggested that the slogan "Pour la patrie, par le livre, par l'épée" (for the motherland, by the book, by the sword) be dropped; for the shocked reaction of Henri Hauser, who was known to have leftist leanings, see Hauser, *La Patrie, la guerre et la paix à l'école*. On pacifist schoolbooks see Amalvi, "Les Guerres des manuels." In his foreword to Bocquillon, *Pour la patrie*, G. Duruy wrote: "It is not by extolling the benefits of the advent of the potato that one imbues souls with the spirit needed to fulfill certain duties."

206. The *bête noir* was Alphonse Aulard (see chapter 5), together with his coauthor Albert Bayet (see *DBF*); the most pronouncedly pacifist school textbook was that written by G. Hervé. For a general, very passionate analysis see Tardieu, "La Campagne contre la patrie."

207. Weber, *Nationalist Revival in France*. It is probably more correct to speak of a nationalist *reaction*.

208. Agathon, *Les Jeunes Gens d'aujourdhui*; Agathon was the pen name of Henri Massis and Alfred de la Tarde. On the inquiry see Wesseling, *Soldaat en krijger*, 84–87;

for a comparison with other inquiries held at the time see Bénéton, "La Génération de 1912–1914."

209. The full instructions were not published until 1911 (see above, n. 171).

210. Louis Liard has characterized the spirit of the 1902 reforms as follows: "This country, which is above all one filled with an idealist and deductive spirit, has need of a great infusion of realism" (quoted in Falcucci, *L'Humanisme dans l'enseignement secondaire*, 510).

211. Isambert-Jamati, *Crises de la société*, 182–83, 191. See also the address by Louis Liard, "Le Nouveau Plan d'études de l'enseignement secondaire."

212. Isambert-Jamati, *Crises de la société*, 221–22.

213. G. Monod, *Revue historique*, no. 77 (1901), 379. For a summary of the attacks on the Sorbonne see Wesseling, *Soldaat en krijger*, 50–64; for greater detail see J. Capot de Quissac, "L'Action française à l'assaut de la Sorbonne historienne," in Carbonell and Livet, *Au berceau des Annales*, 139–91. See also, among others, Maurras, *L'Avenir de l'intelligence*; and Lasserre, *La Doctrine officielle de l'université*. Maurras's attack on Monod was quite uncalled for; incidentally, it had been anticipated in E. Drumont's bestseller *La France juive*, 362: "The multiplication of Monods . . . has been one of the Egyptian plagues that afflict the present epoch most grievously."

CHAPTER FOUR
HISTORY AND HIGHER EDUCATION

1. See chapter 2.

2. For more detail see chapter 5.

3. For the German lead see chapter 3, n. 14.

4. *Statistique de l'enseignement supérieur, 1865–1868.*

5. See chapter 2.

6. Conrad, "Allgemeine Statistik," 118–19.

7. Prost, *L'Enseignement en France*, 243, gives 9,963 as the number of registered students in 1875; Weisz, *Emergence of Modern Universities in France*, 238, says there were 11,204 registered students in 1875–76.

8. Paulsen, *Die deutschen Universitäten*, 165. For the technically complicated calculations (with very different results) of the percentages per age group see Jarausch, *Transformation of Higher Learning*, 16; see also below, n. 27.

9. Conrad, "Allgemeine Statistik," 146–47.

10. Prost, *L'Enseignement en France*, 234.

11. F. Paulsen, "Wesen und geschichtliche Entwicklung der deutschen Universitäten," in Lexis, *Die deutschen Universitäten*, 8–9. See also Paulsen, *Die deutschen Universitäten*, 9; more substantial and concerned mainly with classical education is idem, *Geschichte des gelehrten Unterrichts*.

12. Landes, *Unbound Prometheus*, 347–48. For a case study of the changes in English higher education at the end of the nineteenth century see Engel, *From Clergyman to Don*. See also Rothblatt, *Revolution of the Dons*.

13. Ringer, *Decline of the German Mandarins*.

14. Weber, "Fachmenschentum versus Kulturmenschentum," in *Wirtschaft und Gesellschaft*, 735–37.

15. See, e.g., Victor Duruy in the introduction to *Statistique de l'enseignement supérieur, 1865–1868*; Liard, *L'Enseignement supérieur en France*; and the observations of Albert Dumont and Ernest Lavisse.

16. Milward and Saul, *Economies of Continental Europe*, 73–75.

17. On higher education in theories of modernization see Jarausch, *Transformation of Higher Learning*, 32–36, and the references given there.

18. Paulsen, *Die deutschen Universitäten*, 10.

19. See, e.g., Milward and Saul, *Economies of Continental Europe*, 535.

20. Ariès, *L'Enfant et la vie familiale*, 48–51.

21. O'Boyle, "Excess of Educated Men."

22. "The commerce of letters has banished utterly the trade in merchandise, which heaps riches upon the estates; has ruined agriculture, the true wet nurse of the people, and has in no time at all laid waste to the training ground of soldiers, who are better reared in the coarse school of ignorance than in the polite school of learning; lastly, it has filled France with quibblers, more likely to ruin family life and to disturb the public peace than to bring the least benefit to the estates" (Du Plessis, *Testament politique*, 124–25).

23. The words form the subtitle of L. B. Namier's book *1848*.

24. See, e.g., Hanotaux, *Du choix d'une carrière*, which mentions "Le préjugé scolaire"; and Le Bon, *Psychologie du socialisme*.

25. The *Statistisches Jahrbuch für das deutsche Reich* 32 (1911) gives 62,765 as the number of German students for the summer semester of 1910; at the time the total population of Germany was about 65 million. The "Résumé rétrospectif" in the *Annuaire statistique* 56 (1940–45) gives 41,044 as the number of French students for 1910, when the total population of France was about 39 million.

26. Bourdieu and Passeron, *Les Héritiers*, 132.

27. Jarausch, *Transformation of Higher Learning*, 14–16. The problem with such comparisons is that the definition of higher education is not the same in every country; in the United States, for instance, higher education also includes what is called higher vocational training in many European countries. Jarausch has tried to get around this problem by comparing the percentages of twenty- to twenty-four-year-olds fully engaged in daytime education in the various countries under consideration.

28. Bourdieu and Passeron, *Les Héritiers*, 132.

29. H. Titze, "Enrollment, Expansion, and Academic Overcrowding in Germany," in Jarausch, *Transformation of Higher Learning*, 57–89. Titze concludes that the more open the social recruitment policy of the faculties, the greater the cyclical fluctuations in the supply and in shortages of academics. However, he neglects the cardinal question of the increase in absolute numbers.

30. The figures are from Conrad, "Allgemeine Statistik," 125–26, and from *Statistisches Jahrbuch für das deutsche Reich* 32 (1911).

31. *Statistique de l'enseignement supérieur, 1865–1868; Annuaire statistique* 56 (1940–45), "résumé rétrospectif."

32. Conrad, "Allgemeine Statistik," 123; computations for the summer semester of 1910 are based on *Statistisches Jahrbuch für das deutsche Reich* 32 (1911), 330–31.

33. Data for 1865 are from *Statistique de l'enseignement supérieur, 1865–1868*.

34. See appendix 9.

35. See ibid.

36. *Annuaire statistique* 56 (1940–45), "résumé rétrospectif."

37. Goblot, *La Barrière et le niveau*. There is an extensive literature on the *baccalauréat*; see Isambert-Jamati, *Crises de la société*, bibliography arranged by period.

38. Veblen, *Theory of the Leisure Class*, 254–58.

39. Dupanloup, *De l'éducation*, esp. 1:259–67.

40. Quoted in Prost, *L'Enseignement en France*.

41. Rethwisch, "Geschichtlicher Rückblick," esp. p. 6.

42. *Gazette (spéciale)1 de l'Instruction publique* 10 (1847), 122 (review of J. B. Pointe, *Hygiène des collèges comprenant l'histoire médicale du collège royal de Lyon* [1847]).

43. *Grande Encyclopédie du XIXe siècle*, s.v. "internat," by M. Marion.

44. The figures are from Isambert-Jamati, *Crises de la société*, 85, 121, 201.

45. *Grande Encyclopédie du XIXe siècle*, s.v. "camaraderie."

46. See R. J. Smith's well-considered introduction to his *Ecole Normale Supérieure*, 5–18.

47. Halévy, *La République des ducs*; Thibaudet, *La République des professeurs*, a penetrating essay marked by the Dreyfus affair, written following the victory in 1924 of the Herriot-Painlevé-Blum triumvirate. For a survey of *normaliens* who became members of parliament in the period 1870–40 see Smith, *Ecole Normale Supérieure*, 112–13.

48. Gerbod, *La Condition universitaire*, 422, 460; Smith, *Ecole Normale Supérieure*, 18.

49. Prost, *L'Enseignement en France*, 72.

50. The importance of this development has been wrongly minimized in Smith, *Ecole Normale Supérieure*, 73, a work that is otherwise well informed.

51. These formulations by Victor Duruy can be found, for instance, in his introduction to *Statistique du l'enseignement supérieure, 1865–1868*, ix.

52. Kant, "Der Streit der Fakultäten," 332.

53. A brief indication of the importance of Halle and Göttingen can be found in Paulsen, *Die deutschen Universitäten*, 52–60. Paulsen notes that German scholars were generally employed as university teachers (6).

54. Ibid., 66.

55. Rethwisch, "Geschichtlicher Rückblick."

56. For a discussion of Humboldt's conception see Vossler, "Humboldts Idee der Universität."

57. The classic writings on higher education by Schelling (1802–3), Fichte (1807), Schleiermacher (1809), Steffens (1808–9), and Humboldt (1810) have been brought together in Anrich, *Die Idee der deutschen Universität*. For an inspired comparative study see Flexner, *Universities*. On the origins of the research ethos see Turner, "University Reformers and Professional Scholarship in Germany."

58. The tensions between scholarship and teaching were discussed even earlier in Paulsen, *Die deutschen Universitäten*, 538–42.

59. A still useful historical survey is Liard, *L'Enseignement supérieur en France*.

60. Paulsen, *Die deutschen Universitäten*, 286.

61. On several occasions inspectors' reports referred to the presence of women in lecture halls in similar terms. For a more detailed discussion of these reports see chapter 5.

62. For a more detailed discussion see chapter 5.

63. See chapter 2.

64. Good descriptions of the conditions of service of a *maître d'études* can be found in Vallès, *Le Bachelier*, and Daudet, *Le Petit Chose*, among others.

65. Gerbod, *La Condition universitaire*, 60, 573.

66. Ibid., 65, 572.

67. Crozals, *La Faculté des letters de Grénoble*, 85.

68. See, e.g., Monod, *De la possibilité d'une réforme*.

69. Ibid., 31.

70. The most reliable figures for the 1880s can be found in the *Rapports des conseils*

généraux des facultés, published in the series *Enquêtes et documents relatifs à l'enseignement supérieur*, 23 (1886), 27 (1887), 30 (1888), 35 (1889) and 41 (1890). For the years 1890 on see *Annuaire statistique*.

71. For the number of diplomas issued see *Annuaire statistique* 56 (1940–45), "résumé rétrospectif."

72. These figures are based on figures in the *Annuaire statistique*. It should be noted that no allowance has been made for the fact that, as a result of "vocational Malthusianism," the proportion of those who failed the *licence ès lettres* examination rose from 40% to 50% at the end of the nineteenth century. For "Malthusianism" in secondary education see Prost, *L'Enseignement en France*, 351–54.

73. Seignobos, *Le Régime de l'enseignement supérieur des lettres*, 25. On Seignobos see chapters 3 and 5.

74. Ibid., 25.

75. The atmosphere in the Quartier Latin is splendidly conveyed by a series of police reports in the Archives de la préfecture de police (Seine), Ba 23–27 Etudiants. Surveillance générale des Ecoles (1859–1905). Regular reports were made from 1873 on. In about 1876 the Ecole de médecine appears to have been a hotbed of positivism and anticlericalism (at the time the authorities were still right-wing and Catholic); from the mid-1890s right-wing students were the most troublesome and often disrupted the arts-faculty lectures of professors with known social-radical sympathies. The signature of a professor on the Dreyfusards' manifesto, to which the press gave great prominence, was just one of many welcome occasions for disorder.

76. See the observations of H. W. Steed, *Trente anneés de vie politique en Europe*. Steed, a journalist for the *Times* for twenty-seven years, had studied in Germany (1892–93) and also in Paris (1893–96).

77. Arts students were hardly mentioned in the police reports. The disruption of lectures in the arts faculty was the work of law students. Inspecting student cards at the entrance to lecture halls was the tried method of guaranteeing peace inside. When that happened, the riots were pushed into the streets and took place before or after the lectures (Archives de la préfecture de police, Ba 27) and data culled from the personal files of various professors in AN/F^{17} [Ministère de l'Instruction Publique]; see also chapter 5. For the Ecole normale see Smith, "L'Atmosphere politique à l'Ecole normale supérieure").

78. In that respect, the Ecole normale supérieure does not fit the well-known characterization of *total institutions* in Goffman, *Asylums*, 3–124: "On the characteristics of total institutions."

79. Benda, *La Trahison des clercs*; see also chapter 6.

80. See, e.g., Hanotaux, *Du choix d'une carrière*, 2, 10.

81. Ariès, *L'Enfant et la vie familiale*, 197, 216.

82. Prost, *L'Enseignement en France*, 356. See the apt characterization of social status in Gerbod, *La Condition universitaire*, 629–34: "an ever uncertain condition." On salaries see ibid., 432–38; and Prost, *L'Enseignement en France*, 227, 234.

83. For a detailed discussion of social recruitment see Smith, *Ecole Normale Supérieure*, 30–55. The contrast between *héritiers* and *boursiers* was introduced by Thibaudet, *La République des professeurs*, 120–49. Not wrong, though oversimplified, is the sociological analysis of Bourdieu and Passeron, *Les Héritiers*, which reflects the ideal of complete external democratization.

84. A comprehensive survey of the formal juridical and institutional prehistory of the various faculties can be found in Weisz, *Emergence of Modern Universities in France*.

85. Mayeur, *Les Débuts de la Troisième République*, 115–16.

86. Falcucci, *L'Humanisme dans l'enseignement secondaire*, 339–40.

87. For the step-by-step tactics of Louis Liard see Weisz, *Emergence of Modern Universities in France*, 134–61.

88. See, e.g., the somber analysis of the situation in Clermont-Ferrand by Hauser and Ehrard in "L'Avenir et le rôle d'une petite université." The situation was similar in Dijon and Besançon.

89. Prost, *L'Enseignement en France*, 239.

90. See the opinion of Gabriel Monod in a letter to Lavisse, March 1892, quoted in Weisz, *Emergence of Modern Universities in France*, 156.

91. For the chair for the study of the French Revolution see chapter 2.

92. These figures are based on those in Guigue, *La Faculté des lettres*. Not taken into account were two temporary chairs introduced between 1900 and 1910 and then abolished, in Greek history (1904–7) and auxiliary historical sciences (1906–9).

93. For the contemporary view see Leguay, *Universitaires d'aujourd'hui*, 67–143. Henri Peyre has made an attempt to vindicate the vilified Lanson and so-called Lansonism in his introduction to the republication of articles by G. Lanson, *Essais de méthode, de critique et d'histoire littéraire*.

94. Charles Seignobos was the only holder of this chair (1907–21). In 1921 he succeeded Emile Bougeois in the chair of modern and contemporary political history.

95. Lukes, *Emile Durkheim*, 95, also mentions a few others who recommended the young Durkheim.

96. See ibid., 363–78, for Durkheim's considerable influence at the Sorbonne.

97. For the origins of this chair see G. Weisz, "The Republican Ideology and the Social Sciences; The Durkheimians and the History of Social Economy at the Sorbonne," in Besnard, *Sociological Domain*, 90–119. The first occupant of the chair was Alfred Espinas. During the squabbles about Espinas's successor the historians (in particular Lavisse, who in fact pulled the strings) agreed that this chair would be reserved for a sociologist rather than for an economic historian (in this case, Henri Hauser). It would be going too far to consider this a great victory of the sociologists over the historians. The claims that historians did not consider economic history important enough or that Hauser was thought to be too left-wing is not convincing. One personal factor, perhaps, was that Hauser had written a critical and somewhat ironic review of Lavisse's *Louis XIV* in the *Revue historique* (see chapter 6), though Lavisse was quite able to handle criticism. What probably tilted the balance was that historians had been given a great many posts in the past and that it was simply the turn of the sociologists.

98. The butt of the sociologists, needless to say, was Seignobos, the very active champion of the historical method (see Simiand, "Méthode historique et science sociale"). Memorable debates were held at meetings of the Société française de philosophie, at the first of which Seignobos was able to parry Simiand's attacks without difficulty. On the second occasion, however, when Durkheim was present, he could not quite stand his ground (see *Bulletin de la société française de philosophie* 7 [1907] and 8 [1908]; see also chapter 5, n. 204, and the conclusion).

99. Clark, *Prophets and Patrons*, tends to turn French sociology into too much of a success story; more balanced is Karady, "Durkheim, les sciences sociales et l'université." After the First World War a chair of "pédagogie et sociologie" was added at the new university of Strasbourg, with Maurice Halbwachs as the first occupant.

100. R. Geiger, "Durkheimian Sociology under Attack: The Controversy over Sociology in the Ecoles Normales Primaires," in Besnard, *The Sociological Domain*, 120–36.

101. Lukes, *Emile Durkheim*, 354–60. Lukes, incidentally, never doubts the idealism of Durkheim and his circle and is silent about attempts to strengthen their institutional position.

102. See the indexes of the *Revue internationale de l'enseignement* (since 1881, approximately 1,300 pages each year). See also the large series *Enquêtes et documents relatifs à l'enseignement supérieur*, 1 (1883)—108 (1912–13).

103. See chapter 3.

104. Lavisse, "Le Concours d'agrégation et de géographie," esp. 402.

105. A good impression of the working methods used is conveyed by the *Rapports généraux des facultés* published in the series *Enquêtes et documents relatifs à l'enseignement supérieur*.

106. For a brief account see Prost, *L'Enseignement en France*, 232–33. For more detail see *Enquêtes et documents*, 11 (1884) and 52 (1894).

107. Seignobos, *Le Régime de l'enseignement supérieur des lettres*, 36.

108. Ibid., 37.

109. Gebod, *La Condition universitaire*, 60 and 573, even puts the proportion of failures in the 1870s at 60%. See also above, n. 72.

110. This was the view of Berthelot, quoted in Paris, *Le Haut Enseignement*, 18.

111. From 1821 to 1842 the average failure rate of candidates was 79%, from 1843 to 1866 it was 84.5%, and from 1866 to 1876 it was 81% (see Gerbod, *La Condition universitaire*, 63, 576).

112. In 1877 the makeup of the teaching staff in public secondary education was as follows: 13.2% *agrégé*, 28.8% *licencié*, and 58% *bachelier*. Based on a slightly different criterion it has been calculated that in 1898, 19.6% were *agrégé* (1,759 *agrégés* out of a total of 8,988 secondary teachers at state schools) (see Prost, *L'Enseignement en France*, 371).

113. In 1909 the percentage of *agrégés* engaged in secondary public education was the same as in 1898, that is, 19.6% (1,820 *agrégés* out of a total of 9,283 secondary-school teachers).

114. The following account is from Geffroy, "Le Concours d'agrégation d'histoire." Geffroy was for many years a member of the jury (see chapter 5).

115. *Gazette de l'instruction publique* 10 (1847), 167.

116. Villemain, *Exposé des motifs*, 15.

117. *Gazette de l'instruction publique* 10 (1847), 168.

118. See chapter 3. The following quotations are from Fortoul, *Rapport à l'empereur*, 72–73.

119. Geffroy, "Le Concours d'agrégation d'histoire," 335.

120. For a detailed account of Fustel see chapter 5.

121. Fustel, quoted in Geffroy, "Le Concours d'agrégation d'histoire," 410–11. For a general discussion of Fustel's view of education (in which, incidentally, the *agrégation* is not included) see Mayeur, "Fustel de Coulanges."

122. Geffroy, "Le Concours d'agrégation d'histoire," 418.

123. In addition to Geffroy and Lavisse, the members of this reform committee were Zévort (director of secondary education), Liard (director of higher education), Gréard (vice-rector of the Paris academy), Perrot (director of the Ecole normale supérieure), and Anquès (secretary of the *agrégation* jury).

124. Lavisse, "Pourquoi il fallait réformer l'agrégation d'histoire," reprinted in idem, *A propos de nos écoles*, 131–41. Lavisse was for many years president of the *agrégation* jury.

Proposals and regulations are in *Enquêtes et documents*, 54 (1894), which also includes proposals for decentralization submitted by the provincial faculties.

125. Lavisse, "Le Concours d'agrégation d'histoire," 398.

126. Foncin, "Agrégation d'histoire et de géographie."

127. Langlois, "Remarques à propos de l'agrégation d'histoire."

128. See *Enquêtes et documents*, 54 (1894).

129. Langlois, "Avertissement aux candidats à l'agrégation d'histoire," esp. 250.

130. Lavisse, "Comment a été réformé le concours d'agrégation d'histoire," reprinted in idem, *A propos de nos écoles*, 142–53.

131. See, e.g., the cutting critique by Langlois in "Avertissement aux candidats."

132. Computed from figures in Karady, "Stratégie et hiérarchie des études," 30.

133. Based on figures in Karady, "Stratégie et hiérarchie des études."

134. Particularly instructive was a discussion with Fernand Braudel in Leiden on 29 November 1984. For the complaints of the founders of the *Annales* see Bloch and Febvre, "Le Problème de l'agrégation." *Mirabile dictu*, the reintroduction of textual interpretations was here considered to be the crucial problem. In view of Febvre's fulminations against the adage "l'histoire se fait avec des textes," this may seem rather surprising.

135. Lavisse, "Albert Dumont"; idem, *Un Ministre: Victor Duruy*; idem, "Louis Liard."

136. Lavisse, "La Réforme du concours d'agrégation d'histoire," 216.

137. A good biography of Lot is Perrin, *Un Historien français: Ferdinand Lot*. Rumour has it that Lot's academic career was hampered by these critical comments (Fernand Braudel, communication to author, 29 November 1984).

138. Paris, *Le Haut Enseignement*, with a communication from Lavisse and Paris's reaction.

139. Lot, "Statistique du personnel enseignant."

140. Ibid., 499.

141. "Facultés des lettres des universités françaises: Liste des chaires et des enseignements créés par l'Etat et par les universités de 1904 à 1910," *Revue internationale de l'enseignement* 59 (1910), 107–8.

142. Lot, *Diplômes d'études et dissertations inaugurales*, 16.

143. Paris, *Le Haut Enseignement*, 31, 35.

144. Paris, *Le Haute Enseignement*, 39; Monod, *De la possibilité d'une réforme*, 21–22.

145. Seippel, *Les Deux France*, gave rise to many polemics; see, e.g., the book review by Henri Berr, "Une Philosophie de l'histoire de France."

146. Monod, *De la possibilité d'une réforme*, 14–15.

147. Paris, *Le Haut Enseignement*, 41.

148. A good impression of the depressing atmosphere at many provincial arts faculties was conveyed by the inquiry launched by the *Revue de synthèse historique* (questions in no. 8 [1904], 165–69; conclusions in no. 11 [1905], 181–92, 290–305). Particularly interesting was the response of Henri Hauser on the situation in Dijon, *Revue de synthèse historique*, no. 10 (1905), 34–37. The questions and the answers were published in a separate pamphlet: Barrau-Dihigo, *Nos enquêtes*.

149. Monod, *De la possibilité d'une réforme*, 20.

150. The proportion is based on Lot, "Statistique du personnel enseignant," which in turn was based on Ascherson's *Deutscher Universitätskalender* (Leipzig), winter semester 1909–10.

151. These proportions are based on figures in Lot, *Diplômes d'études et dissertations inaugurales*.

CHAPTER FIVE
THE OLD PROFESSORS AND THE NEW

1. In 1870 there were seventeen history chairs at the arts faculties and three comparable posts at the Ecole normale supérieure. In 1910 there were an extra twenty posts for *professeurs adjoints* and professors of geography, archeology, art history, and history of Christianity; see chapter 4.

2. These and the following calculations are based on personal dossiers in the archive of the Ministry of Education (AN/F^{17}). The careers of all concerned were carefully recorded, as pensions were assessed accordingly. In just one case no dossier could be found, but detailed biographical data could be culled from a different source. For Parisian professors, facts and figures were recently compiled in Charle, *Les Professeurs de la faculté des lettres*. For a general account see C. O. Carbonell, "Les Professeurs d'histoire de l'enseignement supérieur en France au début du XXe siècle," in Carbonell and Livet, *Au berceau des Annales*, 89–104.

3. Not included is the appointment, due to exceptional circumstances, of the seventy-year old Christian Pfister as rector of the Strasbourg academy (see below).

4. In 1892 the inspector of higher education had this to say about Georges Weill: "He is so marked a Semitic type that under the Second Empire just seeing him would have been enough to exclude him for all time from any chair of philosophy or even of history" (AN F^{17} 24470). On Weill see below. The only professor with a Protestant background was Rosseeuw St. Hilaire.

5. Gustave Bloch, Henri Hauser, and Georges Weill were of Jewish descent. Henri Berr, listed among the *patrons*, was also of Jewish descent but not a professor. Denis, Gachon, Monod, Pariset, Pfister, Seignobos, and Waddington had a Protestant background.

6. In 1872 in France there were 580,000 Protestants in the total population of 36.1 million (Mayeur, *Les Débuts de la Troisième République*, 141–42; cf. the figures in Zeldin, *France, 1848–1945*, 2:1034).

7. At the turn of the century there were 80,000 Jews in a population of 39–40 million French citizens (Mayeur, *Les Débuts de la Troisième République*, 143).

8. Zeldin, *France, 1848–1945*, 2:1034–39.

9. AN F^{17} 12935. For the publications of the various professors see, as a first reference, the *Catalogue général des livres imprimés de la Bibliothèque Nationale* and the *National Union Catalogue*.

10. AN F^{17} 21365.

11. AN F^{17} 21631. He also wrote under the name Robiou de la Thréhonnais.

12. AN F^{17} 20455.

13. AN F^{17} 20097.

14. AN F^{17} 20658.

15. AN F^{17} 20516.

16. AN F^{17} 20589.

17. AN F^{17} 21210.

18. AN F^{17} 20423.

19. AN F^{17} 21423.

20. AN F^{17} 20830.

21. AN F^{17} 21043. The year of his death is given in Charle, *Les Professeurs de la faculté des lettres*, 106.

22. Lacroix, *Dix ans d'enseignement historique*; see also Margerie, *Souvenirs*, 147–48.

23. AN F^{17} 21647. See also Aumale, "Rosseeuw Saint-Hilaire."

24. Rosseeuw Saint-Hilaire, *Histoire d'Espagne*.

25. *Revue historique*, no. 39 (1889), 450.

26. AN F^{17} 20592. See also Monod, *Revue historique*, no. 32 (1886), 107.

27. For Cléophas Dareste see AN F^{17} 20518; he also wrote under the name Dareste de la Chavanne. For Rodolphe Dareste see *DBF*.

28. *Revue historique*, no. 20 (1882) 235.

29. AN F^{17} 21893.

30. "Recueil des rapports sur les progrès des lettres et des sciences en France," in Geffroy, Zeller, and Thiénot, *Rapports sur les études historiques*, 85–145.

31. Monod, *Revue historique*, no. 74 (1900), 93–94.

32. See chapter 4.

33. AN F^{17} 20818.

34. Geffroy, Zeller, and Thiénot, *Rapports sur les études historiques*, 1–84.

35. Monod, *Revue historique*, no. 60 (1896), 94–96.

36. AN F^{17} 21880.

37. See the view expressed in Finley, *Ancient Slavery and Modern Ideology*, esp. 13.

38. Monod, *Revue historique*, no. 87 (1905), 206–7.

39. AN F^{17} 20780.

40. See the comment by Marc Bloch in "Christian Pfister," 564.

41. See Lukes, *Emile Durkheim*, 58–65.

42. Fustel de Coulanges, *L'Alleu et le domaine rural*, iv–v.

43. Guiraud, *Fustel de Coulanges*.

44. In 1922 *La Cité antique* went through its 22nd edition. Useful biographies are Herrick, *Historical Thought of Fustel de Coulanges*, and Jullian, "Le Cinquantenaire de la Cité antique"; more recently, Momigliano has published some astute observations in his *Essays in Ancient and Modern Historiography*, 325–43, and in his preface to a new English translation, *The Ancient City*.

45. Halkin, "Deux lettres inédits de Fustel de Coulanges," 8. The letters are included in the 1984 reprint of *La Cité antique*, 474–84.

46. Fustel de Coulanges, preface to his *La Monarchie franque*.

47. Ibid., 1–2.

48. Fustel de Coulanges, *L'Invasion germanique*, 240.

49. Fustel de Coulanges, *La Monarchie franque*, 28–29.

50. Fustel de Coulanges, *L'Alleu et le domaine rurale*, 462.

51. Fustel de Coulanges, *La Monarchie franque*, 32.

52. Ibid., 33.

53. See Momigliano's articles cited above, in n. 44.

54. Inspectors' reports in AN F^{17} 20780.

55. Seignobos, in his preface to Tourneur-Aumont, *Fustel de Coulanges*.

56. Seignobos, "Conditions psychologiques de la connaissance en histoire."

57. Langlois and Seignobos, *Introduction aux études historiques*, 2.

58. A collection of clippings on this question is found in the Bibliothèque historique de la ville de Paris, "Documents d'actualité," including a discussion between Paul Guiraud and Charles Maurras in *Journal des débats*, 17 and 22 March 1905. See also Weber, *Action française*.

59. For an outline of Fustel's view of the ideal constitution see Guiraud, *Fustel de Coulanges*, 75–85. See also Wilson, "Fustel de Coulanges and the *Action française*."

60. AN F^{17} 24193, report dated 25 April 1894 on Dumas, *La Généralité de Tours*.

61. Ibid. The inspector also mentioned M. Wahl's thesis, *Les Premières Années de la Révolution à Lyon.* On Quicherat see chapter 2.

62. AN F^{17} 20503.

63. AN F^{17} 22227.

64. Seignobos's statement is quoted in Steed, *Trente années de la vie politique en Europe*, 45.

65. See *DBF* s.v. "Gaffarel."

66. AN F^{17} 22176.

67. AN F^{17} 24110.

68. Ibid., letter from C.-V. Langlois, further to Stouff's *soutenance*.

69. AN F^{17} 23683.

70. Ibid., report by Dean Himly on the *soutenance*; Inspector Perrens's report was more positive.

71. AN F^{17} 23902.

72. Ibid., Inspector Perrens's report on the *soutenance*.

73. AN F^{17} 24576.

74. AN F^{17} 25864.

75. Ibid., Wallon's report (1880).

76. Ibid., Perrens's report (1880).

77. *Archives des missions scientifiques et littéraires*, 13 (1887) 89–151, review by J. Havet, *BEC*, 1889, 101–4.

78. AN F^{17} 26794.

79. No "dossier personnel" could be found in AN F^{17}. Details are taken from the obituary by Pfister in *Revue historique*.

80. AN F^{17} 24180.

81. Both reports ibid.

82. Febvre, "De l'histoire-tableau."

83. AN F^{17} 23692.

84. Ibid., Perrens's report on the *soutenance*.

85. AN F^{17} 24193. See also *DBF*.

86. Ibid., reports. See also above, n. 60.

87. AN F^{17} 22557.

88. Ibid., reports.

89. On Glotz see, e.g., R. Cohen, in *Revue historique*, no. 175 (1935), 656–58. In 1907 Glotz succeeded Paul Guiraud, but only as junior lecturer ("chargé d'un cours complémentaire"). On Guiraud, Fustel's favorite pupil, see esp. ibid., no. 93 (1907), 325–26.

90. AN F^{17} 22337.

91. Ibid., letter of recommendation by Geffroy, 8 December 1878.

92. AN F^{17} 22468.

93. Ibid., reports.

94. *Revue historique*, no. 145 (1924), 156.

95. AN F^{17} 24150. See also *Académie des Inscriptions et des Belles Lettres, Comptes rendus des séances de l'année 1942*, 88–90.

96. AN F^{17} 24150, reports.

97. AN F^{17} 24409. See also the extremely laudatory obituary in *Revue historique*, no. 193 (1942–43), 93–94.

98. AN F^{17} 26708. See also the obituary in *Revue historique*, no. 172 (1933), 212–13.

99. AN F^{17} 24124. There is a handsome obituary by Marc Bloch in *Revue historique*, no. 172 (1933), 563–70.

100. The "mother" chair of medieval history was held successively by Fustel de Cou-langes (1878–89), Achille Luchaire (1889–1908), and Langlois (1909–13). Pfister was a professor of the history of medieval civilization and institutions from 1906 to 1913, when he succeeded Langlois.

101. See chapter 4. In 1920 Pfister was succeeded by Lot.

102. AN F^{17} 24124, reports.

103. Bloch, "Christian Pfister," 568.

104. AN F^{17} 24662. See also the obituary in *Revue historique*, no. 206 (1952), 380–82.

105. AN F^{17} 24745.

106. Ibid., reports.

107. AN F^{17} 23782.

108. Ibid., report.

109. Seignobos to Langlois, 28 December 1887, in Documents autographes Langlois-Berthelot (Paris).

110. For the general background see Digeon, *La Crise allemande*; on historiography see Gödde-Baumanns, *Deutsche Geschichte in französischer Sicht*.

111. AN F^{17} 25724. See also the well-informed entry by P. Leguay in *DBF*; and Eisen-mann, "Ernest Denis," obituary in the *Revue des études slaves* (founded by Denis).

112. AN F^{17} 25724, Denis to the minister of education, 15 October 1872.

113. Ibid., reports.

114. Quoted in Gödde-Baumanns, *Deutsche Geschichte in französischer Sicht*, 209. "Ab-straction is the greatest threat to history," was one of Denis's assertions in the prospectus for *La Fondation de l'Empire allemand, 1852–1871*.

115. AN F^{17} 26812. See also Gödde-Baumanns, *Deutsche Geschichte in französischer Sicht*, 80–85.

116. AN F^{17} 26812, reports.

117. Gödde-Baumanns, *Deutsche Geschichte in französischer Sicht*, 81.

118. AN F^{17} 26788. See also Pfister's introduction to Pariset, *Etudes d'histoire révolu-tionnaire*, xv–xxxiii.

119. AN F^{17} 26788, reports.

120. Lefebvre, *Etudes sur la Révolution française*, 21.

121. Published in Pariset, *Etudes d'histoire révolutionnaire*. A dossier in the Archives Lucien Herr on the editing of the *Histoire de France contemporaine* has recently been transferred to the Institut d'études politiques in Paris (see P. Nora, "L'Histoire de France de Lavisse," in Nora, *Les Lieux de mémoire*, II, 1:373–75).

122. AN F^{17} does not contain Bourgeois's dossier. See the informative entry by P. Leguay in *DBF* and the obituary by R. Guyot in *Revue historique*, no. 174 (1934), 654–56.

123. Febvre, *Combats pour l'histoire*, vii, 63.

124. AN F^{17} 24361. See also the obituary by L. Bréhier in *Revue historique*, no. 195 (1945), 93–96. A confidential information sheet on Diehl is included here as an example (see fig. 4). Diehl's *La République de Vénise* was reprinted in 1985.

125. AN F^{17} 24262. See also the obituary by Ernest Labrousse in *Revue historique*, nos. 188–89 (1940), 484–87.

126. AN F^{17} 24262, reports.

127. At the invitation of Gabriel Monod, Loutchisky published an article on the subject in the *Revue historique* as early as 1895. Loutchisky was convinced of "the need to clarify the prevailing ideas with the help of approximate percentages" (see Karéiev, "La Révolution française." For an opinion of Marion's work see Lefebvre, "La Vente des biens nationaux," in *Etudes sur la Révolution française*, 223–45).

128. See chapter 4, n. 100.

129. Having lost two children, his wife was anxious to live with her parents in Paris (see AN F^{17} 24262, inspectors' report of 1910).

130. Minutes of meetings held on 21 January and 24 March 1912, in Collège de France, Service des archives.

131. Labrousse in *Revue historique*, nos. 188–89 (1940), 485.

132. AN F^{17} 24638. See also the obituary by G. Lefebvre in *Revue historique*, no. 213 (1954), 178–81.

133. AN F^{17} 24638, reports.

134. G. Lefebvre in *Revue historique*, no. 213 (1954), 180.

135. AN F^{17} 22512 (1). See also the obituary in *Revue historique*, no. 177 (1936), 736–38.

136. AN F^{17} 22512 (1), reports.

137. Cf. H. T. Parker, "Henri Sée," in Halperin, *Essays in Modern European Historiography*, 336–37.

138. AN F^{17} 24507. See also P. Chaunu, "Introduction," in Hauser, *La Prépondérance espagnole*;, and Den Boer, "Henri Hauser."

139. AN F^{17} 24507, reports. On Pariset see above.

140. AN F^{17} 24507, collection of clippings. See also Hauser's dossier in Bibliothèque historique de la ville de Paris, "Documents d'actualité."

141. Chaunu, "Introduction," in Hauser, *La Prépondérance espagnole*.

142. AN F^{17} 24470. Recently reprinted were Weill, *Histoire du catholicisme libéral*, with an introduction by Réné Rémond; and Weill, *Histoire du parti républicain*, with an introduction by Maurice Agulhon.

143. See above, n. 4.

144. See, e.g., the review by Otto Oppermann in *TvG* 46 (1931), 326–28.

145. Fernand Braudel, communication to author, 29 November 1984.

146. There is no dossier for Lavisse in AN F^{17}. See his childhood reminiscences, *Souvenirs*. The Papiers Ernest Lavisse (BN, NAF 25166–25172) contain letters to Lavisse. A fine characterization of Lavisse by Pierre Nora, "Lavisse, instituteur national," appeared in *Revue historique* (1962), reprinted in Nora, *Les Lieux de mémoire, I*, 247–89. See also Seignobos, "Ernest Lavisse."

147. Several highly personal letters from Lavisse to Albert Duruy are included in Papiers Duruy-Glachant.

148. This factor was wrongly ignored by Nora in his "Lavisse, instituteur national."

149. See chapter 6.

150. Lavisse, *Etude sur l'une des origines de la monarchie prussienne*, ix–x.

151. Ibid., 261.

152. On Lavisse's influence and the work of these pupils see Gödde-Baumanns, *Deutsche Geschichte in französischer Sicht*.

153. Lavisse to Albert Duruy, September 1882, Papiers Duruy-Glachant.

154. R. Rolland, Journal, 11 December 1911, Archives Romain Rolland, 89 Bd. Montparnasse, 75006 Paris; C. Benoist's opinion is quoted in Nora, "Lavisse, instituteur na-

tional," in Nora, *Les Lieux de mémoire, I*, 255–56. See also the opinion of H. Bourgin in *De Jaurès à Léon Blum*, 55.

155. Langlois, "Ernest Lavisse," 478.

156. Lavisse to Duruy, September 1882, Papiers Duruy-Glachant.

157. On Lavisse's position during the Dreyfus affair see Rebérioux, "Histoire, historiens et dreyfusisme," 425; on Lavisse's cautious attitude as editor in chief of the *Revue de Paris* see Andler, *La Vie de Lucien Herr*, 134–39.

158. AN F^{17} 21982. See also the scrupulously fair obituary by Bémont, "Gabriel Monod." For a recent biography see Harrison, *Gabriel Monod*. See also Carbonell, *Histoire et historiens*, 418–35; and on Monod's political views see Gérard, "Histoire et politique."

159. Monod, "Tommy Perrens," 108. See also Perrens, *Etienne Marcel*.

160. Carbonell, "La Naissance de la Revue historique," 341.

161. Monod wrote the introduction to the French translation of the memoirs of Malwida von Meysenbug, 2 vols. (1900), suppl. vol. 1908.

162. Monod, "G. Waitz," *Revue historique* 36 (1886), 382–90, reprinted in Monod, *Portraits et souvenirs*.

163. See chapter 2.

164. Lavisse, in the foreword to *Etudes d'histoire du Moyen Age dédiées à G. Monod*.

165. Quoted in Bémont, "Gabriel Monod," 20.

166. Den Boer, "Historische tijdschriften in Frankrijk," 537.

167. Baal, "Un salon dreyfusard."

168. Monod, "Histoire."

169. Bibliography compiled by E. Chatelain in *Annuaire de l'Ecole pratique des hautes études*, 1912–13.

170. For some fragments of Monod's diary see Bémont, "Gabriel Monod." Monod himself published *Souvenirs d'adolescence*. Fragments of Monod's diary were used by B. Harrison for his biography, *Gabriel Monod*. In his grandparents' house, at 18's Rue du Parc Clagny in Versailles, M. Charles Rist kindly allowed me to view the entries Monod made in his diary during the Dreyfus affair (Fonds Mario Rist, Versailles). See also below, n. 173.

171. Monod's letters to Auguste Geffroy are most informative on the subject of study tours (Correspondance A. Geffroy, BN, NAF 12925, fols. 3955–93, and suppl. 12935, fols. 931–39); on Monod's political ideas see his letters from 1883 on to Joseph Reinach (Correspondance J. Reinach, BN, NAF 24882, fols. 164–412, and 24897, fols. 282–91). Also of interest are Monod's letters to a colleague of a more rightist persuasion, Ferdinand Brunetière, editor of the *Revue des deux mondes* (Correspondance F. Brunetière, BN, NAF 25045, fols. 104–346). Monod's confidential letters from 1869 on to Gaston Paris (Correspondance G. Paris, BN, NAF 24450, fols. 104–346) were used by Carbonell in *Histoire et historiens*, 427–35. Letters from Monod can also be found in numerous other collections.

172. Monod, "Du progrès des études historiques."

173. The fragment begins on 30 May 1898: "If I should die, everything entered in this diary under the date 9 June should be published immediately" (Fond Mario Rist, Versailles; see above, n. 170). The diary was consulted by J. Reinach for his *Histoire de l'Affaire Dreyfus*. The diary also contains a clarification of the views Monod put forward in the foreword to Puaux, *Vers la justice*; see also Rebérioux, "Histoire, historiens et dreyfusisme," 418–19.

174. Monod to Romain Rolland, 13 June 1898, 16 November 1899, 8 May 1898, Archives Romain Rolland.

175. Monod to Rolland, 12 March 1909, ibid.

176. AN F^{17} 22600. See also Aulard's dossier in Bibliothèque historique de la ville de Paris, Documents de l'actualité; Belloni, *Aulard*; Godechot, *Un Jury pour la Révolution*, 231–43, 254–88; and the venomous portrait by Bourgin, *De Jaurès à Léon Blum*, 157–66.

177. *La Révolution française* 76 (1923), first published in *Quotidien*, 25 June 1923. I am indebted for this reference to James Friguglietti, who is preparing a study on Aulard.

178. See chapter 2.

179. See above.

180. See chapter 2.

181. See the opinion of Pierre Caron in "Alphonse Aulard."

182. In a sense this is the gist of the criticism put forward by Augustin Cochin in *La Crise de l'histoire révolutionnaire* and repeated in more subtle terms by François Furet in "A. Cochin," esp. 216–17.

183. Bourgin, "A. Aulard et les archives," 77–80.

184. ". . . to put it in modern terms . . . Jaurès's history is structural, while Aulard's is *événementiel*" (Godechot, *Un Jury pour la Révolution*, 266; see also Furet, "A. Cochin," 248–49).

185. Aulard, *Histoire politique de la Révolution française*, ix.

186. Ibid., 780.

187. Ibid., 781. See also Halévy, *La République des comités*.

188. See the positive opinion expressed in Nicolet, *L'Idée républicaine en France*, 96–98.

189. Cochin's *La Crise de l'histoire révolutionnaire* was was a reaction to Aulard's un-sympathetic *Taine, historien de la Révolution française*. Taine had died in 1893, but *Les Origines de la France contemporaine* had continued to enjoy unprecedented popularity (the 23rd edition appearing in 1900). Over hundreds of pages Aulard mentioned countless not particularly important inaccuracies in Taine's work. No matter what shortcomings and prejudices Taine may have had, he was unquestionably a more original and greater historian than Aulard.

190. AN F^{17} 23801. See also Leguay, *Universitaires d'aujourd'hui*, 145–78; and Bourgin, *De Jaurès à Léon Blum*, 177–81.

191. Jolly, *Dictionnaire des parlementaires*, vol. 8, s.v. "Seignobos," and vol. 7, s.v. "Morin-Latour."

192. According to G. H. McNeill, "Charles Seignobos, 1854–1942," in Halperin, *Essays in Modern European Historiography*, 354, Seignobos went to Germany on a state scholarship. It is not clear whether McNeill based this claim on information he received from Seignobos himself. In dossier AN F^{17} there is no mention of this scholarship.

193. Seignobos, "L'Enseignement de l'histoire dans les universités allemandes," 596.

194. Seignobos, "L'Enseignement de l'histoire dans les universités allemandes," 599.

195. AN F^{17} 23801, letter.

196. Ibid., reports.

197. Febvre, "Ni histoire à thèse ni histoire-manuel," in *Combats pour l'histoire*, 87–98.

198. Seignobos to C.-V. Langlois, 27 October 1888, in Documents autographes Langlois-Berthelot (Paris).

199. See, e.g., L. Febvre, "Examen de conscience d'une histoire et d'un historien" (1933), reprinted in *Combats pour l'histoire*, 4–9; and Marrou, *De la connaissance historique*, 54.

200. Seignobos, "L'Enseignement de l'histoire," 587.

201. Seignobos, "Conditions psychologiques de la connaissance en histoire."

202. Seignobos to Langlois, 28 December 1887, in Documents autographes Langlois-Berthelot, Paris.

203. Seignobos stated his views most unequivocally in "La Méthode psychologique en sociologie" (1920), reprinted in Seignobos, Etudes de politique et d'histoire, 3–25.

204. Seignobos, "Les Conditions pratiques de la recherche des causes"; this was an answer to Simiand, "La Causalité en histoire," which had been read at a meeting of the society in Seignobos's absence and had taken him to task. The debate was continued with a rather disappointing address by Seignobos, "L'Inconnu et l'inconscient en histoire." Well-informed but, as usual, one-sidedly pro-Simiand was M. Rebérioux's "Le Débat de 1903: Historiens et sociologues," in Carbonell and Livet, Au berceau des Annales, 219–30. See also chapter 4, n. 98, and the conclusion.

205. Seignobos, Histoire politique de l'Europe contemporaine, 804.

206. Ibid., 805.

207. As Pierre Renouvin did in a famous report, "Epoque contemporaine," 574–78.

208. Seignobos, Histoire politique de l'Europe contemporaine, x.

209. Ibid., xi.

210. See the account by André Siegfried in Revue historique, no. 193 (1942), 193–203.

211. There is no dossier on Langlois in AN F^{17}. Well-informed as ever is Leguay, Universitaires d'aujourd'hui, 215–51. See also Fawtier, "Charles-Victor Langlois," in English Historical Review; and Goelzer, "Charles-Victor Langlois."

212. Langlois, Le Règne de Philippe III le Hardi, 167.

213. Ibid., 284.

214. See Fustel de Coulanges, introduction to his La Gaule romaine, xii.

215. Langlois, Le Règne de Philippe III le Hardi, xiii.

216. See chapter 2.

217. We shall return to the bias of this great work in chapter 6.

218. Quoted by R. Fawtier in "Charles-Victor Langlois," 88.

219. As Marrou did in De la connaissance historique, 54–55.

220. See, e.g., chapter 4.

221. For Langlois's role in the archival world see Fawtier, "Charles-Victor Langlois," in Revue historique.

222. Perrin, Un Historien français: Ferdinand Lot, 43. See also above, chapter 4.

223. Seignobos to Langlois, 28 June 1888, in Documents autographes Langlois-Berthelot (Paris).

224. Perrin, Un Historien français: Ferdinand Lot, 28.

225. See L. Febvre, "Hommage à Henri Berr" (1952), reprinted in Combats pour l'histoire, 339–42; and F. Braudel in Hommage à Henri Berr.

226. AN F^{17} 23815. In 1903 and 1911 Berr put forward his candidature for a chair at the Collège de France. He was not considered a serious contender on either occasion. The first time, he applied for a chair that had been specially created for Monod; the second time, he sought to succeed Levasseur. The details can be found in AN F^{17} 13554, "Demande de création des chaires, Collège de France"; this dossier also contains newspaper clippings with unsavory allusions. See also Collège de France, Service des archives.

227. Berr, La Synthèse des connaissances et l'histoire, 19–20.

228. Berthelot, La Synthèse chimique. Lavoisier defined chemistry as "science d'analyse" (1793).

229. Berr, La Synthèse en histoire, 14.

230. Langlois, *Manuel de bibliographie historique*, 581–82, quoted in Berr, *La Synthèse en histoire*, 14.

231. Berr, *La Synthèse en histoire*, 249.

232. Ibid., 253.

CHAPTER SIX
CHANGES IN PROFESSIONAL WRITING

1. *Catalogue des thèses et des écrits académiques, 26 fasc. année scolaire 1909–10.*

2. Maire, *Répertoire alphabétique des thèses ès lettres*; the number includes Latin dissertations.

3. The four doctorates on Erasmus were Chasles, *De adagiis D. Erasmi Roterodami*; Desdevises du Dézert, *Erasmus Roterodamus*; Feugère, *Erasme*; and Benoist, *Quid de puerorum institutione senserit Erasmus*. The three on Vives were Arnaud, *Quid de pueris instituendis senserit Ludovicus Vives*; Thibaut, *Quid de puellis instituendis senserit Vives*; and Lecigne, *Quid de rebus politicis senserit Ludovicus Vives*.

4. The doctorates having Voltaire as a subject were Anceau, *Parallèle des Choëphores d'Eschyle*; Bonieux, *Critique des tragédies*; Vernier, *Etude sur Voltaire grammarien*; and Lion, *Les Tragédies et les théories dramatiques de Voltaire*.

Those about Rousseau were Herisson, *Pestalozzi*; Izoulet, *De J. J. Russeo (J. J. Rousseau)*; Texte, *Jean-Jacques Rousseau*; Legras, *De Karamzinio, Laurentii Sternii et J. J. Rousseau*; and Windenberg, *Essai sur le système de politique étrangère de J. J. Rousseau*.

5. The two doctorates on Chateaubriand were Nadeau, *Chateaubriand et le romantisme*; and Bertrin, *La Sincérité religieuse de Chateaubriand*. The one on Scott was Maigron, *Le Roman historique à l'époque romantique*.

6. The percentages are based on computations in Karady, "Stratégie et hiérarchie des études," 31.

7. Huizinga, "Universiteit," 5; idem, "Homo Ludens," 186–87.

8. Michelet, *Examen des vies des hommes illustres de Plutarque*.

9. On J. V. Leclerc (1789–1865), see *Nouvelle biographie nationale*, 29 (1859); and Guigniaut, "Notice historique sur la vie et les travaux."

10. Condamin, *Le Centenaire du doctorat ès lettres*, 27.

11. Ibid., 29.

12. Carbonell, *Histoire et historiens*, 264.

13. See, e.g., the comments by the inspector of higher education in his report on Elie Halévy's *soutenance* on eighteenth-century English philosophers (1901) in AN F^{17} 13249, Rapports sur les thèses de doctorat, 1890–1901.

14. See appendix 10 for the full titles of the dissertations compared below.

15. Gazier, *Les dernières années du cardinal de Retz*, vi.

16. Belin, *La Société française au XVIIe siècle*, 190.

17. Lallier, *De la condition de la femme dans la famille athénienne*.

18. Lavisse, *Etude sur l'une des origines de la monarchie prussienne*.

19. See *DBF*, s.v. "Glazier."

20. Joret, *Herder et la renaissance littéraire en Allemagne*. See "Publications principales de Charles Joret," *Bulletin de la société des antiquaires de Normandie*, 1899.

21. Chalandon, *Essai sur la vie et les oeuvres de P. de Ronsard*.

22. Gazier, *Les dernières années du cardinal de Retz*, 210.

23. Berthault, *J. Saurin et la prédication protestante*, 170.

24. Ibid., 311.

25. Gazier, *Les dernières années du cardinal de Retz*, xiii.

26. Lavisse, *Etude sur l'une des origines de la monarchie prussienne*, ix.

27. Drouet, *L'Abbé de Saint Pierre*; Prunel, *Sébastien Zamet*.

28. On Bourgeois see chapter 5.

29. The three theses were, respectively, Dureng, *Le Duc de Bourbon et l'Angleterre*; Guyot, *La Directoire et la paix de l'Europe*; and Rigault, *Le Général Abdallah Menou et la dernière phase de l'expédition d'Egypte*.

30. Cahen, *Histoire des relations de la Russie avec la Chine*.

31. Crémieux, *La Révolution de février*.

32. Lesquieur, *Les Institutions militaires de l'Egypte sous les Lagides*.

33. On Bouché-Leclercq see chapter 5.

34. Fosseyeux, *Une Administration Parisienne sous l'Ancien Régime*; Clergeac, *La Curie et les bénéfices consistoriaux*.

35. Fliche, *Le Règne de Philippe I, roi de France*.

36. For Langlois see chapter 5.

37. Pannier, *L'Eglise réformée de Paris sous Henri IV*.

38. Dutil, *L'Etat économique du Languedoc à la fin de l'Ancien Régime*.

39. Febvre, *Philippe II et la Franche-Comté*.

40. Lauer, *Le Palais de Latran*; L. Hautecoeur, *Rome et la renaissance de l'antiquité*.

41. Fosseyeux, *Une Administration Parisienne sous l'Ancien Régime*, xxvii.

42. The most trenchant formulation of the historical method is Seignobos's *La Méthode historique* (see above, chapter 5).

43. Lauer, *Le Palais de Latran*, iii.

44. In a book review C. Pfister reproached Febvre for not having abandoned chronology altogether (see *Revue historique*, no. 109 [1912], 406).

45. L. Febvre, "Deux amis géographes, Jules Sion, Albert Demangeon" (1941), reprinted in *Combats pour l'histoire*, 376–86.

46. Ibid., 379.

47. It is striking how few maps were included even in geographical studies published at the time; see Meynier, *Histoire de la pensée géographique en France*, 147–51.

48. See Pfister's review in *Revue historique*, no. 109 (1912), 406.

49. Guigue, *La Faculté des lettres*.

50. Karady, "Durkheim, les sciences sociales et l'université."

51. On Alfred Espinas see, e.g., Durkheim, *Textes 1*, 90–91, 112–13, 403. Another leading French pioneer of university sociology was Alfred Fouillée, who took his doctorate with *La Liberté et le déterminisme* (441 pages). Fouillée introduced "social science" to a broad spectrum of educated people with articles in the *Revue des deux mondes*; see also idem, *La Science sociale contemporaine*.

52. Lukes, *Emile Durkheim*, 137–78.

53. The special issue of the *Revue française de sociologie*, 20 (1979), translated and adapted in Besnard, *Sociological Domain*, is very informative on Durkheim's *cercle*. On Bouglé see ibid., 231–47; on Gaston Richard (who is not included in the translation) see Pickering, "Gaston Richard."

54. On Izoulet see Quack, "De ideëen van den Heer Jean Izoulet," extremely well informed as ever about French intellectual life.

55. On Worms and the *Revue internationale de sociologie* see Clark, *Prophets and Patrons*, 147–61.

56. Alengry, *Essai historique et critique* (512 pages).

57. Landry, *L'Utilité sociale de la propriété individuelle* (510 pages); Lapie, *Logique de la*

volonté (400 pages); Bourgin, *Fourier, contribution à l'étude du socialisme français* (541 pages); Hamelin, *Essai sur les éléments principaux de la représentation*. Maurice Halbwachs took his first doctoral degree in the faculty of law with *Les Expropriations et les prix des terrains à Paris, 1860–1900* (415 pages); not until after 1910 did he take his second doctorate in the arts faculty with *La Classe ouvrière et les niveaux de vie* (495 pages). François Simiand too took his doctoral degree in the faculty of law, with *Le Salaire des ouvriers des mines en France* (159 pages).

58. Claval and Nardy, *Pour le centenaire de la mort de Paul Vidal de la Blache*; for a short and lucid appreciation, see Meynier, *Histoire de la pensée géographique en France*, 17–29.

59. Jacobs, *Géographie de Grégoire de Tours* (158 pages); Hanriot, *Recherches sur la topographie des dèmes de l'Attique* (271 pages); and Chotard, *Le Périple de la Mer Noire par Arrien* (240 pages).

60. Quoted in Meynier, *Histoire de la pensée géographique en France*, 30.

61. Not included are three theses on colonization (by P. Gonnaud, 1905; E. Sabone, 1906; and A. Métin, 1907) and several archeologico-topographical theses.

62. Not included (because it was not submitted in Paris) is an outstanding thesis in regional geography, namely, Raoul Blanchard's *La Flandre* (530 pages).

63. On Brunhes see a Dutch dissertation (from the Utrecht school of social geographers): Cools, *De geographische gedachte bij Jean Brunhes*.

64. Under the heading "la sociogéographie" Durkheim wrote a review of F. Ratzel's *Der Staat und sein Boden geographisch beobachtet* in *Année sociologique* 1 (1896–97), 533–39; under the heading "morphologie sociale" he reviewed Ratzel's *Anthropogeographie*, pt. 1, in ibid., 3 (1898–99), 550–58.

65. Simiand, "Bases géographiques de la vie sociale," 727. Laudatory articles on Simiand were written by J. Revel, in Le Goff, *La Nouvelle Histoire*, and by J. Bouvier, in Burguière, *Dictionnaire des sciences historiques*. For Simiand's attack on historians see the conclusion.

66. Simiand, "Bases géographiques de la vie sociale."

67. Thus A. Demangeon's minor thesis, *Les Sources de la géographie de la France aux Archives Nationales*, was dedicated to Pierre Caron. Maximilien Sorre defended, in addition to his major thesis *Les Pyrénées méditerranées*, a comparable minor thesis, *Etude critique des sources de l'histoire de la viticulture et du commerce des vins et eaux-de-vie en Bas-Languedoc au XVIIIe siècle*.

68. Condamin, *Le Centenaire du doctorat ès lettres*, 31–32.

69. On "Gaumisme" see Gerbod, *La Condition universitaire*, 253, 291–92, 336.

70. AN F^{17} 13249, Rapports sur les thèses de doctorat, 1890–1891 (this dossier also contains the newspaper clippings mentioned earlier); Andler, *Les Origines du socialisme d'état en Allemagne* (495 pages). On Andler see Tonnelat, *Charles Andler*.

71. Clipping of an article by Maurras, also contained in AN F^{17} 13249.

72. For a general survey see Lefranc, *Le Mouvement socialiste sous la Troisième République I*.

73. Jaurès, *De primis socialisme germanici lineamentis apud Lutherum, Kant, Fichte et Hegel* (83 pages), published in translation just one year later in *Revue socialiste*, reprinted in *Oeuvres de Jean Jaurès III: Etudes socialistes*, vol. 1.

74. See above, n. 70.

75. Tonnelat, *Charles Andler*, 31–36.

76. Lichtenberger, *Le Socialisme au XVIIIe siècle* (473 pages), 1–11.

77. Report by Perrens, AN F^{17} 13114, Candidatures, Chaires des facultés, 1845–1910. Lichtenberger was not a *normalien*.

78. From 1884 to 1889 the word *socialism* did not appear in the title of a single thesis; from 1889 to 1894 it occurred in two submitted to the theological faculty of Montauban—Roussier, *Le Principe du socialisme en France et l'évangile* (63 pages), and Valez, *Le Socialisme catholique en France à l'heure actuelle* (144 pages)—and in one thesis submitted to the Paris arts faculty (by Jaurès); from 1894 to 1899 two such theses were submitted to the Paris arts faculty (by Lichtenberger and Andler); after 1900 the word *socialism* appeared more frequently in titles and also appeared for the first time in theses submitted to law faculties (*Catalogue des thèses et des écrits académiques*).

79. Benda, *La Trahison des clercs*, 195.

80. Lukes, *Emile Durkheim*, 322.

81. Andler, *La Vie de Lucien Herr*, 120.

82. Charléty, *Essai sur l'histoire du Saint-Simonisme* (498 pages).

83. For a history of the word *socialism* see Lalande, *Vocabulaire technique et critique de la philosophie*, 998–1001, 1276–77. In the 1890s *radicalism* and *socialism* often were treated as synonyms! For a discussion see Jaurès, "Socialisme et radicalisme en 1885."

84. See, e.g., P. Larousse, *Grand dictionnaire universel du XIXe siècle* (n.d.), s.v. "socialism": "[Sociology] aims to regenerate humanity, to transform utterly man's intellectual and physical condition."

85. AN F^{17} 13249, Rapports sur les thèses de doctorat, 1890–1901; Basch, *Essai critique sur l'esthétique de Kant* (634 pages).

86. Quoted in Harrison, *Gabriel Monod*, 314. For a reaction to this interview see H. Berr in *Revue de synthèse historique*, no. 1 (1900), 232.

87. For what follows see Den Boer, "Historische tijdschriften in Frankrijk."

88. Carbonell, "La Naissance de la *Revue historique*."

89. *Revue historique*, no. 1 (1876), 4.

90. For greater detail see Gérard, "Histoire et politique."

91. *Annuaire* (BN 8° R 6900) and *Bulletin* (BN 8° Z 10327) of the Société historique.

92. *Revue historique*, no. 1 (1876), 35.

93. See Den Boer, "Historische tijdschriften in Frankrijk," 540–41, esp. n. 40.

94. See the systematic index of forty volumes (1839–79) in *BEC*, index 1870–79 by E. Lelong (1888), 124–59.

95. For an extensive and lively account of the *Revue des questions historiques* see Carbonell, *Histoire et historiens*, 325–99; cf. Den Boer, "Historische tijdschriften in Frankrijk," 541.

96. Corbin, "Matériaux pour un centenaire," 202.

97. The systematic indexes reveal an impressive number of historical articles and book reviews. The alphabetical indexes of authors reflect the involvement of outstanding contributors; particularly useful are the cumulative alphabetical indexes of the contributors to the *Revue des deux mondes* (1831–1921) in *Table générale, 6e périod*; and Isnard, *Le Correspondant, table générale*. For a general idea of the historical articles published in the *Revue des deux mondes* and *Le Correspondant* see Crubellier, "Histoire et culture," 4–40.

98. The percentages are based on Corbin, "Matériaux pour un centenaire," 203.

99. See chapter 1.

100. The periods covered by articles in the *Revue historique* were as follows: antiquity, 2%; the Middle Ages, 23%; the sixteenth century, 16%; the seventeenth century, 16%; the eighteenth century, 24%; the nineteenth century, 21%, totaling 102% due to the

rounding off of figures. The period 1789–1815 accounted for 23% of the total. The information in the text is taken from the report on the historiographic seminar (Utrecht, 1982) by E. Ribbink, covering the years 1893, 1898, 1903, 1908, and 1913.

101. The following quantitative data are from Corbin, "Matériaux pour un centenaire," 201; for the reproaches see p. 182.

102. Den Boer, "Historische tijdschriften in Frankrijk," 537 n. 24.

103. Siegel, "Henri Berr," appendix 10.

104. The number and percentage of works reviewed that had no bearing on Europe were as follows: 1891–95, 120 (3.2%); 1896–1900, 159 (3.4%); 1901–5, 137 (3.5%); 1906–10, 210 (3.7%) (figures based on the indexes of the *Revue historique*).

105. The percentage is based on data in Corbin, "Matériaux pour un centenaire," 191.

106. Ibid., 215; report of the historiographic seminar (Utrecht, 1982) by Ribbink, 12 (see above, n. 100).

107. Corbin, "Matériaux pour un centenaire," 189 and 204, "Dimensions des groupes humains concernés par les articles."

108. Ibid., 193.

109. The numbers of documents published in the *Revue historique* were as follows: 1876–85, 64; 1886–95, 56; 1896–1905, 31. Cf., e.g., *BEC*, index to vols. 61–70 (1900–1909), "chronological table of dated documents": *A.D.* 632–1100, 30; twelfth century, 37; thirteenth century, 30; fourteenth century, 49; fifteenth century, 43; sixteenth century, 35; seventeenth century, 8; and eighteenth century, 4.

110. Corbin, "Matériaux pour un centenaire," 193.

111. In particular Ratzel's *Anthropogeographie*, pt. 1, was reviewed in *Revue historique*, no. 73 (1900), 194–99.

112. The term *socialisme* first appeared in the index of the *Revue historique* (1896–1900) under the heading "institutions."

113. Ostrogorski, *La Démocratie et l'organisation des partis politiques*, in *Revue historique*, no. 82 (1903), 214; Menger, *Le Droit au produit intégral du travail*, in ibid., no. 84 (1904), 171–72; Bücher, *Die Entstehung der Volkswirthschaft* and *Arbeit und Rhythmus*, in ibid., no. 88 (1905), 177–82; Greef, *La Sociologie économique*, in ibid., no. 86 (1904), 86; Bouglé, "Les Rapports de l'histoire et de la science sociale," in ibid., no. 89 (1905), 440.

114. Marx and Engels, *Le Manifeste communiste*, in ibid., no. 78 (1902), 361–62; Marx, *La Lutte des classes*, in ibid., no. 87 (1905), 163.

115. Frazer, *Le Rameau d'or*, in ibid., no. 84 (1904), 323.

116. Caron and Sagnac, *L'Etat actuel des études d'histoire moderne*, 24.

117. On Radet see chapter 5.

118. The most extensive and reliable information on countless journals can be found in the *Catalogue général des périodiques*, BN, and in Lasteyrie, *Bibliographie générale* (see chapter 1, n. 40).

119. *Revue de questions historiques* 19 (1876), 698.

120. See chapter 5.

121. The 154 articles were divided as follows: theory of history and methodology, 57; organization of historical work, history education, and historiography, 30; ethnopsychology, geography, general and economic history, history of religion and of ideas, 67. These data are based on the excellent systematic index by A. Fribourg, *Première table décennale* (1912).

122. See Berr, "Sur notre programme."

123. See, e.g., Picavet, "Matérialisme historique"; and Cahen, "L'Idée de lutte des classes au XVIIIe siècle."

124. The ninth article in the series was Marc Bloch's splendid study "Ile-de-France."

125. Siegel, *Henri Berr*, appendixes.

126. Ariès, *Le Temps de l'histoire*, 135–36. For a very brief historiographic survey see Reinhardt, *Histoire de France*, 1–24. For the *Grandes Chroniques de France* see the contribution by B. Guenée to Nora, *Les Lieux de mémoire, II*, 1:189–214.

127. Thierry, *Lettres sur l'histoire de France*, 2, 38; Ariès, *Le Temps de l'histoire*, 137–38. For Thierry's letters see also the contribution by M. Gauchet to Nora, *Les Lieux de mémoire, II*, 1:247–316.

128. Michelet, *Histoire de France*, vol. 1, "Préface de 1869," cxxxii.

129. Thierry, *Lettres sur l'histoire de France*, 15.

130. Michelet, *Histoire de France*, 1:cxxxiii.

131. On H. Bordier and E. Charton see chapter 2.

132. On Trognon see chapter 3; on Dareste see chapter 5.

133. Prospectus of Librairie Hachette, bound into BN copy of Taine, *Sa vie et sa correspondence*, vol. 4.

134. See chapter 3. For a "historique de l'histoire de France," for which the archives of the Fonds Hachette were also consulted, see Nora, "L'Histoire de France de Lavisse," in Nora, *Les Lieux de mémoire, II*, 1:344–50.

135. For Seignobos's contribution, see chapter 5.

136. Petit-Dutaillis, "Sébastien Charléty," 2. More information about the method of editing of the second series, the *Histoire de France contemporaine* (letters and corrected manuscripts), can be found in the Archives Lucien Herr (now in the Institut d'études politiques, Paris); see also Nora, "L'Histoire de France de Lavisse," in Nora, *Les Lieux de mémoire, II*, 1:344–50, 373–75. On the volumes contributed by Pariset see above.

137. See above, n. 133.

138. On Fustel see chapter 5.

139. Michelet, *Histoire de France*, 1:cxxxix.

140. Prospectus of Librairie Hachette (see above, n. 133).

141. See chapter 3.

142. We shall not be looking at the introductory, geographical volume, *Tableau de la géographie de la France*, by Vidal de la Blache, which was generally considered to be masterful. For a contemporary appreciation see Monod, *La Vie et la pensée de Jules Michelet*, 283–303; for a recent opinion see J.-Y. Guiomar, "Le Tableau de la géographie de la France de Vidal de la Blache," in Nora, *Les Lieux de mémoire, II*, 1:569–97. For a recent opinion of Luchaire's volume see Nora, "L'Histoire de France de Lavisse," in ibid., 353–55; and for a very brief opinion of Lavisse's own two volumes on Louis XIV see ibid., 358–60.

143. Langlois, *Saint Louis, Philippe le Bel*, 281.

144. See chapter 5.

145. Langlois, *Saint Louis, Philippe le Bel*, 355.

146. Lavisse, *Louis XIV de 1643 à 1685*, 1:50.

147. Porchnev's substantial study is marred by an introduction with a so-called bourgeois glorification of the seventeenth century. The volumes contributed by Lavisse apparently do not fit into Porchnev's picture of earlier historiography. Porchnev does no better when he attributes Lavisse's lack of admiration for Louis XIV to his being an "active champion of a Franco-German rapprochement" (Porchnev, *Les Soulèvements populaires en France*, 27).

148. Lavisse, *Louis XIV de 1643 à 1685*, 1:383.

149. Febvre, "Ni histoire à thèse ni histoire-manuel," in *Combats pour l'histoire*, 80.

150. L. Febvre, "Contre les juges suppléants de la vallée de Josaphat" (1945), in *Combats pour l'histoire*, 109.

151. Lavisse, *Louis XIV de 1643 à 1685*, 1:216–17.

152. The *locus classicus* is J. Meuvret, "Les Crises de subsistances et la démographie de la France d'Ancien Régime," in *Population* 1 (1946), reprinted in Meuvret, *Etudes d'histoire économique*. Prices were obvious objects of study for economists; see, e.g., Say and Chailley, *Nouveau dictionnaire d'économie politique*, s.v. "prix."

153. Goubert, *Cent mille provinciaux au XVIIe siècle*, 23.

154. H. Hauser, in *Revue historique*, no. 97 (1908), 346, elaborated in Hauser, *La Pensée et l'action économiques du cardinal de Richelieu*, 188–89.

155. Goubert, "Un Louis XIV républicain," 11, 14. For a recent evaluation of Colbert's work see Meyer, *Colbert*.

156. Lavisse, *Louis XIV de 1643 à 1685*, 2:382.

157. Cf. the pertinent critique by Henri Hauser, *Recherches et documents sur l'histoire des prix*. Hauser, incidentally, expressed his appreciation of Paul Raveau's searching local investigation "Le Pouvoir d'achat de l'argent et de la livre tournois en Poitou du règne de Louis XI à celui de Louis XII," in Raveau, *L'Agriculture et les classes paysannes*. See the opinion of W. Kula in "Histoire economique," 306.

158. On this subject, discussed in the context of the famous quarrel between A. Daumard and F. Furet, on the one hand, and R. Mousnier, on the other, see Bertels, *Geschiedenis tussen struktuur en evenement*, 86–93, which, strangely enough, praises Daumard and Furet for their anachronisms (93 n. 286).

159. See the opinion of Pierre Goubert in "Un Louis XIV républicain."

160. The word *capitalisme* had not yet been included in Littré's *Dictionnaire* but could be found in Larousse, *Grand dictionnaire du XIXe siècle*, as a neologism, defined as "the power of capital and of capitalists," and derived from Proudhon. A treasure house for the conceptual history of economic terms during the 1890s is Say and Chailley's liberally inclined and historically minded *Nouveau dictionnaire d'économie politique*; it does not mention the word *capitalisme*, though *capital* does of course appear.

161. H. Hauser, "Les Origines du capitalisme moderne en France" (1901), reprinted in Hauser, *Les Débuts du capitalisme*. For the history of that concept see Febvre, "Capitalisme et capitaliste" and "Les Mots et les choses en histoire économique"; and Braudel, *Civilisation matérielle, économie et capitalisme*, 201–7. In Germany the concept was used earlier by, among others, Max Weber (1897) and of course Werner Sombart, who conceived *Der moderne Kapitalismus* in 1902; see also *Geschichtliche Grundbegriffe*, 3:442–51.

162. *Conjoncture* does not appear as a heading in the *Nouveau dictionnaire d'économie politique*. The Institut für Konjunkturforschung in Berlin was founded in the 1920s. The word itself, incidentally, without a clear economic significance, is very old. N. W. Posthumus came across the word in Leiden sources from as early as 1674 (Posthumus, *De geschiedenis van de Leidsche lakenindustrie*, 1129; I am indebted for this reference to Dr. L. J. Dorsman, Utrecht). The terms *déflation* and *inflation* also are absent from the *Nouveau dictionnaire d'économie politique*; according to the *Grand Robert de la langue française*, *inflation* was first used in the modern economic sense of the word in about 1920.

163. E. Le Roy Ladurie, "La Révolution quantitative et les historiens français: Bilan d'une génération, 1932–1968" (1969), reprinted in Le Roy Ladurie, *Le Territoire de l'historien*, 15–17.

164. See Hauser, *Recherches et documents sur l'histoire des prix*, 61–72. See also G. Lefebvre, "Le Mouvement des prix et les origines de la Révolution française" (1937), reprinted in Lefebvre, *Etudes sur la Révolution française*, esp. 155. The critical opinion of

M. Lévy-Leboyer in "L'Héritage de Simiand" elicited a rather unconvincing defense from J. Bouvier in "Feu Français Simiand?"

165. For a history of concept *mentalité primitive* see Den Boer, "Mentaliteitsgeschiedenis."

166. Bloch, *La Société féodale*, 115. The contrast between Langlois's work and these notes in telegraphic style is striking—Bloch was expected to deliver his lectures to meet the demands of the traditional *agrégation* (Bloch, *La France sous les derniers Capétiens*).

167. L. Febvre, "Examen de conscience d'une histoire et d'un historien" (1933), reprinted in *Combats pour l'histoire*, 9.

168. Butterfield, *Whig Interpretation of History*.

169 See, e.g., Taine's elegant and concise account of this method: "In keeping with critical usage . . . he would set down in short and vivid words, the striking peculiarities, the dominant features, the qualities characteristic of its author" (Taine, preface to *Essais de critique et d'histoire*, esp. viii–ix). For a detailed discussion, though from a different viewpoint (Taine's "historical naturalism"), see Carbonell, *Histoire et historiens*, 299–315. Henri Hauser had already criticized this approach in a book review written for *Revue historique*, no. 97 (1908), 346: "Lavisse is too apt to treat particular examples as types."

170. Goubert, *Cent mille provinciaux au XVIIe siècle*, 100. See also Bertels, *Geschiedenis tussen struktuur en evenement*, 159–60.

171. Lavisse, *Louis XIV de 1643 à 1685*, 1:206–12.

172. Michelet, *Histoire de France*, 1:cxxxii.

173. See chapter 5.

CONCLUSION

1. Simiand, "Méthode historique et science sociale." The bone of contention was Seignobos's *La Méthode historique*. There was also criticism of Henri Hauser's refreshing and comprehensive survey *L'Enseignement des sciences sociales*. Simiand's review a few years earlier of the *Introduction aux études historiques* had been much more moderate (see Simiand, "Etudes critiques").

2. See chapter 5. The famous debates between Seignobos and Simiand are mentioned above; see chapter 4, n. 98, and chapter 5, n. 204.

3. Simiand, "Méthode historique et science sociale," 154. On Simiand's criticism of geographers see chapter 6.

4. Durkheim expressed this view in a debate with Seignobos; see Seignobos, "L'Inconnu et l'inconscient en histoire," 232.

5. Febvre's famous critiques too were partly inspired by the Communist sympathies he entertained briefly in the 1930s.

6. Quoted in Nicolet, *Le Radicalisme*, 21.

7. A summary of this discussion can be found in Lukes, *Emile Durkheim*, 302–13.

8. See Berr, *La Synthèse en histoire*; review of Durkheim's *Les Règles de la méthode sociologique* by Lucien Herr in *Revue universitaire* 2 (1894), 487–88; and Gourmont, "La Physiologie et l'invention de la mentalité."

9. Hauser, *L'Enseignement des sciences sociales*, 424.

10. See, e.g., Sagnac, "De la méthode (historique) dans l'étude des institutions de l'Ancien Régime"; and the (printed) application by Hauser (1912) to succeed Levasseur at the Collège de France, in Bibliothèque historique de la ville de Paris, "Documents d'actualité."

11. Sagnac too was very clear on this point (see above, n. 10).

12. See Lévi-Strauss, "Introduction: Histoire et ethnologie," 22.

13. See, e.g., Hauser, *L'Enseignement des sciences sociales*, 418–20; and G. Glotz in his inaugural address, "Réflexions sur le but et la méthode de l'histoire."

14. Langlois and Seignobos, *Introduction aux études historiques*, e.g., 186. See also chapter 543.

15. Quoted in Rougerie, *Paris Libre: 1871*, 172.

S O U R C E S A N D B I B L I O G R A P H Y

Where no place of publication is mentioned, Paris is meant.

ARCHIVALIA

Archives Nationales

MINISTÈRE DE L'INSTRUCTION PUBLIQUE
F^{17} 3023. Liste des sociétés savantes des départements. Enquête, 1875–76; 1884
F^{17} 12823. Procès-verbaux de la Commission de l'Instruction publique, 1818
F^{17} 13068–13072. Inspection générale de l'enseignement supérieur, 1831–1914
F^{17} 13111–13115. Candidatures. Chaires des facultés, 1845–1910
F^{17} 13248–13249. Rapports sur les thèses de doctorat, 1890–1901
F^{17} 13550–13557. Chaires du Collège de France
F^{17} 13617. Ecole Pratique des Hautes Etudes, IVe section
F^{17} 13946–13947. Commission de révision des programmes, 1900–1905
F^{17} 13948. Plan de réforme, 1882–1902
F^{17} 12935, 20097, 20197, 20362, 20423, 20455, 20503, 20516, 20518, 20589, 20592, 20593, 20658, 20659, 20686, 20780, 20783 (2), 20818, 20830, 20996, 21043, 21210, 21365, 21423, 21521, 21569, 21631, 21647, 21811, 21880, 21893, 21982, 22176, 22227, 22337, 22468, 22512 (1), 22557, 22600, 23683, 23692, 23782, 23801, 23815, 23902, 24110, 24150, 24180, 24193, 24214, 24262, 24361, 24409, 24470, 24507, 24576, 24638, 24662, 24745, 25754 25839, 25864, 26708, 26788, 26794, 26812. Dossiers individuels. Anciens fonctionnaires des enseignements primaire, secondaire et supérieur, XIX–XXe siècles

ACADÉMIE DE PARIS
61 AJ 46. Agrégation d'histoire, 1860–1875

ARCHIVES PRIVÉES
114 AP 2. Papiers Duruy-Glachant
AB XIX 2941. Seignobos, Cours, conférences et notes

Bibliothèque Nationale, département des manuscrits

NOUVELLES ACQUISITIONS FRANÇAISES
NAF 25166–25172. Papiers Ernest Lavisse

GABRIEL MONOD CORRESPONDENCE IN:
NAF 12925, 12935. Correspondance A. Geffroy
NAF 24450, 24465. Correspondance G. Paris
NAF 24882, 24897. Correspondance J. Reinach
NAF 25045. Correspondance F. Brunetière

Bibliothèque de l'Institut

Ms. 2651. Les Souvenirs d'un homme de lettres par L. F. Alfred Maury, vol. 5 (1864–70)

Archives de la préfecture de police (Seine)
Ba 23 Etudiants. Manifestations diverses, 1896–1905
Ba 24 Etudiants. Surveillance générale des Ecoles, 1859–1875
Ba 25 Etudiants. Surveillance générale des Ecoles, 1876–1880
Ba 26 Etudiants. Manifestations, 1881–1882
Ba 27 Etudiants. Surveillance. Manifestations, 1883–1893

Bibliothèque historique de la ville de Paris

"Documents d'actualité." Dossiers: Fustel de Coulanges, Aulard, Berr, Hauser, Monod, and Seignobos

Collège de France

Service des archives. Procès-verbaux des assemblées

Private Collections

Fonds Mario Rist (Versailles)
Archives Romain Rolland (Paris)
Documents autographes Langlois-Berthelot (Paris)

PUBLISHED SOURCES

General Bibliographies

Bibliographie de la France (= *Journal général de l'imprimerie et de la librairie*; weekly publication with annual index)
Bulletin mensuel des récentes publications françaises
Catalogue général des livres imprimés de la Bibliothèque Nationale. Auteurs
National Union Catalogue

Historical Bibliographies

G. Brière et al., *Répertoire méthodique de l'histoire moderne et contemporaine de la France* (1898–)
R. de Lasteyrie, *Bibliographie générale des travaux historiques et archéologiques, publié par les sociétés savantes de la France*
J. Lelong, *Bibliothèque historique de la France contenant tous les ouvrages tant imprimez que manuscrits qui traitent de l'histoire de roiaume ou qui y ont rapport avec des notes critiques et historiques* (1719), rev. ed., vols. 1–5 (1768–78)
G. Monod, *Bibliographie de l'histoire de France, catalogue méthodique et chronologique des sources et des ouvrages relatifs à l'histoire de France depuis les origines jusqu'en 1789* (1888)

Budgets
Budget général des dépenses et des services de l'exercice, 1825, 1835, 1842, 1850, 1860, 1870, 1880, 1890, 1900, 1910, 1914 (BN 4° Lf156 8)

Statistical Data
Annuaire statistique de la France
Statistiques de l'enseignement supérieur, 1865–1868 (1869), *1869–1876* (1877), *1877–1888* (1889), *1889–1899* (1900)

Laws, Instructions, Circulars, and Inquiries
Bulletin administratif de l'instruction publique (1856–)

Circulaires et instructions officielles relatives à l'instruction publique, 1802–1900, vols. 1–12 (1863–1902)

Enquêtes et documents relatifs à l'enseignement supérieur, 1–110 (1883–1913)

Journal officiel, Chambre des députés, documents parlementaires et annexes, 1899 session, vol. 2 (1899)

Recueil des lois et règlements concernant l'instruction publique depuis l'édit de Henri IV en 1598 jusqu'à ce jour, vol. 6 (1822)

Frequently Consulted Annuals and Journals
Almanach de l'Université royale de France, 1822, 1828
Almanach de l'Université, République française, 1848
Annuaire de l'instruction publique, 1870, 1890, 1911
Annuaire de l'Association des anciens élèves de l'Ecole normale supérieure
Annuaire de l'Ecole pratique des hautes études
Bibliothèque de l'Ecole des chartes (1839–)
Gazette (spéciale) de l'instruction publique (1838–48)
Revue historique (1876–)
Revue internationale de l'enseignement (1881–)
Revue de synthèse historique (1900–)
Revue universitaire (1892–)

WORKS CITED

Abraham, P. *Viollet-le-Duc et le rationalisme médiéval.* 1934.
Agathon [Henri Massis and Alfred de la Tarde]. *Les Jeunes Gens d'aujourd'hui.* 1913.
Agulhon, M. *1848, ou l'apprentissage de la République.* 1973.
Aillery, Abbé d'. "Quel est le meilleur plan à suivre pour la rédaction des chroniques paroissiales." *Congrès archéologique de France* 31 (1864).
Alembert, J. d'. *Oeuvres complètes.* Vol. 4. 1821.
Alengry, A. F. H. *Essai historique et critique sur la sociologie chez Auguste Comte.* 1899.
Altamira, R. *La Ensenanza de la historia.* 2nd ed. Madrid, 1895.
Amalvi, C. "Les Guerres des manuels autour de l'école primaire en France." *Revue historique,* no. 262 (1979), 359–98.
——. *Les Héros de l'histoire de France.* 1980.
——. "L'Erudition française face à la révolution d'Etienne Marcel: Une histoire mythologique, 1814–1914." *BEC* 142 (1984), 287–311.
Anceau, J. *Parallèle des Choëphores d'Eschyle, des Electres de Sophocle, d'Euridipe, de Crébillon et de l'Oreste de Voltaire.* 1817.
Anderson, R. D. *Education in France, 1848–1870.* Oxford, 1975.
Andler, C. *Les Origines du socialisme d'état en Allemagne.* 1897.
——. *La Vie de Lucien Herr.* 1932. 2nd ed. 1977.
Annuaire de la Société historique. BN 8° R 6900.
Annuaire des docteurs (lettres) de l'Université de Paris et des autres universités françaises, 1899–1965. 1965.
Annuaire des sociétés savantes de la France et de l'étranger. 1866.
Anrich, E., ed. *Die Idee der deutschen Universität.* Darmstadt, 1964.
Antoine, M. E. "Un Service pionnier au XIXe siècle: Le Bureau des travaux historiques d'après ses papiers aux Archives Nationales." *Bulletin de la section d'histoire moderne et contemporaine,* fasc. 10 (1977).

Arbois de Jubainville, H. d'. *Abbeyes cisterciennes*. 1858.

——. *Mémoire présenté à l'Académie des inscriptions et belles-lettres*. 1893.

——. *Deux manières d'écrire l'histoire: Critiques de Bossuet, d'Augustin Thierry et de Fustel de Coulanges*. 1896.

Archives parlementaires, 2nd ser., 19 (25 February 1817).

Ariès, P. *Le Temps de d'histoire*. 1954. Reprint. 1986.

——. *L'Enfant et la vie familiale sous l'Ancien Régime*. 1960. Reprint. 1973.

Armengaud, A. *La Population française au XIXe siècle*. 1971.

Arnaud, E. C. J. *Quid de pueris instituendis senserit Ludovicus Vives*. 1887.

Arnould, A., and P. Nicole. *La Logique ou l'art de penser*. Rev. ed. 1683. Reprint. 1970.

Aron, R. *Essai sur la théorie de l'histoire dans l'Allemagne contemporaine*. 1938.

——. *Introduction à la philosophie de l'histoire*. 1938.

Aubier, Abbé. "De la rédaction des chroniques paroissiales." *Congrès archéologique de France* 31 (1864).

Aulard, A. *Les Orateurs de l'Assemblée Constituante*. 1882.

——. *Danton*. 1886.

——. *Le Culte de la raison et le culte de l'Etre suprême, 1793–1794*. 1892.

——. *Etudes et leçons sur la Révolution française*. 7 vols. 1893–1913.

——. *Histoire politique de la Révolution française: Origines et développements de la République, 1789–1804*. 1901.

——. *Taine, historien de la Révolution française*. 1907.

——. *Napoléon Ier et le monopole universitaire*. 1911.

——. *La Révolution française et le régime féodal*. 1919.

——, ed. *La Société des Jacobins: Recueil de documents pour l'histoire du club des Jacobins de Paris*. 6 vols. 1889–97.

——. *Recueil des Actes du Comité du Salut Public avec la correspondance officielle des représentants en mission et le registre du Conseil exécutif provisoire*. 19 vols. 1889–1909.

——. *Paris pendant la Réaction Thermidorienne et sous le Directoire: Recueil de documents pour l'histoire de l'esprit public à Paris*. 5 vols. 1898–1902.

Aulaunier, C. *Le Nouveau Louvre de Napoléon III: Histoire du palais et du musée du Louvre*. Vol. 2. n.d.

Aumale, Duc d'. "Rosseeuw Saint-Hilaire, 1802–1889." *Séances et travaux de l'Académie des sciences morales et politiques*, n.s., 33 (1890), 91–115.

Baal, G. "Un salon dreyfusard des lendemains de l'Affaire à la Grande Guerre: La marquise Arconati-Visconti et ses amis." *RHMC* 26 (1981), 443–62.

Bakhtine, M. *L'Oeuvre de François Rabelais et la culture populaire au Moyen Age et sous la Renaissance*. 1970. Originally in Russian.

Barante, P. de. *La Vie politique de Royer Collard: Ses discours et ses écrits*. 3 vols. 2nd ed. 1863.

Barrau-Dihigo, L., ed. *Nos enquêtes: L'enseignement supérieur de l'histoire*. 1906.

Barza, F. L., et al. *La Vie et l'oeuvre de Gabriel Hanotaux à propos de son 80ième anniversaire*. 1933.

Basch, V. *Essai critique sur l'esthétique de Kant*. 1896.

Baschet, J. *Histoire du Dépôt des archives des Affaires Etrangères à Paris, au Louvre en 1710, à Versailles en 1763 et de nouveau à Paris en divers endroits depuis 1796*. 1875.

Bautier, R. H. "Le Comité des travaux historiques, bilan d'activité." In *Humanisme actif: Mélanges d'art et de littérature offerts à Julien Cain*, 29–46. 1968.

Belloni, G. *Aulard, historien de la Révolution française*. 1949.

Bémont, C. "Gabriel Monod." *Annuaire de l'Ecole pratique des hautes études*, 1912–13.

Benda, J. *La Trahison des clercs*. 1927. Reprint. 1977.

Ben-David, J. *The Scientist's Role in Society: A Comparative Study.* Englewood Cliffs, N.J., 1971.

Bénéton, P. "La Génération de 1912–1914: Image, mythe et réalité." *Revue française de science politique* 21 (1971), 981–1009.

Bénichou, P. *Le Sacre de l'écrivain, 1750–1830.* 1973.

Benoist, A. *Quid de puerorum institutione senserit Erasmus.* 1876.

Bernard, C. *Introduction à l'étude de la médecine expérimentale.* 1865.

Bernard, C. *L'Enseignement de l'histoire de France au XIXe siècle, selon les ministres de l'Instruction publique.* 1976.

Bernheim, E. *Lehrbuch der historischen Methode.* 1889.

Bernier, A., ed. *Journal des Etats généraux de France tenus à Tours en 1484 sous le règne de Charles VIII, rédigé en latin par Jehan Masselin, député du bailliage de Rouen et traduit pour la première fois sur les manuscrits inédits de la Bibliothèque du Roi.* 1835.

Berr, H. *La Synthèse des connaissances et l'histoire: Essai sur l'avenir de la philosophie.* 1898.

———. "Sur notre programme." *Revue de synthèse historique,* no. 1 (1900), 1–6.

———. "Une Philosophie de l'histoire de France: Les deux France de M. Paul Seippel." *Revue de synthèse historique,* no. 14 (1907), 271–89.

———. *La Synthèse en histoire: Son rapport avec la synthèse générale.* 1911. Reprint. 1953.

Bertels, K. *Geschiedenis tussen struktuur en evenement.* Amsterdam, 1973.

Berthelot, M. *La Synthèse chimique.* 1874.

Bertrin, M. G. *La Sincérité religieuse de Chateaubriand.* 1899.

Besnard, P., ed. *The Sociological Domain: The Durkheimians and the Founding of French Sociology.* Cambridge, 1983.

Besnier, M. *Lexique de géographie ancienne.* 1914.

Blaas, P. B. M. *Continuity and Anachronism: Parliamentary Development in Whig Historiography and in the Anti-Whig Reaction between 1890 and 1930.* The Hague, 1978.

———, ed. *Geschiedenis als wetenschap.* The Hague, 1979.

Blanc, L. *Histoire de la Révolution française.* Vol. 1. 1847.

Blanchard, R. *La Flandre: Etude géographique de la plaine flamande en France, Belgique et Hollande.* Lille, 1906.

Bloch, C. *L'Assistance et l'état en France à la veille de la Révolution (généralités de Paris, Rouen, Alençon, Orléans, Châlons, Soissons, Amiens, 1764–1790).* 1908.

Bloch, G. *Les Origines du sénat romain: Recherches sur la formation et la dissolution du sénat patricien.* 1884.

Bloch, M. "L'Ile-de-France." *Revue de synthèse historique* 25 (1912), 209–23, 310–39, and 26 (1913), 131–99, 325–50.

———. *Les Rois thaumaturges: Etude sur le caractère surnaturel attribué à la puissance royale particulièrement en France et en Angleterre.* 1924. Reprint. 1961.

———. *Les Caractères originaux de l'histoire rurale française.* 1931.

———. "Christian Pfister." *Revue historique,* no. 172 (1933), 563–70.

———. *La Société féodale.* 1939. Reprint. 1968.

———. *Apologie pour l'histoire ou métier d'historien.* 1949. Reprint. 1967.

———. *La France sous les derniers Capétiens, 1223–1328.* 1958.

Bloch, M., and L. Febvre. "Le Problème de l'agrégation." *Annales d'histoire économique et sociale* 9 (1937), 115–29.

Bocquillon, E. *La Crise du patriotisme à l'école.* 1905.

———. *Pour la patrie.* 1907.

Boissonnade, P. *Histoire de la réunion de la Navarre à la Castille: Essai sur les relations des Princes de Foix-Albret avec la France et l'Espagne, 1479–1521.* 1893.

Bonieux, B. *Critique des tragédies de Corneille et de Racine par Voltaire.* 1866.

Boon, H. N. *Rêve et réalité dans l'oeuvre économique et sociale de Napoléon III.* 1936.

Bordier, H. *Les Archives de la France.* 1855.

Bosher, J. F. *French Finances, 1770–1795: From Business to Bureaucracy.* Cambridge, 1970.

Bossuet, J. B. *Discours sur l'histoire universelle.* 1680. Reprint. 1823.

Bouché-Leclercq, A. *Les Pontifes de l'ancienne Rome.* 1871.

———. *Histoire de la divination dans l'antiquité.* 4 vols. 1879–82.

———. *Histoire des Lagides.* 2 vols. 1903–7.

Bouglé, C. *Les Idées égalitaires: Etude sociologique.* 1899.

———. "Les Rapports de l'histoire et de la science sociale." *Revue de métaphysique et de morale,* special Cournot issue, May 1905.

Boulard, F. *Essor ou déclin du clergé français?* 1950.

Bourdé, G., and H. Martin. *Les Ecoles historiques.* 1983.

Bourdieu, P., and J. C. Passeron. *Les Héritiers: Les étudiants et la culture.* 1964.

Bourgeois, E. *Le Capitulaire de Kiersy-sur-Oise (877): Etude sur l'état et le régime politique de la société carolingienne à la fin du IXe siècle, d'après la législation de Charles Le Chauve.* 1885.

———. *Neuchâtel et la politique prussienne en Franche-Comté de 1702 à 1713.* 1887.

———. *Manuel historique de politique étrangère.* 4 vols. 1892–1925.

Bourgin, G. "A. Aulard et les archives." In *Cahiers d'histoire de la Révolution française.* Toulouse, 1955.

Bourgin, H. *Fourier, contribution à l'étude du socialisme français.* 1905.

———. *De Jaurès à Léon Blum: L'Ecole normale et la politique.* 1938.

Bouvier, J. "Sur les dimensions mesurables du fait financier, XIXe et XXe siècles." *Revue d'histoire économique et sociale* 46 (1968), 161–84.

———. "Feu Français Simiand?" *AESC* 28 (1973), 1173–92.

Braesch, V. *Finances et monnaies révolutionnaires.* 3 vols. Nancy 1934.

Brands, M. C. *Historisme als ideologie: Het "onpolitieke" en "antinormatieve" element in de Duitse geschiedwetenschap.* Assen, 1965.

Braudel, F. *Civilisation matérielle, économie et capitalisme.* Vol. 2. 1979.

Bréal, M. *Quelques mots sur l'instruction publique en France.* 1872.

Bréhier, L. *Le Schisme oriental du XIe siècle.* 1899.

Bruneau, C. *L'Epoque romantique.* Vol. 12 of *Histoire de la langue française,* ed. F. Brunot. 1948.

Brunhes, J. *Etude de géographie humaine: L'irrigation, ses conditions géographiques, ses modes et son organisation dans la péninsule ibérique et dans l'Afrique du Nord.* 1902.

Bücher, K. *Die Entstehung der Volkswirthschaft: Vorträg und Versuche.* 2nd ed. Tübingen, 1898.

———. *Arbeit und Rhythmus.* 2nd ed. Leipzig, 1899.

Bulletin de la Société historique. BN 8° Z 10327.

Bulletin de la Société historique et archéologique du Périgord 91 (1964).

Burguière, A., ed. *Dictionnaire des sciences historiques.* 1986.

Burke, P. "A Survey of the Popularity of Ancient Historians, 1450–1700." *History and Theory* 5 (1966), 135–52.

Burton, J. K. "L'Enseignement de l'histoire dans les lycées et les écoles primaires sous le Premier Empire." *Annales historiques de la Révolution française* 44 (1972), 98–109.

Butterfield, H. *The Whig Interpretation of History.* 1931. Reprint. London, 1950.

Le Cabinet du Roi. Exposition au Louvre. 1977.

Cadot, L. "Le Budget et les fonctionnaires." *Le Correspondant* 237, no. 4 (1909), 3–26.

Cahen, L. "L'Idée lutte des classes au XIIIe siècle." *Revue de synthèse historique*, no. 12 (1905), 44ff.

Cahier, C. *Caractéristiques des saints dans l'art populaire.* Vol 1. 1867.

Cain, J., R. Escarpit, and H. J. Martin, eds. *Le Livre français.* 1972.

Camena d'Almeida, P. *Les Pyrénées: Développement de la connaissance géographique de la chaine.* 1893.

Carbonell, C. O. "Guizot, homme d'Etat et le mouvement historiographique français du XIXe siècle." In *Actes du Colloque François Guizot*, 1974 (1976).

———. "La Naissance de la *Revue historique*: Une revue de combat 1876–1885." *Revue historique*, no. 518 (1976), 331–51.

———. *Histoire et historiens: Une mutation idéologique des historiens français, 1865–1885.* Toulouse, 1976.

———. "Historiographie vers 1900." Paper delivered at the Historiographical Congress, Montpellier, July 1983.

Carbonell, C. O., and G. Livet, eds. *Au berceau des Annales.* Toulouse, 1983.

Carette, Madame (née Bouvet). *Souvenirs intimes de la Cour des Tuileries.* Vol. 1. Reprint. 1890.

Caron, P. "L'Organisation des études locales d'histoire moderne." *La Révolution française* 42 (1902), 481–510.

———. "Alphonse Aulard." *La Révolution française* 81 (1928), 229–31.

———. *Manuel pratique pour l'étude de la Révolution française.* Rev. ed. 1947.

Caron, P., and P. Sagnac. *L'Etat actuel des études d'histoire moderne en France.* 1902.

Carré, H. *Essai sur le fonctionnement du Parlement de Bretagne après la Ligue (1598–1661).* 1888.

Carrière, V. *Introduction aux études d'histoire ecclésiastique locale.* Vol. 1. 1940.

Catalogue des thèses et des écrits académiques. 1884–1913.

Caumont, A. de. "Histoire de l'association normande." *Annuaire des cinq départements de l'ancienne Normande* 36 (1870), 98–104.

Cayx, C. *Précis de l'histoire de France.* 3rd ed. 1852.

"Centenaire de la préhistoire en Périgord." *Bulletin de la société historique et archéologique du Périgord* 91 (1964).

Certeau, M. de, D. Julia, and J. Revel. *Une politique de la langue: La Révolution française et les patois.* 1975.

Charle, C. *Les Professeurs de la faculté des lettres de Paris: Dictionnaire biographique, 1809–1908.* Vol. 1. 1985.

Charléty, C. S. G. *Essai sur histoire du Saint-Simonisme.* 1896.

Charmes, X. *Le Comité des travaux historiques et scientifiques, histoire et documents.* 3 vols. 1887.

Chartier, R. "Des Livres par milliers." *AESC* 32 (1977), 537–39.

Charton, E. *Dictionnaire des professions.* 1842.

Chasles, C. E. *De adagiis D. Erasmi Roterodami.* 1862.

Chateaubriand, F. R. de. *Oeuvres complètes.* Vol. 4. Brussels, 1831.

Chaunu, P. *De l'histoire à la prospective.* 1975.

Chaussinand-Nogaret, G. *La Noblesse au XVIIIe siècle: De la féodalité aux Lumières.* Reprint. Brussels, 1984.

Chéruel, A. *Dictionnaire des institutions, moeurs et coutumes de la France.* 6th ed. 1884.

Chotard, M. H. *Le Périple de la Mer Noire par Arrien.* 1860.

Clark, T. N. *Prophets and Patrons: The French University and the Emergence of the Social Sciences.* Cambridge, Mass., 1973.

Claval, P., and J. P. Nardy. *Pour le centenaire de la mort de Paul Vidal de la Blache.* 1968.

Clerc, M. *Les Métèques athéniens.* 1893.

Cochin, A. *La Crise de l'histoire révolutionnaire: Taine et M. Aulard.* 1909.

Condamin, J. *Le Centenaire du doctorat ès lettres, 1810–1910.* 1910.

Conrad, J. "Allgemeine Statistik der deutschen Universitäten." In W. Lexis, ed., *Die deutschen Universitäten.* Vol. 1. Berlin, 1893.

Conseil municipal de Paris, procès-verbaux, année 1887, 2e semestre. 1888.

Conseil municipal de Paris, rapports et documents, année 1886. 1887.

Conseil municipal de Paris, rapports et documents, année 1892. 1893.

Cools, R. H. A. *De geographische gedachte bij Jean Brunhes.* Utrecht, 1942.

Corbin, A. "Matériaux pour un centenaire: Le contenu de la *Revue historique* et son évolution, 1876–1972." *Cahiers de l'Institut de l'histoire de la presse et de l'opinion* 2 (1975).

Correspondance et papiers de la famille impériale: Pièces retrouvées aux Tuileries. 2 vols. Brussels. 1870–71.

Courajod, L. *Alexandre Lenoir, son journal et le musée des Monuments français.* 3 vols. 1878–87.

Cousin, V. *Oeuvres.* Vol. 2. Brussels, 1841.

Coutau-Bégarie, H. *Le Phénomène "nouvelle histoire": Stratégie et idéologie des nouveaux historiens.* 1983.

Croce, B. *Zur Theorie und Geschichte der Historiographie.* Tübingen, 1915. Originally in Italian.

Crozals, J. de. *La Faculté des lettres de Grénoble.* 1897.

Crubellier, M. "Histoire et culture: Recherches sur l'histoire et la culture en France de 1871 à 1914." Doctorat d'Etat, 1973.

Dainville, F. de. "L'Enseignement de l'histoire et de la géographie et le ratio studiorum." *Analecta gregoriana* 70, series Facultatis historiae ecclesiastica, sectio A (Rome, 1954), 123–56.

Dansette, A. *Naissance de la France moderne: Le Second Empire.* 1976.

Dareste, C. *Histoire de l'administration en France et des progrès du pouvoir royal depuis le règne de Philippe Auguste jusqu'à la mort de Louis XIV.* 2 vols. 1848.

———. *Histoire des classes agricoles en France depuis Saint-Louis jusqu'à Louis XVI.* 1854. 2nd ed. 1858.

———. *Histoire de France depuis les origines jusqu'à nos jours.* 9 vols. 1865–79. 3rd ed. 1884–85.

Darnton, R. "Reading, Writing and Publishing in Eighteenth Century France: A Case Study in the Sociology of Literature." In F. Gilbert and S. R. Graubard, eds., *Historical Studies Today*, 238–80. New York, 1972.

———. *The Business of Enlightenment: A Publishing History of the Encyclopédie, 1775–1800.* Cambridge, Mass., 1979.

Darras, J. E. *Histoire générale de l'église depuis le commencement de l'ère chrétienne jusqu'à nos jours.* 2nd ed. 1878.

Daru, P. *Notions statistiques sur la librairie pour servir à la discussion des lois sur la presse.* 1827.

Dassonville, R. P. *Les Belles Familles des religieux français.* 1927.

Daudet, A. *Le Petit Chose.* 1868.

Davin, V. *Etude critique sur Bossuet.* 1904.

De la position des professeurs d'histoire dans les collèges de l'université. 1844. BN Lf244 29.

Delisle, L. *Recherches sur la librairie de Charles V.* 1907.

Demangeon, A. *La Plaine picarde: Picardie, Artois, Cambrésis, Beauvaisis. Etude de géographie sur les plaines de craie du Nord de la France.* 1905.

————. *Les Sources de la géographie de la France aux Archives Nationales.* 1905.

Den Boer, P. "Henri Hauser: Traditie en vernieuwing in de Franse geschiedschrijving." Doctoral essay. Leiden, 1975.

————. "Mentaliteitsgeschiedenis: Een begripsbepaling." *Bijdragen en mededelingen betreffende de Geschiedenis der Nederlanden* 98 (1983), 319–28.

————. "Historische tijdschriften in Frankrijk, 1876–1914." *TvG* 99 (1986), 530–46.

Denis, E. *Huss et la guerre des Hussites.* 1878.

————. *Fin de l'indépendance bohême.* 2 vols. 1890.

————. *La Bohême depuis la Montagne Blanche.* 2 vols. 1903.

Descartes, R. *Discours de la méthode.* 1636. Reprint. 1966.

Desdevises du Dézert, T. A. *Erasmus Roterodamus morum et litterarum vindex.* 1862.

Desjardins, A. *Négociations diplomatiques de la France avec la Toscane.* 6 vols. 1859–86.

Despois, E. *Le Vandalisme révolutionnaire: Fondations littéraires, scientifiques et artistiques de la Convention.* 1868. Reprint. 1888.

Diehl, C. *Etudes sur l'administration byzantine dans l'exarchat de Ravenne.* 1888.

————. *L'Afrique byzantine: Histoire de la domination byzantine en Afrique (533–709).* 1896.

————. *La République de Vénise.* 1915. Reprint. 1985.

Digeon, C. *La Crise allemande de la pensée française, 1870–1914.* 1959.

Doublet, V. *Dictionnaire universel des professions ou guide des familles pour les diriger dans le choix d'un état pour leurs enfants.* 1858.

Drumont E. *La France juive: Essai d'histoire contemporaine.* N.d.

Duchesne, L. *Fastes épiscopaux de l'ancienne Gaule.* 3 vols. 1907–15.

Ducoudray, G. *Histoire de France et histoire générale depuis 1789 jusqu'à nos jours.* 2nd ed. 1869.

Dumas, F. *La Généralité de Tours au 18e siècle: L'administration de l'intendant Cluzel, 1766–1783.* 1894.

Dumesnil, A. *Aux amis du très regretté Armand Dumesnil.* 1903.

Dumont, A. "Les Etudes d'érudition en France et en Allemagne." *Revue des deux mondes* 5 (1 November 1874).

————. *Notes sur l'enseignement supérieur en France.* 1884.

Dupanloup, F. *L'Histoire, la philosophie, les sciences.* 1867.

————. *Conseils aux jeunes gens sur l'étude de l'histoire.* 1872.

————. *De l'éducation.* 3 vols. 11th ed. 1887.

Dupin, C. *Forces productives et commerciales de la France.* 1827.

Du Plessis, Armand. *Testament politique d'Armand Du Plessis, cardinal duc de Richelieu.* Amsterdam, 1683.

Durkheim, E. *De la division du travail social: Etude sur l'organisation des sociétés supérieures.* 1893.

————. *Les Règles de la méthode sociologique.* 1895. 20th ed. 1981.

————. *Textes I: Eléments d'une théorie sociale.* 1975.

Duroselle, J. B. *La France et les Français, 1900–1914.* 1972.

Duruy, V. *Histoire romaine.* 1850. 21st ed. 1909.

————. *Histoire grecque.* 1851. 15th ed. 1902.

————. *Les Papes, princes italiens.* 1860.

————. *Histoire du Moyen Age.* 1861. 15th ed. 1902.

————. *Histoire des temps modernes depuis 1453 jusqu'à 1789.* 1863. 11th ed. 1904.

————. *Histoire de France.* 1864. 18th ed. 1908.

————. *Notes et souvenirs, 1811–1894.* 2 vols. 1901.

Dussaud, R. *La Nouvelle Académie des Inscriptions et des Belles Lettres, 1795–1914.* 2 vols. 1946–47.

Eisenmann, L. "Ernest Denis." *Revue des études slaves* 1 (1921), 138–43.

Emerit M., ed. *Lettres de Napoléon III à Madame Cornu.* 2 vols. 1937.

Engel, A. J. *From Clergyman to Don: The Rise of the Academic Profession in Nineteenth Century Oxford.* Oxford, 1975.

Escarpit, R., et al. *Le Littéraire et le social: Eléments pour une sociologie de la littérature.* 1970.

Espinas, A. *Des sociétés animales: Etudes de psychologie comparée.* 1877.

Esquiros, A. *Les Montagnards.* 1846.

Estivals, R. *La Bibliometrie bibliographique.* Lille, 1971.

Etudes d'histoire du Moyen Age dédiées à Gabriel Monod. 1896.

"Evolution de la population active en France depuis cent ans d'après des dénombrements quinquennaux." In *Etudes et conjonctures, économie française.* May–June 1953.

Falcucci, C. *L'Humanisme dans l'enseignement secondaire en France au XIX siècle.* Toulouse, 1939.

Fawtier, R. "Charles-Victor Langlois." *English Historical Review* 45 (1930), 85–91.

————. "Charles-Victor Langlois." *Revue historique,* no. 164 (1930), 465.

Febvre, L. *La Terre et l'évolution humaine.* 1922.

————. "Les Mots et les choses en histoire économique." *Annales d'histoire économique et sociale* 2 (1930), 231ff.

————. "De l'histoire-tableau: Essai de critique constructive." *Annales d'histoire économique et sociale* 5 (1933), 267–81.

————. "Capitalisme et capitaliste." *Annales d'histoire sociale,* 1939, 402–3.

————. "Travail: Evolution d'un mot et d'une idée." *Journal de psychologie* 41 (1948), 19–28.

————. *Combats pour l'histoire.* 1953.

Feugère, G. C. E. *Erasme: Etude sur sa vie et ses ouvrages.* 1874.

Filangeri, G. *Oeuvres.* 1822.

Finley, M. I. *Ancient Slavery and Modern Ideology.* London, 1980.

Fleury, C. *Traité du choix et de la méthode des études, avec le devoir des maîtres et des domestiques.* 1686. Reprint. Brussels, 1729.

Flexner, A. *Universities, American, English, German.* New York, 1930.

Foncin, P. "Agrégation d'histoire et de géographie, concours de 1905." *Revue universitaire* 15 (1906), 1–13.

Fortoul, H. *Rapport à l'empereur sur la situation de l'Instruction publique depuis le 2 décembre 1851.* 1853.

————. *Instruction générale sur l'exécution du plan des études des lycées.* 1854.

Fossier, F. "Le Charge d'historiographe du seizième au dix-neuvième siècle." *Revue historique,* no. 258 (1977), 73–92.

————. "A propos du titre d'historiographe sous l'Ancien Régime." *RHMC* 32 (1985), 361–417.

Fouillée, A. *La Liberté et le déterminisme.* 1872.

————. *La Science sociale contemporaine.* 1880.

Fourastié, J. *Les Trente glorieuses.* 1979.

Frankeville, M. de. *Le Premier siècle de l'Institut de France, 1795–1895.* 2 vols. 1896.

Franklin, A. *Les Sources de l'histoire de France.* 1877.

Frazer, J. G. *Le Rameau d'or.* 1903. Originally published as *The Golden Bough* (London, 1840).

Freud, S. "Two Artificial Groups: The Church and the Army." In *The Standard Edition*, 13:93–99. London, 1955.

Freyssinet-Dominjon, J. *Les Manuels d'histoire de l'école libre, 1882–1959.* 1969.

Froehner, W. *Souvenirs de Froehner, recueillis par la comtesse de Rohan-Chadot.* Noget-le-Rotrou, n.d.

Furet, F. "La Librairie du royaume de France au 18e siècle." In *Livre et société dans la France du XVIIIe siècle.* 1965.

———. "A. Cochin: La théorie du Jacobinisme." In *Penser la Révolution française.* 1978.

Furet, F., and J. Ozouf. *Lire et écrire: L'alphabétisation des Français de Calvin à Jules Ferry.* Vol. 1. 1977.

Furet, F., and M. Ozouf. "Deux légitimations historiques de la société française au XVIIIe siècle: Mably et Boulainvilliers." *AESC* 34 (1979), 438–50.

Fustel de Coulanges, N. D. *La Cité antique.* 1864. Reprint. 1984.

———. *La Gaule romaine.* 1875. 5th ed. 1922.

———. *La Monarchie franque.* 1888. 4th ed. 1922.

———. *L'Alleu et le domaine rural pendant l'époque mérovingienne.* 1889. 3rd ed. 1923.

———. *L'Invasion germanique et fa fin de l'Empire.* 1891. 5th ed. 1922.

Gachon, P. *Les Etats de Languedoc et l'édit de Béziers, 1632.* 1887.

Gadille, J. *La Pensée et l'action politique des évêques français au début de la IIIe République, 1870–1883.* 1967.

Gaehtgens, T. *Versailles, de la résidence royale au musée historique.* 1984.

Gallois, L. *Les Géographes allemands de la Renaissance.* 1890.

Geffroy, A. *Gustave III et la cour de France.* 2 vols. 1867.

———. "Le Concours d'agrégation d'histoire, ses dernières transformations." *Revue internationale de l'enseignement*, no. 9 (1885).

Geffroy, A., J. Zeller, and J. Thiénot. *Rapports sur les études historiques.* 1867.

Gembicki, D. "Jacob-Nicolas Moreau et son mémoire sur les fonctions d'un historiographe de France." *XVIIIe siècle* 4 (1972), 191–215.

Gérando, J. M. de. *De la génération des connaissances humaines.* 1802.

Gérard, A. "Histoire et politique: *La Revue historique* face à l'histoire contemporaine, 1885–1898." *Revue historique*, no. 518 (1976), 353–405.

———. "Origines et caractéristiques du Malet-Isaac." In *Colloque Jules Isaac*, 52–59. Rennes, 1977.

Gerbod, P. *La Condition universitaire en France au XIXe siècle: Etude d'un groupe socioprofessionnel, professeurs et administrateurs de l'enseignement secondaire public de 1842 à 1880.* 1965.

———. "La Place de l'histoire dans l'enseignement secondaire de 1802 à 1880." *L'Information historique* 27 (1965).

———. "La Scène parisienne et sa représentation de l'histoire nationale dans la première moitié du XIXe siècle." *Revue historique*, no. 266 (1981), 3–30.

Gérin, C. *Recherches sur l'assemblée du clergé de France de 1682.* 1869.

Geschichtliche Grundbegriffe: Historisches Lexikon zur politisch-sozialen Sprache in Deutschland. Ed. O. Brunner, W. Conze, and R. Koselleck. 7 vols. Stuttgart, 1972–92.

Geyl, P. *Napoleon voor en tegen in de Franse geschiedschrijving.* 1946. Reprint. 1965.

Ghellinck, J. de. *Les Exercices pratiques du séminaire en théologie.* 1948.

Gibbon, E. *Autobiography of Edward Gibbon: As Originally Edited by Lord Sheffield.* 1796. Reprint. Oxford, 1978.

Girardet, R. *La Société militaire dans la France contemporaine, 1815–1939.* 1953.

———. *Le Nationalisme français, 1871–1914.* 1966.

Giraud, V. *Bibliographie critique de Taine.* 1901.

Giry, A. "Jules Quicherat, 1814–1882." *Revue historique*, no. 19 (1882), 241.

Glotz, G. *La Solidarité de la famille dans le droit criminel en Grèce.* 1904.

———. "Réflexions sur le but et la méthode de l'histoire." *Revue internationale de l'enseignement*, no. 54 (1907), 481–95.

Goblot, E. *La Barrière et le niveau: Etude sociologique sur la bourgeoisie française.* 1925.

Godechot, J. *Un Jury pour la Révolution.* 1974.

Gödde-Baumanns, B. *Deutsche Geschichte in französischer Sicht: Die französische Historiographie von 1871 bis 1918 über die Geschichte Deutschlands und der deutsch-französischen Beziehungen in der Neuzeit.* Wiesbaden, 1971.

Goelzer, H. "Charles-Victor Langlois." In *BEC* 90 (1929), 221–25.

Goffman, E. *Asylums: Essays on the Social Situation of Mental Patients and Other Inmates.* New York, 1961.

Gontard, R., and R. Raphaël. *Un Ministre de l'instruction publique sous l'Empire autoritaire: Hippolyte Fortoul, 1851–1856.* 1975.

Gooch, B. D., ed. *Napoleon III, Man of Destiny: Enlightened Statesman or Protofascist?* New York, 1963.

Gooch, G. P. *History and Historians in the Nineteenth Century.* 2nd ed. London, 1952.

Gorce, A. de la. *Une Vocation d'historien: Pierre de la Gorce.* 1948.

Gosselin, L. "Arcisse de Caumont et la politique." *Bulletin de l'association normande*, 1933.

———. "La Jeunesse studieuse d'Arcisse de Caumont." *Annuaire de l'association normande* 104 (1936).

Goubert, P. *Louis XIV et vingt millions de Français.* 1966.

———. *Cent mille provinciaux au XVIIe siècle: Beauvais et le Beauvaisis de 1600 à 1730.* Abr. ed. 1968.

———. *L'Ancien Régime.* 2 vols. 1969–73.

———. "Un Louis XIV républicain: Relire Ernest Lavisse." *Le Monde*, 28 July 1978.

Gourmont, Remy de. "La Physiologie et l'invention de la mentalité." In *Le Problème du style*, 55–67. 1902.

Gramsci, A. *Selections from the Prison Notebooks of Antonio Gramsci.* Ed. Q. Hoare and G. Nowell Smith. London, 1971.

Gras, C., and G. Livet, eds. *Régions et régionalisme en France du XVIIIe siècle à nos jours.* 1977.

Gréard, O. *Education et instruction.* Vol. 2. 2nd ed. 1889.

Greef, G. de. *La Sociologie économique.* 1904.

Grosperrin, B. *La Représentation de l'histoire de France dans l'historiographie des Lumières.* Vol. 1. Lille, 1982.

Guigniaut, J. D. "Notice historique sur la vie et les travaux de Joseph-Victor Le Clerc." *AIBL, comptes rendus des séances de l'année 1866*, n.s., 2 (1866), 247–60.

Guigue, A. *La Faculté des lettres de l'université de Paris depuis sa fondation (17 mars 1808) jusqu'au 1 janvier 1935.* 1935.

Guillaume, J. *L'Internationale: Documents et souvenirs.* Reprint. Geneva, 1980.

Guillaumin, E. *La Vie d'un simple.* 1904. Reprint. 1943.

Guiraud, P. *Fustel de Coulanges.* 1896.

Guizot, F. *Histoire de la civilisation en Europe* (lectures, 1828–30). 1829. Reprint. 1985.

———. *Histoire des origines du gouvernement représentatif* (lectures, 1820–22). 2 vols. 1851.

————. *Mémoires pour servir à l'histoire de mon temps.* 3 vols. 1858–60.

Halbwachs, M. *Les Expropriations et les prix des terrains à Paris, 1860–1900.* 1909.

————. *La Classe ouvrière et les niveaux de vie: Recherches sur la hiérarchie des besoins dans les sociétés industrielles contemporaines.* 1912.

————. *La Mémoire collective.* 1950.

Halévy, D. *Visites aux paysans du Centre, 1907–1934.* 1922–35. Reprint. 2 vols. in 1. 1978.

————. *La Fin des notables.* 2 vols. 1929–37.

————. *La République des comités: Essai d'histoire contemporaine, 1895–1934.* 1934.

————. *La République des ducs.* 1937.

Halkin, L. "Deux lettres inédits de Fustel de Coulanges au sujet de la Cité antique." *L'Annuaire de l'Institut de philologie et d'histoire orientales,* 1933–34, vol. 2.

Halperin, S. W., ed. *Essays in Modern European Historiography.* Chicago, 1970.

Hamelin, O. *Essai sur les éléments principaux de la représentation.* 1907.

Hanotaux, G. *Du choix d'une carrière.* 1902.

Hanriot, C. M. E. *Recherches sur la topographie des dèmes de l'Attique.* 1853.

Harrison, B. *Gabriel Monod and the Professionalization of History in France.* Ann Arbor, Mich., 1972.

Haskell, F. *Rediscoveries in Art: Some Aspects of Taste, Fashion and Collecting in England and France.* London, 1976.

Hauser, H. *Ouvriers du temps passé.* 1899.

————. *L'Enseignement des sciences sociales.* 1903.

————. *La Patrie, la guerre et la paix à l'école.* 1905.

————. *Les Compagnons d'arts et métiers à Dijon aux XVIIe et XVIIIe siècles.* 1907.

————. *Etudes sur la Réforme.* 1909.

————. "Emile Levasseur, 1828–1911." *Revue historique,* no. 108 (1911), 88–91.

————. *Travailleurs et marchands dans l'ancienne France.* 1920.

————. *Les Débuts du capitalisme.* 1927.

————. *La Prépondérance espagnole, 1559–1660.* 1933. Reprint. The Hague 1973.

————. *Recherches et documents sur l'histoire des prix en France, 1500–1800.* 1936.

————. *La Pensée et l'action économiques du cardinal de Richelieu.* 1944.

————, ed. *Sources de l'histoire de France, XVIe siècle (1494–1610).* 4 vols. 1906–15.

Hauser, H., and A. Ehrard. "L'Avenir et le rôle d'une petite université." *Revue universitaire* 6 (1897), 225–39.

Hauser, H., and A. Renaudet. *Les Débuts de l'âge moderne.* 1929.

Hautecoeur, L. *Histoire du Louvre.* 1928.

Hémon, F. *Bersot et ses amis.* 1911.

Henry, P. *Manuel des maîtres d'études ou conseils sur l'éducation dans les collèges de l'université.* 1842. Reprint. 1854. BN R 38395.

Herder, J. G. *Idées sur la philosophie de l'humanité.* Translated by E. Quinet. 1827.

Herisson, J. B. F. *Pestalozzi, élève de J. J. Rousseau.* 1886.

Hermant, D. "Destructions et vandalisme pendant la Révolution française." *AESC* 33 (1978).

Herrick, J. *The Historical Thought of Fustel de Coulanges.* Washington, D.C., 1954.

Hommage à Henri Berr, 1863–1954: Commémoration du centenaire de sa naissance. 1963.

Houtin, A. *La Controverse sur l'apostolicité des églises de France au XIXe siècle.* 3rd ed. 1903.

Huizinga, J. "Natuurbeeld en historiebeeld in de achttiende eeuw." 1933. Reprinted in *Verzamelde Werken,* 4. Haarlem, 1949.

———. "Homo Ludens." 1938. Reprinted in *Verzamelde Werken*, 5. Haarlem, 1950.

———. "Geschiedenis der (Groningse) universiteit gedurende de derde eeuw van haar bestaan, 1814–1914." 1914. Reprinted in *Verzamelde Werken*, 8. Haarlem, 1951.

———. "Universiteit." 1938. Reprinted in *Verzamelde Werken*, 8. Haarlem, 1951.

Huppert, G. *The Idea of Perfect History: Historical Erudition and Historical Philosophy in Renaissance France.* Chicago, 1970.

Iggers, G. G. *Deutsche Geschichtswissenschaft: Eine Kritik der traditionellen Geschichtsauffassung von Herder bis zur Gegenwart.* 1968. Reprint. Munich, 1971.

———. "Historicism." In P. P. Wiener, ed., *Dictionary of the History of Ideas*, vol. 3. New York, 1973.

———. *Neue Geschichtswissenschaft: Vom Historismus zur historischen Sozialwissenschaft. Ein internationaler Vergleich.* Munich, 1978.

Isaac, J. *Résumé, aide-mémoire, l'histoire contemporaine.* 1907.

Isambert-Jamati, V. *Crises de la société, crises de l'enseignement: Sociologie de l'enseignement secondaire français.* 1970.

———. "Une Réforme des lycées et des collèges: Essai d'analyse sociologique de la réforme de 1902." *Année sociologique* 20 (1970), 9–60.

Isnard, A. *Le Correspondant, table générale de 1875 à 1900.* 1902.

Izoulet, J. B. J. *La Cité moderne et la métaphysique de la sociologie.* 1894. 11th ed. 1910.

———. *De J. J. Russeo (J. J. Rousseau) utrum misopolis fuerit an philopolis ex genavensi codice cum caeteris Russei operibus collato quaeritus.* 1894.

Jacobs, A. J. *Géographie de Grégoire de Tours: Le pagus et l'administration de la Gaule.* 1858.

Jacquemart, P. *Professions et métiers: Guide pratique pour le choix d'une carrière à l'usage des familles et de la jeunesse.* Vol. 1. 1891.

Janet, P. *Victor Cousin et son oeuvre.* 1885.

Jarausch, K. H., ed. *The Transformation of Higher Learning, 1860–1930: Expansion, Diversification, Social Opening, and Professionalisation in England, Germany, Russia, and the United States.* Stuttgart, 1983.

Jardin, A., and A. J. Tudesq. *La France des notables: L'evolution générale, 1815–1848.* 1973.

Jaurès, J. *De primis socialisme germanici lineamentis apud Lutherum, Kant, Fichte et Hegel.* Toulouse, 1891. Translation in *Oeuvres de Jean Jaurès III: Etudes socialistes*, vol. 1, *1888–1897.* 1933.

———. "Socialisme et radicalisme en 1885." Introduction to Jaurès, *Discours parlementaires*, vol. 1. Ed. E. Claris. 1904.

Johnson, D. *Guizot, Aspects of French History, 1787–1874.* London, 1963.

Jolly, J., ed. *Dictionnaire des parlementaires: Notices biographiques sur les ministres, députés et sénateurs de 1889 à 1940.* Vols. 7 and 8. 1972–77.

Jullian, C. *Extraits des historiens français du XIXe siècle.* 1896.

———. "Le Cinquantenaire de la Cité antique." *Revue de Paris* 23 (February 1916), 852–65.

Kamerbeek, J., Jr. *Tenants et aboutissants de la notion "couleur locale."* Utrecht, 1962.

Kant, I. "Der Streit der Fakultäten." Reprinted in *Werke*, vol. 7. 1922.

Karady, V. "Stratégie et hiérarchie des études chez les universitaires littéraires sous la Troisième République." 1972.

———. "Durkheim, les sciences sociales et l'université: Bilan d'un semi-échec." *Revue française de sociologie* 17 (1976), 267–311.

Karéiev, N. "La Révolution française dans la science historique russe." *La Révolution française* 42 (1902), 321–36.

Kelley, D. R. *Foundations of Modern Historical Scholarship: Language, Law and History in the French Renaissance.* New York, 1970.

Keylor, W. R. *Academy and Community: The Foundation of the French Historical Profession.* Cambridge, Mass., 1975.

Kleinclausz, A. *L'Empire carolingien: Ses origines et ses transformations.* 1920.

―――. *Charlemagne.* 1934.

Knibiehler, Y. *Naissance des sciences humaines: Mignet et l'histoire philosophique au XIXe siècle.* 1973.

Koselleck, R. *Vergangene Zukunft: Zur Semantik geschichtlicher Zeiten.* Frankfurt am Main, 1979.

Kossmann, E. H. "De doctrinairen tijdens de Restauratie." *TvG* 64 (1951), 123–67.

Krauss, W., and H. Kortum, eds. *Antike und Moderne in der Literaturdiskussion des 18. Jahrhunderts.* Berlin, 1966.

Kuhn, T. S. *The Structure of Scientific Revolutions.* International Encyclopedia of Unified Science 2, pt. 2. 1962. 2nd ed. Chicago, 1970.

Kula, W. "Histoire économique: La longue durée." *AESC* 15 (1960).

La Bruyère, Jean de. *Les Caractères ou les moeurs de ce siècle.* 1688. Reprint. 1965.

Lacombe, P. *De l'histoire considérée comme science.* 1894.

Lacroix, L. *La Religion des Romains d'après les Fastes d'Ovide.* 1846.

Lacroix, L. *Dix ans d'enseignement historique à la faculté des lettres de Nancy.* 1865.

Lacroix, S. *Actes de la Commune de Paris pendant la Révolution.* 16 vols. 1894–1914.

Lakatos, L., and A. Musgrave, eds. *Criticism and the Growth of Knowledge.* Cambridge, 1970.

Lalande, A. *Vocabulaire technique et critique de la philosophie.* 11th ed. 1972.

Lamartine, A. *L'Histoire des Girondins.* 1847.

Lamennais, F. de. "Des Progrès de la Révolution et de la guerre contre l'Eglise." 1829. Reprinted in *Oeuvres complètes,* vol. 2. Brussels, 1839.

Landes, D. S. *The Unbound Prometheus: Technological Change and Industrial Development in Western Europe from 1750 to the Present.* Cambridge, 1972.

Landry, A. *L'Utilité sociale de la propriété individuelle.* 1901.

Langlois, C. "Des études d'histoire ecclésiastique locale à la sociologie religieuse historique." *Revue d'histoire de l'église de France* 62 (1976), 330–35.

Langlois, C.-V. *Le Règne de Philippe III le Hardi.* 1887.

―――. "Remarques à propos de l'agrégation d'histoire." *Revue universitaire* 2 (1892), 11–26.

―――. *Manuel de bibliographie historique.* 1896–1904.

―――. "Avertissement aux candidats à l'agrégation d'histoire." *Revue de synthèse historique,* no. 3 (1901), 249–66.

―――. *Saint Louis, Philippe le Bel, les derniers Capétiens directs, 1226–1328.* 1901.

―――. *La Société française au XIIIe siècle d'après dix romans d'aventure.* 1903.

―――. *La Vie en France au Moyen Age d'après quelques moralistes du temps.* 1908.

―――. *Connaissance de la nature et du monde au Moyen Age.* 1911.

―――. "Ernest Lavisse." *Revue de France* 2, no. 5 (1922).

Langlois, C.-V., and C. Seignobos. *Introduction aux études historiques.* 1897. 5th ed. 1924.

Langlois, C.-V., and H. Stein. *Les Archives de l'histoire de France.* 1891.

Lanson, G. *Essais de méthode, de critique et d'histoire littéraire.* 1965.

Lapie, P. *Logique de la volonté.* 1902.

Laprade, V. de. *Le Baccalauréat et les études classiques.* 1869.

Lartet, E. *Matériaux pour l'histoire positive et philosophique de l'homme, deuxième série.* 1866.

Lasserre, P. *La Doctrine officielle de l'université*. 1912.

Lavisse, E. *Etude sur l'une des origines de la monarchie prussienne ou la marche de Branden-bourg sous la dynastie ascanienne*. 1875.

————. *Etudes sur l'histoire de Prusse*. 1879. 6th ed. 1912.

————. "Albert Dumont." *Revue internationale de l'enseignement*, no. 9 (1885), 97–112.

————. *Essais sur l'Allemagne impériale*. 1887.

————. *Trois Empereurs de l'Allemagne*. 1888.

————. *Vue générale de l'histoire politique de l'Europe*. 1890.

————. *La Jeunesse du Grand Frédéric*. 1891.

————. "Le Concours d'agrégation et de géographie en 1892." *Revue universitaire* 2 (1892), 385–408.

————. *Le Grand Frédéric avant l'avènement*. 1893.

————. "La Réforme du concours d'agrégation d'histoire." *Revue universitaire* 3 (1894).

————. *A propos de nos écoles*. 1895.

————. *Un Ministre: Victor Duruy*. 1895.

————. *Louis XIV de 1643 à 1685*. 2 vols. 1905–6.

————. *Souvenirs*. 1912.

————. "Louis Liard." *Revue internationale de l'enseignement*, no. 72 (1918), 81–99.

————, ed. *Histoire générale du IVe siècle à nos jours*. 12 vols. 1893–1901.

————. *Histoire de France*. 18 vols. 1901–1911.

————. *Histoire de France contemporaine*. 9 vols. 1920–22.

Le Bon, G. *Psychologie du socialisme*. 1898.

Le Goff, J., ed. *La Nouvelle Histoire*. 1978.

Le Roy Ladurie, E. *Le Territoire de l'historien*. 1973.

————. *Paris—Montpellier: PC—PSU, 1945–1963*. 1982.

Lecanuet, R. P. *Montalembert*. Vol. 2. 1899.

Lecigne, C. *Quid de rebus politicis senserit Ludovicus Vives*. 1898.

Lecrivain, C. *Le Sénat romain depuis Dioclétien, à Rome et à Constantinople*. 1888.

Ledos, E. G. *Histoire des catalogues imprimés de la Bibliothèque Nationale*. 1936.

Lefebvre, G. *Etudes sur la Révolution française*. 1954.

Lefranc, G. *Le Mouvement socialiste sous la Troisième République I: 1875–1920*. 1977.

Legras, J. E. *De Karamzinio, Laurentii Sternii et J. J. Rousseau / nostri discipulo*. 1897.

Leguay, P. *Universitaires d'aujourd'hui*. 1912.

Lelong, E. *C. Port, 1828–1902*. Angers, 1902.

Leroux, P. *Réfutation de l'éclectisme*. 1839. Reprint. 1979.

Levasseur, E., and A. Himly. *Rapport général sur l'enseignement de l'histoire et de la géo-graphie*. Extract from *Bulletin administratif*. 1871. BN G 31602.

Lévi-Strauss, C. "Introduction: Histoire et ethnologie." In *Anthropologie structurale*. 1958.

Lévy, R. *Le Havre entre trois révolutions*. Le Havre. 1912.

Lévy-Leboyer, M. "L'Héritage de Simiand: Prix, profit, et termes d'échange au XIX siècle." *Revue historique*, no. 243 (1970), 77–120.

Lexis, W., ed. *Die deutschen Universitäten*. Vol. 1. Berlin 1893.

Liard, L. *L'Enseignement supérieur en France, 1789–1889*. 2 vols. 1888–94.

————. "Le Nouveau Plan d'études de l'enseignement secondaire: Les cadres—l'esprit." 1902. Reprinted in *Instructions concernant les programmes de l'enseignement secondaire*, 1–7. 1911.

Lichtenberger, A. *Le Socialisme au XVIIIe siècle: Etude sur les idées socialistes dans les écri-vains français du XVIIIe siècle avant la Révolution*. 1895.

Lion, H. G. M. *Les Tragédies et les théories dramatiques de Voltaire*. 1895.

Littré, E. *Dictionnaire de la langue française: Supplement.* 1878.

Locatelli, R., et al. *La Franche-Comté à la recherche de son histoire, 1800–1914.* 1982.

Longnon, A. *De la formation de l'unité française.* 1890.

———. "A. Maury." *Revue internationale de l'enseignement,* no. 13 (1893).

Lot, F. *L'Enseignement supérieur en France ce qu'il est, ce qu'il devrait être.* 1892.

———. "Chartistes et archivistes: Réponse à M. Aulard." *Revue internationale de l'enseignement,* no. 26 (1906).

———. "Statistique du personnel enseignant des facultés de philosophie en Allemagne (philosophie, histoire, philologie)." *Revue internationale de l'enseignement,* no. 58 (1909), 494–99.

———. *Diplômes d'études et dissertations inaugurales: Etude de statistique comparée.* 1910.

———. "L'Histoire à l'école pratique des hautes études." *Bibliothèque de l'école des hautes études, IVe section,* 231 (1922).

Löwith, K. *Weltgeschichte und Heilsgeschehen: Die theologischen Voraussetzungen der Geschichtsphilosophie.* 1953. Reprint. 1967.

Lucas-Dubreton, J. *Le Culte de Napoléon, 1815–1848.* 1960.

Lukes, S. *Emile Durkheim, His Life and Work: A Historical and Critical Study.* Harmondsworth, 1975.

Lulofs, B. H. *Nederlandsche Redekunst of grondbeginselen van stijl en welsprekendheid voor Nederlanders.* 2nd ed. Groningen, 1831.

Maarsen, N. J. *De strijd om de Revolutie in de Restauratie.* Assen, 1976.

Maigron, L. *Le Roman historique à l'époque romantique: Essai sur l'influence de Walter Scott.* 1898.

Maire, A. *Répertoire alphabétique des thèses ès lettres des universités françaises, 1810–1900.* 1903.

Mandrou, R. *De la culture populaire aux XVIIe et XVIIIe siècles.* 1964.

Mantoux, P. *La Révolution industrielle au XVIIIe siècle: Essai sur les commencements de la grande industrie en Angleterre.* 1905.

Marcilhacy, C. *Le Diocèse d'Orléans sous l'épiscopat de Mgr. Dupanloup, 1849–1878: Sociologie religieuse et mentalités collectives.* 1962.

Margerie, A. de. *Souvenirs.* Sens, 1907.

Mariéjol, J. H. *Un Lettré italien à la cour d'Espagne (1488–1526): Pierre Martyr d'Anghera, sa vie et ses oeuvres.* 1887.

Marion, M. *Machault d'Arnouville: Etude sur l'histoire du contrôle général des finances de 1749 à 1754.* 1891.

———. *La Vente des biens nationaux, avec étude spéciale des ventes dans le département de la Gironde et du Cher.* 1908.

———. *Histoire financière de la France depuis 1715.* 6 vols. 1914–31.

———. *Dictionnaire des institutions de la France aux XVIIe et XVIIIe siècles.* 1923.

Marrou, H. I. *Saint Augustin et la fin de la culture antique.* 1938.

———. *Histoire de l'éducation dans l'antiquité.* 1948.

———. *De la connaissance historique.* 1954.

———. "Philologie et histoire dans la période du pontificat de Léon XIII." In *Aspetti della cultura cattolica nell'eta di Leone XIII,* 71–105. Rome, 1960.

Martin, H. J. "Culture écrite et culture orale, culture savante et culture populaire dans la France d'Ancien Régime." *Journal des savants,* 1975.

Marx, K. *La Lutte des classes.* 1900.

Marx, K., and F. Engels. *Le Manifeste communiste.* Translated and introduced by C. Andler. 1901.

Maspéro, G. *Histoire ancienne des peuples de l'Orient.* 1875.

Masson, F. "Correspondance d'Ernest Renan et du Prince Napoléon." *Revue des deux mondes* 92 (1 November 1922).

Mathiez, A. *La Vie chère et le mouvement social sous la Terreur.* 1927.

Maurras, C. *L'Avenir de l'intelligence.* 1909.

Maury, A. *La Terre et les hommes.* 1861.

———. *L'Ancienne Académie des Inscriptions et des Belles Lettres.* 1864.

Mayer, A. *The Persistence of the Old Régime: Europe to the Great War.* London, 1981.

Mayeur, F. "Fustel de Coulanges et les questions d'enseignement supérieur." *Revue historique,* no. 274 (1985), 388–408.

Mayeur, J. M. *Les Débuts de la Troisième République, 1871–1898.* 1973.

Meaux, A. de. *Augustin Cochin et la génèse de la Révolution.* 1928.

Mélanges de Caumont. BN Lj¹ 259.

Mellon, S. *The Political Uses of History: A Study of Historians in the French Restoration.* Stanford, 1958.

Menger, A. *Le Droit au produit intégral du travail.* Translated and introduced by C. Andler. 1900.

Merlin, R. Preface to *Bibliographie de la France.* 1850.

Merton, R. K. *The Sociology of Science: Theoretical and Empirical Investigations.* Ed. N. W. Storer. Chicago, 1973.

Meuvret, J. *Etudes d'histoire économique: Recueil d'articles.* 1971.

Meyer, J. *La Noblesse bretonne au XVIIIe siècle.* Vol. 2. 1966.

———. *Colbert.* 1981.

Meynier, A. *Histoire de la pensée géographique en France.* 1969.

Michelet, J. *Examen des vies des hommes illustres de Plutarque.* 1819.

———. *Précis de l'histoire moderne.* 1827. 7th ed. 1842.

———. *Le Peuple.* 1846. Reprint. 1974.

———. *Histoire de la Révolution française.* 2 vols. 1847.

———. *Journal.* 4 vols. 1959–76.

———. *Oeuvres complètes.* 3 vols. to date. 1971–.

———. *Histoire de France.* Edition J. Rouff. 4 vols. N.d.

Mignet, A. *Notices et mémoires historiques.* Brussels, 1843.

Milhaud, G. *La Philosophie de Charles Renouvier.* 1927.

Milward, A. S., and S. B. Saul. *The Development of the Economies of Continental Europe, 1850–1914.* London, 1977.

Mireaux, E. *Guizot et la renaissance de l'Académie des sciences morales et politiques.* 1957.

———. *Le Coup d'état académique du 14 avril 1855.* 1963.

Mirecourt, E. de. *Salvandy.* 1856.

Molinier, C. *L'Inquisition dans le Midi de la France aux XIIIe et au XIVe siècles.* 1880.

Momigliano, A. *Studies in Historiography.* New York, 1966.

———. *Essays in Ancient and Modern Historiography.* Middletown, Conn., 1977.

———. Preface to N. D. Fustel de Coulanges, *The Ancient City.* Baltimore, 1982.

———. "The Introduction of History as an Academic Subject and Its Implications." *Minerva* 21 (1983) 1–15.

Monglond, A. *Le Préromantisme français.* Vol. 2. Grenoble, 1930.

Monnier, H. *Alcuin et Charlemagne.* 2nd ed. 1864.

Monod, G. *Allemands et Français.* 1871.

———. *De la possibilité d'une réforme de l'enseignement supérieur.* 1874. Reprint. 1876.

————. "Du progrès des études historiques en France depuis le XVIe siècle." 1876. Reprinted in *Revue historique*, no. 255 (1976), 297–324.

————. "Les Réformes de l'enseignement secondaire." *Revue historique*, no. 14 (1880), 358–69.

————. *Les Maîtres de l'histoire: Renan, Taine, Michelet.* 1894. 3rd ed. 1896.

————. *Portraits et souvenirs.* 1897.

————. "Tommy Perrens, 1822–1901." *Revue internationale de l'enseignement*, no. 21 (1901).

————. *Souvenirs d'adolescence: Mes relations avec Mgr. Dupanloup. Lettres inédits.* 1903.

————. "La Chaire d'histoire au Collège de France." *La Revue politique et littéraire (Revue bleue)*, 9, 16, 23 December 1905.

————. "Albert Sorel." *Revue historique* 92 (1906), 91–99.

————. *A Gabriel Monod en souvenir de son enseignement: Ecole pratique des hautes études 1868–1905, Ecole Normale supérieure 1880–1904.* 1907.

————. "Histoire." In *De la méthode dans les sciences*, 319–409. 1909.

————. *La Vie et la pensée de Jules Michelet.* 1923.

————. Introduction to the translation of J. R. Green, *Histoire du peuple anglais.* 1888. Originally in English.

————. Introduction to the translation of H. Boehmer, *Les Jésuits.* 1910. Originally in German.

Monseigneur L. Duchesne et son temps. Colloquium of the Ecole française de Rome. 1975.

Montaigne, M. *Essais.* 1580. Reprint. 1969.

Montalembert, C. de. *Histoire de la Sainte Elisabeth de Hongrie.* 1834.

————. *Les Moines d'Occident depuis Saint Benoist jusqu'à Saint Bernard.* Vol. 1. 1860.

Morel, E. "La Production de la librairie française et le Dépôt légal en 1908." *Mercure de France* 78 (1909), 181–84.

————. "La Statistique internationale de la production intellectuelle." *Le Droit d'auteur* 21 (1909), 162–63.

————. "La Production de l'imprimerie française en 1909." *Mercure de France* 84 (1910), 466–82.

Nadeau, L. *Chateaubriand et le romantisme.* 1871.

Namier, L. B. *1848: The Revolution of the Intellectuals.* 1944. 6th ed. London, 1971.

Napoléon I. *Correspondance de Napoléon I.* Published by order of the Emperor Napoléon III. Vols. 15 and 20. 1864 and 1866.

Newman, P. *Un Romancier périgordin: Eugène Le Roy.* 1957.

Nicolet, C. *Le Radicalisme.* 1957.

————. *L'Idée républicaine en France: Essai d'histoire critique.* 1982.

Nietzsche, F. "Vom Nutzen und Nachteil der Historie für das Leben." In *Unzeitgemässe Betrachtungen.* 1873. Reprint. Stuttgart, 1976.

Nisbet, R. A. *The Sociological Tradition.* London, 1966.

Nora, P., ed. *Les Lieux de mémoire, I: La République.* 1984.

————. *Les Lieux de mémoire, II: La Nation.* 3 vols. 1986.

O'Boyle, L. "The Problem of the Excess of Educated Men in Western Europe, 1800–1850." *Journal of Modern History* 42 (1970), 471–95.

Offringa, C. "Een whig-interpretatie van de Duitse geschiedenis: Een aspect van de DDR-historiografie." *Kleio* 16 (1975), 448–60.

Orléans, Henri d', duc d'Aumale. *Histoire des princes de Condé pendant les XVIe et XVIIe siècles.* 2 vols. 1869.

Ostrogorski, M. *La Démocratie et l'organisation des partis politiques.* 2 vols. 1903.

Pagès, G. "L'Histoire au lycée." *Revue de synthèse historique*, no. 15 (1907), 299–311.

Paris, G. *Le Haut Enseignement historique et philologique en France.* 1894. Originally in *Journal des débats*, 1893–94.

Pariset, G. *L'Etat et les églises en Prusse sous Frédéric-Guillaume Ier, 1713–1740.* 1897.

———. *Etudes d'histoire révolutionnaire et contemporaine.* 1929.

Parker, H. T. *The Cult of Antiquity and the French Revolutionaries.* Chicago, 1937.

Parmentier, A. *Le Moyen-Age.* 1898.

Paulsen, F. *Geschichte des gelehrten Unterrichts auf den deutschen Schulen und Universitäten.* 2 vols. Leipzig, 1896–97.

———. *Die deutschen Universitäten and das Universitätsstudium.* Berlin, 1902.

Paxton, R. O. *La France de Vichy, 1940–1944.* Translated by Claude Bertrand. 1973.

Paz, M. "Alfred Maury, membre de l'Institut, chroniqueur de Napoléon III et du Second Empire." *Revue des travaux de l'Académie des sciences morales et politiques*, 1964, 248–64.

Perrens, T. *Etienne Marcel et le gouvernement de la bourgeoisie au XIVe siècle, 1356–1358.* 1860.

Perrin, C. E. *Un Historien français: Ferdinand Lot, 1866–1952.* Geneva, 1968.

Perrot, G. "Léopold Delisle." *BEC* 72 (1912), 5–72.

———. "Notice sur la vie et les travaux de Auguste-Honoré Longnon." *AIBL, séance publique annuelle.* 1913.

Petit de Julleville, L., ed. *Histoire de la langue et de la littérature française des origines à 1900.* Vol. 8. 1900.

Petit-Dutaillis, C. "Sébastien Charléty, 1867–1945." *Revue historique*, no. 195 (1945).

Pfister, C. *Etudes sur le règne de Robert le Pieux, 996–1031.* 1885.

———. "Robert Parisot." *Revue historique*, no. 165 (1930), 430–31.

Picavet, C. G. "Matérialisme historique." *Revue de synthèse historique*, no. 20 (1910), 182ff.

Pickering, W. S. F. "Gaston Richard: Collaborateur et adversaire." *Revue française de sociologie* 20 (1979), 163–82.

Pocock, J. G. A. "The Origins of the Study of the Past, a Comparative Approach." *Comparative Studies in Society and History* 4 (1961–62), 209–46.

Poirson, A., and C. Cayx. *Précis de l'histoire ancienne.* 1827. 12th ed. 1853.

La Politique et l'histoire contemporaine dans une école du clergé. 1864.

Pommier, J. "Un Témoignage sur Ernest Renan: Les souvenirs de L. F. A. Maury." *Cahiers Ernest Renan* 1 (1971).

Popper, K. *The Logic of Scientific Discovery.* London, 1959.

Porchnev, B. *Les Soulèvements populaires en France de 1623 à 1648.* Abr. ed. 1972.

Posthumus, N. W. *De geschiedenis van de Leidsche lakenindustrie.* Vol. 3. The Hague, 1939.

Poulot, D. "Naissance du monument historique." *RHMC* 32 (1985), 418–50.

Pouthas, C. H. *Guizot pendant la Restauration.* 1923.

———. "Le Clergé sous la monarchie constitutionelle." *Revue d'histoire de l'église de France* 29 (1943), 49ff.

Préteux, P. A. G. *Camus avocat, premier garde général des Archives Nationales.* 1932.

Primi Visconti, L. *Mémoires sur la cour de Louis XIV.* Translated by J. Lemoine. 1909.

Prost, A. *L'Enseignement en France, 1800–1967.* 1968.

Prou, M. Introduction to *Livre du centenaire: Ecole des chartes.* 1921.

Puaux, F. *Vers la justice.* 1906.

Quack, H. P. G. "De ideeën van den Heer Jean Izoulet." *De Gids* 62, no. 2 (1898), 434–84.

Quicherat, J. *Mélanges d'archéologie et d'histoire*. Vol. 1. 1885.

Quinet, E. *Le Christianisme et la Révolution française*. 1845.

Rabanis, J. F. *Lettre à M. Cousin, pair de France, ancien ministre de l'instruction publique sur l'enseignement de l'histoire*. Bordeaux, 1842.

Radet, G. *La Lydie et le monde grec au temps de Mermnades, 687–546*. 1892.

———. *L'Histoire et l'oeuvre de l'école française d'Athènes*. 1901.

Ragon, F. *Histoire de France*. 1835. 14th ed. 1852.

———. *Histoire générale des temps modernes*. 5th ed. 1845.

Ratzel, F. *Der Staat und sein Boden geographisch beobachtet*. Leipzig, 1897.

———. *Anthropogeographie*. Pt. 1. *Grundzüge der Anwendung der Erdkunde auf der Geschichte*. 2nd ed. Stuttgart, 1899.

Raveau, P. *L'Agriculture et les classes paysannes dans le Haut-Poitou au XVIe siècle*. 1926.

Rebérioux, M. *La France radicale? 1898–1914*. 1975.

———. "Histoire, historiens et dreyfusisme." *Revue historique*, no. 518 (1976), 407–32.

Refort, L. *L'Art de Michelet dans son oeuvre historique jusqu'en 1867*. 1923.

Reid, T. *Inquiry into the Human Mind on the Principles of Common Sense*. 1764.

———. *Essai sur les facultés intellectuelles de l'homme*. Translated and introduced by Th. Jouffroy. 1829.

Reinach, J. *Histoire de l'Affaire Dreyfus*. 7 vols. 1901–11.

Reinach, S. "Esquisse d'une histoire du musée Campana." *Revue archéologique*, 1905.

Reinhardt, M., ed. *Histoire de France*. Vol. 1. 1954.

Reisov, B. *L'Historiographie romantique française, 1815–1830*. Moscow, 1963. Originally in Russian.

Rémond, R. *La Droite en France de 1815 à nos jours: Continuité et diversité d'une tradition politique*. 1954.

Renan, E. *La Réforme intellectuelle et morale de la France*. 1871. Reprint. 1967.

Renouvin, P. "Epoque contemporaine." In *IXe Congrès internationale des sciences historiques*. 1950.

Rethwisch, C. "Geschichtlicher Rückblick." In W. Lexis, ed., *Die Reform des höheren Schulwesens in Preussen*, 1–34. Halle, 1902.

Ringer, F. *The Decline of the German Mandarins: The German Academic Community, 1890–1933*. Cambridge, Mass. 1969.

Rollin, C. *Traité des études: De la manière d'enseigner et d'étudier les belles lettres par rapport à l'esprit et au coeur*. 4 vols. Reprint. 1810.

Rosseeuw Saint-Hilaire, E. F. A. *Histoire d'Espagne depuis les premiers temps historiques jusqu'à la mort de Ferdinand VII*. 5 vols. 1836–41. Rev. ed. 14 vols. 1844–79.

Rothblatt, S. *The Revolution of the Dons: Cambridge and Society in Victorian England*. London, 1968.

Rougerie, J. *Paris Libre: 1871*. 1971.

Roussel, A. "Correspondance inédite de Lamennais et de l'abbé Guéranger, 1829–1832." *Demain: Politique, social, religieux* (weekly), 24 November and 1 December 1905.

Roussier, T. *Le Principe du socialisme en France et l'évangile*. Croix, 1890.

Roux, E. "Correspondance d'Emmanuel Roux: Les débuts de l'Ecole française d'Athènes." *Bibliothèque des universités du Midi*, fasc. 1. Bordeaux, 1898.

Sagnac, P. *La Législation civile de la Révolution française, 1789–1804*. 1898.

———. "De la méthode (historique) dans l'étude des institutions de l'Ancien Régime." *RHMC* 6 (1904–5), 5–21.

Samaran, C., ed. *L'Histoire et ses méthodes*. 1961.

Say, L., and J. Chailley, eds. *Nouveau dictionnaire d'économie politique*. 4 vols. 1891.

Schlumberger, G. *Mes Souvenirs, 1844–1928*. 2 vols. 1934.

Scott, J. A. *Republican Ideas and the Liberal Tradition in France, 1870–1914*. New York, 1951.

Séché, A. *Dans la mêlée littéraire, 1900–1930: Souvenirs et correspondance*. 1935.

Sée, H. *Louis XI et les villes*. 1891.

——. *Les Etats de Bretagne au XVIe siècle*. 1895.

——. *Etudes sur les classes serviles en Champagne du XIe au XIVe siècle*. 1895.

——. *Etudes sur les classes rurales en Bretagne au Moyen Age*. 1896.

——. *Les Classes rurales et le régime domanial en France au Moyen Age*. 1901.

——. *Les Classes rurales en Bretagne du XVe siècle à la Révolution*. 1906.

——. *Französische Wirtschaftsgeschichte*. 2 vols. 1930.

Sée, H., and A. Lesort, eds. *Cahiers de doléances de la sénéchaussée de Rennes*. 4 vols. 1909–13.

Seignobos, C. "L'Enseignement de l'histoire dans les universités allemandes." *Revue internationale de l'enseignement*, no. 1 (1881).

——. *Le Régime féodal en Bourgogne jusqu'en 1360: Essai sur la société et les institutions d'une province française au Moyen-Age*. 1882.

——. "Conditions psychologiques de la connaissance en histoire." *Revue philosophique* 24 (1887), 1–32, 168–97.

——. *Histoire politique de l'Europe contemporaine: Evolution des partis et des formes politiques, 1814–1896*. 1897.

——. *La Méthode historique appliquée aux sciences sociales*. 1901.

——. *Le Régime de l'enseignement supérieur des lettres: Analyse et critique*. 1904.

——. "Les Conditions pratiques de la recherche des causes dans le travail historique." *Bulletin de la société française de philosophie* 7 (1907), 263–309.

——. "L'Inconnu et l'inconscient en histoire." *Bulletin de la société française de philosophie* 8 (1908), 216–47.

——. *L'Evolution de la Troisième République, 1875–1914*. 1921.

——. *La Révolution de 1848: Le Second Empire, 1848–1859*. 1921.

——. "Ernest Lavisse." *Revue universitaire* 31 (1922), 257–67.

——. *Histoire sincère de la nation française*. 1933. 7th ed. 1969.

——. *Etudes de politique et d'histoire*. 1934.

Seippel, P. *Les Deux France et leurs origines historiques*. Lausanne, 1905.

Serman, S. W. *Les Corps des officiers français sous la IIe République et le Second Empire: Aristocratie et démocratie dans l'armée au milieu du XIXe siècle*. Lille, 1978.

Seznec, J. *Essais sur Diderot et l'antiquité*. Oxford, 1957.

Siegel, M. "Science and Historical imagination: Patterns of French Historiographical Thought, 1866–1914." Ph.D. diss., Columbia University, 1965.

——. "Henri Berr, French Prophet of Total Science at the Turn of the Century." Paper delivered at the Historiographical Congress, Montpellier, July 1983.

Simiand, F. "Etudes critiques: L'année sociologique 1897." *Revue de métaphysique et de morale* 6 (1898), 633–41.

——. "Méthode historique et science sociale." *Revue de synthèse historique*, no. 6 (1903), 1–22, 129–59. Reprinted in *AESC* 15 (1960), 83–120.

——. *Le Salaire des ouvriers des mines en France*. 1904.

——. "La Causalité en histoire." *Bulletin de la société française de philosophie* 6 (1906), 245–72.

——. "Bases géographiques de la vie sociale." *Année sociologique* 11 (1906–9), 723–32.

Sion, J. *Les Paysannes de Normandie-Est: Etude géographique sur les populations rurales de Caux et du Bray, du Vexin normand et de la vallé de la Seine.* 1908.

Smith, R. J. "L'Atmosphère politique à l'Ecole normale supérieure à la fin du XIXe siècle." *RHMC* 20 (1973), 248–68.

———. *The Ecole Normale Supérieure and the Third Republic.* New York, 1982.

Snyders, G. *La Pédagogie en France aux XVIIe et XVIIIe siècles.* 1963.

Solla Price, D. J. de. *Little Science, Big Science.* New York, 1963.

———. *Science since Babylon.* 2nd ed. London, 1975.

Sorre, M. *Les Pyrénées méditerranéennes: Etude de géographie biologique.* 1905.

———. *Etude critique des sources de l'histoire de la viticulture et du commerce des vins et eaux-de-vie en Bas-Languedoc au XVIIIe siècle.* Montpellier, 1913.

Spiess, P. E. *Von Archiven.* Halle, 1777.

Spruijt, C. B. "Een doctoraat in de geschiedenis." *De Gids* 20, no. 2 (1882), 103–33.

Stadler, P. *Geschichtsschreibung und historisches Denken in Frankreich, 1789–1871.* Zurich, 1958.

Statistisches Jahrbuch für das deutsche Reich, vol. 32. 1911.

Steed, H. W. *Trente années de vie politique en Europe.* Vol. 1. *Mes Souvenirs, 1892–1914.* 1926. Originally published as *Through Thirty Years* (1924).

Stewart, D. *Histoire abrégée des sciences métaphysiques, morales et politiques depuis la Renaissance des lettres.* Translated by M. Buchon. 3 vols. 1820–23.

Stoianovich, T. *French Historical Method: The Annales Paradigm.* Ithaca, 1976.

Le Surveillant politique et littéraire. May 1818.

Table générale, 6e périod, 1911–1921. 1921.

Taine, H. *Les Philosophes classiques du XIXe siècle en France.* 1856.

———. Preface to *Essais de critique et d'histoire.* 1866. 8th ed. 1900.

———. *Les Origines de la France contemporaine: L'Ancien Régime.* 1876. 16th ed. 1887.

———. *Les Origines de la France contemporaine: La Révolution.* 3 vols. 1878–85.

———. *Les Origines de la France contemporaine: Le régime moderne.* 2 vols. 1891–94.

———. *Sa vie et sa correspondance.* 4 vols. 1902–7.

Tanguy, B. *Aux Origines du nationalisme breton: Le Renouveau des études bretonnes au XIXe siècle.* 2 vols. 1977.

Tardieu, A. "La Campagne contre la patrie: L'instrument, la doctrine, l'application." *Revue des deux mondes* 83 (1 July 1913), 80–105.

Tascher de la Pagerie, S. de. *Mon Séjour aux Tuileries.* Vol. 1. Reprint. 1893.

Texte, J. H. *Jean-Jacques Rousseau et les origines du cosmopolitisme littéraire: Etude sur les relations littéraires de la France et de l'Angleterre au XVIIIe siècle.* 1895.

Thabault, R. *Mon Village, ses hommes, ses routes, son école: 1848–1914, l'ascension d'un peuple.* 1943. Reprint. 1982.

Thibaudet, A. *La République des professeurs.* 1927. Reprint. Geneva, 1979.

Thibaut, F. *Quid de puellis instituendis senserit Vives.* 1888.

Thierry, A. *Lettres sur l'histoire de France.* 1820. Reprint. 1827.

———. *Récits des temps mérovingiens.* 1840.

Thuillier, A. *Economie et société nivernaises au début du XIXe siècle.* The Hague, 1972.

Tonnelat, E. *Charles Andler, sa vie et son oeuvre.* 1937.

Tourneur-Aumont, J. M., *Fustel de Coulanges, 1830–1889.* 1931.

Trognon, A. *Etudes sur l'histoire de France et quelques points de l'histoire moderne.* 1836.

Trompf, G. W. *The Idea of Recurrence in Western Thought from Antiquity to the Reformation.* Berkeley, 1979.

Tronchon, H. *La Fortune intellectuelle de Herder en France: La préparation.* 1920.

Tudesq, A. J. *Les Grands Notables en France, 1840–1849: Etude historique d'une psychologie sociale*. Vol. 1. Bordeaux, 1964.

Turner, R. S. "University Reformers and Professional Scholarship in Germany, 1760–1806." In L. Stone, ed., *The University in Society*, 2:495–531. Princeton, 1974.

Turpin, F. H. *La France illustre ou le Plutarque français*. 4 vols. 1780.

Valès, A. *Edgar Quinet, sa vie et son oeuvre*. Carrières-sous-Poissy, 1936.

Valez, A. *Le Socialisme catholique en France à l'heure actuelle*. Montauban, 1892.

Vallès, J. *Le Bachelier*. 1881.

Vauthier, G. "Chateaubriand, historiographe du roi." *Feuilles d'histoire du XVIIe au XXe siècle*. 1912.

Veblen, T. *The Theory of the Leisure Class*. 1899. Reprint. New York, 1953.

Vernier, L. V. *Etude sur Voltaire grammarien et la grammaire au XVIIIe siècle*. 1888.

Véron de Forbonnais, F. *Recherches et considérations sur les finances de France depuis l'année 1595 jusqu'à l'année 1721*. Vol. 1. Basel, 1758.

Viallaneix, P. *La Voie royale: Essai sur l'idée de peuple dans l'oeuvre de Michelet*. Rev. ed. 1971.

Viardot, L. *Les Musées de France*. 1860.

Villemain, F. *Exposé des motifs et projet de loi sur l'instruction publique secondaire, présenté à la Chambre des députés le 2 février 1844, précédé du rapport au Roi en date du 3 mars 1843 sur l'état de cette instruction en France*. 1844.

Viollet-le-Duc, E. E. *Dictionnaire raisonné du mobilier français*. 6 vols. 1858–75.

———. *Dictionnaire raisonné de l'architecture française du XIe au XVIe siècle*. 10 vols. 1867–73.

Voss, J. *Das Mittelalter im historischen Denken Frankreichs*. Munich, 1972.

Vossler, O. "Humboldts Idee der Universität." *Historische Zeitschrift* 178 (1954), 251–68.

Waddington, A. *L'Acquisition de la couronne royale de Prusse par les Hohenzollern*. 1888.

———. *La République des Provinces-Unies: La France et les Pays-Bas espagnols de 1630 à 1650*. 2 vols. 1895–97.

———. *Le Grand Electeur Frédéric Guillaume de Brandenbourg, sa politique extérieure, 1640–1688*. 2 vols. 1905–8.

Wahl, M. *Les Premières Années de la Révolution à Lyon, 1788–1792*. 1894.

Wailly, N. de. *Eléments de paléographie*. Vol. 1. 1838.

Weber, E. *Action française*. Stanford, 1962.

———. *The Nationalist Revival in France, 1905–1914*. Berkeley and Los Angeles, 1959.

———. *Peasants into Frenchmen: The Modernization of Rural France 1870–1914*. London, 1977.

Weber, M. *Wirtschaft und Gesellschaft: Grundriss der verstehenden Soziologie*. In Studienausgabe J. Winckelmann, ed. Vol. 2. Cologne, 1964.

Weill, G. *Les Théories sur le pouvoir en France pendant les guerres de religion*. 1892.

———. *Histoire du parti républicain en France de 1814 à 1870*. 1900. Reprint. Geneva, 1980.

———. *Histoire du mouvement social en France, 1852–1902*. 1904.

———. "Le Catholicisme français au XIXe siècle." *Revue de synthèse historique*, no. 15 (1907), 330–35.

———. *Histoire du catholicisme libéral en France, 1828–1908*. 1909. Reprint. Geneva, 1979.

———. *Histoire de l'idée laïque en France au XIX siècle*. 1925.

———. *L'Eveil des nationalités et le mouvement libéral, 1815–1848*. 1930.

———. *Le Journal: Origines, évolution et rôle de la presse périodique*. 1934.

————. *L'Europe du XIXe siècle et l'idée de nationalité*. 1938.

Weisz, G. *The Emergence of Modern Universities in France, 1863–1914*. Princeton, 1983.

Wesseling, H. L. *Soldaat en krijger: Franse opvattingen over leger en oorlog, 1905–1914*. Assen, 1969.

Wilson, S. "Fustel de Coulanges and the *Action française.*" *Journal of the History of Ideas* 34 (1973), 123–34.

Windenberg, J. L. M. *Essai sur le système de politique étrangère de J. J. Rousseau—La République confédérative des petits états*. 1899.

Wittram, R. "Das Interesse an der Geschichte." *Welt als Geschichte* 1 (1952).

Worms, R. *Organisme et société*. 1895.

Zeldin, T. *France, 1848–1945*. 2 vols. Oxford, 1973–77.

Zeller, J. *Pie IX et Victor Emmanuel, 1846–1878*. 1879.

About the Author

PIM DEN BOER is Professor of History of European Culture at the University of Amsterdam. He is the author of *Europa: De geschiedenis van een idee* (*Europe: The History of an Idea*).